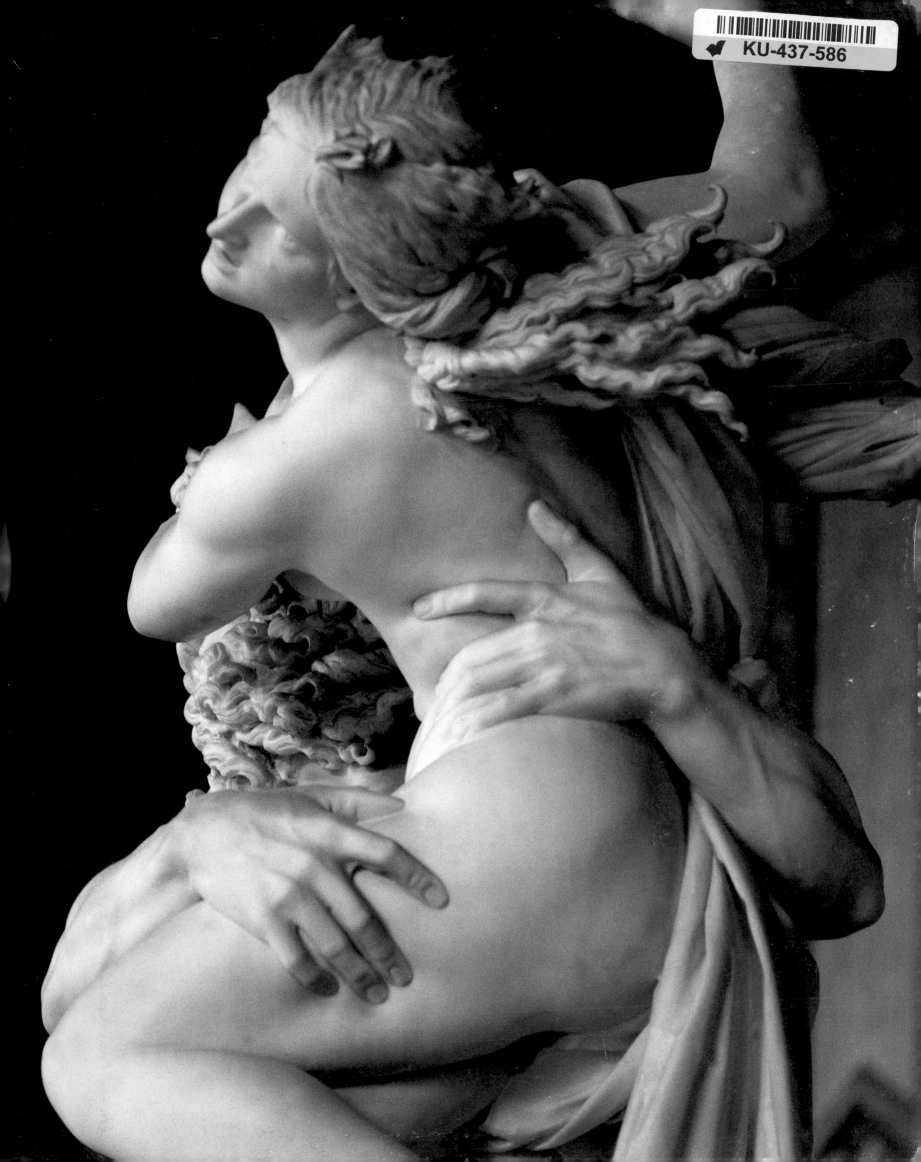

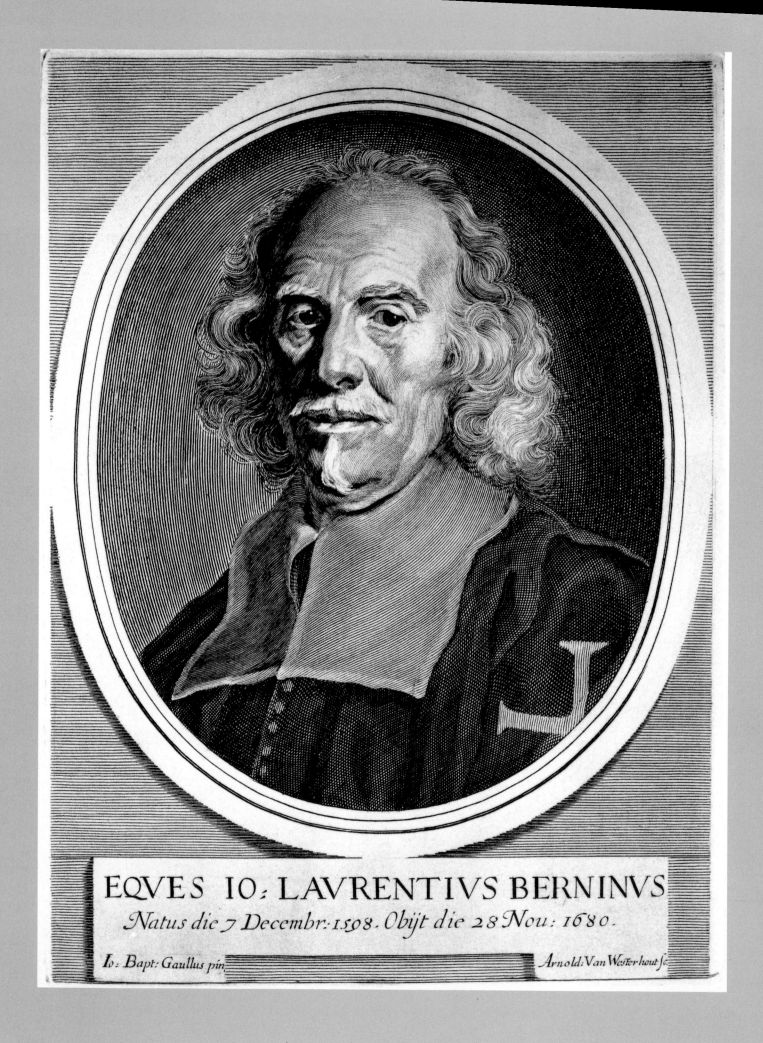

EQVES IO: LAVRENTIVS BERNINVS

Natus die 7 Decembr: 1598. Obijt die 28 Nou: 1680.

Io: Bapt: Gaullus pin. Arnold: Van Westerhout sc.

BERNINI

Genius of the Baroque

CHARLES AVERY

Special photography by David Finn

*With 400 illustrations, 80 in colour
and 142 duotone*

Thames & Hudson

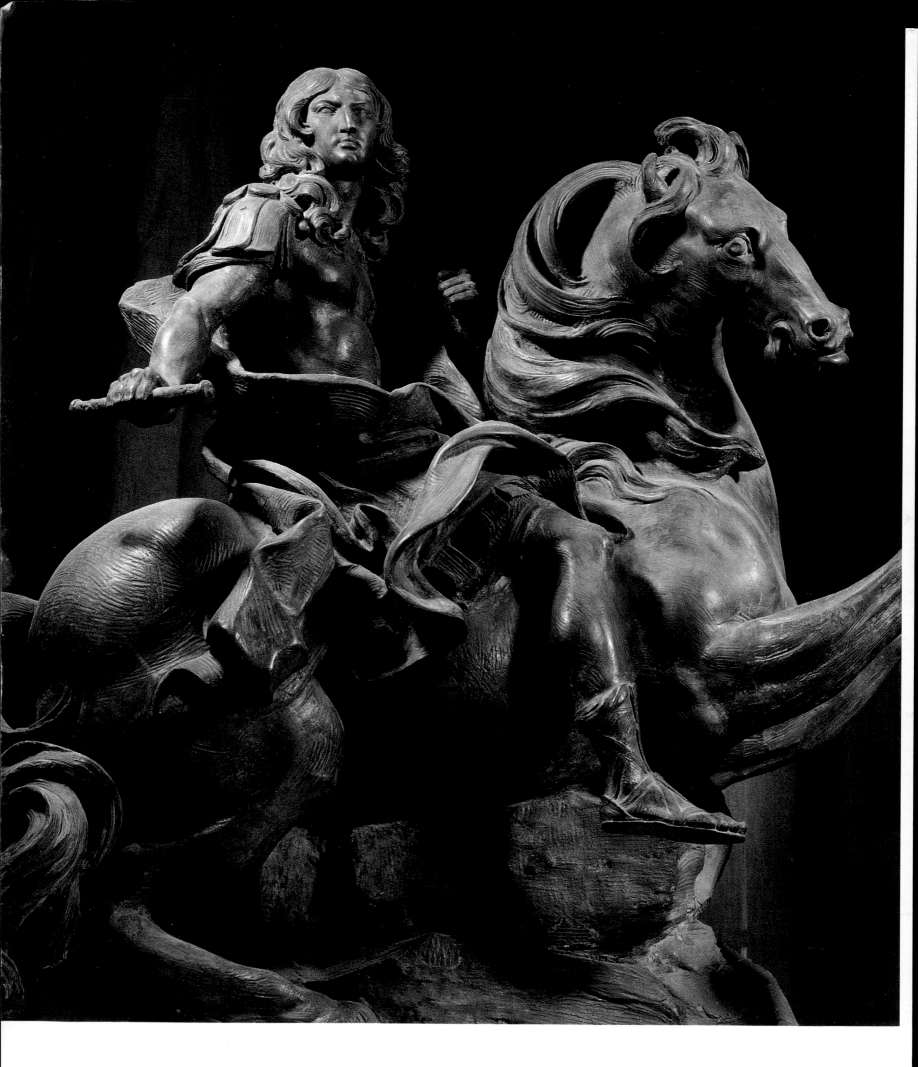

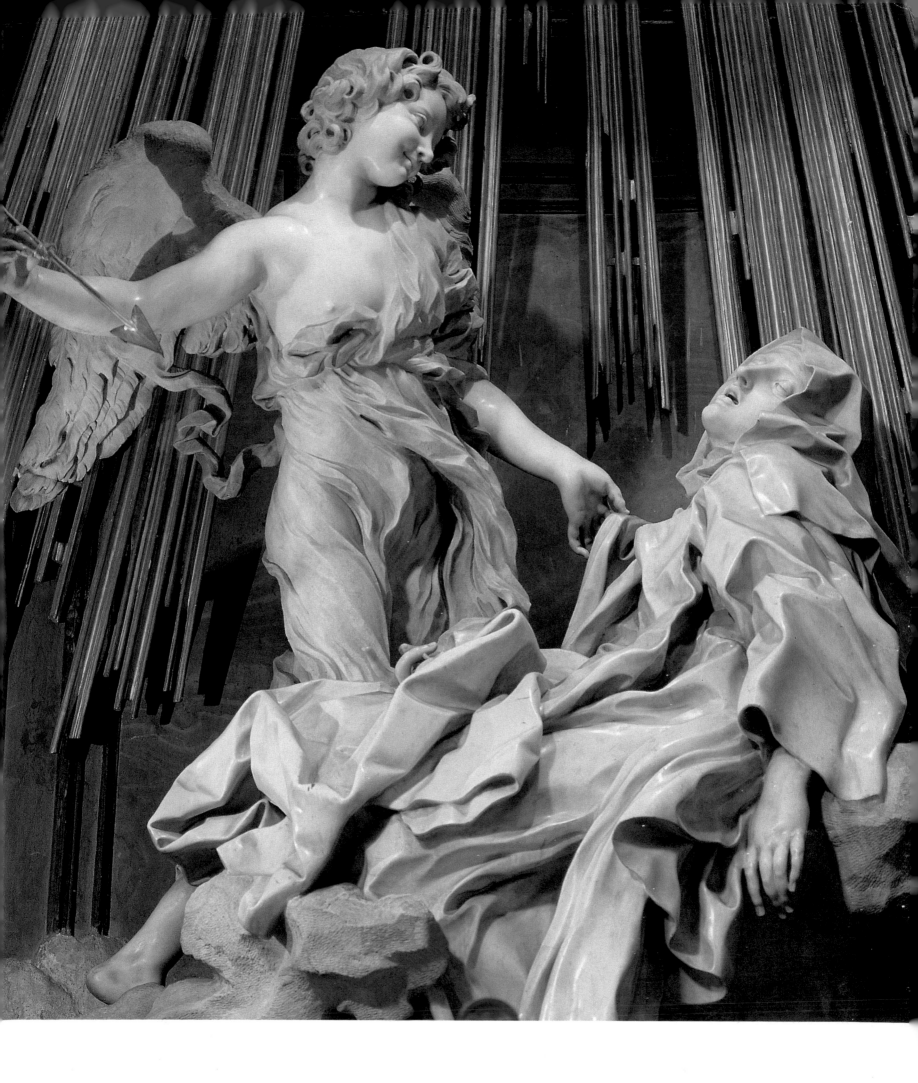

For my dear wife Mary

The idea of producing this book occurred during a visit to the office of David Finn
in New York, when I first saw a selection of his superb photographs of
Bernini's sculpture hanging around the walls. David espoused the project enthusiastically
and took many new photographs too, notably of the terracottas in the Fogg Museum
of Art, Harvard University, and the two marble portraits of Louis XIV at Versailles.
I am most grateful for his cooperation and advice: his excellent photographs make their
own distinguished contribution to the book. I am grateful too to Mrs Virginia
Guichard for her accurate typing of the text from my manuscript. All quotations from
Baldinucci are taken from the English translation by Catherine and Robert Enggass:
The Life of Bernini by Filippo Baldinucci, University Park, Pa. and London, 1966. C.A.

1. (half title) The young Gianlorenzo Bernini. Portrait,
engraved by Ottavio Leoni, 1622.
2. Head of Daphne, from *Apollo and Daphne* (Villa Borghese, Rome).
3. Detail of *Pluto Abducting Proserpina* (Villa Borghese, Rome).
Frontispiece. The elderly Gianlorenzo Bernini,
engraved by A. van Westerhout, after
G. B. Gaulli, Il Baciccio, 1680.
4. Terracotta model for the equestrian monument of Louis XIV
(Villa Borghese, Rome).
5. *The Ecstasy of St Teresa*
(Santa Maria della Vittoria, Rome).

First published in the United Kingdom in 1997 by Thames & Hudson Ltd,
181A High Holborn, London WC1V 7QX

www.thamesandhudson.com

© 1997 Thames & Hudson Ltd, London

First paperback edition 2006

British Library Cataloguing-in-Publication Data
A catalogue record for this book is available from the British Library

ISBN-13: 978-0-500-28633-3
ISBN-10: 0-500-28633-7

Printed and bound in Singapore by C.S. Graphics

Contents

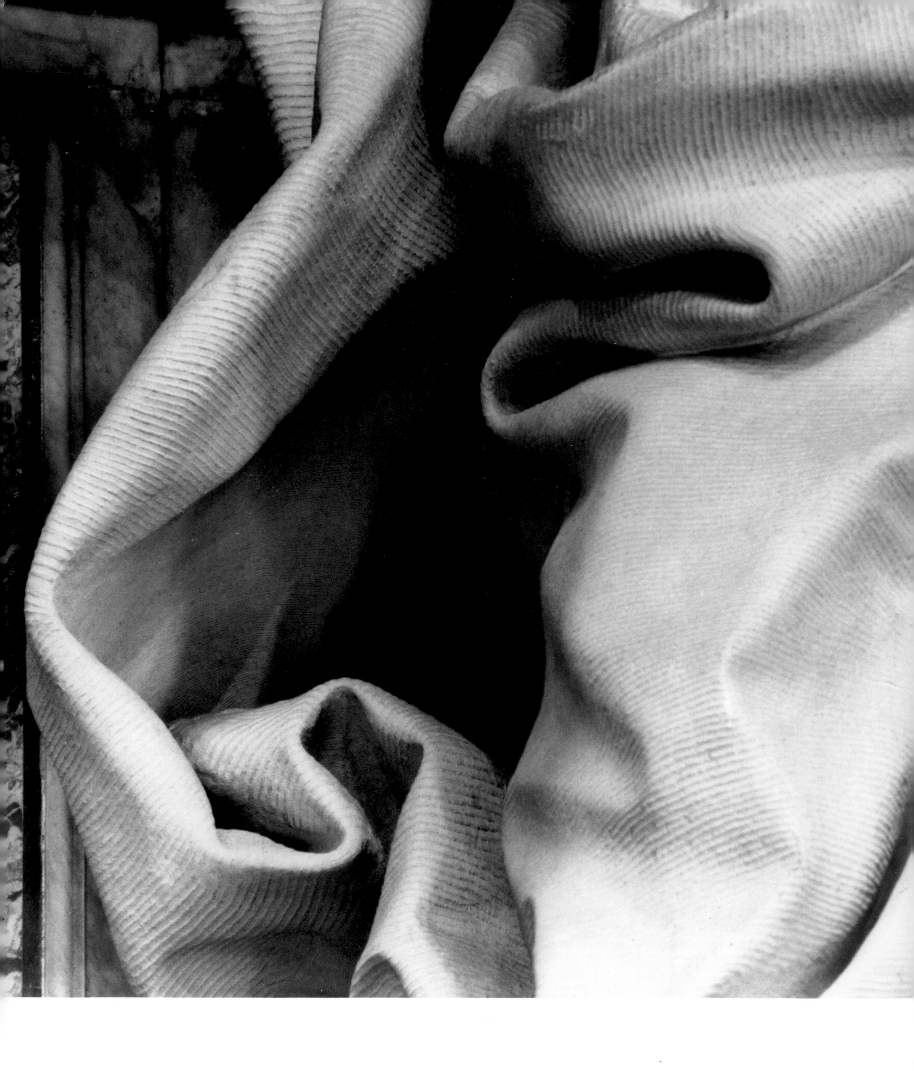

Preface

THE FOURTH centenary of the birth of Gianlorenzo Bernini in 1598 and the dawning of a new millennium present an ideal occasion to reconsider his diverse achievements. Bernini's activity ranged far beyond the traditional confines of sculpture: architecture, urban planning and gorgeous fountain displays, exuberant interior decoration, theatrical design and festival decorations, lavish ornaments of every sort, right down to masks for the finials of his own carriage. He was a competent painter and a brilliant draughtsman, and one of the inventors of the art of caricature, applying it with devastating effect to patrons as illustrious as the popes themselves. He designed medals, and even wrote plays. In fact Bernini was the latter-day epitome of the Renaissance ideal of the *uomo universale*.

Bernini was in effect the maker of Baroque Rome. Without his immense and varied contributions, the Eternal City as we know it today would not exist: a whole layer of its fabric would be missing. We could not march across the Ponte Sant'Angelo escorted by the angelic statuary that he designed for its balustrades, nor wonder at the embracing arms of the colonnade around the Piazza San Pietro. The Basilica of St Peter would not have the sonorous crescendo of Bernini's bronze Baldacchino over the tomb of St Peter, framing the partly gilded throne of the saint held aloft by the four Fathers of the Church and leading the eye to the glory of angels around the oval west window that filters and tints the rays of the afternoon sun, as though we are beholding a miraculous apparition of the dove of the Holy Spirit. Our understanding of the Roman Catholic faith would be impoverished without such intensely felt and memorable images as *The Ecstasy of St Teresa* or *St Longinus*. We could not enjoy the splashing water display and vigorous drama of the huge figures on his *Fountain of the Four Rivers* and of the *Fountain of the Moor* in Piazza Navona, or that of the *Triton Fountain*, with its amazing vertical jet of water, in Piazza Barberini. The street scene would lack the endearing *Elephant and Obelisk* that articulates Piazza Santa Maria sopra Minerva, beside the Pantheon. And our image of the most powerful men in the world during the seventeenth century would be far less convincing and elevated were it not for Bernini's portraits in marble or bronze, at full length or in the form of busts, not only of the popes and cardinals of the Catholic Church, but also of foreign monarchs such as Louis XIV of France and Charles I of Great Britain.

As a sculptor, Bernini is most famous for his series of mythological groups of *c.* 1620 in the Villa Borghese, vividly imagined and carved with miraculous virtuosity. The daring undercutting and hollowing out of the marble by the drill as much as by the chisel, the cunning imitation of textures and colour and the manipulation of light and shade on the surface had no precedents and have never been surpassed.

Since Rodin, modern observers have tended to have a particular penchant for sketches and models, the primary evidence of an artist's creative imagination at work. Bernini's large corpus of drawings and preliminary models in terracotta enables us to see how he developed his projects with speed and bravura and then carefully cogitated, revising their every aspect and detail before committing them irrevocably to the permanent materials of marble or bronze. Although Bernini's drawings were the subject of a major book by Brauer and Wittkower published in Berlin in 1931 (which has itself become a rare and valuable collector's item), the models have never been the subject of a separate publication. Close attention is therefore given in this book to both drawings and models. Bernini's architecture, the subject of a recent specialized study by Franco Borsi, is treated here only from the point of view of its importance as a setting for sculpture.

The standard work in English on Bernini's sculpture was written by the late Professor Rudolf Wittkower in 1955. It took the then fashionable form for a monograph of a short discursive text, followed by a *catalogue raisonné*, a format which does not make for easy reading, even by a specialist. The book remains a monument of scholarship and its catalogue is indispensable, having gone into four editions, the last in 1990, although several entries have been superseded with the passage of time. Wittkower was a pioneer in the English-speaking world in expounding a style which had been until then deeply unfashionable, and of which Bernini was the central figure: the Baroque.

6. Detail of drapery from *St Longinus* (St Peter's, Rome). See also plate 120.

7. Panini's 18th-century fantasy of a gallery filled with the most famous views of Rome shows how forcefully Bernini had set his own stamp on the city. Starting bottom left is his *Fountain of the Four Rivers* in Piazza Navona and near it on the floor the *Barcaccia* fountain at the foot of the (later) Spanish Steps. Above it is the Piazza San Pietro and at the top on that side is the *Triton Fountain* in Piazza Barberini. In the centre, under the arch, are the sculptures of *Apollo and Daphne* and *David*. On the right (left of the column) is the Ponte Sant'Angelo lined with Bernini's angels and (right of the column) Sant'Andrea al Quirinale, *The Vision of the Emperor Constantine* from the Scala Regia, the *Neptune Fountain* and the *Fountain of the Moor*. Further right are Palazzo Montecitorio and the whole Piazza Navona (Museum of Fine Arts, Boston).

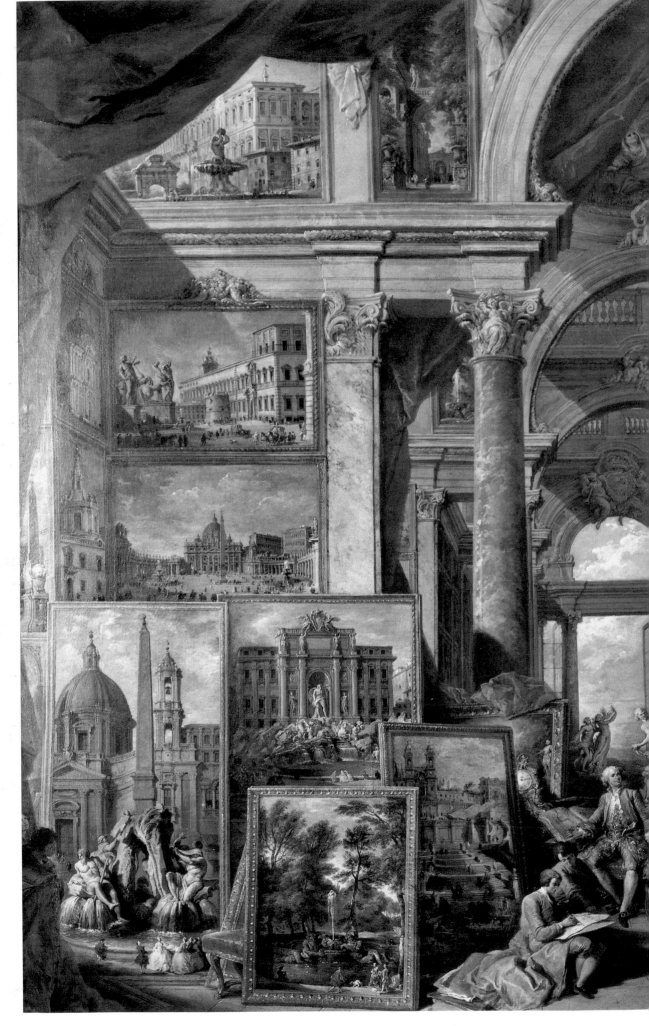

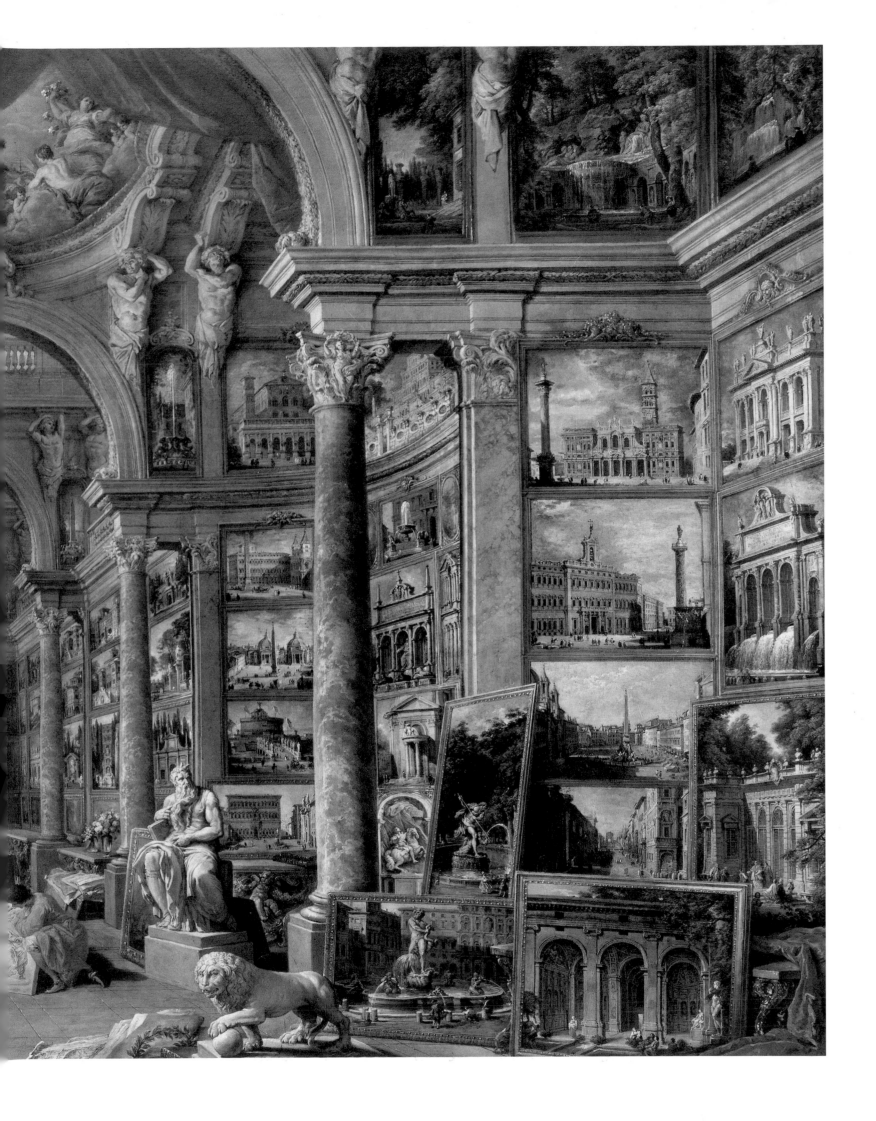

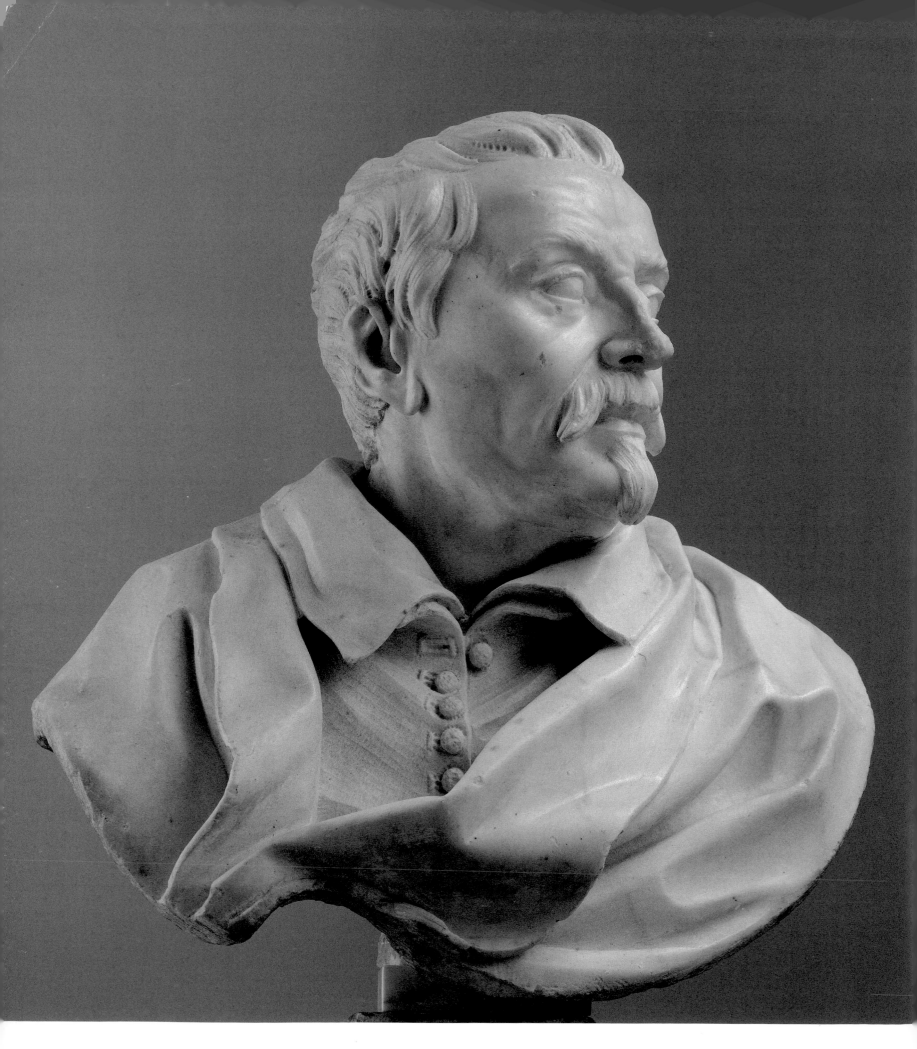

14

Prologue: 'Padre Scultore' – Pietro Bernini and his studio

A gifted but facile late Mannerist sculptor
Rudolf Wittkower

GIANLORENZO BERNINI'S FATHER, Pietro, was born near Florence and trained under Ridolfo Sirigatti. An able but little-known sculptor, Sirigatti came within the ambit of Giambologna, the leading sculptor, not only in Florence but in the whole of Europe, who died in 1608.[1] For further training Pietro had gone to Rome in 1584, where he may have found work as a journeyman not far from the city at the Villa Farnese at Caprarola, which was being completed at that date, as well as in the Vatican. But Pietro soon proceeded southwards to Naples, where he married a local girl and spent the following decade carving a number of statues for churches.

His first identifiable sculptures there are competent but unremarkable. They are characterized by over-complicated drapery carved into patterns of flat folds with sharply delineated edges, but no great intellectual or spiritual quality is noticeable in their poses or faces. Pietro's style is a pastiche of the greater Florentine marble sculptors of his day, Francavilla and Caccini. Indeed it was to work with Caccini that Pietro returned briefly to Florence in 1594, in order to assist him with a huge relief, the *Trinity*, for the façade of the church of Santa Trinità, but Pietro's contribution is not discernible.

Pietro returned to Naples after only a year, apparently in connection with a commission awarded to Caccini by the Viceroy of Naples for some statues and reliefs for the church of the great Carthusian monastery of San Martino. These included a large relief of the patron saint by Pietro; it is a disappointingly provincial affair, with a wooden-looking horse and a beggar whose movements are not at all well co-ordinated. Pietro tried in vain to unify the two figures by introducing a sweeping curve to the drapery of the cloak that the Roman centurion cuts in half to clothe the beggar.

A group of the *Virgin and Child with the Infant St John*, also from San Martino, is very contrived in composition, and while the Virgin's face is indebted in type to Caccini, it lacks his soft handling of surface suggesting emotion: instead, the effect is lifeless and saccharine, in spite of much well-carved detail, for example the pelt with which St John is clad and the woolly coat of his symbolic sheep. Even so, one can see here the roots of Gianlorenzo's early sculptures of infants and his love of naturalistic detail.

Pietro continued to attract patronage in Naples. All his works are competent and decorative, but convey little emotion. In the year 1600, he contributed four marine monsters to the *Medina Fountain*, an undertaking characteristic of Florence: the rest was by Naccherino, a secondary Florentine sculptor who specialized in such projects. The *Medina Fountain* at least hints at Gianlorenzo's later interest in and success with sculptural fountains in Rome.

In 1605–6, Pietro and his family were drawn by the magnet of Rome, where grandiose papal projects for the embellishment of Santa Maria Maggiore promised gainful employment for a whole workshop of sculptors and masons. Pietro was commissioned on 30 December 1606 by Pope Paul V to carve a large relief depicting the *Assumption of the Virgin*;[9] payments continued until 1610. Gianlorenzo spent his formative years between the ages of eight and twelve with this relief being carved in his father's workshop: it was to be the background against which his juvenilia were carved. And it is Pietro's masterpiece.

Being a relief and featuring a popular subject, its composition seems to be indebted to painted altarpieces, especially to two by Lodovico Carracci of *c.* 1585.[2] An isosceles triangle forms an armature: the ascending Virgin is seated at its apex, her veil falling down to the left and directing one's eye to the bottom corner, where it is taken up in the diagonal folds of the cloak falling from the shoulders of the kneeling St Peter. His right foot even projects outside the dark frame to the front corner of the slab of marble. A similar, though less pronounced, diagonal runs from the left foot of an apostle standing opposite, up through his cloak towards the Virgin: his face is turned upwards and his gaze completes this side of the notional triangle. Such a composition is characteristic of the High Renaissance and imparts stability to a relief that is otherwise full of activity and implicit movement. Pietro achieves in his multiple figures of the apostles with intensely characterized heads – all but caricatures (one is even bespectacled!) and all shown at wildly differing angles – a feeling of genuine excitement about the miracle. Mary meanwhile is borne up to heaven amid banks of cloud on the backs of a host of charmingly depicted cherubim, while two prominent seraphim playing the harp and the organ serve to fill the upper corners of the rectangle.

8. Gianlorenzo Bernini: portrait bust of his father Pietro (with Antichi Maestri Pittori, Turin).

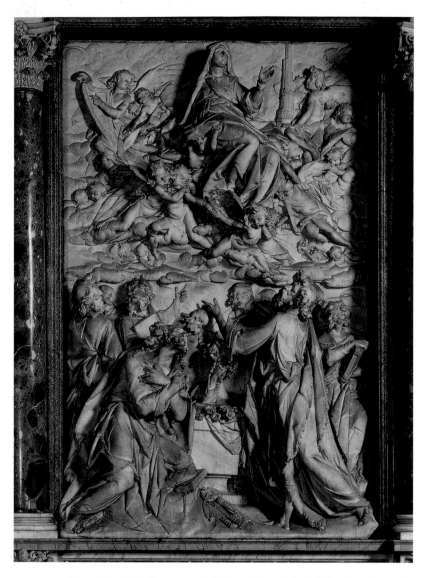

9. Pietro Bernini: *Assumption of the Virgin* (Santa Maria Maggiore, Rome). The hand of the young Gianlorenzo has been detected in the cherubim bearing the Virgin to heaven.

Could the young Gianlorenzo possibly have lent his juvenile talent to some of these putti, or is this spectacularly enhanced level of quality simply Pietro at his very best, enthused by a major commission and stimulated by the ambience of Rome and the competition of many rivals? Perhaps the challenge of his growing son, who manifested such precocious talent, drove Pietro to compete with himself, as he later instructed the child to do. The relief was ultimately mounted near eye-level in the baptistery of Santa Maria Maggiore and must have enhanced Pietro's reputation considerably.

Regrettably, in his very next commission, also for a relief, Pietro failed to repeat his success. Indeed his *Coronation of Pope Clement VIII*, when delivered in 1611, fell so far short of expectations that even though it was to be mounted high

above eye-level over the papal tomb, he was forced ignominiously to recarve it.[3] The first attempt was consigned elsewhere, and we have no idea what it was like. Pietro's contemporary, Ippolito Buzio, had been content to carve a similar subject, the *Coronation of Pope Paul V*, for a tomb on the opposite wall of the Pauline Chapel in a calm, legible style with an open foreground, leaving the pope easily discernible on his throne, as the focus of attention, and flanked by phalanxes of mitred bishops. In his second version, finished in 1614, Pietro, presumably under some pressure, rather over-reached himself by introducing three courtiers into the foreground: they are shown half-length in animated conversation, as though behind a window-sill, but they tend to dominate the scene, leaving poor Pope Clement in relative obscurity in the background.

Pietro borrowed the bold idea of closing his composition at the left with a helmeted figure, who turns his back towards the spectator and who has his elbows sharply bent, from a relief showing the *Coronation of Cosimo I as Grand Duke* by Giambologna (under the equestrian monument in Piazza della Signoria, Florence). The helmeted figure was probably intended to be the Captain of the Swiss Guards who attend the pope, but his courtly interlocutors are not identified and seem an ill-judged distraction from the focus of the scene.

Despite this setback, Pietro was also commissioned to create four caryatids, two of them flanking his relief, to support the entablature of the whole tomb wall.[4] Their architectural function required figures that were easily legible and ornamental, but not spiritually uplifting. Pietro's statues, in uniformly cross-legged poses and with arms raised, swathed in intricately folded drapery and with pretty faces and caps of curly hair, more than fitted the bill: they are well designed, carefully carved and exceedingly elegant. Thereafter, Pietro received a steady flow of commissions, without in any way being singled out as the leading sculptor of Rome: this privilege was to be accorded within only a decade to his brilliant son.

Pietro's finest statue – as distinct from relief – is beyond doubt the *St John the Baptist* that he carved in May 1615 for a niche in the newly established Barberini Chapel in Sant'Andrea della Valle.[5] Pietro's statue was one of four by different artists for niches round the chapel; his son Gianlorenzo contributed two portrait busts and, like Pietro, a pair of reclining cherubim. But the *Baptist* is regarded as entirely Pietro's work: the half-seated pose, with the legs set at different heights on a rocky outcrop, recalls that of Jacopo Sansovino's figure in the church of the Frari in Venice (though it is not clear how Pietro could have known it).[6] The pose and complicated ponderation of the nearly nude figure are well handled, and, as in his Neapolitan image of the Baptist as an infant, the details of the pelt he wears and of

the coat of his symbolic lamb lying tranquilly below are well carved.

The statue leans well forward, as though keen to impart St John's message, with its head, framed in a mop of curls, reaching to the lintel and thereby filling the niche. Meanwhile, the dominantly raised left knee is thrust forward into the space of the chapel to catch the light, by dint of having the rock on which that foot rests, alongside the lamb, projected out on a volute below. Here too, as in the Pauline Chapel in Santa Maria Maggiore, much play is made of the elegantly contrasting colours of the marble employed in and around the niche: this use of polychrome marble to give colour and suggest mood, as in a painting, helps to break down the traditional barriers between these arts; it was to be extremely influential upon Gianlorenzo.

41–44
47–49

After the commission for the Barberini *Baptist*, the mutual involvement of father and son comes to the fore with their major group of *The Flight from Troy*. Attributed to Pietro at least once within Gianlorenzo's lifetime, it was probably a genuinely collaborative project, seemingly the result of an organic growth from the foundations laid by Pietro in his statue of the Baptist, as will be described in Chapter One. Thereafter Pietro and his shop collaborated with Gianlorenzo on many projects, even though the younger man soon took the lead. But they continued to operate quite independently too, filling orders for garden sculpture (for example back at Caprarola where Pietro had worked in his youth), and religious statues, often to ornament the surrounding architectural frames of memorials whose focus was a portrait bust carved by Gianlorenzo. This was the case in two foreign commissions: the first for two figures to form an *Annunciation*, commissioned by François d'Escoubleau, Cardinal de Sourdis for St Bruno, Bordeaux;[7] and the second for allegories of Faith and Prudence for a monument to Cardinal Dolfin, in San Michele in Isola, Venice.[8] None of these marble statuettes, however, is worthy of much note. Pietro was now content to play a subsidiary role, but provided a vital infrastructure for the meteoric career of Gianlorenzo. His son was by now earning the lion's share of the money and Pietro willingly acted as his business manager and book-keeper.

Wittkower defined Pietro as 'a gifted but facile late Mannerist sculptor' and this is perfectly fair, for, in essence, he was a sound craftsman rather than an imaginative artist. It is to his credit that he was prepared to admit his deficiencies when confronted with Gianlorenzo's precocious talent, encouraging rather than resenting him, as he might so easily have done. Pietro's supportive attitude enabled Gianlorenzo, once in his stride, to overtake his father – and indeed everyone else on the sculptural horizon – like a rocket.

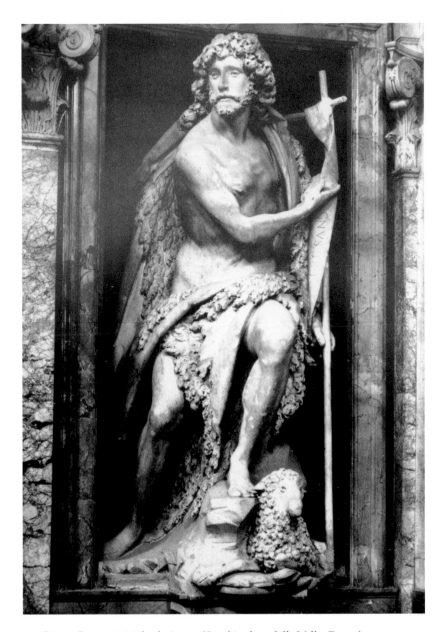

10. Pietro Bernini: *St John the Baptist* (Sant'Andrea della Valle, Rome).

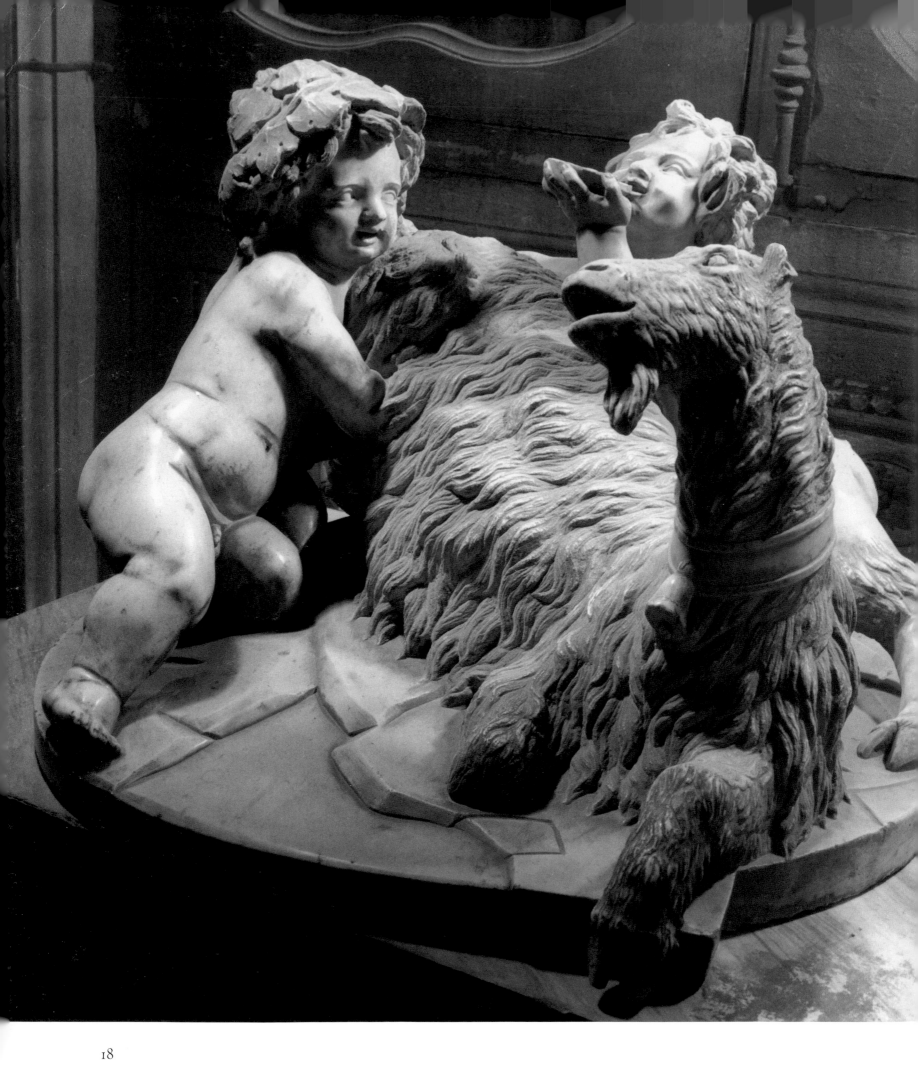

1 * Father and son:
Pietro and Gianlorenzo in partnership

Gianlorenzo Bernini was always destined for a brilliant career in sculpture. While tales of his precociousness may be exaggerated by fond memories of a golden childhood from all who knew him, they cannot be totally discounted. He was the darling of his father, who, when confronted early on with the probability that his son would surpass him, responded glibly, 'In this game, he who loses, wins.' One can imagine the strong-willed and intensely competitive *bambino* being indulged too by everyone in the busy workshop, from the stonecutters and apprentices to the older specialist carvers. He grew up to the sound of the chipping, sawing, drilling and smoothing of marble, and would have been eager to emulate the adults around him as soon as he had the grip and stamina. Before then he would have played like any child with the pliable materials used for modelling — beeswax or clay — and was probably schooled in manipulating them at his father's knee. Some of his childish efforts at rendering human beings and their faces might even have been at the back of his mind when he later drew wicked caricatures.

According to Baldinucci, even before Pietro moved to Rome, his son, 'at the age of eight [had] made a small head of a child that was the marvel of everyone'. This story need not be untrue, given Gianlorenzo's background. During his teens he specialized in images containing putti, and his works drawn or carved only a few years later reveal an astonishing precociousness, for example a head of St Paul that he drew in front of Pope Paul V who ascended the papal throne in 1605. Its success occasioned the pope to command Cardinal Maffeo Barberini to supervise the boy's further training:

He strictly enjoined the Cardinal not only to attend with every care to Bernini's studies but also to give them fire and enthusiasm. He told him that he stood as the guarantor of the brilliant result that was expected of Bernini. And then the Pope, after encouraging the boy with kind words to continue the career he had begun with good heart, gave him twelve gold medals, which were as many as he could hold in his hands, and turning to the Cardinal, said prophetically, 'We hope that this youth will become the Michelangelo of his century.'

The boy, instead of vainly inflating himself because of the success of his efforts and the praise of the mighty (a practice befitting only the small-minded and those whose goal is all things save the

attainment of true glory), tirelessly dedicated himself to new and continuous study. But what cannot a gifted nature accomplish when it is accompanied by wise and prudent guidance! His father, to whom he showed his fine studies, expressed both admiration and disparagement, praising the drawings while telling him that he was sure that he could not achieve the same result a second time, as if to say that the perfection of the first efforts was due to a lucky accident, rather than to his son's ability. This was a very clever device as each day Giovan Lorenzo attempted to emulate his own virtues, and thus he was in constant competition with himself.

Curiously enough, several of Gianlorenzo's juvenilia depict infants (the putti beloved of Italian — and especially Florentine — sculptors since the earliest days of the Renaissance). Perhaps this pleased his indulgent father's sense of decorum. Furthermore, nearly life-size infants could be carved out of relatively small blocks of marble that would not defeat or discourage the young sculptor. Even within the confines of these blocks, which may have been irregularly shaped off-cuts from larger commissions, Gianlorenzo's compositions are by no means naïve or straightforward. It is impossible to tell in such early works, let alone the slightly later monumental mythologies, to what extent Pietro or his colleagues may have intervened in designing or even blocking out the figures to help the little boy: such collaboration in carving was the norm and not the exception in studio practice of marble sculptors of the day. It was obviously in Pietro's interests as well as his son's to be able to boast of such phenomenal achievements coming out of his workshop.

Of the three marble groups of putti thought to be 'by' Gianlorenzo, only one is approximately datable: a carpenter was paid in 1615 for providing a wooden pedestal for the group of *The Goat Amalthea Suckling the Infant Jupiter and a Satyr*.[1] It may even have been carved some years earlier, *c.* 1611–12, when Bernini was in his early teens, if one bears in mind the dates of his earliest portrait busts: one of these, depicting G. B. Santoni, is associated with a frame ornamented with similar cherubim.[2] The subject of the group was a variation on a theme particularly popular in Rome since ancient times: the twins Romulus and Remus being suckled by a she-wolf.

Amalthea was the daughter of a king of Crete, and fed the infant Jupiter with goat's milk. She was confused by some authors with the obliging goat, and represented as such; Jupiter, later king of the gods, rewarded and immortalized

11. *The Goat Amalthea Suckling the Infant Jupiter and a Satyr* (Villa Borghese, Rome).

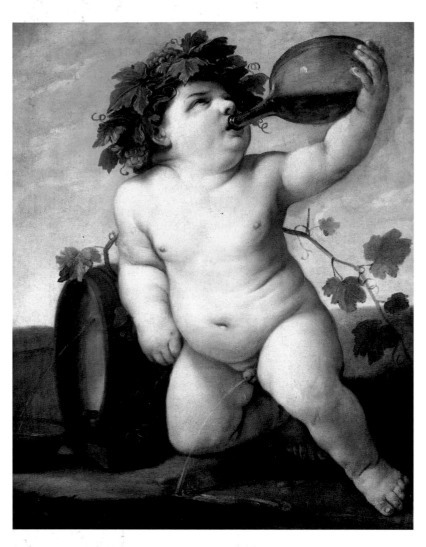

12. Guido Reni: *The Infant Bacchus Drinking* (Gemäldegalerie, Dresden).

shell is also reminiscent of drinking from a wine cup, a motif omnipresent in representations of Bacchus, such as those by Michelangelo and by Jacopo Sansovino in the Bargello Museum, Florence. The *double entendres* of the interpretation would have stimulated much learned and amused discussion among the circle of friends of Cardinal Scipione Borghese, for whom it was probably carved: indeed he may even have passed it off as a Hellenistic antiquity of the type on which it is in any case based, for the blank eyes and realistic rendering of the goat's shaggy coat are surely deliberate references to Alexandrine work.

The composition is an exercise in triangular forms being melded into spiralling ones, all encompassed and unified by the oval outline of the base, apart from the deliberate, though seemingly casual, extension of the goat's left forehoof. The broad facial type of Pan, with endearingly wide-set eyes and dimpled cheeks whose sharp indentations divide them from the snub nose, is inspired by ancient Roman prototypes, notably those to be seen on sarcophagi of Bacchic routs performed by infants. It may even be traced back to Donatello's mischievous putti.

Around 1613–15, Gianlorenzo carved the two independent figures of children seated on the ground and struggling with inimical beasts, the *Putto Sporting with a Dragon*, contentedly stretching open the jaws of a small dragon, and the *Putto Bitten by a Dolphin*, who, writhing and grimacing with pain, attempts to open the dolphin's mouth by tugging back its snout.[3] Neither is documented, individually recorded, nor specifically dated, which makes discussion nebulous. However, they are stylistically and thematically associated with the group of Amalthea, and usually dated between it and the image of the child Ascanius that accompanies Pietro's and Gianlorenzo's first great mythological group, *The Flight from Troy* of *c*. 1618. These are designed, like *The Goat Amalthea Suckling the Infant Jupiter and a Satyr*, to be seen from above, on a table top or on a pedestal of only knee-height. The motif of a figure seated astride a dolphin and pulling open its jaws could have been suggested by an antiquity which Bernini could have seen in the Borghese collection showing a youth riding on a dolphin. It may also have been inspired by Giovanni Montorsoli's *Fountain of Triton* in the garden of the Palazzo del Principe in Genoa of *c*. 1543, which features such a group.[4]

By representing the head thrown back with the pupils of its eyes dilated and the mouth open, deformed by pain and apparently uttering a cry, Bernini parodies the expression of pathos used in Hellenistic sculpture, the prime examples of which in Rome were the *Laocoön* and the group of *Niobe and her Children*. At the same time he enlivens the pathos by direct observation of nature, perhaps noting how a child reacts to sudden pain, such as that caused by a blow or a bee-sting.

her by setting her in the heavens as the constellation Capricorn (literally 'goat's horn'). One of her horns was given to the nymphs who had also helped to nurture the god, and became the cornucopia (literally 'horn of plenty').

In Gianlorenzo's interpretation, perhaps based on learned advice from his mentor and friend, Cardinal Barberini, the child Jupiter also doubles as Bacchus, the god of wine, shown by the prominent wreath of vine leaves in his hair. Furthermore, a probable source for his half kneeling and aslant pose is to be found in a painting by Guido Reni which shows the infant Bacchus drinking and relieving himself simultaneously as he leans against a leaking wine cask. The lower half of this figure was simply reversed by Bernini, as he lowered the arm to grope for the goat's udder. The action of drinking was transferred to the accompanying infant satyr, probably Pan, for, in one version of the story, Pan became Jupiter's foster brother by sharing the same animal as stepmother. The way that he sips the warm goat's milk from a

Soon afterwards he was to take his study of the expression of intense pain to its ultimate conclusion in his bust of a *Damned Soul*. Some years later, Gianlorenzo again exploited the expressive effect of distorting a child's face but this time with rage, in the deprived infant who flanks the statue of Charity on the Tomb of Urban VIII.[5]

The theme of the *Putto Bitten by a Dolphin* is related to a story told by the Roman writer Aelian in his *De Natura Animalium* of the late second century AD. A dolphin which loved a child would carry and sport with him in the sea until one day the dolphin accidentally killed the child by piercing his heart with its dorsal fin. The story reflects and allegorizes the docile nature of the aquatic animal, its gift of communication and the warm relationship it easily develops with human beings. In Bernini's adaptation however, no accident is involved, for the dolphin fixes its teeth deliberately into the infant's plump right calf. The artist concentrates on depicting a momentary sensation and the reaction to it, as the child tugs with might and main against his assailant, his left arm and bent leg in tension and his right arm in compression. Because of the relatively small size of the dolphin and its spiral lashings about, the action of the group is not explicit or instantly comprehensible. For instance, from the point of view in plate 15 it is not apparent what the child is tugging at, nor why he is so posed, and yet from the front the group is disagreeably foreshortened. The spectator is compelled to circumnavigate the composition in order to comprehend it fully and appreciate its complexity.

14 The other putto, shown sporting with a dragon, is on roughly the same scale, for while it is rather taller – 58 cm. compared with 44.8 cm. – the infant protagonist is sitting more upright on top of his adversary. He is looking forwards and down to the focus of his successful action. In this case, there is an obvious analogy with the classical story of the infant Hercules who, while still in his cradle, strangled some serpents that had been sent to kill him. Given the context of Gianlorenzo's early patronage, the transposition of a dragon is almost certainly a reference to the heraldic charge on the coat of arms of the Borghese, the family of the reigning pontiff, Paul V. A large bronze image of a dragon in the gardens of the Villa Borghese, was, we learn from a flattering verse by Bernini's protector, Maffeo Barberini, meant to be benevolent: 'I sit not as guardian, but as host to all who enter here: this villa is just as accessible to you as to its owner.' Therefore the smiling putto should be seen to be sporting playfully with the heavily symbolic dragon rather than attempting to kill it.

The theme of a putto struggling in play or otherwise with a marine or mythological creature had been a commonplace in garden and fountain sculpture in the Renaissance. A tradition begun in bronze by Donatello (*Atys-Amorino*,

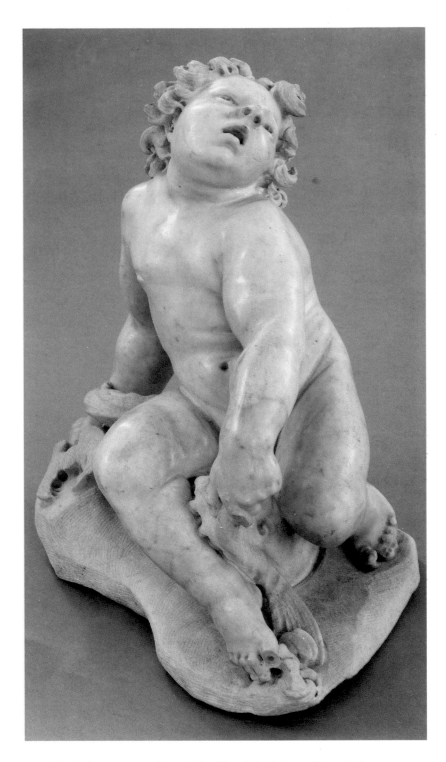

13, 15. (*overleaf*) *Putto Bitten by a Dolphin* (Staatliche Museen Preussischer Kulturbesitz, Berlin).

Bargello, Florence; *Cupid with a Dolphin*, Victoria and Albert Museum, London) was continued by Verrocchio with his supremely successful *Cupid and a Dolphin* (Palazzo della Signoria, Florence) which was designed as a finial for a fountain in the gardens of the Medici villa at Careggi, seat of the Platonic Academy.

14. (*overleaf*) *Putto Sporting with a Dragon* (J. Paul Getty Museum, California).

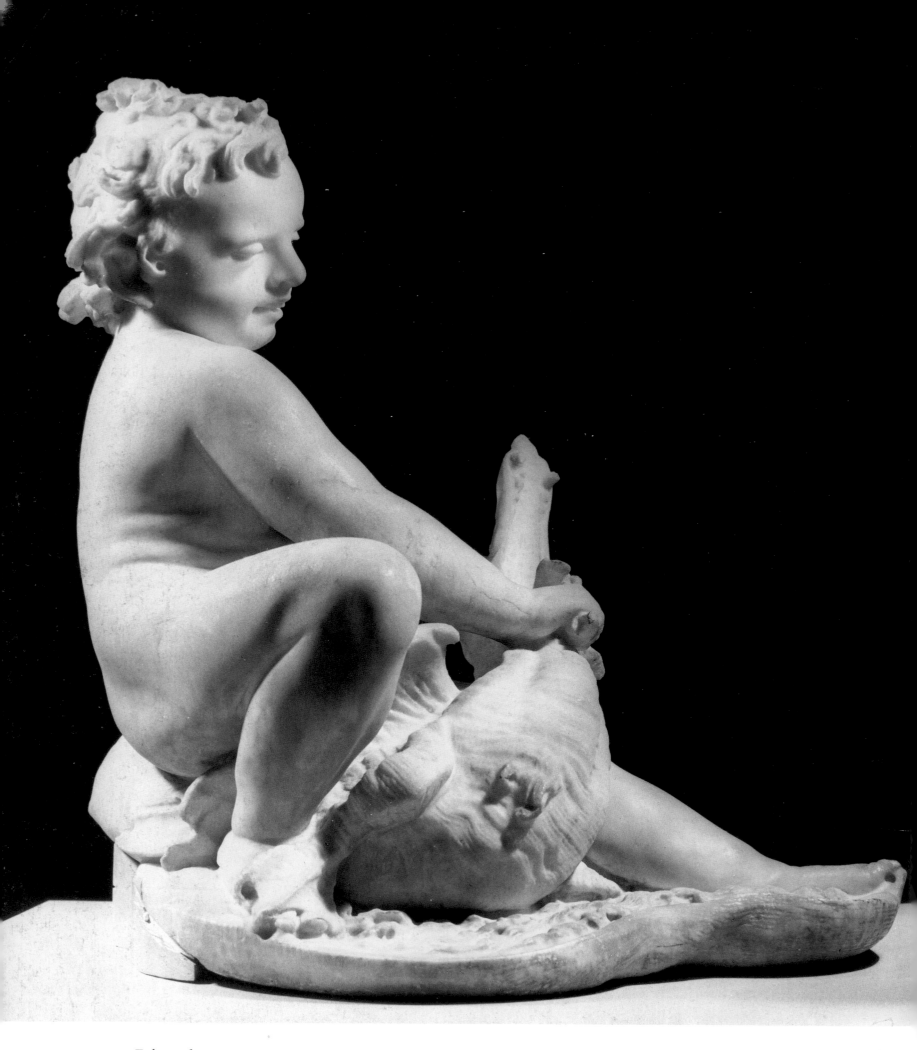

22 *Father and son*

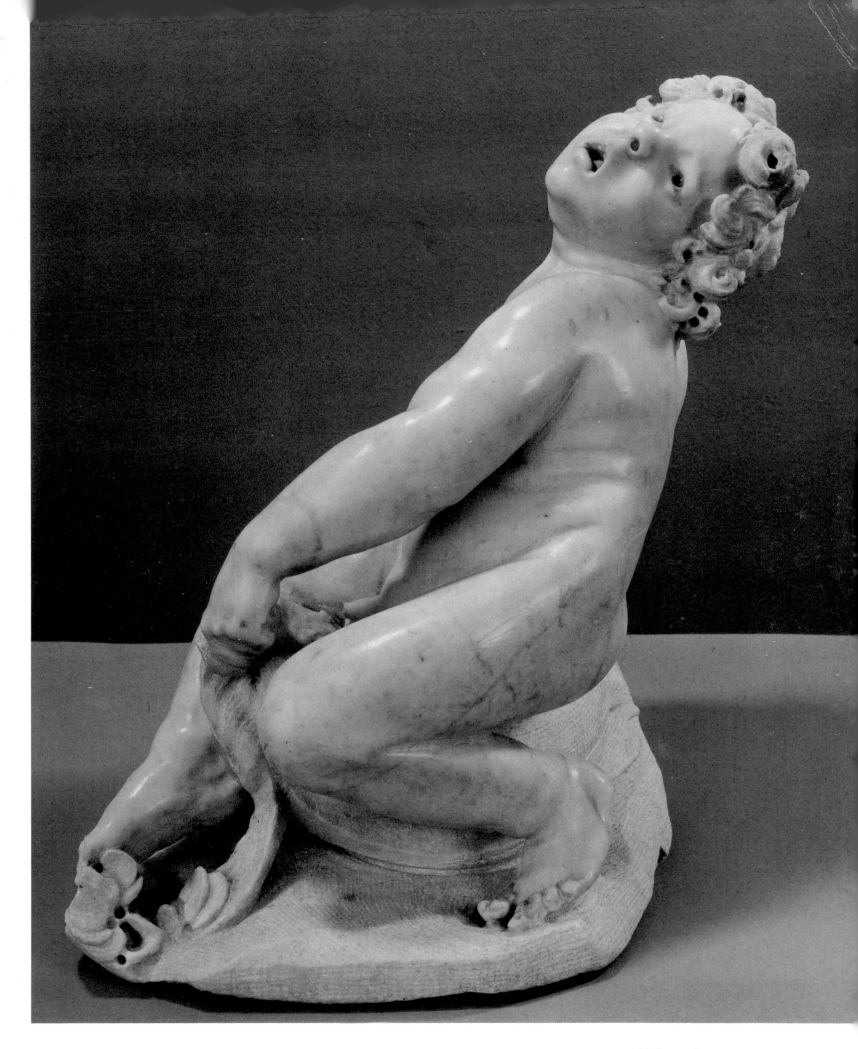

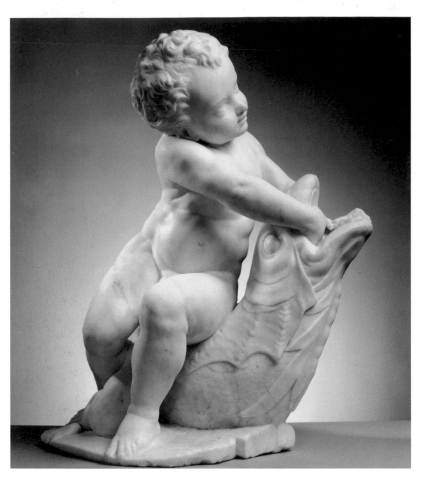

16. Stoldo Lorenzi: *Putto Astride a Dolphin* (with Trinity Fine Art, London).

In the sixteenth century, marble carvers in the wake of Michelangelo, such as Il Tribolo, Pierino da Vinci and Stoldo Lorenzi, added to the repertory of types with putti throttling geese (*Fountain of Hercules*, Villa Il Castello) and other unfortunate creatures, but, in the context of fountains, fish, and especially dolphins, remained a firm favourite.

The *Putto Sporting with a Dragon* in the Getty Museum shows signs of weathering and slight abrasions, notably at the rim of the shell in front, which are consistent with its having stood out of doors, while its function as a fountain ornament is confirmed by the fact that the dragon's lolling tongue is drilled to receive a water pipe. This would have emitted a jet diagonally, parallel with its upper jaw, which would have fallen back into a lower basin to the viewer's right. Within the irregular circumference of the shell in which the struggling pair are set, Gianlorenzo has carved fictive ripples of water, which glisten with real droplets and enhance the effect of realism and movement.

The boy sits firmly on the back of the dragon to anchor it down, while he pins its tail onto a rock with his left hand and pulls the jaw downwards with his right. His hair is less undercut with the drill than Bernini would later prefer,

though it is curly enough. Unlike the close-cropped cap of hair that Stoldo Lorenzi had chosen in deference to the antique, the curls vivaciously interrupt the silhouette of the head. The pupils of the eyes are deeply drilled to either side of a small dib of marble beneath the upper eyelid, which catches the light and conveys the effect of a highlight on the eyeball. The face is unnaturally squashed into a caricature of childhood's sweet mischievousness.

The group has definite front and side views, while its reverse, though well modelled, is neutral. Indeed the back of the base is uncarved and undercut below so that, in the museum, it needs to be supported by a wedge. This suggests that it projected from a wall or from a niche, rocky grotto or even topiary. It may be imagined not far from the large herms of *Flora* and *Priapus*, now in New York, which stood near the main entrance to the gardens of the Villa Borghese.

On the first landing of the main stairway of his house, Bernini proudly kept on display throughout his life the *Faun Teased by Putti*, a youthful *tour de force*.[6] In the heads of the embracing pair of putti above the faun, Gianlorenzo was caricaturing the facial type that he had inherited from Pietro, the wide-set eyes, flabby cheeks and rosebud lips of sentimentally idealized infancy. If one assumes, not unreasonably, that this ambitious group only just antedates that of *The Flight from Troy*, and required a production time of at least a year, a date of *c.* 1616–17 emerges.

It was perforated to such an extent that the block of marble resembled a composition modelled in wax over an armature for casting into bronze.[7] As with the other groups showing putti at play, the exact iconography is unclear, perhaps deliberately so: it was inaccurately listed by Bernini's son in 1706 as a Bacchus, while a Swedish visitor, Count Nicodemus Tessin, had called it a satyr. However, although it has the pointed ears and facial features of a satyr and a little tail, its legs are not those of a goat, and so it should correctly be described as a faun. The three infants accompanying it are not endowed with the wings of Cupid and are therefore, strictly speaking, putti. The composition is bizarre, while the diagonally erect and curving tree trunk against which the faun's legs are extended is distinctly suggestive of the animal eroticism associated in antiquity with these lusty creatures of the woodland. That the faun forms part of a bacchanal is indicated by the attributes of his master, Bacchus, the god of wine: a lion's pelt hangs over the rear branch of the tree and a panther, from whose back one putto is precipitately dismounting, nibbles at some grapes.

Pan and his followers, satyrs and fauns, were associated in the Renaissance with the concept of *luxuria* (lust) one of the seven deadly sins. Despite the vagueness of its iconography, it has recently been suggested that the meaning is as follows:[8] Pan (half intoxicated, to judge from the hazy expression on

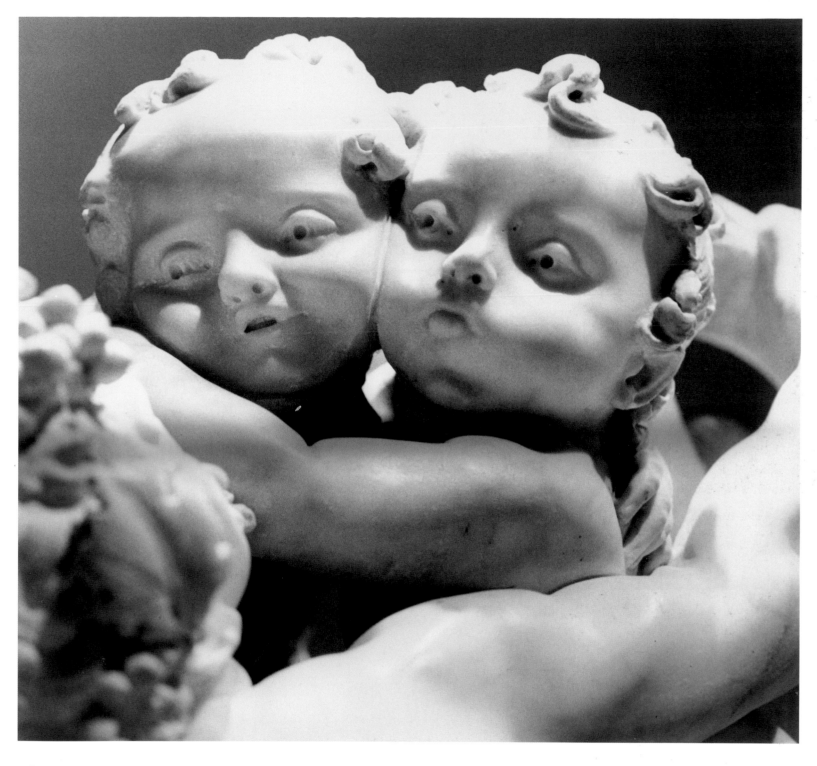

his face) is attempting to gather the fruits of eternal love (symbolized by the living vine entwined around a dead tree) but is being held at bay by the two cupids. One of them provocatively sticks his tongue out at Pan, who is incapable of understanding the distinction between earthly, animal love (or lust) and divine love. Bernini's inspiration came partly from Virgil's *Tenth Eclogue*, on unrequited love, which concludes with the line, 'Omnia vincit Amor: et nos cedamus Amori' ('Love conquers all: and let us yield to Love').

17. Detail from *Faun Teased by Putti* (Metropolitan Museum of Art, New York).

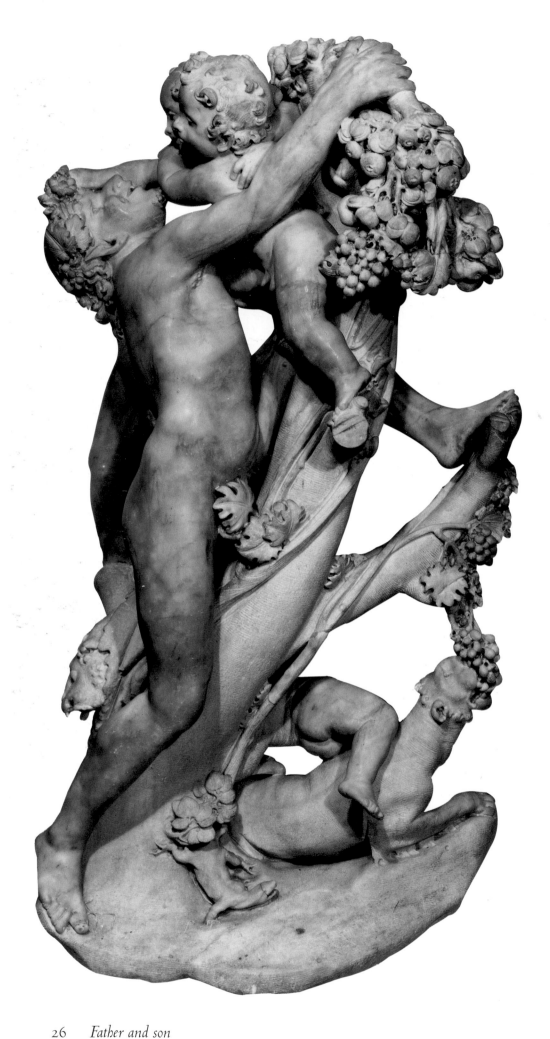

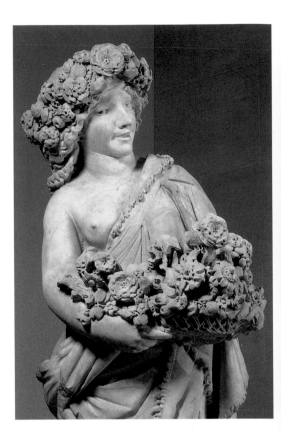

19, 21. Pietro and Gianlorenzo Bernini: herms of *Flora* and *Priapus* (Metropolitan Museum of Art, New York). The flowers held by Flora and the fruit by Priapus (possibly modelled on Caravaggio's fruit, below) have been proposed as the work of the young Gianlorenzo.

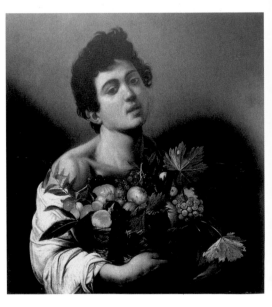

20. Caravaggio: *Youth with Basket of Fruit* (Villa Borghese, Rome). Acquired by Pope Paul V Borghese in 1607, this was readily available to Bernini.

18. (*left*) *Faun Teased by Putti* (Metropolitan Museum of Art, New York).

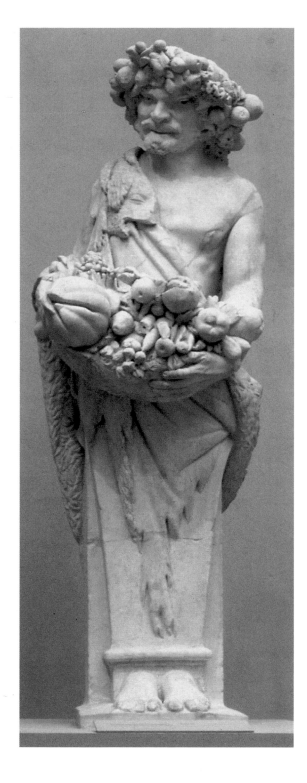

22. Roman Bacchic herm, 1st century AD (formerly Galerie Uraeus, Paris).

23. Part of a balustrade by Giuseppe di Giacomo and Paolo Massone after Pietro Bernini, similar to the bases on which the two herms originally stood (Cliveden, Buckinghamshire).

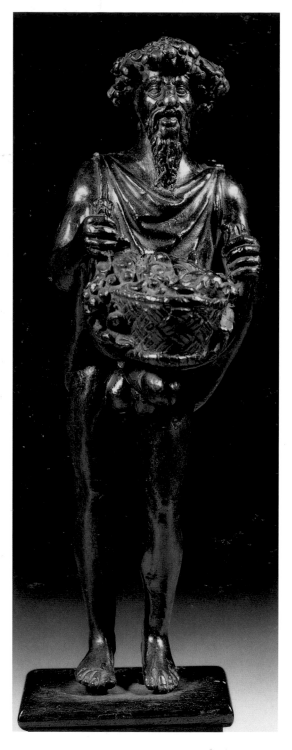

24. Renaissance bronze statuette of Priapus (formerly Adams Collection, London).

This sculpture raises the question of the collaboration which undoubtedly took place between Pietro Bernini and his precocious son during the second decade of the seventeenth century. The Bacchic subject and the complex, interwoven group of figures recalls a marble group of *Putti Harvesting Grapes, with a Billy-goat* which last appeared on the art market in Rome early in the twentieth century and which bore the initials 'P. B.', leading to an attribution to Pietro.[9]

These groups are also related to two others representing Autumn. They are both still in private hands, and one of them belongs to the *Four Seasons* series at the Villa Aldobrandini, Frascati, whose authorship vacillates between father and son too.[10] Both are weathered, having been garden statuary and this — together with the facial features and emphasis on the exuberant rendering of ripe fruit — links them to an amazing pair of monumental herms now in the Metropolitan Museum, New York.[11] These are dated to 1616 by payments to Pietro Bernini and come from the semicircular 'theatre' just inside the main entrance to the gardens of the Villa Borghese, but an author writing within Gianlorenzo's lifetime (1650) stated that the fruit borne by *Priapus* and the flowers by *Flora* had been delegated to him. The flowers of the latter are also closely related to the veritable rose-bush against which the statue of Spring leans in the Aldobrandini *Four Seasons*.

Such a distribution of labour is quite likely and would have provided the ambitious young artist with an opportunity to display his mettle. The laborious undercutting of the fruit, the vegetables and especially the basket of roses and other summer flowers, as well as that of the wreaths that weigh down the heads of these herms, is clearly the work of a conscientious apprentice who has been set a ticklish task and wishes to get full marks for succeeding. Pietro himself may have made the models and helped to execute the human parts, but the rest of the carving was quasi-architectural and not especially demanding, and so may well have been done by an assistant. Thus the fact that Pietro's name is the only one mentioned in the documents cannot be taken to rule out the participation of others, including his own son, who was still theoretically only an apprentice. These were, after all, intended as ornaments to a scheme of formal gardening, and not as major works of art for intensive contemplation indoors by learned collectors and connoisseurs. The spontaneous reaction of John Evelyn on 15 November 1644 was just what was intended: 'I walked to Villa Borghesi, a house and ample garden on Mons Pincius, yet somewhat without the Citty walls . . . Within it is an elysium of delight, having in the centre a noble Palace; but the enterance of the garden presents us with a very glorious fabrick or rather dore-case adorn'd with divers excellent marble statues.'

It is the superabundance of the autumnal fruits that distinguishes the Berninis' renderings from earlier antique examples, where the grapes are not much undercut but treated as a mass, or from late Renaissance examples, such as those on which Ammanati's marble personification of Hippocrene from his *Fountain of Juno* rests her left hand (Bargello, Florence).

The herm *Priapus* stops at the waist and so tactfully omits his genitals, which were normally included in classical statues because of their relevance to the fertility cult. They also feature in a Renaissance bronze statuette of Priapus of unknown origin where in an unseemly manner they help to support the heavily laden basket of fruit that he holds up in both hands with the end of his goatskin tunic. The heavy wreath of ripe fruit is also a feature of the statuette. Such an obscene image would not have been appropriate in a monumental version on view to the general public at the entrance to the gardens of a papal nephew.

Before they became dulled by exposure to the weather, Gianlorenzo's harvest of fruit and basket of flowers must have been the sculptural equivalents of Caravaggio's early still-life paintings, or similar details in his several self-portraits, some showing him as Bacchus. Indeed the openwork weaving of Flora's basket recalls that of the painter's renderings, one of which came into the possession of Pope Paul V in 1607 and still hangs in the Villa Borghese. In order to emulate Caravaggio's luscious colour, the young Bernini had to render a chiaroscuro effect by vigorously undercutting with the drill and playing various illusionistic tricks to differentiate the texture of leaves, flowers and the skins of different fruits.

When seen at eye-level, and if the feet projecting in front of the bases of their architectural lower halves are read as if belonging to their transmuted bodies, the herms appear so squat as to look almost deformed. A viewing point from well below would have improved their proportions by foreshortening. Originally they stood quite high on separately carved rectangular pedestals of travertine marble ornamented with dragons and eagles from the Borghese coat of arms: though apparently lost, they closely resembled some that form part of a balustrade from the gardens, carved by the same team three years later in 1619. The entire complex was sold off in 1891 and is now at Cliveden, Buckinghamshire.[12]

Much as in the early work of Michelangelo, secular, pagan subjects such as those just described were interspersed with Christian ones in the young Bernini's *œuvre*. Once his precocious childhood had passed, it became necessary for Gianlorenzo, situated in the heart of papal Rome, to demonstrate his ability independently of his father to treat sacred sculpture just as seriously and with the same degree of innovation as secular. His earliest essay (made according to his biographers 'in his fifteenth year', i.e. 1613) was devoted to

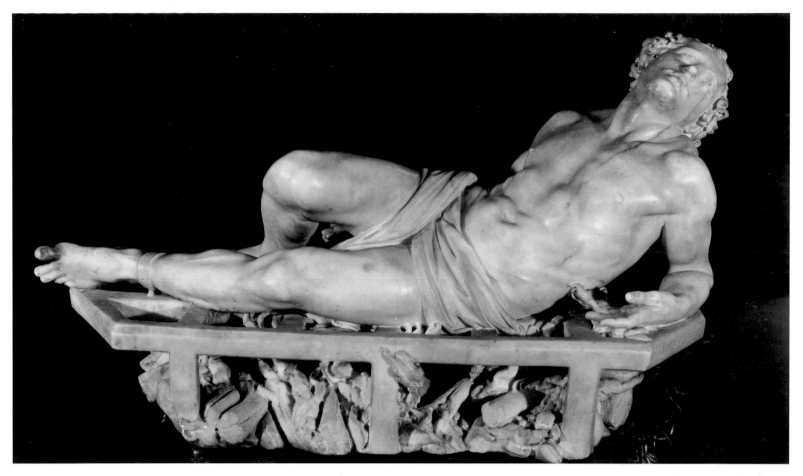

25. *Martyrdom of St Lawrence* (formerly Contini Bonacossi Collection, now La Meridiana, Palazzo Pitti, Florence).

the second of his name-saints, St Lawrence.[13] It thus indirectly recalled the Medici parish church of San Lorenzo in his father's native city of Florence, with its images of the saint by Donatello and Desiderio da Settignano. Furthermore, in its New Sacristy, that church harboured the famous series of figures by Michelangelo allegorizing the Times of Day recumbent on the lids of the sarcophagi of the Medici. There were to have been four similar statues below depicting river-gods, conforming exactly in subject to the classical statues on which the whole series was based. Michelangelo's full-scale clay model for one of these has survived; together with various other remnants in the form of small models and drawings, it perhaps inspired Gianlorenzo's unique rendering of the *Martyrdom of St Lawrence*.[14]

Although the way in which St Lawrence props his torso up on one elbow is common to most images of river-gods, which either rest an elbow on, or embrace, an overturned urn flowing with fictive water, the most prestigious source is Michelangelo's figure of Dusk. The idea of the further knee being drawn up and bent towards the spectator over the extended leg beneath also recalls the matching statue of Dawn, as too, to some extent, does the taut neck and thrown-back head of the saint, though the angle of his face is different.

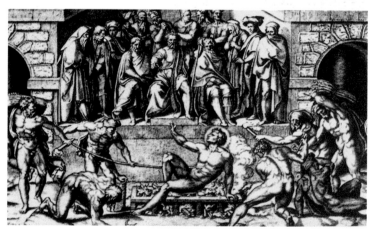

26. Detail from Baccio Bandinelli's *Martyrdom of St Lawrence*, engraving.

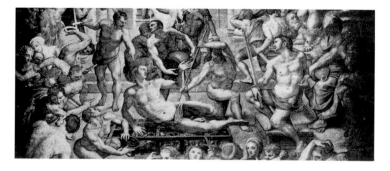

27. Detail from Agnolo Bronzino's fresco, the *Martyrdom of St Lawrence* (San Lorenzo, Florence).

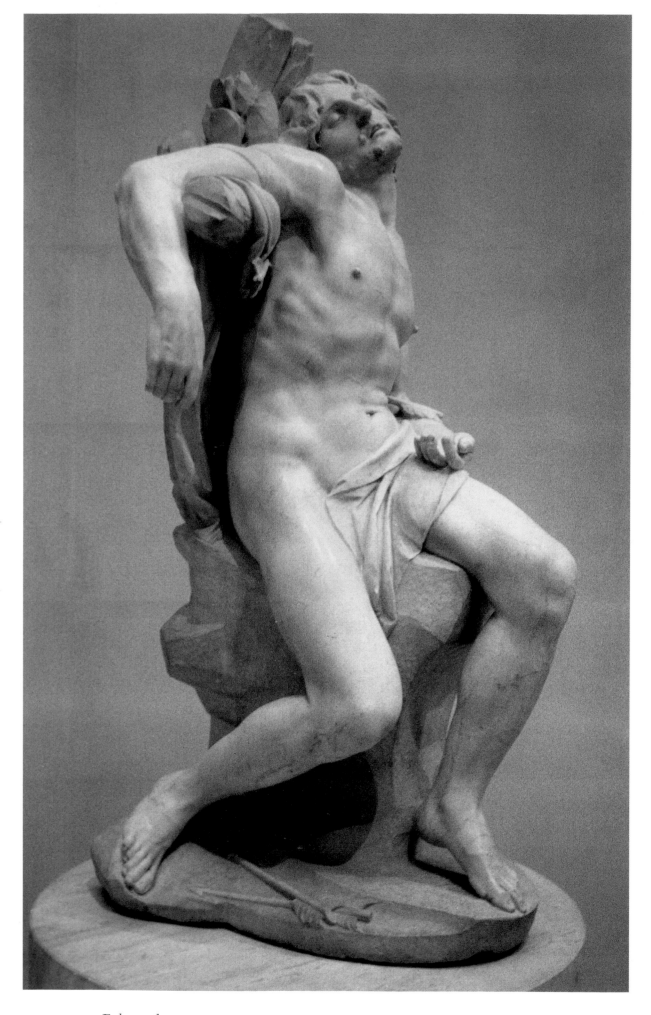

28. *St Sebastian*
(Thyssen-Bornemisza
Foundation, Madrid).

A print of the *Martyrdom of St Lawrence*, by Michelangelo's rival, Baccio Bandinelli, dating from *c.* 1525 was particularly famous for its sculptural rendering of the figures in a heavily populated scenario.[15] Bandinelli disposed the protagonist lengthwise on the iron grille and parallel with the picture plane (just as Bernini did with the front surface of the original block of marble) and emphasized the flames licking up around the body. However, Bandinelli's Lawrence supports himself in a more upright position with his arm fully extended and his forward leg sliding off the grille, as he altercates with the supervisor of his torture. At the same time, as in Donatello's bronze relief of the same subject on the pulpit in San Lorenzo, a servant is attempting to thrust him back down onto the grid and turn him over, in order, at the martyr's own request, to roast his other side.

Another rendering of the scene, this one on a monumental scale, also emulated Bandinelli's engraving. The fresco on the south wall of San Lorenzo, near the pulpit, painted in 1569 by Agnolo Bronzino shows the saint posed in the opposite direction, but is derived from as major (and incongruous!) a source as Michelangelo's *Venus and Cupid*.[16] Gianlorenzo's marble saint is posed in mirror image to the figure in Bronzino's fresco, and may therefore be fairly regarded as a brilliant amalgamation of Bandinelli's and Bronzino's versions. It has recently been pointed out that the young sculptor's goals were twofold: to equal the narrative and lifelike possibilities of the art of painting in a sculpture by depicting convincingly something as evanescent as flames, or as dependent on colour as glowing coals, thus overcoming a deliberate challenge (*difficoltà*) that an artist sets himself; and to be inventive in terms of composition, for, as Poussin was to say, 'novelty does not consist principally in a new subject, but in good and new disposition and expression, and thus the subject from being common and old becomes singular and new'.

By rendering in three dimensions, yet with striking naturalism and emotional intensity, a subject that hitherto had been restricted to the graphic media or low relief, Bernini thus challenged the traditionally accepted boundaries between the arts. He was clever enough to involve the spectator in a mental reconstruction of, and personal involvement with, the rest of the scene, the torturers, the judge and the crowd of onlookers, precisely by omitting them altogether and focusing simply on the protagonist. By setting himself this tricky subject, he intended to show off his imaginative and technical prowess to prospective patrons. The work is a manifesto of his ability on the threshold of his adult career, much like the 'master piece' with which a craftsman matriculates into his guild.

Bernini succeeded admirably, for an exiled Florentine purchased the piece, but not before it had been inspected twice by the papal nephew, Cardinal Scipione Borghese, who – probably as a result – commissioned from Bernini in 1618 *The Flight from Troy*, the young artist's first major sculpture.

Immediately after the success of the *Martyrdom of St Lawrence*, Bernini carved another small statue (just under one metre high) of another martyr, *St Sebastian*.[17] Once again its imagery departs from the norm, for instead of showing the martyr standing tethered to a tree and shot full of arrows as had been traditional since the Middle Ages, Gianlorenzo shows him slumped and half seated on a rock in front of the tree with his legs bent and splayed out in a pose that is almost a swastika. His right arm is crooked over a truncated branch and his head is slumped backwards. These features deliberately assimilate the pose of Sebastian with those standard in the Crucifixion and Lamentation of Christ; indeed a probable source was Michelangelo's *Pietà* now in Florence but originally intended for his own tomb and carved by him in Rome, where it was still to be seen in Bernini's day.[18] Moreover, Sebastian's face is modelled on that of the dead Christ in Michelangelo's early *Pietà* in St Peter's.

The unusual pose was seemingly forced upon Gianlorenzo by the need to reuse a block of marble in which another sculptor had begun an image of St John the Baptist seated. That commission had passed to Pietro Bernini, who had received the block in its partially carved state from his predecessor in 1615, as part-payment for his own statue of the *Baptist* (carved from a new block), for the Barberini Chapel in Sant'Andrea della Valle. It may be inferred that the indulgent Pietro passed the mangled block to his son, who was thus constrained to fit his different saint within its confines.[19]

The *St Sebastian* was first recorded in a Barberini inventory of 1628 as a 'modern' work, though without its sculptor's name; this was supplied four years later in another, more professional list drawn up by a sculptor who worked for Gianlorenzo. The connection with the family of Maffeo Barberini, the mentor of the young sculptor, suggests that it was commissioned by him.

Despite their modest scale, these two religious statues established Gianlorenzo's ability to render the ideal human nude in a graceful and convincing manner, emulating antique and High Renaissance prototypes. Although they were followed directly by an amazing series of grand mythological groups (apart from David, the one religious subject) they presage the fervour and imagination with which, beginning in the papacy of his mentor Maffeo Barberini (Urban VIII), Bernini would address the challenge of the supremely important Christian themes in the Basilica of St Peter and in the other great churches of Rome. The sculptor's own self-assurance at this early stage of his career is manifest in a brilliantly mature self-portrait drawing in coloured chalks, now in the National Gallery of Art, Washington D.C.

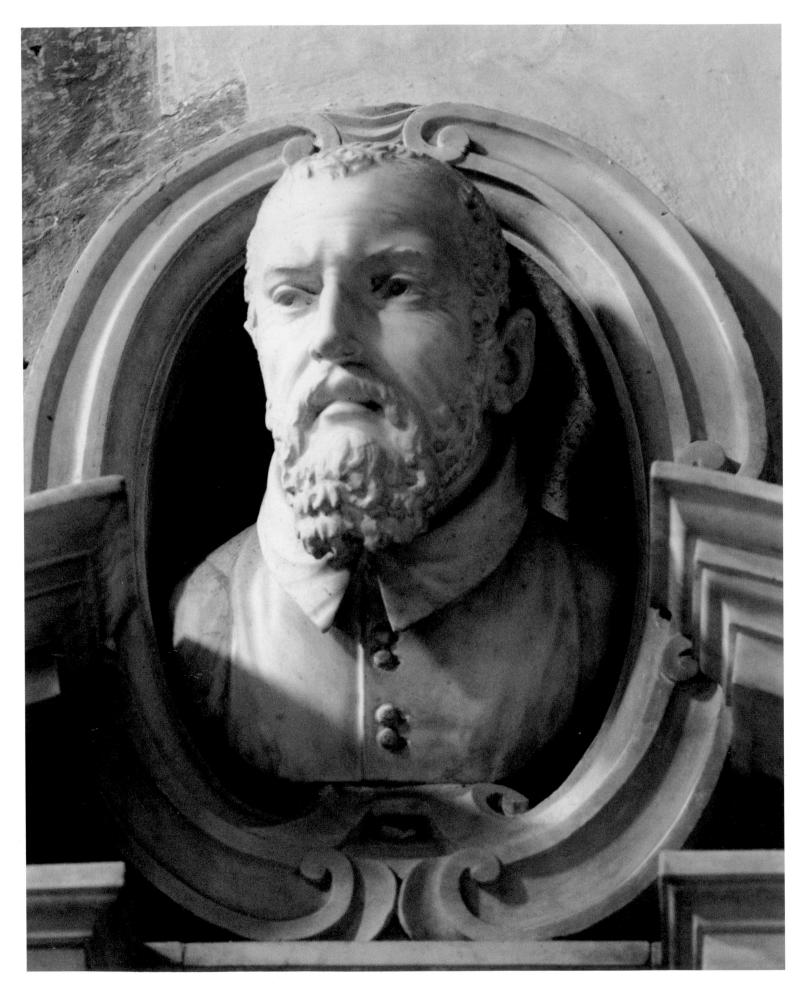

2 * Coming of age: the first portraits

The man who gives life to pieces of marble
Paolo Giordano II Orsini, Duke of Bracciano, 1648

GIANLORENZO Bernini rapidly became famous for his ability to produce 'speaking' likenesses. We have seen how heads were among his earliest recorded efforts, including one of a child that he produced at the age of eight or ten and presented to the pope, and how interested he was in recording his own appearance throughout his life in the graphic media of chalk on paper or oils on canvas. Similar portraits of his family were noted in the posthumous inventories of his personal effects, and some of these, those of his parents, might have been early essays in the difficult art of portraiture.

Indeed, a recently discovered marble bust of Pietro Bernini convincingly attributed to Gianlorenzo, though in general technique and the arrangement of its drapery seeming to date from *c.* 1640, may be based on a model in terracotta of Gianlorenzo's father's head made in 1612 or so, for Pietro appears to be aged about fifty.[1] The deeply etched features of Pietro's pudgy face and his moustache, goatee beard and waving, swept back hair would have presented a perfect opportunity for an early shot at portraiture by his precocious son in those formative years. Such portraits of family and friends would naturally tend to have preceded any commissioned by outside patrons.

Pietro Bernini was not by inclination a portraitist, but two of the few identified works of his master Ridolfo Sirigatti are impressive busts of his parents dating from 1576–8. They were praised by Borghini in his book *Il Riposo* of 1584, 'a marble head of his father done from life, which is extremely like, and another of his mother, which enables us to see her as though she were still alive'.[2]

There was also a strong tradition during the Counter-Reformation period in Rome of including busts – sometimes little more than the head – on mural epitaphs in churches.[3] Among the fairly standardized images of respectable gentlemen in armour or a cloak truncated in a curve to fit the oval, a particularly vivacious bust of a pretty young widow, Virginia Pucci-Ridolfi, stands out. Her sweet little face with its wide-eyed innocence is framed in an upstanding starched linen collar, daringly undercut by the sculptor. Dating from

c. 1600, it is in a prominent position at the back of the church of Santa Maria sopra Minerva, and would certainly have been known to Gianlorenzo Bernini, who worked there too; it inspired his later portraits of Maria Barberini Duglioli and Costanza Bonarelli.

Bernini's earliest heads and busts were designed for oval frames and are often set off with coloured marble surrounds, in conformity with this fashion. As Baldinucci writes, 'The first work to emerge from his chisel in Rome was a marble head . . . Bernini had then scarcely completed his tenth year.' This is part of a mural epitaph to G. B. Santoni (d. 1592)[4]; it is life-size, with only a small segment of the shoulders, and is set tightly in an oval frame with Mannerist mouldings behind and in between a broken pediment. Three cherubim ornament its elaborate frame and have been mentioned as models for the heads of Bernini's early mythological statues of putti. Baldinucci's date of 1609 may be a trifle early, as it was most probably the appointment of Santoni's nephew to a bishopric in 1610 that occasioned the commission for this posthumous portrait of the old man. So the boy had not only to carve a good likeness, presumably on the basis of a death mask or other form of portrait, but to infuse with character and life an image of someone he had never even seen. He avoided a 'deadpan' effect by turning the head slightly off-axis to our left and swivelling the deeply drilled irises of the eyes still further in that direction, while contracting the muscles of the eyebrows into a slight frown, as though Santoni had just been interrupted. The cranium beneath the wrinkled skin is convincingly apprehended and the lifelike effect is enhanced by the crow's-feet at the corners of the eyes. The large ears are well modelled and the head and neck are set firmly into the collar.

Indeed, the head projects so strongly from the oval aperture, while the shoulders remain within it, that it resembles a person leaning out of a porthole. This degree of projection serves a practical purpose, for it permits a play of natural light across the features that is particularly important in modelling the head with gradations of shadow. Bernini was always careful to use such sources of directed light to give maximum plasticity to his sculptures, and normally composed and carved to accommodate his figures accordingly. He was able thereby to endow the monochrome material of marble with chiaroscuro and something like the

29. Detail from the monument to Monsignor G. B. Santoni (Santa Prassede, Rome).

30. Monument to Monsignor G. B. Santoni (Santa Prassede, Rome).

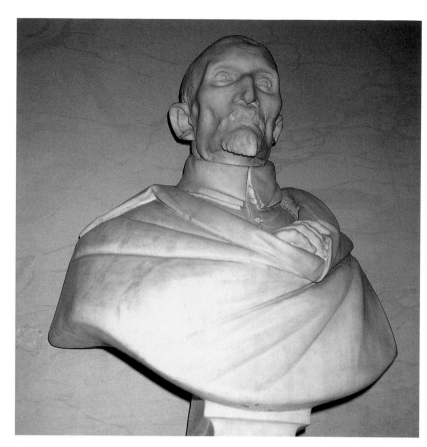

31. Memorial bust of Antonio Coppola (San Giovanni dei Fiorentini, Rome).

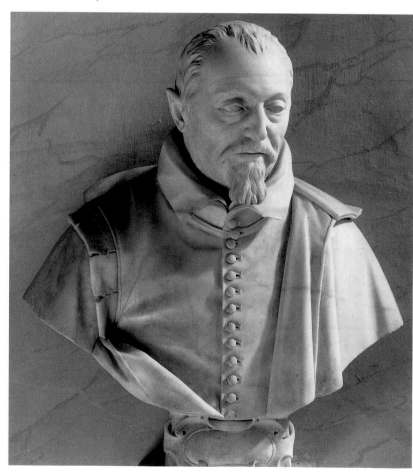

32. Bust of Antonio Cepparelli (San Giovanni dei Fiorentini, Rome).

effects of 'colour' derived by painters from the use of actual pigments, as he later explained to his French confidant, Chantelou.

Bernini's next commission for a bust was occasioned by the death early in 1612 of Antonio Coppola at the age of seventy-nine.[5] He was an eminent surgeon at the Florentine hospital in Rome, adjacent to the church of San Giovanni dei Fiorentini, and left all his effects to the hospital. In view of this generosity it was determined to erect a memorial with his portrait in the hospital, above the door leading to a balcony overlooking the Tiber. A wax cast was taken from a death-mask and Bernini was commissioned to create a marble bust from it. This he did in the time-honoured way by beginning with a model in terracotta. The carving took only four months, and Pietro received payment on behalf of his son, who was a minor, on 10 August. As the hospital was still being built, the memorial was not installed until 1614.

This bust and one made by Bernini ten years later depicting Antonio Cepparelli were cleverly discovered by Professor Irving Lavin in 1966 in the basement of the church of San Giovanni dei Fiorentini. This added considerably to our knowledge of the young Gianlorenzo's capacities, and usefully corroborated his own and his biographers' accounts of his amazing precociousness. Lavin has written eloquently about his find:

The portrait of Coppola is an unforgettable image of an emaciated old man with sunken cheeks and cavernous eye sockets. The spidery fingers cling without force or tension to the drapery that envelops the figure like a shroud. Here, the difference between life and death has been obliterated. It is the figure of a man in suspended animation, motionless and timeless, yet with the penetrating effect that only the spectre of death can have upon the living.

It may be added that the seeming smallness of the head of Dr Coppola may be due in part to the natural shrinkage that occurred when the molten wax poured into the plaster face-mask cooled. This diminution of size may subsequently have been transmitted by accurate measurement to the clay model. When fired into terracotta, clay also shrinks, owing to the loss of the volume of water that has evaporated. If a sculptor does not compensate deliberately therefore, the finished marble image will be distinctly smaller than the human 'original'. The use of casts from face-masks is therefore a doubtful help. It is ironic that Bernini's head of Santoni, a man who had died before the sculptor was born, looks more lifelike than that of Coppola, whom Bernini may even have known personally.

A lost bust that must also have been made in 1612, when its subject left Rome for an archbishopric in Bologna, depicted Monsignor Alessandro Ludovisi, later Pope Gregory XV. This commission is a mark of the esteem in which

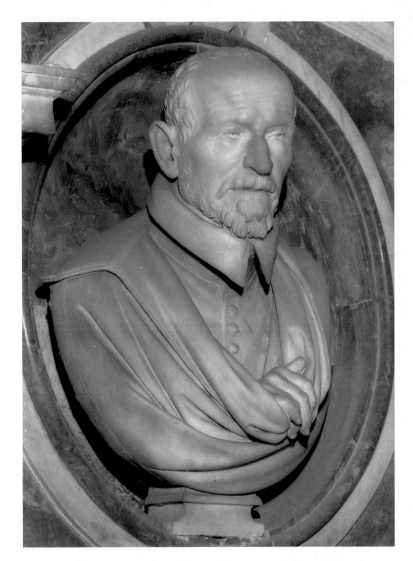

33. Bust of Giovanni Vigevano (Santa Maria sopra Minerva, Rome).

Bernini was held by yet another major and ultimately papal family, alongside the Borghese and the Barberini. On 26 April 1618, he received the sum of 50 scudi from Maffeo Barberini for a bust of his mother, Camilla, née Barbadori, who had died in 1609, and, in February 1620, the same amount for one of his father Antonio (lost).[6] Initially, both were installed in the family chapel in Sant'Andrea della Valle, but they had been removed to the private collection by 1628, and supplied with new yellow marble socles (on which the bust of Camilla is still mounted), indicating that they had previously been set directly into oval frames. The bust of Camilla is startlingly frontal and unadorned, with little attempt to 'revivify' her; in this respect she adheres to the formulae that had been popular in Rome for the past fifty years. She engages one's emotions far less than Sirigatti's portrait of his mother. This may be due partly to Bernini's enforced reliance on a death-mask, but partly also to the desire of Maffeo for a hieratic image, resembling a solemn bust of the Virgin Mary.

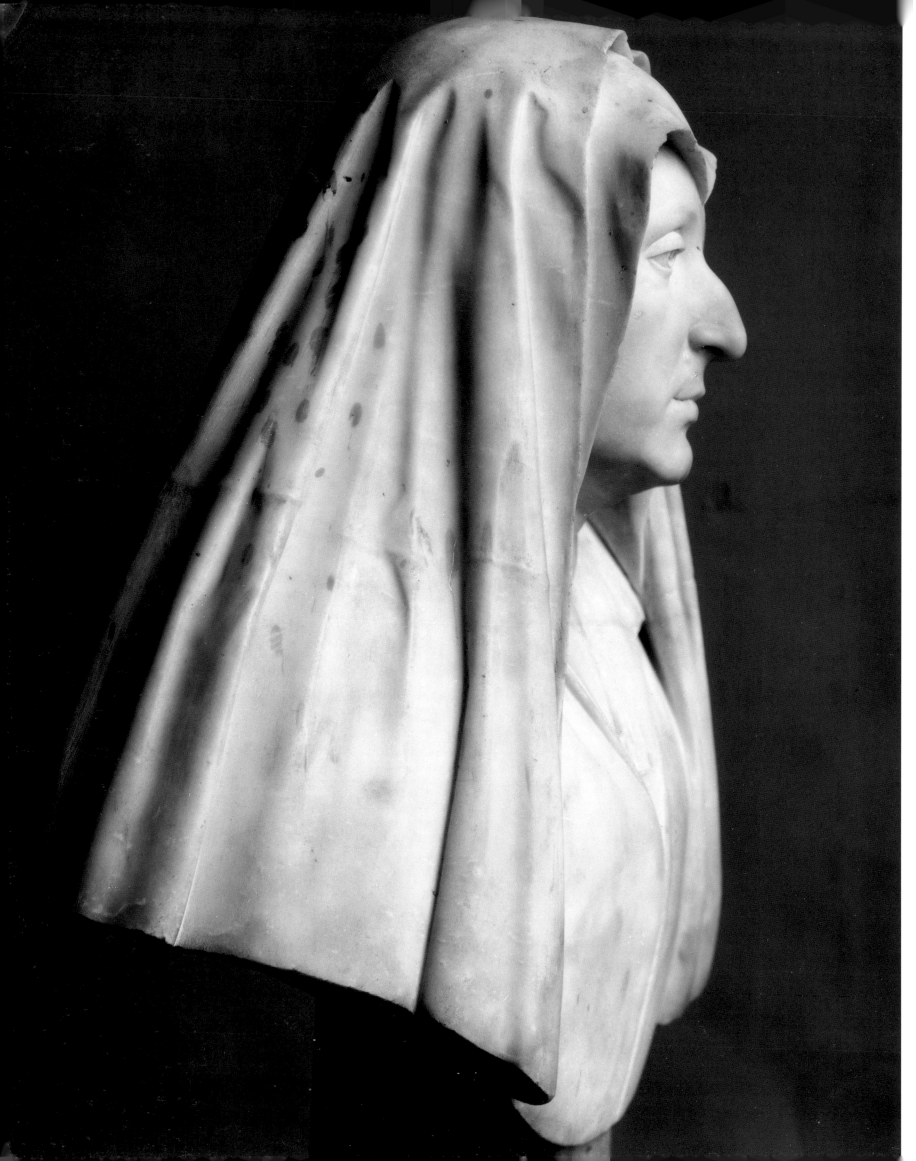

Bernini's next bust of a gentleman, Giovanni Vigevano, is an amalgamation of the two earlier ones:[7] it has the more lifelike head of Santoni, but borrows from Coppola the enlivening motif of depicting the right hand resting on a loop of the cloak (which would later reappear in the bust of Thomas Baker). Vigevano did not die until 1630, but it is generally agreed that, from a stylistic point of view, the bust cannot be so late and must have been made when the subject was still alive, probably around 1618–20. It exploits a motif that had just begun to appear in the bust of Coppola: a mouth deeply excavated with the drill so that it appears slightly open. Bernini had obviously already conceived the idea, later expounded to Chantelou vis-à-vis his bust of Louis XIV, that the expression most characteristic of an individual is just before – or just after – he has spoken.

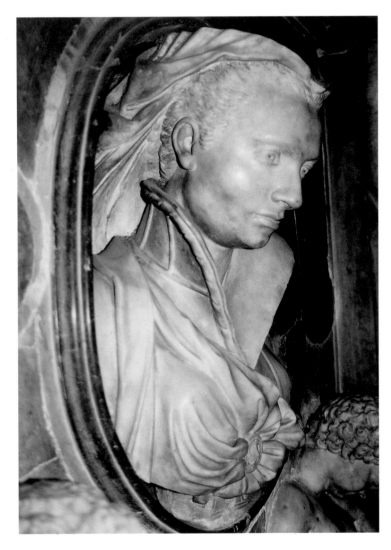

35. Memorial bust of Virginia Pucci-Ridolfi (Santa Maria sopra Minerva, Rome).

34. Bust of Camilla Barberini, née Barbadori (Statens Museum for Kunst, Copenhagen).

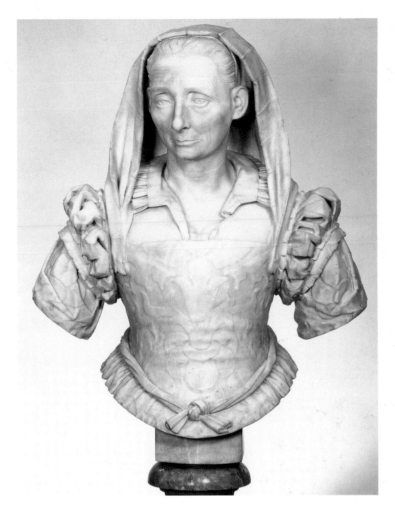

36. Ridolfo Sirigatti's bust of his mother (Victoria and Albert Museum, London) shows a sensitivity and psychological subtlety that prefigures Bernini's busts. Sirigatti was Pietro Bernini's master.

At around the time he started to work for Scipione Borghese in 1618, Bernini carved, on a slightly reduced scale, an image of his patron's uncle, Pope Paul V.[8] In terms of power, both spiritual and temporal, Borghese was his most important patron so far; Bernini had to bring all his ingenuity to bear in order to imbue the small marble head – the face is only some six inches high – with the characteristics of this calculating and potent personality. The eyes he left blank, in deference to the classical tradition and perhaps from a feeling of shyness at making the pope seem too human and accessible. The bullet-like shape of the head is unforgiving, and Bernini polished its convex surfaces into a picture of dynamism that is almost aggressive. The frown, the pursed lips and set of the jaw beneath the stubbly jowls, combined with the sharp points of moustache and goatee beard, give Pope Paul a forbidding appearance. The head is firmly set within the crinkled linen of the amice, which in turn acts as a foil both for the drilled perforations of the lace border of the

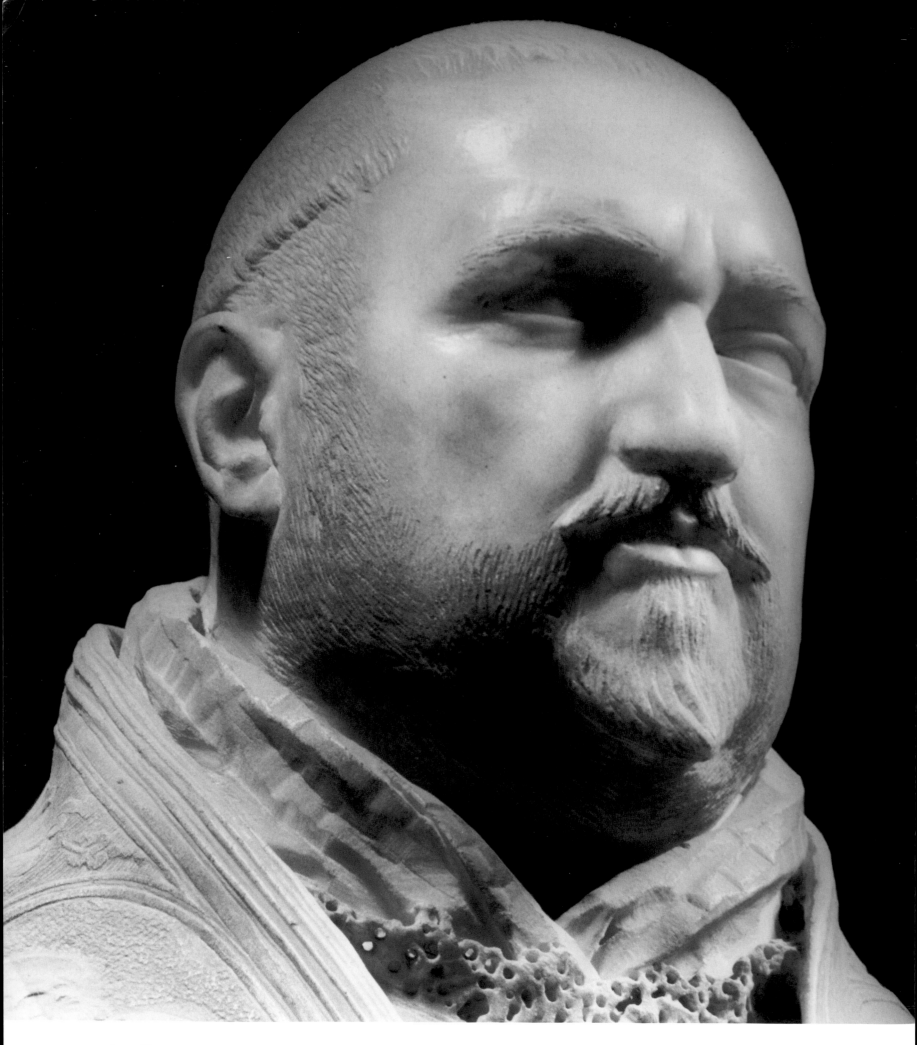

alb in front and for the almost metallic-looking curve of the embroidered cope.

The young Bernini also allowed himself an exercise in positively Donatellian shallow relief in the pair of images in the cartouches on the collar of the cope: in accordance with tradition they show the major Roman saints, Peter with the keys of the Church and Paul brandishing the sword with which he was martyred. Bernini even differentiated the stitching of the backgrounds and adopted some motifs from Donatello, such as the claw-like hands and the projection of the feet beyond the frames. The general effect is rather drier than one might expect if the artist had been attempting to depict the real saints, but he was after all rendering hieratic images that were in reality embroidered in stiff gold thread.

Not long afterwards Bernini was called upon to create a full-scale bust of the pontiff. Pope Paul V died on 28 January 1621 and the portrait was paid for later the same year. Formerly kept in the church of the Gesù and later in the Villa Borghese, it was sold in 1893 and is now missing, but happily its appearance is preserved in a bronze cast acquired from the sale of the surplus contents of the Villa Borghese.[9] This is mounted on an elaborate voluted pedestal bearing the papal arms, which perfectly matches one that supports a bronze cast of the sculptor's image of his successor, Gregory XV; evidently they were considered a pair.[10]

Let Baldinucci take up the narrative:

Meanwhile, Pope Paul V died and the holy tiara was given to Alessandro Cardinal Ludovisi of the most noble Bolognese family, who took the name Gregory XV. Not much time elapsed before the new Pope, who appreciated Bernini's merit above that of any other artist of his age, was pleased to engage him to carve his portrait. Bernini made not one portrait but three, in both marble and bronze. The portraits corresponded so much to the pontiff's expectations that Bernini gained a great measure of esteem through them. Afterwards, the cardinal-nephew, knowing that Bernini possessed great nobility of thought and not a little erudition to match his excellence in art, was pleased to have him dine with him regularly on holidays in order that he might engage him in stimulating conversation. He arranged for Bernini to receive the Order of Christ and the rich pension that went with it.

39, 40 The marble bust of Gregory XV was begun immediately after his election in February 1621 and was finished — with remarkable expedition perhaps in view of the pontiff's age and infirmity — by September, a period of only eight months, while two casts were made in bronze.[11] Bernini achieved this *tour de force* by reusing the arrangement and pattern of the cope, amice and alb that he had just contrived for Paul V,

37. Detail of the bust of Pope Paul V (Villa Borghese, Rome).

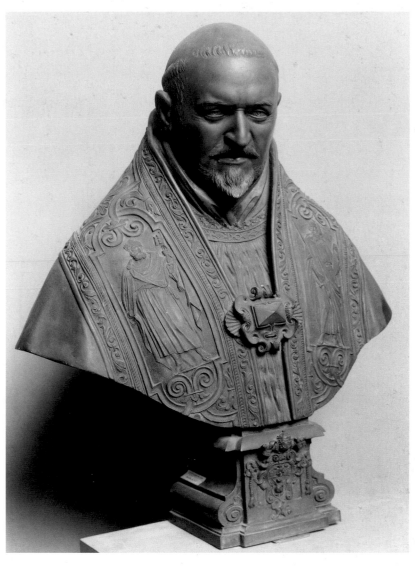

38. Bronze bust of Pope Paul V (Statens Museum for Kunst, Copenhagen).

making only a few minor alterations to the flanking images of Saints Peter and Paul and the details of the morse. Not surprisingly, despite their very diverse physiognomies, the images of the pontiffs closely resemble each other. In both, the sculptor made the head of the pope nestle still lower into the collar of his cope than in the small, earlier bust of Paul V, so that the silhouette becomes more triangular.

Bernini's task was to portray a sickly, though mentally alert, man of sixty-seven, showing him in the majestic role of pope, a direct successor to St Peter, head of the Roman Catholic Church, and a force to be reckoned with in international affairs. The sculptor used the cope, heavy with gold thread, with its stiff, formal embroidery of geometric and foliate patterns, and clasped with a jewelled morse, to convey the might and wealth of the Church. The two inset panels depicting St Peter and St Paul indicate the office of the sitter and his saintly protectors. The thickness of the fabric and its unyielding, metallic embroidery are suggested

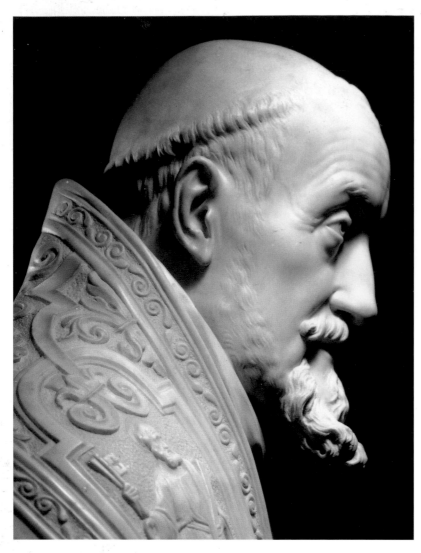

39. Profile view of bust of Pope Gregory XV
(Mr and Mrs J. Tanenbaum, Toronto).

by the abrupt bends with which it conforms to the curve of the pope's shoulders. Within the springing, horseshoe-shaped frame formed by the cope's inner border, the pope's delicate and refined head is set off by the pleats of softer fabric in the amice and alb.

The pope's head is bowed forward, indicating not only his age, but the weight of his supreme office, which is symbolized by the apparent weight of the cope resting on his shoulders. In order to focus his gaze horizontally ahead of him, Pope Gregory is forced to raise his eyebrows, causing a series of wrinkles to appear across his forehead. His cheeks cave in and his lips are slightly parted with this exertion. The gaze appears to be steady and far-seeing, focused not on the spectator, but on eternity. The skin is buffed to a high polish to indicate the natural pallor of Pope Gregory's complexion noted by his contemporaries. Its smoothness is accentuated by the crisp, dry carving of the myriad tufts of hair around his tonsured head and down his cheeks and jowls, carving which then seems to burst forth almost luxuriantly – by

contrast – in his curly moustache and square-cut beard: here light and shade, as well as physical depth, are imparted by Bernini's favourite sculptural tool, the drill.

Bernini's approach to portraiture is recorded in a number of significant remarks and explanations he gave later in life.[12] Rather than relying on normal sittings, which were difficult for his preoccupied clientele, and in any case tended to make the portrait stiff and over-formal, the sculptor liked to observe his subjects during their daily activities, making numerous sketches as a way of fixing their features and characteristic poses and expressions in his mind's eye. Only towards the end of the process of building up a preliminary model in moist clay, and later during the advanced stages of carving the marble version, would he resort to sittings from life.

Most apposite to the present instance is Bernini's explanation of the problems engendered by making a portrait in white marble. 'When someone faints,' Bernini explained, 'the pallor which spreads over his face is enough to make him almost unrecognizable, so that one says, "He is not himself."' Therefore, in a marble bust it is necessary to create effects of colour by a number of tricks and even exaggerations or distortions, drilling more deeply than was natural in places to create accents of shadow, or leaving the marble upstanding to catch the light. This technique is evident in the present bust, in the creation of shadows around the eyes, the sinuses, the crow's-feet at the corners and so forth. Bernini also remarked, 'Mere resemblance is not sufficient. One must express what goes on in the heads of heroes.' As leaders of the Church, both Popes Paul and Gregory would have seemed heroes to him. In his bust of the latter, the young sculptor succeeded in giving an admirable impression of character and mood: the dignity and uprightness of the law-giver is combined with the personal humility and sensitivity of the priest. The physical weakness of the flesh is contrasted with the spiritual resolve of a reforming pope.

Gianlorenzo Bernini was well rewarded for his pains; at the age of twenty-two, he was given a papal knighthood and the salary that went with it.[13] In 1622, Antonio Leoni published an engraving of him wearing the special cross of the order, and indeed he was known thereafter as 'Il Cavaliere'. He was also elected at this tender age the Principal of the Academy of St Luke, the artists' society of Rome, into which he had matriculated only three years before. These honours were the summation of his early success, which also included the series of great mythological statues in the Villa Borghese which will be discussed in the next chapter.

40. Bust of Pope Gregory XV
(Mr and Mrs J. Tanenbaum, Toronto).

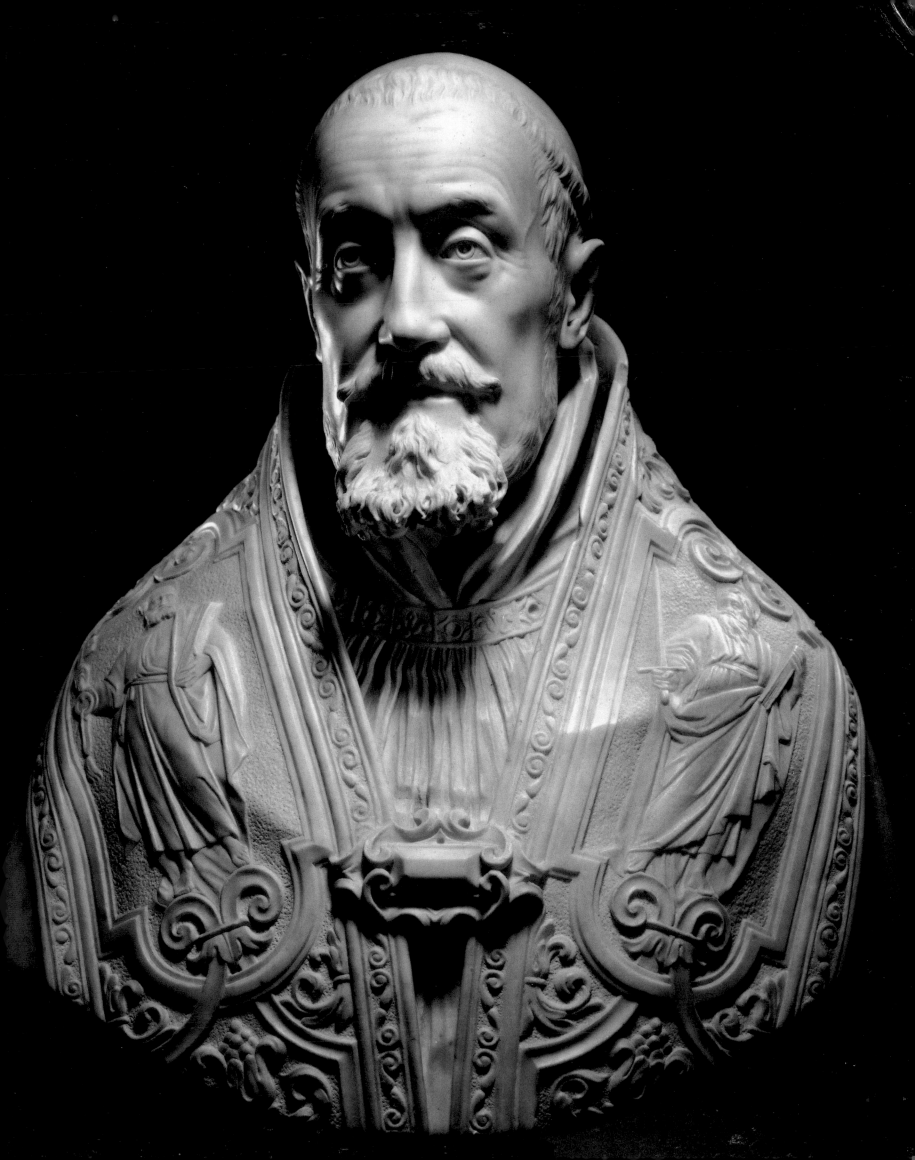

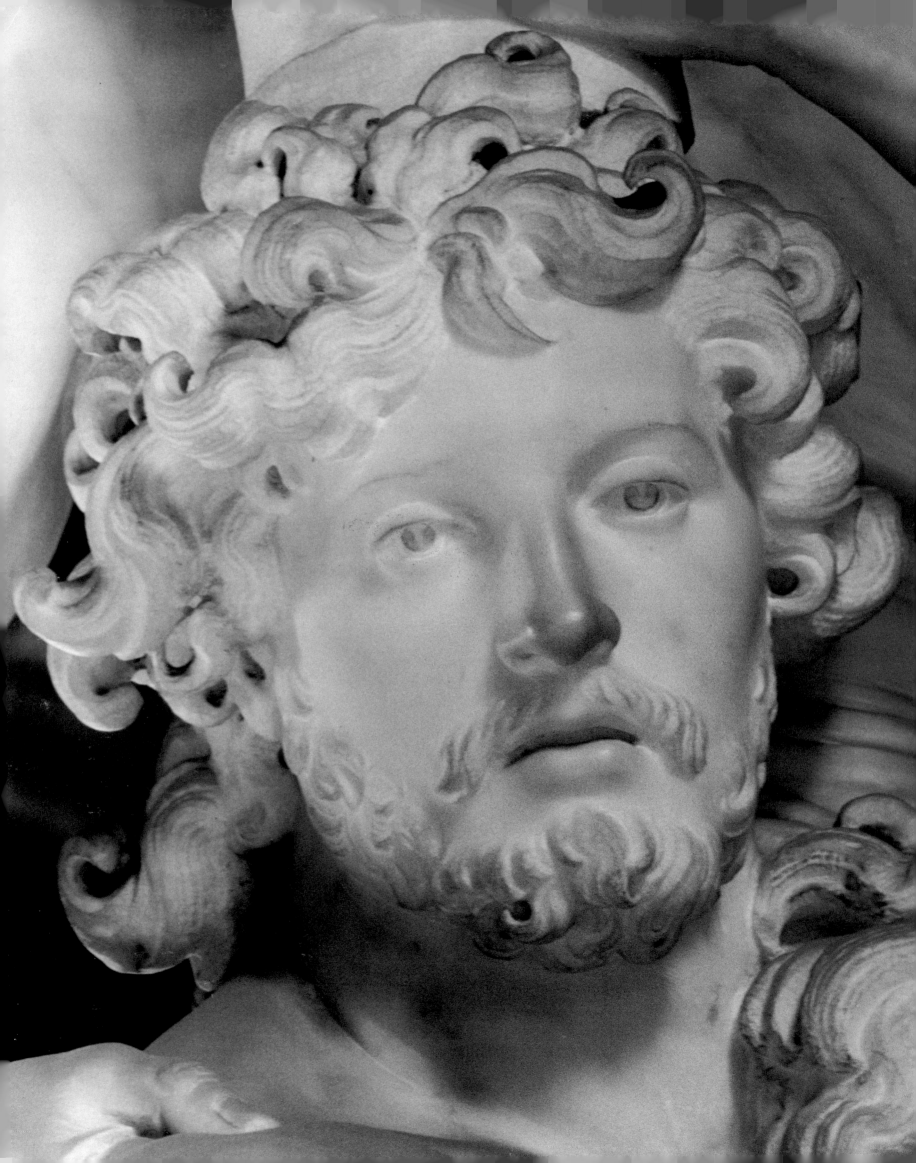

3 * The great mythological groups: Aeneas, Proserpina and Daphne

From youth I devoured marble and never struck a false blow Gianlorenzo Bernini

BERNINI'S star was now firmly in the ascendant: successful portrait busts and religious statuary for members of the Florentine colony in Rome and for Maffeo Barberini were matched with sculptures for the papal family, which included works as diverse as *The Goat Amalthea Suckling the Infant Jupiter and a Satyr*, *Priapus* and *Flora*, and the small bust of Pope Paul V. Baldinucci provides a history and brief critique of Bernini's first major work, *The Flight from Troy*:

Then, for the Cardinal Borghese, he made the group of Aeneas carrying the aged Anchises, figures rather more than life-size. This was his first large work. In it, although something of the manner of his father, Pietro, is discernible, one still can see, through the fine touches in the execution, a certain approach to the tender and true, toward which from then on his excellent taste led him. It appears most clearly in the head of the old man.

This must have been around 1618, for on 14 October 1619 a stonemason was paid for adapting a classical cylindrical altar as a pedestal for a 'statue of Aeneas'; while on the same day Gianlorenzo Bernini received in his own name a payment of 350 scudi for 'a statue newly made by him', which can scarcely be other than the group of Aeneas to stand on the said pedestal.[1] Nevertheless, the involvement of his father is implied by Baldinucci, and was believed by the German art historian Joachim von Sandrart on his visit to Rome in 1629, for in his book of 1675 he actually attributed the group to Pietro alone.

The subject is the flight from Troy of Aeneas, hero of Virgil's epic poem the *Aeneid*,[2] who was, after many adventures, to found the city of Rome. From the burning city, in a spirit of filial piety (an important concept in the ancient Roman religion), he carried his aged father Anchises, who clutches precariously their household gods (Lares and Penates). At his side plods his own son, Ascanius, bearing an oil lamp, with the sacred flame of Vesta, stylized in a way that recalls the flames of Bernini's *Martyrdom of St Lawrence*. This was to provide light in darkness and a means to kindle fires in their exile.[3]

The three male figures are at very different stages of life and thus convey – deliberately – an image of the 'Three Ages of Man', another theme derived from antiquity. Bernini may have intended to respond to the age-old challenge of Leonardo's 'Paragone', that sculpture owing to its lack of colour was bound to be less convincing than painting.[4] Ascanius, unmarked by time and experience, has the chubby blandness of an innocent child; Aeneas, on the threshold of his stressful odyssey, has a perfect adult face, following the classical norms. But Bernini's Aeneas also has distinct overtones of Michelangelo's *Christ with the Cross* in Santa Maria sopra Minerva. Indeed, Aeneas' whole body in its particular stance, the arrangement of the arms and the outward and downward glance over the lowered, foremost shoulder make it clear that Michelangelo's statue was Bernini's basic model.

Aeneas also distinctly resembles Pietro Bernini's *St John the Baptist*.[5] Indeed this work is the pivotal term in the equation between Michelangelo's *Christ with the Cross* and Bernini's Aeneas, for Pietro had arranged his Baptist in mirror-image to Michelangelo's Christ, thus providing the seminal motif for Aeneas, even down to the animal's pelt with which the figure is draped in rather angular folds (though here it is transformed from the hide of a camel to that of a lion, whose flayed face decently conceals the loins of Anchises).[6] Pietro also provided a translation of Christ's even features and relatively calm hair into those of a man of the deserts, whose more savage appearance is underlined by vigorous undercutting of his abundant curls. In the case of Aeneas, Bernini made the curls more flame-like, with curls and counter-curls (as on the lion's mane too), in keeping with the theme and tenor of the whole group.

Anchises, in his look of wide-eyed horror, seems almost literally 'petrified'. Bernini, carving him out of cold, snow-white marble, utilized other current ideas for showing how an old man looked when frozen stiff. A greybeard shivering in the cold was the standard personification of Winter in series of the Four Seasons. Indeed, the fur-lined hat and the long beard (the details of which in this case also hint at the flames consuming Troy) were normal attributes for hoary old figures of Winter, who is usually shown attempting to warm himself at a brazier, hinted at here in Ascanius' lamp.

The projecting chin, which suggests that most of Anchises' upper teeth have fallen out, also indicates the

41. Head of Aeneas, from *The Flight from Troy*, a joint work of Pietro and Gianlorenzo Bernini, showing pencil shading around the eyes (Villa Borghese, Rome).

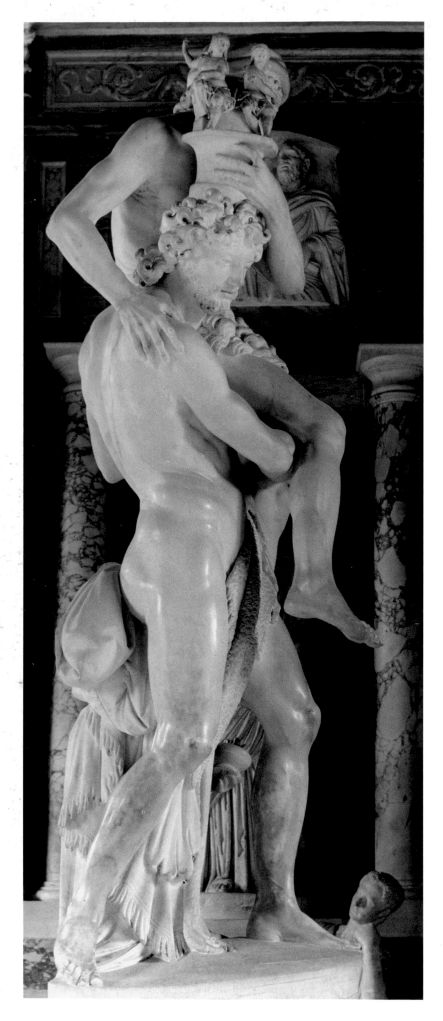

stubbornness of old age when confronted by a threat. Bernini pulled out all the stops in his repertory to create this characterful face: the deep excavation of the staring pupils of the eyes, and the arching of the muscles over the outer ends of the eyebrows indicate fear, again following a Leonardesque formula. He used some of the same signs of old age when a few years later he came to portray the aged and infirm Pope Gregory XV, as discussed in the previous chapter.

Bernini also heeded Leonardo's dicta when modelling the soles of Anchises' feet, which are appropriately gnarled and 49 wizened. The slackness of the skin over the muscles and bones, also noted by Leonardo as characteristic of old age, is brilliantly rendered where the smooth, firm, beautifully manicured fingers of Aeneas' right hand accidentally pull at the loose flesh over the sinews behind his father's left knee as he steadies him. These are bravura passages of detailed carving indeed, and there are many others besides!

The group is carved fully in the round and yet is not contrived to be equally interesting from behind; unlike its obvious prototype, *The Rape of a Sabine* of 1583 by 54 Giambologna, Bernini probably never intended it to be seen from that angle, although the group now stands deceptively in the centre of a room in the Villa Borghese on an incongruously rectangular modern base (1909).[7] The classical one intended for it is utilized elsewhere in the gallery, and its 48B cylindrical shape would have emphasized the circularity of the Bernini composition, but one can infer from the fact that a segment is cut off vertically, that it was abutted against a wall. It should be imagined projecting from a short stretch of wall between two windows of a room at the north-eastern corner of the villa, the room called the Chamber of Daphne because Bernini's group of *Apollo and Daphne* stood lengthways against the opposite, western wall.

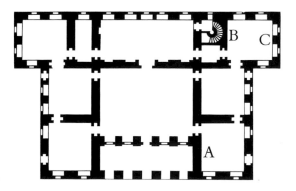

43. Plan of the Villa Borghese showing the original positions of the groups. A: *David.* B: *Apollo and Daphne.* C: *The Flight from Troy.*

42. Pietro and Gianlorenzo Bernini: *The Flight from Troy* (Villa Borghese, Rome).

44. Head of Anchises, with the household gods, from *The Flight from Troy* (Villa Borghese, Rome).

44 *The great mythological groups*

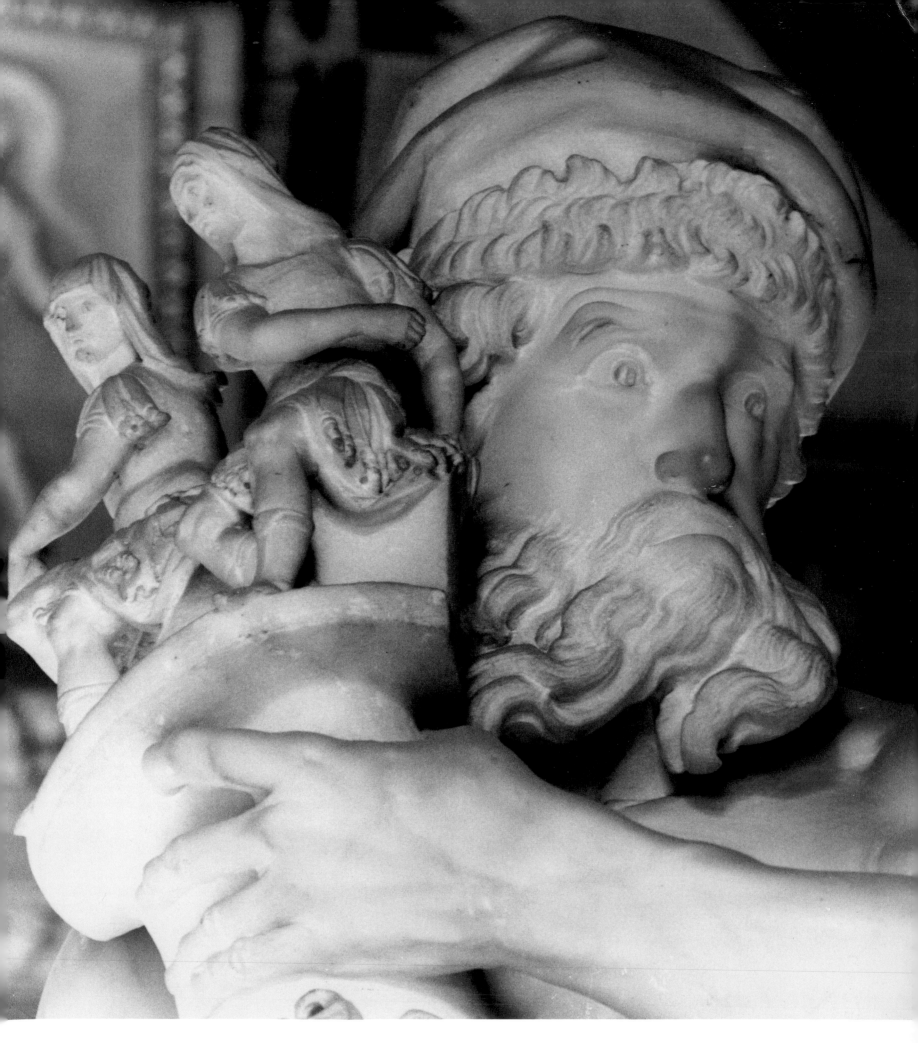

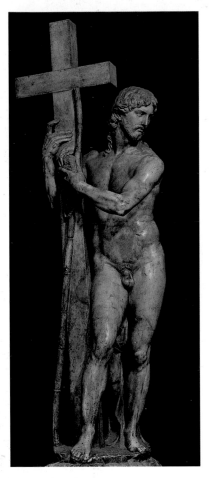
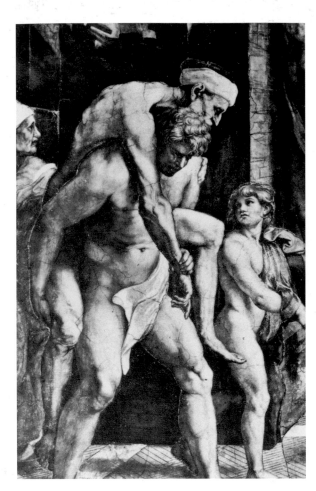
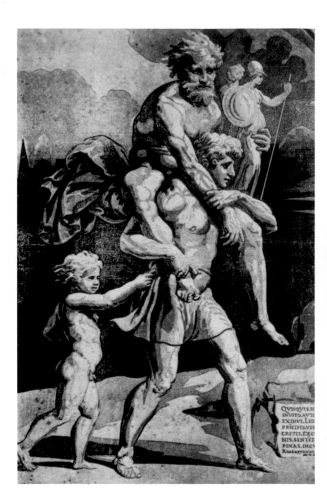

45, 46, 47. Possible sources in Bernini's mind when carving *The Flight from Troy*. Michelangelo's *Christ with the Cross* (Santa Maria sopra Minerva) was the model for Aeneas. Raphael's *Fire in the Borgo* (Stanze, Vatican) provides a close parallel, as does his composition of the same classical subject, known from Ugo da Carpi's woodcut of 1518.

Positioned in this way, the side of the group with Ascanius would have been visible diagonally as one entered the room from either of the adjacent doorways at the south-western corner of the room. This must be considered its principal view, for from the 'front' or other side of the spiralling composition this third, but important, participant is not visible at all (except for the oil-lamp that he holds out, which is unexplained from these angles). The layout of the windows is such that the sculpture would have been well illuminated from behind and from either side, with softer light from a more distant window falling diagonally from the viewer's left, but with no source from directly in front, let alone above.

The most obvious sources for the subject are to be found in paintings. One is Raphael's celebrated and dramatic fresco in the Stanze of the Vatican, the *Fire in the Borgo*, where a prominent group of three male figures of diverse ages in the left foreground (with a female one half hidden behind them) is clearly intended to recall the story of Aeneas saving his family from the burning city of Troy.

Less well known, but doubtless available to Bernini, is a

chiaroscuro woodcut by Ugo da Carpi after Raphael, entitled *Flight from Troy*. Aeneas is shown carrying Anchises – holding the household gods (in the guise of two statuettes, one of Minerva) – much as the anonymous elderly man does in the *Fire in the Borgo*.

To translate such a diffuse narrative group into a viable, free-standing sculpture and at the same time suggest the concomitant drama and fire was a challenge. Bernini resorted to two devices: one was to integrate the child Ascanius into the lower part of the group adjacent to his father's left leg and the other – time-honoured from antiquity – was to introduce behind Aeneas a broken column, in itself suggestive of the ruination of Troy, and to drape it with his abandoned, fringed cloak and the trailing lion's pelt. These 'cheats' gave Bernini adequate support for the two adult figures, while allowing the legs to look free, as they take an impressive stride forward. The ambitious and complex composition thus exemplifies Michelangelo's theory that a group of three figures in unified action and with a flame-like outline was the *ne plus ultra* of sculpture. The 'Roman-ness' of the group would have been further enhanced by the reuse as a pedestal of the classical sacrificial altar, with its funereal *bucrania* (bulls' skulls), conveying a solemn impression appropriate to the fall of an ancient city.

The pagan history of Aeneas was interpreted at the time as having a profound bearing on the origins not just of Rome, but of the Catholic Church.[8] Passages from Virgil were

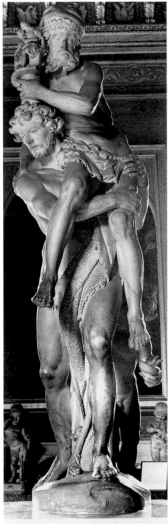

48A, B. *The Flight from Troy* originally stood on a circular base adapted from an ancient Roman altar, approximately as shown in this reconstruction.

49. Side view of *The Flight from Troy*, showing the young Ascanius, Aeneas' son, accompanying his father and grandfather, and carrying an oil-lamp with the flame of Vesta.

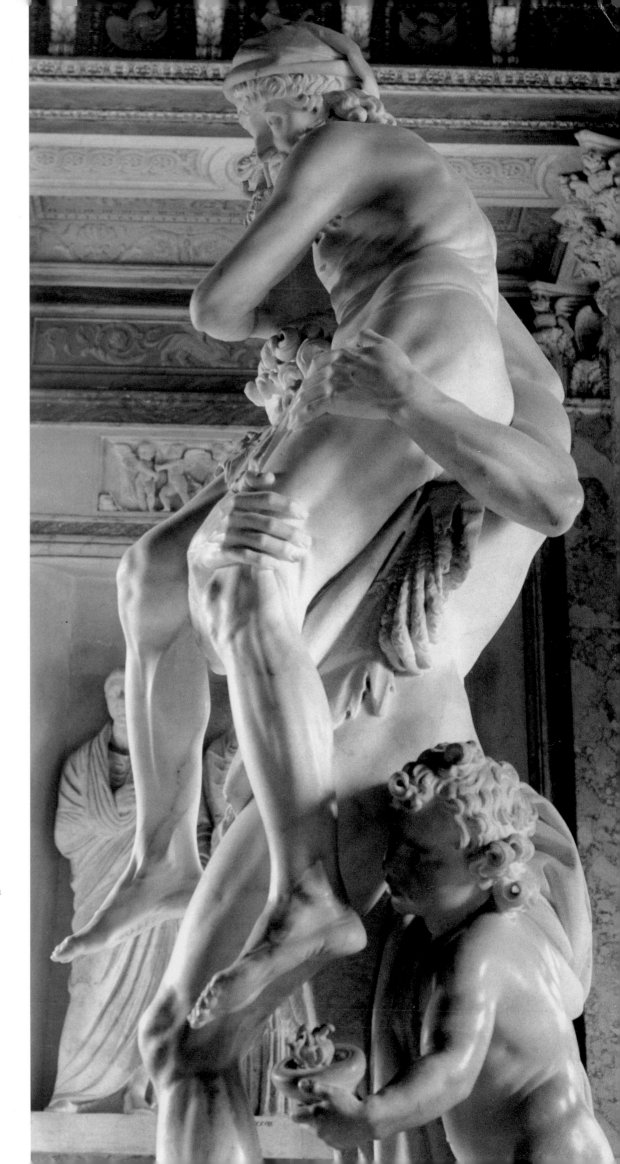

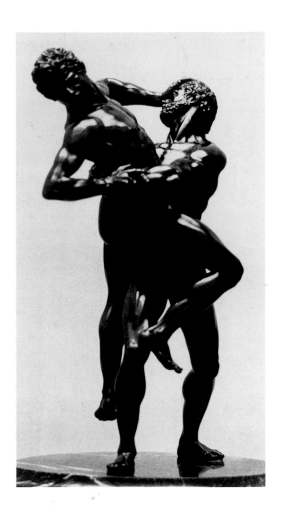

50. This bronze group attributed to Pietro Tacca showing *Hercules and Antaeus* (Art Institute of Chicago), is an exercise in one figure lifting up another, which Bernini must have known.

51. Bernini's preliminary chalk drawing for *Pluto Abducting Proserpina* (Museum der bildenden Künste, Leipzig).

believed to prophesy the Virgin Birth of Jesus, as well as the eternal rule of the Church. The group was therefore perfectly appropriate for the villa of a prince of the Church.[9]

After the completion late in 1619 of *The Flight from Troy*, Scipione entrusted the sculptor, who had now proved his independent worth, with the task of restoring a fragmentary classical figure, the recumbent *Hermaphrodite*. This was particularly dear to Scipione, who in order to lay hands on the seductive trophy had allegedly financed the rebuilding of the entire façade of Santa Maria della Vittoria. Bernini designed his restorations to emphasize the figure's bewitching naturalism, inventing a well stuffed and tightly buttoned mattress and squashy pillow for it to lie on.[10]

In 1621, he was also called upon urgently to carve the important portrait busts of two successive popes, Paul V and Gregory XV, as has been described. About this period, too, he was involved with the undocumented group of *Neptune and Triton* carved for the gardens of Cardinal Alessandro Damasceni-Peretti Montalto, who died in June 1623. This was a major exercise on the time-honoured and especially Florentine theme of two figures combined in a single action that had been sparked off by the groups of Victory that Michelangelo had planned for the Tomb of Pope Julius II. It will be dealt with in the chapter on fountains.[11]

In June 1621, Bernini was paid for his next group that *is* documented, *Pluto Abducting Proserpina*:[12] the advance of 300

242, 248

scudi was also to cover his second marble bust of Pope Paul V.[13] He received a further payment of 150 scudi on 15 September and work was finished a year later, though he did not receive his final settlement until 1624, when payment was recorded for the transport of the statue from the family studio near Santa Maria Maggiore to the Villa Ludovisi, just outside the Porta Pinciana: such was the fate of artists in those days, who dared not press their grand but desultory patrons. The original base – long since lost – was carved by a stonemason during the summer of 1622.[14]

The subject involved a further, yet more complicated and challenging, variation on the theme of a figure supporting another in mid-air, for in this instance, the upper figure, Proserpina, was struggling to escape, instead of sitting passively like Anchises. Earlier essays on such a theme had mostly, for practical reasons, been made of bronze, thereby exploiting its tensile strength to support the cantilevered dead weight of the victim.[15] Some marble versions existed too: a restored antique *Hercules and Antaeus* in the courtyard of the Pitti Palace, a group of the same subject by Girolamo Campagna in northern Italy,[16] and two of Vincenzo de' Rossi's monumental *Labours of Hercules* (Hall of the Five Hundred, Palazzo della Signoria, Florence). The most obvious sources of inspiration for Bernini were some of the treatments of two figures in strife, available as statuettes in bronze, by his immediate predecessor, Giambologna.

Pluto Abducting Proserpina is the earliest of Bernini's statues for which a preparatory drawing, as well as some — albeit fragmentary — models in terracotta exist. The drawing also happens to be his earliest datable one and is hence an important indicator of the sources of his style, which seem to be, broadly speaking and perhaps surprisingly, the Venetian school, in particular the soft chalk anatomical studies of Palma Vecchio and Tintoretto, as well as, more predictably, the Carracci.[17] In this sketch — perhaps a first thought — Bernini depicts a violent struggle between the striding Pluto and his victim Proserpina, whom he holds precariously in front of him with her buttocks against his midriff. She struggles against his embrace, thrusting her torso away from his head with her straightened left arm, trying with her bent right arm to disengage his hand from her waist and turning her head away in revulsion. The composition is clearly in the shape of an X, a basic form that implies conflict and opposition and in which the arms emphasize outward movement.[18]

The dramatic battle of the sexes in the chalk sketch recalls a bronze group, *Hercules and Antaeus*, now attributed to Pietro Tacca, that is derived from one of Giambologna's *Labours of Hercules*. The similarities are distinct: the stance and grip of Hercules, the directional thrust of both of Antaeus' arms and the violent turning away of his grimacing head. In the event, Bernini transformed his erotically charged composition into a more acceptably elegant, though still dramatic, version with the figures in reverse from those in the sketch. He contrived support by introducing behind Pluto the ferocious three-headed canine door-keeper of the underworld, Cerberus, against whom falls — as though by accident — a long trailing end of Proserpina's drapery, which also serves conveniently to conceal her assailant's private parts. Cerberus is thus analogous in practical, sculptural terms to Ascanius in the preceding group. The introduction of Cerberus also enlivens the lower portion of the composition — which, when mounted on a pedestal, is nearer to the spectator's eye-level — and provides extra narrative information and eye-catching detail, though it cannot readily be seen either from in front or from the left of the group. Its seated but alert pose is derived from a well known antiquity, the *Hound of Molossus*, and Bernini may also have known Bandinelli's rendering of the beast when lulled by the music of Orpheus in a statue in the courtyard of the Medici Palace in Florence.[19]

Proserpina's left arm, flailing upwards desperately in mid-air with its fingers urgently — but elegantly — spread, is an unashamed borrowing from the similar gesture, the visual equivalent of a shriek, in Giambologna's bronze and marble versions of *The Rape of a Sabine*. The tactile suggestion of Pluto's right hand pressing into Proserpina's thigh comes from the same source too, but is emphasized in a still more sensuous way.

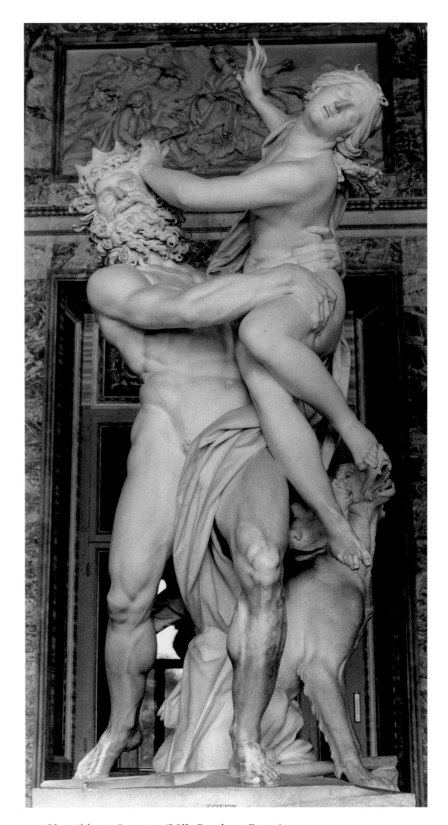

52. *Pluto Abducting Proserpina* (Villa Borghese, Rome).

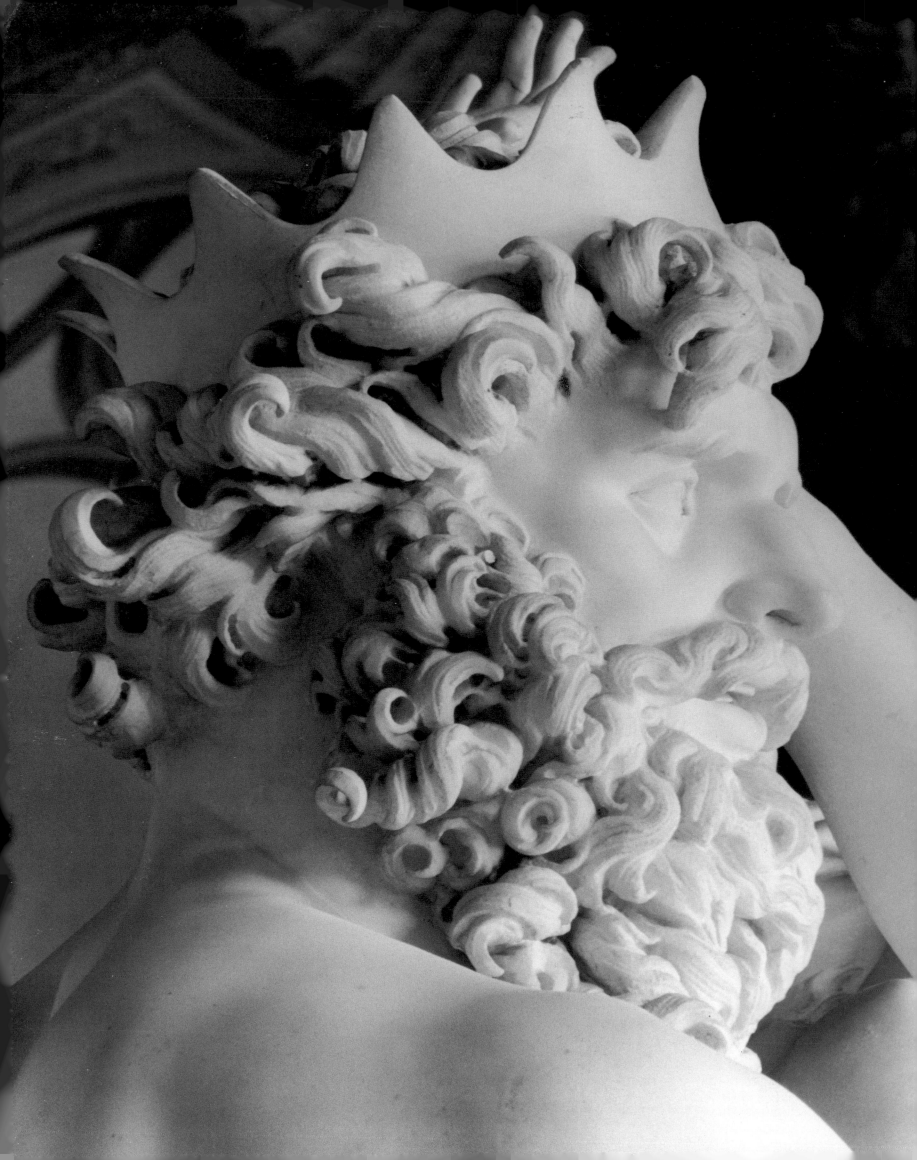

53. Head of Pluto from *Pluto Abducting Proserpina* (Villa Borghese, Rome).

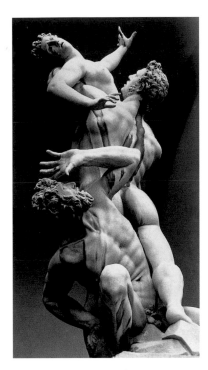

54, 55. Two versions of *The Rape of a Sabine* by Giambologna which must have influenced Bernini: the marble group in the Loggia dei Lanzi, Florence; and a detail from the bronze relief on its base (1583).

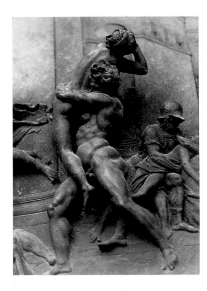

56. *Pluto Abducting Proserpina*, showing Cerberus (Villa Borghese, Rome).

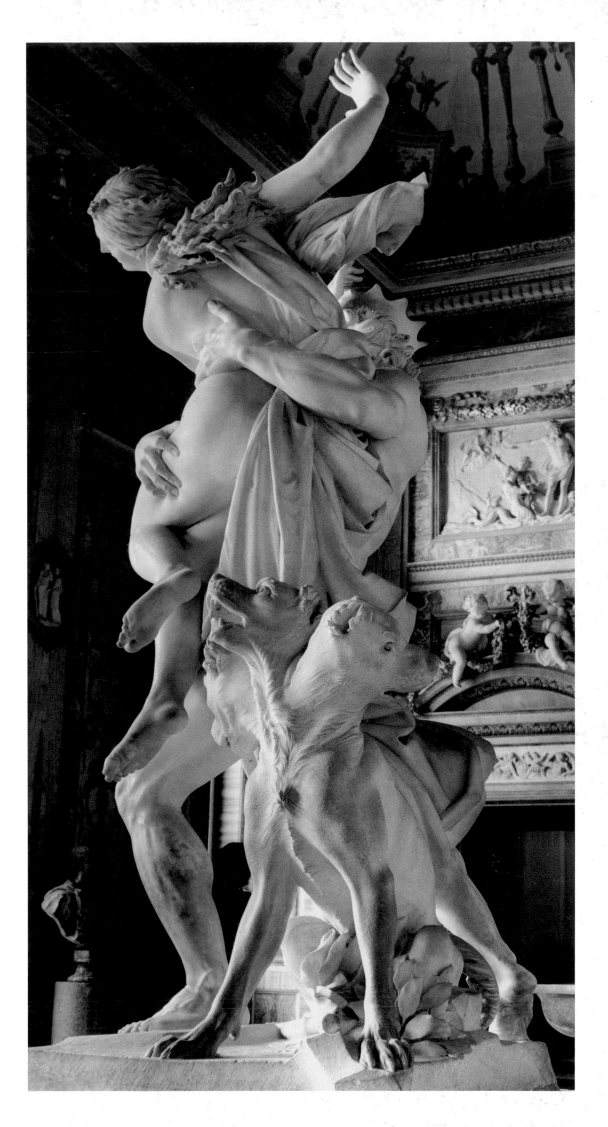

57. Giambologna's bronze of *The Centaur Nessus Abducting Deianeira* must have influenced the position of Proserpina's legs in Bernini's group (Staatliche Kunstsammlungen, Dresden).

What has not been appreciated previously is the fact that other works by Giambologna furnished Bernini with *all* the significant elements for his revised composition.[20] The aggressively masculine forward stride that Pluto now takes, grasping his prey at shoulder height so that his arm is almost horizontal, is a mirror-image of the Roman triumphantly carrying off a Sabine woman to the left of centre in Giambologna's bronze narrative panel which is installed beneath the monumental group in Florence. If Bernini did not know the original, he could have equally well noted it from the spectacularly large chiaroscuro woodcut rendering of 1585 by Andreani.[21] Having pilfered the pose of the male figure, he then twisted round the taut, bow-like curve of the woman's body so that it is opposed to, and springs away dramatically from, her abductor.

The ingenious young sculptor then borrowed the female figure from yet another bronze group by Giambologna, *The Centaur Nessus Abducting Deianeira*, for his desperately wriggling Proserpina: the positioning of her arms and turned away head is the same as that visible in the normal, lengthwise,

view of the bronze; the telling motif of the girl's left knee being drawn sharply upwards and pressed urgently over her right thigh to preserve her modesty is taken from the view from the rear of Giambologna's polyvalent composition.

Granted that Bernini evidently knew the bronze group intimately, the head of the centaur might also have provided a source of inspiration (albeit on a minute scale) for Pluto's strongly featured face with lowering brow, as well as for the luxuriant curls of hair that radiate centrifugally round his face like licking tongues of infernal flame, appropriately enough for the master of the underworld.

Unlike *The Flight from Troy*, *Pluto Abducting Proserpina* was designed not for a circular base, but for a square one, to emphasize the forward movement of the protagonist. From the four faces of the block of marble Bernini cut back the edges of the present base to the very extremities of the participants' feet: to the claw of Cerberus' right forepaw and the tip of the left one; to the tips of the leaves of laurel against which he sits; to the tips of Pluto's left big toe and right big and second toes, while the points of his bident, abandoned on the ground, actually project slightly beyond the base, outside the confines of the sculpture and into the spectator's space. Meanwhile, his right forearm is thrust forward parallel and level with the original surface of the front of the block. Everywhere, one sees virtuoso use of the drill to punctuate the centre of each curl in the corkscrew strands of Pluto's beard and to describe the spirals of Proserpina's flowing locks. The tail of drapery round her right shoulder spirals bravely out into a curlicue at its end, rather like the dolphin-face effect on the cloak of his *Neptune and Triton*, while its lower edge falls in broader rectilinear folds, meeting at angles that recall the style of Pietro Bernini, and, through his mediation, of Giambologna or Caccini in Florence.

It remains to explain Scipione Borghese's choice of subject. One reason may be the supposed propinquity of the family palace, which was near the Campus Martius and the River Tiber, to an ancient Roman shrine called the Tarentum in which there had been an altar dedicated to the subterranean deities of Dis (Pluto), Proserpina and Ceres.[22] In 17 BC the Emperor Augustus had celebrated the Ludi Seculari there with a sacrifice. After the death of Pope Paul V in January 1621, Scipione moved into this palace with the family's sole male heir Marcantonio Borghese, Prince of Sulmona. There the cardinal kept his collection of antiquities until they were moved to his new villa in 1625. The combination of this lugubrious ancient site with his grief over the demise of the pope may have influenced his choice of theme for the statue.

58. One of the heads of Cerberus, from *Pluto Abducting Proserpina*.

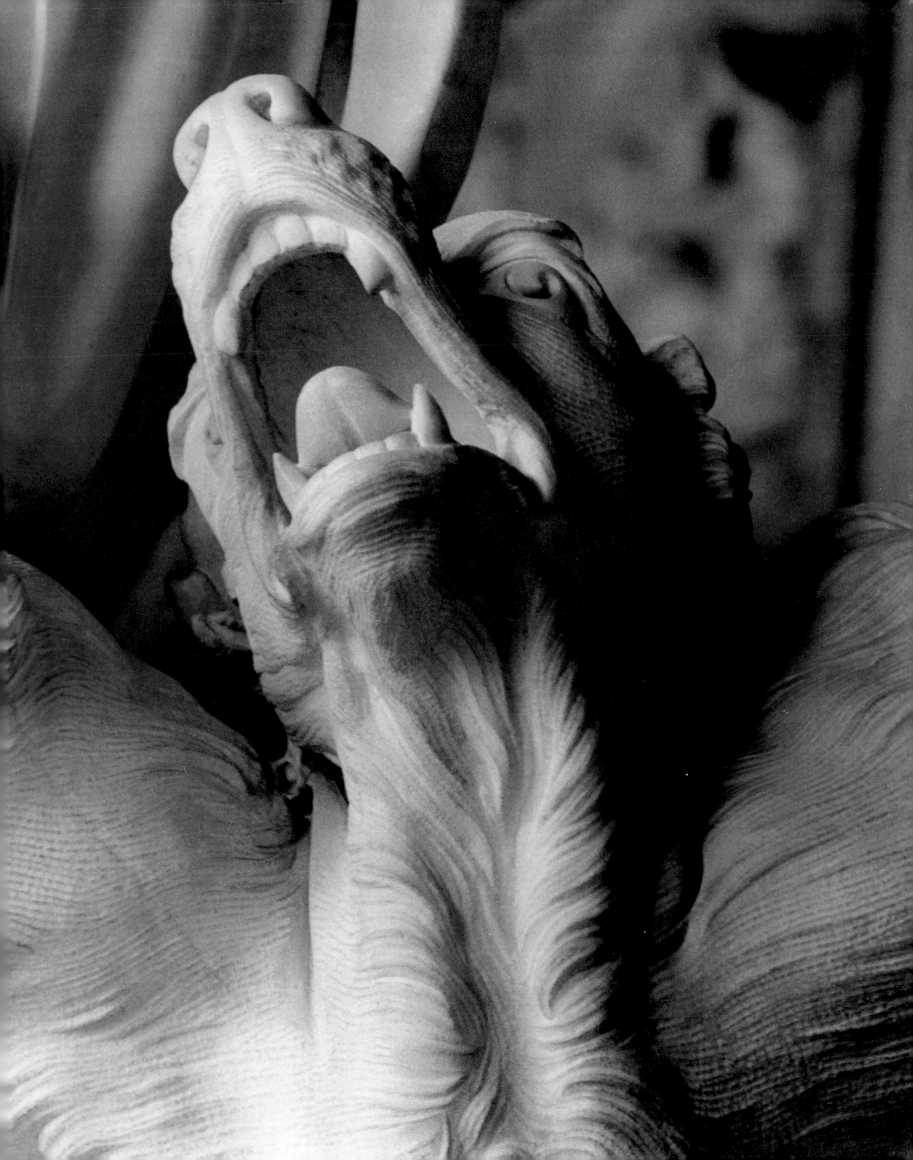

59, 60. Details supplied by Bernini to a damaged classical sculpture, the *Ludovisi Mars* (Museo Nazionale delle Terme, Rome): the god's right hand and sword-hilt with grotesque head, and the head of Cupid.

There may also be allegorical overtones in the subject, which had been expounded at length in Claudian's poem *De Raptu Proserpinae* (3, ll. 1–66), which was linked with Bernini's work in a poem of 1661.[23] Behind Cerberus, who has been identified sometimes as an emblem of nature's fertility, there sprout new leaves from a truncated laurel tree: such an image was commonly used in the Renaissance, for instance on the reverses of medals, as an emblem of continuity in a family after the death of an important member (with the motto, taken from Virgil, 'Primo avolso, non deficit alter', 'Though one has been snatched away, another will not be lacking'). Marcantonio Borghese had married Camilla Orsini in 1620, and so the hope of an heir might have been mingled with the idea of bereavement.

From a reference in Pliny and from a mention in the preface to Vasari's *Lives of the Artists* (1568), it was also well known at the time that the subject had been treated in bronze by the famous ancient Greek sculptor Praxiteles. It might therefore have been regarded as an appropriate challenge for the ambitious patron and his promising sculptor. In Rome, Praxiteles was commonly and incorrectly thought to have carved one of the pair of ancient marble groups of the *Horse Tamers*, now on the Quirinal Hill, and his striding pose might have had some influence on Bernini.[24] Furthermore, and equally incorrectly, Praxiteles was also held to be the author of a famous group of distressed figures depicting *The Punishment of Niobe*, which had been discovered as recently as 1583 and was on show in the Villa Medici: the statue of Niobe herself provided a source for a beautiful but mournful female face, such as Proserpina's.

Further inferences about the relevance that Scipione Borghese found in the legend may be drawn from the fact that he chose it for a huge fresco by Lanfranco on the vaulted ceiling of the hall of the *piano nobile* of his villa: this was begun in 1624, just one year after Borghese had given away Bernini's group to Cardinal Ludovisi, perhaps for reasons of Church politics.

Bernini's achievement was to amalgamate pre-existing sculptural ideas and classical references into a new, much more dramatic composition. Curiously enough, perhaps because the group was less in the public eye in the Ludovisi villa, and away from its companions in the Villa Borghese (until 1908), Baldinucci skated past it in his narrative, noting simply:

During this period Cardinal Borghese presented to Cardinal Ludovico

Ludovisi the beautiful group of the Rape of Proserpine which Bernini had carved for him shortly before. Cardinal Ludovisi rewarded the artist no less generously for it than if it had been made expressly for him. There is no doubt that if the reign of Gregory XV had been less brief Giovan Lorenzo would have been commissioned to do great and most honourable works.

It would have been odd if Cardinal Ludovisi had actually rewarded the sculptor afresh for a group that the donor had already paid for. What Baldinucci may have been conflating with Bernini's rewards for this well known statue was the restoration of certain antiquities, among them the *Ludovisi Mars*, which entered Ludovico's collection in 1622 and for which Bernini was indeed paid on 20 June that year.[25] He supplied several missing extremities, most importantly the god's right hand and sword-hilt. The latter terminates in a fascinating grotesque head as its pommel, recalling the monstrous faces created by Giambologna and Tacca as well as one that Bernini was to model later in life and replicate four

174 times in bronze to serve as ornamental finials for his own carriage. He also supplied a new right foot for Mars and a head for Cupid who sits looking up at him. This head of a putto, a subject at which Bernini excelled, is a close cousin to that of Ascanius in *The Flight from Troy*, though its eyes are blank and its hair slightly less curly in order to adapt it to the classical style of Mars. Bernini caressed the plump little face out of the inert block of crystalline marble, finishing it with rifflers and abrasives, the varying directions of whose strokes reflect the pull of the infant skin over bone and muscle and even suggest the texture created by the pores in his skin: the subtle sculptor refrained deliberately from polishing it, in order not to obviate these lifelike effects, and to assimilate the head with the slightly weathered and abraded antique statue.

Apart from this brief epsiode of Ludovisi patronage, Scipione Borghese apparently wished to monopolize Bernini, at least insofar as major narrative statuary was concerned, for on 8 August 1622, six weeks before *Pluto Abducting Proserpina* was moved to his villa, he reimbursed Bernini for a new block of marble and its carriage to his studio in order for the sculptor to carve 'a statue of Apollo'. The next instalment of 100 scudi, paid in February 1623, was specified as being on

1, 65, 66 account for a statue of *Apollo and Daphne*, while a third one was paid on 17 April 1624, with a final settlement of 450 scudi following in November 1625.[26]

The ornamental pedestal on which the group still stands was produced in September 1625. The long side that was visible in the original position bears a fascinating, grotesque creature, seemingly flayed, that may be the heraldic dragon of the Borghese pressed into service to support and surround an

69 oval cartouche bearing an inscribed poem.[27] Its horrid extremities overlap the architectural moulding, so that it is thrust forward against the darker background for our

attention. The complete carving of *Apollo and Daphne* and its pedestal thus occupied Bernini and his studio for three years, for him a comparatively long time, even granted the group's complexity.

The reason is partly that from 18 July 1623 he was also working on a statue of *David* that Scipione Borghese 70, 73–75 commissioned almost immediately after the death of Pope Gregory XV. Perhaps Scipione hoped to pre-empt any incoming pope's interest in 'his' sculptor. The *David* was completed quite rapidly, in under a year, for its pedestal was made in May 1624. Bernini then received from the new pope, his mentor Maffeo Barberini (who was elected on 6 August 1623), a commission for a much more specifically Christian and devotional statue, that of *St Bibiana*. 81

But this is to anticipate the sequence of events. Let us turn once more to Baldinucci's life of Bernini for a more or less eyewitness account of the commission and success of *Apollo and Daphne*, Bernini's last mythology:

But Cardinal Borghese . . . would not permit him to remain in his service without some beautiful work underway, so he had him carve the group of the youthful Apollo with Daphne who is in the process of changing into a laurel tree . . . In its design, in the proportions, in the expression of the heads, in the exquisiteness of all the parts, and in the fineness of its workmanship it surpasses anything imaginable. In the eyes of the expert and learned, Bernini's Daphne always was and always will be a miracle of art, since it is in itself the standard of excellence. I need only say that as soon as it was finished such acclamation arose that all Rome rushed to view it as though it were a miracle. When he walked about the city, the young artist, who had not yet attained his nineteenth year, attracted everyone's eye. People watched him and pointed him out to others as a prodigy. Certainly, from that time onward everyone who came to Rome and wished to see splendid things had among his chief objectives that of viewing a work of such magnificence. In order that the figure of Daphne – so true and alive – would be less offensive to the eyes of a chaste spectator, Cardinal Maffeo Barberini had carved there the following distich, the noble fruit of his most erudite mind:

> The lover who would fleeting beauty clasp
> plucks bitter fruit; dry leaves are all he'll grasp.[28]

The original Latin verse by the pope-to-be was intended as a prudent warning, and hence to endow the subject with a Christian moral. The sheer attractiveness of Daphne (as the delighted Bernini was later to relate to Chantelou) had so upset François d'Escoubleau, Cardinal de Sourdis, that he 333 said to Cardinal Borghese that he would not have had it in *his* house, for such a beautiful nude girl could easily excite those who beheld her.[29] Even so, the prudish Frenchman did not hesitate to employ the sculptor to make his portrait bust.[30]

For so classical a subject as *Apollo and Daphne*, taken from Ovid's *Metamorphoses* (I, 453 ff.), Bernini predictably turned to

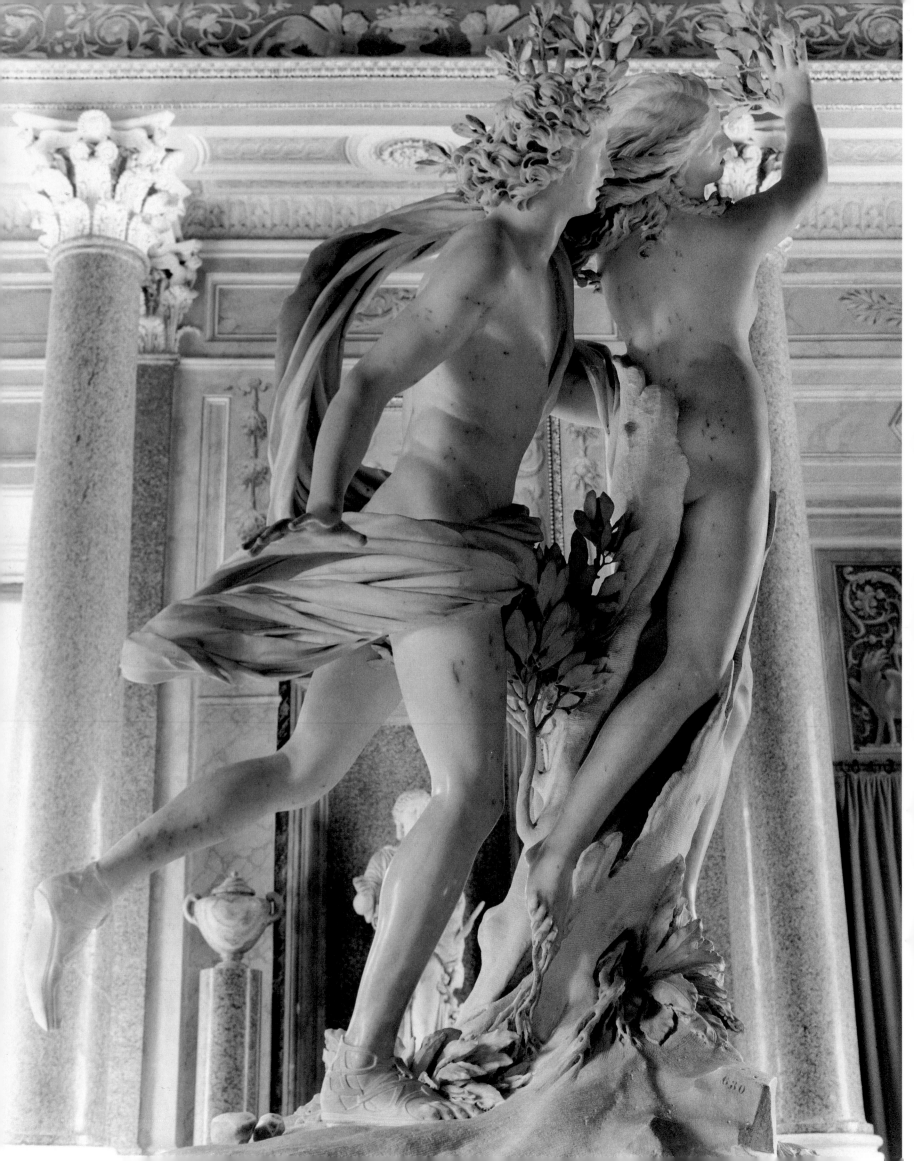

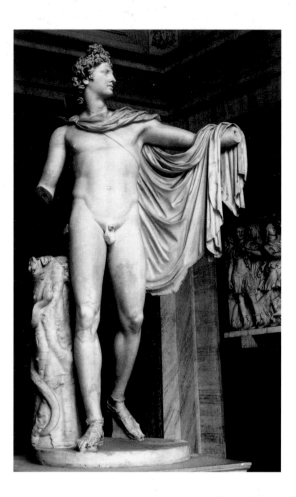

61. *Apollo and Daphne* (Villa Borghese, Rome).

62. *Apollo Belvedere* (Musei Vaticani): the famous classical statue that was Bernini's model for his own Apollo in *Apollo and Daphne*.

63. The moment of Daphne's capture and metamorphosis portrayed by the engraver 'JB with the Bird', probably known to Bernini.

the antique for visual inspiration. By general consent the figure of the god is a derivation of the long famous *Apollo Belvedere* that stands, near the *Laocoön*, in the Vatican. The stride of the ancient statue of Apollo the archer, has been quickened by Bernini's imagination into that of a runner, slackening his pace as he nears his goal: the left arm that is extended in the prototype to hold a (missing) bow now reaches out covetously to encircle the nymph he is pursuing. The perfect but mute face that one sees in the Belvedere is now gasping, both for breath after the chase and in amazement at the transformation of the nymph that he loves into a laurel tree. She is also thought to have been inspired by an appropriate classical statue of *Laurea*, that Bernini could have known through an engraving by G. B. Cavalieri.

It is unfortunate that no preliminary sketches on paper or models in terracotta survive to show how Bernini arrived at what may properly be regarded as the definitive solution in sculpture to the problem of representing such an unlikely metamorphosis: a fleeing female, who becomes miraculously transfixed to the ground and transformed into a tree.[31] Like all great works of art, its eventual composition seems to be a foregone conclusion.

The subject lends itself more naturally to renderings in two dimensions, for instance in Renaissance paintings and engravings, which Bernini *could* have seen:[32] two in particular have been singled out as relevant, one after Giulio Romano, where the pursuit dominates the foreground, but its climax features in the distance; and another by the anonymous engraver 'JB with the Bird', where the moment of capture and metamorphosis, described with a strongly unified and diagonal emphasis, could almost have inspired the rear view of Bernini's group.

A major sculptural source closer to Bernini's own time, 64 that seems scarcely to have been noticed – but of which Pietro Bernini could easily have been aware from his apprentice years – stood over a fountain in a grotto at the Villa Il Paradiso, near Florence, that belonged to Alamanno Bandini.[33] It was carved *c.* 1570–4 by the Mannerist sculptor Battista Lorenzi and shows another story from Ovid's *Metamorphoses* (V, 562–600) – one that follows on from that of Pluto, Proserpina and Ceres – that of the river-god Alpheus and the nymph Arethusa. When the statue was purchased by the Metropolitan Museum, New York in 1933, Ovid's diffuse account was elegantly summarized as follows:[34]

For this subject Lorenzi chose the most dramatic moment in one of the most delightful of classical myths. The story goes that the lovely wood nymph Arethusa, heated after a day of strenuous hunting, found herself at the edge of a clear and silent-flowing stream. Unable to resist the temptation, she cast aside her garments and stepped into the

64. Battista Lorenzi: *Alpheus and Arethusa* (Metropolitan Museum of Art, New York). This group, close in subject to *Apollo and Daphne* — Arethusa, pursued by the river-god Alpheus, was transformed into a fountain — was carved about 1570 and stood in a garden near Florence.

cool waters. But her pleasure was all too brief; for scarcely had she commenced to bathe when a voice called faintly from the stream's mysterious depths. Frightened, she fled to the bank and across the countryside, the river-god Alpheus close in pursuit. At last, nearly overcome with exhaustion, Arethusa called upon Diana for help and the goddess came to her aid, transforming her into a fountain just as she was finally overtaken.

Lorenzi's group portrays that thrilling instant before the metamorphosis. Alpheus has caught up with his fair quarry and is in the act of restraining her. They are both still running as he passes his left arm over her shoulder in a final attempt at capture. In his right hand he carries a vase, the traditional attribute of a river-god. His handsome head is turned toward Arethusa, and his face wears an expression of intense longing. She looks upward beseechingly as she implores Diana to protect her.

It seems almost impossible that Bernini could have created so similar a group on the difficult theme of an arrested flight and metamorphosis of the quarry into a disparate object, without knowing Lorenzi's impressive group.[35] The 'domestication' of a statue from the context of a garden or grotto is typical of his broad-minded research for sources, as will be related later in the chapter on fountains.

Lorenzi arranged the figures within the quadrangular block as though they are turning a corner. Alpheus strides with his right foot foremost along the side of the base, while Arethusa is stepping across the block diagonally, her left foot marking the opposite corner: she thus seems about to twirl away to our right and elude his grasp (in the myth she was cloaked in a cloud). Bernini took the pose of Alpheus for his Apollo, but turned him parallel with the long face of his block of marble, so that both participants are shown from the side, running across its length. More self-confident than Lorenzi had been, Bernini allowed Apollo's left leg to extend backwards, unsupported in mid-air, setting up a strong diagonal thrust that exits almost vertically in the raised right forearm of Daphne, which turns into a branch of laurel. The underlying geometric design is a right-angled triangle, but this is disguised within a rush of converging diagonals formed by the limbs and bodies and even the ground, as it seems to swell up and burgeon forth into the roots of a tree. These diagonals are then swathed in the swirls of Apollo's windswept cloak, flowing horizontally in a rush of folds behind his thighs and then billowing out freely behind his back, an effect most apparent from the far side.

It is difficult to know where to begin in describing the finesse of textures and details since, as Baldinucci wrote, 'only the eye and not the ear can form an adequate impression of it'. He might almost have added that the sense of touch would be beneficial in appreciating the diverse textures if only one were allowed to caress the sculpture with one's fingers! Just as a painter uses contrasts of colour to distinguish between different components in a scene, so the sculptor uses a contrast of texture. The naked flesh of both figures is polished to a silky smoothness, which reflects light and enhances the relief of the various parts of the body with gleaming highlights, depending on the direction from which the composition is illuminated. Perhaps the glistening of perspiration at their efforts is also hinted at. Apollo's cloak is carefully smoothed, but not polished, to point the contrast of a woven and hence matt textile with the shiny skin; traces from the riffles or pumice-powder applied with cloths emphasize the direction of the movement of particular areas. The leaves of the freshly sprouting laurel are on the whole left matt, and traces of the flat chisel that was used to shape their slightly crinkled surfaces are evident on close examination. The ground and the bark of the laurel that is encasing the luscious female form are coruscated in parallel grooves with a claw-chisel, which is also used for passages in the locks of hair that frame Apollo's face. By contrast, the flowing strands of Daphne's hair, running away to either side from her neat central parting, and swinging out centrifugally as she turns to look back at her pursuer, are — surprisingly but effectively — cut with a flat chisel into a series of waving,

68

66, 67

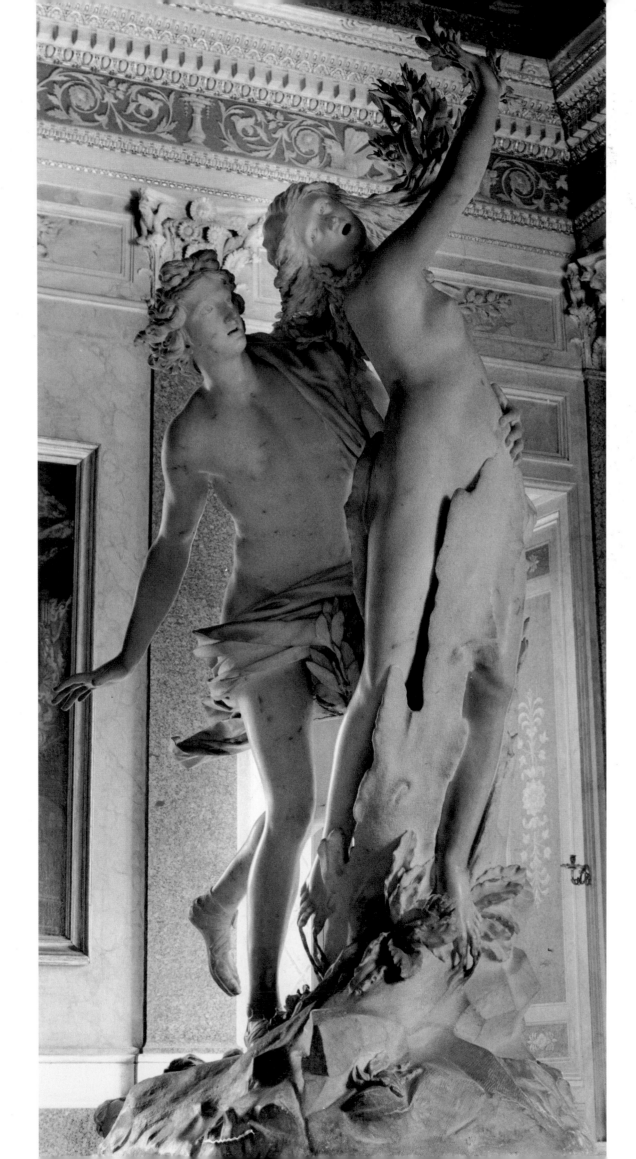

65. *Apollo and Daphne* (Villa Borghese, Rome).

but more or less parallel, facets, separated by sharply incised grooves: here highlights were created by the contrasting angles along certain narrow planes or by minute flanges of marble that were left protruding. This choice of technique may have been intended to suggest that her hair was blonde, for the faceted strands reflect light, instead of its being absorbed by grooves between them.

At the point where Daphne's loose hair tumbles over her shoulders and is caught up against her skin, a running drill was used to cut out troughs of marble and excavate undercuts to relieve certain little hook-like curls at the ends. Apollo's tousled mop of curls looks quite different from Daphne's tresses because a large number of curvaceous shadows permeate it owing to very deep drilling which gives a staccato effect. Both young creatures have charming kiss-curls that have been left standing proud by a millimetre or so from their cheeks or brow, and then defined carefully with curving lines actually cut into the surface.

The highlights in their eyes are suggested by little dibs of marble, while the curving shapes of the irises were formed by a semicircle below, lightly drilled or cut into the eyeball. One learns from Chantelou's account how, towards the end of the process of carving, Bernini gave the final expression to the eyes of his bust of King Louis XIV by marking with great care and accuracy the pupils with charcoal on the convexity of the eyeball. This seems to have been a long-standing practice, 67 for here there remain on both figures traces of black 'pencil' marks that, by providing real colour to reinforce the cast shadows, give additional emphasis to the irises and the inside edges of the eyelids. This brings one to a discussion of the conditions under which the group was designed to be viewed. While it is fully – indeed intricately – carved from all sides, its predominant views are the long front of the block, across which the action flows almost as though it were a rendering in deep relief of a graphic prototype, and the short end to the spectator's right, from which Apollo's face and shoulder are clearly visible behind the frontal figure of Daphne. It is from a diagonal between these two points that the extraordinary transformation of her voluptuous form is best appreciated. From the other long side and the far end, only backs are to be seen, with the faces hidden. In fact, as has been mentioned in discussion of the locations in the Villa Borghese for which 43 *The Flight from Troy* and *Pluto Abducting Proserpina* were destined, the group of *Apollo and Daphne* did not stand as it does today in the centre of the room that is named after it, but flat against its west wall.[36] This entirely obviated the view of the other long side of the group, for only an arc of about 200 degrees was visible.

66. Detail of the faces of *Apollo and Daphne* (Villa Borghese, Rome): the contrast between passion and terror.

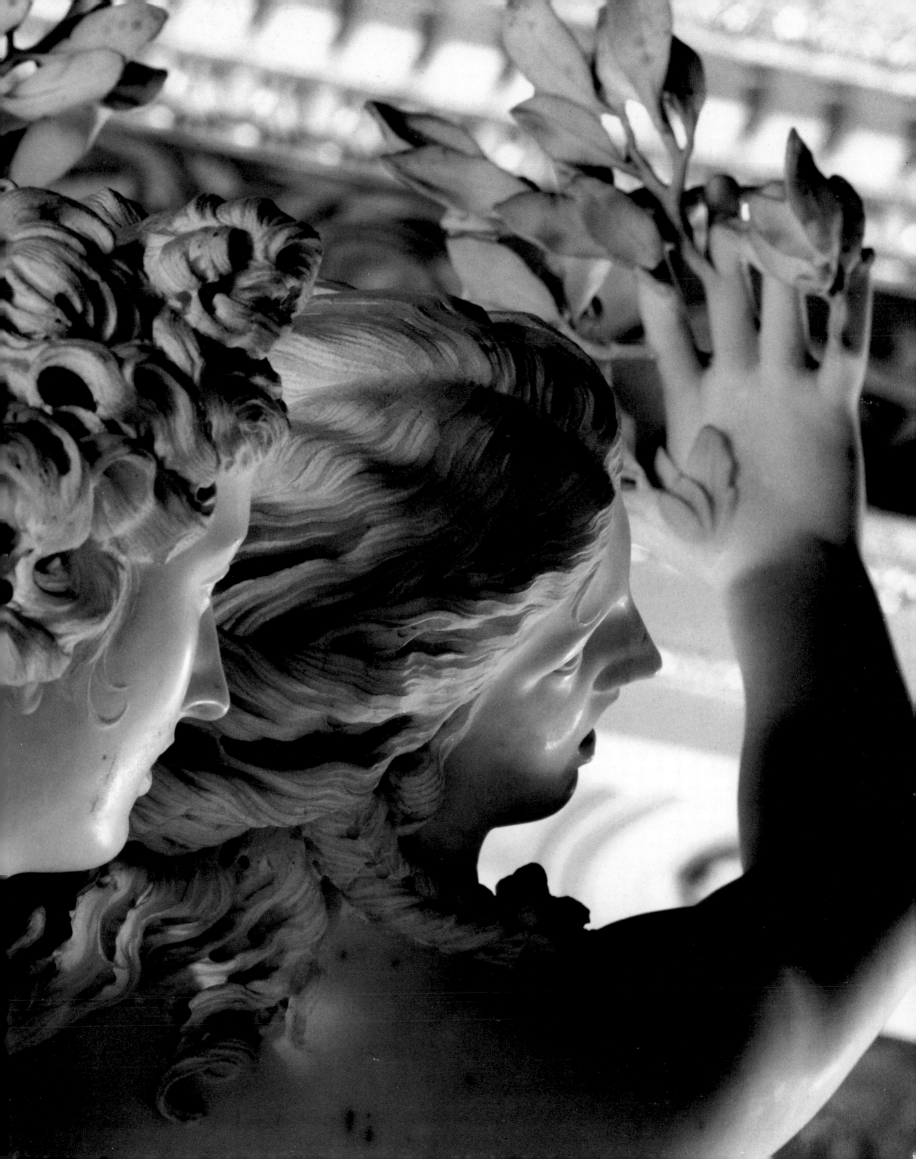

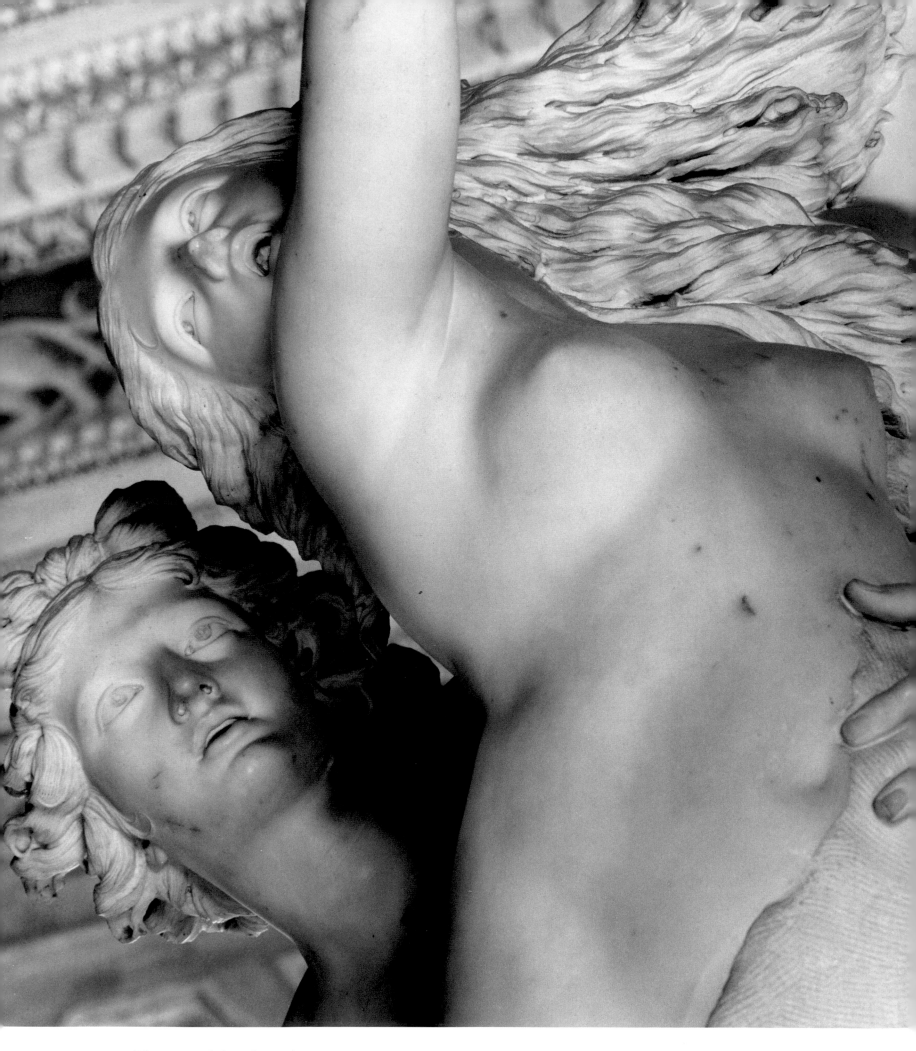

62 *The great mythological groups*

What is even more extraordinary is that the two doorways into this room were *behind* the short end of the group, so that one would first get only a view of Apollo's back and Daphne's flowing tresses of hair and raised hands turning into twigs and leaves of laurel beyond Apollo's left shoulder. Nonetheless, this has the effect of catching the spectator's attention and drawing him or her into the centre of the room in order to resolve the enigma of what is going on, and encouraging movement in the same general direction as the pair of running figures. To see the faces and apprehend the denouement of the drama, one has to follow the counterclockwise spiralling form of Daphne and be drawn round by it to the further short end of the original marble block. The figures would have faced a window onto the private garden, towards which they would thus have appeared to have been running, and would have received from it the strongest source of direct natural light, boosted by that from the nearby window also facing north. The present arrangement of the statue, facing the doors and confronting one abruptly, negates all these factors which seem to have been deliberately contrived by Bernini to enhance the drama of his group and to involve the spectator emotionally and almost physically in the action.

The design was acknowledged to be outstanding and the execution, partly the work of an assistant, superb. But, the ambitious young Cavaliere was quick to arrogate to himself all the credit for the new achievement; he was becoming unscrupulous in his pursuit of personal glory. As Jennifer Montagu has indicated:[37]

The group of *Apollo and Daphne* was of course conceived by Bernini himself. In this image of metamorphosis the roots stitch her toes to the ground; the rough bark encases the soft flesh of her thighs, and the leaves sprout from her fingers. But the equally miraculous metamorphosis of the block of marble into delicate roots and twigs, and into floating tresses, was largely the work of Giuliano Finelli. The extraordinary virtuosity of this young sculptor from Carrara was exploited here[38] . . . Bernini, perhaps because he was jealous of Finelli's obvious talents, or because he was wary of his prickly personality, held him back from the advancement he had promised and promoted instead his compatriot and rival, the more tractable Andrea Bolgi. Like all great men, Bernini had his enemies, and they were not slow to point out that someone else had done the work for which he received the credit. Nor did Finelli hesitate to tell them so. Tired of seeing his triumphs enriching another, he left Bernini's studio and set up on his own, seeking the opportunity to demonstrate that it was he who had produced these admired carvings. This incident is worth recording, for, so far as I know, it was not only the first but also the last time that

68. Detail of *Apollo and Daphne* (Villa Borghese, Rome) showing Daphne's foot taking root in the ground.

69. Latin poem by Pope Urban VIII on the base of *Apollo and Daphne* (see p. 55).

67. Detail of *Apollo and Daphne* (Villa Borghese, Rome) showing Apollo's hand pressing into Daphne's soft flesh.

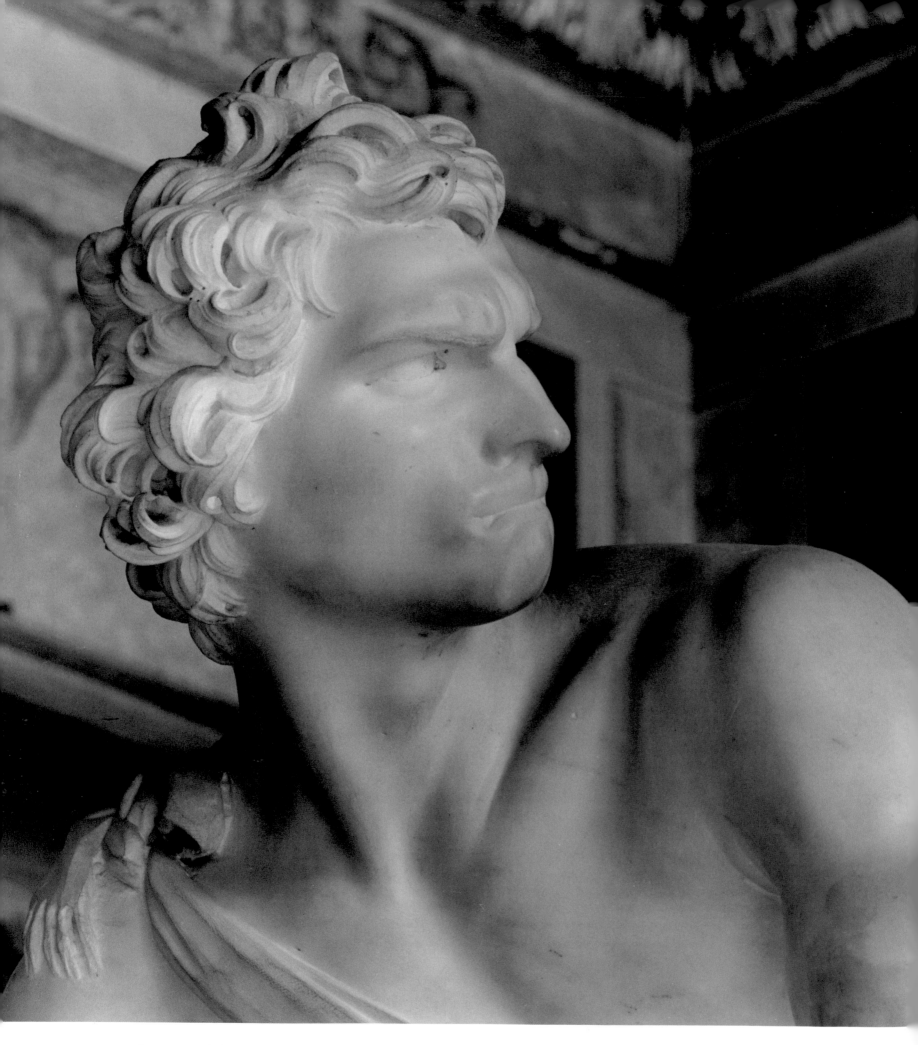

a sculptor employed in Bernini's studio left in disgust, revolting against the menial position to which his talents had been confined. Indeed, Bernini appears to have learned a lesson from it, for never again did a sculptor of comparable talents work for him in such an anonymous capacity.

Finelli happened to appear in Rome at the right moment in 1622 and, on the strength of his expertise in handling marble, had been invited by Pietro to join the Bernini workshop, though in a junior capacity. Gianlorenzo was at the time under increasing pressure from a welter of commissions, quite apart from Cardinal Borghese's continuous demand for grand mythologies, and so fell back on his new associate to add the finishing touches. Finally (in what was the normal tradition of any artist's studio, then as nowadays) he succumbed to the temptation of claiming as all his own work virtuoso passages of carving that ethically he perhaps ought to have declared as the *morceau de réception* of the gifted newcomer.

Bernini's fiery Mediterranean temperament comes across particularly strongly in one of his painted self-portraits that hangs in the Villa Borghese; it probably dates from the time when he was employed by Cardinal Scipione. His 'eagle-eye' transfixes one and, combined with the waxed tips of his moustache and carefully barbered goatee, conveys a distinctly ferocious expression: an expression such as this might have met anyone who questioned him about the role played by Finelli in carving the *Apollo and Daphne*.

In view of its shared patronage and simultaneous execution, the statue of *David* is usually discussed in tandem with the three great mythological groups:[39] its virtual nudity, ferocious action and ultra-realistic expression make it hard to classify as a 'religious' sculpture, and it is the last in the series of major commissions that Bernini was to receive from Scipione Borghese. But its subject is taken from the Old Testament and has strong Christian overtones, since Jesus was a descendant of the House of David. With the advent of the new papacy, Bernini was to be almost permanently employed on Christian works of architecture and sculpture; in tune with his illustrious patrons, he became increasingly immersed in Roman Catholic doctrine himself.

The subject of David for free-standing statues had been a mainstay of the sculptural tradition in Florence, where he was regarded as a civic hero of almost equal standing with St John the Baptist and Hercules. Donatello had treated the subject twice: he had made his name with an armoured and draped figure carved in marble, which from 1416 was displayed as a political emblem in the Palazzo della Signoria, the seat of

Florentine democracy; and at a later date he had cast a nearly nude version – probably with Neoplatonic overtones – in bronze for Cosimo de' Medici. Both show David as a youthful figure after his victory, with Goliath's head lying at his feet. Donatello's successor as 'house sculptor' to the Medici, Verrocchio, used the same image for his more practically clothed and naturalistic version, also made to decorate the Medici Palace. All three of these icons of Florentine Renaissance sculpture are today preserved in the Bargello Museum.

The fourth Florentine statue of David, carved at the behest of the Republican government *c.* 1502, is the most amazing: this is the marble colossus by Michelangelo, which was placed, like a sentry, outside the very portal of the Palazzo della Signoria. It enshrined the notion of David as a totally nude – and therefore positively Grecian – athlete hero, and broke with the earlier tradition of including at his feet the severed head of his victim Goliath. Indeed it seems to show the youth before the fray, measuring his giant adversary and summoning up all his powers with divine aid. Though he is poised and alert (like Donatello's *St George*, who had also been imagined before his combat with the dragon), he has not yet embarked on the actual combat.

Bernini thus confronted a great challenge in matching – let alone outdoing – this series of long-established masterworks. Even so he must have welcomed the opportunity of showing his mettle. Baldinucci recounts:

In this work Bernini overwhelmingly surpassed himself. He completed it within a period of no more than seven months, thanks to the fact that from youth, as he was wont to say, he devoured marble and never struck a false blow, an accomplishment of those who have made themselves superior to art itself, rather than of those who are merely expert in art. He modelled the beautiful face of this figure after his own countenance. The powerful knitted brows, the terrible fixity of the eyes, and the upper jaw clamped tightly over the lower lip wonderfully express the rightful wrath of the young Israelite in the act of aiming his sling at the forehead of the giant Philistine. The same spirit of resoluteness and vigour is seen in all parts of the body, which lacks only movement to be alive. It is worth recording that while Bernini was working on the figure in his own likeness, Cardinal Maffeo Barberini came often to his studio and held the mirror for him with his own hand.

Romanticized though it may sound, there is no reason to doubt the accuracy of this account. The documents confirm the short period – seven months – of execution that Baldinucci claimed. Nearly all great portraitists begin by recording their own appearance in different states of mind by using a mirror. Among painters Albrecht Dürer springs immediately to mind for his obsession with his own face, but Bernini too was a prolific self-portraitist in chalks and paints.

70. Head of *David* (Villa Borghese, Rome).

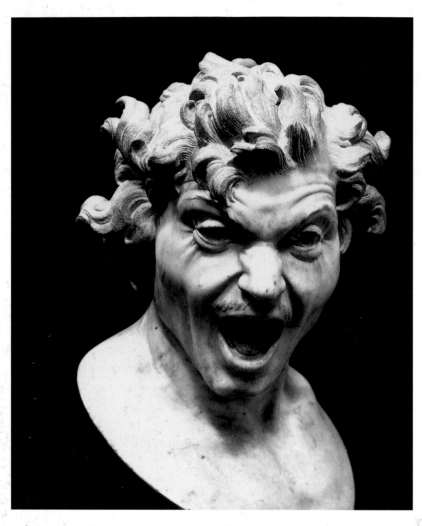
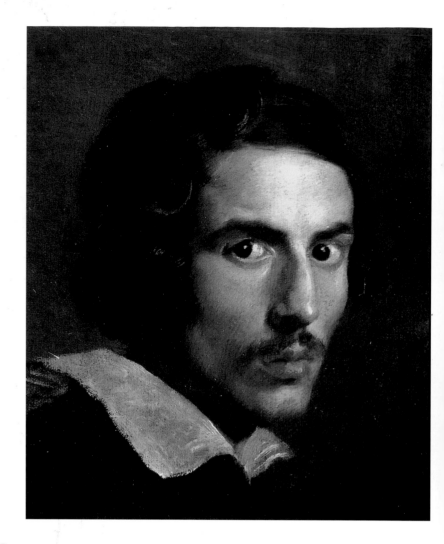

71, 72. Bernini is said to have used his own face as the model for *David*, as well as for his *Damned Soul* (Santa Maria di Monserrato, Rome). (*Right*) one of Bernini's painted self-portraits (Villa Borghese, Rome).

As a sculptor he would probably have begun with a life-size clay model, taking a few critical measurements between salient points of his own head with a pair of calipers. The present project was more demanding, for he had to gauge very accurately how the shape of the muscles in the face altered when tensed to the extreme for action, and he may well have exaggerated these deformations slightly in order to enhance the desired effect in his sculpted hero.

91 He was no stranger to physiognomic experimentation, having just created for Monsignor Montoya, a Spanish prelate and the subject of one of his most celebrated portraits, a pair of heads in marble representing two poles of
80 expression, the *Damned Soul* and the *Blessed Soul*. Like most of us, Bernini found it easier to imagine eternal damnation than the happiness to be experienced in paradise; his female bust is very tame by comparison, and to modern eyes verges on sentimentality. For the *Damned Soul* he seems also to have used his own face, caught at a moment of pain engendered, so the

story goes, by holding his left hand over a lighted candle (appropriate to the torture of hell-fire). He was also able to call upon the well known series of facial studies of warriors in the stress of conflict drawn a century earlier by Leonardo da Vinci for his lost fresco, *The Battle of Anghiari*; and he may have known some three-dimensional renderings, for derivatives of the painted battle were produced in Florence in terracotta too.[40]

A comparison between the carved heads shown in states of stress and Bernini's self-portraits in paint (even though they show a calm demeanour) tends to corroborate the stories that he served as his own model. In the case of the *David* he may well have studied the whole figure in a similar manner, as Baldinucci states, 'working on the *figure* [i.e. not just the head] in his own likeness'. In any case, for confirmation, one need only turn to Chantelou's diary for 14 July 1665 to read:[41]

Bernini said that to try and succeed [in giving expression] he had used an approach that he had invented all by himself: when he wanted to give expression to a figure that he wanted to represent, he posed in the same action that he intended the figure to make and had someone who was a good draughtsman do a drawing of him like that.

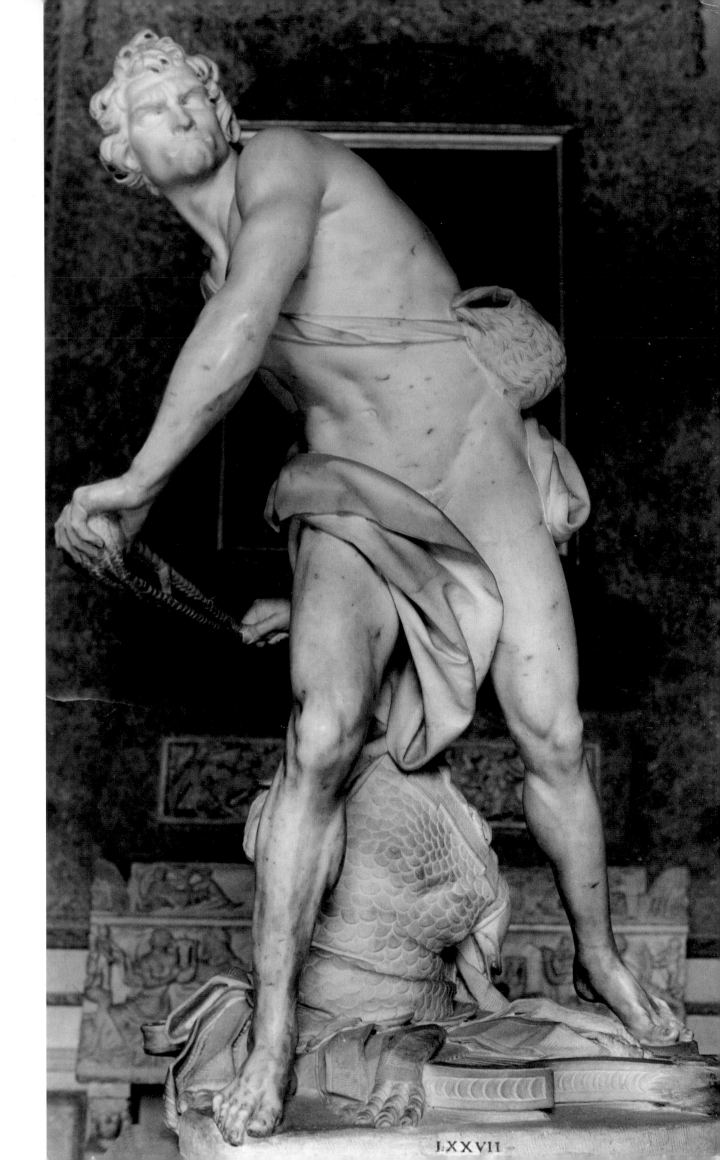

73. *David*
(Villa Borghese, Rome).

LXXVII

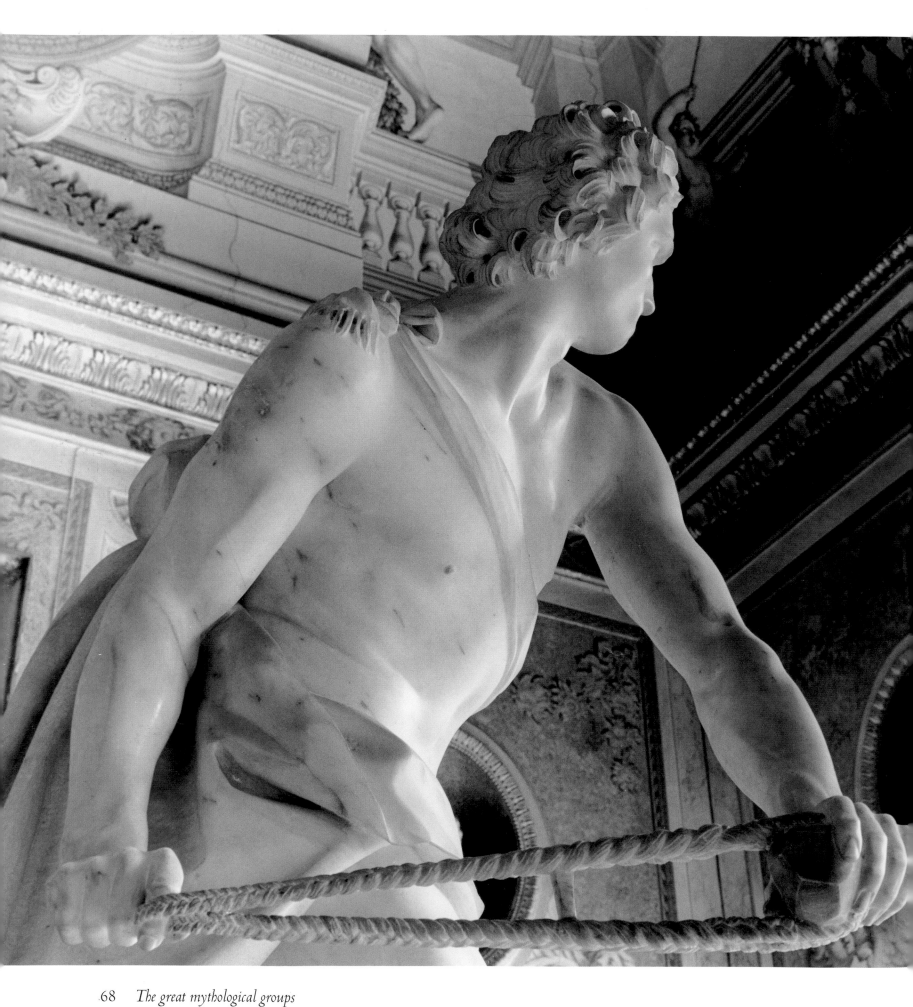

In this instance, Bernini assumed very nearly the stalwart pose of the *Borghese Gladiator*,[42] a marble figure that had been excavated as recently as 1611 and acquired by Scipione Borghese by 1613. The sculptor however brought his left arm downwards to grip the stone in David's sling and rotated his hips, to suggest the swivelling action of unleashing the stone, rather than replicating the uni-directional lunge of the classical prototype. The very pose of the *David* was thus a visual compliment to that of Cardinal Scipione that would instantly have been appreciated by any of his circle of antiquarian friends, who included Cardinals Barberini and Ludovisi.

Unlike Donatello or Michelangelo – though perhaps in homage to the impressiveness of the trophies of arms from the Medici tombs in the New Sacristy of San Lorenzo – Bernini chose to explain and thus in a way to emphasize David's nudity. This he did by translating the irrational tree-stump, to which the ancient sculptor had had recourse as a support for his gladiator, into an abandoned classical corselet: the royal armour offered by King Saul to David but which he rejected as being untested. It is linked 'invisibly' to the nude figure by the tumbling folds of his brief cloak that is clipped to him by the belt of his furry shepherd's pouch.

Bernini's radical interpretation of his subject was also deeply indebted to the *Treatise on Painting* by Leonardo da Vinci.[43] From it the sculptor certainly derived some elements of the face, as Rudolf Preimesberger has written:

The mimicry of rage follows traditional rules, the hair standing on end, the eyebrows low and drawn together, the teeth clenched. Not every feature of David's face, however, represents an element of mimicry. The receding forehead, the protruding eyebrows, the curved nose, all follow the traditional animal physiognomy of the [leonine face] appropriate to the choleric character of the [man of war] and the 'Lion of Judah'.

Furthermore, the extreme pose of Bernini's *David*, the pose that catches every spectator's attention and makes it a gripping and memorable work of art, reads like an illustration of Leonardo's instructions on how to depict 'a man who wants to throw a spear or rock or something else with an energetic motion':

If you represent him beginning the motion, then the inner side of the outstretched foot will be in line with the chest, and will bring the opposite shoulder over the foot on which his weight rests. That is: the right foot will be under his weight, and the left shoulder will be above the tip of the right foot . . . The first in vigour having turned his feet toward [the weight to be thrown], twists and moves himself from

74, 75. *David* (Villa Borghese, Rome).

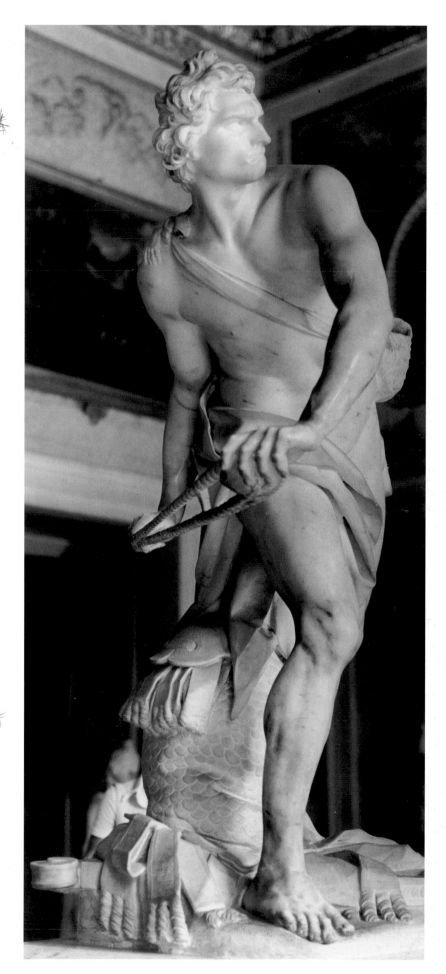

76. Annibale Carracci: *Polyphemus* (Farnese Gallery, Rome), a fresco that provided a source for the pose of Bernini's *David*.

there to the opposite side, where, when he gathers his strength and prepares to throw, he turns with speed and ease to the position where he lets the weight leave his hands.

Bernini may also have been influenced, as so frequently, by that great painted repertory of noble and convincingly posed figures, the frescoed ceiling of the Farnese Gallery in Rome by Annibale Carracci, whose representation of the one-eyed giant Polyphemus preparing to hurl a rock supplied the frontal view for the *David*. It also suggested the artificial raising of the rear leg above the level of the other and the concomitant swing of both arms with their respective burden of imminent destruction to the right of the muscular figure, while David's head tracks the exact position of his adversary, his eyes staring intently over the forward shoulder.

Carving is a very physical form of artistic activity, and a sculptor develops a very strong right arm through hours of strenuous exercise with the mallet. The mature Bernini therefore may well have developed the athletic musculature

that appears to such advantage in this 'self-portrait as David', and he may well have posed repeatedly in the act of hurling a chunk of marble so that one of his associates could make a number of action sketches: speedy notations in pen and ink, such as the sculptor himself frequently resorted to when jotting down his first thoughts from life for a figure.

For Scipione Borghese the choice of David as the subject for a statue by his gifted employee may have had a rationale of its own. Lying on the ground beneath the abandoned corselet, is shown a fanciful lyre, the instrument to which David would sing his Psalms later in life: this allusion to music and poetry, to singing the praises of the Lord, is probably crucial to understanding the choice of theme. As Preimesberger has pointed out:

In the functional context of a villa dedicated to cultural activity and owned by a cardinal, the image of David, who enhanced the *cultus divinus* with poetry and music, is a model of the ecclesiastic *princeps litteratus* ('well-lettered ruler'). As a patron of cultural activity, *David* stood in the first [room] of the villa. The *Apollo and Daphne* stood in the last room which because of its location next to the chapel, gallery and ['secret' garden] seems to have been more private.

David may even have been understood as a symbol of a current ecclesiastical reaction against some of the very successful but overly sensuous poetry of Marino, a movement with which the religious-minded poet Maffeo Barberini (Urban VIII) was heavily involved, and for whose published poems Bernini designed a title page showing a battling David.[44]

As with the other groups by Bernini in the Villa Borghese the present, free-standing display of the *David* was not intended. Indeed, 'the seventeenth-century visitor could not have grasped the statues' meaning in one dramatic moment nor have seen them, upon entering their respective rooms, from an ideal frontal viewpoint'.[45] The *David* originally stood in the corner room at the south-east corner of the villa, abutted against the inside wall, so that a visitor coming from the main entrance hall would have come across it on his right. He would thus first have seen the view that resembles the pose of the *Borghese Gladiator*, which, though very striking, does not reveal the action or the subject of the statue. The spectator is thus drawn into the room by the strong diagonals and the swing of the figure to the right, to be confronted next with the three-quarter view, from which the sling and action of the left hand become explicit and the eyes of the figure are just visible. Moving on clockwise to the front, the whole, deeply expressive face is revealed, and so is the retracted right hand holding the cords of the sling. David's right toes urgently clutch the very edge of the base, like those of Donatello's *St Mary Magdalene*, or one of his Prophets from Giotto's Campanile in Florence. This motif intimates

43

subliminally that the statue is stepping into the 'real' world, and thus enhances the spectator's identification with the figure and the actions that are being represented.

From the succeeding diagonal view, the far leg disappears and the figure is shown taut as a bow and pivoting on the forward leg, while the twisted cords of the sling diverge aggressively from the far hand, almost like an express train hurtling towards one along a railway track. From this angle too, the all-important profile of the hero's face is etched against the shadows of the inner corner of the room. From a mid-point along the third available side of the statue the tension in the plaited cords of the sling becomes almost palpable: the sculptor's technical prowess in cutting away durable marble – apart from one little cross-strut – from all round these narrow extensions is breathtaking. It is a miracle that they have never snapped. The spectator is now seeing the distant Goliath in his mind's eye almost from David's point of view, and this heightens the drama, just as in a film the camera is often mounted behind the barrel of a gun, so that the audience sees the intended victim down its whole length and in the very gunsight, thus sharing in the concentration and emotions of the would-be killer. This is the climax of Bernini's composition, reached only after walking halfway round the statue or a little more. The full meaning and action have unfolded step by step.

This modern, 'sequential' interpretation accords far better with the observed facts than the previous and strenuously defended notion that Baroque sculpture – unlike Mannerist sculpture, which was designed to be viewed from all round – was to be appreciated from a single dominant point of view, conditioned by its position within a room *vis-à-vis* the main door. While Bernini did indeed deny access to the rear of his groups by setting them against a wall, we have seen that they were (increasingly) designed not to stop a spectator in his tracks, but to intrigue him and draw him into the room to embark on a voyage of discovery through which form and meaning would gradually be revealed until he reached the final denouement. This was indeed Bernini's greatest invention as regards sculptural narration.

In a burst of concentrated youthful adrenalin equalling Michelangelo's when he frescoed in only four years the entire Sistine Ceiling, Bernini, in only just over five years (1618–23) had accomplished a series of five statues that, as well as being one of the high points of Western art, together constitute a manifesto of a totally new style: the Roman Baroque. He had also established himself as the greatest sculptor in the world.

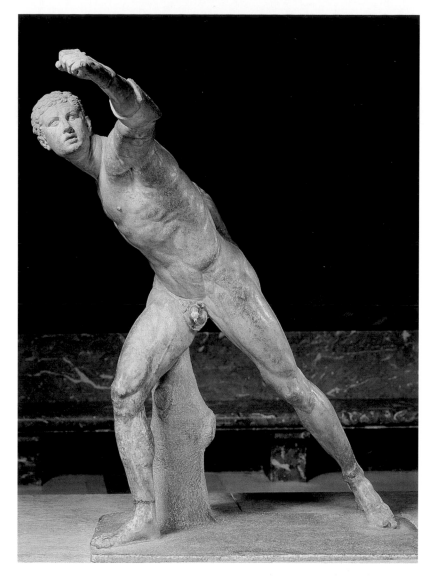

77. The *Borghese Gladiator* (Musée du Louvre, Paris), a Roman statue which from one angle is close to the pose of *David*.

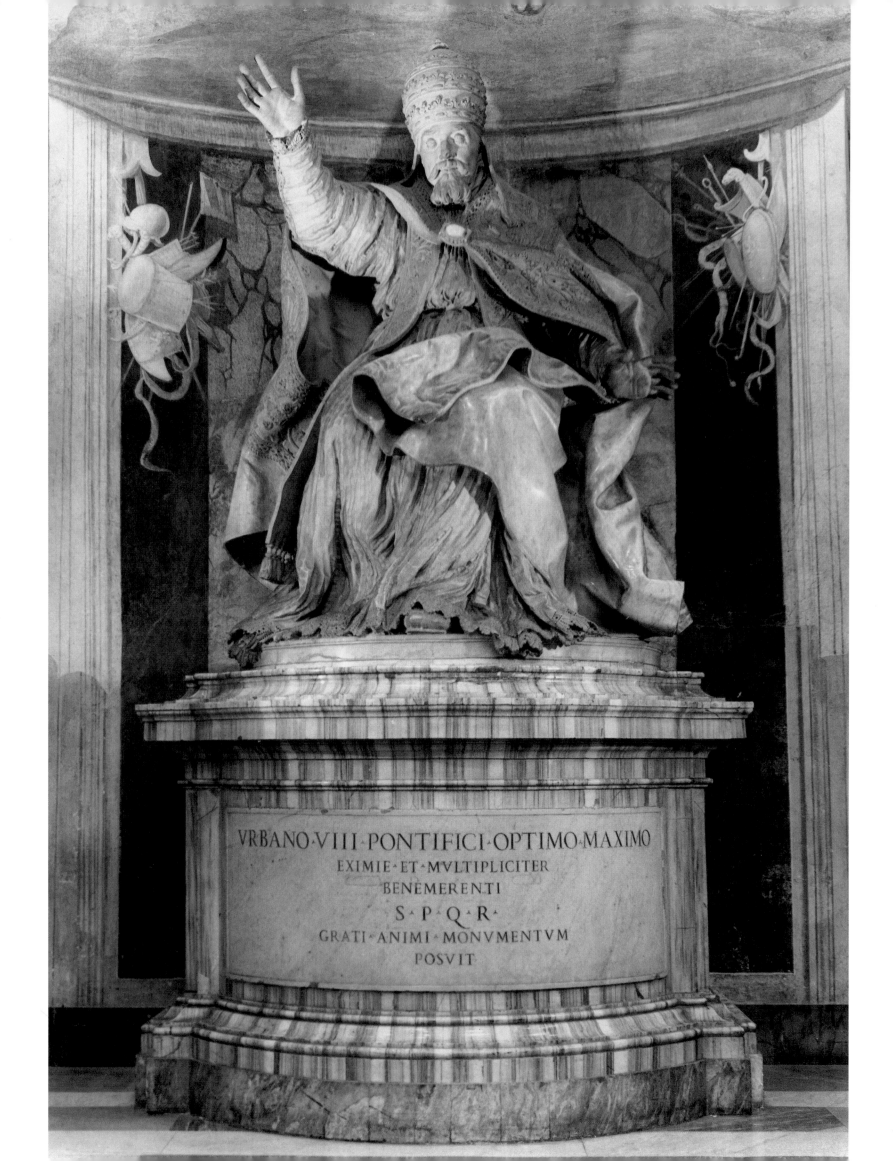

URBANO·VIII·PONTIFICI·OPTIMO·MAXIMO
EXIMIE·ET·MULTIPLICITER
BENEMERENTI
S·P·Q·R·
GRATI·ANIMI·MONUMENTUM
POSUIT

4 * *The patronage of Urban VIII Barberini*

It is your great fortune, Cavalier, to see Cardinal Maffeo Barberini made Pope, but our fortune is far greater in that Cavalier Bernini lives during our pontificate

Pope Urban VIII

THE ELECTION to the papacy in August 1623 of Bernini's mentor, Maffeo Barberini, as Urban VIII, marked a turning point in the sculptor's career. Bernini was by now nearly twenty-five years old and had some fifteen years of experience as a sculptor behind him, culminating in the stupendous series of mythological groups and the *David*. So he was ready for a still greater challenge from his new papal patron (who at fifty-six was more than twice his age): the glorification of the Roman Catholic faith, conjoined with the name of Barberini, through the embellishment of its central shrine, the Basilica of St Peter. Apart from fountains, Bernini was to carve no more mythological figures, with their slightly dubious reputation for pagan licentiousness.

When new rulers ascend thrones, the first demand is generally for their portraits: one of Urban wearing the pontifical cope, like those of his immediate predecessors Paul V and Gregory XV, was rapidly produced, as was another less formal example that is still in the possession of the Barberini family.[1] These seem to have sufficed for nearly a decade until, with the strain of office and advancing age, Maffeo's appearance had so changed that a new 'public image' had to be created.[2]

Within a year of Urban's election, he and his chosen artist were presented with an opportunity for what amounted to a trial run for their dreams for St Peter's. As Baldinucci relates:

> The Pope restored the ancient church of Santa Bibiana situated [near] . . . a catacomb very rich in treasures of martyred saints. During the restoration it pleased God that . . . the body of that saint should be recovered . . . Bernini was ordered to make a statue of the saint which was then placed in the church in the place where it is now seen.

The body of the Early Christian virgin martyr, Vivian in English, came to light in March 1624, and the discovery was seized upon by Urban as a good augury for his pontificate. After personally visiting the site to venerate the saint's relics he commissioned Bernini to refurbish the church, rebuild its façade[3] and redesign its chancel to focus attention on a new altarpiece: a statue of the name-saint.[4]

Bernini turned the dark interior of the small basilica to his advantage by introducing into its chancel what, in the

early morning, amounts to a blaze of light from the east. A large lunette emblazoned in stained glass with the Barberini arms and papal insignia lets the rays of the sun flood through to illuminate the vault of the chancel, and then the nave. However, Bernini also contrived a hidden side-light from a dormer window to the upper left of the altar wall that casts a soft, 'heavenly' glow directly onto the focus of the whole new design, his statue of the beautiful maiden. The statue is mounted well to the front of the shell niche to catch the light which highlights in particular her cheek. She is standing with obedient Christian resignation and quiet joy, as she awaits her martyrdom at the column, on which, for the moment, she rests her elbow. This is the first use of controlled but concealed lighting, a theatrical device that Bernini was to use to such effect in several of his major commissions. Bibiana's head is a variation on the theme of a female entranced by a beatific vision such as Bernini had first employed for his *Blessed Soul* five or so years earlier.

To relieve the plain whiteness of the marble figure in its dark niche, rich colour and gilding are introduced all around. The triangular embrasure of the dormer window is adorned with a pattern of laurel branches and the three heraldic bees of the Barberini in gilded stucco; in an octagonal compartment of the vault, to which the languishing saint raises her eyes, is frescoed God the Father flanked by radiant suns, another device of the Barberini, while on the right hand wall, opposite the real window, is another fresco showing life-size angelic musicians with a trombone and a violin.

As with his Borghese statues, Bernini contrived the pose of St Bibiana to provide a sequence of special views, though here they are conditioned and divided into three by the architecture, for the aisles are separated from the nave by thick ancient columns. From the left aisle, near the door of the sacristy, one sees into the open palm of her hand (which seems subconsciously to be protesting her innocence, while warding off and at the same time accepting, her approaching martyrdom); beyond that is her face in *profil perdu*, and finally the golden palm frond sweeping up out of the niche, closing the composition and leading one's gaze upward, with that of the saint, towards heaven.

The principal view is emphasized by the converging lines of the heavy marble entablature of the colonnades flanking the nave, while the horizontal moulding that divides the shell

79, 81

78. Monument to Pope Urban VIII commissioned by the Senate of Rome in 1635 (Palazzo dei Conservatori, Rome).

79, 81. Chancel of the church of Santa Bibiana, Rome, with Bernini's statue (*opposite*) over the altar.

80. *Blessed Soul*, the companion to the *Damned Soul* (plate 71); a characteristic expression of Bernini's to convey the beatific vision.

from the vertical part of the niche draws attention to Bibiana's raised hand and palm frond. From the right aisle, her face is nearly fully frontal and her hand is nearly in profile, while her head is framed centrally within the radiating flutes of the shell.[5] The projection of Bibiana's relaxed knee is emphasized by the hem and folds of her cloak that run forward out of the shadows to the point where they are pressed to her thigh by her lowered hand.

The execution of the statue took just under two years: from August 1624, when Bernini was reimbursed for the cost of the block of marble, until July 1626 when the balance was settled.[6] He delegated some of the actual carving to Finelli, and the laurel leaves sprouting at the base of the column certainly recall those in the group of *Apollo and Daphne* which was being finished in the studio simultaneously.

The fairly prolonged time taken over the statue of *St Bibiana* may in part be explained by technicalities, including the need to adjust its salient features carefully for maximum effect to the novel concept of concealed lighting, which may well have necessitated minor alterations *in situ*. Also, as Baldinucci relates:

The Pope had conceived the lofty ambition that in his pontificate Rome would produce another Michelangelo. His ambition grew even stronger, as he already had in mind the magnificent idea for the high altar of St Peter's in the area which we call the confession and also for the painting of the benediction loggia. Therefore, the Pope informed Bernini that it was his wish that he dedicate a large part of his time to the study of architecture and painting so that he could unite with distinction these disciplines to his other virtues. The youth did not hesitate in agreeing with the counsel of his friend, the pontiff.

He studied under no masters other than the antique statues and buildings of Rome . . . For a period of two continuous years he devoted himself to painting; that is, to gaining experience in handling colour, since he had already mastered the great problems of drawing through intensive study. During this period, without neglecting the study of architecture, he painted a great number of pictures both large and small which today display their splendid qualities in Rome's most celebrated galleries and in other worthy places.

Some of these pictures have been identified and show competence, if not brilliance.

There are two sculptures in marble in St Peter's that may conveniently be dealt with out of chronological sequence before turning to the major, unified, scheme evolved over a number of years by Bernini for the embellishment of the crossing, nave and chancel of St Peter's.

Closest to the project for *St Bibiana*, because it involved a central standing female figure, was a wall-tomb of a decade later for a historical personage, Countess Matilda of Tuscany (1046–1115).[7] She was especially important for the papacy, for she had left her estates to the Holy See, and for the Barberini,

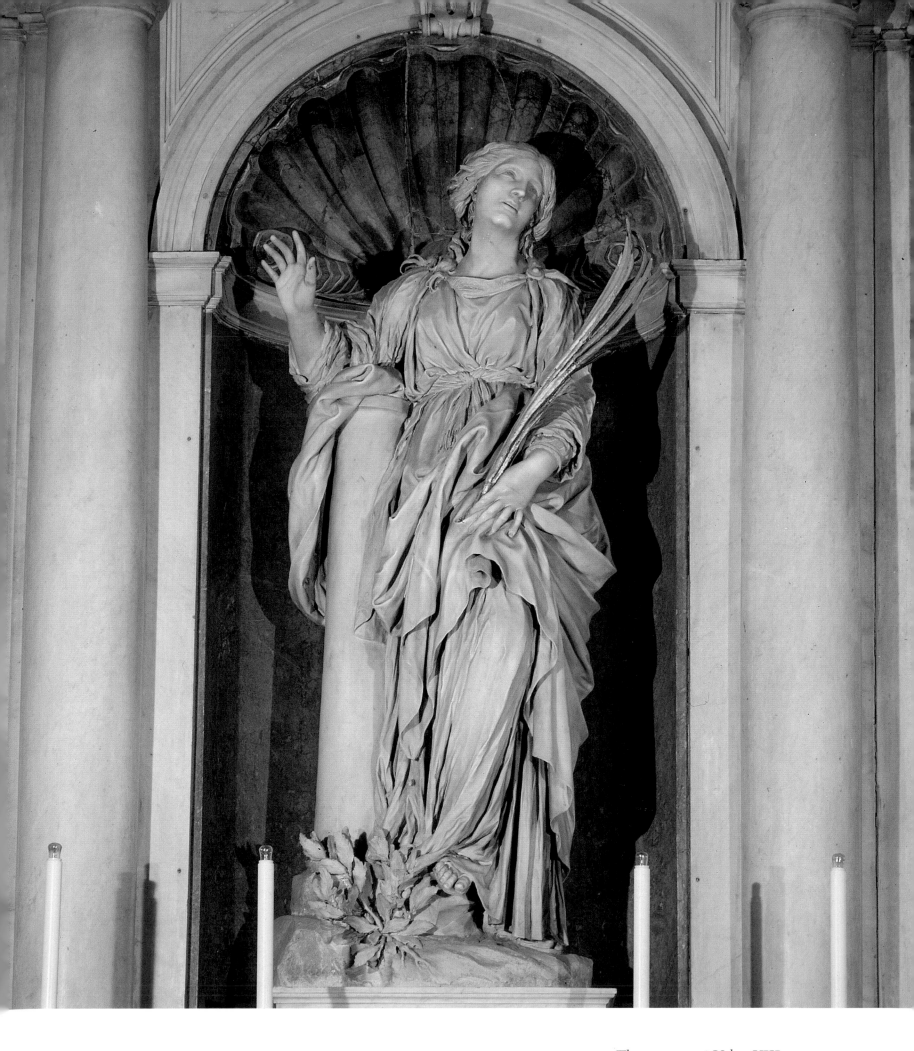

82. Bernini's definitive model for the Tomb of Countess Matilda, one of several copies cast in bronze.

because they were from Florence. Urban VIII therefore had her remains transferred to Rome in 1633 for reburial with suitable pomp in St Peter's and ordered Bernini to design a sumptuous tomb.

85 The tomb's location in the sombre right aisle meant that Bernini had to design the figure of Countess Matilda to take advantage of such natural light as there is, falling from the left, as in the case of *St Bibiana*. Approached from that direction and seen from ground level, Matilda's face is silhouetted against the darker mouldings of the arch surround, while her sceptre projects outwards over the spectator's head. A preliminary sketch in pen and wash survives, showing that Bernini envisaged from the start the rhomboidal sarcophagus with a historical narrative, but had intended to crown it with a more elaborate frontispiece in the form of a broken voluted pediment, centred with a high cartouche of swinging contours and supported by two seated female statues of Faith and Justice. These were eventually reduced to a pair of pensive, kneeling putti, in order to

accommodate a radical enlargement of the memorial statue. In the final design, Countess Matilda seems to be about to step regally forth from the dark niche of grey veined marble, which, in proportion to her, appears to be no bigger than a small, round-headed doorway.

What must be Bernini's definitive preliminary model for the figure is recorded in a small edition of statuettes cast in bronze, which are not highly finished but bear all the hallmarks of his technique of working moist clay with toothed wooden tools.[8] One of them, presumably presented to Maffeo, is still in the Barberini collection. As had been the case with such *bozzetti* since the time of Cellini and Giambologna, the proportions of the figure – most noticeably in her neck and head – are more attenuated than in the final statue, which looks distinctly stocky by comparison. All the essentials of the *contrapposto* and the drapery patterns that derive from and emphasize it are to be noted in the cast of the model. So too is the balancing of the notionally heavy weight of the papal tiara, the symbolic keys of St Peter and the corresponding extrusion of Matilda's elbow to that side, against her arm and hand firmly grasping the sceptre which extend beyond the confines of the block of marble in the opposite direction. Matilda's face, only a symbolic 'portrait', for she was long dead, is given the impassivity of an ancient Roman matron, an image which is strengthened by the Juno-esque proportions of her bosom indicated by the deeply excavated folds of fabric in her dress where it is pushed through the bodice over her chest.

The carving of the figure was carried out largely by subordinates whose names are known, though in a document of 1644 Bernini claimed to have contributed the following: small and large drawings; models for the decorative surrounds; models of all the figures, and the finishing of all the figures, in particular that of Matilda, 'which is almost entirely by him since there is no part that he has not worked over and finished'. There are passages of great subtlety to be sure, for instance in the way that the soft linen of her shirtsleeve is left in the rough but animated by occasional strokes with the claw-chisel. Its gently spiralling folds fall into more or less vertical bands of shadow. However, the evidence of one's eyes does not entirely confirm the sculptor's claim. For example, the figures in the narrative relief, even though quite near eye-level, are barely finished.[9]

The next commission for a work in marble to embellish St Peter's was given by Pope Urban in 1633. Its subject was to be the command given to St Peter by Christ after his Resurrection, 'Feed my sheep' ('Pasce oves meas'), as related in St John's Gospel (XXI, vv. 15–19).[10] This command was one of the foundations of the papacy, and it also comprised the idea of forgiveness, since Peter had denied Christ three times on the eve of the Crucifixion. This was to be depicted on a

83, 84. Preliminary sketches for the relief *Feed My Sheep* (Museum der bildenden Künste, Leipzig): in the upper one Christ moves away from St Peter, while in the lower one he turns towards him, as he does in the finished relief above the door of St Peter's (*right*).

huge marble relief set high over the entrance portal of the basilica, at first inside the nave, below a mosaic panel with a related theme, *The Miraculous Draught of Fishes* (the *Navicella*), by Giotto from old St Peter's. Later it was remounted by Bernini himself outside above the portal, under the great portico. Here it symbolizes the role of the Church in fostering the worshippers and welcoming pilgrims who are represented as sheep grazing contentedly in the left foreground.

Three exploratory sketches for *Feed My Sheep* survive.[11] The artist concentrated initially on the focal pair of figures, with St Peter kneeling obediently on the ground with his arms clasped to his bosom and gazing up in wonder and incomprehension at his master: this figure survived by and large into the final rendering, though St Peter's hands became parted, as though opening his very heart to Jesus' command. In the relief he seems to prop himself against its spiritual weight as though it were a physical force, with his exposed left leg, whose foot presses against the ground where it is intersected by the vertical frame. However, the figure of Christ in the first idea (*invenzione*) swayed *away* from the Prince of the Apostles, looking back over his own shoulder.

Bernini realized, apparently within minutes, that in this instance it would be more appropriate for the Saviour to adopt more encouraging 'body language' towards his chosen disciple and so, in the sketch below, his weight-bearing leg

and slung hip face the kneeling saint. But how were Christ's arms to be positioned? In what looks like a frenzied mêlée of pen strokes he ran through a number of alternatives, particularly as regards Christ's left arm, the one nearer to St Peter. It might beckon to him in mid-air (he even tried a similar gesture with the other arm); it might solicitously embrace his near shoulder, or – apparently – might even reach down to his bent elbow. Alternatively, this arm might stretch across the body and echo the direction of the further arm, which indicates the symbolic flock. In the event, a curtailed version of the last position was adopted, with the arm swathed in the knotted folds of drapery and the fingers embedded in diagonal folds that lead the eye to lower left, while a great swathe of Jesus' cloak falls almost vertically, creating a caesura between the interlocutors. This division, reinforced by a tree trunk behind, also reflects a division between two adjacent blocks out of the three from which the huge relief was carved. St Peter has a dark wood behind him, which contrasts with the open landscape to the left of the relief, against which in the middle ground are silhouetted several disciples, some of whom had been adumbrated standing behind St Peter in the second sketch. Christ's pose and the pattern of his drapery are quite close not only to those in the model for Countess Matilda, but also to those in a model that he had made just before the relief was initially ordered, for his marble colossus, *St Longinus*. After the initial payments in 1633, owing to distractions, the execution of this huge relief was protracted over many years and delegated to assistants during the span 1639–46. Bernini was to adapt the design fifteen years later for the back of the *Cathedra Petri*. 137

118

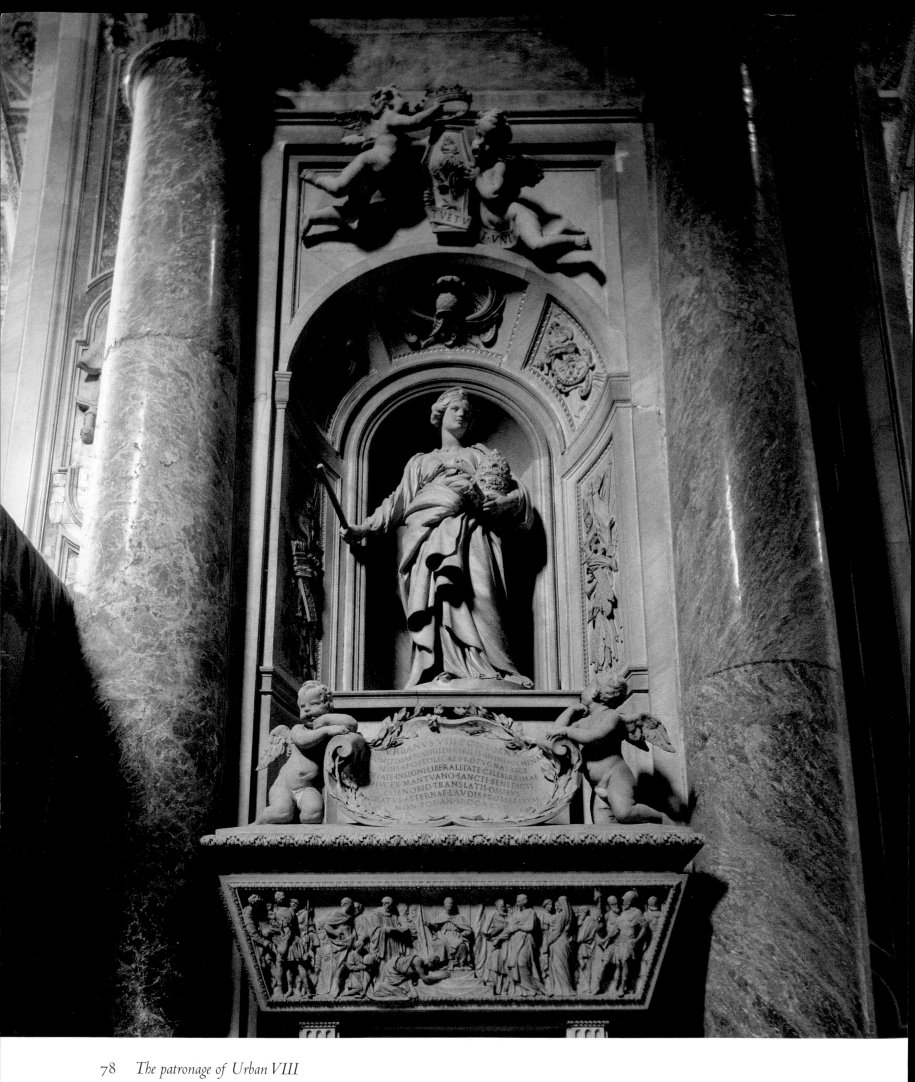

78 *The patronage of Urban VIII*

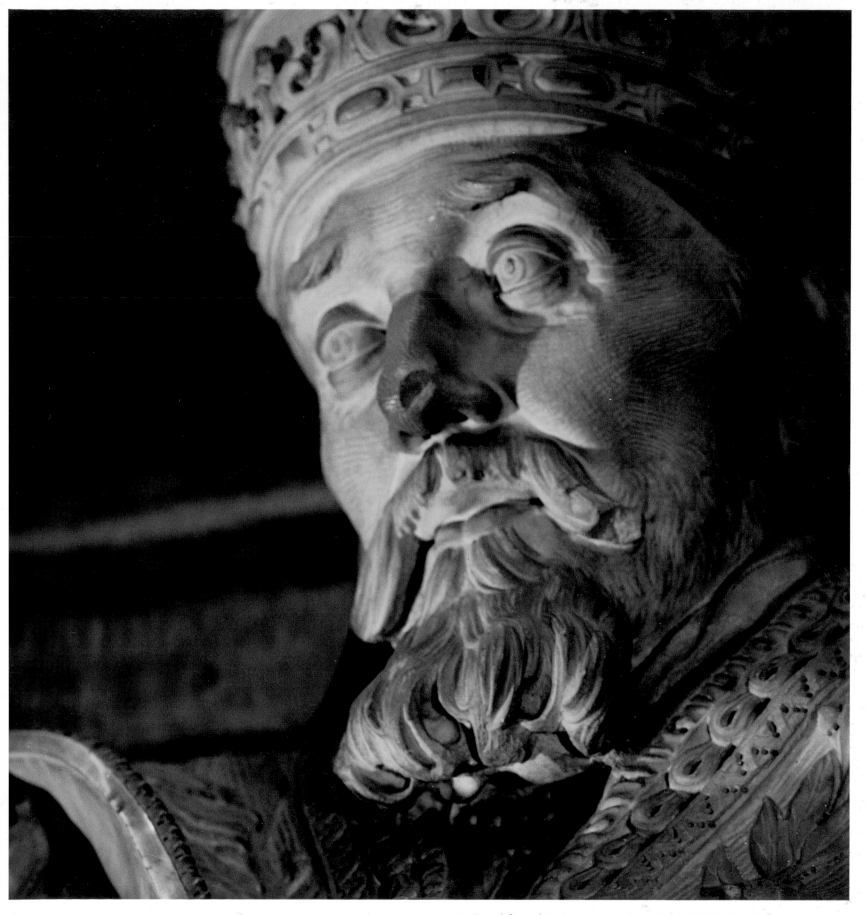

86. Detail from the Monument to Pope Urban VIII (plate 78).

85. Tomb of Countess Matilda of Tuscany (St Peter's, Rome); the sarcophagus was carved by Stefano Speranza.

87. Memorial to Carlo Barberini (Santa Maria in Aracoeli, Rome).

88. Preliminary sketch for the Memorial to Carlo Barberini (Museum der bildenden Künste, Leipzig).

89. Terracotta model of the Church Triumphant, part of the Memorial to Carlo Barberini (Fogg Museum of Art, Cambridge, Mass.).

Bernini was involved in several other commissions commemorating the activities of the Barberini. They consist of elaborate surrounds for adulatory inscriptions that dominate the inner face of the western wall of the civic church of Rome, Santa Maria in Aracoeli, adjacent to the Capitol. The earlier was occasioned by the death of Urban's brother, Carlo, the military General of the Church, in 1630: he was given a splendid funeral in Santa Maria in Aracoeli with an elaborate catafalque by Bernini, which is known from a detailed drawing, although he was actually buried in the Barberini Chapel in Sant'Andrea della Valle.

The permanent memorial to Carlo Barberini consists of a large, irregularly shaped cartouche with curly edges like a piece of leather or pastry — Bernini claimed elsewhere to have rendered marble as malleable as pasta — surmounted by his coat of arms and coronet.[12] Below, a winged skull pops out lugubriously, seemingly supporting the whole superstructure, while above, flanking the arms, though not supporting them, are two over life-size female mourning figures (distantly recalling Michelangelo's Times of Day in the Medici tombs). They represent the Church Militant and the Church (or, perhaps, Military Virtue) Triumphant: for the latter there survives a freshly and vigorously modelled sketch in terracotta, which proves Bernini's personal involvement with that particular figure.[13] Its design was derived from a catafalque that had been erected briefly in Ferrara Cathedral to accommodate Carlo Barberini's remains.[14] The other allegory was carved by an assistant. A preliminary sketch on paper shows two variations on a more traditional scheme, a rectangular tablet framed with strapwork and flanked by figures of Fame. The memorial must have been executed immediately, for, by 30 September 1630, Bernini received the

370

90. Monument commemorating the return of Urbino to the Papal States designed, but not executed, by Bernini (Santa Maria in Aracoeli, Rome).

final payment totalling 500 scudi, a generous amount to reflect his concerted efforts. Bernini was also commissioned to carve a portrait head of Carlo to be set on an ancient torso of Julius Caesar in military uniform for the Palazzo dei Conservatori in Rome.[15]

The second commission for Santa Maria in Aracoeli covered the whole width of the west wall above the Memorial to Carlo Barberini. It was decided by the Roman Senate in 1634 to commemorate the return of Urbino to the Papal States and Pope Urban's other services to the City of Rome.[16] Bernini received only a paltry 100 scudi, indicating that he was not deeply involved in the project's execution, which is correspondingly rather weak. The design, however, is clearly his; the ingenuity with which he accommodated the existing

rose-window of the façade, masking its outline from inside the church by transforming it into a shield and emblazoning it in stained glass with the Barberini bees in gold on a blue ground 'as if flying through the air' (Baldinucci), is unmistakable.

The Senate of Rome also commissioned in 1635 an enormous monument in marble to Urban that took the time-honoured form of a statue enthroned and giving a benediction.[17] Its composition is closely derived from the similar figure that the sculptor had modelled for the pope's tomb to be cast in bronze in c. 1630. Though often ignored or decried, this statue is expertly carved and the bravura of its details suggests considerable participation by the master, alongside his assistants. Who but Bernini would have had the audacity to leave the papal visage covered with the tracks of the claw-chisel? As in the case of his St Longinus, the deliberate lack of finish actually animates the statue.

5 * Popes and prelates: the mature portraits

This is Montoya petrified
Anonymous cardinal, 1622

BEFORE proceeding with the story of Urban VIII's patronage in St Peter's, one must digress to a discussion of the superb portraits, including some of Urban, that the sculptor was adding to his repertory almost year by year as he advanced into maturity.

Baldinucci takes up the story with one of the best loved anecdotes concerning Bernini:

Not much later [Pedro de Foix] Montoya decided to order his tomb with his own portrait carved in marble for the Church of San Jacopo degli Spagnuoli . . . Bernini made a portrait of him so very lifelike that in our time there was no one who was not stunned by it. When the work had been put in place many cardinals and other prelates came to the church for the express purpose of seeing such a fine work. One of them said, 'This is Montoya petrified.' The words were scarcely out of his mouth when Montoya himself appeared. Cardinal Maffeo Barberini, later to be Urban VIII, who was also among the cardinals, went to meet him and touching him said, 'This is the portrait of Monsignor Montoya,' and turning to the statue, 'and this is Monsignor Montoya.'

The portrait was carved in *c.* 1622, well before the Spanish jurist's death in 1630.[1] Bernini had by now completely mastered the exact rendering of physiognomy and was able to suggest the firm shape of the skull beneath muscle and flesh, not only in the balding cranium, but around the eye-sockets, cheek-bones and nose. The eyes are wide apart and set deeply into the sockets, beneath overhanging brows: this indicates the subject's age, but also serves to emphasize the mental abilities contained within his lofty, lightly furrowed forehead, and a capacity for deep thought and concentration. The eyes, swivelling to Montoya's right, are rendered by careful chiselling of the iris and pupil around a remaining highlight of marble above, an effect comparable to Bernini's second bust of Paul V and to that of Gregory XV, as well as to Proserpina.

The high starched collar provides a firm socket within which the ovoid head seems to be sensitively and alertly posed. The potential of movement is enhanced by the set of the shoulders, one of which is slightly advanced beyond the

confines of the oval niche, while the other is gently retracted, a movement which is reflected in the slightly asymmetrical fall of the pronounced folds of his robe. The way in which Montoya's knotted sash falls down in front of the socle, which it half conceals, softens the juncture between the truncated human being and the stark, architectural surround. Furthermore, the diagonal direction of its bows tends to link the sash visually with the flanking volutes below, which almost double as ribbon-like extensions of its ends.

Bernini's skill in rendering the wispy hair of the head and distinguishing its texture from that of the razor-shorn stubble over the pinched cheeks and the stiffer bristles of the walrus moustache is phenomenal. When Joshua Reynolds visited Rome in 1751, he noted with the trained eye of a professional:[2]

The marble is so wonderfully managed, that it appears flesh itself; the upper lip, which is covered with hair, has all the lightness of nature. He has a meagre, thin face, but a vast deal of spirit in his look. This [bust] certainly yields in no respect to the best of the Antique: indeed I know none that in my opinion are equal to it. 'Twas said to be so wonderfully like (and indeed, from that strong character of nature which it has, one easily believes it to have been like) that those who knew him used to say it was Montoya petrified.

Interestingly enough, Reynolds continues:

There are likewise in the Sacristy two heads by the same master – one representing an *Anima damnata* – wonderful for the expression as well as the execution and management of the marble. The former has all the sweetness and perfect happiness expressed in her countenance that can be imagined.

It was for Cardinal Montoya that Bernini had carved, perhaps a couple of years earlier than the portrait, the pair of Christian allegories, the *Blessed Soul* and the *Damned Soul.* Indeed they may have been destined to adorn Montoya's projected tomb, though they were not incorporated in its final form.[3] As Professor Lavin points out, Bernini deliberately adapted the pagan form of the bust, which traditionally had been used to depict an individual, to a Christian end, in order to represent abstractions of the two opposing sides of human nature, good and evil. The serious contemplation of, and preparation for, death had been a standard spiritual exercise imposed on the pious since the late

71, 80

91. Portrait bust of Pedro de Foix Montoya (Santa Maria di Monserrato, Rome).

92. Monument to Cardinal Roberto Bellarmine (Gesù, Rome).

Sourdis, the disapproving French cardinal who had accompanied Cardinal Barberini to inspect *Apollo and Daphne*.[6] Less well known and photographed than it deserves to be, this work is closely similar to the sculptor's contemporaneous busts, notably to that of the reigning pope, Gregory XV. Bernini enthusiastically explored the wiry, tousled hair, bushy eyebrows and neatly trimmed beard and moustache of this handsome and dynamic churchman. His sympathetic expression, focused gaze and slightly parted lips convey the 'speaking likeness' for which the sculptor was becoming famous, while the crisply incised folds of his linen amice and alb, the heavy cope with its ornamental embroidery of stiff, gold thread, the morse in the form of a cherub with which it is clasped and the curvaceous forms of the cartouche on the socle below all provide a sumptuous foil and support for the elegant and distinguished head. The other bust is a portrait of the nobleman and benefactor of the Florentine hospital in Rome, Antonio Cepparelli, who died in April 1624. Here the sculptor employed his trick of having the mouth open ever so slightly, as though the subject had just spoken.

Among other busts of the early 1620s is one showing Cardinal Alessandro Damasceni-Peretti Montalto (1571–1623), great-nephew of Pope Sixtus V (1585–90).[7] He was an

Middle Ages, and various manuals (sometimes illustrated with woodcuts or, later, with engravings) were published to impart the art of 'dying well'. During the Counter-Reformation this discipline was espoused especially by the Jesuits; Cardinal Roberto Bellarmine wrote about it in his *Shorter Catechism*.[4] Bernini's allegorical busts are thus firmly ensconced in the Jesuit tradition, to which he was an adherent.

Shortly afterwards, he carved a three-quarter length figure of the same Cardinal Bellarmine, who had died in September 1621, for his tomb in the Roman church of the Gesù, a project sponsored by Pope Gregory XV and Cardinal Odoardo Farnese.[5] Bernini showed the deceased praying, as was usual in French tombs, but gave the impression of life by balancing mildly asymmetrical diagonals about the central axis: the cardinal's head and upper torso tilt to the viewer's left and are followed by the dip of his shoulders to that side, while his projecting hands, joined arrow-like in prayer, compensate with a position slightly to the viewer's right. The sculptor's loving differentiation of the crinkled, fine linen of the alb, which is rendered with matt lines of chiselling against the highly polished cape imitating the sheen of satin, is seen to good advantage.

Simultaneously with *Apollo and Daphne*, Bernini was carving two busts. One was a portrait of François Escoubleau de

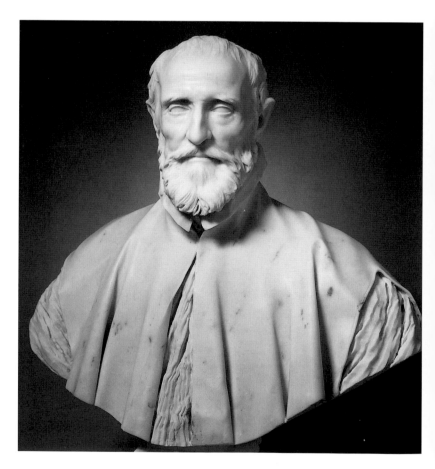

93. Bust of Monsignor Francesco Barberini (National Gallery of Art, Washington D.C.).

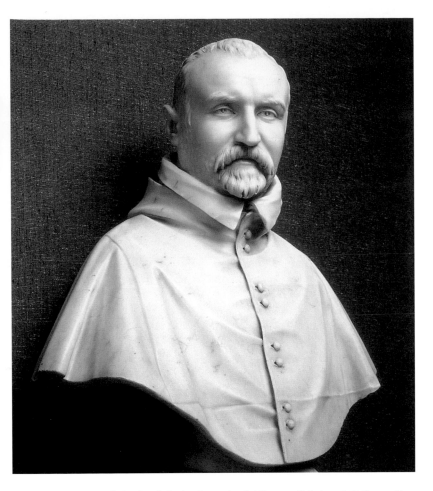

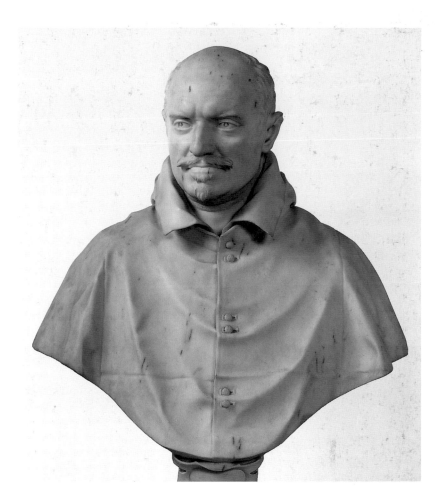

94. Bust of Cardinal Carlo Antonio dal Pozzo (National Gallery of Scotland, Edinburgh).

95. Bust of Cardinal Alessandro Damasceni-Peretti Montalto (Hamburger Kunsthalle, Hamburg).

important patron of the arts and had commissioned Bernini's group of *Neptune and Triton* shortly before his death. The bust once stood on a giltwood pedestal near the main hall of the *piano nobile* in the Peretti Palace,[8] but may have been intended by the cardinal's heirs for a tomb (that was never realized) in the chapel of his great-uncle Pope Sixtus V in Santa Maria Maggiore. The Berninis would have had a special interest in such a project, for Pietro had carved a major narrative relief in the chapel, and his home and studio were near the apse of the church.

To be dated near the Montalto bust on account of similarities in details of technique, such as the rendering of the eyes, is a portrait of Carlo Antonio dal Pozzo, Archbishop of Pisa, who had died in Bernini's youth in 1607.[9] A similar date can be ascribed to a yet more majestic and intricately carved bust of Monsignor Francesco Barberini, the uncle of Pope Urban VIII. Being posthumous, both portraits demonstrate Bernini's mastery of the art of seemingly revivifying people he had never met by sleight of hand, drawing on the slender evidence of paintings, engravings or death-masks.

In both busts, the treatment of the hair is particularly convincing. Bernini wielded his chisel on the marble as a barber would use a razor on real hair. The hairs of the subjects' beards were picked out with rows of fine drill-holes, with concave traces left in order to create an intermediate tone of grey between the highlights and the dark shadows. The subtlety with which the sculptor graded the tones of shadow on the skin as it rises and falls over the firmly apprehended bone structure 'beneath', can be captured readily by careful photography that avoids over-lighting the variously reflective surfaces.

Another Barberini – the pope's pretty, married niece Maria Duglioli who had died prematurely in 1621 – was the subject of one of Bernini's most bewitching busts. In carving the phenomenally dainty lace collar of Maria's fashionable attire he is said to have been assisted by Giuliano Finelli, the same specialist who helped him with *Apollo and Daphne* and *St Bibiana*. This can only have been after Finelli joined the shop in 1622; the bust was duly delivered by Bernini to the Barberini Palace in 1627, and is discussed further in Chapter Twelve.

In one of his busts of the same period, which was modelled in mid-1623, the spirited sculptor seems to have produced a three-dimensional caricature such as he loved to draw: this was a portrait of a portly military man with a handlebar moustache, Paolo Giordano II Orsini, Duke of Bracciano. The original version, cast in bronze by September

388

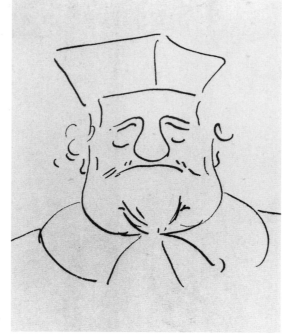

96, 97. Bernini's sketch in black chalk of Cardinal Scipione Borghese (Pierpont Morgan Library, New York) and his caricature of the same sitter in a few forceful pen-strokes (Biblioteca Vaticana).

98. Bust of Cardinal Scipione Borghese (Villa Borghese, Rome).

1624, may have been on a small scale, for the foundryman Sebastiani only received 25 scudi for his pains. Three slightly different small bronze busts of Paolo Giordano exist, though one of them is documented as having been cast by another foundryman, the gifted medallist Cormanno. That in general terms all three record Bernini's portrait is however indicated by their similarity to a later life-size version, carved in marble, that still resides in the castle at Bracciano.[10] A surprisingly buffoon-like impression is conveyed by these busts. This the sitter was content to accept without demur, for he shared the sculptor's outrageous sense of humour and himself enjoyed drawing caricatures, as we learn from a poem of his describing a dinner party in 1648 at which Bernini, dubbed by his sitter the 'animator di marmi' (the man who gives life to pieces of marble), was also present. That a duke was prepared to be so familiar indicates Bernini's success in raising his own social status above that of a mere artist.

There follow the crucial portraits of Bernini's career, depicting his most enthusiastic patrons. Baldinucci regales us with a classic tale:

Afterward, the artist carved the portrait of Cardinal Scipione Borghese, the Pope's nephew. This handsome work was almost completed when a mishap occurred. A crack appeared in the marble across the whole of the forehead. Bernini who was very bold and who already had a marvellous knowledge of the working of marble, in order to free himself, and even more the Cardinal, from the embarrassment resulting from such news, had a sufficiently large piece of marble of known quality secretly brought to him. Without telling a soul, he worked for fifteen nights (which was all the time he had for that tedious task) on another bust exactly like the first and not one jot

less in beauty. He then had the first bust transported to his studio, well wrapped, so that no one in his household would be able to see it. Then he waited for the Cardinal to come to see the completed work. That gentleman finally arrived and saw the first portrait, whose defect in the polished state appeared even more prominent and disfiguring. At first glance the Cardinal became agitated, but he masked it in order not to distress Bernini. The astute artist, meanwhile, pretended to be unaware of the Cardinal's disappointment, and since relief is more satisfying when the suffering has been most severe, he engaged the Cardinal in conversation before finally uncovering the other beautiful portrait. The gaiety that the prelate displayed upon seeing the second portrait without defect made very evident how much pain he had felt when he beheld the first one . . . Today both portraits are to be found in the Palace of Villa Borghese. They are such fine and splendid works that Bernini himself, when coming upon them with Cardinal Antonio Barberini forty years later, exclaimed, 'How little progress I have made in the art of sculpture through these long years becomes clear to me when I see that, as a boy, I handled marble in this manner.'

Baldinucci (and Domenico Bernini, Gianlorenzo's own son) were wrong about the date of this amazing tour de force, believing that it had been done in the sculptor's youth, whereas it is one of the greatest achievements of his maturity. Indeed the portraits proved to be Bernini's last tribute to the patron who had given his career a flying start by commissioning the mythologies and David, for Scipione Borghese died in October 1633. Bernini was paid just before Christmas 1632, but the 500 scudi were perhaps for only one of the busts and, as the commission had redoubled itself accidentally, a further similarly generous sum seems to have followed.[11] The existence of the virtually duplicate busts in

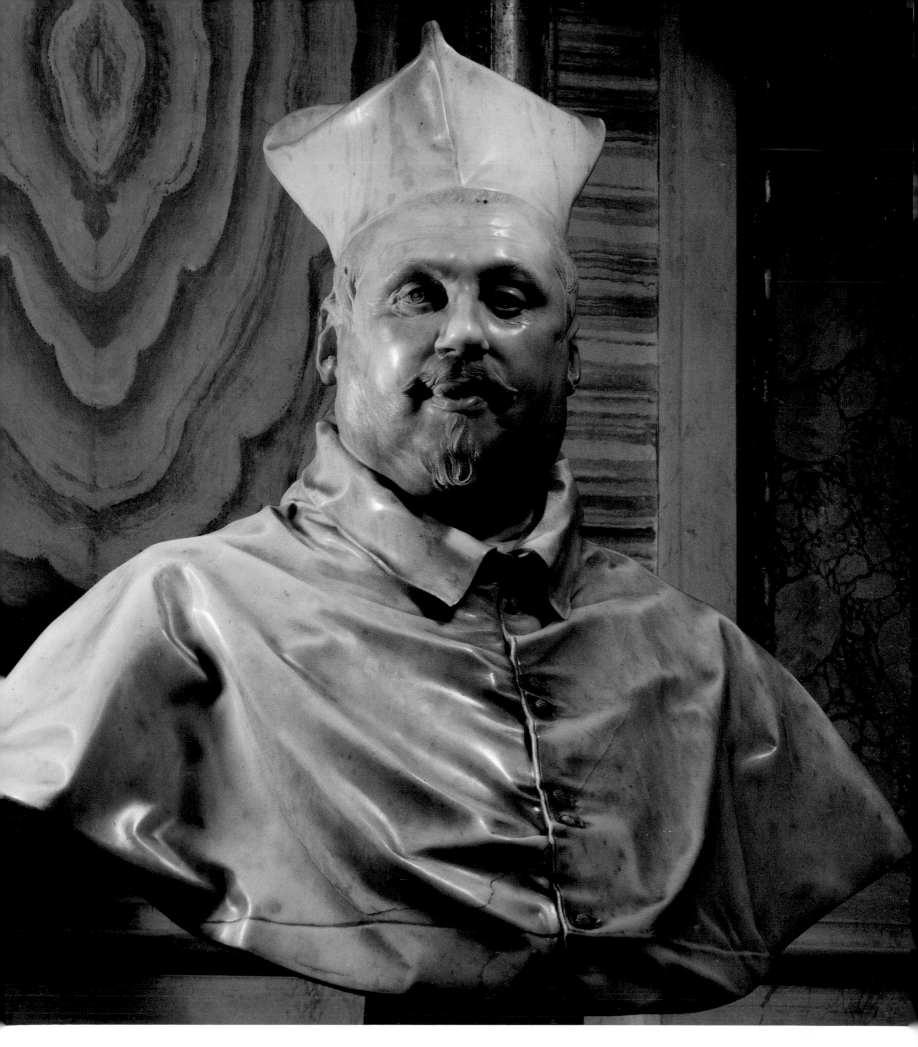

99. Frontispiece to an edition of Pope Urban VIII's Latin poetry, based on a painting by Bernini.

the Villa Borghese, one of them with a disfiguring vein running diagonally through the marble across its expansive forehead, corroborates the amazing tale. If it is true that Bernini could, under pressure, produce a portrait of this excellence in a fortnight (and that by carving only at night-time, presumably after a normal day's work), his prolific output of brilliantly characterized busts is explained.

An engagingly spontaneous sketch in black chalk, an almost unique survival, shows Borghese in a moment of calm conversation: numerous pentimenti show the draughtsman searching for the telling profile, the angle of the biretta and so forth.[12] They result from Bernini's practice of sketching his subjects while they were engaged in their normal activities. The movements of a head in conversation could account for the slight changes in the contours as Bernini noted them rapidly in chalk. He then laid in the characterful details of hair, moustache and beard, always relating them to the crucial features, the ear and the eye. The rough surface of Scipione Borghese's jowls, the pull of the skin and the subtle changes of plane are indicated with faint cross-hatchings, just as they

would be with striations of chisel or rasp on the marble. A sketch such as this, as distinct from his more finished portrait drawings (many of them self-portraits), served only to fix the head in the sculptor's mind and to find the concept (*invenzione*) for the particular image that he wished to convey in the bust. He alleged to Chantelou that he had no need to refer to these sketches or successive *bozzetti* in clay during the processes of modelling or carving; to copy something that was already a copy was a sure way to lose freshness.

One can surmise Bernini's 'general idea' of the sitter of this portrait by examining a brilliant caricature that unkindly – but tellingly – emphasizes Borghese's bovine jowls and rotund breast, conveying an impression of self-satisfaction and well-being in a determined and successful personage.[13] Even the pronounced form of the cardinal's biretta that jauntily crowns both busts is derived from the five forceful pen strokes of the caricature, while the curiously crumpled forms of his ears that punctuate the contours of the marble are derived from the squiggles in pen that serve both for ears and for the stray curls of hair above them.

The flawless marble of the second bust conveys Borghese's appearance and character directly to the observer. His fleshy eyelids and sinuses seem to palpitate with his heartbeat, and so intense is the gaze incised into those bright marble eyes that the viewer almost feels anxious about a daunting interview. The satin of the cape, whose sheen is again rendered by a high polish, seems to be rumpled by the sheer volume and the heaving of the mighty chest within: one can all but hear the cardinal's stertorous breathing in this momentary interval between speech. The rippling of the folds serves not only to suggest form, but also to convey the effect of watered silk. One button is not quite done up, but seems to be securely gripped between the stiff thread stitched around the edge of the buttonhole.

It may seem amazing that, in an age of courtly niceties, Bernini was allowed to produce an image as unflattering as that of Borghese: there seems to be no attempt to slim down his more than ample proportions. Presumably his clients were placated by the almost photographic, tangible likeness that could be considered from a multiplicity of angles. One of the greatest portraits of all time in any medium, this bust is a work of genius.

Bernini's marble portrait of his other favourite patron, Maffeo Barberini, Pope Urban VIII, now in old age, seems to have been carved almost simultaneously with the busts of Cardinal Borghese, in the summer of 1632, for both are highly praised in a letter of the following year. Here too there exist two impressive and seemingly autograph versions of the same image of Urban in marble: one still in Rome, from the Barberini collection[14] and the other in Ottawa.[15] The latter is heavily veined across the chest (though this is cleverly

disguised among the ripples on the surface of the cape and suggests watered silk) and cracked at the rear. Nevertheless the quality of carving is first rate, so this may simply be an earlier version that, as in the case of Scipione, had to be replaced with a duplicate in perfect marble.

In 1631, Bernini made a drawing and a painting of Urban, now aged under the strains of his high office, and this image was engraved as a frontispiece to an edition of Urban's Latin poetry. These exercises sufficed to suggest the form that a bust might take, though the mood conveyed in the engraving by the wide-open eyes and distended pupils gazing directly at the beholder is more self-confident. In the Canadian version of the bust, the head is tilted slightly forward, the eyelids are narrowed and the eyebrows puckered, conveying a look of introspection, even of disenchantment.

The head is turned through some ten degrees to the viewer's left, while the glance of the eyes swivels another ten degrees or so in the same direction. Bernini pulls the brows forward to create pools of shadow underneath; he cuts right in above the eyelid, where the eyeball is set into the socket; the eyelids then project over the sunken spheres and the hollowed out, dark irises, so as to catch the light and to transmit it through the eyelids' translucent rims, where the eyelashes would be. Even the treatment of the eyes differs: Urban's right eye is created by small but deep drill-holes to either side of an isthmus of marble joining the white of the eye to the projecting highlight in the pupil, whereas his left eye is made with three tiny drill-holes, one in the centre, without the isthmus of marble remaining. The iris is described by an incised circle, and the crow's-feet by the most delicate of incisions, while the crinkled, ageing skin between them is abraded, not polished.

The sculptor also pulls the cheek-bones well forward to catch the light and to emphasize by contrast the shadows formed by the channels running diagonally down from the nostrils. Urban's drooping moustache to our right is undercut behind, though its tip runs back against the cheek, while on the opposite side the delicate tip has been snapped off. The same is regrettably true of one strand of the beard. Both defects interfere with the intended visual rhythms and effect of symmetry, about which Urban was in fact most particular: he was once even nicknamed by a critic *Papa Urbano della bella barba* ('Pope Urban of the beautiful beard')! Indeed Bernini was most conscientious in portraying the beard, whose tips, sticking forward into the light and then curling neatly into shadow, are rendered as a series of calligraphic 'S' shapes, relieved from the mass by means of daring undercuts with a drill: thus he managed to create a filigree of fictive hair. The stubble over the jaws is scratched in with a single point chisel, for none of the minute striations indicating the shorn hair are parallel, as they would be if he had used a claw-chisel.

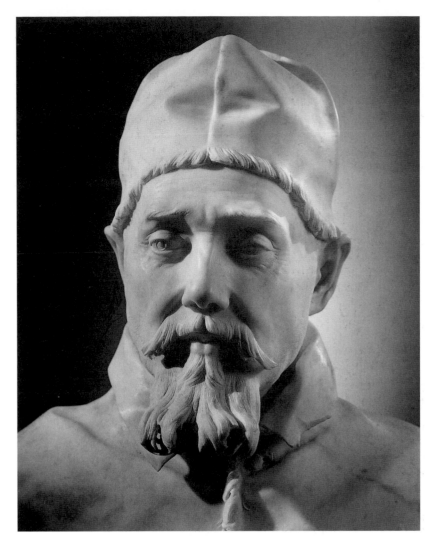

100. Bust of Pope Urban VIII (National Gallery of Canada, Ottawa).

The ears are large but in proportion and generously excavated in organic crinkles, being pushed slightly outwards at the top by the fur trimming of the cap, so that the marble, when illuminated brightly, is as translucent as real flesh. The head rests snugly like an egg in a cup within the circuit of the collar, though a deeply drilled slot forms a curve of shadow in between. This contrasts with the starched linen of the collar, whose crispness is indicated by the angles between the contrasting planes in which it has settled. The fur lining visible down the front of the cape is rich and varied in modelling: its individual hairs were divided into calligraphic waves with a point chisel, worked round the convexity of the trimming from upper right to lower left in repeated spiral cuts. Shadows between some of the locks of fur were then drilled in. Finally, the back and its central support were neatly trimmed with a claw-chisel, as was Bernini's practice.

It seems worth giving such a detailed description to emphasize the infinite pains Bernini took, the pride in every tiny detail — even the fur linings of cap and cape — and the imagination he brought to bear in endowing his work with variety, and hence with naturalism and vivacity. The sculptor

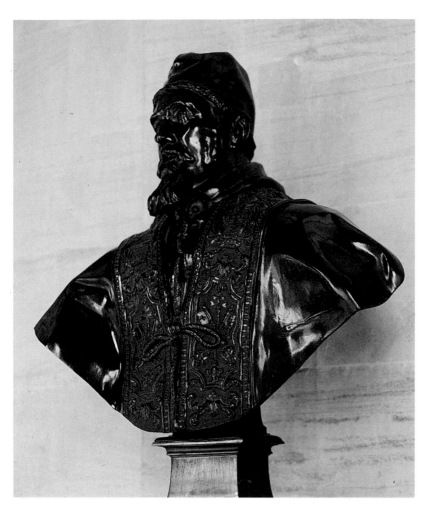

101. Bronze cast of Bernini's bust of Urban VIII (Blenheim Palace, Oxfordshire).

In the following pontificate, that of Innocent X (1644–55), Bernini's monopoly of papal portraiture ceased abruptly; it was the turn of his rival Alessandro Algardi to bask in the favour of Camillo Pamphili, at least until the triumph of the *Fountain of the Four Rivers*. Bernini's view of Innocent may therefore have been rather jaundiced, though he was desperate to curry favour. Algardi's portrait of Innocent was the 'official' one that was reproduced time and time again in a variety of media, including one in gilt bronze for the head and porphyry for the shoulders. Bernini's was an alternative, less benign interpretation reserved for the delectation of the Pamphili family rather than for the adulation of the public.

As in the cases of the near-duplicate busts of Scipione Borghese and Maffeo Barberini, Bernini seems to have been forced to carve a second version of Pope Innocent X; an internal flaw in the marble of the first version became apparent at a late stage. In this case, the first bust has a break running through the lower jaws and chin which inevitably disfigures it: this may have been exacerbated by some accident in the carving process. The sculptor kept this slightly spoilt bust in his own house.[21] An attentive examination of both busts reveals the same tricks of technique that had vitalized the images of Urban VIII: buttons not fully pushed through buttonholes, two in this case; the shaggy effect of fur trimmings created by chisel-strokes spiralling downwards, interspersed with three or four drill-holes, and the rendering of Innocent's straggly beard by an intricate filigree, achieved by drilling up from below with a wide bit (about ¼ in. in diameter) and then using a finer bit (about ⅛ in. in diameter), as well as a running bow drill to make tracks of weaker shadow. Beneath the chin and inside the collar the dark shadows are created by a veritable trough excavated with a mixture of drilling and chiselling. This pope's enormous ears are, once again, pushed slightly outwards by the fur of his cap. The skin is smooth, with the stubble scratched in. In both versions, Innocent's rather small eyes are inscribed with two concentric circles, instead of being excavated deeply, so there are no dark areas caused by shadow. This was intended either to convey the lighter colour of blue irises, as the sculptor explained was his practice, or to give a myopic look. The most extraordinary feature, exaggerated far more than in Algardi's busts or, indeed, in Velázquez's painted rendering of the same face, is the almost Neanderthal projection of the brows above the eye-sockets, which are counter-sunk by about an inch. This is especially apparent from a three-quarter or profile view. Together with the broad, blunt nose this endows the head with a pugnacious quality, perhaps a subconscious memory on Bernini's part of their initially mutual dislike.

Bernini also made portraits of the succeeding popes, Alexander VII, his next most important patron after Urban, and Clement X, shown half-length in the act of benediction, 381–38

hated to be interrupted, and no wonder, for it broke the spell of his intense concentration, and upset the rhythm of his hands.

So successful was the portrait that, as was usual, casts were made in bronze from the terracotta model that Bernini kept in his house until his dying day.[16] Over the ensuing years two further elaborated variants of the image were produced. In one, Urban wears a chasuble with a heavily embroidered border: King Louis XIV owned a cast of this version which is now in the Louvre.[17] Another excellent, unpublished cast is – surprisingly – at Blenheim Palace.[18] The last and most splendid variant, showing the sitter in full pontifical regalia, was personally ordered by Urban for Spoleto Cathedral in 1640. This was really a new bust altogether, for Urban was eight years older still, and Bernini spent some time remodelling the head, tiara and cope.[19] The result is similar to elements of Urban's tomb.

It was also under the pontificate of Urban, in *c.* 1636, that the sculptor produced three of his finest portraits depicting distinguished foreigners: the Englishmen King Charles I and Mr Thomas Baker, and Cardinal Richelieu of France.[20] These merit a separate discussion.

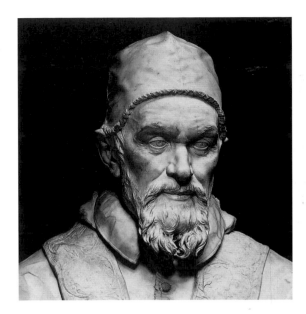

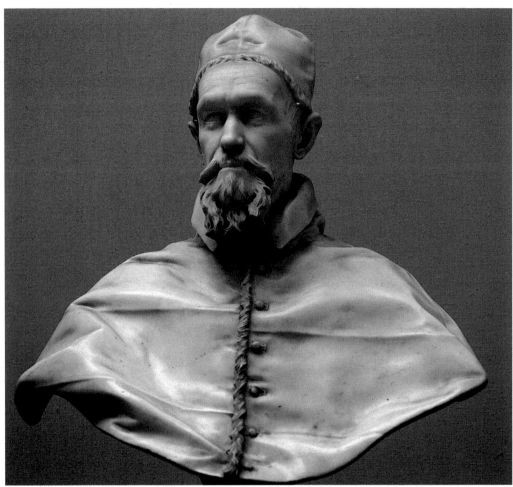

102. Alessandro Algardi: head of Pope Innocent X
(Palazzo Doria, Rome).

103. Bernini's rival bust of Innocent X
(Palazzo Doria, Rome).

but unfinished on account of the sitter's death. These will be discussed later.[22]

Two rather different busts should be considered next, each depicting a female, one real and one mythological. Costanza Bonarelli, very much a creature of flesh and blood, was carved around 1637–8.[23] The wife of a studio assistant who joined the *équipe* around 1636, this evidently vivacious and well-endowed young woman became Bernini's mistress as well as his model, in spite of her Christian name. This may not have been Bernini's only amorous adventure, for even the discreet Baldinucci had to admit that 'until his fortieth year, the age at which he married, Cavalier Bernini had some youthful romantic entanglements'. Costanza's husband Matteo seems to have remained remarkably complaisant, perhaps to retain gainful employment in Bernini's studio. But their prolonged affair – the talk of the town – came to grief with violence ignobly offered by Bernini to Costanza. This episode, related on page 274, eventually embarrassed Pope Urban beyond endurance, and, in 1639, he insisted that the reluctant sculptor take a respectable wife. For the sake of propriety, the bust had to be disposed of; it ended up in exile in Florence in the collection of the grand dukes of Tuscany, where it was noted by John Evelyn in 1645 and has remained ever since.

Unlike all Bernini's other portraits, however spontaneous, the bust of Costanza Bonarelli is deliberately informal, and, by comparison with them, is little more than a head.

Costanza after all had no official garb by which an observer might judge her standing; Bernini shows her with her chemise unbuttoned a little more than is proper. She is the forerunner of French and English portraits *en déshabillé* of the eighteenth century. This sets the mood of spontaneity and the impression of a 'speaking likeness'. With a trace of a frown, Costanza parts her lips as though in surprise, as she flashes her enormous eyes towards a newcomer in the studio. Her face, by modern standards, is a trifle fleshy, but this was the age of Rubens, and her aquiline nose and full lips impart distinction to her profile. Bernini ran the chisel over the soft volumes of her hair time and time again to suggest its gleaming strands by a series of striations, especially where it grows from her forehead. He then sketched in with the drill some kiss-curls to either side of her temples and cheek-bones. The hair at the side is only loosely drawn back into the coiled plait at the back of her head, so that its weight is almost palpable, while an adorable ringlet, whose end is drilled right through to form its curly tip, enlivens the nape of her neck. Costanza may have been the model for the figure of Charity on the Tomb of Urban VIII, which Bernini was carving in the same span of years as their affair, while the companion figure of Justice, begun only in 1644, five years after his marriage, may reflect instead his comely young wife, Caterina Tezio.

The other bust from this period showing a female is the

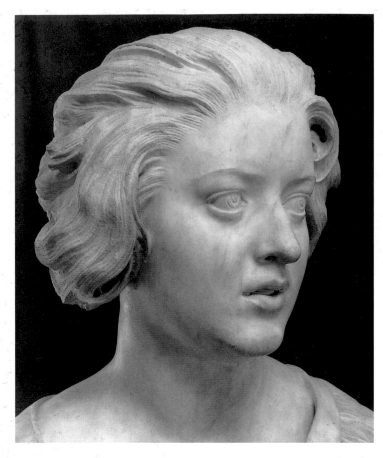

104. Head of Costanza Bonarelli, Bernini's mistress (Bargello, Florence).

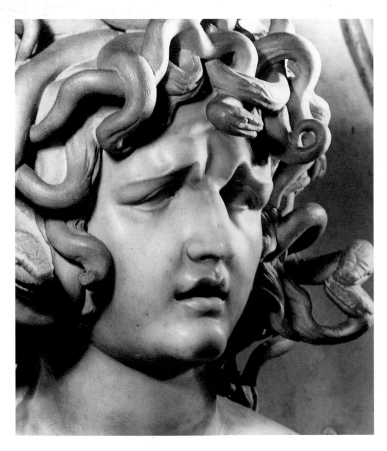

105. Head of *Medusa* probably modelled on Costanza (Palazzo dei Conservatori, Rome).

Medusa, a malign mythological monster with snakes for hair.[24] The subject had been tackled before in a circular painting by Caravaggio, who had worked from the reflection of his own face in a mirror, intending to represent the reflection of Medusa's shrieking face in the polished shield of Perseus, as she was beheaded by him. This rendering in three dimensions is not documented, but one cannot better the case for Bernini's authorship given by Wittkower:

The brilliant surface treatment, the technical wizardry of the serpents' bodies curling free in space, the powerful and convincing transformation of an ancient tragic mask into the head of Medusa, the play with transitions between hair and snakes (an ingenious interpretation of Ovid's text, *Metamorphoses*, IV, 794 ff.) – all this favours the traditional attribution.

If the bust is by Bernini, the absence of documentation is strange, in view of the usual abundance of archival material. The alarming undercutting of the entwined snakes poised to strike in every direction is a demonstration of technical virtuosity *par excellence*. Wittkower deduced that the *Medusa* may have been one of the sculptures produced for Bernini's own amusement when he was housebound after an illness in 1636. These were kept thereafter in his house. This may be the case, yet the choice of subject demands an explanation.

It has been remarked that the figure of Charity on the Tomb of Urban VIII may have been modelled on Costanza Bonarelli. If one then compares the bust of Costanza with the *Medusa* is it not possible that they represent one and the same person? Bernini was no doubt guilt-stricken about his adulterous relationship and enraged at its violent ending. So might he not in a frenzy have worked out his feelings of rejection and revenge by depicting Costanza as his own Medusa, and might not the look of sorrow – as much as of pain – that deforms her pretty face be a reflection of his own turbulent emotions? We know that he was prone to use allegorical sculptures as a release for his own feelings, for such was the rationale behind his carving *Time Unveiling Truth*: a snub for his critics over the fiasco of the ruined campanile for St Peter's. If there is any merit in this hypothesis, then the two busts might be seen as a highly personal variation on the much earlier constrasting pair of the *Blessed Soul* and the *Damned Soul*, and this would provide a reason for Bernini carving the *Medusa* for himself, just as he had done the head of Costanza Bonarelli. Wittkower's proposed dating would be postponed by only a year or two, until the violent end of the affair in 1638–9, or shortly thereafter.

By far the most dramatic of Bernini's Italian busts, that of Duke Francesco I d'Este of Modena, was carved from painted portraits of both profiles and full-face, without the sculptor ever meeting the subject.[25] This had also been the case with his renditions of King Charles I and Cardinal

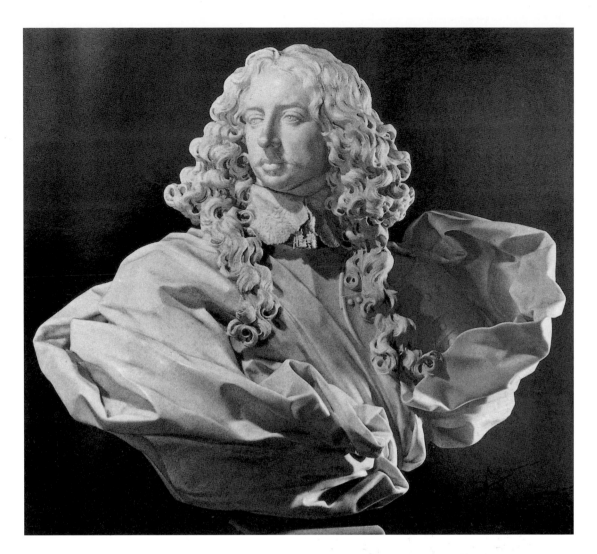

106. Bust of Duke Francesco I d'Este of Modena (Galleria Estense, Modena).

Richelieu,[26] as well as some of his earlier portraits of deceased clerics, but the result that he managed to achieve on this occasion was truly spectacular. Duke Francesco commissioned the bust in July 1650 via a brother who was a cardinal in Rome; Bernini had begun work by 20 August; by 31 August rapid progress had been made, and carving continued under the watchful eye of the Francesco's brother throughout September. By January 1651, the image was reported to be well advanced, but then the pace slackened, apparently, as Bernini complained, because of the difficulty of getting the right expression from indifferent paintings. After this promising start, completion dragged on for fourteen months; the bust was viewed by *cognoscenti* in the studio and finally despatched to Modena on 1 November. Despite the lapse of time, Bernini was paid the princely sum of 3,000 scudi, six times the generous Cardinal Scipione's payment, and only 1000 scudi less than the worth of the diamond which Bernini received for his bust of King Charles I.

We cannot easily verify the accuracy of the likeness, for the paintings have vanished, though the subject's brother would presumably have checked it by memory. But in this case the likeness was not Bernini's principal accomplishment; rather, it was the way in which he was able to convey the abstract idea of monarchy in the tangible form of a piece of marble. Queen Christina of Sweden and other nobles were enviously impressed.[27] Armour was a traditional indication of rank in a bust, while a sharp turn of the head nearly into profile to indicate imperiousness had been exploited by Michelangelo in his *Brutus*, itself inspired by ancient portraits of the Emperor Caracalla. Bernini may also have recalled Michelangelo's *Moses* in the church of San Pietro in Vincoli, for Moses' long, wavy beard may have suggested the curling tails of Francesco d'Este's hair.[28]

But only Bernini could have contributed the unnaturally windswept drapery to suggest, by its cloud-like forms, an ethereal aura around Francesco; he would exploit this device to its utmost in his bust of Louis XIV. The crumpled edges of drapery that zigzag wildly about divide the cloak into planes of light and shade, just as in a preliminary sketch he might have indicated its creases and contours with a swirling flourish of the pen. Such free-flowing drapery had been used before only to indicate a heavenly aura around flying angels and ecstatic religious figures, so it was a leap of the imagination to apply it to a layman, however illustrious. The bust of Francesco d'Este was, within Italy, the apogee of Bernini's career as a portraitist.

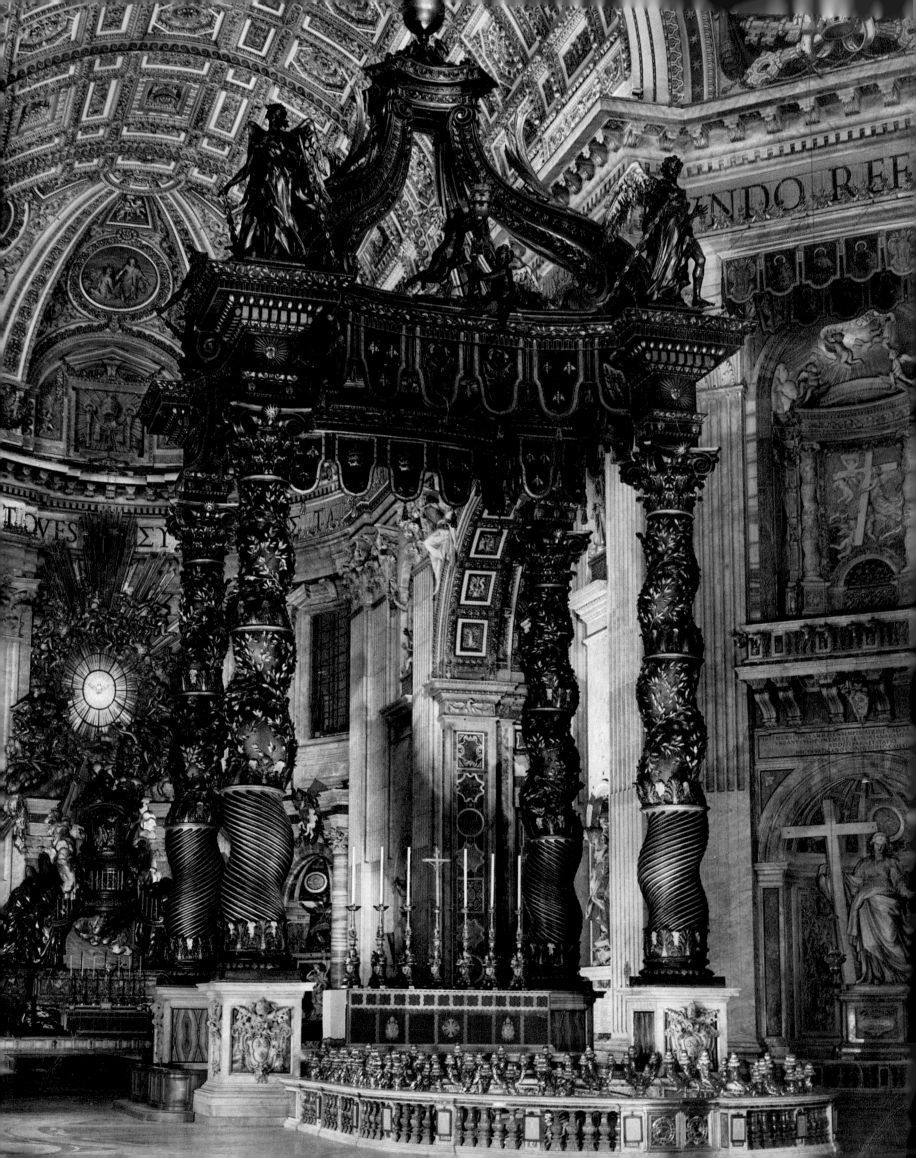

6 * Architect to St Peter's: the Baldacchino and Cathedra Petri

Oh, if only I could be the one!

Gianlorenzo Bernini, aged ten, to Annibale Carracci

What appears to the viewer is something completely new, something he never dreamed of seeing

Filippo Baldinucci, 1682

The Baldacchino

As a preamble to the discussion of Bernini's contribution to the focal elements of the interior of St Peter's, it would be as well to recall how recently the architecture had been completed. The dome had been closed only during the period 1589–93. Lengthy discussions ensued concerning the relationship between the shrine at the tomb of St Peter, which was directly beneath the dome, and another altar at the entrance to the newly built chancel. A series of temporary canopies ('baldacchini' in Italian) covered and marked the tomb, the holy of holies in the Basilica: these always had to allow a clear view through to the high altar beyond and were simply enlarged versions of the usual portable ceremonial canopy held up on poles by papal knights over the pope's head when he progressed out of doors.

A simple wooden baldacchino was replaced in 1606 at the instigation of Pope Paul V with one supported by four large figures of angels to the design of the architect Carlo Maderno: this design (with the high altar close behind it) is therefore that which Bernini would have known as a child. As Baldinucci relates:

It happened one day that he found himself in the company of Annibale Carracci and other masters in the basilica of St Peter's. They had finished their devotions and were leaving the church when that great master, turning toward the tribune, said, 'Believe me, the day will come, no one knows when, that a prodigious genius will make two great monuments in the middle and at the end of this temple on a scale in keeping with the vastness of the building.' That was enough to set Bernini afire with desire to execute them himself and, not being able to restrain his inner impulse, he said in heartfelt words, 'Oh, if only I could be the one.'

In the event, alterations envisaged under the short reign of Gregory XV were put in hand by his successor Urban VIII, with the help of Bernini, who produced four new, larger,

angels in stucco as supporters for the canopy, receiving several payments in 1624. This replacement design is known from an engraving, which shows that the angels were conceived supporting the poles in a realistic fashion. Its lifespan however was very short, amounting to probably only two or three years.

A certain urgency was induced by the fact that the forthcoming completion of the nave would permit the final dedication of the whole church, a major event to which Urban VIII naturally looked forward, determining that it should take place in 1626, exactly 1300 years after the dedication of old St Peter's in 326. As Carracci had perceived, the challenge was to design a 'transparent' structure that nevertheless would have sufficient substance not to be dwarfed by the huge space of the vast crossing and dome by Bramante and Michelangelo: it would also have to relate satisfactorily to the eventual form of the high altar.

The solution was to conflate the shrine of St Peter with the papal altar at the entrance to the chancel, and then to have a new high altar, at the far end of the chancel. Thus the idea of an honorific canopy marking the shrine could be combined with an appropriately solid and grandiose ciborium, distantly echoing that which had served both purposes in the old basilica and had remained in use until quite recently. The four straight and unadorned poles of the existing canopy were replaced by twisted columns, recalling, on a greatly magnified scale, those that had supported the ciborium in old St Peter's. They were particularly sacrosanct and imbued with intensely symbolic meaning because they were (wrongly) believed to have been imported by the first Christian emperor, Constantine, from the Holy of Holies in the ancient Temple of Solomon in Jerusalem (hence the technical term for their particular form, 'Solomonic'; they appear in pictures of the Temple by, for instance, Raphael and Giulio Romano). Eight of the actual columns were reused by Bernini to frame his great reliquary tabernacles facing in towards the Baldacchino from the canted inner corners of the piers of the crossing.

108

109

107. Bernini's Baldacchino in St Peter's, with the *Cathedra Petri* in the background.

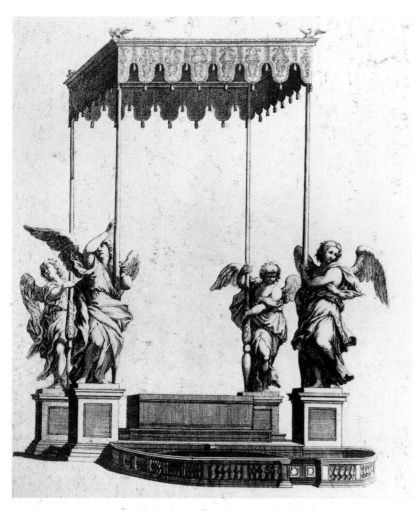

108. Maderno's baldacchino of 1606 with the four new angels designed by Bernini.

Twisted columns had also been quite frequently used in Italian Gothic architecture – perhaps owing to this association – and had often been enhanced with inlays of scintillating mosaic. The marble columns in old St Peter's had been clad in silver for added effect. This may have suggested the use of metal for the new columns, though their size precluded precious metal. Bronze alloy has a golden hue and partial gilding would emphasize the colour still further. Thus in their sensuously swelling form and in their actual colour Bernini's columns would contrast startlingly, though judiciously, with Michelangelo's severe fluted colossal pilasters in plain marble that articulate the architecture around the Baldacchino. This was the sort of dramatic visual counter-effect that Bernini delighted in, terming it a 'contrapposto'.[1]

A decision to make the vast replacement ciborium in bronze had already been taken by late 1624, for estimates were being made of the amount of alloy that could be collected by removing any surplus bronze clamps from the dome of St Peter's itself and the coffering from the ancient Roman Pantheon. There was a symbolic attraction in plundering valuable metal from a pagan building to use at the focal point of the central shrine of Christendom, but for a humanist pope the idea was shockingly philistine. Nevertheless, it was acted upon, causing an outraged Roman citizen to coin a neat epigram involving Urban's surname: 'Quod non fecerunt barbari, fecerunt Barberini' ('What even the barbarians did not do, the Barberini have done').

Excavations for the foundations of the mighty structure were begun in March 1625. Its proposed scale was truly monumental and quite unprecedented. A useful summary of Bernini's contribution to the process of modelling and casting the columns was given in a *Memorandum* of 1627: 'He made the design and small model for the said columns. He also made the big models.' The only trace of these preparations is a large pen drawing for the right-hand front column, lovingly delineating the twisting trails of laurel, the Barberini bees and playful putti.[2] The extremely naturalistic laurel twigs entwining the columns recall those of the marble *Apollo and Daphne* that was being finished at that very moment with the help of Finelli.

The small model probably consisted of a wooden shaft, turned on a lathe, to which the trails of laurel were added in wax. The spirals run in opposite directions on the two pairs of columns and so *two* big models were required from which to make the casts in wax, prior to pouring the bronze. These may also have been constructed round wooden carcases, like barrels, with the swellings, flutings and ornamentation added in stucco. Probably on the advice of Pietro Tacca – the court sculptor in Florence, skilled in fine-art casting on a grand scale, who visited Rome in 1625 – Bernini decided to make the columns out of three sections of hollow bronze, on account of their sheer size, the volume of metal needed and the weight of the finished products. These were then slotted one above the other and centred on a vertical iron armature bedded into the foundations. Round this was poured mortar filling the cavity from bottom to top, thus solidifying the whole assemblage to take the great weight of the projected superstructure. The models must have been made in similar sections and were paid for on 8 June 1625.

Bernini's personal part in the complex technical procedure of making these gigantic casts by the lost wax process has been analysed by Dr Montagu on the basis of the *Memorandum*, which states:[3]

that he had made the designs and the small and large models, that he had made the plaster moulds and cast the wax, that he had cleaned the wax casts and fitted them together to cast the metal, that he had attached the tubes for the metal to enter and the air to escape, that he had worked with the foreman to cover the wax in its final mould, to bind the moulds with metal, heat out the wax, bury the moulds in the ground for greater strength, melt the metal, and cast the twenty pieces. In sum, he had himself worked with his hands on the casting of the

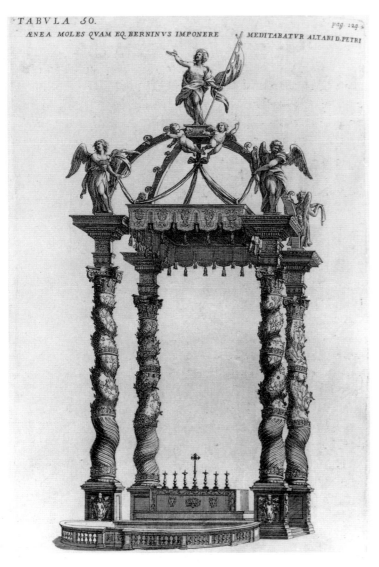

109. Bernini's first design for the Baldacchino, with the statue of the Risen Christ on top.

110. Detail of one of the twisted columns, showing the trails of laurel cast from real leaves.

columns for three years, and there was a considerable difference between working in his own house, and going to St Peter's through the hot sun and the pouring rain, even at night-time, and working at the furnace at great risk to his life.

Individual specialist foundrymen, or small teams, were also employed on each set of castings, under Bernini's close supervision. The five bronze components for each column, including the base and the capital, had all been cast by September 1626 and were installed over a period of five months in the summer of 1627. They were unveiled on 1 September, just three years after Bernini had submitted his first scale model of a single column. This had been a tremendous feat of engineering as well as one of sheer artistry. It had brought Bernini into direct contact with the other major medium of classical and Renaissance sculpture, cast bronze. And it had revealed his potential as an impresario, organizing manifold tasks and leading a diverse team of artists and skilled craftsmen by setting them the example of his own unflinching efforts. When his adrenalin was flowing, nothing could stand in his way: 'Leave me alone, I am in love with my work', he used to say to those who for his own good tried to make him desist, or to proceed more conventionally.

Once the columns were erected, the more tricky question of design emerged: what was to crown the edifice? The reverse of a medal struck to commemorate Urban's official dedication of St Peter's in 1626 bears on its reverse a miniature rendering of the first solution that was proposed; these indications are corroborated by a later engraving. On the intersection of four semicircular cross-ribs springing from the tops of the columns, where they were anchored by statues of angels, there was to stand a colossal statue of the Risen Christ. From four fictive ribbons suspended between

III, II2. (*Top*) the Dove inside the canopy of the Baldacchino. (*Above*) Bernini's first rough sketch of the solution eventually adopted for the top of the Baldacchino (Biblioteca Vaticana).

the intersection of the angels' hands, a quadrangular canopy was to hang by loops. This was apparently to be independent of the capitals crowning the columns. A full-size model of this affair was constructed out of wood and papier mâché (for the sake of lightness, cheapness and speed) and gilded to resemble gilt bronze. This was offered up *in situ*, remaining there until June 1631, when it was replaced by a similar model of a radically changed scheme, which – following Urban's approval on 28 June (SS Peter's and Paul's day) – was to prove definitive.

The changes had been wrought only by degrees, with the help of many sketches for alternatives, in collaboration with Francesco Borromini, a man who was to become a famous professional architect of the Baroque era and ultimately a rival of Bernini. Between them, they confronted the

mechanical problems caused by the weight and the sideways thrust of the superstructure and gradually resolved them with great artistry. They also had to bear in mind the necessity of leaving sight-lines clear around and through the whole structure in order to leave the chancel visible, and this seems to have been the purpose of a drawing of one half vertically of the Baldacchino made by Borromini.[4] A bitter sacrifice for Bernini, as sculptor, must have been his crowning statue of the Risen Christ, for its dead weight when cast in bronze and resting only on the ribs would have pushed the columns dangerously outwards. This sacrifice may have been no bad thing, for the figure, high above one's head, would have been very foreshortened and therefore difficult to appreciate.

Furthermore, an ornamental rather than a figurative finial was perhaps more in keeping with the supporting structure, with its architectonic, rather than narrative, character. So Bernini had recourse to the standard form of finial for church domes, indeed one that crowned the great dome of St Peter's, a symbolic globe surmounted by the Cross of Christ. A variety of possible mountings flooded into his imagination, some rather like the crow's nest of a contemporary ship, and several involving a large Barberini coat of arms, and putti with palms. All of these look rather congested in comparison with the solution that Bernini set down in a few deft strokes of his pen that probably took no more than a couple of minutes. Here he took the plunge of doing away with virtually all the figurative and heraldic ornament beneath the globe that had cluttered the previous designs. Instead he allowed the flowing lines of the ribs, which took the form of the S-shaped volutes that we see today, to lead organically up to the globe and allowed their geometric shapes to create a bold silhouette against the lighter surroundings of the marble architecture and the golden ornament of the coffered barrel-vault. In the event the mounting of the globe is quadrangular, with concave sides, echoing those of the fictive canopy below, and is decorated by four great bees symbolizing the Barberini facing inward and upward to the emblems of Christ's power.

The four angels at the corners, which survived from the first scheme, give physical weight at the springing of the ribs and provide variety and animation, as do pairs of cherubim innocently sporting at the centre of each side with the weighty symbols of St Peter's keys and the sword of St Paul's martyrdom as well as the pope's triple tiara. The models for the angels of the earlier scheme, having been prepared for casting in winter 1628, were easy to rework. They were eventually cast by September 1632, along with the architraves, frieze and cornice, in a frenzy of activity in the foundry, and the superstructure was immediately installed.

The four great ribs were constructed in such a way as to deceive the onlooker into thinking that they were also massively cast in bronze. In fact they consist of three thinner

113. Four of Bernini's possible solutions to the problem of the top of the Baldacchino (Graphische Sammlung Albertina, Vienna).

curving wooden ribs each, the deeper central one being supported by a firm metal bar inside, all dressed with sheets of patinated copper. These are embossed with architectural mouldings and sprigs of laurel to harmonize with similar foliage running around the columns below. The lappets of the canopy bearing Barberini insignia are also deceptive; made of wood and repoussé sheets of copper, their metal tassels hang from loops, like the real thing. The whole affair smacks of the stage scenery and machinery which we know that Bernini loved to design most ingeniously for his many theatrical productions. It also resembles the constructions of elaborate catafalques in temporary materials which were a common feature of contemporary state funerals. Indeed, just at this time, in 1630, Bernini was working on one for Carlo

Barberini; indeed it was the recipient of his frustrated idea for the Risen Christ flying above the Baldacchino, inasmuch as it was crowned with a similar figure, though a skeletal one instead.

As has been mentioned, the young Borromini probably worked out the mechanics and practicalities of the Baldacchino, while Bernini concentrated on the sculptural components and supervision of the whole tremendous and intricate undertaking, forever trying to meet deadlines imposed by the rhythm of the great feast days of the Church, in order to oblige his eager patron and friend, Pope Urban. Work was finished by 1633. When asked later what system of proportion he had used when relating the scale of the Baldacchino to that of the Basilica, Bernini tersely replied, 'My eye.'

By way of giving variety – a quality much sought after at the time – to this sonorous masterpiece in bronze, Bernini seems to have exploited the possibility offered by the lost wax

114. Panel with the Barberini papal coat of arms on one of the pedestals of the Baldacchino.

115, 116. One of Bernini's jokes: a rosary and crucifix hang carelessly over the base of one of the columns. It is a tradition that goes back to the foundrymen, for instance the Lucenti family who cast both the base and a massive mortar (*below*) with a relief of a lizard, leaf of herb and a medal on it (Victoria and Albert Museum, London).

process of bronze casting of accurately reproducing from nature. It is thought that the trails of laurel which cling to the curving surface may once have been *real* ones, carefully applied to the full-scale wax model, with the help of some size or gesso to stiffen and support their projecting leaves. The real plant would then have been burned out with the heat of the furnace used to melt the wax out of the plaster moulds. Bees – symbolic of the Barberini – wander freely across the surface, as though they had just alighted in search of honey, while the occasional fly or lizard also appears, as if trapped by accident in the casting.

Yet more amusing, though scarcely visible to the naked eye now that the surface of the bronze has become so darkened by deposits of candle soot, are details such as the rosary that seems accidentally to have been left by some passing cleric on the square base of one of the columns: some of its beads are silhouetted, while the terminal crucifix and some devotional medallions hang down over the edge. This is Bernini the humorist, daring with tongue in cheek – surely only with the tacit approval of Maffeo Barberini – to indulge himself as the endearing author of comedies for the stage, droll caricatures and witty but risky retorts to patrons. Even so, casting on extraneous, previously man-made ornaments such as medals, or natural phenomena such as leaves of herbs or lizards was a common practice in Renaissance and Baroque foundries. They enliven many a workaday utensil, for instance a massive mortar cast by a foundryman of the same family that helped to cast one of the columns, the Lucenti.[5]

Further unexpected touches of variety and humour are to be found at eye-level in the elaborate cartouches surrounding the eight huge Barberini coats of arms carved in marble on the outer faces of the pedestals of the columns: beneath the papal crossed keys a human head pops out, while below the shield hangs a hideous mask, seemingly an integral part of the flayed hide from which the strapwork has been fashioned. Every one of the masks and heads is differently characterized, though most of the latter have open mouths as though crying out, and their features are contorted into a frown: it is thought that they may be meant to tell a story.[6]

Bernini was honest enough, though perhaps with a suspicion of false modesty, to admit that this great feat of engineering and artistic design turned out to be a success 'by good luck' (as well as by good management, which we can follow from the myriad documents recording every stage). It has been noted that a tenth of the income from the Papal States – 200,000 scudi – had been spent over nine years on the Baldacchino, while Bernini received personally 10,000 scudi, as well as world fame, for his services.

The crossing, the reliquary balconies and St Longinus

Scarcely were the columns of the new Baldacchino in place than the authorities of St Peter's decided to surround it with monumental altars connected with four celebrated relics in the niches on the canted inner faces of the piers that support the dome: by May 1628 a design by Bernini for the south-eastern pier was approved. A sculptor at heart, he persuaded them to relegate the altars to the crypt below and in their stead to have colossal statues of the four saints with whom the relics were connected occupying the whole height of enlarged niches .[7] Enormous images of the relics were to be sculpted in relief above, behind balconies from which the real relics could be shown on major feast days. It was decided to put his ideas to the test by placing full-size models in stucco of the four statues in the cavernous niches.

Baldinucci gives the background to this major commission:

At the instigation of Urban VIII, Bernini adorned, after his own designs, the four great niches in the piers which carry the great dome of St Peter's. These niches are below the relics. Earlier, an iron grating covered the space from top to bottom. These niches, then, were the admirable receptacles for four colossi of marble made by four highly individual artists. Longinus is from the chisel of Bernini; St Andrew is the work of Francesco [Duquesnoy]; St Helena was carved by Andrea Bolgi; and Veronica is the beautiful work of Francesco Mochi.

The enormity of the commission, which involved figures over fourteen feet high, persuaded the authorities to divide the responsibility between Bernini, who doubtless would have liked to have kept it all to himself, and the other well-qualified sculptors mentioned here.

Bernini's design for *St Longinus* was accepted in May 1628 and by July 1631 he had produced a full-scale stucco model (*modello in grande*) that was inspected and approved by Pope Urban in February 1632. Contrary to traditional Italian sculptural practice and professional pride, but in view of the problem presented by quarrying and transporting from Carrara blocks of the size needed, it was determined to make each statue from more than one block of marble. *St Longinus* needed four pieces, which were manoeuvred into position in Bernini's studio in mid-1635. Carving them required three whole years before Urban could be brought to see the statue completed in May 1638. This campaign was probably the principal interruption to the carving of the relief, *Feed My Sheep*.

On his visit to Rome in 1629–35, the German artist and art historian Joachim von Sandrart recalled being shown no fewer than twenty-two *bozzetti* for the *St Longinus*, an indication of Bernini's almost obsessive habit, instilled into him in his childhood by his father, of 'competing with himself' by

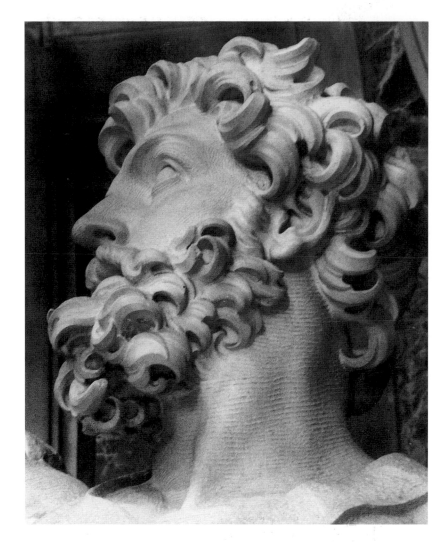

117. The head of *St Longinus*, detail of the statue in the crossing of St Peter's.

making serial variations for a single composition .[8] Sandrart described them as being in wax, and while he may have been right, the only two models to survive are in terracotta; this seems to have been Bernini's preferred medium. These *bozzetti* must have preceded the erection of the full-size stucco that ensued in 1631. The composition already established in a preliminary sketch in pen and ink remained in the smaller, earlier *bozzetto* and survived into the final design; it is dramatically articulated by the tilted right angle formed by the saint's outstretched right leg and sharply extended right arm and the contrasting angles and movements of this right angle are emphasized by the strongly linear pattern of drapery folds.

The introduction of the lance (only implied in the model) into the final statue helps to complete an exercise in triangulation by forming one side while the arms form another; the third side may be visualized by connecting the point at the lower end of the lance beside the saint's extended toe, through his left knee, to the palm of his extended left hand. This geometrical, but unstably arranged, form is boldly

118, 119

118, 119. The only surviving models of the twenty-two made by Bernini in preparation for *St Longinus* (Fogg Museum of Art, Cambridge, Mass. and Museo di Roma).

120. *St Longinus* (St Peter's, Rome).

at variance with the vertical axis established by the heel of the weight-bearing leg and the tendons of the saint's neck, and thereby helps to set up the emotional abandon in Longinus' gesture of mingled amazement, regret and recognition as he belatedly realizes that he, a Roman centurion, has just crucified the Son of God. This is corroborated by the way in which the head is thrown back and the eyes roll upwards, an image of supreme despair or pathos derived from Hellenistic sculpture, of which the best known example in Rome was the head of *Laocoön*. The surface of the marble was deliberately left unfinished, in order to absorb rather than to reflect light. The parallel grooves of the claw-chisel are left visible in order to animate the planes of the surface by emphasizing its various directions, as though they were the hatchings on a drawing.

It is interesting to note in the larger surviving *bozzetto* and in the marble version that Bernini has changed the earlier, strictly geometric and classical pattern of folds in the cloak

worked out in pen drawings and confirmed in the *bozzetto* into a less logical, deeply excavated and mobile pattern, with many a sinuous doubling-back of ridges and edges. This is to emphasize both the centurion's inner turmoil and express the realities of the biblical account of the Crucifixion, when the skies went dark, there was a terrible storm and the curtain of Solomon's Temple was rent asunder. The generous gesture of acceptance of a new faith expressed in the centurion's wide-flung arms has caused further commotion to the cloak, imparting a hither and thither rippling movement that is yet another weapon in Bernini's armoury of expressiveness.

Above the statue of *St Longinus*, angels display his lance. 121 Their whiteness is contrasted with the polychromy of the varicoloured sheets of marble against which they are set. Bernini retained the concave plan of the round-headed niches – echoing those below – and made it an excuse for an intriguing exercise in three-dimensional curves in his new architecture, for he crowned the columns with segmental pediments, the upper edges of which are 'broken'. Below, the doorway to the spiral stairway inside the pier was also round-headed and closed by a magnificent door of pierced and gilt metalwork.

Elaborate detail, in keeping with the ornamental vines twining round the columns, covers most of the surrounding flat surfaces, while gilding of the background sets off the angels supporting the sculpted relics and the putti flying

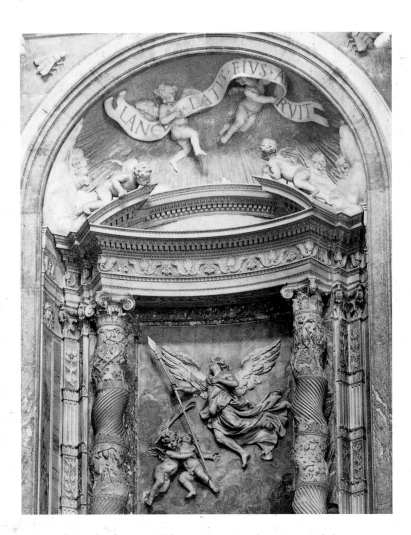

121. Above the four over-life-size statues in the corners of the crossing are reliquary loggias, with reliefs illustrating the relic contained in them – here the spear of St Longinus carried aloft by putti and an angel.

122. The inscription identifying St Longinus.

above with fluttering ribbons bearing relevant quotations in Latin. The gold and polychromy differentiates these reliquary balconies from the austere grey-veined marble of the colossal order of pilasters which flanks them. The carving of the reliefs of angels displaying relics and the modelling in stucco of the putti with ribbons above were delegated to a number of assistants under Bernini's supervision between 1633 and 1640.

Decoration of the nave and side chapels

The side-altars of St Peter's each had to be furnished with a matching set of crucifix and candlesticks on identical stands. This project was put in hand under Alexander VII in 1657 and, accordingly, his Chigi emblem of mounds and a star appears as prominently on them as the bees of the Barberini had done on Urban VIII's commissions.[9] A neatly drawn and carefully shaded drawing from Bernini's workshop (probably worked up from a quick sketch by the master) constituted the blueprint for the stands.[10] From this a master-model was carved in wood, to permit the moulding in wax and casting in bronze by G. M. Giorgetti of twenty-five sets of seven pieces each. The crosses were distinguished by curious shield-shaped terminals with voluted borders to render them visible against the varied backdrops of polychrome marble, or the lower edges of mosaics or paintings.

The earlier model of the crucified figure showed Christ dead, with head sunken and eyes closed: eighteen casts remain in St Peter's, while one has passed through the art market.[11] Because of the pressure of competing major projects, Bernini's contribution can have been no more than a sketch, for documents inform us that it was his trusted associate, Ercole Ferrata, who actually made the wax model. The bronze figures were then cast in series by Paolo Carnieri and chased by Bartolommeo Cennini. The design of the crucified Christ is close to one featuring in Bernini's almost contemporary statue, *St Jerome*. The subdued expression of suffering in the face and the slight *contrapposto* of the body, together with the languid flow of the knotted loincloth away from the Saviour's hips, contribute to a serene and attractive image, appropriate for contemplation. The figure is deliberately designed for optimal viewing from about thirty degrees below the horizontal by worshippers kneeling before the altar, as a comparison of photographs taken from those positions shows. Even though the results would never be seen under normal conditions, the back of the Saviour too was modelled with mastery and love.[12]

So huge was the task of embellishing the bare architecture of Carlo Maderno's recently built nave that it lasted over several successive papacies, with each pontiff keen to set his own stamp on the great basilica, usually through the agency of Bernini. He became increasingly expert at managing this continuous programme of work alongside a variety of other personal commissions, though he naturally paid greater personal attention to the latter. A young English student of sculpture, Nicholas Stone the Younger, on a visit in 1639 marvelled over it all and noted (with somewhat uncertain spelling):

all the pillasters cloath'd with white marble fluted, the little pillosters

123, 124. Candlestick and crucifix designed
by Bernini for the side-altars of St Peter's.

or pedestalls under the impost of the arches wrost and inlay'd with divers coulours of marble. All the altars besydes the Maggior are made in one manner, each having 2 large collomes antique taken from Therma Dioclesiano [Baths of Diocletian], being in number 44; and to conclude absolutely it is the most marvelouse fabrike and best composed that is in the world of modern times.[13]

It fell to Innocent X to prosecute work on the nave and side chapels, the crossing having been completed shortly before his election in 1644. He was critical of Urban VIII's vast expenditure of ecclesiastical resources and, partly on this account, took against one of its principal beneficiaries, whose grandiose projects – supremely impressive though they were – Innocent felt had seduced his successor beyond what was fitting. Bernini also suffered a severe eclipse of his previously buoyant reputation over the threatened collapse and

consequent demolition of one of the towers that he had begun to build over Maderno's foundation and lower storeys at either end of the façade of St Peter's. As Nicholas Stone noted: 'the upper part of the campanile or steple of St Peeters att Rome taken downe. In the same month the Cauellyer Bernine sicke to death and [at] once dead as itt was reported.' Bernini had apparently ordered a survey of the existing structure, which was indeed prone to subsidence owing to underground streams, and it had seemed satisfactory; clearly he felt that he had covered himself professionally. Nonetheless, this setback was eagerly exaggerated into a major scandal by numerous disaffected parties, some of whom had once worked for him and felt aggrieved at his tendency to arrogate to himself all the credit for achievements which owed much to their collaboration.

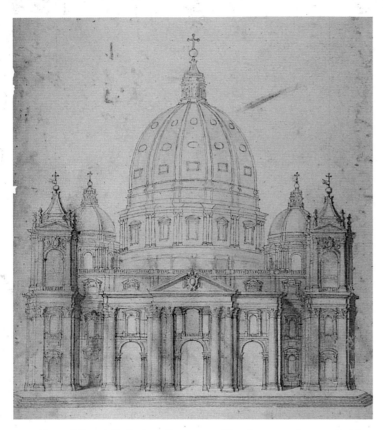

125. One of Bernini's designs for campanili to be erected on each side of the façade of St Peter's, 1645 (Biblioteca Vaticana).
126. The nave of St Peter's. Bernini had overall control of the decoration.

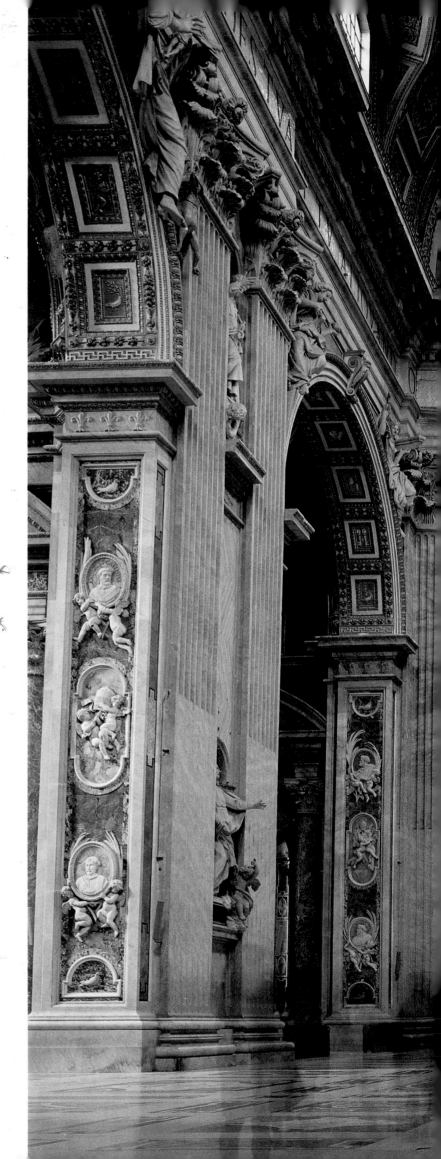

The architect Borromini was one of these, and he delighted in exposing Bernini's shortcomings and arrogance in front of the new pope, who preferred him anyway.

Despite this fiasco, Bernini retained the post of Architect to St Peter's until his death and therefore continued to bear responsibility for designing and supervising the decoration of the interior ordained by the authorities in 1645: they took the wise precaution of having full-scale painted models of two alternative schemes made before a final decision was taken. Bernini provided for a lavish cladding of flat surfaces with polychrome sheets of marble encrusted with figurative panels set in ornamental frames, which are indeed eye-catching: the spandrels above the arches were decorated with reclining allegories of the Christian Virtues, modelled on a huge scale in stucco. The work was prosecuted by an army of nearly forty masons and sculptors in as short a time as two years, 1647–8. Virtually every available sculptor was pressed into service to push the project through to completion, and it suffered from a corresponding lack of consistency and brilliance in the sculpted elements. Long series of rather repetitious figures of angels, putti and papal portraits were produced with so little actual involvement by Bernini himself that, interesting though they may be for the study of his collaborators and followers, they need not detain us.

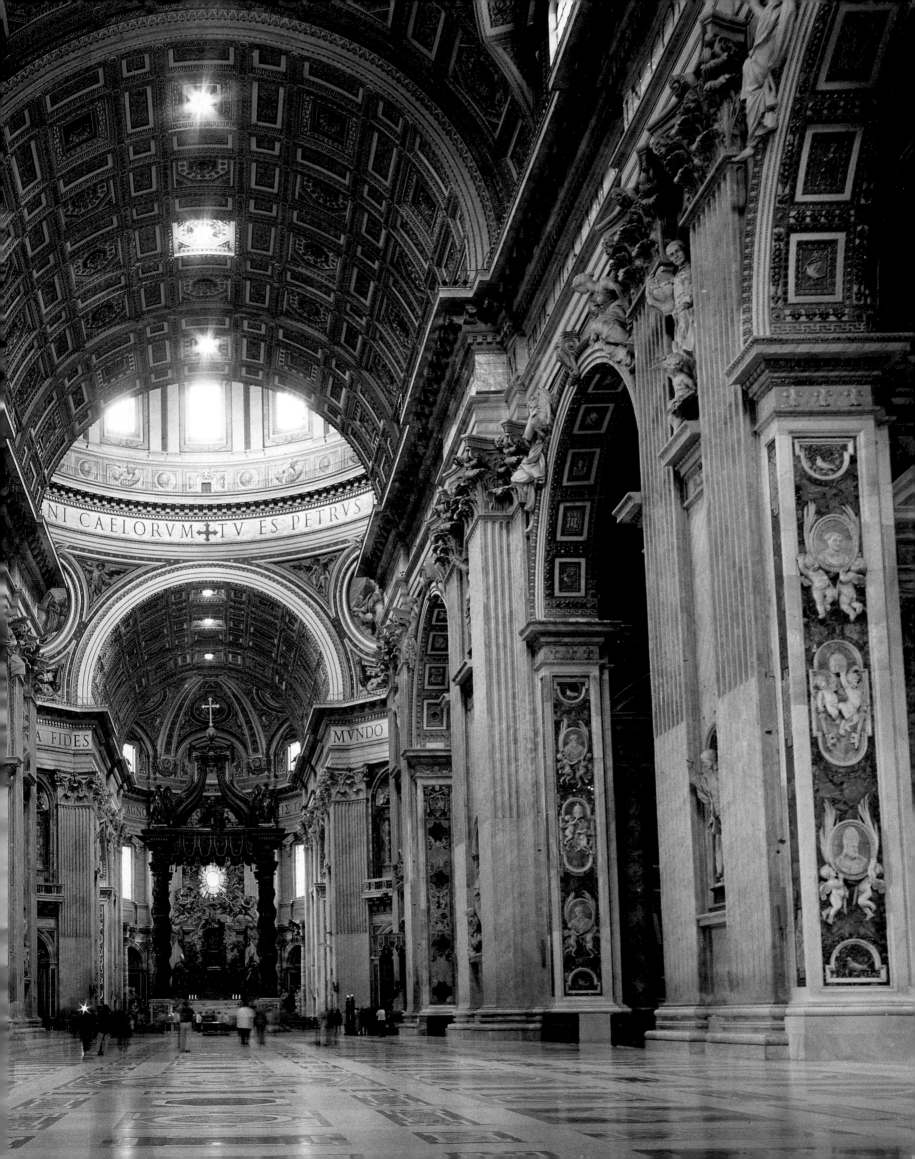

127, 128. The ninth-century Carolingian *Cathedra Petri* and Bernini's first, wooden, container for it (Fabbrica di San Pietro).

129, 130. The sixteenth-century tabernacle in the Chapel of Sixtus V in Santa Maria Maggiore, Rome; and the *Cathedra Petri* (inside Bernini's container), as it was initially displayed in the Baptistery of St Peter's.

131, 132. Bernini's first (Royal Collection, Windsor Castle) and second schemes for relocating the *Cathedra Petri* in the main apse of St Peter's.

The Cathedra Petri and the Gloria[14]

The most crucial commission for the interior of St Peter's of Bernini's whole career came in the pontificate of Alexander VII, an admirer of the sculptor. In 1630, under Urban VIII, the Congregation of St Peter's had commissioned him to design a new altar in the baptistery to house their most venerated relic, believed to be the throne used by St Peter as first Bishop of Rome, the *Cathedra Petri*: this was in fact a ninth-century Carolingian wooden throne clad with narrative plaques of ivory.[15] It embodied (in the idea of the empty seat at a feast) the unseen presence and rule of God; symbolized the apostolic succession (the handing down of spiritual authority from pope to pope, their elections being presided over by the Holy Spirit); the primacy of Peter among the twelve disciples and, finally, the primacy of the Church of Rome.

Bernini drew upon these powerful associations when inventing a fitting container for the throne, a sort of large reliquary, to be placed initially in the baptistery and later behind the high altar of the basilica. In 1630, he designed a hollow wooden simulacrum of a throne, with double doors in its front like a cupboard, to permit access on feast days to the venerated chair within. This still survives in the storerooms and is sumptuously decorated with cherubim masks, scrolls and – inevitably in view of the reigning pope – the Barberini bees.[16]

This container was then hoisted aloft in the baptistery in front of a backdrop formed by a relief of clouds sculpted in marble, while a bronze dove of the Holy Spirit hovered above in a blaze of glory, with spiky gilt bronze rays of light, bursting the clouds asunder. The throne was flanked by a pair of marble angels clutching the papal insignia of tiara to the left and keys to the right. An arched window above supplied light, but the reliquary throne over the altar can only have been dimly illuminated by reflected light or candles.[17]

A decade later it was determined to move the throne to a more prominent and traditional position in the main apse. There it was to be centred in a niche and flanked by a magnificent pair of columns in pinkish *cottanello* marble: these survive *in situ*. By March 1657, Bernini had dreamed up a splendid *mise-en-scène* recorded in a drawing from his workshop:[18] this would have supplied a central, focal panel in an open triptych, for it was to be flanked by arches filled with the sculptural tombs of Paul III by Della Porta on the left, and Urban VIII by Bernini on the right.[19] The thrones of those popes would have been on a level with that of St Peter. The *cottanello* columns with their lofty concave entablatures would have marked out the archway, while the animated figure of an archangel, appearing in a burst of light from above and brandishing the papal insignia, was to have

occupied a position over the keystone of the arch. This was also a symbolic reference, similar to the placing of the papal coat of arms over the Tomb of Urban VIII.

In order to fill the niche, assimilate the round back of the container to its shell shape and make the relic more eye-catching for the congregation from afar, the whole structure was raised seemingly in mid-air by two huge statues of the Fathers of the Church, whose hands visibly support its lower plinth: their gilded mitres catch the light at various angles, punctuating the dark interior of the niche, while their copes are blown upwards dramatically by the celestial wind of the apparition above. They stand on high rectangular plinths to either side of the altar below. A similar arrangement and imagery survive to this day, though the Fathers of the Church are much enlarged and now number four, while, for the sake of variety, two are bare-headed, not mitred.

The dove featured as a relief on the back of the throne and was to be flanked by a pair of flying angels bearing the palms of St Peter's and St Paul's martyrdoms, so as to form an ogival arch above. A scrolling design on the altar frontal echoed that to be found on the lower doors of the reliquary.

The idea of a precious relic in a special container being held up to the view of the faithful by angels was normal in Gothic precious metalwork, but Bernini's scheme was unique, not only in its superhuman scale, but also in the identity of the supporters. The nearest precedent in scale and material (bronze) was a sacramental tabernacle of the 1580s in the chapel of Sixtus V in Santa Maria Maggiore, where a Renaissance *tempietto* rests on the shoulders of angel-caryatids, above and behind an altar. A scale model in wood and stucco was prepared, for which four Fathers of the Church were supplied by Ferrata, Raggi and Morelli. Then in the following year, 1658, presumably as a result of intervening confabulations over the visual effect and the sacred iconography, Bernini devised a second scheme: the central grouping was retained but expanded sideways to fill the whole space between the flanking columns instead of being confined within the niche. The Fathers of the Church support the throne less ostensibly by four voluted brackets in this scheme, as they do today. But the principal change is above, for the dove has flown off the back of the throne container (where the relief Feed My Sheep is substituted) and instead hovers within the aureole of rays, replacing the archangel, as in the earlier arrangement in the baptistery.

Meanwhile, a pair of angels kneeling in adoration have alighted on top of the flanking columns and are accompanied by cherubim, one clinging precariously to the entablature.

133. Second and third of three sketches by Bernini showing the *Cathedra Petri* through the Baldacchino (Biblioteca Vaticana).

134. Terracotta model for the *Cathedra Petri* showing the reliefs of Feed My Sheep and the Miraculous Draught of Fishes (Detroit Institute of Arts).

135, 136, 137. Three details from the *Cathedra Petri* and the Gloria: an angel, one of the Fathers of the Church, and the back of the throne showing the relief *Feed My Sheep*.

138. The whole ensemble of the *Cathedra Petri* and the Gloria around the Dove in the west window of St Peter's surrounded by putti, angels and rays of divine light.

The papal insignia are distributed evenly around the back of the throne: the two keys are held out symmetrically to either side by flying cherubim, who with their inner hands support the tiara centrally above. These six angelic worshippers begin to form a distinct segment of a circle below the dove, and it is this component that would ultimately be transmuted by a leap of imagination into the Gloria, the rendering in bronze and stucco of the heavenly host that now encompasses the oval west window of the basilica around the dove in stained glass.

The design recorded in the engraving was evidently an important stage, probably regarded as definitive at the time. Owing to its complexity and to the critical nature of its location it was determined to construct a full-scale model *in situ*. The same subordinate sculptors as before were employed and the wooden structure was supplied by a carpenter. This took about two years and, in the making, further alterations seem to have suggested themselves: Bernini was never one to let things just take their course. Indeed at this point he made a *modellino* of the throne that survives in Detroit. This may be surmised from the existence of two almost life-size models of angels in ephemeral materials that Bernini designed next for the front legs of the throne on a *modello in grande*. They are less relaxed and statuesque in pose than what remains of the angels on the *modellino*.[20] Instead of the angels' wings curving down along the arms of the throne, they hang vertically, so that their upper joints would have protruded beyond its silhouette. They are gentle creatures with truly benign expressions, leaning in a relaxed *contrapposto* against the legs of the throne, which they entirely obscure. Even so, they were still two stages away from the final angels. Several other large

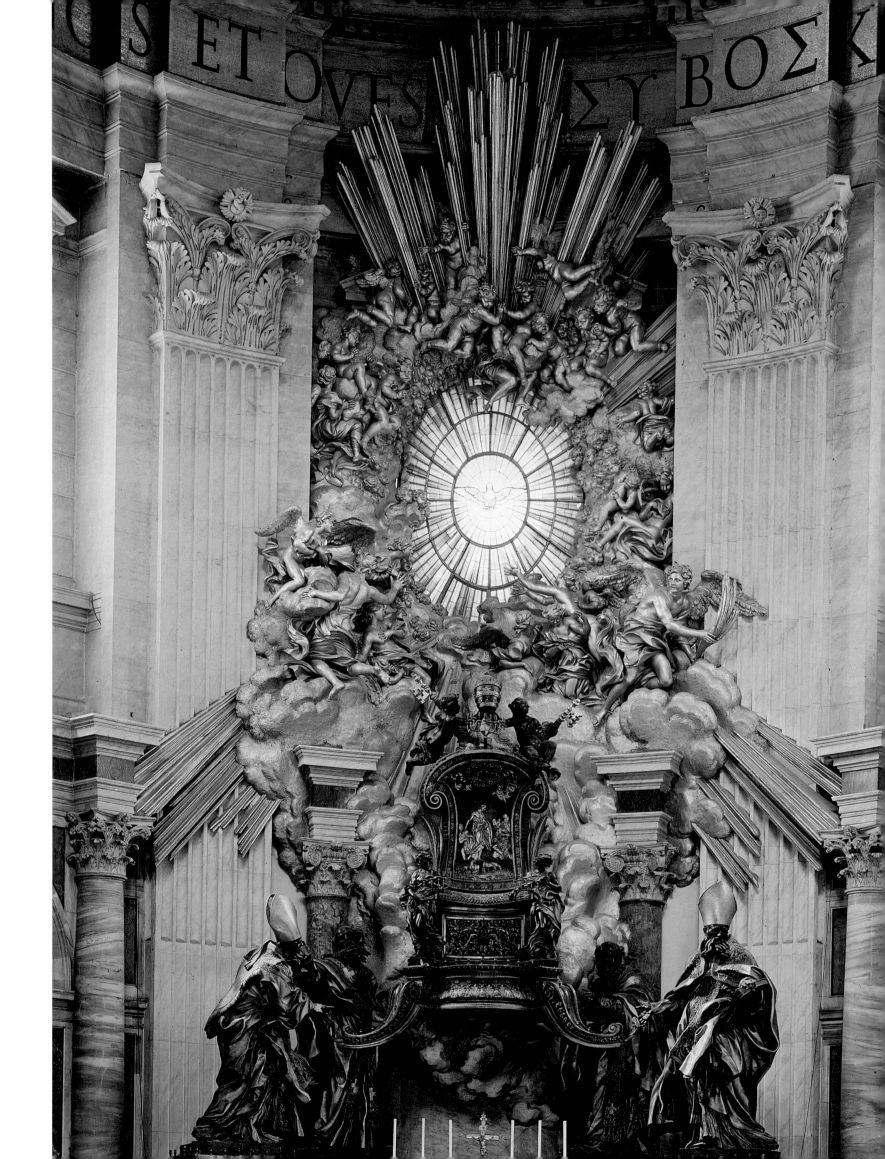

139. Alternative full-scale models for one of the angels flanking the *Cathedra Petri* (Pinacoteca Vaticana).

angels were cast in bronze by Giovanni Artusi in 1660–1, but they were finally incorporated piecemeal among those in the Gloria.

134 The two-foot-high *modellino* in terracotta virtually embodies the final design. An increase in size of the new *Cathedra Petri* when compared with the pre-existing wooden and bronze containers allowed it to be much more elaborate. In the *modellino*, instead of a semicircular back, it has one with voluted 'ears' to either side, with counter-curves in three dimensions below them, running into the arms and echoed by those of the martyrs' palms that rest on them. The front legs, as provided for in the previous design, were formed as angels, but as taller, single ones, rather than the outward-facing pair apparent in the engraving. Yet they are still endowed with their own wings. In the throne as executed, these are melded away visually into the palm fronds behind.

The relief on the back is beautifully delineated as 'Feed My Sheep' and closely echoes – no doubt deliberately – the

great marble narrative panel over the portal of the church, 84 with which it is in line axially at the opposite end of the nave. This subject survived into the final design, though the relief 137 lower down on the *modellino*, the Miraculous Draught of Fishes, with its curvaceous sinking fishing boat (reminiscent of Bernini's *Barcaccia* fountain) was deleted in favour of an openwork grille, behind which the actual throne of St Peter could notionally be seen.[21] The model also has a feature evolved from the single cherub's head below the throne shown in the engraving: a pair of cherubim holding a cockle-shell centrally, perhaps as a symbol of the goal of pilgrims. This too was eventually deleted before the final design, probably being considered too fussy. Whereas the shell was here set into a concave platform following the line of the front of the throne, in the final arrangement this became a convex edge, thrusting forward and, being seen from below, echoing the curvature of the top of the back of the throne, while forming a counter-curve with the voluted brackets below.

Three very faint and schematic sketches in chalk, still preserved in the Vatican, probably date from this critical 133 period, when the big model of the ensemble was going up, and indicate Bernini's interest in the view from the centre of the nave, the crucial importance of which Carracci had pointed out years earlier. This would be framed by the twisted columns of the Baldacchino and the lappets of its canopy. In the first sketch, a general view with a concave altar below was envisaged; in the next, the height of the throne seems to be in question, with a change rapidly drawn in by an arched line, while the Fathers of the Church are only roughly entered as ovoid heads on straight lines for bodies. The final sketch is still rapidly drawn, but with greater emphasis on the crucial elements of throne and supporters, and with chiaroscuro effects blocked in by cross-hatching. The concept of the Gloria behind seems to appear in faint oval outlines above, interrupted by the canopy, which is indicated by a horizontal zigzag and some shallow curves running crosswise.

Bernini's succeeding ideas are embodied in a carefully scaled drawing of the oval window with radiating rays above and cherubim, mostly in pairs, dancing for joy in mid-air, some even in front of the window. On the verso is a sketch for the Holy Dove in an aureole of rays, for the centre of the window. The cherubim were eventually banished to the periphery, but all the angelic throng crowd in to such an extent that the oval architectural frame is masked by clouds and punctuated by gesticulating arms or stray legs. Several further sheets in soft chalk or pen, similar to some others for the poses and play of drapery of the Fathers of the Church, survive to show the successive ideas that flooded into Bernini's fertile imagination, once this astounding idea had been conceived. The Gloria would be especially strongly illuminated by the rays of the setting sun, as though by a

heavenly burst of light, the high altar of St Peter's being at the west end.

The crucial decision to incorporate into the altar-tableau the window high above, that had been ignored hitherto, necessitated a radical and final enlargement of the whole affair: it was now to be measured against Michelangelo's order of colossal pilasters that runs right round the basilica, instead of against the lower order of engaged columns and the new pair in *cottanello* marble. The throne is raised right up between their capitals while the physical rays of the Gloria explode downwards to either side, abutting the adjacent capitals beyond. The capitals are in turn adjacent to the twin papal tombs. Indeed, the rays point directly towards the enthroned bronze popes. The upper echelon of rays spurt almost vertically upwards, so as to interrupt dramatically the great inscription running round the apse on its band of gold mosaic. The isosceles triangle formed by the tableau below is centred on the Holy Dove, while the dark lines of the supporting ribs between the stained glass radiate vigorously outwards in a series of diagonals that are picked up by the composition of the surrounding cherubim and seraphim dispersed among the banks of cloud.

At the end of this lengthy process of trial and error that resulted in continuous improvement, all the figurative elements had to be substantially enlarged to accommodate the heightening of the whole scheme. Four very impressive models for the heads of the Fathers of the Church survive.[22] Just over one yard high, they impress upon one the truly colossal size of the bronze statues; these are in scale with the lofty interior of the apse and do not seem particularly large in context. The heads and the full-length Fathers of the Church from which they remain were modelled largely by Bernini himself, for Raggi and Ferrata were collaborating less from that year onwards. Therefore the verve with which their massive craniums, rolling eyes and flowing beards are worked is that of the master himself. The last item, redesigned as late as 1665 on the eve of Bernini's departure for Paris and when the stucco of the Gloria was almost complete, was the pair of angels to flank the throne, which replaced the earlier pair and measured half as much again in height, some seven and a half feet, instead of only five.[23]

The casting of the Fathers of the Church took place, with some difficulty in view of their sheer size, between 1661 and 1663, and that of the throne container ensued in the summer of 1663. Cleaning and gilding lasted until the end of 1665, when a skilled designer, G. P. Schor, furnished the delicate floral ornamentation for the underside of its platform. Bernini also had to oversee the design and chasing of the prominent relief on the throne's back, as well as those concealed on its sides.[24]

While Bernini was away for six months in Paris in 1665,

140. Sketch by Bernini showing the treatment of the oval window surrounded by cherubim (Royal Collection, Windsor Castle).

the stucco figures of the Gloria were modelled *in situ*, by Raggi (1664) and Morelli (1663–6), from a high scaffold, with various subordinates to help them on this physically enormous task. The focal image of the Holy Spirit, added last after the messy work on the stuccoes had been finished, was painted on the glass by G. P. Schor. The real throne of St Peter was installed on 16 January 1666 and the whole was triumphantly unveiled the following day. The total expenditure had been an enormous sum of over 106,000 scudi, of which the foundryman Artusi received 25,000 and Bernini himself a considerable 8,000.

The combination of sculpture and architecture, picked out in gilding and coloured marble, and bathed in real light – itself tinted golden by the stained glass in the window – was the summation of Bernini's lifelong quest for the 'total work of art' (*Gesamtkunstwerk*, to use the evocative German word). From it is derived what Professor Wittkower aptly summarized as 'a sublime dynamic intensity'. This was arguably the supreme achievement of Bernini's career.

141. Terracotta *bozzetto* for an angel in an early scheme for the ciborium opposite (Fogg Museum of Art, Cambridge, Mass.).

142. Ciborium in the Chapel of the Blessed Sacrament in St Peter's.

The Altar of the Blessed Sacrament

Bernini's last contribution to the adornment of the interior of St Peter's was not on the main axis, but in a chapel off the right aisle. It was a focal one nonetheless, for in it was reserved the consecrated host of the Blessed Sacrament.[25] Over forty years earlier, Urban VIII had directed his sculptor-architect's attention to a project for a monstrance beneath the Baldacchino, but this was abandoned in favour of one for a ciborium in the side chapel. Initially, the project was not carried out, though in 1633 Pietro da Cortona did provide a painted altarpiece showing the Trinity adored by tumbling angels, against which Bernini's final production was designed to be displayed. Further plans, considered under Alexander VII, were also postponed, perhaps owing to overwork and Bernini's visit to Paris. Finally, Clement X revived the long-drawn-out project in 1672 and saw it through to completion by Christmas Eve 1674, inaugurating it during a Jubilee year, 1675. Extensive documentation indicates in fascinating detail every stage of manufacture and the names of all the skilled artisans involved. An extra lantern opening was even made in the dome to provide Bernini with lighting for his altar. He was paid 3,000 scudi.

An early sketch for one of the successive schemes, almost scribbled on a piece of paper with a fine pen, shows four large angels kneeling above an altar and looking reverently up to the host in a gleaming transparent monstrance lit by candles, the spreading foot of which they all support with their hands.[26] Much nearer to the finished product – and therefore presumably dating from the second or the last phase – is a superb drawing for presentation to a pope; in view of a possible lapse of time it lacks a specific papal escutcheon.[27]

The concept of the four large angelic supporters was retained, but the design of the altar below and their

143

144

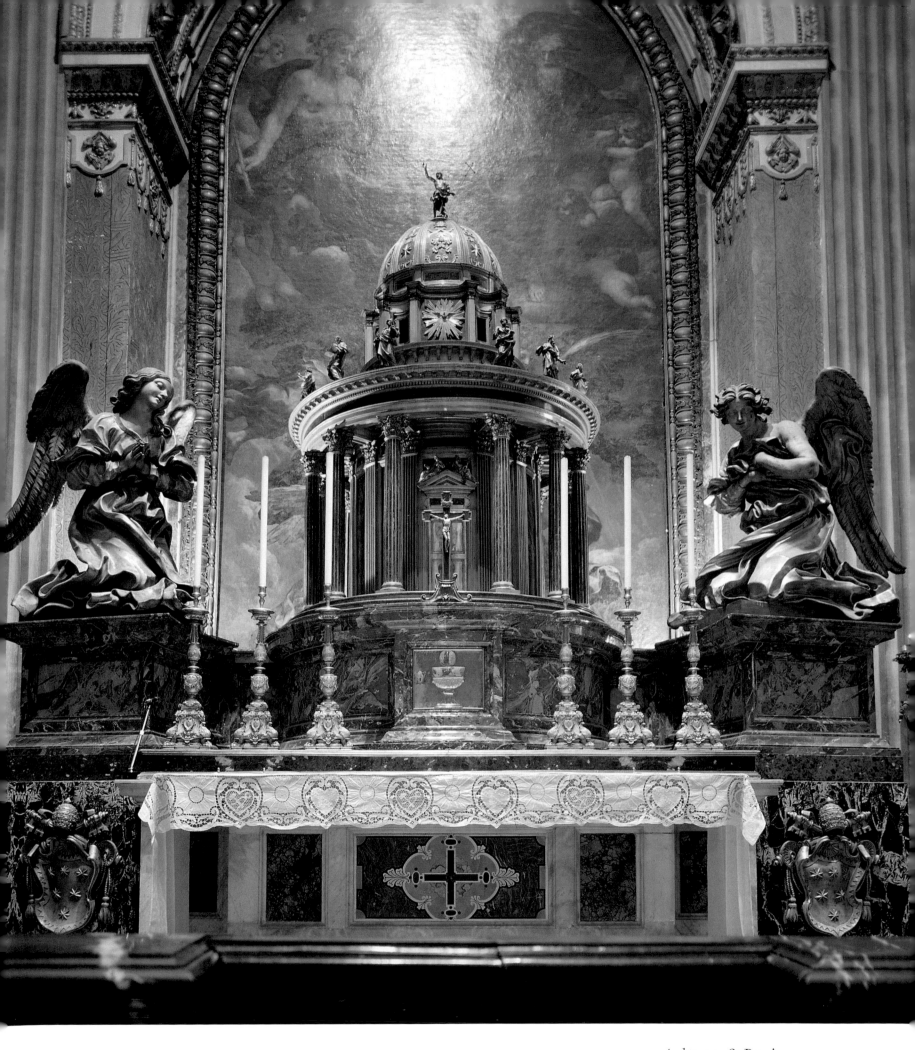

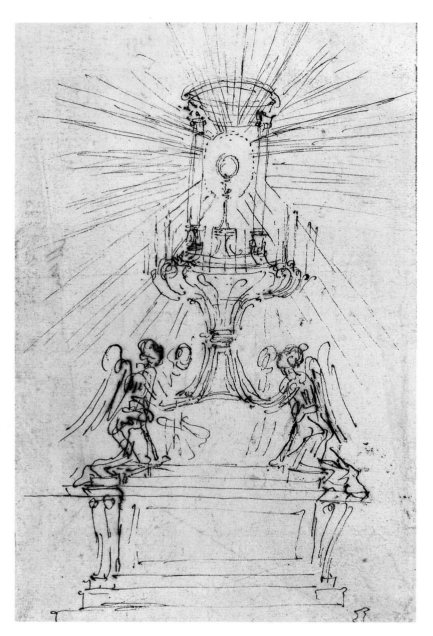

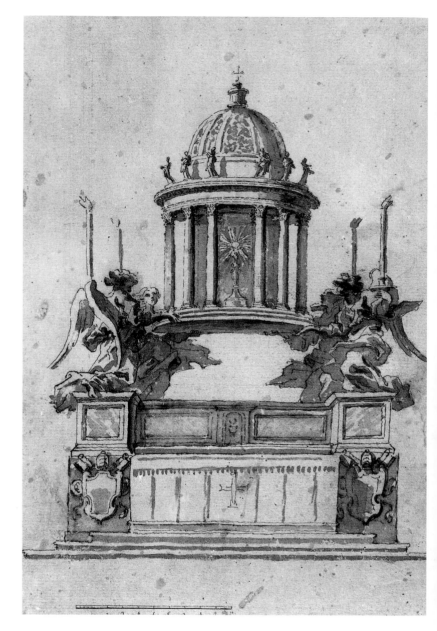

143. An early pen sketch possibly connected with the Altar of the Blessed Sacrament: four angels look up at a transparent monstrance (Museum der bildenden Künste, Leipzig).

144. Later scaled drawing showing the altar and ciborium closer to their final forms (State Hermitage, St Petersburg).

projecting plinths distinctly recalls the penultimate design for the *Cathedra Petri*. Their wildly windswept robes and hair also recall the angels that had once been designed to kneel on top of the flanking columns of the high altar of the basilica, as indeed do the two that he finally executed. As in the case of the Fathers of the Church round the *Cathedra Petri*, the angels now seem able to steady with only one hand the weight of the superstructure, as though it were suspended miraculously in mid-air, while in the other they hold up a candle. But the principal novelty in this drawing is the cylindrical *tempietto* that they hold aloft. Indeed the composition is derived, more directly than in the case of the *Cathedra Petri*, from the Sacramental Tabernacle of the 1580s in Santa Maria

Maggiore. The centrally planned edifice was indebted furthermore to Bramante's Renaissance *tempietto* at San Pietro in Montorio, as well as to a sober little hemispherical tabernacle with a domed roof in Santa Croce in Gerusalemme. Designed in 1536 by Bernini's Renaissance predecessor as sculptor-architect, Jacopo Sansovino, this is also flanked by kneeling angels bearing candles.[28] Both had of course been inspired by the idea of the centrally planned Church of the Holy Sepulchre in Jerusalem itself.

A wooden model was produced over the winter of 1672–3 and the architectural components of the *tempietto* were cast by December 1674, using Hungarian copper: the best. Plaques of lapis lazuli from Naples were then inlaid into its columns and over the surface of its walls and dome. Together with the gilding, the lapis lazuli made it sumptuous to behold, and analogous with the more usual and smaller reliquaries in precious metal and *pietra dura*.

In the presentation drawing, as in the finished work, the Twelve Disciples, 'pillars of the Church', stand above the

colonnade while the top is crowned by a cross. In this respect there was a curious exchange of ideas with the Baldacchino, which was ultimately surmounted by a globe and cross: in the final version of the tabernacle the cross was replaced by a bronze statuette of the Risen Christ, similar to the large figure intended (and perhaps even cast) to crown the Baldacchino, but ultimately abandoned.[29] The design in the drawing looks satisfactory – indeed brilliant – enough, and yet the restless eye and imagination of the master were not satisfied. In a series of chalk drawings,[30] he gradually abandoned the idea of the kneeling angels supporting or even illuminating the splendid *tempietto*, concentrating instead on their adoration of the host reserved within. Several of the sequence of sketches show the angels kneeling low, but they are either adjacent to, or still holding, vertical strokes indicating candlesticks. However, in a series of characteristically vivacious and tactile models in the Fogg Museum of Art these residual ideas have disappeared and the angels simply kneel in adoration.[31]

By moving the flanking bronze angels sideways and lowering the *tempietto* to the surface behind the altar, Bernini finally contrived that it would impinge on only the lower zone of Cortona's *Trinity* that hangs directly behind. Indeed, some of the large painted angels in the picture seem to flutter about the *tempietto* too.

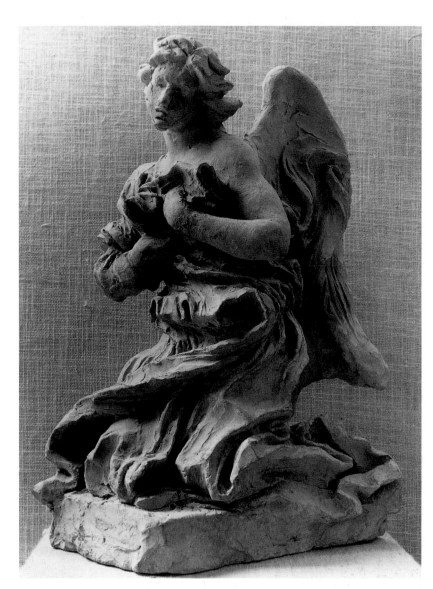

146. Terracotta *bozzetto* of the angel on the right of the Altar of the Blessed Sacrament (Fogg Museum of Art, Cambridge, Mass.).

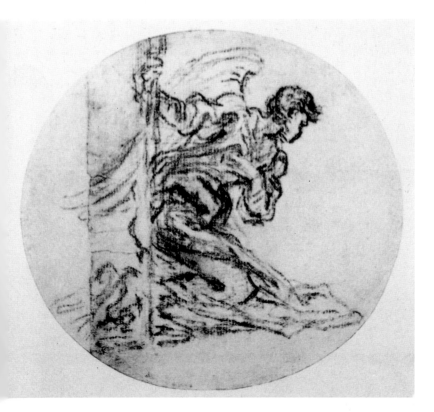

145. Sketch in chalk for one of the kneeling angels for the Altar of the Blessed Sacrament (Royal Collection, Windsor Castle).

Even the circularity of the *tempietto* acts as a spiritual and psychological bridge, reflecting the fundamental belief in the Eucharist and, through participation in it, the efficacy of Christ's sacrifices in the salvation of the individual. His words at the Last Supper, repeated at every Mass, and the references to his death and resurrection in the Creed are made visible in the tomb structure and the statuette triumphantly crowning it, while the eternal Trinity hovers symbolically over the whole, in the illusionistic heavenly space of Cortona's picture. As we have seen, the fusion of the tangible and the spiritual is Bernini's great achievement.

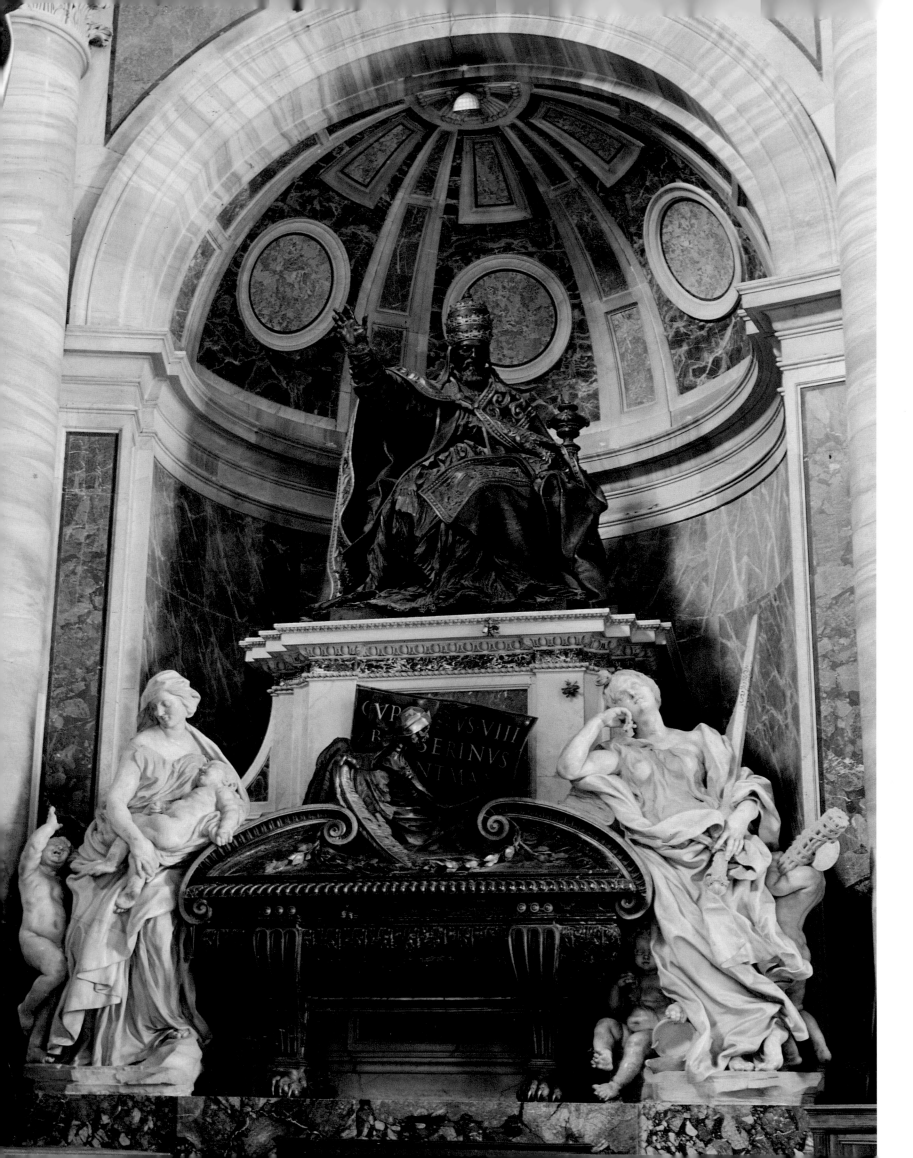

7 * The papal tombs: Bernini and the Dance of Death

So living has Bernini made great Urban,
His spirit so impressed into hard bronze,
That to restore belief here Death herself
Stands on the sepulchre to prove him dead
Cardinal Rapaccioli, 1647

DEATH was omnipresent in the Europe of Bernini, with extensive wars, fatal epidemic disease widespread and medical science still primitive. Indeed in 1657 he personally designed a reverse for a papal medal — ascribed to the intervention of the patron saint, Peter — to celebrate Rome's recovery from a severe plague. But that very awareness of death led to positive steps to cope with its terrors and to 'die well'. This has been mentioned in connection with the rationale that links the busts carved for Cardinal Montoya: his portrait and those of the *Damned Soul* and the *Blessed Soul*. Every well-to-do family throughout Europe aspired to bury its dead with due ceremony and to commemorate them with a tomb, be it a simple inscribed slab or an elaborate monument with architectural pretensions, set in a family chapel in the parish church or cathedral.[1]

The Tomb of Urban VIII

Pope Urban VIII had reigned for four years and reached the age of sixty when, in 1627, he first approached his favourite sculptor to design a splendid tomb to vie with those of his predecessors.[2] To complete it, alongside all the competing projects for the basilica and elsewhere, took a good twenty years and it was not unveiled until 1647, three years after Urban's death. Baldinucci gives an accurate and enthusiastic description that conveys the authentic flavour of the period and voices the typical concerns and reactions of a contemporary:

But what shall we say of that great miracle of art, the grand tomb of Urban VIII that Bernini made in marble and bronze for St Peter's. This monument, truly, has in it qualities so original that if anyone came to Rome solely to see it, he could be sure of expending well his time, effort, and his expense. It stands in an immense niche on the left of the great chapel of the *Cathedra Petri*. Between two columns of smooth marble an oblong base rises from the floor . . . in three registers. Above it stands the tomb's great sarcophagus, richly ornamented. Above the sarcophagus rises a great plinth which supports the large bronze statue of Urban VIII, enthroned, and in the

act of benediction. He is so realistically described that nothing more could be desired. On the right Justice is represented, with two infants beside her, one and one-half times life-size in the finest, whitest marble. Leaning against the sarcophagus, she raises her eyes to the figure of the pontiff, and seems immersed in the most profound sorrow. Charity is on the left. She has a suckling infant at her breast and another larger child beside her who looks upward, unrestrainedly grieving at the loss of that great father, while Charity looks at him with compassion. She seems to be giving testimony of her own sorrow by expressing her grief at the child's tears. Over the great sarcophagus in the very centre of the composition, we see the figure of Death. She is at once shameful and proud. Her back is winged and turned away from us; her head is partially veiled and covered, with the face turned inward. The large book in her hand is poetically imagined to be the one used by Death to register the names of the popes cut down by her scythe. She appears in the act of writing in letters of gold the words: URBANUS.VIII BARBERINUS PONT.MAX. On that tiny section of the preceding page that Bernini's skilful artistry makes visible, we see written in letters of gold a part of the name of Gregory, Urban's predecessor. Truly a completely magnificent concept, the tomb was the admiration of all.

Bernini faced the task of matching an earlier tomb in plain and coloured marble with a bronze seated effigy that had just been displaced by a scheme of 1627 to clear the four niches of the crossing of St Peter's.[3] This was the remnant of Guglielmo della Porta's originally more ambitious and free-standing monument to Pope Paul III Farnese.[4] It had once all but rivalled the tomb that Michelangelo had designed for Julius II and it proved almost as ill-fated, though, unlike Michelangelo's project, it at least remained in the basilica, and in a prominent position. It was erected in part and then moved almost literally from pillar to post in the building, which was still under construction, until around 1585. Then it lost its status as an independent structure and came to rest in a niche in the south-eastern pier of the crossing.

Urban had initially earmarked the niche at the end of the right transept for his own tomb, where now stands that of Alexander VII, while in the niche to the left of the high altar was the pope's ceremonial throne as Bishop of Rome. The niche to the right of the altar was, however, available as a

147. The Tomb of Pope Urban VIII (St Peter's, Rome).

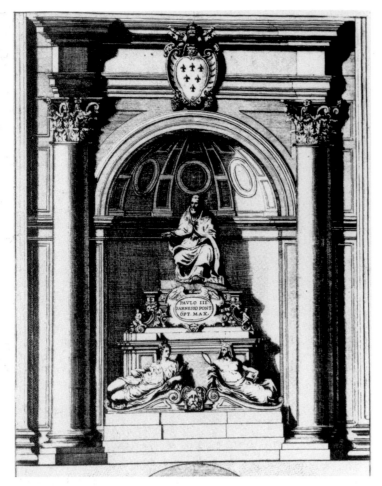

148. Guglielmo della Porta's Tomb of Pope Paul III in St Peter's, Rome, engraving.

include a sarcophagus and chose a design based on those by Michelangelo in the Medici Chapel of San Lorenzo, Florence, with segmental broken pediments. These he adapted visually to the S-shaped volutes on which Della Porta's surviving allegories of Justice and Prudence recline, by creating concavities in the outstretched wings of a skeletal figure of death, whose skull and forearms are to be seen in the central space, emerging from the sarcophagus. Meanwhile, Bernini's activated allegories stand and lean on either end. The central location and character of this skull also matched a long-missing feature on Della Porta's Tomb of Paul III, a monstrous mask in coloured marble symbolizing death.

The masonry and cladding of the twin niches with richly variegated marble ensued forthwith, between 1628–31, with

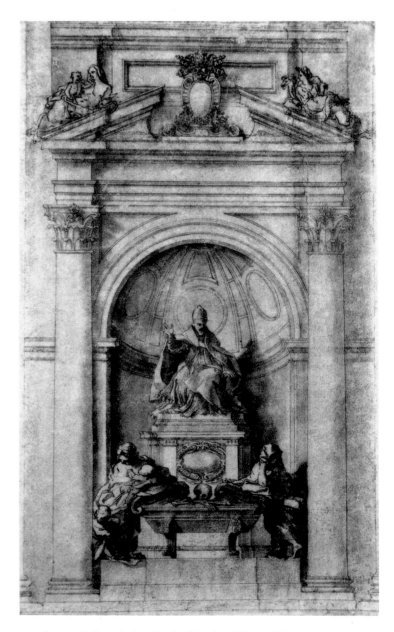

149. Bernini's first design for the Tomb of Pope Urban VIII (Royal Collection, Windsor Castle).

suitable space for Paul III's tomb. However, around the turn of the year 1627–8, the idea occurred to patron or sculptor to make them into a matching pair flanking the altar, and so the throne was moved away. Finally, by January 1629, the positions of the two tombs were switched, probably for the practical reason that Della Porta's Pope Paul gestures and glances down to his right and in the new position these actions would be towards the congregation rather than the high altar. Bernini made his statue of Urban face down the chancel towards the congregation too, and thus also towards the Baldacchino, the greatest joint contribution to the interior of St Peter's by pope and sculptor.

Bernini's earliest design provides for a triangular arrangement of three figures, in order to match visually that of Della Porta's design.[5] A pair of recumbent marble allegories of Peace and Abundance – like those which had previously been removed from the ground level of Paul's free-standing tomb for reasons of diminished space and had subsequently been set over its pediment – reappear on Bernini's design for the broken pediment of Urban's tomb.[6] This demonstrates the intimate connection envisaged between the two tombs. Even the oval shape of the cartouche for the epitaph is the same. Bernini however wished to

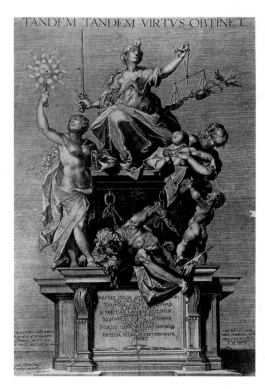

TANDEM TANDEM VIRTVS OBTINET

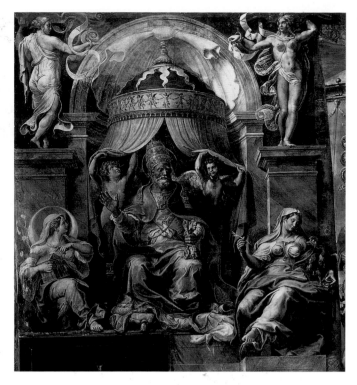

150, 151. Two works which probably influenced Bernini in his design for the Tomb of Urban VIII: a late Mannerist engraving, *The Triumph of Justice*, and a Renaissance fresco by Giulio Romano, *St Peter Enthroned*, in the Stanze of the Vatican.

the young Borromini taking part, while marble for the sarcophagus and allegories was acquired through the good offices of Pietro Bernini, at least until his death in 1629. Gianlorenzo must have made preparatory models for the crucial figure of the pope very rapidly, for by December 1628 the large model for casting was in preparation and by April 1631 the bronze had been cast. This burst of activity was then interrupted by external factors for eight years, until 1639.

Bernini chose to revitalize the deliberately pacific demeanour and gesture of Della Porta's statue of Paul III (which Michelangelo had likened to that of a judge settling a dispute), by raising Urban's right hand high in a triumphant gesture of benediction, 'Urbi et Orbi'. The essence of this conception, with its strong diagonals, survived from the drawing into the statue as executed. Such an image was perfectly traditional, especially for statues cast in bronze, for the tensile strength of bronze permitted the radical extension of the right arm. Indeed, as long ago as 1498, Antonio Pollaiuolo had employed it for his monument in St Peter's to Pope Innocent VIII, where a similar, though less accentuated, diagonal (from spectator's upper left to lower right) was set up by the different levels of the hands.[7] There had ensued several intervening honorific statues of popes in bronze elsewhere: Michelangelo's statue of Julius II for San Petronio, Bologna, cast in 1508 but destroyed soon afterwards;[8] Bandinelli's design for the marble effigy on the tomb of Pope Clement VII in Santa Maria Maggiore;[9] Vincenzo Danti's statue of Pope Julius III in Perugia of 1555;[10] Alessandro Menganti's on the balcony of the Palazzo Pubblico, Bologna, of 1575–8, and most recently Paolo Sanquirico's competent but weaker bronze statue of Pope Paul V in Santa Maria Maggiore.[11]

Of all these precedents, it was Danti who (possibly following Michelangelo's lost statue of Julius II) invented the continuous downward diagonal line of the cope pulling to either side of the clasp and the return of its lower embroidered border across the pope's knees. Menganti, who obviously knew Danti's statue in nearby Perugia, separated the legs and engineered the diagonal, curving fall over his pope's left leg of the corner of the cope, caught up under the left hand. This is exactly the device that Bernini hit upon, combining zigzagging angles in Urban's cope with the smoothly sinuous curves of the edge and broken folds. However, his final statue has a grandiloquent breadth that surpasses any of these prototypes, for Urban's right arm reaches outwards boldly across the niche, with the elbow hardly bent, while the border of the cope picked out in gilding makes a nearly vertical line that closes the composition and effectively separates the silhouette of the figure from the obscurity of the niche behind. The raised hand is counterbalanced visually on the opposite side by the richly turned finial of the papal throne, decorated, inevitably, with the bees of the Barberini. The finished statue was seen, probably on an otherwise bare pedestal in the tomb niche, and noted briefly by John Evelyn in his diary in November 1644 as 'stately'.[12]

Once Bernini had established the principal statue, he could turn to the rest of his dramatis personae, for the scheme is intensely animated by grief, unlike the austere remnant of the Tomb of Paul III. A possible stimulus to his imagination may have been a superb late Mannerist engraving by Lucas Kilian after Joseph Heinz, *The Triumph of Justice*, where the architectural ensemble and frenzied activity of the allegories indeed resemble those of Urban's tomb, while the

152

153

The papal tombs 121

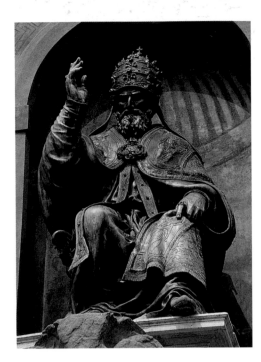

152, 153. Prototypes in bronze for the figure of Urban VIII: Vincenzo Danti's statue of Pope Julius III in Perugia, and Alessandro Menganti's of the same pope in Bologna.

154. (*opposite*) Bernini's second *bozzetto* for the figure of Charity on the Tomb of Urban VIII (Musei Vaticani).

putti at the right of both schemes are very similar.[13] However, a fresco painted by Giulio Romano in *c.* 1523 in the Stanze of the Vatican Palace, *St Peter Enthroned*, shows the saint in a fictive architectural niche between a pair of painted female allegories, The Church and Eternity, with sinuous folds of busy drapery linking them all visually. This provides a compelling prototype for Bernini's arrangement of his active allegories: the identification of all popes with St Peter would undoubtedly have appealed to Urban. Bernini's early presentation drawing of 1627 depicts a figure of Charity on the left, suckling a child lying in the crook of her elbow, which in turn rests comfortably on the pediment of the sarcophagus. Another weeps, half sitting at her feet, with its back apparently resting in the gap between the flanking pilaster and the column. This is the essence of the final composition, though the marble statue is more upright and slimmer.

While no further drawings survive, two gorgeously plump and tactile terracotta *bozzetti* show successive changes in the sculptor's thinking about the number of infants that should accompany the nubile Virtue. From a document of March 1630 we know that Bernini was undecided between two or three babies. The earlier model actually includes four and perhaps precedes even the drawing: the additional pair are embracing each other affectionately under what would have been the end of the sarcophagus, but they do cause something of a distraction, while the crying boy is quite differently posed from his more definitive successors.[14] Dr Olga Raggio has appositely remarked of the composition:

The still Mannerist double torsion of the figure; the complication of her clinging, windswept garments; and the sensitive modelling of the children recall Bernini's early admiration for the paintings of Guido Reni and suggest a very early date for this study.

The second model is almost, though not quite, definitive, as Dr Raggio again elucidates:

There are significant differences in detail: both Charity and the sleeping baby have more pointed features than the marble figures, and the crying infant clings to her more closely, pulling his arm across his tearful face rather than raising his arm toward her. Thus, the terracotta clearly must be understood as a nearly final *modello*, immediately preceding its execution in marble. The changes between this group and the earlier sketch show Bernini's progress from a still conventional, fragmented, and essentially Mannerist formula toward a strongly monumental composition. The windswept draperies of the first Charity have now become more ponderous, cradling the infant who has fallen asleep while feeding. By simplifying the pose, as well as the component elements of Charity, Bernini conveys the feeling of her all-embracing maternal nature: a powerfully controlled creation, she has been organically related to the overall architecture of the papal monument.

Although the marble blocks were supplied in 1631, it was not until 1634 that one of Bernini's trusted carvers roughed one out for Charity. This suggests that the second model may by then have been in existence; it certainly was by 1639, when carving began in earnest. The distinct change to the more rounded features of the marble Charity noted by Raggio may be due to Bernini's obsession after 1636 with Costanza Bonarelli, as has been suggested.[15] In his much later Tomb of Alexander VII, it is interesting to note the change to a simpler pose and movement in another figure of Charity that appears on the same side, where the rushing diagonals of the multiple, more or less parallel folds of her skirt intimate a still greater sense of turbulent activity.

In the case of the figure of Justice, at the opposite end of the sarcophagus, greater changes were wrought, but there is less evidence of how they came about. A tiny sketched outline

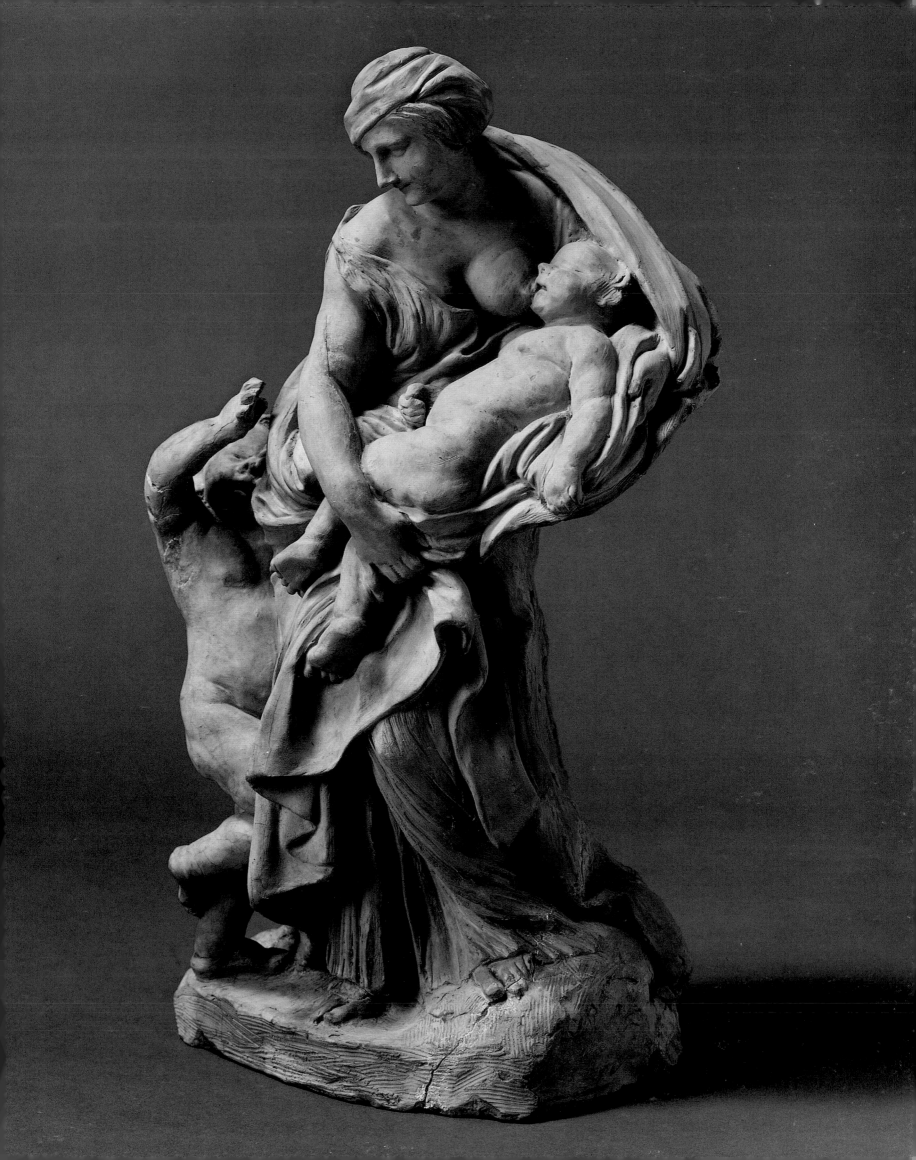

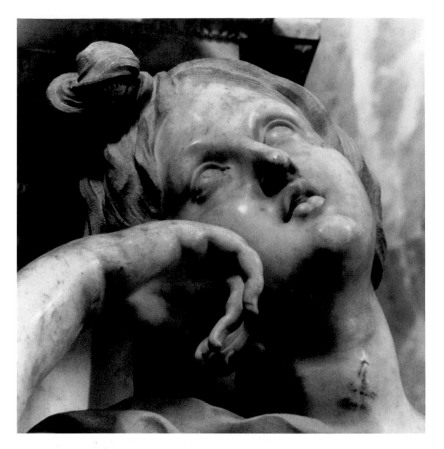

155. Detail from the Tomb of Urban VIII in St Peter's: the face of Justice.

156. Detail from the Tomb of Urban VIII, the child at the feet of Justice.

of a form leaning in the right direction may be Bernini's initial thought, but the position of the arms is not properly defined, and apparently it was not as shown on the presentation drawing.[16] There one sees a cowled, pensive figure resting its chin on the hand of a bent arm and stretching the other one along the curve of the pediment, while looking 'off-stage' to our right, perhaps in mournful abhorrence at the thought of the pope's decease. Though a strong composition, this seems not to have remained in favour. Instead, Bernini resorted to a virtually frontal and more casual, cross-legged pose for the marble version. Justice now rests her bent right arm on a fat law book that lies precariously on the segmental pediment, and gazes dreamily upwards with mouth open, her cheek lightly supported by her bent knuckles. In her left arm she cradles the hilt of her enormous symbolic sword, wisely protecting herself from its sharp blade by gathered folds of drapery. Its pommel is ornamented with Barberini bees. Right under the end of the sarcophagus, as though hiding in a cave, sits a bewitching little child gazing directly out at the beholder as it toys with one of the two pans of the scales of justice, the other components of which lie abandoned on the ground. To the far right, Bernini invented an amusing side show: a small boy struggles manfully to carry the *fasces*, an axe bound with sticks, the ancient Roman symbol of temporal power. Even so minor a figure was composed with concentration, as one can tell from a sheet with two emphatic studies in pen: neither was ultimately employed for, although the staggering pose is the same, the almost back-breaking load is held over the nearer and not the farther shoulder.

Finally — and most intriguingly — Bernini transformed the image of death, the mute skull, spread wings and crossed arm bones, into a hyperactive participant. This was a brilliant conceit characteristic of Bernini and of Baroque thinking in general. For now a winged skeleton, cowled probably with the abandoned shroud of the deceased, seems to rise out of the sarcophagus. Bernini may have been inspired by an engraving

157. Two sketches by Bernini for the boy carrying the *fasces* behind the figure of Justice on the Tomb of Urban VIII (Museum der bildenden Künste, Leipzig).

124 *The papal tombs*

158. The Tomb of Erard de la Marck, formerly in Liège Cathedral. Was this the inspiration for Bernini's skeleton rising from the Tomb of Urban VIII?

159, 160, 161. Three sketches by Bernini for alternative actions by the skeleton writing the epitaph of Pope Urban VIII (Museum der bildenden Künste, Leipzig).

showing a major tomb in northern Europe, begun in 1527 for Erard de la Marck, Prince-Bishop of Liège (1472–1538), in which the deceased is shown praying as he faces a skeletal figure of Death rising out of the sarcophagus and brandishing an hourglass. So delighted, and yet perhaps rather nervous, was the artist about his almost mischievous invention, that he studied its precise form of activity very carefully in four swiftly dashed off alternative sketches.[17] In one, the skeleton holds up with its left fingers a large, squarish and apparently firm tablet on which it writes with a pen at the right edge. The curve of its spine and summarily indicated wings are calligraphically disposed in counterpoint to the curves of the broken pediment from which it rises: they are all treated as flourishes of the quill. In the next variant, the skeleton is more upright and the surface on which it is writing curls along the horizontal axis, as though it were a huge scroll of parchment; there are many squiggles indicating lines of rapid script. In the sketch to the right of this, the scroll is transformed into a rectangular folio book with its wide pages covered in manuscript, and the skull seems to be turned so as to begin reading from the top left hand corner, while the right hand is at rest. The fourth variant is not dissimilar, but seems to revert to the idea of writing in such an open book, for the angle of its jaw is visible and the quill of the pen is accented strongly at lower right.

Bernini's solution was yet more subtle, but rather simpler and more monumental: the skeleton appears to be reading the Latin inscription with approbation and using a small bone as a stylus to dot the last full stop, to mark the end of Urban's reign. Death will then pin up the top sheet of a stack in the

162. Detail from the Tomb of Urban VIII: Death writing the epitaph.

rectangular space reserved for the epitaph: on it are inscribed in golden capitals Urban's name and supreme office. On the left side of the previous sheet can just be descried the initial letters of his predecessor's, Gregory's, name and, still further back, those of Clement VIII Aldobrandini, a pope whom Urban greatly admired. In the fourth of the sketches and more visibly on the tomb, death's right leg appears, radically folded back on itself, so that the foot sticks forward below the bent elbow, pressing against the heel of the blade of a scythe that is lying flat on the surface. Death rests back on large wings, which – like the scythe – have been appropriated from normal images of Father Time, the 'grim reaper'.

This imagery will be discussed later. A finishing touch was an enormous Barberini coat of arms over the keystone of the arch. This has a black veneered marble background against which hover two putti in white marble. The one on the right supports the shield of red marble with golden bees, while the other is carrying the crossed keys on his right shoulder, so that his head is concealed. Parcel gilt bronze swags of laurel

hang down to either side below, linking this with the convex curve of the arch. Last but not least, three bees dispersed from the Barberini hive, the family coat of arms, seem to be desperately seeking their resurrected master, Urban. As Baldinucci relates:

This stupendous work was . . . unveiled about thirty months after [Urban] went to Heaven, in the presence of Pope Innocent X, his successor. I do not wish to neglect reporting here a sharp response that Bernini made to a person of high rank, unfriendly to the house of Barberini, who was looking at the tomb with some other people. Through a certain whimsy Bernini had placed here and there over the tomb some bees, which allude to the Pope's coat of arms. That personage observed them and said, 'Signor Cavaliere, Your Lordship must have wished to show the dispersion of the Barberini family by the random placing of these bees' (for at that time members of the house were in retirement in France). Bernini replied, 'Your Lordship, however, knows well that dispersed bees congregate at the sound of a bell,' referring to the great bell of the Capitoline which sounds after the death of a pope.

Bernini and the Dance of Death

Thus ends all human pomp
Gianlorenzo Bernini, 25 September 1665[18]

Live properly in order to die properly
Bernini's will, November 1680

From the day of Bernini's marriage, and (as we now know) in penitence for the dire events that preceded it, Baldinucci reports:

he began to behave more like a cleric than a layman. So spiritual was his way of life that . . . he might often have been worthy of the admiration of the most perfect monastics. He always kept fixed in his mind an intense awareness of death. He often had long discussions on this subject with Father Marchesi, his nephew who was an Oratorian priest at the Chiesa Nuova, known for his goodness and learning. So great and continual was the fervour with which he longed for the happiness of that last step, that for the sole intention of attaining it, he frequented for forty years continuously the devotions conducted toward this end by the fathers of the Society of Jesus in Rome. There, also, he partook of the Holy Eucharist twice a week.

The devotions mentioned here are specified in the earlier biography by Domenico Bernini, as 'the devotion of the good death'[19] that took place every Friday at the Gesù. Domenico adds that people were quite amazed that so busy a man went to Mass every morning, visited the Holy Sacrament (wherever it was reserved) daily, and each evening recited the 'Crown of the Most Holy Virgin' and on his knees attended the official services of the Virgin and the seven penitentials, keeping up this habit until his dying day. By way of justification, Bernini used to say of death, sympathetically, 'This step was hard for every one, because it was new for them'; he pretended to be dying quite often, in order to try and assuage its terrors, and learn how to cope when it came for real.[20] In his will of 28 November 1680, he expounded this reasoning:

As death is the fearful point from which depends an Eternity either of good or of punishment, it behoves a person always to think of living properly in order to die properly. It is an unforgivable mistake to put off until the last moment of life the arrangement of one's earthly affairs, just when the soul ought to be with great fear preparing itself for the rendering of accounts before divine justice, from which there is no appeal.[21]

Treatises on the art of dying go back to the Middle Ages. In Renaissance Italy the subject had been famously treated by the Dominican friar Savonarola, whose sermon of 1497 was illustrated by a superb woodcut frontispiece of Death flying over a symbolic landscape strewn with corpses. In the Protestant north, Schongauer, Dürer and Holbein all

163. Woodcut illustrating a sermon by Savonarola, 1495. Death sits on the end of the bed but the dying man, the crucifix before him, sees a vision of the Virgin and Child.

produced series of engravings showing death coming for 'Everyman', depicted in a range of human activities and professions. Holbein's *Dance of Death* (1538) has forty plates where intensely animated skeletons intervene in a wide variety of scenes of high and low life.[22]

Parallel with such graphic works are sixteenth-century German wood carvings of horrendously realistic skeletal figures (*Tödlein*), with skin falling off them and sometimes worm-ridden as well, engaged in appropriate activities, such as holding up an hourglass. Engravings of the skeleton, often posed as though it were a live model, also appeared in anatomical treatises. One can be seen in Giovanni Stradano's *The Academy of Art* of 1587, which Bernini must have known. Indeed, it seems likely that skeletons were available in the bigger studios for the study of the anatomy and proportion of the human frame.

Major public spectacles in those days included the stately exequies of grandees, which involved elaborate funeral processions full of appropriate imagery on the hearse, and on the interior (and sometimes exterior) of the church, and the construction of a catafalque, or ceremonial canopy, for the bier during the lying-in-state and funeral. Obviously these had to be constructed within a few weeks of the death, to the designs of major court artists and with all available artistic hands mobilized. Ephemeral materials were used for the sake of speed and economy and because of the transitory nature of the work. Nevertheless, great artistry was involved and major painters and sculptors were employed; these were perfect occasions for the display of their talents and for the earning of a rapid reward.

While a simple skull, with or without crossbones, and occasionally winged, was the normal symbol of death, several of these funeral schemes in the later sixteenth and early seventeenth centuries involved reanimated skeletons of

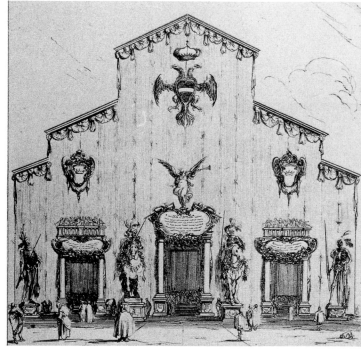

164, 165. The façade of San Lorenzo in Florence, decorated for two elaborate funerals: (*left*) for Queen Margaret of Spain, 1612 and (*right*) for the obsequies *in absentia* of the Emperor Ferdinand II, 1637.

life-size or over, engaged in various activities. Most 'skeletal' of all was the temporary façade invented for the Medicean church of San Lorenzo in Florence by Giulio Parigi, the court designer, for the funeral of Queen Margaret of Spain in 1612: this is recorded in a book of superb etchings, commissioned for publication by the Grand Duke Cosimo II himself.[23] Fifteen skeletons, all well over life-size, animated the upper storeys of the façade, probably showing up white against the sombre hangings: six are herm-caryatids with hands clasped in prayer, while the remainder gesticulate against the skyline or engage in two superposed central tableaux. Maffeo Barberini or the Florentine-trained Pietro Bernini may well have obtained a copy out of professional interest, so the fourteen-year-old Gianlorenzo, already performing miracles as a sculptor, may have leafed through the illustrations. For the funeral of young Francesco de' Medici in 1634, the nave of San Lorenzo was lined with great skeletons against each column, while a pair on horseback flanked the bier under the dome.[24]

Finally, in 1637, at the very moment when Bernini was about to return to the question of the winged skeleton for his Tomb of Urban VIII, there were erected in Florence another elaborate façade and an extensive catafalque for the obsequies *in absentia* of the Holy Roman Emperor Ferdinand II, a relation of the Medici. Inside the church of San Lorenzo the bier was flanked by four monumental statues of skeletons standing like sentries, while four smaller ones squatted above gesticulating excitedly, perhaps in grief, for they seem to look up to heaven. Over the main door stood a figure of Fame,

with wings and trumpet, above one of three great cartouches encircled by skeletons. The flanking pair leaned backwards and had wings, forming the outer curves of the design: could they have been direct prototypes for Bernini's similar sketches and ultimate figure in bronze? He may have known the etchings of Stefano della Bella. The designer of the façade itself was Alfonso Parigi, the son of Giulio.

In 1620, a skilful draughtsman in Rome, Filippo Napoletano (1585/90–1629), had sketched a number of ideas for frontispieces of printed books, often on themes of mortality, of which one in particular might have inspired Bernini, *Death Seated on a Stone*.[25] The skeleton is winged and seems to be uttering a hollow laugh as it brandishes a winged hourglass, symbolizing the ancient Roman adage 'Tempus fugit' ('Time flies'). Its intimate association with a block of stone (cracked to indicate how even the most seemingly durable materials eventually perish) and the way in which its arm and leg bones are aligned with the edges, and its bony hand hangs limply over them, are suggestively similar to the pose of the semi-concealed skeleton on Bernini's presentation drawing.

It was along these lines in *c.* 1640 that Bernini dreamed up two extraordinary memorials, both sponsored by Cardinal Francesco Barberini and executed by the workshop: one commemorates Ippolito Merenda, an ecclesiastic who had bequeathed a large sum for the rebuilding of the church that eventually housed his memorial, San Giacomo alla Lungarna; the other, in the church of San Lorenzo in Damaso, commemorates Alessandro Valtrini (d. 1633).[26] Both are *scherzi* on the theme of an animated skeleton and a white shroud or black pall bearing an inscription, all carved in relief. They are evolved from the skeleton holding up (and largely concealed by) the rectangular epitaph in the Barberini Chapel in

Sant'Andrea della Valle, designed by the Berninis, father and son, in *c.* 1615.

In the case of Merenda the skeleton flies directly against the mottled marble of the church wall, its lower foot overlapping the frame of a real window or door below, as though it had just flown into the church. Like a draper measuring a length of cloth, the skeleton catches the centre of the shroud in its teeth and stretches its arms outwards, though the cloth is not taut but wrinkled, and its edges have gathered by the grasp of the bony fingers. To heighten the realism the lines of neat Roman capitals in the inscription are not horizontal, but follow the rise and fall of the cloth, just as in the inscribed parchment of Urban VIII's tomb. In the Valtrini monument, the bleached skeleton flies in front of a pall carved out of black marble looped up against the wall:[27] this was how a church interior was draped for a funeral. It too has an inscription whose lines follow the drapery. The skeleton in this instance carries an oval portrait medallion of the deceased, while the pall is suspended from his shield of arms, surmounted by a Greek cross.

Bernini's fascination with death and the means of alleviating its terrors, found expression in other works involving skeletons, as well as imagery implying the inevitable passage of time. One of these was a long, rhomboidal relief modelled in terracotta to guide his French assistant Niccolò Sale when carving the frontals of a pair of sarcophagi for two of the Raimondi family in a chapel that Bernini had designed for them in San Pietro in Montorio. The relief's shape recalls that of Countess Matilda's tomb in St Peter's, and was probably carved about a decade later. The model represents the story of the Valley of the Dry Bones, from the Book of Ezekiel:[28] 'As I prophesied, there was a noise, and behold, a rattling; and the bones came together, bone to its bone. And as I looked there were sinews on them, and flesh had come upon them.' There follows a prophecy of the resurrection of the dead. Bernini and his assistant revelled in depicting the various stages of reanimation of bones into semblances of human beings, all to the sound of the Last Trump blown by an angel descending from above. They seem to have been inspired by a superb Mantuan engraving of 1554 showing the identical scene. It had been reissued commercially several times in Rome, most recently by Giovanni Giacomo de' Rossi, who operated between 1638 and 1691 near Santa Maria della Pace. His copper plate still survives in Rome.[29] It is therefore probable that Bernini and Sale were influenced by a print that was hot off the press, even though it was an image created some eighty years earlier. The correspondences are

166. Filippo Napoletano: *Death Seated on a Stone*, a likely source for Bernini's figure of Death (Musée des Beaux-Arts, Lille).

167. Bernini's Monument to Alessandro Valtrini (San Lorenzo in Damaso, Rome).

168, 169. Bernini's terracotta model (Sacristy, Santa Maria in Trastevere) for one of the Raimondi sarcophagi in San Pietro in Montorio, Rome: the Valley of Dry Bones, from Ezekiel. The design owes something to a Mantuan engraving of the same scene (*below*).

170. Detail from Bernini's decoration to the Chigi Chapel, Santa Maria del Popolo, Rome: Death carrying the Chigi arms to heaven, with inscription whose enlarged letters, MDCL, give the date 1650.

171. Bernini's design for a huge medallion in low relief: Death standing by a sarcophagus whose lid is open revealing the corpse inside (with Marcello Aldega and Margot Gordon, New York).

mostly general, but there is one that betrays the sculptors' debt: the male figure to the right of centre, raising the lid off a grave with his back to the viewer and his head turned to the left, is surely copied from the figure in the engraving who pulls another resurrected corpse into life by the arm.

Among other novel features in the Raimondi Chapel is one that seems to be borrowed from earlier French sculpture and so may have been suggested by Niccolò Sale: the lids of the two sarcophagi are held open by pairs of putti with torches, and effigies of the deceased are to be seen carved within, while half-length figures above portray them as still alive and in full action. The idea of kneeling portraits of the deceased in prayer (*priants*), combined with standard effigies of the deceased in their finery (*gisants*) and, below, with horrifying images of their corpses putrefying (*transis*) was typical of royal and other grand tombs in France. The ingredients of realism and horror evidently appealed to Bernini in his continual, obsessive search to make a new impression in every sculpture.

The macabre idea of a sarcophagus shown with its lid open and the corpse inside also features in a recently discovered drawing for a huge medallion to be executed in very low relief (*bassissimo rilievo*) and – amazingly – at life-size (*grande quanto il naturale*) according to Bernini's instructions penned rapidly below.[30] Its style is perhaps a little later, *c.* 1660, and it seems on the evidence of the inscription to have been destined for execution far afield, possibly in France.

The winged skeleton standing behind snuffs out the flame of life by blowing on a candle, while simultaneously preparing to drop the lid of the unusual, cylindrical sarcophagus with a resounding clang. Within, a churchman lies at peace, his coat of arms (surmounted by a prelatical hat with tassels) left blank on the near end, no doubt to be supplied by the recipient. Learned books are scattered on the ground below, while the bony foot of the skeleton may be descried projecting beneath the sarcophagus. The great roundel seems to have been intended to appear to hang by a loop – probably of bronze – from a pin on a dark wall surface.

The very first commission that Bernini received from Pope Alexander VII, within days of his election in 1665, was for a real coffin and a marble skull to put in the papal bedchamber, constantly to remind the pontiff of his mortality. The skull is probably identical to one resting on a cushion of black marble in the Chigi Palace at Ariccia. The coffin has not survived, but may have been used for Alexander's burial in 1667. However, a model of a coffin features in an intriguing terracotta *bozzetto* of *Time Arrested by Death* attributed to Bernini.[31] The group is vivaciously modelled in the moist clay, which remains in the rough behind: many details of handling are characteristic of Bernini, notably the summary rendering of the hands of death on top of the coffin and the attention to detail in death's skull carved out of moist clay with a knife. The general composition of the group, with a dominant standing figure looking down at a supplicant is also similar to that of Christ and St Peter in the relief, *Feed My Sheep*. Furthermore, 84 similar figures of Father Time appear in an early drawing for the mounting of the obelisk in the Piazza Santa Maria sopra Minerva and in a cognate scheme showing him holding up an empty circle, possibly for mounting a clock face.[32]

The distinguished, bearded and lightly draped figure of Father Time is carrying a coffin with a skull and crossbones on its end. It is covered with a pall which is plucked by the skeletal figure of Death, rising from a grave in the ground below. There are also remains of a cardinal's hat. An oval incised in the clay perhaps indicates a cover to a funeral vault, for in the Chigi Chapel in Santa Maria del Popolo Bernini 170 designed a skeleton carrying to heaven the Chigi arms to be inlaid in coloured marbles on just such a cover. Pleased with the effect, he also inserted two half-skeletons, in different 190 attitudes of prayer, on the twin roundels in the floor of the Cornaro Chapel in Santa Maria della Vittoria.[33]

172. *Bozzetto* of *Time Arrested by Death*, traditionally ascribed to Bernini. Note the skull and crossbones on the end of the coffin carried by Time (Victoria and Albert Museum, London). Bernini made a real coffin and a marble skull for Pope Alexander VII.

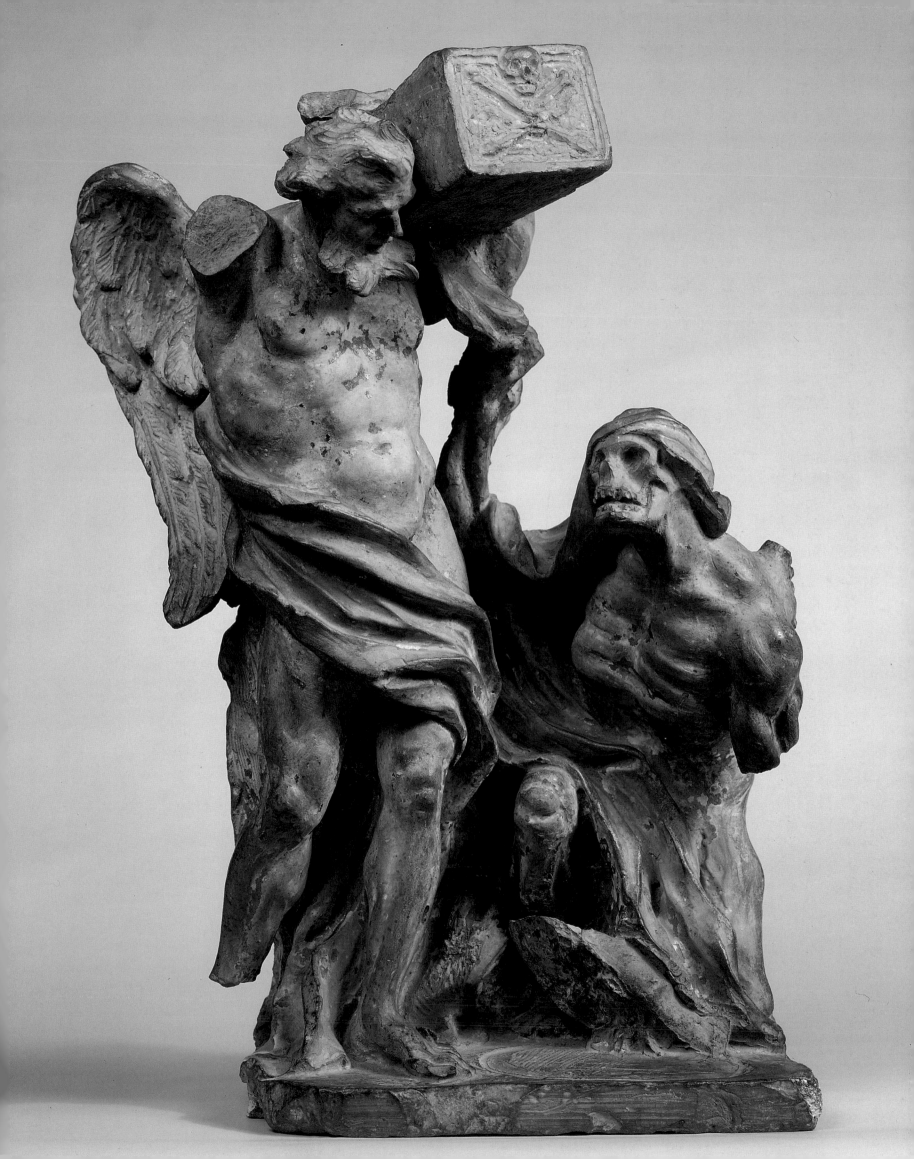

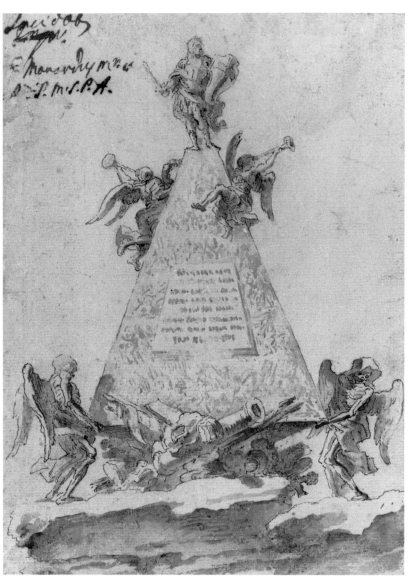

The inclusion in the group of an actual coffin is unusual even in a funerary context, and may indicate a connection with one of the lay confraternities – *Compagnie della Morte* – dedicated to the proper burial of the dead which had long been active in Italy. Alternatively, the model may have been prepared for another catafalque,[34] for equally animated skeletons with cowled heads and wings supported the funeral pyramid in a splendid catafalque that would be designed by Bernini and erected by Pope Alexander in Santa Maria in Aracoeli for the exequies of the Duc de Beaufort in 1669. Interestingly enough, in an engraved frontispiece to an adulatory description of the funeral of Duke Francesco d'Este in 1658, Bernini's bust of him is depicted on top of a pedestal, on one side of which a skeletal Death is shown as sculptor, adding the finishing touch with a hammer and chisel to an inscription recording the date of Francesco's demise. Death is in clear competition with Fame, shown as a more comely sculptress, intent on completing on the front a more positive record of Francesco's titles and achievements.[35]

Linked with Bernini's skeletal, flayed and grotesque figures is a small head that Bernini modelled in wax at an unknown date for casting in bronze, to furnish ornamental finials for his own carriage. The elderly male head, characterized by a few shocks of hair and beard, raises its eyebrows in extreme alarm as it looks upward with its mouth wide open, as though shrieking in horror or agony.[36] The precise meaning of this very personal *scherzo* remains to be elucidated.

173. Pyramid designed by Bernini for the funeral of the Duc de Beaufort in Santa Maria in Aracoeli, Rome, in 1669 (British Museum, London).

174. Grotesque head cast in bronze as a finial on Bernini's carriage (still in the possession of his descendants).

175. Frontispiece to the description of Duke Francesco d'Este's funeral, 1658, which includes Bernini's bust of him (plate 106).

The Tomb of Alexander VII

Mention of Alexander's order from Bernini for a coffin and skull in his rooms as a sanguine *memento mori*, brings us to the very summation of his use of the motif of the reanimated skeleton, for the most eye-catching of all is part of the Tomb of Alexander VII in St Peter's. Baldinucci elucidates with his usual clarity and enthusiasm:

During Alexander VII's lifetime Cavalier Bernini had made a design and a model completely by his own hand of the Pope's tomb to be placed in St Peter's. These had received the approval not only of His Eminence Cardinal Chigi, the Pope's nephew, but of Alexander VII, himself, who ordered Bernini to complete the whole project. When Clement X died and Innocent XI . . . was elevated to the papal throne, Bernini applied himself diligently to the tomb and brought it to conclusion. In this tomb Bernini's genius shines forth with its customary vitality. He set the tomb in a great niche containing a door through which there is a continual coming and going. But he made such good use of the door, which to others would have seemed a great impediment, that it served him as an aid, or rather, a necessary component for working out his splendid concept. What Bernini did was to create the illusion that the door was covered by a great pall. This he carved of Sicilian jasper. On the pall in gilded bronze is Death emerging from the door and lifting the pall with which it covers its head, almost as if in shame. At the same time it extends an arm out toward the figure of Pope Alexander VII, who is represented above by a kneeling marble figure twice life-size. Death demonstrates by the hour glass in its hand that, for the Pope, time has run out. At the bottom of the tomb on either side are two large marble figures, one representing Charity, the other Truth . . . In the upper part of the tomb are two other statues of which we see only the upper half. They are Justice and Prudence. The whole tomb is crowned by the arms of the Pope, placed over the gilded niche and sustained by two great wings.

In dealing with this tomb in the same chapter as that of Urban VIII, which was unveiled in 1647, we vault over a quarter of a century of intense sculptural activity on other fronts, not to mention the architectural schemes connected with St Peter's that Alexander initiated and Bernini's visit to France. Yet the two designs, though not visible in the same *coup d'œil* (as were those of Urban VIII and Paul III in the apse), share so many features that they demand to be treated as integral components in the development of Bernini's thinking on the theme.[37] So numerous are the considerations in this massive project that it has recently been accorded a whole scholarly monograph to itself.[38] Here we can touch on only the major issues and points of interest.

The model that Baldinucci records has disappeared, although two *bozzetti* which may be derived from it remain, both of which are superb examples of the mature Bernini's

176. Bernini's terracotta model of Charity from the Tomb of Pope Alexander VII (Pinacoteca, Siena).

capacity for transforming earlier ideas into a new and original concept. The models, for Charity (now in Siena where it was taken by Giuseppe Mazzuoli, the sculptor responsible for carving the marble statue) and for the pope kneeling at prayer are both close to the tomb as finally erected.[39] However, there were many successive variations prior to the ultimate design. As early as 1655, Alexander entrusted his nephew, Cardinal Flavio Chigi, with the erection of a tomb, and by the following year 'marbles' were being ordered, though this may have been for the architectural surroundings, rather than for the statuary. Like that of Urban VIII, the tomb was planned to go in one of the many niches of uniform width (40 *palmi*) that exist in the deep walls of St Peter's; both surviving presentation drawings have a scale measuring this dimension. The tomb was to be flanked with a pair of freshly quarried columns of the same *cottanello* marble as had been chosen for those flanking the apsidal niche for the *Cathedra Petri*.

368

177, 178

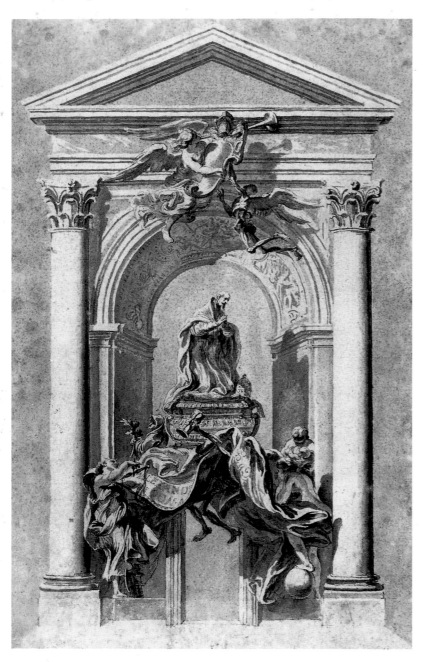

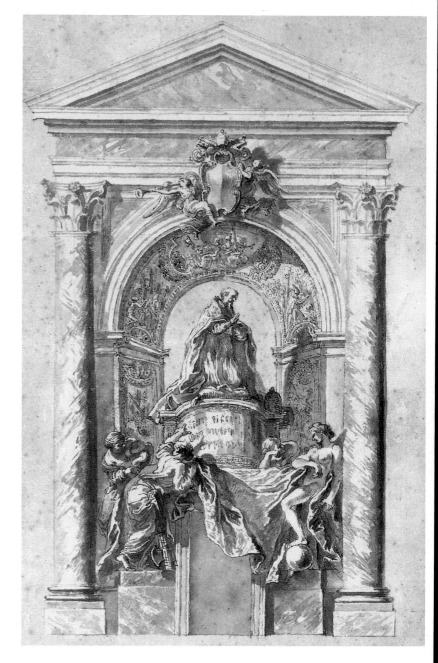

177, 178. Two preliminary versions of the Tomb of Alexander VII. The first (private collection) has two skeletal figures of Death, one at the top, helping Fame to raise the papal coat of arms, the other caught in the heavy drapery over the door. In the second (Royal Collection, Windsor Castle), Death has disappeared, though he reappears in the final design.

Curiously enough, neither drawing is for the niche eventually chosen, which' has a segmental pediment above, while the drawings show a triangular one; these designs alternate regularly throughout St Peter's. Nevertheless three features in the drawings indicate the only position for which it can initially have been intended, directly to the left of the chancel arch: the presence of an intrusive central doorway; the direction in which the papal figure prays towards the right, and the direction of the light (from the left). No

shadows are shown on the background of the round-headed arch behind the pope and so this may have been intended to be left open, allowing light into the sacristy behind; this is not the case in the final position, where the rear of the niche is solid. The reason that the tomb was moved from a niche so prestigiously adjacent to the chancel was probably that the niche was invisible from the nave, being obstructed by the Baldacchino and its accessories. In its present position, the tomb is clearly visible from the top of the nave, diagonally across the wide transept. Indeed, the position of the pope, who now kneels frontally in the niche, with his head tilted slightly, favours a spectator who stands in the nave. Here, natural light falls from the right, and this must have entered into Bernini's calculations.

179. The Tomb of Alexander VII (St Peter's, Rome).

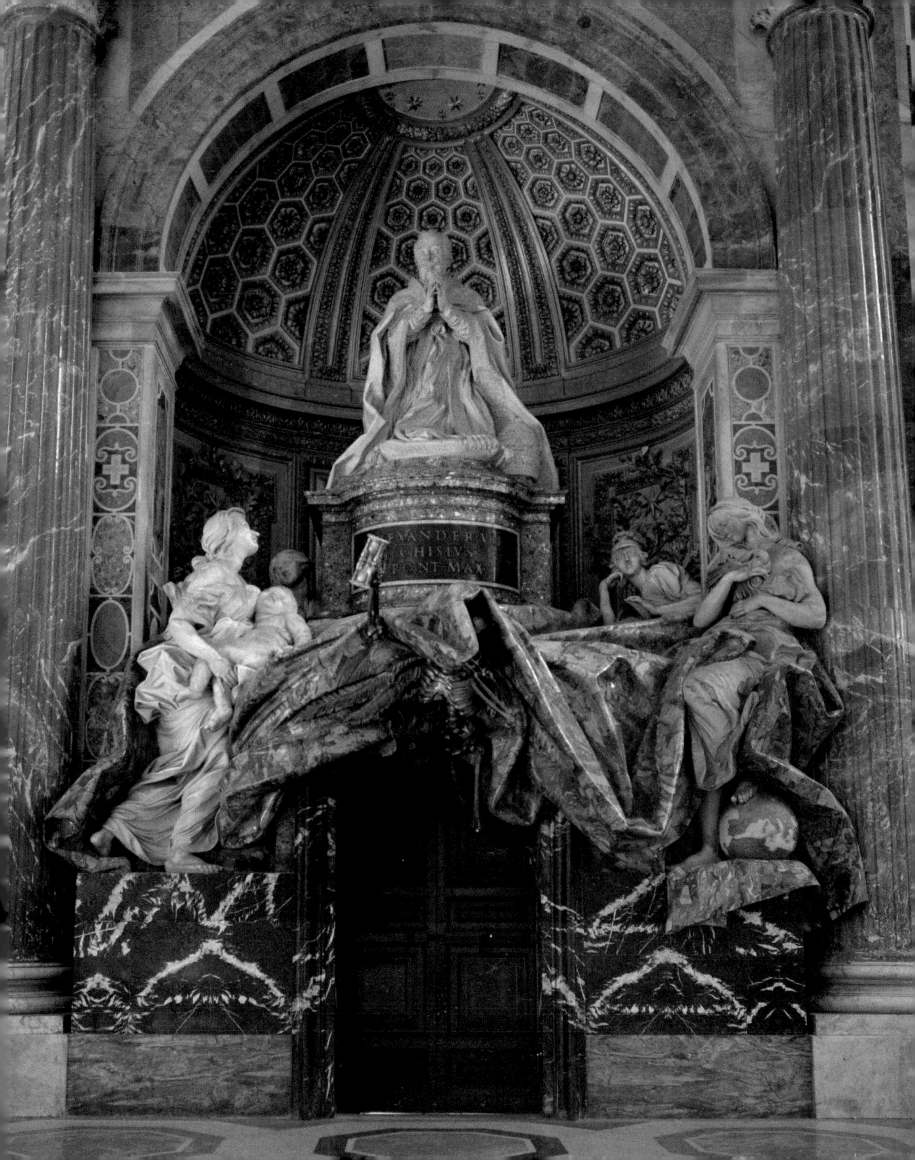

In all three schemes, the presence of the doorway below was a challenge to the designer, but he took a characteristically positive view, as Baldinucci noted, deciding to make a virtue out of a necessity and incorporate it as the door into the underworld; this was a perfectly normal concept at the time, a slightly open double door with this symbolism sometimes having featured in ancient Roman sarcophagi. The lintel then provided support for the image of the pope, and Bernini tried him kneeling, once on a rather truncated sarcophagus, with his tiara punctuating the silhouette to the right, and once, as in the final design, on a break-fronted pedestal with the epitaph inscribed on its convex central panel.

Four Virtues are disposed symmetrically below, with the rear pair not fully visible; indeed on the monument only the upper torsos are carved at all. The earlier drawing is enlivened by two full-size skeletal representations of Death: from the

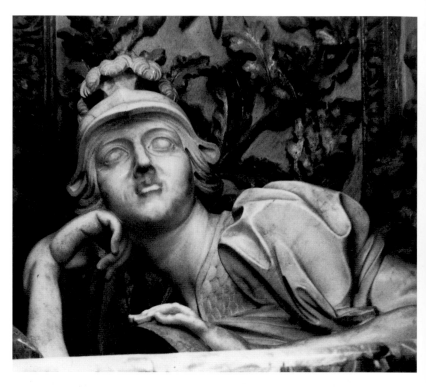

181. Detail from the Tomb of Alexander VII: Justice.

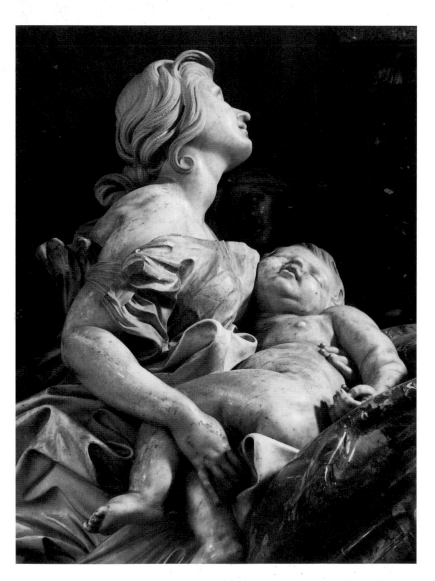

180. Detail from the Tomb of Alexander VII: Charity.

door of the underworld, one rises up with its skull still caught beneath the heavy folds of the pall (on the hem of which at the left Alexander's name is embroidered). It brandishes an hourglass in front of the praying figure, while its etiolated legs dangle down horrifically – and impractically – in front of the doorway: they would have been a menace to any cleric taller than average. The essentials of this dramatic skeleton survived into the final monument, not before disappearing altogether – though temporarily – from the alternative design. Another figure of Death appears far above, flying in mid-air and helping an allegorical figure of Fame trumpeting to raise the papal coat of arms into position on the keystone. The emphatic double appearance of the skeleton reminds one of the medieval idea of continuous narration, whereby a figure appears simultaneously in two episodes of a story that are actually separate and successive. The wings of the upper skeleton both help it notionally to fly, and also convey the idea of the passage of time that brings death, resurrection and fame. They also correlate the figure with that of Fame on the opposite side, and with the kind of angel or cherub that is more usual in this sort of representation, for example the group with the coat of arms in Sant'Andrea al Quirinale. The upper apparition was eventually discarded.

The Virtues, more numerous than those of Urban's tomb, were treated as movable entities. In both drawings Justice, with *fasces* at her feet and holding up a pair of scales, is at the left front, while ultimately she would be banished diagonally to the rear, helmeted and looking pensive, carved

only in half-length. In both drawings *and* on the tomb, the only constant figure, determinedly standing her ground at lower right, is the least usual Virtue, Truth, shown as a beautiful young woman. The imagery is of course related to that of Bernini's own 'secular' interpretation, now in the Villa Borghese: in the drawing with skeletons, Truth turns in towards Alexander and is hidden by the whiplash folds of the turbulent cloth of state, which has the advantage of concealing much of her nakedness. In the Windsor drawing a sideways stance, close to the final one, reveals more of her comely figure in a passage that is reminiscent of a luscious Tiepolo drawing. In the event, as Baldinucci reveals, the sculptor had to make a concession:

This latter figure was completely nude, though the nudity was concealed somewhat by the play of the pall about her and also by the sun which covered some of the bosom. But a nude woman, even though of stone and by Bernini's hand, was unsuitable to the purity of mind of Pope Innocent XI. He let it be known in a gracious way that it would be to his liking if Bernini would cover her somewhat in whatever manner seemed best to him. Bernini quickly made her a garment of bronze which he tinted white to look like marble. For him it was a work of immense thought and labour, as he had to unite one thing to another that had been made with a different aim in mind.

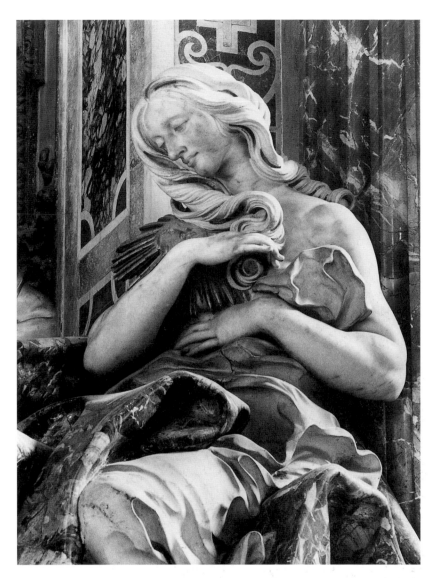

The statue of Charity (which at the stage of the model also had bare breasts) proved to be the most nomadic figure; from relative obscurity (visibly nursing only one infant) at rear right, she moved over to the left in the Windsor sheet, where she is visible full-length between Justice and the flanking column. Finally, on the monument, Charity assumed much the same pose as the Windsor Justice, standing prominently in the foreground, like her sister on Urban's tomb. Here, her diagonal movement, her lines of drapery and her upward gaze all direct the spectator's attention towards the focus of the composition, Alexander himself. This is particularly important in the long view from the crossing and nave.

Meanwhile the skeleton of Death, cleverly cast in bronze and picked out by gilding against the jasper of the pall, reappears, wings and all, with only its face still hidden by a fold and its bony legs tactfully canted sideways to avoid clerical pates. Its bony feet rest on the door jamb. This increases the ambiguity of 'real', as opposed to 'pictorial' space. Is this alarmingly natural-looking skeleton really exiting in flight from the (real) sacristy door, or does it belong to the heavenly vision above? Fiction, allegory and belief all enter into Bernini's conception.

From a practical point of view this was an incredibly complicated and multifarious project. 'Every single payment is specified and justified in a statement written by Bernini himself,' wrote Wittkower, 'This shows how vigilantly he

182. Detail from the Tomb of Alexander VII: Truth.

183. Detail from the Tomb of Alexander VII: the hand of Death holding the hourglass.

supervised every stage of the work.'[40] Nevertheless, as will have been inferred from the appearance of the name of Innocent XI (two pontificates after that of Alexander) in Baldinucci's narrative, after a prompt beginning the monument had to yield priority to the decoration of the chancel of St Peter's. Indeed it was not to be constructed for some time: in 1670 or so Innocent X seems to have flirted briefly with the idea of removing the project to Santa Maria Maggiore and having Bernini design a matching tomb for him, where he would be shown kneeling on top of a sarcophagus (as Alexander was shown in one of the drawings), or in front of it. This has created confusion for modern students, for two surviving drawings at Windsor are therefore virtually identical and previously have all been connected with Alexander's tomb.[41]

The first record of the whole affair is an entry in Alexander's own diary for 11 November 1660, when he noted that Bernini 'came with the drawing of our sepulchre'. Only one drawing seems to be in question thus far and it was probably that showing skeletons, for, late the following January, Alexander wrote an instruction to his sculptor: 'let Death have a scythe instead of the book'; the latter features in that project.[42] The other drawing, in Windsor, must antedate Alexander's death in 1667, for Domenico Bernini affirms that Alexander approved the *final* design for his tomb and that was quite different from this project; indeed the lower skeleton reappeared almost as before. There are myriad other details in the iconography and rendering of the allegories that were pondered by patron and sculptor. It was not until a dozen years later, in 1672, that Bernini received the round figure of 1000 scudi for his drawings and model, as well as for supervision of the development of the monument. All the work was delegated: full-size models for the Virtues, Death and the pall were also ready by 1672. The names of all the carvers and the spans over which they were involved — broadly speaking between 1673 and 1677 — are recorded, as are those of the foundryman (Girolamo Lucenti, 1675–6) who, with difficulty on account of its skeletal protrusions, cast the figure of Death. Various details were also added, among them the winged coat of arms of the Chigi above the entablature, as well as components long since missing, such as a pair of wings for the hourglass and a mirror for Prudence, whose symbol it is.

183

After Innocent XI had raised his objection to the nakedness of the foremost Virtues, Bernini again had to be personally involved in order to contrive that their 'clothing' would interfere as little as possible with the general composition. The new pieces of drapery were modelled, either on the finished marble or the large models, by an assistant, cast in bronze, then fitted and painted white to match the surrounding marmoreal clothing. It is probable

180, 182

that Bernini also had a hand in finishing Alexander's portrait in *c.* 1676, for he had known him intimately for so long and modelled his head in clay early in his pontificate without ever producing a definitive, autograph portrait bust.[43] He had also produced in 1661 a model for an over-life-size statue of the Chigi pope for the cathedral of his native Siena.[44] Alexander was shown seated and giving a blessing, in the same pose as Bernini's statues in bronze and marble of Urban VIII, but the carving, with the possible exception of the face, was left to Antonio Raggi.

The fact that there were four Virtues at the corners of the construction implied that this was in essence a free-standing monument, a more impressive version of the fiction that Bernini had already employed to good effect (and in the event more visibly) on his Tomb of Cardinal Pimentel in Santa Maria sopra Minerva, in *c.* 1653.[45] There a rectilinear armature of architecture in dark marble provided a firm matrix for the white marble statues. With Alexander's tomb, the presence of the real doorway to a sacristy meant that the actual structure was irregular and so Bernini resorted to the clever device of disguising the changes of level and depth with the great pall. Its folds wrap around the two figures in front and extend sideways right outside the original niche to touch the flanking columns. Truth indeed leans comfortably back against the right-hand column, whose contrasting colour — almost matching the Sicilian jasper intarsia of the pall — serves to silhouette the contours of her white marble hair, her shoulder and her smooth, pretty bare arm. Charity meanwhile, rushing in distractedly from the left, is within the compass of the arch. Light falling naturally from the west tends to highlight her upturned face and the baby that she cradles.

The whole composition is bound together by the strong diagonals formed by the axes of the Virtues in front and by the more eye-catching diagonals along the crumpled edges of the pall, most of which lead upwards to the isosceles triangle of the kneeling pope at the apex. It is also unified by the riot of colour, gilding and patterned intarsia in its surroundings, against which the five figures in white marble stand out bravely. The sumptuous and dramatic Tomb of Alexander VII is a thrilling climax to Bernini's career in the field of funerary sculpture and is one of the greatest emanations of the Baroque spirit.

184. Detail from the Tomb of Alexander VII: the Chigi pope himself.

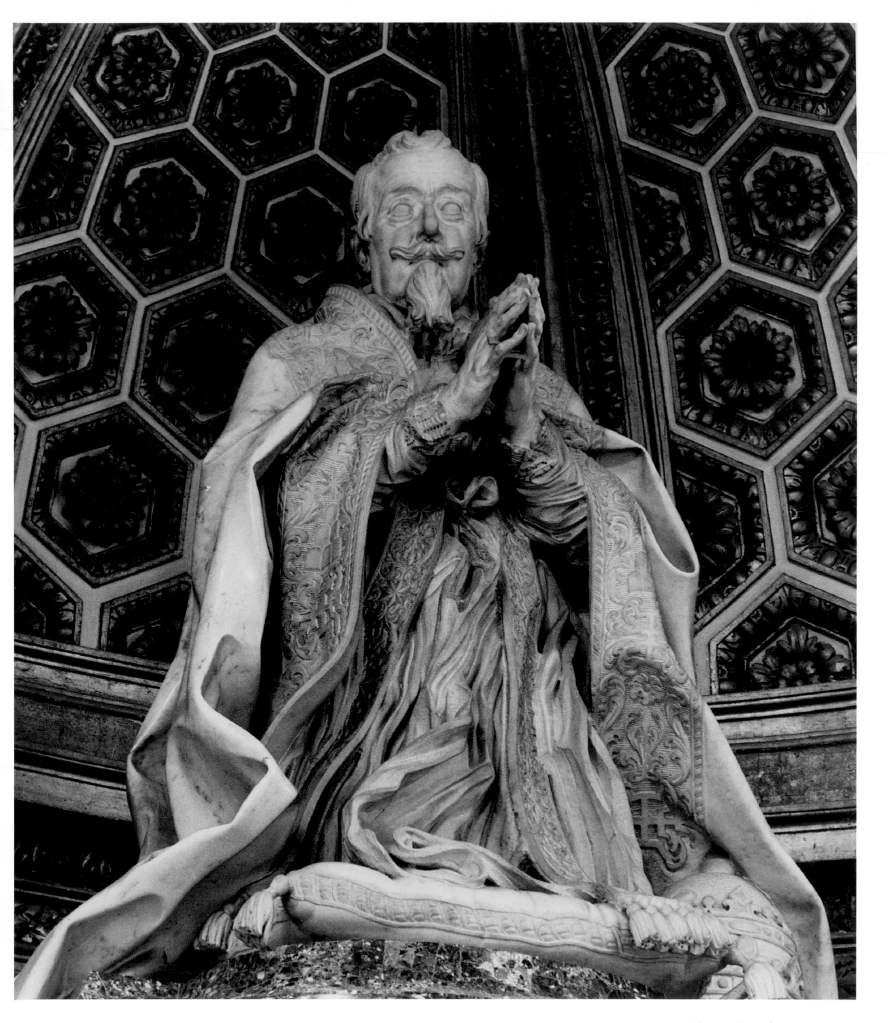

185. Preliminary drawing for the Memorial to Sister Maria Raggi
(Palazzo Chigi, Ariccia).

8 * Mystic vision: the later religious sculpture

*The opinion is widespread that Bernini was the first to attempt to unite architecture with sculpture
and painting in such a manner that together they make a beautiful whole*
Filippo Baldinucci, 1682

Those who do not sometimes break the rules never transcend them
Gianlorenzo Bernini

Unified designs for chapels: St Teresa and the Blessed Ludovica Albertoni

QUALIFIED IN ALL three fine arts, all of which, he believed, were based on the same principle of *disegno* (design) and fiercely ambitious to excel, Bernini was by middle life ideally equipped to exploit his versatility to a new end. This was to create wonder and surprise, '*stupori incredibili*', as Marino, a contemporary poet, put it when defining one of the principal aims of poetry.[1] In the Baroque period, this was also taken to apply equally to painting (and, by extension, to sculpture): '*ut pictura poesis erit*'. It was the author's or artist's task to make the impossible or scarcely believable plausible, through deceptive realism. Another aim in poetry, that of achieving 'Magnificence' by displaying acts of 'imperious and irresistible force' or 'illuminating an entire subject with the vividness of a flash of lightning' was equally applicable to sculpture, especially within an architectural setting.

The idea of richness, of layer upon layer of meaning to be revealed progressively through the contemplation of a work of art, was also dear to Bernini and his contemporaries. One example has already been cited: the Barberini bees escape from the arcane and immobile realm of heraldry to which they properly belong to take part in all sorts of major events symbolically and occasionally humorously. The stages of surprise (a bee seems to be on the loose: is it a monster-sized real one, perhaps?); of realization (that there are more than one, perhaps the three from the coat of arms of the pope?); of mental association (with the real events commemorated in the work of art); and finally of comprehension (of the artist's, and sometimes the patron's, message) are those that Bernini built in to a work of art to capture the attention of his audience. Anthony Blunt has written that, 'the greatest master of illusionism in its widest sense was Bernini: [he] used it to express a particular kind of deeply felt religious emotion, and so raised it to an altogether higher level of imaginative creation'.[2]

Bernini, skilled dramatist that he was, always aimed at stunning the bystander into reverence and acceptance. He does not appeal unassumingly or apologetically, but veritably demands suspension of disbelief. An essentially simple motif, for instance a realistically rendered piece of cloth tossed by the wind such as that introduced in the Valtrini and Merenda monuments, could be used to suggest the passing of Death, the breath of the Almighty or the presence of an angel. It affects one subconsciously first of all, catching the attention and begging intelligent interpretation.

Bernini exploited and refined this very motif in his splendid Memorial to Sister Maria Raggi:[3] she was a married woman who when widowed had joined the Dominican order, leading a saintly life in the convent attached to the church where she is buried, and describing herself as 'a poor nun, ignorant and a sinner'. She became renowned for her goodness and the working of miracles. In 1585, she had a vision of Christ and, like St Francis and St Catherine of Siena (another Dominican), received the stigmata, the marks of Christ's Crucifixion. In 1625, moves were set afoot to seek Maria's beatification, but these were frustrated by Urban VIII. The epitaph was sponsored by members of her late husband's Genoese family: Ottaviano Raggi bequeathed funds in 1643, while Lorenzo, after he was made cardinal in 1647, saw the work to completion.

This memorial had to be mounted against a compound pier of the nave in Santa Maria sopra Minerva. Bernini combined the idea of the hanging pall of black marble from the Valtrini monument with that of a superimposed vision.[4] This appears very clearly in a preliminary drawing in pen and wash, but is more disguised in the final arrangement. The drawing also shows the nun crowned with flowers, in accordance with one of her visions of the Virgin Mary, and holding her hands up frontally (in the 'orans' position) to demonstrate the stigmata. In the monument as executed these features disappear or were minimized, possibly because they had not been authenticated by the Church.

In deference to the gender and sanctity of the deceased, the figure of Death is not involved in this instance. Instead, the cloth is heavily indented by an imaginary draught, which one could interpret either mundanely as a 'real' one blowing

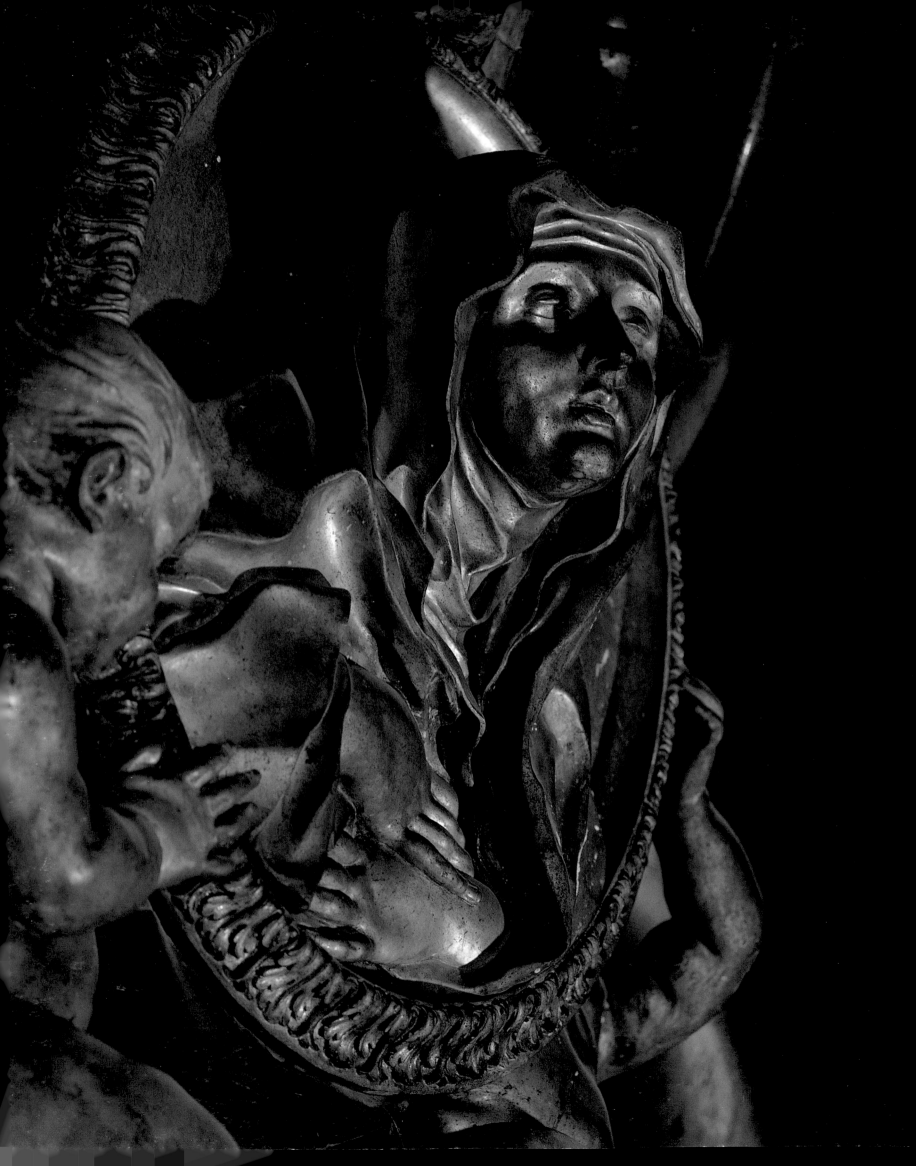

from the west door of the church towards its subsidiary entrance at the eastern end, or as a 'heavenly' one engendered by the beating wings of the apparition of cherubim with the medallion hovering in front of the pall. In practical terms, this flapping movement serves to disguise the inconvenient fact that the cloth is tied back around an engaged half column.

Two subsidiary but visually important components, a bronze cross above, such as Maria had contemplated on her deathbed in 1600, and the shield of arms of the Raggi family below, were indicated in the drawing in logically axial and vertical positions. When it came to applying them in gilt bronze to the monument, the cross was tilted leftwards and its arm was shown caught up under a fold of the pall, and its stem hidden behind the oval seems to be supported by the putto on the right. The shield was removed to the lower left corner, where it is better illuminated by glancing candlelight and so more visible to a worshipper in the nave. These innovations initiate other diagonal movements, counterpointing those of the general drift of ripples in the cloth.

Bernini gave the cenotaph a gorgeous inner border of *giallo antico* marble to make it stand out from the sombre interior, and made the medallion of the deceased, the cross above and the flying cherubim who support it all in gilt bronze.[5] For added visibility Maria's cowled head projects fully from the background into the surrounding space occupied by the beholder: it is cantilevered out above her hands. These are pressed eloquently to her bosom in a standard gesture of pious emotion, the back of one being faintly indented, just alluding to, without emphasizing, her stigmata. Maria faces diagonally towards the high altar and thus looks in the direction of Michelangelo's *Christ* which stands by the left pier of the chancel.[6] This was almost certainly intentional, for it recalled another vision that the nun had experienced on her deathbed, when Jesus appeared and said, 'Be of good cheer, Sister Maria, my wife, for I am awaiting you.' So here Bernini set up a dramatic interplay at a spiritual level between the spectator and what were actually two inert pieces of sculpture. Morbid though the subject and treatment might seem today, this is one of Bernini's most imaginative and successful minor devotional masterpieces.

The 1640s were a decade during which Bernini received commissions from all sides for the design of chapels or shrines, several of which were perforce executed by remote control, using the talents of juniors. The earliest, for the Raimondi family, in San Pietro in Montorio, has already been mentioned on account of the fact that the deceased are shown within their sarcophagi, while the frontal of one is carved with the story of the Valley of the Dry Bones.[7] Although such a concept had of course been cherished generally since the days of the Renaissance,[8] this is the first of

186, 187. Memorial to Sister Maria Raggi (Santa Maria sopra Minerva, Rome) and detail (*opposite*).

45

168

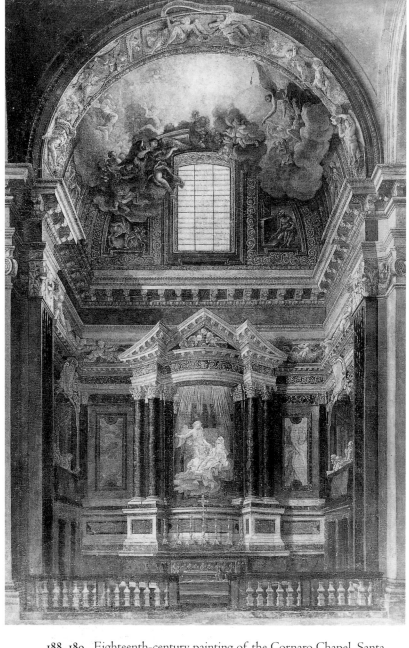

188, 189. Eighteenth-century painting of the Cornaro Chapel, Santa Maria della Vittoria, Rome (Staatliches Museum, Schwerin), and (*below*) plan by Count Nicodemus Tessin showing arrangement of the altar.

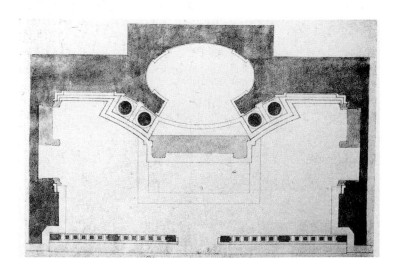

Bernini's major complexes in which the sculptural and architectural elements are completely amalgamated, together with fresco paintings on the vault. He also reused the idea of a source of carefully directed light falling on a sculptural altarpiece that he had pioneered in the church of Santa Bibiana. Here however the heavy and protruding concave entablature and the flanking pilasters form a frame around the marble high relief, *The Ecstasy of St Francis*, and conceal the source of light (a small window at top left). This creates an impression that a supernatural source is illuminating a vision and the effect is enhanced by the insertion of ribs and rays of fictive light descending from an image of the Holy Spirit painted in the semi-dome above. The chapel is richly adorned with delicately carved floral ornament, but as yet Bernini is keeping to the rules, by separating the paintings from the sculpture with architectural elements (even though some of the compartments show, as in the case of Michelangelo's Sistine Ceiling or Carracci's Farnese Gallery, many fictive sculptures, such as seemingly three-dimensional putti in white marble supporting medallions in bronze, alongside fictive bas-reliefs).

It is precisely this strict compartmentation of the three fine arts that is renounced in Bernini's most magnificent, complete chapel, the chapel of the Cornaro family, whose marble altarpiece, *The Ecstasy of St Teresa*, is his most famous religious sculpture. It was commissioned by a Venetian cardinal, Federico Cornaro (1579–1653), who acquired the patronage of the empty left transept of the newly built church of the Discalced Carmelite brothers in Rome, Santa Maria della Vittoria, in 1647. Cornaro had been interested in this monastic order when still in Venice, and the principal miraculous vision of their foundress was a logical choice for the subject of an altarpiece in the mortuary chapel. Federico intended to commemorate both himself and earlier members of his illustrious family who were buried elsewhere. Unlike the official commissions for the Vatican, little documentation exists in the case of this private commission, but it has recently been discovered from the Cardinal's ledger that it cost the gigantic sum of 12,089 scudi.[9] Bernini himself carved only the focal group of the altarpiece, and not the portraits, most of which are decidedly second-rate. The chapel was opened in 1651.

The Cornaro Chapel is a riot of colour and movement, originally lit in four ways: by direct light through a stained glass window above at the end of the transept; by light falling vertically from a concealed source on to the sculpted altarpiece itself; by reflected light from the nave, glancing off the polished marbles of the interior, and, on high days and holidays, by myriad candles, whose flames flickering in the draught would have sent scintillating points of light all over the scene. The whole essence of Bernini's achievement, a sense

of mystery and divine presence, is destroyed today by unforgiving electric lights in the chapel which over-illuminate its every part.

The fiction in which Bernini induces us to participate is that this chapel in the transept of the church has turned into an intimate little theatre, the private preserve of the Cornaro family. Some of its members are to be descried in two balconies on either side, rather like boxes flanking a stage. They are in animated conversation with one another, presumably about the miracle, apart from one who is observing it intently. And the stage is shown too: it is oval in ground plan, behind a proscenium arch flanked by paired piers and columns that support an amazing broken pediment. This has a convex centre and concave flanks, forming a reverse curve characteristic of Baroque architecture. The sacred drama and the divine force of the miracle being enacted within thus seem to be bursting its surroundings asunder. The focal group is dramatically illuminated by natural light, directed along various diverging, sharply profiled, gilded rays, as though from heaven, but actually from a lantern above (visible from outside the church).

The drama is one of St Teresa's repeated mystical experiences, dwelt on in her *Autobiography*:

I would see beside me, on my left hand, an angel in bodily form . . . He was not tall, but short, and very beautiful, his face so aflame that he appeared to be one of the highest types of angel who seem to be all afire . . . In his hands I saw a long golden spear and at the end of the iron tip I seemed to see a point of fire. With this he seemed to pierce my heart several times so that it penetrated to my entrails. When he drew it out, I thought he was drawing them out with it and he left me completely afire with a great love for God. The pain was so sharp that it made me utter several moans; and so excessive was the sweetness caused me by this intense pain that one can never wish to lose it, nor will one's soul be content with anything less than God.[10]

191. Sketch by Bernini showing the window of the Cornaro Chapel surrounded by clouds and angels (Biblioteca Nacional, Madrid).

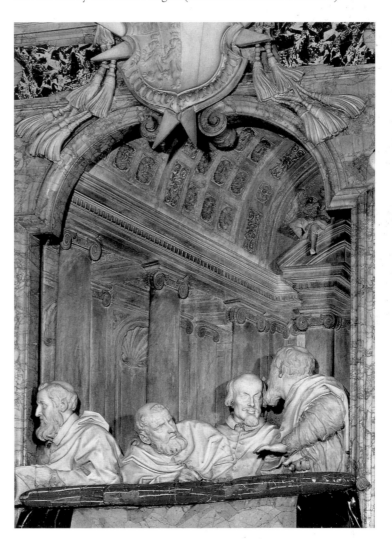

192. Right side of the Cornaro Chapel (Santa Maria della Vittoria, Rome). Members of the Cornaro family (including the patron, Cardinal Federico, second from right) witness the ecstasy of St Teresa.

190. Half-skeleton praying, a detail from the pavement of the Cornaro Chapel.

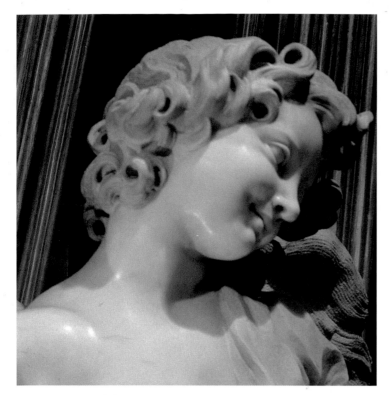

193, 194. Altar of the Cornaro Chapel (Santa Maria della Vittoria, Rome). (*Above*) the head of the angel. The group of *The Ecstasy of St Teresa* is illustrated at the front of the book, plate 5.

To an unbeliever this may seem far-fetched and to a Protestant, then or today, distasteful, while its sexual overtones invite a psychological interpretation. Yet at the time, it must be remembered, Teresa of Avila was an important figure in the international Catholic Church. She had founded a reformed order of nuns, the Discalced Carmelites (i.e. barefoot, so-called on account of her renewed emphasis on poverty), with sixteen monasteries in Spain to her credit by the time of her death in 1582. After forty years of serious investigation into her claims, having been beatified along the way in 1614, she was canonized by Pope Gregory XV in 1622. She was thus, to someone of Bernini's generation, a very real person, with palpable earthly achievements quite apart from her mystical spirituality.

The sculptor's tribute was to transform Teresa's words into marble, as conscientiously and as delicately as he knew how, to make the experience actual to the viewer. The whole chapel 188 encapsulated this divine revelation. Its entrance arch high above one's head is populated – like the border of some medieval illuminated manuscript – with a host of fluttering cherubs hanging up swags of foliage, while angels bear a banner tossed in a wind with an inscription that provides a key to the whole scene:[11] 'If I had not created heaven, I would create it for you alone,' words spoken by Christ to Teresa during one of her visions.[12]

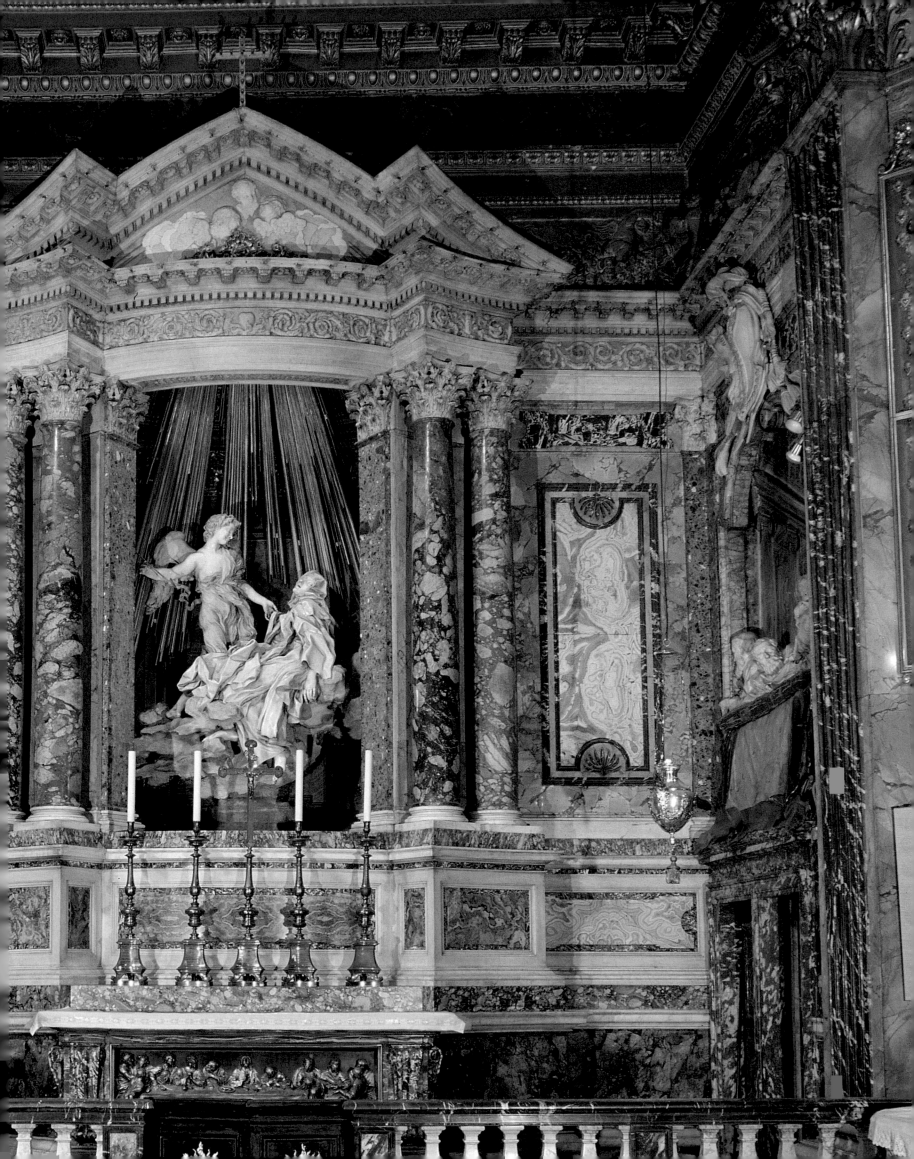

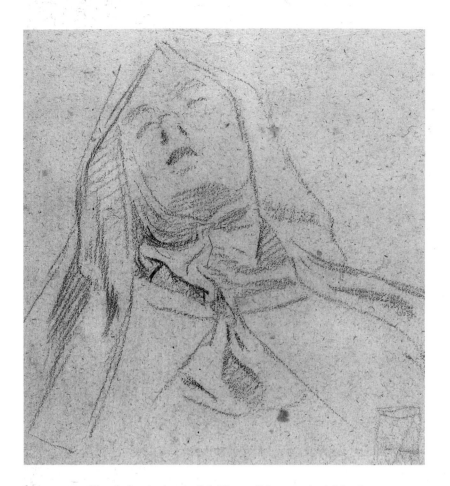

195. Sketch for the head of St Teresa (Museum der bildenden Künste, Leipzig).

opposite numbers emerge symmetrically only as one arrives at the chapel: it is for them that a preliminary sketch in clay survives. By now, one's attention has inevitably been caught by the extraordinary apparition emphasized by the dark proscenium arch and the brighter illumination beyond it. Even the decoration of the marble floor forms part of the intellectual concept behind the chapel, for in it are the two roundels with half-length praying skeletons shown in 190 perspective: the implication is that the roundels are entrances to the underworld beneath the floor, out of which, by the power of prayer, the skeletons are attempting to be resurrected.

Bernini's early ideas for the focal figure of St Teresa are recorded in some studies carefully executed in soft chalk, a medium perhaps chosen deliberately to convey from the start a melting impression of feminity and mystical softness.[14] The by now standard image of swooning ecstasy is employed: the thrown-back head, parted lips uttering the moans to which Teresa alluded and half-closed eyelids, in this case framed by her hood. Bernini draws this as a sharp point, perhaps with reference to the arrow with which the saint felt she had been 'transverberated'. In the event this form was not pursued. With areas of hatchings in different directions he rapidly indicated where the darkest shadows would fall, and hence

Within the arch one encounters (in what is in reality a rather shallow space) a fresco of the heavenly dove in a halo of rays bursting through great banks of cloud, interspersed with yet more angels. All this is painted on smooth plaster as though it was *inside* the actual vault, which is decorated with framed reliefs – genuinely three-dimensional – showing
191 episodes of Teresa's life.[13] An initial sketch shows the real window in the end wall with some of the clouds and angels projecting across its frame, thus deliberately infringing the rules, for the sake of effect. A cornice strongly projecting below this heavenly realm separates it from the earthly one. The fiction now changes to that of the self-contained theatre, described briefly above, whose walls are richly clad in marble of many hues, closed off by a balustrade, from which the spectator may humbly look on as though from the front row of the stalls.

As one proceeds up the nave of the church, it is the gentlemen carved out of white marble in the right-hand balcony who first catch one's eye in the gloom: the patron,
192 Federico, staring straight out at us, is the second figure of this group. As one approaches, his illustrious relatives become increasingly visible, diagonally across the entrance, while their

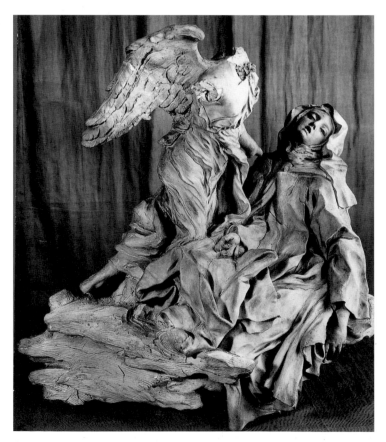

196. Bernini's terracotta *bozzetto* for the angel and St Teresa (State Hermitage, St Petersburg).

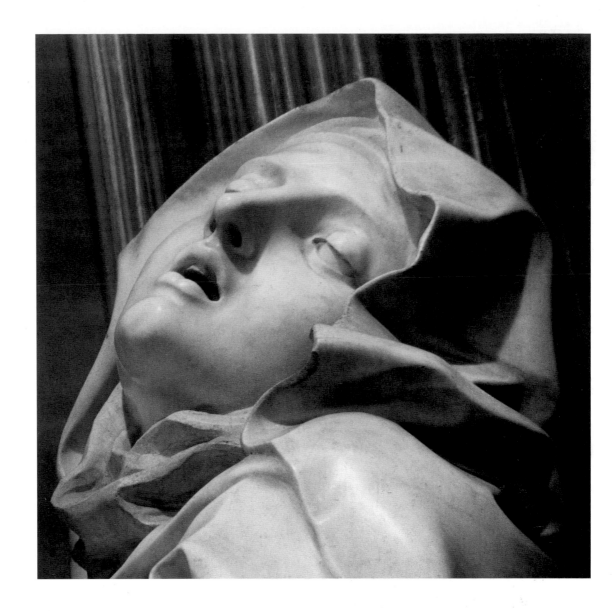

197. Head of St Teresa, Cornaro Chapel
(Santa Maria della Vittoria, Rome).

where he would have to carve most deeply. Another study begins to establish the pose of her body, abandoned beneath its heavy monastic habit: her dangling left arm and leg and the raising of the far knee suggest that she is suspended in mid-air, experiencing levitation, as she did on certain other occasions. In the final carving this is rationalized by showing her borne up on a bank of cloud, with these extremities completely limp, following Teresa's own description, 'The entire body contracts and neither arm nor foot can be moved.'

Bernini used an open, swastika-like arrangement of the limbs, not unlike that of the naked figure of *Time Unveiling Truth* that he was carving at much the same date. In the sketch her right hand was shown clasping her midriff with the pain of the piercing arrow; in the marble Bernini moved it, so that it lay open, resting on her raised knee. A highly finished model in terracotta was produced to guide the carvers.[15] In it the general play of the rippling folds of the habit and the angel's diaphanous robe is established, though further changes suggested themselves in the process of carving: for instance, the saint's right foot is allowed to appear in order to give a sense of stability. The benevolence that Bernini managed to

impart to the face of the angel, set in its mop of curls, and the sense of yearning that he gave to Teresa's open mouth, gasping for breath, and her fluttering eyelids make this one of his most moving creations, full of sublime spirituality and other-worldliness. 193

His son Monsignor Pier Filippo Bernini was inspired to write:

> *So fair a swoon*
> *Should be immortal;*
> *But since pain does not ascend*
> *To the Divine Presence*
> *In this stone Bernini made it eternal.*

Baldinucci too waxed lyrical, calling it 'the wonderful group of St Teresa and the Angel who pierces the Saint's heart with the arrow of Divine Love while she is in the transports of the sweetest ecstasy. For its great tenderness and for all its other qualities this work has always been an object of admiration.' Bernini called it 'one of my least bad works' and later in life was sometimes to be found quietly praying before it.

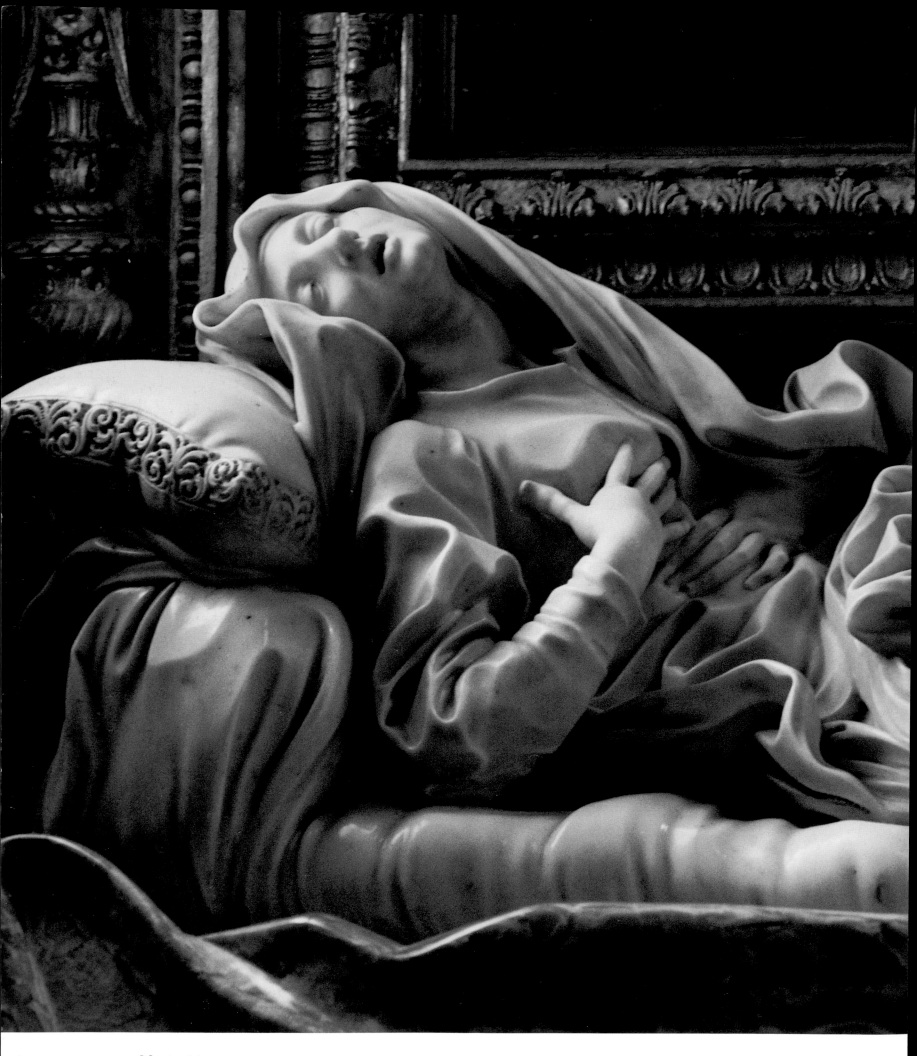

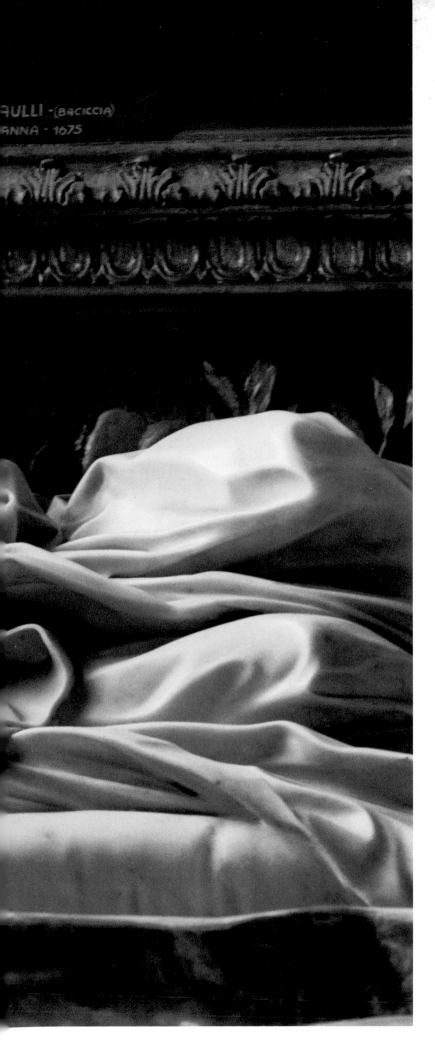

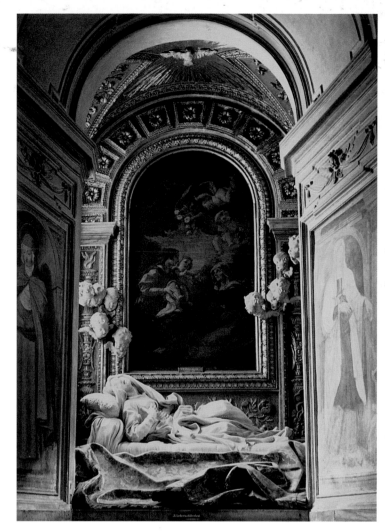

198, 199. Chapel of the Blessed Ludovica Albertoni (San Francesco a Ripa, Rome), with Il Baciccio's *Virgin and Child with St Anne*, and (*left*) the statue of Ludovica in the throes of mystical experience.

Twenty years and several pontificates after Bernini finished the Cornaro Chapel, he became involved in a similar commission. This was a chapel to celebrate the cult of a Franciscan nun, Ludovica Albertoni. She had been a Roman noblewoman who took her vows after being widowed and lived a life of piety, working for the poor of Trastevere under the direction of the fathers at San Francesco a Ripa, where she was buried in 1533. The nephew of one of her descendants, Cardinal Albertoni, had married the niece of the new pope, Clement X. This happy event encouraged the Clement to adopt the cardinal formally as his nephew, to grant him the use of his own surname, Altieri, and in 1671, to raise the status of the cardinal's worthy ancestor within the hierarchy of Catholic sanctity to that of Blessed.[16] The cardinal responded enthusiastically by commissioning major improvements to the chapel in San Francesco a Ripa which had since the time of Ludovica's death been the location of a cult. In order to curry favour with Pope Clement, the elderly Bernini undertook to work unpaid.[17] He carved the principal

200. Bernini's terracotta model of the Blessed Ludovica Albertoni (Victoria and Albert Museum, London).

figure mostly by himself, as its superb quality indicates. The work took three years, however, because he was very busy with other major works: the Tomb of Alexander VII and the Altar of the Blessed Sacrament in St Peter's.

As with St Teresa, Bernini devised an architectural scheme to focus attention on the marble sculpture above the altar, by framing it within a new archway that he cut through the end wall of the chapel, where a painted altarpiece had hung. This has deep returns set at an oblique angle, with earlier frescos of St Clare and of Ludovica herself giving alms to a beggar: these continued to function as wings of a triptych on either side of the altar scenario, and help to define the identity of the protagonist. Beyond the arch, Bernini built an extension with large windows concealed at either side from which the scenario is brightly lit.[18] Beyond the archway, Ludovica is seen prostrate on a mattress, as though in her death throes (as Baldinucci thought) or more probably in mystic communion with God. Her habit is in turmoil and her head sinks back against an embroidered pillow set on a headrest. Below and in front is a deeply crumpled cloth of state (originally rendered in carved wood, but since *c.* 1700 coloured with an inlay of reddish marble) and a bulbous sarcophagus in red marble, where Ludovica was re-interred. Behind her is a panel carved with stylized pomegranates, while beneath the windows are flaming hearts. On the new end wall above her is a painting, the *Virgin and Child with St Anne* by Il Baciccio, whose composition was carefully adapted to that of the statue. Its frame is overlapped by two series of asymmetrically disposed cherubim in stucco, whose foreheads catch the light. In the vault above, amid a burst of rays, hovers the dove of the Holy Spirit, while the triangular embrasures to either side contain gorgeous sprays of roses. All around is richly carved and gilded ornamentation. The effect is truly sumptuous.

A rough pen sketch concentrating on the basic pose and drapery shows Ludovica twice, with a pattern of folds that already predicates the end result.[19] She is lying at a diagonal, like St Teresa, and this has been dismissed as accidental, for in the surviving *bozzetti* she lies flat. However, in the sketch there are no signs of a horizontal plane, similarly canted, for her to lie on, and as the initial commission referred to a relief, perhaps the diagonal pose was intentional, for it would have helped to fill an upright rectangular field better than a horizontally recumbent figure at the lower edge. The position of her hands and the tilt of her head result in a composition quite close to that of the oval relief of Maria Raggi.

Perhaps the earliest *bozzetto*, now in the Hermitage, shows Ludovica lying directly on a flat, hard, surface, with her head raised on two piled-up cushions.[20] Her mouth is wide open and excavated deeply round the lolling tongue, while her pupils are impressed beneath her eyelids. Her hands are very delicately articulated and their position has been altered: Ludovica now grasps her breast with her right hand, in a gesture that immediately recalls that of the standard image of Charity, giving suck to a baby. This is plainly a new and subtle reference to her own charitable activities. There are tool-marks on her drapery which give a sense of organic flow, rather than the agitated folds that are a feature of another model, now in London, which is closer to the eventual solution.[21] By this stage the mattress has been inserted comfortingly beneath her, while both it and the headrest have been wrapped in a sheet with folds running at right angles to the axis of the figure, thus being clearly distinguished from it. Light catches all the raised edges of folds, making a pronounced linear pattern over the deeply excavated areas of shadow.

Her hips, which would have been the lowest part of the nun's body had she been lying inert, are actually raised, a movement that is emphasized by the turmoil of drapery above. Ludovica is probably meant to be reacting ecstatically to the effects of a communion with God that she enjoyed after receiving the last rites, before expiring a day later. She said that her heart was afire with divine love, as indicated symbolically on the panels at her head and foot, as well as on the sarcophagus-altar below, where there is a little heart-shaped vitrine revealing a permanently lit flame inside. The fact that Ludovica had taken communion perhaps led Bernini to set her body above the altar, rather than below, as was traditional with the remains of martyrs and saints.[22] The whole scheme does, however, generically resemble certain earlier wall-tombs which have a fresco beneath the arch above, an effigy of the deceased flanked by angels above eye-level and an altar below. The painted altarpiece surrounded by cherubim may then be interpreted as the nun's vision of the saints that she hoped so shortly to join.

199

186

Prophets and penitents for Pope Alexander VII:
Chigi Chapels in Rome and Siena

When Fabio Chigi attained the rank of cardinal in 1652, he turned his attention to his ancestral mortuary chapel in Santa Maria del Popolo.[23] Designed in the High Renaissance for the wealthy banker Agostino Chigi by no less a figure than Raphael, it had been left not quite finished because of the deaths of both artist and patron.[24] Idealized portraits of two of the deceased Chigi were now carved on marble ovals, and set on the flanking pyramidal memorials provided in the original scheme. Owing to the sloping surface of the pyramid and the height above the floor they became foreshortened into discs. With great mastery Bernini modelled in low relief – for him an unusual medium – the noble heads rising from shoulders swathed in criss-cross togas. He was also required to supply two statues to fill a pair of empty niches and to match those of Raphael's generation that stood in the other niches. *Daniel in the Lions' Den* now stands to the left of the entrance, corresponding diagonally with the extraordinary group of *Habbakuk and an Angel* to the right of the altar (the first of the four statues to catch the eye as one approaches the chapel). They form part of a single narrative, suggested to Bernini by the learned librarian of the Vatican, on the basis of a Greek manuscript in the library of the Chigi. This was

206

205

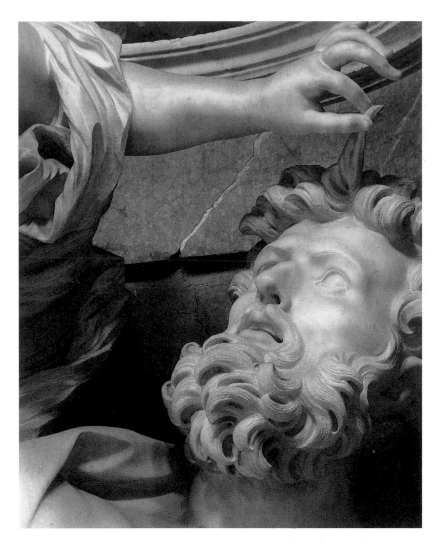

202. Detail from *Habbakuk and an Angel* (Santa Maria del Popolo, Rome): head of Habbakuk.

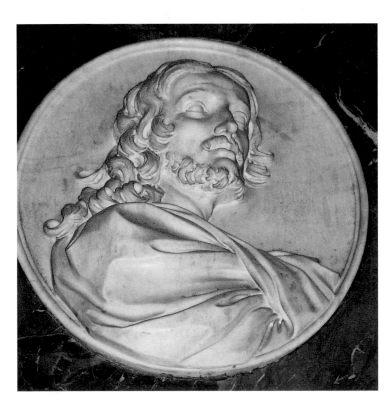

201. Relief medallion of a member of the Chigi family, (Santa Maria del Popolo, Rome).

an apocryphal supplement to the Book of Daniel, in which it was related that an angel appeared to the prophet Habbakuk when he was carrying a basket of bread to feed workers in the fields; taking him by the forelock, the angel was able miraculously to carry him and the food to Daniel. The whole story with both saints had been depicted in a single spandrel elsewhere by Carracci.

For Bernini, the physical breadth of the Chigi Chapel represents the much greater distance over which the angelic transportation took place: the charming young angel – a 204 cousin of the one appearing to Saint Teresa that Bernini had just finished carving for the Cornaro Chapel – points 193 diagonally out of the niche, across to the other figure, indicating his new destination to the amazed Habbakuk. In vain he protests that the basket of bread had been intended for others nearer at hand. While the group occupies its niche fully, it is anything but contained within it: the upper torso, left arm and wing of the angel all project well beyond its limits, as too does the forward leg of the prophet, protruding over a rock.

203, 204, 205. Bernini's terracotta *bozzetto* for *Habbakuk and an Angel* (Musei Vaticani) and (*opposite*) the finished group in Santa Maria del Popolo, Rome, with (*above*) a detail of the head of the angel.

By contrast, the Renaissance statues carved from Raphael's design by Lorenzetto in *c.* 1520 fit neatly into their niches, especially the *Elijah*, while *Jonah* protrudes only inasmuch as his right foot treads open the jaw of the symbolic whale from which he has just emerged.[25] Bernini was scrupulous in respecting the efforts of his forebear – each of which attempted to mirror the other in pose – for he would have held them to be 'by' Raphael. Particularly noticeable is the echoing of Elijah's pose – seated with legs wide apart and his right arm reaching right across his body – in that of Habbakuk, though the latter is recoiling from the angel that has alighted beside him. The head of Jonah had been inspired by classical portraits of Antinous (favourite of the Emperor Hadrian); Bernini responded by giving his Daniel the head of classical busts of Alexander the Great (as later he was to do for Louis XIV). 352, 355

The pose of Daniel is serpentine and flame-like, two 206 characteristics that had been recommended by Michelangelo. As in Bernini's first drawings for St Teresa, the dominant motif is an arrow shape pointing heavenwards, in this case formed by his hands joined desperately in a prayer for salvation. This has evidently been granted, for the lion is 207 licking his vulnerable foot quite gently, in one of Bernini's adorable vignettes of animals, on a par with the lion, horse 288, 2 and armadillo of the *Fountain of the Four Rivers*. The beast is unmistakably human in character, rather than authentically feline, in the tradition of Donatello's *Marzocco*. A series of lovely chalk sketches, seemingly an amalgam of reminiscences of antique statuary and studies from the life, experiment first

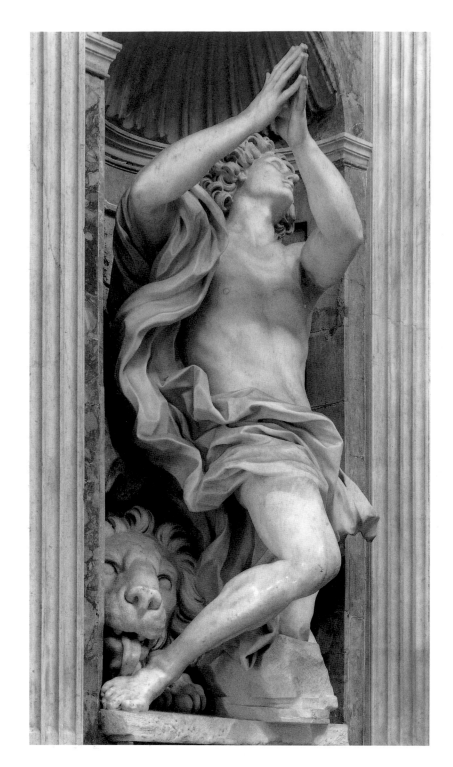

the axis of the torso and then the sharply bent leg, with its knee projecting almost aggressively into the spectator's space. Its angularity, redolent of Bernini's eternal search for *disegno*, is then softened by the gentle flutter of the cloak wrapped round his shoulder and crossing his loins, which are cleverly draped with its other end. Bernini draws dark lines on it, as with a black chalk on paper, by cutting deep grooves with the gouge chisel and then undercutting still further with the running drill to emphasize the darkest shadows.

This statue does not fit symmetrically or snugly into its niche, and, as in the case of the great papal tombs, Bernini seems to have relied on last minute adjustment to perfect his general composition. He may even have altered a logical arrangement that had been planned initially, whereby his pair of figures would have flanked the altar in the two niches that were empty at that time, and instead moved one of the Renaissance pair of statues to make way for his own, giving the final, diagonal narrative connection.

When his patron became pope in 1655, Bernini's remit in Santa Maria del Popolo was radically extended to include the embellishment of the whole church and the adjacent city gate, the Porta del Popolo. He produced a number of drawings for the new Baroque decoration of the interior of the church with stucco figures in relief of saints, angels,

206, 207. *Daniel in the Lions' Den* (Santa Maria del Popolo, Rome), and (*right*) detail of the lion's head.

378, 379 with the swaying torsion of the lithe male form and then with the crucial gesture of joined hands and their relationship to Daniel's head, ensuring its visibility.[26] In the
210 *modellino*, when seen from the front the head is fully visible over the shoulder, while when seen from below and to the left (as by a worshipper on his knees praying in the chapel) it emerges below neatly framed by the arms and hands: indeed it is caught in a virtual parallelogram of upper and lower arms bent at the elbows. These linear patterns are pursued in

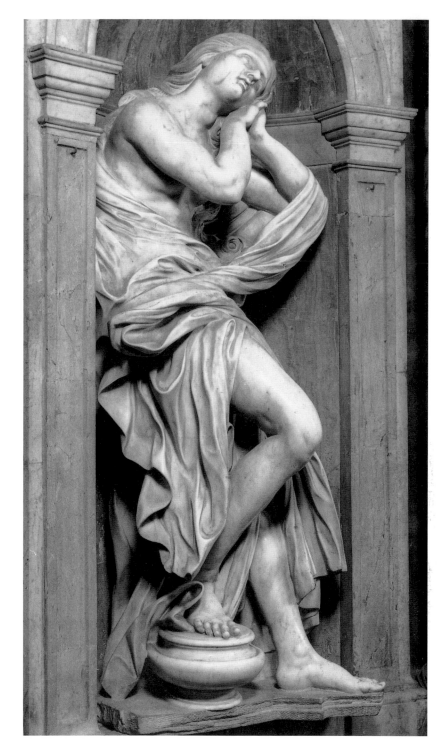

208, 209. Bernini's sketch for *St Mary Magdalene* (Museum der bildenden Künste, Leipzig) and (*right*) the finished statue in the Chigi Chapel, Siena Cathedral.

allegories and cherubim, but had to delegate all the work to his team of skilled assistants.[27] The master was by then principally occupied with the far more publicly significant project for the *Cathedra Petri*.

Alexander VII created Bernini his personal architect and in this capacity he more or less simultaneously (1658–70) designed not only three whole churches just outside Rome (discussed in a later chapter), but also a Chigi Chapel in the

cathedral of the family's native city, Siena (1659–63).[28] Situated in the southern angle between the nave and transept, the chapel is circular in plan, within the square site. It is lit by a central oculus in the coffered vault above and by several generous rectangular windows round the drum.[29] The angles between the circle and the square are occupied by round-headed niches. The two flanking the altar, with its venerated painting of the Madonna, house the most prominent local monastic saints, *St Bernardino* (by Raggi) and *St Catherine* (by Ferrata), while those flanking the door accommodate more distant hermit and penitent figures, *St Mary Magdalene* and *St Jerome*. Both were designed and carved by Bernini between 1661

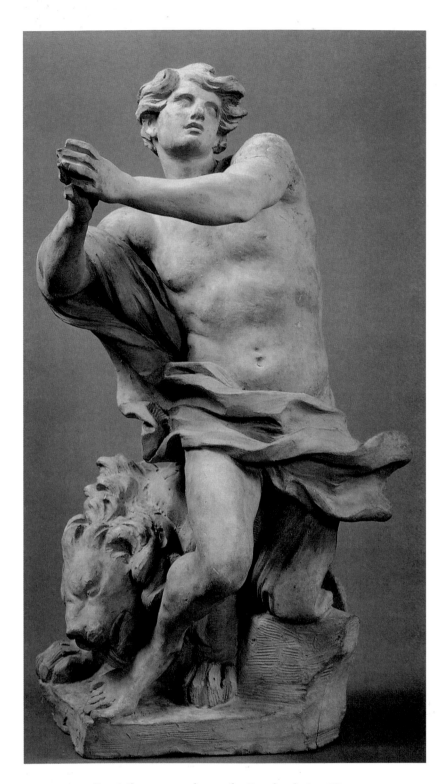

210. Bernini's terracotta *bozzetto* for *Daniel in the Lions' Den* (Musei Vaticani).

and 1663, and in June, after inspection in his studio by Pope Alexander, they were transported to Siena. The general theme of penitence was imposed because the doorway of the chapel, previously a side entrance to the cathedral, had been known as the Porta del Perdono – the 'Door of Forgiveness' – and had been open only rarely, on solemn occasions.

Bernini's figures were, as usual, carefully conceived and thought out. A bowed posture and downcast eyes conventially expressed repentance and both share these features, though they are standing, rather than (as more usually) kneeling, although each sags at one knee. Three successive, rapid 213 sketches in ink show St Jerome retaining the same stance throughout, with his weight borne on his right leg and the other one relaxed and bent on an outcrop of rock in the drawings, and in the statue on his acquiescent pet lion, curled at his feet. The principal alteration, which was to be definitive, was to open out the silhouette at the spectator's right by having the saint's left arm – instead of clasping the trunk of the crucifix to his body, as it does in the first sketch – touch very gingerly the end of its crossbar. Not only does this alteration expand the figure, but it also enables the sculptor to make both it and the cross project dramatically into the body of the chapel, over the heads of the worshippers.

In fact, the relationship of the figure to its niche, being very much a matter of three dimensions, was next studied in a clay *bozzetto*.[30] This shows how Jerome's cloak is swept by the wind – perhaps in this instance a sign of an inhospitable desert – against the edge of the niche, illusionistically overlapping it, as though it were the cave mouth of his hermitage (as it was usually depicted in the Renaissance). The preferred type of head had been established by then, and was repeated in a number of *modellini* and in a superb life-size study in clay. This is one of Bernini's most admirable models, revealing traces of his working methods: modelling tools, pointed or toothed; spatulas (for carving the basic planes of the head, most visible in the profile view, where its strokes are the same as if the sculptor had been whittling a head with a sharp knife in soft wood), and finally fingers and thumbs, for smoothing over and giving direction and flow to certain passages. The head is an object lesson in sculptural technique. So lifelike is the face that one wonders if he did not use a model; so sunken into their sockets are the eyes and so sagging are the corners of the mouth that this might be a portrait of an elderly gentleman fast asleep in a chair, or propped up in bed. Does the distinct asymmetry of the features suggest that the head might have slumped slightly to one side as he snoozed?

Expressive though the terracotta may be, Bernini still wrought changes, as ever, when he came to apply the chisel, riffler and abrasives to the surface of the marble. Some are 214 occasioned by the fact that the left cheek is now pressed

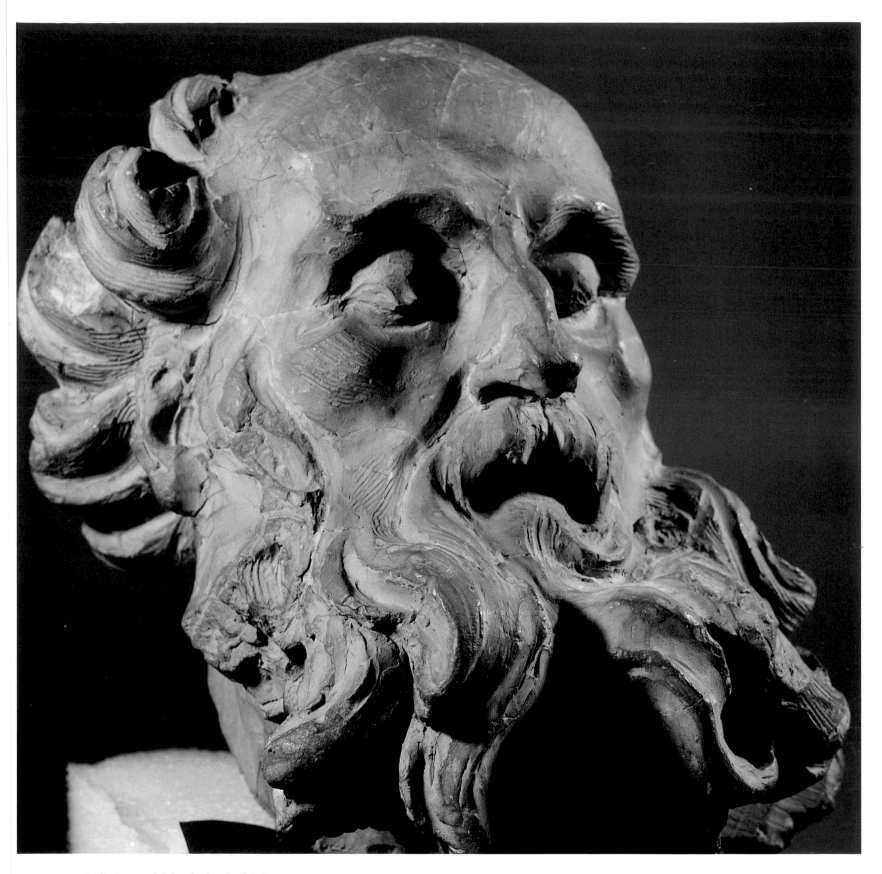

211. Life-size model for the head of *St Jerome*
(Fogg Museum of Art, Cambridge, Mass.).

215, 216. The Ponte Sant'Angelo, Rome. (*Above*) a contemporary print by Falda showing Pope Clement X crossing the bridge soon after Bernini's angels were installed and (*right*) the bridge today.

The angelic throng

Early in the papacy of Clement IX, Bernini received a commission to repair and enlarge by one whole archway the old Roman bridge that had been designed by the Emperor Hadrian as a triumphal approach from the city to his mausoleum in AD 134.[31] The mausoleum had long since been transformed into a great fortress standing guard over the approach to Rome and, just as importantly, to the Vatican. Hadrian was believed to have adorned the bridge with winged victories holding out laurel wreaths, and it was but a step from this to a series of their Christian equivalents, angels, bearing the Instruments of the Passion. This constituted a symbolic Way of the Cross (*Via Crucis*), a devotion traditionally followed by pilgrims to the original sites of Christ's martyrdom in Jerusalem. It had also been widely imitated with Stations of the Cross in shrines out of doors in Italy, usually up steep hillsides (for example the Sacro Monte of Varallo), a form of penance promulgated by the popes in the middle of the seventeenth century and so a live issue in people's minds.

A visitor to the Vatican crossing the Tiber from the centre of Rome would thus be escorted by a sacred company of angels over what had been an old pagan bridge. The river might also have been associated by the more intellectually aware with the mythical, gloomy River Styx over which, according to ancient Graeco-Roman belief, one was ferried by Charon to the afterlife in Hades. Water for Christians also has associations of purification and redemption. Christ's triumph over death and the subsequent triumph of the Holy

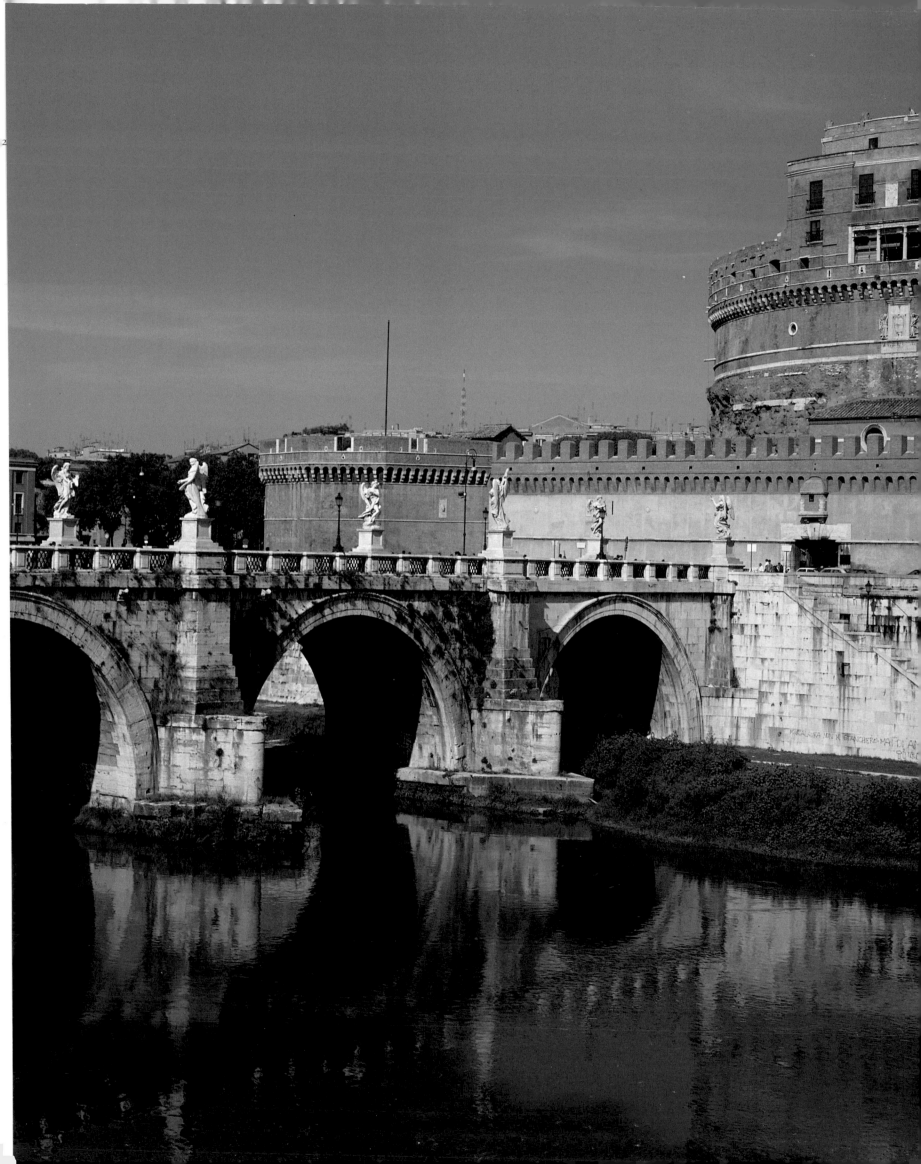

220. Bernini's *bozzetto* for the *Angel with the Crown of Thorns* (Kimbell Art Museum, Fort Worth, Texas).

221. Bernini's *bozzetto* for the *Angel with the Superscription* (Fogg Museum of Art, Cambridge, Mass.).

would give to the ankles in the final statue and so the sculptor left a substantial wall of clay behind the lower part, differentiating it from the subtly tooled and sponged legs by horizontal striations impressed with a stylus, just as on paper he would have used hatching. A model of the other angel at the corresponding stage does not survive. Indeed, once he had mastered the composition in one direction and with a mirror image in mind, he possibly felt that he did not need to go to the trouble.

The next model for the *Angel with the Crown of Thorns*, in the Louvre (not illustrated), shows the figure still attenuated, as in the pen sketch, but carefully draped. The direction of the wings is changed, while the increased torsion in the pose and the downward (rather than heavenward) direction of the angel's gaze suggests greater sorrow.

Bernini then wrought a rather surprising change in the next two successive *bozzetti* which can be appreciated easily in close-ups of the respective midriffs: he dispensed with the *contrapposto* and swung the hips instead to the viewer's right, beneath the crown. A great arc of drapery now runs almost horizontally across the stomach, which it obscures competely, and acts as a ridge of cloth supporting the forearm. Only tentatively indicated in the Kimbell *bozzetto*, it is gashed into the raw clay of the Fogg *bozzetto* quite fiercely, while the subsidiary zigzag bunches of folds at either side are emphasized by gouging out the material to leave strong shadows between the ridges that remain highlighted. A feeling of intense agitation is thus imparted to the inanimate matter. Presumably Bernini had decided to heighten the emotional pitch to the utmost that he could achieve by using his idiosyncratic patterns of rippling drapery, which keeps doubling back on itself and allows the spectator's eye no rest. In the final statue, probably during the actual process of carving, the pattern of folds was broken up into still smaller rippling units.

222–22

223

230

The Fogg *bozzetto* is seventeen inches high and makes a monumental impression. From an attentive examination it is possible to read the way in which the sculptor built up the figure from, and in front of, a pyramidal buttress of inert clay. Firing cracks between the shoulders and the wings prove that they were modelled separately and added on: indeed, the angel's left wing has fallen off at the point of attachment and left a scar. The inside of the surviving wing bears the imprints of Bernini's thumbs, as he worked a thick sheet of clay into the rounded and concave form and pressed it on to the back. He used a stylus to mark the central point of the pit of the neck, as a guide to anatomical accuracy and symmetry, and he defined creases in flesh or fabric with it, as well as excavating shadowy holes, for example beneath the right armpit. The crown of thorns at this stage was simply a cylinder of clay rolled between the fingers and joined into a

222. *Angel with the Crown of Thorns*, first *bozzetto*, detail (Fogg Museum of Art, Cambridge, Mass.).

223. *Angel with the Crown of Thorns*, second *bozzetto*, detail (Fogg Museum of Art, Cambridge, Mass.).

circle, and looks rather like a pretzel. Pellets of clay were touched on to the surface of the well-formed cranium to represent locks of hair and thus animate the silhouette: they give a fair impression of the general flow of locks about the face on the final marble carving.

From the moment of conception, as we have seen, Bernini thought of his two statues as a pair, endowing them with equal and opposite poses and gestures. At a relatively early stage, however, realizing that they could never be appreciated as a pair on the bridge, he decided to depart from strict symmetry and allow the hips of the *Angel with the Crown of Thorns* to swing in the same direction as those of the *Angel with the Superscription*. Both therefore ended up with their right legs advanced and bared of drapery; the drapery is blown upwards by an undercurrent of wind as the angels alight on their puffs of cloud along the pedestals on the bridge. There is no *bozzetto* of the second angel in the nude, but thereafter, there is a steady progression of preliminary models more or less in tandem, starting with the pair in the Kimbell Art Museum. Here, the *Angel with the Superscription* is posed as in the two sketches, though its musculature is not greatly developed. The focus of attention is on the curves of the scroll that the angel is attempting to unfurl and on the development of the patterns of drapery above and below the single swirl that had

been adumbrated in the left-hand sketch: this now forms an X-shape against a number of ridges flowing in parallel down towards the right and into a sinuous, flicked-up tail.

This scheme was evolved in a *bozzetto* in the Fogg Museum of Art (not illustrated) that has been gravely damaged: the left-hand diagonal now seems more like a girdle and, although the angel's bare right leg is missing, the musculature of the left arm extending across the chest is more thoroughly explored. In what is perhaps the next model in the series, that in Palazzo Venezia, the folds above the belt are enriched and tumble down to hide it completely, while there is a general increase in sinuosity all over the surface of the figure, which now virtually disappears beneath this welter of autonomous drapery. In the succeeding model, in the Fogg Museum of Art, Bernini evolved, in parallel with what he was doing with its companion figure at the same stage, a boldly upward floating flange of drapery to replace, or at least to disguise, the diagonal girdle. Starting from a point over the hip to the viewer's left, the folds fan out across the stomach and loins in a coherent pattern, and this motif survived into the finished statue. The drapery now works particularly well from a viewing point to the left of the figure, whence one can follow the rich curves of bunched folds running behind the bare leg and whiplashing back at the right.

This is one of the most attractive of all Bernini's *bozzetti*: it projects forward from a tapering buttress of clay which he differentiated by striating it with a toothed tool, and he modelled the figure mostly with his fingertips, whose prints can be descried all over the areas of flesh. The toes meanwhile are slashed out with a stylus from an abstract form of foot,

and the same tool was employed to great effect in gouging out rivulets to define the sinuosity of the windswept patterns in the drapery which terminates in an intriguing spiral at the lower right. These linear details stand out in sharp contrast to the plain, curving surfaces of the scroll and inside surfaces of the wings: from an aesthetic point of view, one might prefer the effect of variety in this model to the uniformly agitated surface of the final statue in Sant'Andrea delle Fratte, which is almost overdone. The totally free right leg is also a leitmotif of this composition when viewed from the right, becoming still more apparent in the second version, as it stands in the full light of day on the bridge.

What may be classed as *modellini* for the pair of statues, on account of much additional detail, are to be found among the Farsetti Collection in the Hermitage, but their precise status is not yet generally agreed. On the basis of these, or similarly detailed but lost models, Bernini and his son Paolo carved the final statues: it is questionable whether the master needed to make a full-scale *modello* at this point, as he was going to carve the blocks in person, rather than delegate. When it came to the surface treatment, he employed every skill at his command: the marble is finessed, or as he might have said caressed, into perfection. He feathered the yet more pronouncedly S-shaped wings, undercut the curly locks of windswept hair, excavated marble patiently and daringly with a drill from between the spiny twigs of the crown of thorns, and matted the surface of the curlicues of cloud below. All these features serve to enrich to the utmost degree the finished work and its pair as well.

On seeing such bravura the patron was duly impressed, as Baldinucci relates:

226. *Angel with the Superscription*, fourth *bozzetto* (Fogg Museum of Art, Cambridge, Mass.).

227. *Angel with the Crown of Thorns*, *modellino* (State Hermitage, St Petersburg).

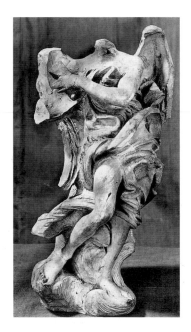

228. *Angel with the Superscription*, *modellino* (State Hermitage, St Petersburg).

229. *Angel with the Superscription*, *bozzetto* for the replacement statue actually on the Ponte Sant'Angelo (State Hermitage, St Petersburg).

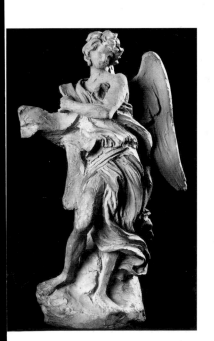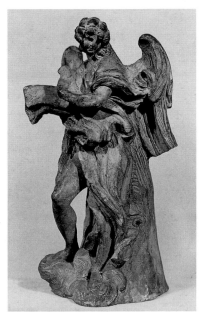

224. *Angel with the Superscription*, first surviving *bozzetto*, paired with plate 220 (Kimbell Art Museum, Fort Worth, Texas).

225. *Angel with the Superscription*, third *bozzetto* (Museo di Palazzo Venezia, Rome).

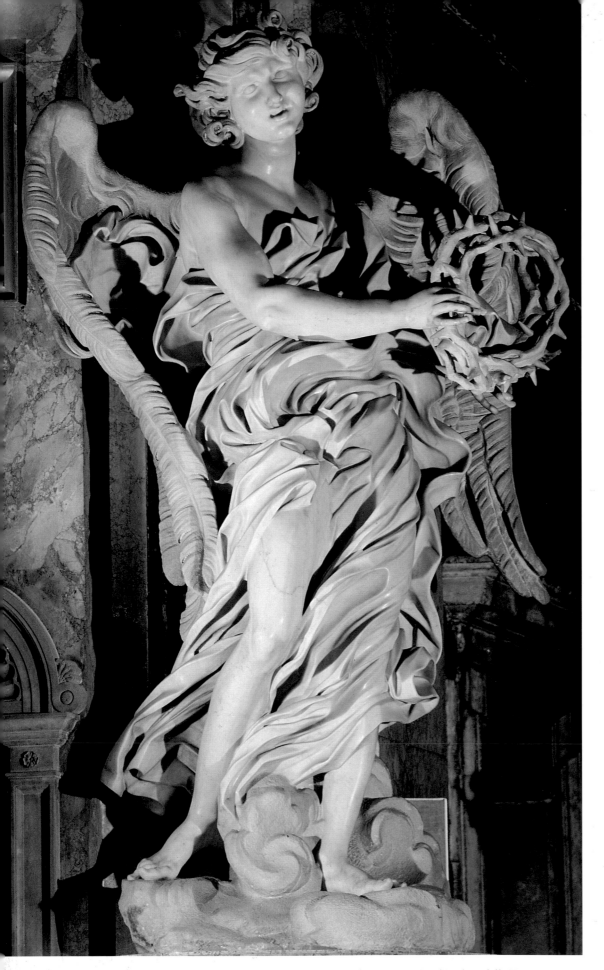

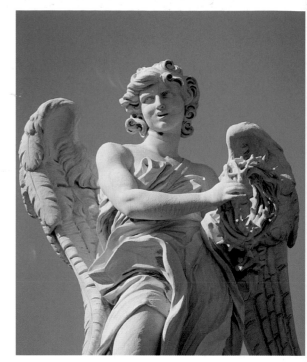

231, 232. Copies of the *Angel with the Crown of Thorns* and the *Angel with the Superscription* on the Ponte Sant'Angelo, Rome.

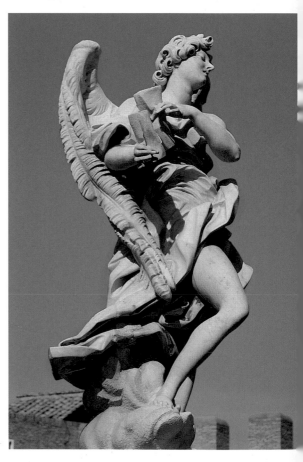

230. *Angel with the Crown of Thorns*: Bernini's original version in Sant'Andrea delle Fratte, Rome, later replaced by a copy on the Ponte Sant'Angelo.

233. *Angel with the Superscription*, Bernini's copy with variations on the Ponte Sant'Angelo, Rome.

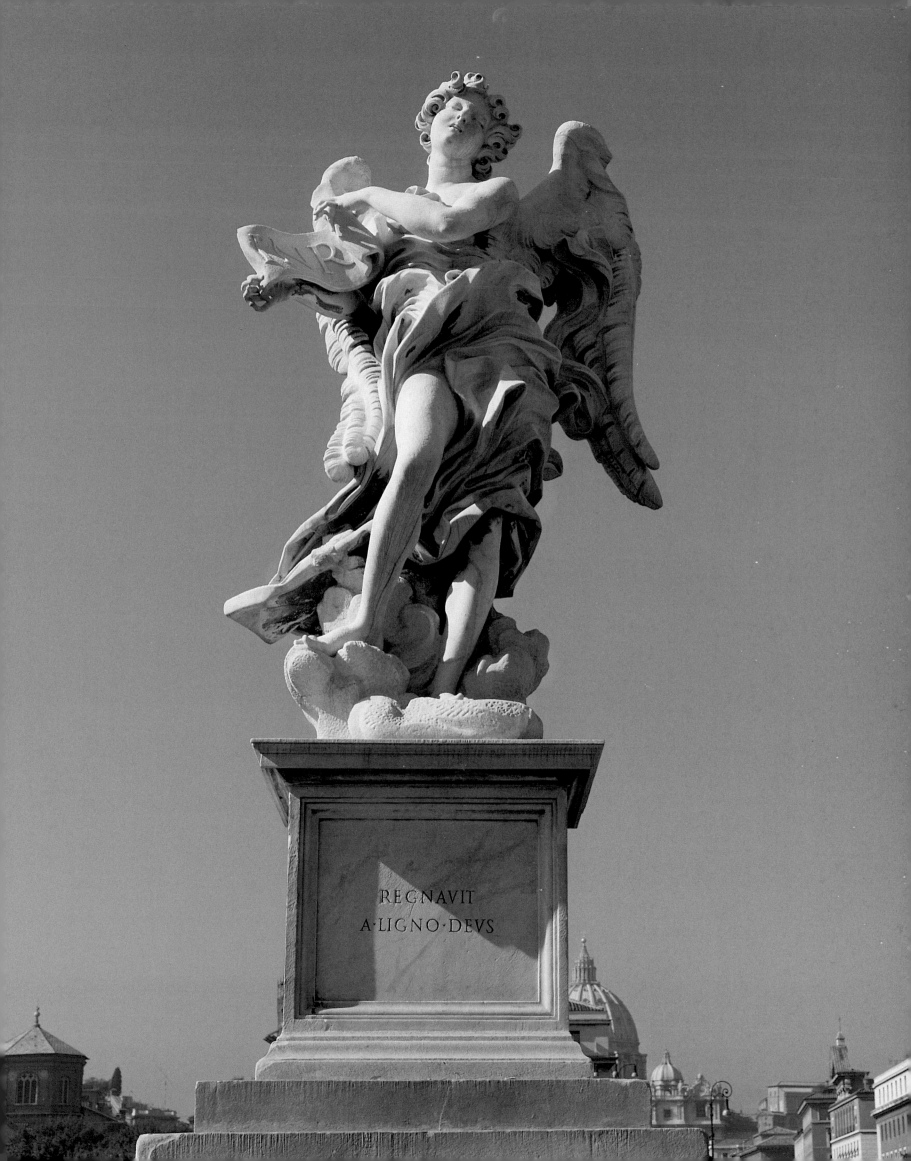

REGNAVIT
A·LIGNO·DEVS

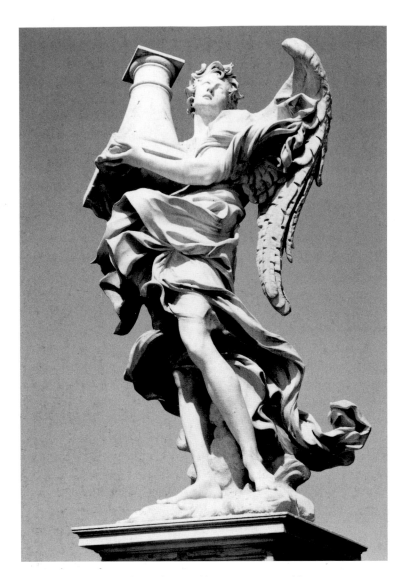

234. *Angel with the Column*, designed by Bernini, carved by Antonio Raggi on the Ponte Sant'Angelo, Rome.

But it did not seem right to Pope Clement that such beautiful works should remain there exposed to damage from the weather. Therefore he had copies of them made. The originals were placed elsewhere at the disposal of the cardinal-nephew. Nevertheless, Bernini carved another angel secretly, the one with the superscription, so that the commission for the Pope, to whom he owed so much, would not be without some work by his hand. When the Pope learned of it, although he was very pleased, he said, 'In short, Cavaliere, you wish to compel me to have yet another copy made.'

Even though this gave Bernini an opportunity to revise and physically to strengthen the compositions, modelling the surfaces more broadly and undercutting the statues less deeply, they have indeed suffered from weathering over the last three centuries, whereas the originals are preserved in mint condition in Sant'Andrea delle Fratte, Bernini's parish church.

When it came to making the copies commanded by Pope Clement, the sculptor Naldini was engaged to carve a simplified version of the *Angel with the Crown of Thorns*, but

231

Bernini himself, while giving the credit to Giulio Cartari, actually remodelled and carved much of the second *Angel with the Superscription*, for the reason Baldinucci explained. In a fresh model, now in the Hermitage, he introduced one or two significant variations in the drapery, designed to strengthen the undercut figure against the elements. The main bulk of the skirt now flies out to the left, behind the exposed leg, thus reinforcing the statue considerably with a mass of marble disguised as rising clouds and drapery. He also introduced a strut to strengthen the wing to the right, disguising it too as a tail of drapery swept upwards against the feathers, as if by a thermal current.

232, 233

229

Bernini's contribution to the success of the whole series, embodying a measure of diversity within an overall uniformity, may be gauged by examining his drawings and one surviving *bozzetto* for a work executed by a junior, the *Angel with the Scourge*, and one of the most graceful of the other statues, the *Angel with the Column* by Antonio Raggi. The *bozzetto* when seen from the right might almost be for Raggi's angel, so similar is the basic zigzag pose of the figure, with tilted head and sharply projecting, undraped, knee, ensconced within the generous curve and counter-curve of the wing and sweep of drapery. Bernini's expert manipulation of a lump of moist clay into the semblance of an alert human figure in clinging drapery, the ends of which are delightfully flicked by a breeze, could not be better demonstrated than in the lower part of this *bozzetto*. Raggi's statue is so close in style to his master's, and even more daringly undercut, if that is possible, that it seems scarcely credible that it is not by Bernini himself.

No doubt because Clement, for once in Bernini's career, made a tidy sum of 10,000 scudi available at the outset in November 1667, and also because of the advanced age of both patron and artist, this project was pushed through expeditiously and 'by the book'. Eight, and later ten, blocks of flawless white marble were ordered and conveyed in a rolling programme to the studios of the various subcontracting sculptors. Bernini must have produced the amazing sequence of drawings and models for his own and the others' statues in a frenzy of activity through that winter, for in mid- to late 1668 all eight carvers were set to work in quick succession (the last beginning in January 1669). Bernini's own pair of statues was completed by June 1669, for one month later, following the papal interdict against wasting them outside, the first block for one of the copies was on order. By June 1670, both were nearing completion, though one still lacked its wings, which were to be carved from separate pieces of marble and dowelled on. In October 1671, the copies were added to the other eight, which had been installed on the bridge for some time, five indeed by the date of a papal inspection on 21 September 1669.

For over-life-size statues of such ingenuity of design and complexity of carving, a production schedule of two years or under was very respectable indeed. The rapid delivery of the series in so short a span was virtually unprecedented and is a tribute to Bernini's powers of organization, especially when a team of eight different personalities was involved. Sadly, Pope Clement did not live to see the whole series *in situ*, but so pleased had he been with the progress made that he commissioned two commemorative medals showing it complete: one struck by the master of the papal mint, Alberto Hamerani, showing the bridge in perspective with Castel Sant'Angelo looming in the background,[38] and another cast, because it was of unusually large size and so had to be modelled in wax, from a young French medallist, C. J. F. Chéron (1635–98). This was Chéron's public début and is generally accounted a masterpiece among cast medals. It made his name, with its extremely sensitive portrait of the aged Clement (with which he may even have been helped by Bernini) and a charming reverse, showing the bridge with all twelve statues, while Fame trumpets in the sky above and Father Tiber reclines contentedly in the foreground, and nearby the she-wolf suckles Romulus and Remus. Chéron went on to portray, after the painters Pietro da Cortona and Carlo Maratta, Bernini himself (1676), at the behest of their later, mutual, patron, King Louis XIV.

397

235. Chéron's commemorative bronze medal: the reverse.

The last portrait busts

The heightened religious emotion that the contemplation of such all-embracing works of art as the Cornaro and Albertoni Chapels were supposed to engender is usefully represented by a half-length figure of a layman gazing in rapture at an altar, as though at a vision, which Bernini had carved a few years earlier. This was a portrait of Gabriele Fonseca, a Portuguese doctor who had attended Pope Innocent X until 1654 and who about a decade later seems to have commissioned a whole chapel design from Bernini.[39] He was shown as though leaning and looking into the chapel through a square aperture (alongside his wife, who was carved by another hand). His gaze is focused on the Eucharist on the altar. Above is an oval altarpiece, in a black marble frame with gilt mounts, carried by bronze angels in high relief, while zigzag rows of jubilant cherubim in stucco lead up from the altarpiece and crowd the vault above. Fonseca is richly clad in a fur-lined robe, the turned edges of which form rich loops down his front and round his wrists. He is anxiously clutching a rosary in his right hand, resting his forearm for comfort on the edge of his cloak along the parapet, while he begins to recite, 'Hail, Mary, full of grace, the Lord is with thee . . .'. His knuckles would in reality be white with tension, just as they appear in the marble. His left hand is pressed emotionally to his heart, a gesture of belief, its bony fingers pressed deeply into the folds of his robe and its fur border. His head juts forward, its brow wrinkled with wide-open eyes focused on the altar. In his will Fonseca besought Mary and her angels in heaven to intercede for him.[40] This is one of Bernini's most convincing and endearing portraits: Fonseca must somehow have impressed the sculptor as a fellow-spirit and from this image we surely know how earnestly Bernini prayed for his own salvation at his frequent masses. Theatrical it may be, but it is deeply expressive for all that.

236, 238

Bernini's personal spirituality was deepening with old age and he gave expression to it not only in sculpture but in a number of drawings of saints such as Jerome, Magdalen and Francis doing penance before crucifixes. The fluid sensitivity of the sharp outlines in pen is characteristic of his late style of drawing. One of the finest compositions that he produced around 1670 was a *Vision of the Blood of the Redeemer*. It graphically illustrates a vision of Maria Maddalena dei Pazzi, a Florentine mystic of the sixteenth century, who had been canonized in 1669 by Bernini's patron, Pope Clement X.[41] This was published in an engraving and also painted on a canvas that Bernini kept at the foot of his bed until his dying day. It shows a crucifix floating in mid-air with God the Father above, the Virgin Mary lower left and an angel hovering to the right. But what is extraordinary and most moving is that blood is streaming from all of Christ's wounds

390

237

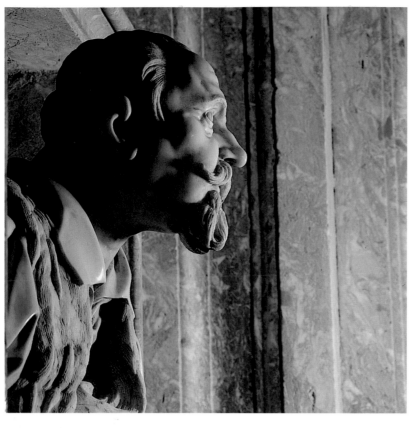

236, 238. Memorial bust and detail of Gabriele Fonseca (San Lorenzo in Lucina, Rome).

into a boundless sea below. Two spurts from the lance wound in his side are caught by Mary in her outstretched hands, to be offered in turn to God the Father in supplication. The drawing was acquired by Queen Christina of Sweden. A convert to Catholicism, she had abdicated her throne and moved to Rome, where she was of course embraced with enthusiasm by the papacy and held court as a patroness of the arts and an important collector.

Indeed, it was to her that Bernini bequeathed his last, deeply religious work, as Baldinucci relates:[42]

Bernini was already in the eightieth year of his life. For some time past he had been turning his most intense thoughts to attaining eternal repose rather than to increasing his earthly glory. Also, deep within his heart was the desire to offer, before closing his eyes to this life, some sign of gratitude to Her Majesty the Queen of Sweden, his most special patron. In order, therefore, to penetrate more deeply into the first concept and to prepare himself better for the second, he set to work with the greatest intensity to create a half-length figure, larger than life-size of Our Saviour Jesus Christ. This is the work that he said was his favourite and it was the last given the world by his hand. . .[43] In this divine image he put all the force of his Christian piety and of art itself.

Bernini chose a half-length format for this most sacred representation that he intended would crown his career. In this respect its roots lie in the busts of a few years earlier —

those of Fonseca and Pope Clement X Altieri that he had worked on personally in 1676.[44] The latter was a departure from his previous busts of popes inasmuch as it showed Altieri half length, including both hands, the left clutching a papal bull and the right raised and open, as though to impart a blessing. It is carved in deep relief and was not brought to completion because of the subject's death on 22 July. Bernini left it to Altieri's nephew Cardinal Paluzzo. As with the unfinished works of Michelangelo, it is of great technical interest, for it manifests various stages of carving prior to the final few that are normally visible.[45] The dramatic form of half-length figure had been explored years earlier in the portrait of Cardinal Bellarmine in prayer, and was to provide Bernini with the motif (*invenzione*) of his bust of Christ, also unfinished, this time owing to the sculptor's own infirmity. Perhaps the very fact that the Altieri image was promising, but had had to be aborted owing to circumstances beyond Bernini's control and so was not widely known, encouraged

381–383

92

237. *Vision of the Blood of the Redeemer*, engraved version of a painting by Bernini illustrating a vision of Maria Maddalena dei Pazzi.

240

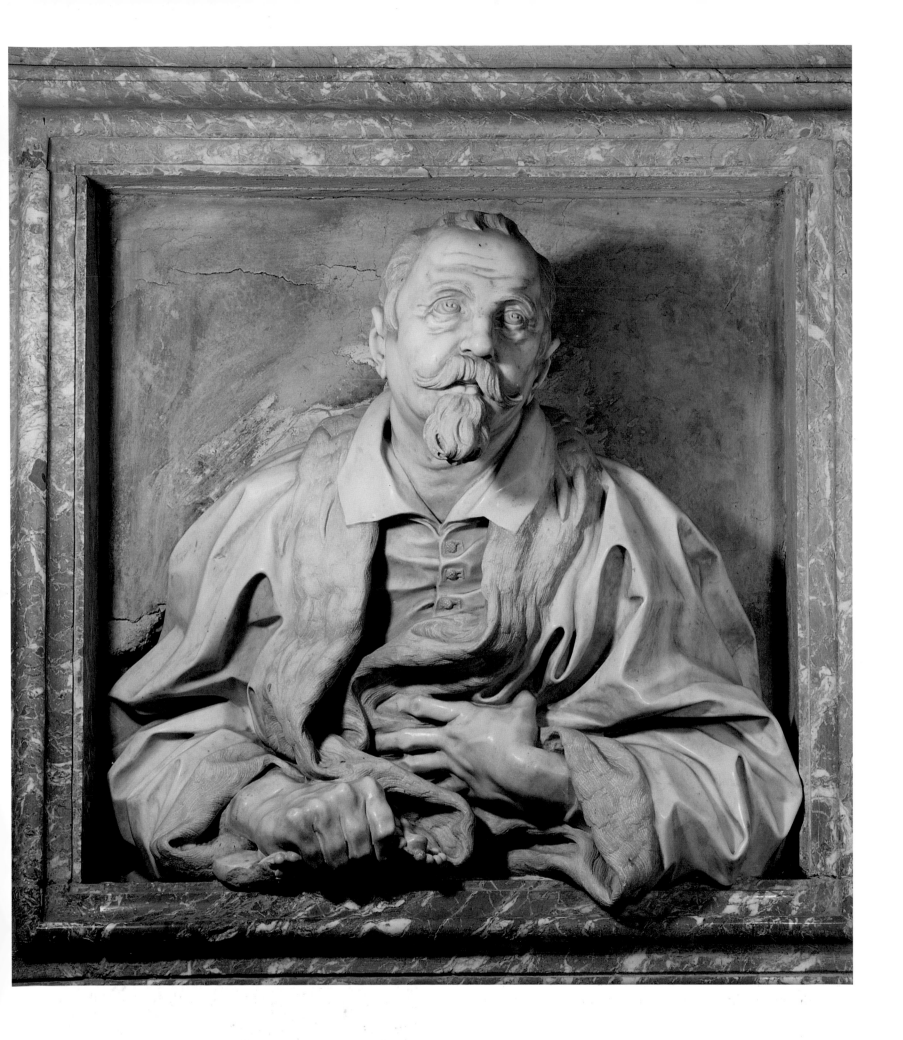

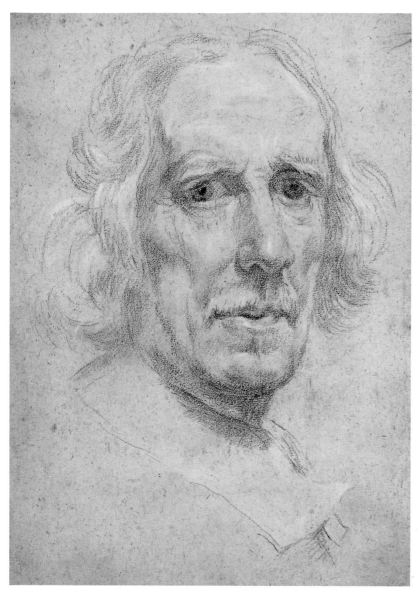

239. Self-portrait by Bernini (Royal Collection).

intention. Indeed, Domenico Bernini felt obliged to write defensively of it, claiming that its bold conception compensated for the weakness of his father's wrist when carving. One can easily imagine the dying sculptor being determined, but physically unable, to finish the sculpture with his own hands, as he had still been able to do three years earlier with the bust of Clement X. He had presumably made a model in clay, which he could still manage. It probably had the brilliance of a late self-portrait of which only the head survives.[46] But when it came to carving the block of marble his powers simply deserted him. He was never one to admit defeat and with the obstinacy of old age he probably called in an underling to block out the bust, not wishing to delegate to a qualified sculptor who would then stand to gain the credit!

Though the block is a yard wide, it is only about one foot deep, and so the image is a relief and not a sculpture in the round. Accordingly the front could not be excavated as deeply or excitingly as Bernini might have wished. He would have had to suggest recession into depths illusionistically, and it is in this respect perhaps that the final effect falls short. The forearm in actuality runs across the frontal plane and the hand is of course within the thickness of the slab. It is turned sideways as though emerging from the sleeve and is carved well, with delicately defined fingers: this passage may be Bernini's own work. Indeed the view of the bust from three quarters to the right (when the face is in profile to the left and the palm of the hand is frontal) is, in its present state, arguably the best. The palm is then in shadow, which emphasizes its soft gracefulness, while the luxuriant hair with deeply undercut divisions into ringlets is seen to best advantage. The comparative flatness that mars the frontal aspect is minimized.

The gesture of Christ's hand, his upturned, solemn face, the eyes (staring as in a vision) and the pathetic hand (seemingly warding off some evil) suggest that Bernini was thinking of Jesus on the Mount of Olives on the eve of the Crucifixion, when he prayed to God to be spared:[47] 'Father, if thou art willing, remove this cup from me; nevertheless, not my will, but thine, be done.' Then the vision that Christ is seeing could almost have been Bernini's own *Vision of the Blood of the Redeemer*.

The bust was made to tell from a distance and to be seen from below. Bernini designed a seven-foot-high pedestal to distance it from prying fingers, as he had done in the case of the bust of Louis XIV.[48] Made of richly carved giltwood, it supported a pair of kneeling angels on top, who in turn held it aloft on a socle of Sicilian jasper, the same mottled blood-red colour (with all its associations) that Bernini had used for the cloths of state or palls in his Tomb of Alexander VII and the Chapel of the Blessed Ludovica Albertoni. This system of support assimilates the bust with a reliquary or a sacramental

the elderly sculptor to adapt the idea to the most sacred figure of all.

Unlike his famous predecessors Michelangelo and Bandinelli, who in later life had both made a *Pietà* to decorate their own tombs, Bernini chose a more positive image of Jesus. A drawing in chalk explores the gesture of his right arm and concomitant play of drapery: it is brought across the chest and turned palm outwards, though not in a distinct sign of benediction, while the left one is laid over his heart. Then, at the right, he sketched the Saviour's head framed in softly spiralling hair, giving it penetrating eyes (whose pupils are emphasized in circles of chalk), a closed mouth and a forked beard.

The bust, which has only recently been identified, perhaps owing to a distinct lack of Berninesque bravura in the handling, has unfortunately not been endowed with the gentleness that in the drawing was clearly its creator's main

tabernacle, recalling several of his early projects for the Altar of the Blessed Sacrament in St Peter's.

That great expert on the Baroque, Anthony Blunt, eloquently summed up this aspect of the sculptor's achievement:[49]

In these late works Bernini makes as full use of illusionism as in his earlier days, but to a more specific purpose. The marble sheets of the bed on which lies the Blessed Ludovica make the spectator grasp the reality of the scene and hence of the Beata's ecstasy, and they carry the event into the world of those standing in the chapel. The rendering of muscular tension in Fonseca's hands convinces us of his penitence. The cross floating unsupported over the ocean of our sins expresses the miraculous character of the salvation which is the theme of the composition. In his early days Bernini may have pursued illusionism for its own sake – deception as an end in itself – but in these last works it has a much more serious purpose: to express a deep inner conviction of a particular kind of religious truth.

240, 241. Bernini's bust of Christ (Chrysler Museum, Norfolk, Virginia) and two preliminary sketches (Galleria Nazionale, Rome).

9 * 'Friend of the waters': Bernini's Roman fountains

'UN AMICO DELLE ACQUE', Bernini once declared himself and a friend indeed he proved to be with his incredibly imaginative repertory of fountains. Fountains were the principal means whereby he left his mark on secular Rome. By the precise positioning and specific design of fountains he articulated both Piazza di Spagna and Piazza Barberini (prior to its aesthetic destruction by modernization) as well as, most importantly, Piazza Navona, which he transformed into one of the principal attractions of Rome. Pope Innocent X, no admirer of Bernini, on seeing a preliminary model for the *Fountain of the Four Rivers* in Piazza Navona was forced to concede, 'The only way to avoid executing his works "is not to see them', and thereupon commissioned the monumental version.

By Bernini's day the sculptural fountain already had a long history. During the early days of the Renaissance both Donatello, with his *Judith and Holofernes*, and Verrocchio, with his *Cupid and a Dolphin*, had boldly designed bronze sculptures as the centrepieces of marble fountains, destined respectively for the Medici Palace in Florence and for the Medici villa of Careggi. In the middle of the sixteenth century, Tribolo had designed two still more splendid fountains crowned with bronze sculpture for the garden of Duke Cosimo's new villa, Il Castello, outside Florence: these are classic examples of the cylix type of fountain, which has a central stem, with *tazze* of diminishing size extending from it. The bronze sculptures at the apex were piped within their hollow castings to emit water, giving added meaning to the actions of the figures and contributing to the general display.

An alternative type of fountain, often with a colossal marble statue at its centre, which could not so easily be piped for water, also emerged. Montorsoli's *Fountain of Neptune* for Messina was the prototype, soon to be followed by those with the same aquatic theme in the city centres of Florence (by Ammanati) and Bologna (by Tommaso Laureti and Giambologna, whose *Neptune* was cast in bronze, but not piped). Fountains were also installed in grottoes, and were sometimes given the appearance of springing out of the living rock: the Florentine gardens of Boboli and Pratolino were enlivened with many such — frequently humorous —

displays. These were often combined with trick 'wetting games', whereby sprays of water (controlled by a secret tap) would unexpectedly rise from a pebbled floor to soak spectators from below. Early Grand Tourists such as Montaigne and Evelyn were much taken with the hydraulic ingenuity and frivolous impertinence of such devices. A colossal half-figure, seemingly concealed by an islet in a pond with a spray of water continually bathing his head, was the essence of Ammanati's *Fountain of the Appennines* at Il Castello; its lineal successor, *The Appennine*, the amazing colossus built at Pratolino by Giambologna in the 1580s, was big enough to contain rooms and even a grotto within its enormous frame.

Towards the end of the sixteenth century, the whole range of such light-hearted, even if quite intellectually conceived, fountains was pressed into service in the gardens of the villas of the great papal and noble families around Rome, most notably at the Villa d'Este at Tivoli and the Villa Aldobrandini at Frascati. Bernini must have been quite familiar with these since his infancy, innocently enjoying their mechanical devices such as water organs or birds that ceased their twittering when an owl suddenly hooted. Perhaps through his Florentine father, Pietro, he seems also to have been well aware of contemporary developments in the Grand Duchy of Tuscany, where the Medicean court sculptor Pietro Tacca was following in Giambologna's footsteps in the design of ever more weird and wonderful forms.

It was therefore with a joyous and vivacious tradition of 'fountaineering' that Bernini was to identify himself when he was commissioned to introduce displays of water from the newly restored aqueducts into the private villas and public places of Rome. A vast repertory of ideas for fountains existed, and, when Bernini wished to add a distinctively personal contribution, he did not always find it easy to choose between the various attractive possibilities, as one can sometimes see in the sheets of quick sketches he made as he worked through a number of permutations of a concept. Bernini believed, according to Baldinucci, that 'the good architect when designing fountains should always give them some real meaning, or at least one that alluded to something noble, whether real or imaginary'. Furthermore he maintained that 'seeing as fountains are made for the enjoyment of water, they ought always to be made to play in such a way that it is readily visible'.[1] A rapid sketch for a rather simple fountain made in 1658 to play in front of the church of Santa Maria in

242. Head of Neptune from the fountain of *Neptune and Triton* (Victoria and Albert Museum, London).

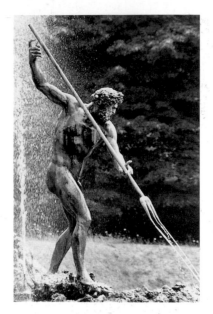
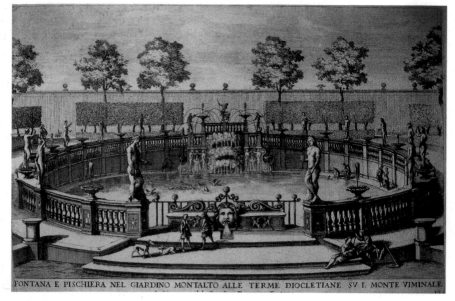

FONTANA E PISCHIERA NEL GIARDINO MONTALTO ALLE TERME DIOCLETIANE SV I MONTE VIMINALE

243. A sixteenth-century prototype for Bernini's figure of Neptune: Stoldo Lorenzi's bronze figure in the Boboli Gardens, Florence.

244, 245. Two early engravings of Bernini's *Neptune and Triton*, the first showing its setting in the garden of the Villa Montalto, Rome, the second showing water spouting from Triton's shell.

306 Trastevere exemplifies precisely the importance that Bernini accorded to the role of water, displaying its capacity to fall prettily and forming a vital element in the design of the whole.

The fountain of Neptune and Triton

Bernini benefited from a dress rehearsal for his public fountains, insofar as he had early in the 1620s set his marble group of *Neptune and Triton* – which may also be seen as one of his great series of mythologies – above a fountain designed like a cataract and set over a huge sunken fish-pond (*peschierone*), designed in 1579–81 by Domenico Fontana in the newly laid-out gardens of the Villa Montalto. It was commissioned not long before his death in June 1623 by Cardinal Alessandro Damasceni-Peretti Montalto, who had inherited the villa from Pope Sixtus V. There is some dispute over whether the subject is derived from Ovid's *Metamorphoses* (i, 330–42), where Neptune calms the deluge wrought by Jupiter and summons Triton to blow on his conch as a signal for the flood waters to recede,[2] or – as has traditionally been accepted – from Virgil's *Aeneid* (i, 133 ff.).[3] In the latter source, Neptune, wishing to protect Aeneas, orders the winds whipped up by Juno to be still. The original setting, long since destroyed, is known from an engraving that shows the statue mounted on a pedestal in the middle of a balustrade flanked by two plain cylix fountains and a pair of subsidiary statues of Orpheus and Mercury. The whole complex was bound together visually by a fine mesh of parabolic sprays of water, providing both a linear and a kinetic effect.

Since it was carved in marble, only the figure of Triton at the base could be made to spout water. The group was evidently mounted sideways to the pool across which it was to be seen, for Neptune's right arm raised with the shaft of his trident is shown in dramatic silhouette to the left. The same view was also chosen by Dorigny for his engraving of the statue in close-up, which also indicates the jet of water from Triton's conch. This orientation would have enabled spectators who walked around the pool eventually to see the triumphant frontal view of the group, and not just its side and reverse views. The front view was deliberately defined by the central nodule at the hinge of the shell and from this angle the tail of Neptune's windswept cloak assumes as a visual pun (a *scherzo*) the form of a stylized dolphin's head. However, the absence of a rectilinear front to the base encourages the spectator to move round the smoothly oval periphery of the shell, in order to enjoy a sequence of attractive views of the group, as does many a sculpture by Giambologna from the preceding age of Mannerism.

This statue demonstrates Bernini's knowledge of a much earlier rendering of Neptune which is in the Boboli Gardens, Florence: cast in bronze by Stoldo Lorenzi and dating from 1565–8, Neptune is similarly posed, threatening the rebellious winds and waters with his trident.[4] The idea of Triton with bifurcating fish tails replacing human legs may have been inspired by the four similar marble figures carved by Lorenzi. These were designed to crouch as caryatids beneath the spreading basin of his original fountain, but now lurk anachronistically in rocky caverns in the islet on which Neptune stands.

The motif of Triton blowing a conch, derived from Ovid's account of the great flood, had also been employed by Battista Lorenzi for a marble fountain carved in Florence during the early 1570s which was sent shortly afterwards to Palermo for the garden of the Viceroy's Palace.[5] Probably through his father, or perhaps from drawings or small bronze

246. Polidoro da Caravaggio: *Neptune*. Engraving by Goltzius after a lost fresco.
247. Fragmentary *modellino* of the figure of Neptune (State Hermitage, St Petersburg).

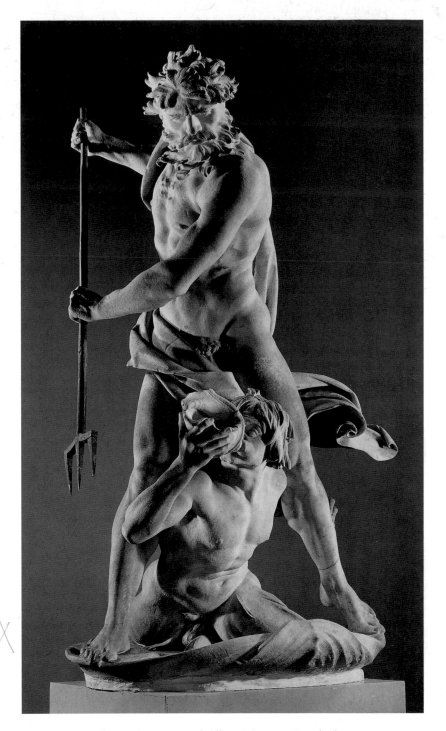

248. *Neptune and Triton* (Victoria and Albert Museum, London).

versions,[6] this fountain seems to have been known to Bernini for it was certainly influential on his own later *Triton Fountain*, even down to the type and shape of the enormous conch. Other prototypes for a Triton blowing on a shell for a horn and kneeling within a shell – a motif that Bernini also borrowed – are to be found in the basin of Giacomo della Porta's fountain of 1574 at the southern end of Piazza Navona, the Roman piazza which Bernini was later called upon to enhance with a splendid centrepiece.[7] The way in which Triton is placed between the widespread legs of Neptune, thus creating a conical spiralling composition, also inevitably recalls Giambologna's group of *Samson Slaying a Philistine* that had also been set over a fountain in the grounds of the Casino Mediceo in Florence in 1569, but had been exported to Spain in 1601. Similar though it is to the finished statue, a fragmentary *modellino* of the torso and spiralling drapery which survives in the Hermitage seems to show greater torsion, with the god's right arm raised higher, as in the *Samson* by Giambologna.

Neptune's wildly tousled hair and beard, which brilliantly convey the effect of the storm that he is quelling, together with his stalwart pose and the windswept cloak billowing around him, recall a fresco of Neptune by Polidoro da Caravaggio that Bernini would have known in the original, and which was also recorded for posterity in an engraving by Goltzius in 1592. In his rendering Bernini adopted Polidoro's front view as one of the main diagonal views from the left.

Thus, Bernini's achievement in his *Neptune and Triton* was not so much originality, as an artful amalgamation of a number of ideas received from diverse sources into a homogeneous composition, whose firm conical structure is enlivened by an open silhouette; it is punctuated by a skilfully balanced series of protrusions of limbs, accoutrements and drapery into the surrounding space, which its protagonist thus seems to dominate both physically and psychologically. This places the *Neptune and Triton* triumphantly at the apogee of the Florentine tradition of sculpted groups with two figures involved in action that encompasses Donatello's *Judith and Holofernes* (*c.* 1460), Michelangelo's *Victory* and his unrealized compositions of the 1520s, and Giambologna's *Samson Slaying a Philistine* of 1562.

The later history of the Neptune group is of interest. So highly regarded was it, that some fifty years after it was installed, it was removed inside the villa in order to preserve it from further damage from the continuous spray of water and the weather.[8] Perhaps at this juncture moulds were taken and a plaster cast made, which later entered the Farsetti Collection and went to Russia, where it was last recorded in 1871 in the collection of the St Petersburg Academy of Fine Arts.[9] The reason for making the moulds may have been to facilitate the carving of a copy to replace the original over the fish-pond.[10] Within a matter of months, however, the whole villa, which had changed hands before, fell into the hands of a property developer, who on 4 September 1784 advertised his intention to sell it off in lots and dispose of the statuary to the highest bidder. The statues were valued in May 1786, including *Neptune and Triton* at two thousand zecchini, and were sold to Thomas Jenkins.[11]

Fountains of the Barcaccia, Triton and Bees

At the foot of the Spanish Steps stands one of the oddest fountains in the world, and on that account one of the most popular.[12] The bizarre motif of a waterlogged ship was conceived either by Bernini or by his father Pietro (there was confusion even within their lifetimes as to who was responsible) to cope with the very low head of water at this point on the conduit of the Acqua Vergine, which precluded rising jets or sprays. The Bernini capriccio caught the imagination of the Romans, who christened it not 'La Barca', the boat, but 'La Barcaccia', an affectionately pejorative ending that signifies something like 'the rotten old tub'. Actually, the curvaceous, fleshy forms of the gunwale of the supposed ship are anything but shipshape or wooden-looking, but recall the sensuous, auricular style of Giambologna's basin for his fountain of *Samson Slaying a Philistine* in Florence.[13] Another protoype for the generally smooth, oval shape is one of Giacomo della Porta's odder creations, the so-called *Fountain of the Soup-tureen* that now stands outside Santa Maria Nuova in Rome, for it originally had no lid and so was more like a boat-shaped bowl.[14] The Bernini fountain was planned, the water pipes from the aqueduct were laid and the site levelled in 1627, and the blocks of travertine marble were carved by a stone-cutter in 1628–9.

Bernini *père* had been appointed architect of the Acqua Vergine by Urban VIII in 1623, and the ship is emblazoned with the pontiff's coat of arms on prow and stern and his personal device of a radiant sun at either end, functioning as water spouts. The idea of having a ship at the centre of a fountain was not unprecedented: as early as the papacy of Leo X Medici, in the days of the High Renaissance, an

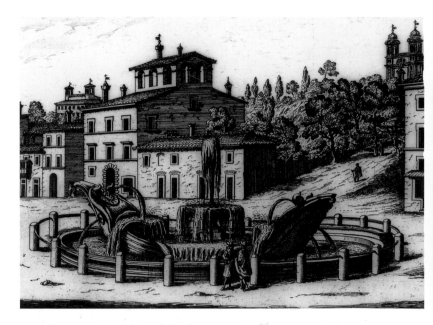

249. Engraving by Falda of the fountain of the *Barcaccia* in Piazza della Santissima Trinità dei Monti, now Piazza di Spagna, Rome. (The Spanish Steps now rise up the slope to the right.)

ancient Roman model of a ship carved out of marble – the *Navicella* – had been erected as the dominant feature of a fountain in front of Santa Maria in Domnica on the Celian Hill.[15] That fountain also provided the idea of having an oval basin at ground level to represent the sea. The little internal fountain that stands where the mast of the *Barcaccia* would have been resembles the *Navicella*. There were also more recent imitation ships amid pools in the gardens of the Villa d'Este at Tivoli, of the Villa Aldobrandini at Frascati (whose ship also had a smoothly curved organic-looking gunwale like the *Barcaccia*) and of the Vatican: the latter, *La Galera*, the galleon, is some four metres long, fully rigged and spouts water from its cannon.[16] It had been constructed as recently as *c.* 1620 by a Fleming, Giovanni Vesanzio (Jan van Santen). Perhaps with this warlike prototype in mind, as well as a recent series of papal victories in *c.* 1626–7 over various forces of Protestantism, Pope Urban penned the following distich:

> *The papal warship does not pour forth flames,*
> *but sweet water to extinguish the fire of war.*

Much other religious symbolism may be read into the idea of the ship, notably that of its representing the Church itself, with St Peter and his successors at its helm.

Thus although the concept of the *Barcaccia* was by no means novel, it was amusing, especially as the ship is filled to its gunwales with water and apparently sinking. The main innovation of Bernini's team was the boldness of importing a previously rustic idea into a grand position in the centre of the city. The Spanish Steps were not built until much later, and the ground level of the piazza has since been allowed to rise around the fountain, and so it looks more sunken than

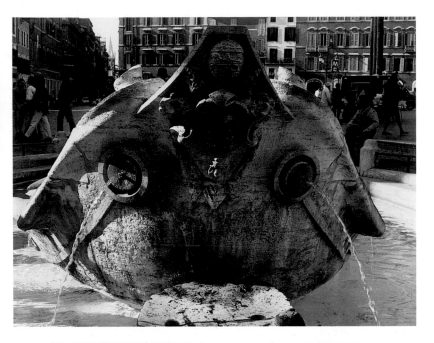

250, 251, 252. The fountain of the *Barcaccia* in Piazza di Spagna, Rome.

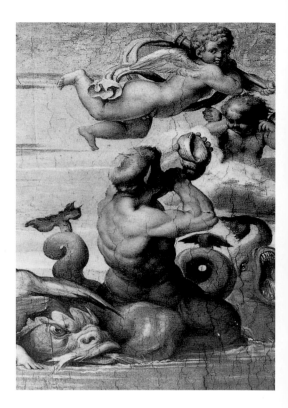

253. Detail from an engraving by Falda of Bernini's lost Triton Fountain for the Villa Mattei.

254. Domenico Pieratti: fountain of *Love Opening a Heart* in the Giardino dell'Isolotto, Boboli Gardens, Florence.

255. Agostino Carracci: detail of Triton blowing a shell, from the ceiling fresco in the Farnese Palace, Rome.

ever; old engravings show it standing out bravely above the muddy flank of the open hillside on which it was built.

Three or four years later Bernini addressed the idea of a Triton Fountain for the Villa Mattei, but it is now known only from an engraving by Falda showing the figure from behind: the figure was in strong *contrapposto*, leaning back on his left elbow and raising a conch to his mouth with his concealed right arm. It was surrounded by four dragons spouting water into a circular basin with a rustic, rocky rim.

This commission provided a trial run for Bernini's first independent fountain in a public place, the centre of Piazza Barberini, for which he chose the same aquatic theme.[17] Here, in 1642–3, he achieved a brilliantly original effect with an ensemble of motifs derived from a variety of sources. The Triton himself was virtually copied from one carved in deep relief as recently as 1612 by Stefano Maderno for the *Fountain of the Eagle* in the gardens of the Vatican. This provided the symmetrical and frontal pose of the whole figure, whose arms are both raised to support the conch, which conceals all but the bearded chin of the sharply upturned face. Maderno's Triton is mounted astride a huge dolphin which appears to be swimming forward out of a cavern into the pool directly towards the spectator, its nostrils ferociously spouting jets of water. Bernini combined this image with elements from a

statue by Battista Lorenzi in Palermo, borrowing the shape and position of the conch and the device of a school of dolphins, whose raised and thrashing, intertwined tails provide a support for the figure, while their heads spread out below to provide a firm basis. In 1625, Pieratti had employed a pair of entwined dolphins as a pedestal for his fountain of *Love Opening a Heart*, near the Isolotto of the Boboli Gardens in Florence.[18] The motif also recalls a Triton in Agostino Carracci's ceiling fresco in the Farnese Palace, for which a drawing by Annibale Carracci survives. Interestingly enough, Bernini's preparations for his Triton included a rather similar study (now in the Metropolitan Museum, New York) from the front, which even indicates faintly the division between the blocks of travertine that would be necessary.[19]

Nearer at hand was a fountain by the French émigré sculptor Nicolas Cordier, long since lost but documented and recorded in a fresco and engravings showing the gardens of the Vatican. He was paid in 1610 for 'a putto with a round shell in his hand spurting water into the air, set over the tails of four sea-dragons',[20] which was just over one metre high. The image in the fresco is simplified, but suffices to show that the putto indeed acted in much the same way as Lorenzi's had, and as Bernini's Triton would.

Bernini increased the number of dolphins to four, opening out a space between them which is cruciform in plan, so that they resemble four legs of an elaborately carved table or throne: they are lashed together above and support mistilinear cartouches bearing the papal insignia of tiara and crossed keys over the Barberini arms. Instead of seating his Triton directly on the dolphins' backs or tails, as in the prototypes, Bernini decided to increase the girth of the

256. Bernini's drawing for the *Triton Fountain* (Royal Collection, Windsor Castle).

257. Pietro Tacca: fountain in Piazza Santissima Annunziata, Florence.

258. The *Triton Fountain* in Piazza Barberini, Rome; engraving by Rossi.

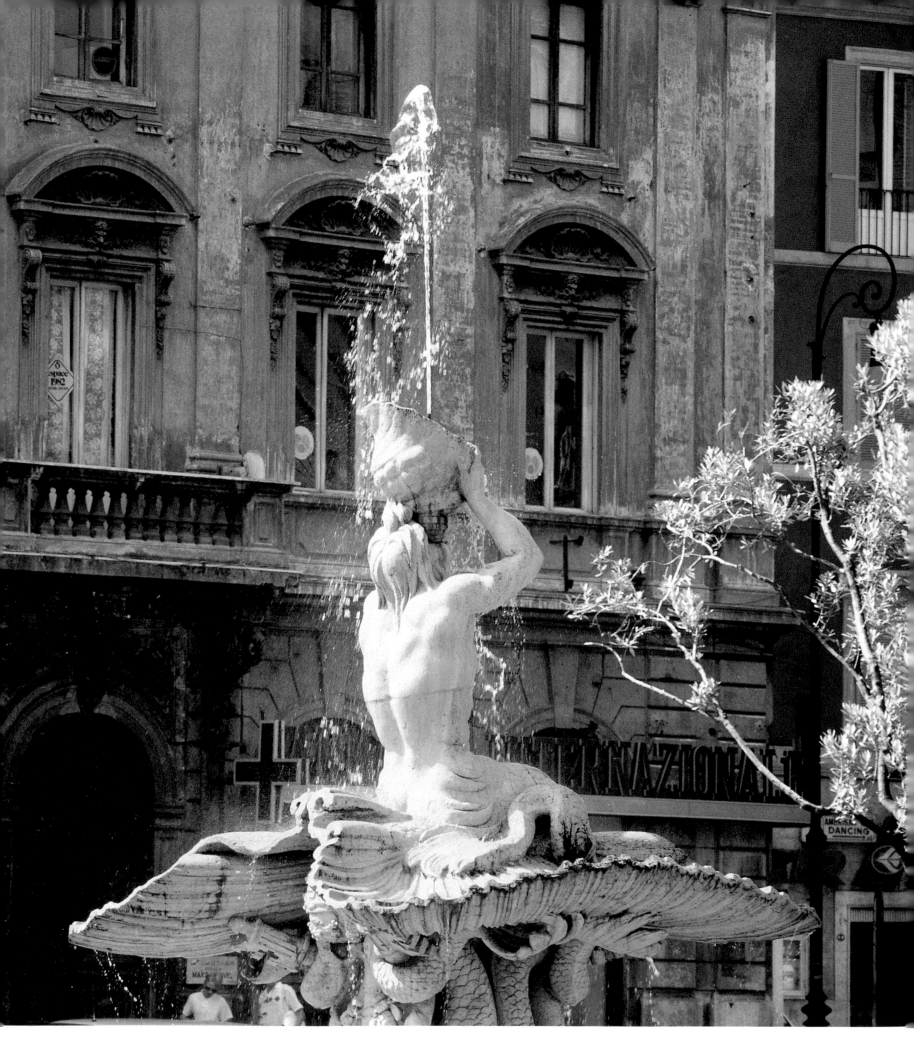

186 *'Friend of the Waters'*

sculptural complex by inserting an enormous double-ridged shell, wide open and running from front to back of the group, with the figure seated astride the central hinge. Both this device (reminiscent of many a Venetian or Milanese Mannerist salt-cellar in gilt-bronze), and indeed the whole upper silhouette of the *Triton Fountain*, recall the form of Pietro Tacca's bronze fountains now in Piazza Santissima Annunziata, Florence that were begun in 1626 but unveiled as long afterwards as 1641. Bernini met Tacca in Rome in 1625, and so they may have exchanged ideas about fountains in person. Tacca's weird monkey-like monsters also have bifurcating fishtails for legs, and the pair of lobed basins resemble two stingrays lying on their backs and curving their heads upwards and inwards to spurt water in the opposite direction to that emitted by the monsters' mouths. Their heads are aligned along the axis, for Tacca's fountains are rectangular in plan, and not equilateral, as is Bernini's. Furthermore, the bases of Tacca's fountains — cone-shaped shafts of marble with bronze grotesque ornamental appliques — are not part of the narrative content whereas Bernini's dolphins react to the sound of the Triton's conch.

257

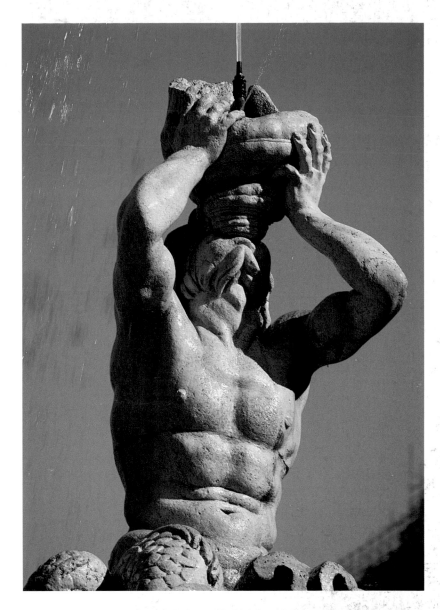

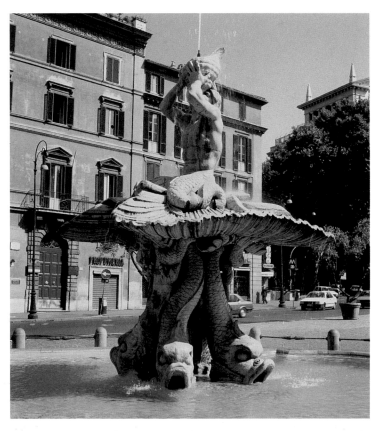

259–262. The *Triton Fountain* in Piazza Barberini, Rome.

The plan of the ridged shell that forms the basin recalls that of the auricular-style basin of Giambologna's fountain of *Samson Slaying a Philistine*, which is roughly square, but has rounded corners with curving indentations between. Its rim rises and falls continuously to create sinuous three-dimensional curves: the sensuously organic smoothness of Giambologna's rim is, in Bernini's version, coruscated by the flutes of the shell. An evocative drawing of the *Triton Fountain* at Windsor Castle shows how its designer intended the complex to look when the water first played: it was to gush up vigorously in three jets, and then fall onto the spreading shell, bouncing over its edges into the water-filled basin below in which the dolphins seem to swim. Another small drawing shows the fountain much as it was executed, and has an indication of the plan of the basin in black chalk below.[21] 'Bernini's originality lies', writes Howard Hibbard, 'on its simplest level, in transplanting this familiar sea-god into a Roman piazza and setting him up in a free version of the typical geometric piazza fountain.'

The choice of theme for this fountain was apparently made not purely on account of its obvious aquatic associations. These are derived, as in the case of the previous fountain where Triton was linked with Neptune, from Ovid's account of the ending of the great flood (*Metamorphoses*, I, 330–42):

> *King Neptune*
> *Puts down his trident, calmed the waves, and Triton,*
> *Summoned from far down under, with his shoulders*
> *Barnacle-strewn, loomed up above the waters,*
> *The blue-green sea-god, whose resounding horn*
> *Is heard from shore to shore. Wet-bearded Triton*
> *Set lip to that great shell, as Neptune ordered,*
> *Sounding retreat, and all the lands and waters*
> *Heard and obeyed.*[22]

But unlikely as it may seem today, the Triton was also an emblem of 'Immortality Acquired by Literary Study' as quoted by Hibbard, and so conveyed a hidden meaning to the educated beholder, reminding him of Pope Urban's skill in Latin poetry.[23]

Bernini also designed a subsidiary and complementary drinking fountain set against the corner of a building where Via Sistina leaves the square.[24] Illogically, it now stands away from any building on the pavement at the foot of Via Veneto, and – owing to hard wear and weathering – only the central bee and piece of shell on which it stands are original. An inscription on the spreading inner surface of the open shell records that it was erected by command of Pope Urban VIII in 1644, only two months before his death. With the papal name so prominently displayed, a coat of arms could be dispensed with, but Bernini allowed the Barberini bees to crawl freely down towards the water spouts, as though to drink, hence the name by which it is known, the *Fountain of the Bees*. The water contained in the horizontal half of the shell acts as a mirror, reflecting a rippling pattern of light onto the vertical half, and enlivening the whole with a kinetic effect.[25] Once again, Bernini was playing a variation on a similar theme, a fountain designed by Maderno's studio and carved by Francesco Borromini in *c.* 1625–6 for the gardens of the Vatican which shows a semicircle of bees, all spurting water from their mouths, gathered around the mouth of a cavern in a hillock with flanking trees. Behind both was the idea of the Barberini bees emitting 'honey-water', just as their master Urban spoke and wrote 'honeyed words'.[26]

263. Bernardo Buontalenti: fountain in Via dello Sprone, Florence; an earlier example (*c.* 1608) of a shell-shaped fountain on the corner of a building.

264. *Fountain of the Bees*,
originally by Bernini, but
largely reconstructed;
foot of Via Veneto, Rome.

265. Francesco Borromini:
Fountain of the Bees in the Vatican
Gardens.

266. Lieven Cruyl: detail from a drawing of
Piazza Barberini showing Bernini's *Fountain of the Bees*
in its original location on a street corner.

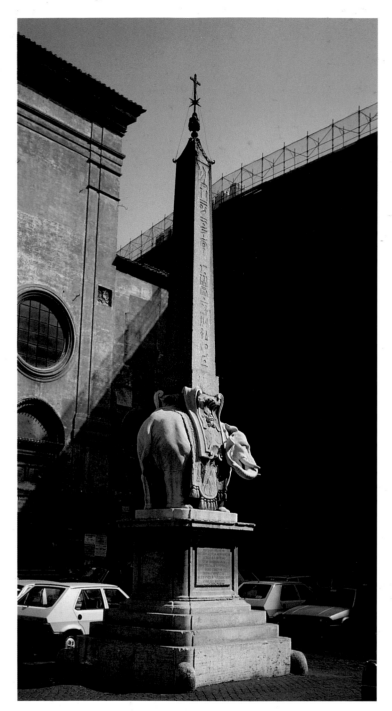

The Elephant and Obelisk

Pope Urban VIII's next commission fitted in well with Bernini's designs for fountains, owing to its capricious and initially garden-orientated design. This was an obelisk ultimately mounted on the back of an elephant, that was to have stood near a bridge connecting the Barberini Palace with its garden.[27] An ancient Egyptian obelisk had been transported in 1632 from outside the Porta Maggiore, and Bernini's concept of setting it on the back of an elephant is recorded in an impressive drawing at Windsor Castle, as well as in a highly finished terracotta model once in the Barberini collection. The combination of these two component parts had been suggested long before in a woodcut illustration in the *Hypnerotomachia Poliphili* (Venice, 1494) by Francesco 270 Colonna, a well-known visual source for anyone with an interest in antiquities. Bernini's realistic rendering may have been inspired by a fresco of the elephant Hanno that was painted by Raphael in 1518, now lost but recorded in an engraving by F. de Holanda,[28] as well as by a living elephant that had been exhibited in Rome in 1630. Roman Bacchic sarcophagi also sometimes feature elephants,[29] while the idea is also related to the medieval heraldic devices of the elephant and castle. Bernini would certainly have known of this from a life-size version of the theme hewn out of stone in the celebrated and enigmatic Orsini gardens at Bomarzo, near Rome. Nevertheless, as Hibbard justly observes, 'of all the elephants in art, Bernini's humorous beast is surely the most engaging'. This project for the Barberini, whose heraldic bees may be seen in the Windsor drawing in profile to either side 271 of the apex of the obelisk beneath the cross and globe, as on

267, 269. (*Above, opposite*) *Elephant and Obelisk* in Piazza Santa Maria sopra Minerva, Rome. It was sited so that its diagonal views correspond with streets entering the small square in front of the church, near the Pantheon.

268. Life-size stone elephant and castle in the Orsini gardens, Bomarzo.

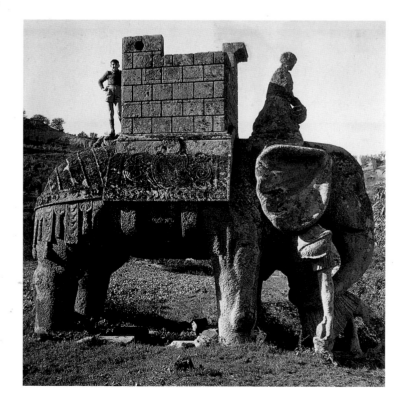

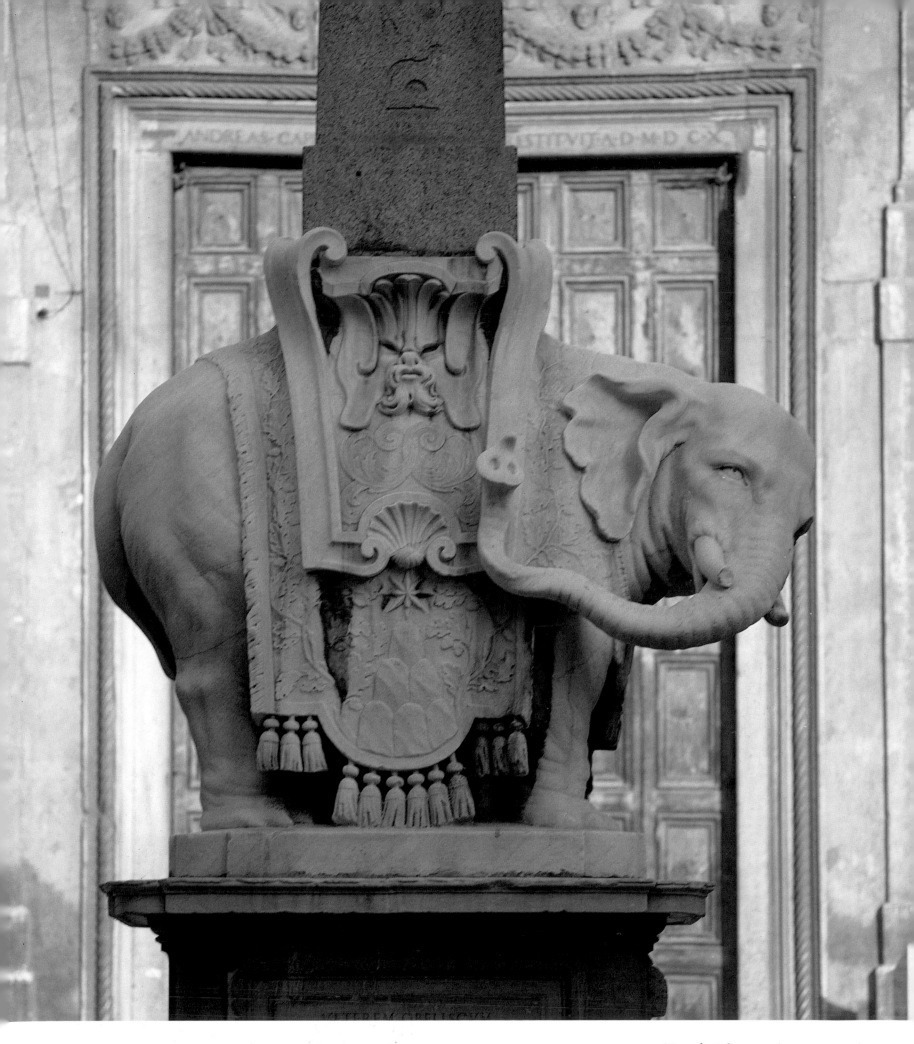

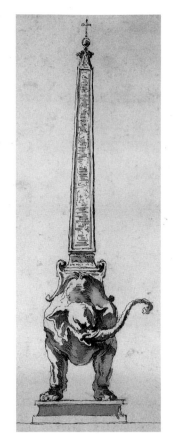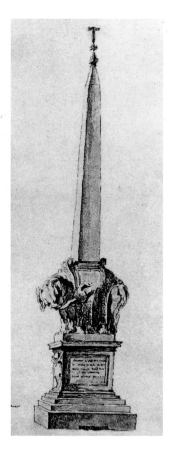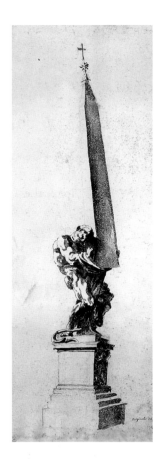

270. Elephant and Obelisk, from the *Hypnerotomachia Poliphili* (Venice, 1494).

271, 272, 273. Preliminary ideas for the obelisk (Royal Collection, Windsor Castle). (*Right*) Hercules carrying it as it teeters at a dangerous angle (Biblioteca Vaticana).

the Baldacchino, was not executed, possibly because of the demise of Pope Urban.

The idea lay dormant for a quarter of a century until Alexander VII revived it, following Bernini's return from Paris and the discovery of a small obelisk in 1665 in the garden of the Dominican monastery of Santa Maria sopra Minerva in the heart of Rome. Pope Alexander was fascinated by the hieroglyphics and had them interpreted by a scholar. The obelisk symbolized sunlight and hence the light of learning. Hibbard notes:[30]

The kernel of the arcane meaning was expressed in a contemporary poem: 'The Egyptian obelisk, symbol of the rays of *Sol*, is brought by the elephant to the Seventh Alexander as a gift. Is not the animal wise? Wisdom hath given to the World *solely* thee, O Seventh Alexander, consequently thou hast the gift of *Sol*.'

A series of drawings in the Chigi archives at the Vatican, including three magnificent autograph sheets, record Bernini's preparations. Several logical and attractive possibilities were probably suggested by Padre Paglia of the Dominican

monastery: they included resting the obelisk on some realistically rocky renderings of the heraldic mounds of the Chigi coat of arms, or upon the shoulders of seated caryatid figures, together with dogs to recall the fact that the convent of Santa Maria was Dominican (*Domini-canes* = 'Hounds of the Lord').

The sculptor himself seems initially to have flirted with a decidedly mad (*pazzo*) concept of having a gigantic figure of Hercules either heaving the obelisk up a rocky mound or staggering to hold it aloft at a slant. The architectonic stability of the obelisk as a shape was contrasted as a visual *scherzo* (joke) with its teetering position. The monumental scale and the attendant problems of equilibrium combined with the deliberate lack of decorum scuppered such an entertaining solution. Two drawings show Bernini reverting to the more sensible arrangement designed years before for Urban VIII, with the substitution of the heraldic emblems of the Chigi and an elongation of the hangings of the howdah so that their tassels touch the ground, thus providing further physical support for the weighty obelisk. The marble was carved by Ercole Ferrata between 1666 and 1667. The group was set on a high socle, bearing laudatory and explanatory inscriptions, at the centre of the small piazza in front of the church. It serves to articulate the piazza with a sure sense of urban design in relation to the various approaches from adjacent streets.

Piazza Navona: the Fountain of the Four Rivers and the Fountain of the Moor

In between these two projects of mounting an obelisk on the back of an elephant, and during the intervening papacy of Innocent X, a pontiff less well disposed towards Bernini, the sculptor once more had occasion to confront the problem of how to mount an obelisk in a dramatic and eye-catching way, this time above a fountain.[31] It was to mark a new supply of fresh water from the Acqua Vergine that had been brought by conduit into the very centre of Piazza Navona between two fountains that already stood at either end. This was a rectangular public space in the heart of old Rome that had survived since AD 86 when it had been laid out under Domitian as a stadium for foot races. The surrounding banks of seats had provided firm foundations for later structures, as well as a convenient supply of squared stone, but the open area had been encroached upon by haphazard medieval building and housed a squalid market place.

Innocent had decided to glorify his family, the Pamphili, by constructing a new façade to their palace on the long western side of the piazza (1644–50), by commissioning the

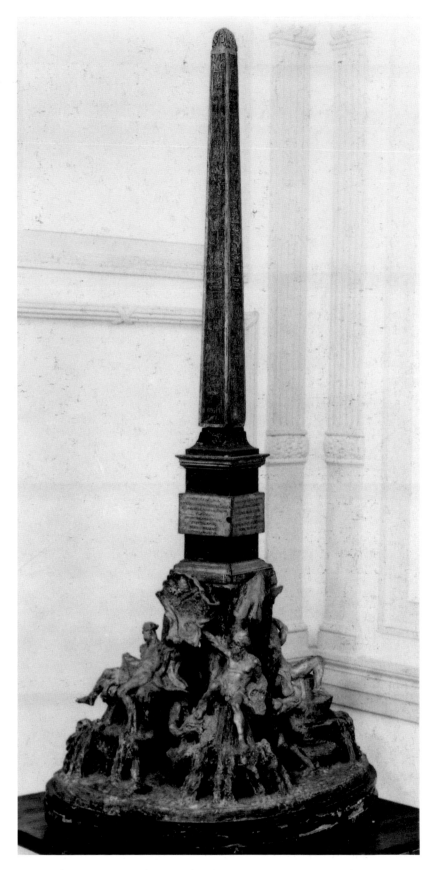

275. Model in wood and terracotta of Bernini's *Fountain of the Four Rivers* (private collection), perhaps the original from which a silver version was cast.

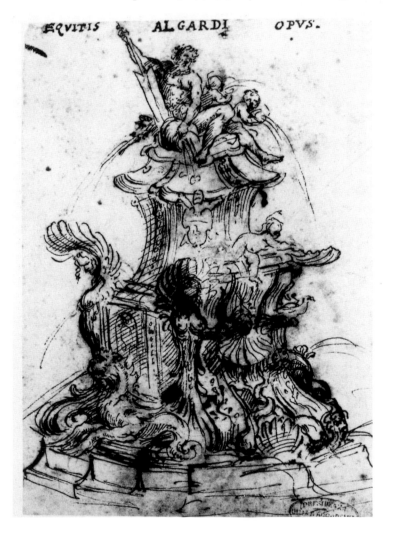

274. Alessandro Algardi: project for the central fountain in Piazza Navona, discarded in favour of Bernini's (Accademia, Venice).

276

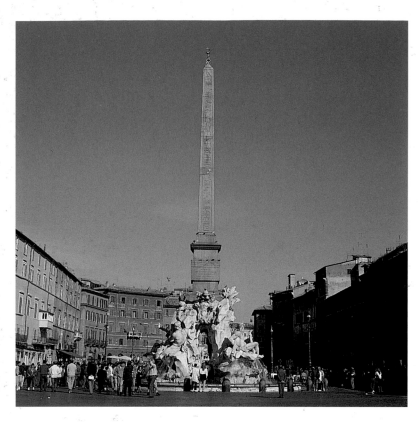

276, 277. The *Fountain of the Four Rivers* in Piazza Navona, Rome, from the south, showing the Danube and the Ganges.

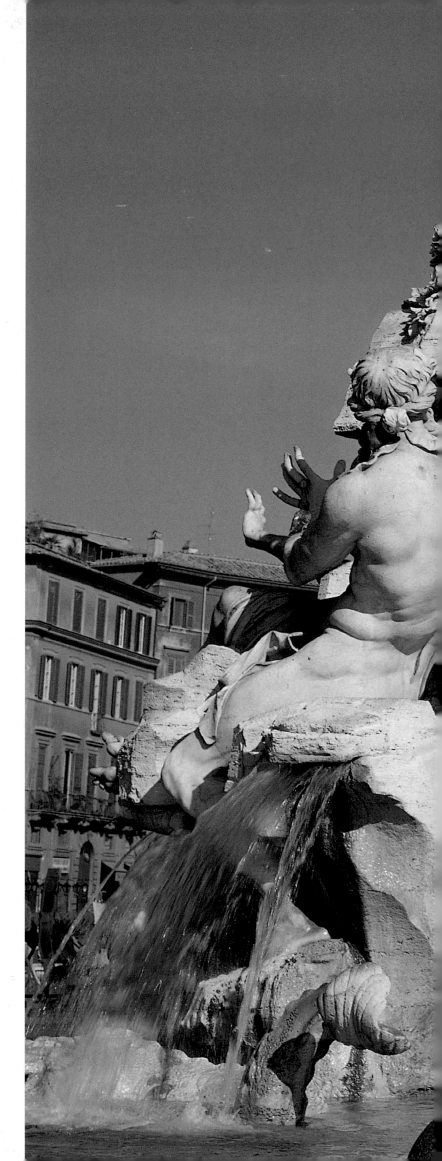

rebuilding of the adjacent small church of Sant'Agnese as a grandiose family chapel, and by enhancing the water supply. The man in charge of these major works was his favourite architect and Bernini's rival, Borromini. Around 1645–7, while the conduit was being installed, the design of the fountain was being considered and Algardi, Innocent's preferred sculptor, produced a drawing featuring a figure of the River Tiber in the recumbent pose that had been standard for representations of river-gods since antiquity.[32] This, or another design since lost, was claimed by a contemporary biographer to have been the best, but after it was done Pope Innocent seems to have conceived the idea of incorporating an obelisk, which he went in person to inspect on 27 April 1647. Borromini, architect of the water conduit in question, then submitted a design showing the obelisk surrounded by four river-gods.

What followed is told in several stories with slightly conflicting details that reflect the partiality of the writers. Pope Innocent, confronted with rival designs, announced a limited competition, but Bernini, whom he personally disliked, was not invited to enter. Other architects and sculptors submitted drawings, some of which survive, or models in clay or wax on wooden armatures, as was traditional. Meanwhile Prince Niccolò Ludovisi, a nephew by marriage of the pope, who did like Bernini, persuaded him to

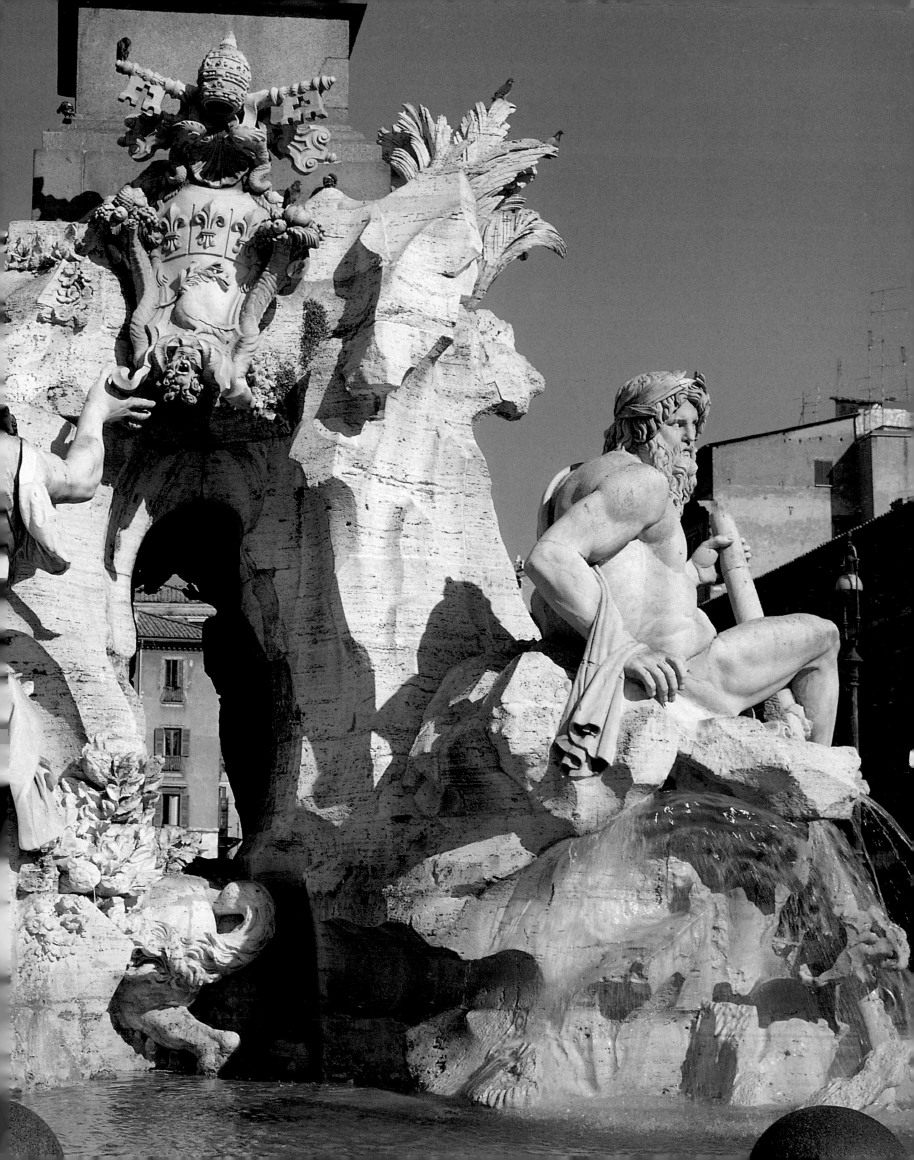

278. The *Fountain of the Rock* at the Villa d'Este, Tivoli, a possible source for the *Fountain of the Four Rivers*.

279. Pietro Tacca: bronze galley slaves around the base of a statue of Grand Duke Ferdinand I of Tuscany in Livorno.

280. Giambologna: *Fountain of Ocean* in the Boboli Gardens, Florence; a detail of river-gods.

take the initiative and make a model, despite the papal veto. This he did, but as an act of bravura he had it cast in silver. Next, with the connivance of Donna Olimpia, the pope's sister-in-law, it was smuggled into the Pamphili Palace and placed in a room where Innocent would come across it by surprise in the company of these two relations. This duly occurred and he was bowled over by the grandeur of its conception, grudgingly uttering the back-handed compliment quoted at the beginning of this chapter. There is no trace in the Pamphili inventories of such a silver model. But one *was* owned by Cardinal Mazarin which might have been given to him by Bernini. In any case, it is now lost. What does exist is a very impressive and startlingly beautiful model constructed in clay on a wooden armature which has many of its sculptural details embellished with gilding. This may have been the model from which the silver was cast: its sculptural merit and decorative appeal are obvious enough for it to have turned the pope's head and so won the commission for its inventor.

What are the sources of Bernini's design? A number of sketches and drawings help us to follow its evolution. The basic idea of having the fountain depict four great rivers, possibly reflecting the medieval concept of the four rivers of paradise, came from Bernini's bitterly disappointed rival, Borromini. He may also have been influenced, perhaps subconsciously, by the gardens of villas around Rome: first, perhaps, the *Fountain of the Rock* at the Villa d'Este, Tivoli shown in an engraving by Falda. This consisted of two artificial hillocks resting on four rocky piers, which oozed water into a cavern, cruciform in plan, where it collected in a pool. A vertical water spout above provided a strong vertical accent, the visual equivalent of an obelisk. A second influence was the Villa Lante, Bagnaia, where, in the centre of the water garden, a fountain exists which consists of four stalwart nude male figures, each with one hand raised to hold aloft a three-dimensional rendering of the Chigi coat of arms. From it Bernini could have learned the effectiveness of contriving voids of light and air permitting a distant view right *through* a group of sculpture. This concept he had already used in a small way to some advantage in his *Triton Fountain*, as has been mentioned, but now he was ready to exploit it.

Recumbent figures of river-gods, descended from those that had once served to fill the awkward triangular ends of the Graeco-Roman pediment, were of course a commonplace in connection with fountains. Six such images of colossal size had survived from ancient Rome – some having been excavated only during the High Renaissance – and had been given places of honour over wall-fountains, three on the Capitoline Hill, and three others in the Belvedere of the Vatican. Michelangelo had famously been inspired by them when designing his four Times of Day and the four

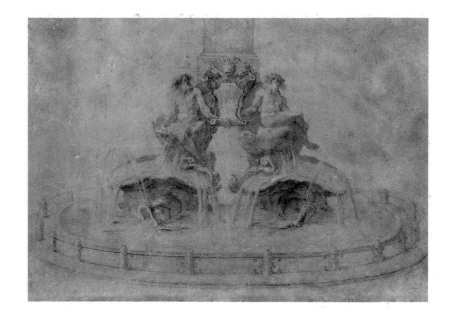

281, 282. Two early sketches for the *Fountain of the Four Rivers*. In the first (*above*), the obelisk is set diagonally. In the second (*right*), the obelisk is frontal and river-gods support a prominent papal coat of arms.

unexecuted river-gods for the Medici tombs in the New Sacristy of San Lorenzo, Florence. Only one of Bernini's four river-gods, the River Ganges, was ultimately to conform with this calm, classical type. The other three figures were shown seated, rather than recumbent, thus recalling the three river-gods addorsed against the shaft of Giambologna's *Fountain of Ocean* (Boboli Gardens, Florence) and the four bronze galley slaves by Pietro Tacca at Livorno.[33]

Bernini's gods are in extremely animated poses. Two fling out their arms forming dramatic silhouettes against the sky. The River Danube steadies the Pamphili coat of arms against the face of the rock (just as the Nile does at the northern end). The River Plate is seemingly bowled over by the façade of the hated Borromini's Sant'Agnese. The violent movement of these figures is characteristic of Bernini, as is the way in which their limbs project into the surrounding space, almost as though they had been cast in bronze to give the necessary tensile strength. He was able to do this by piecing on extremities: on the left leg of the River Nile for instance a joint is disguised by an ornamental band.

All the elements of this fountain were therefore already present in Bernini's mind. Even so, he did not immediately light upon the eventual solution, as is shown by a fascinating series of drawings. Thought to be the earliest is a sheet from the Chigi collection in which a half-length river-god emerges from a grotto in a rocky mound, with both arms raised sideways to support the curling cartouches of a pair of coats of arms. He recalls Triton, as does the way in which water flows down from all round him into symmetrically arranged shallow shells, which in turn disgorge it into a circular basin at ground level. A small irregular opening pierces the mound directly below the river-god. The obelisk was set diagonally

above, its faces parallel with four coats of arms facing outwards above the rocky corners of the mound. Although only one side of the base is shown, it is likely that its design was to be repeated around the other three, and this would have generated a cruciform plan for the lower grotto, as in the final work. The diagonal setting of the obelisk, which was indeed boldly Baroque in conception, was abandoned in favour of a more classical solution.

This is shown in an evocative drawing softly executed in chalk and with a pale blue wash for the water, in the Royal Collection, Windsor Castle, where the architectural pedestal of the obelisk has been rotated by forty-five degrees. The papal arms are now prominently frontal, and the river-gods have emerged from their individual grottoes. They are shown full-length, contentedly perched atop the rocky supports of the mound: they look inward and upward, as though in admiration of the obelisk that towers above. Below them water gushes into outward-curving shells, from whose murky shadows emerge great dolphins with their mouths open and nostrils spurting water. Most important is the daring enlargement of the previous opening into a veritable chasm below the obelisk and between the rocky supports, its void silhouette corresponding roughly with the indented contours of the solid cartouche above. It would have framed distant glimpses across the piazza. It seems likely, though the drawing provides no evidence, that this scheme was to be repeated at the back though, not at the sides, for the gods (and the shell basins below) are turned *away* from these faces which would *ipso facto* have been subsidiary. This too may have seemed problematic in Piazza Navona, where the long axis clearly indicates the two sides that are most visible to the majority of spectators approaching from either end, but an access halfway up the eastern side and the towering façade of Sant'Agnese suggest a cross-axis.

The gilt terracotta model — and the silver presentation piece if it was cast from it — document the next stage: here,

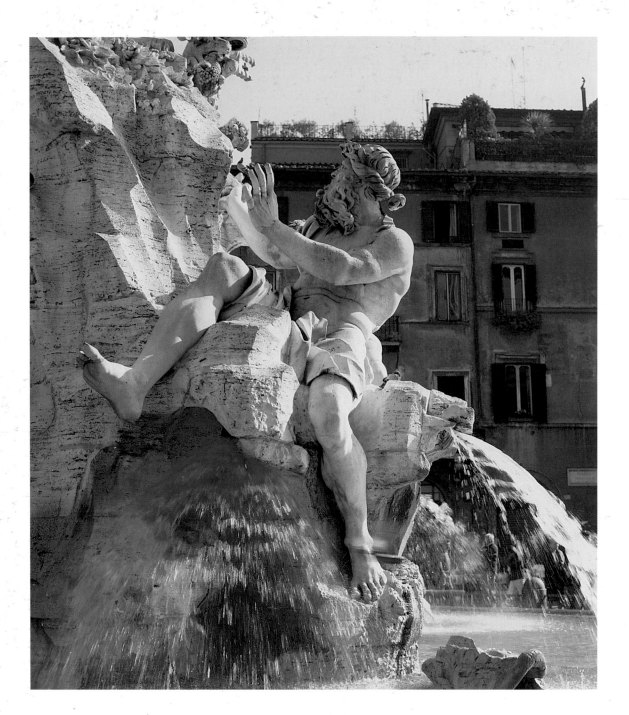

283, 284. Details of the *Fountain of the Four Rivers*: (*left*) the River Danube and (*right*) the River Nile.

approximate symmetry on all sides was envisaged, and the cross-axis, which lacked the papal coat of arms, was compensated for by the introduction of exciting new dramatis personae in the shape of a rearing horse and a growling lion coming down to the water's edge to drink. A sheet of sixteen rapid pen sketches shows the side of the fountain seen when looking towards Sant'Agnese, allowing one virtually to look over the sculptor's shoulder as he grapples with the aesthetic and mechanical problems of designing and constructing the dangerously hollow rocky support. The natural bias of Bernini's uninhibited strokes with the quill pen held in his right hand causes the slant upward and to the right of the strata in the rock from which the mound is formed. The central opening also assumed a slant, as it is indicated with a shorthand zigzag. In some of the sketches Bernini reminded himself of reality by drawing

diagrams of how the blocks of travertine marble would have to be laid horizontally in two piles, with one bridging the gap between them. A variety of sitting or reclining poses for the river-gods is also indicated. The diagonal slant gave it a more natural appearance and a greater feeling of unity than in the earlier design, with its four distinctly separate and roughly symmetrical piers. It also differentiates the rocky base from the verticality of the obelisk on top.

Bernini drew sensitive studies in red chalk and white heightening on rough grey paper for at least two of the river-gods – the River Nile, recognizable from the motif of having his head partially concealed by a cloth (symbolizing the fact that the source of the river had not been discovered), and the River Plate, in mirror-image from the statue as finally carved. The balding but bearded appearance and rather abandoned pose of the River Plate recall those of a river-god carved by

285

292

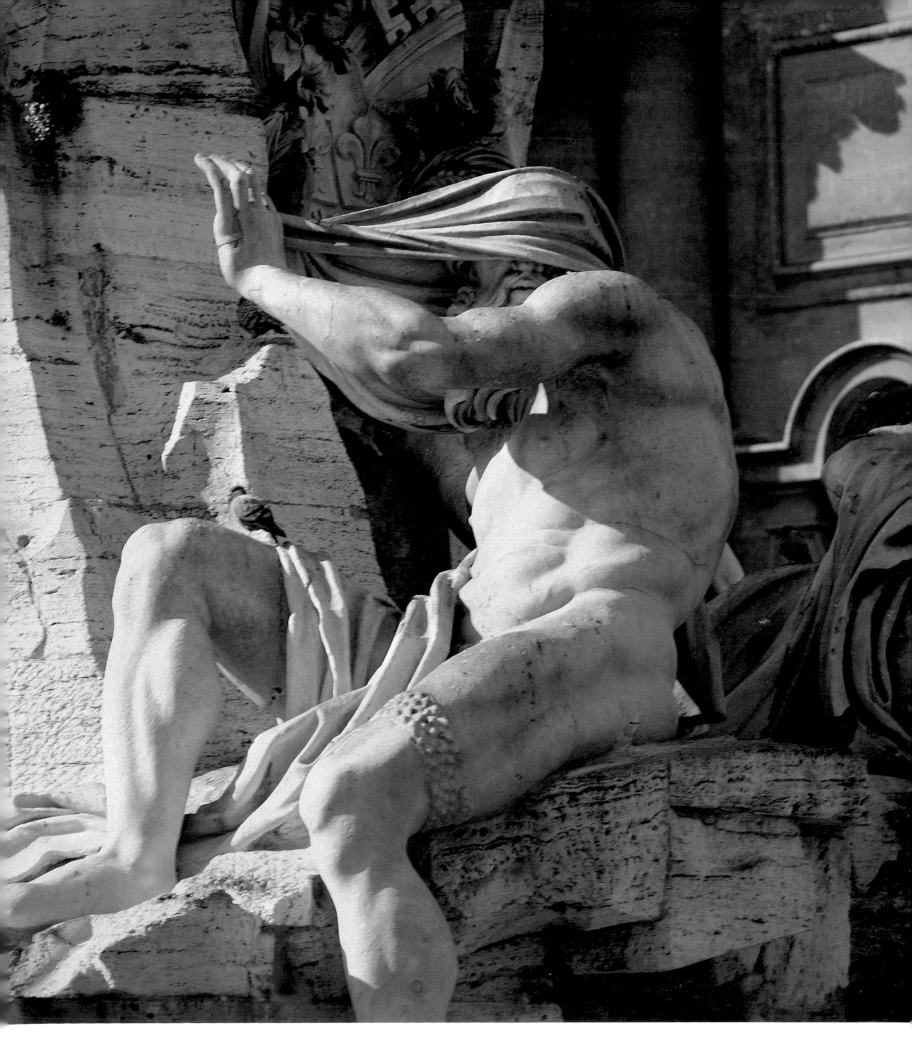

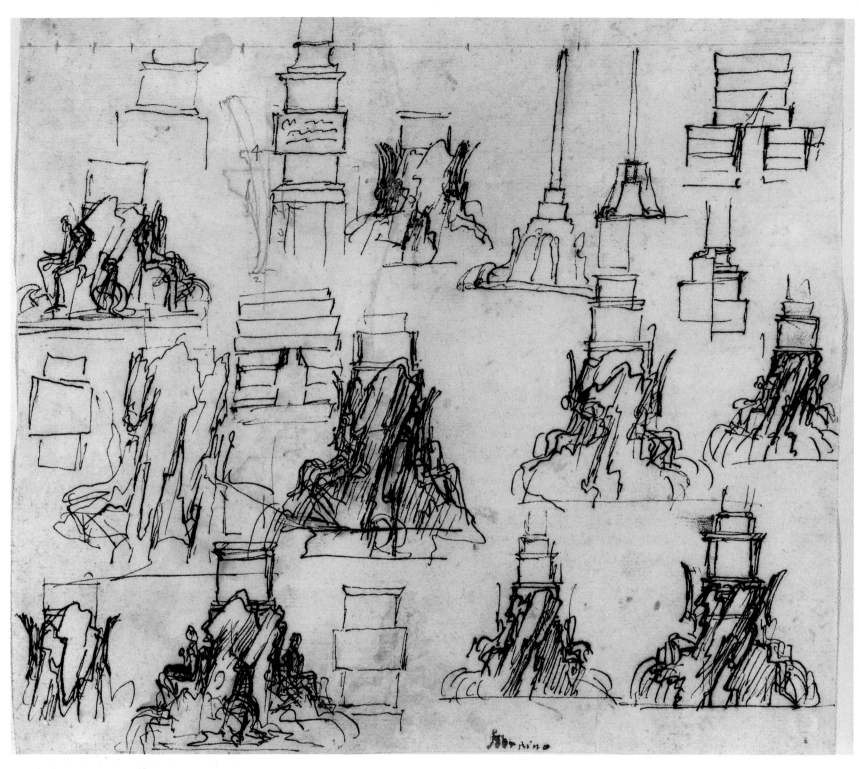

285. Page of rapid pen sketches for the *Fountain of the Four Rivers*, exploring both the form of the fountain and the structure that would support it (Museum der bildenden Künste, Leipzig).

Naccherino for a fountain in Palermo, which Bernini may have known through his father, who had worked alongside Naccherino in Naples.

The final stages of preparation are recorded in a wooden model with clay figures, where the base showing the circular pool and its low rim are formed from a row of planks, and the rocky eminence is carved with a gouge into the same scooped, glacial forms with sharp ridges in between as those hewn out of travertine marble in the final version. Of the four river-gods, only the River Plate survives, but it shows the same concentrated vivacity as a larger successor now in the Cà

292 d'Oro, Venice, which is more highly finished and is paired with a model for the River Nile. Both must date from late 1649, for the assistants to whom the actual carving *in situ* of the enormous blocks was delegated were paid 740 scudi each between February 1650 and July 1651: Antonio Raggi carved

283 the River Danube (with his arms raised, and a horse nearby);

284 Jacopo Antonio Fancelli the River Nile (with his head hidden under a cloth and an adjacent palm tree); Claude Poussin the

277 Ganges (with a great steering oar, round which a dragon winds its neck, its wing tip supporting his left foot); and Francesco Baratta the River Plate (a balding Moorish type, with a curious armadillo below). The Pamphili arms with papal insignia are cleverly given a marine flavour by being ensconced within elongated cockle-shells. Those on the northern side have flanking bouquets of martyrs' palms, roses and Madonna lilies, while fruit-laden cornucopiae are inserted at the south: for the latter a minuscule terracotta

Tailpiece model was made with the help of a stylus by Bernini, for the guidance of his carvers. It is also recorded which assistants were responsible for particular details, while the master himself allegedly gave the finishing touches to the rock and

88, 289 palm tree, as well as to the horse and the lion. A highly

finished model for the lion is arguably autograph, because of the near impossibility of reconstructing the whole animal from the parts of the finished carving that are visible: as with the horse, its rump appears in one gap in the rocks and its forequarters in the diagonally adjacent one.[34] This is one of the master's devices to encourage the spectator to circumnavigate this aquatic monument. Others are the diagonal and spiralling poses and the gestures and glances of the river-gods, which tend to lead the eye up and down as well, building up the effect of their variety and sheer *joie de vivre*.

Bernini's *Fountain of the Four Rivers* is the *ne plus ultra* of designs for free-standing fountains in a civic setting and has always been regarded as a monument to his towering genius as sculptor and urban designer. The majesty with which it articulates and dominates the open space of Piazza Navona has never been surpassed. It was accorded by Innocent, originally a reluctant patron, the signal honour of being depicted minutely on the reverse of a papal medal, which put it on a par with the sculptor's contributions to St Peter's that were similarly recorded by Urban VIII and Alexander VII. It was also, uniquely, accorded *two* views in Falda's engraved picture-book of the fountains of Rome.

286. Wooden model of the *Fountain of the Four Rivers* with clay figures (Museo Civico, Bologna).

287. *Modellino* for the figure of the River Nile on the *Fountain of the Four Rivers* from the Farsetti Collection (Cà d'Oro, Venice).

288, 289. (*overleaf*) Two details from the *Fountain of the Four Rivers* in Piazza Navona, Rome: horse and lion.

290, 291. Two sketches by Bernini for a subsidiary fountain at the southern end of the Piazza Navona. The first, in pen and ink (Akademie, Düsseldorf), shows the Pamphili papal arms supported in mid-air, while the second (Royal Collection, Windsor Castle) has a scarcely visible blue wash to indicate the flow of water and shows two dolphins holding up a shell. This was actually built but was replaced by the *Fountain of the Moor*.

At the southern end of Piazza Navona stands a fountain constructed by Giacomo della Porta on a complex geometrical ground plan towards the end of the sixteenth century.[35] It is inhabited by Tritons blowing on twin shells (the original statues have been removed to the Villa Borghese and replaced with copies). After the articulation of the centre of the piazza with the *Fountain of the Four Rivers*, it seemed desirable to enhance this fountain, which is nearer the front of the Pamphili Palace, with a striking centrepiece. At the bidding of Innocent X, Bernini in 1652 designed an ornamental motif consisting of a spiral and coruscated sea snail shell held aloft – most improbably – by the curly tails of three entwined dolphins. The dolphins are undercut below and have their mouths open at water-level, just like those of the *Triton Fountain*. A pen and ink drawing at Windsor Castle conveys the vivacity of Bernini's concept with hundreds of short, curving strokes, while a generous play of water spurting up from and falling back down upon the shell is indicated in a blue wash so faint as to be scarcely visible in reproductions. For once, however, Bernini had miscalculated, and his centrepiece was deemed too small, so it was removed and given by Innocent to his sister-in-law in 1653.[36]

Also related to this fountain by their aquatic subjects are a first-rate drawing showing a pair of facing Tritons, tails and arms entwined, endeavouring to support four dolphins in mid-air and a corresponding, though fragmentary, model in Berlin. These may record Bernini's second thoughts about the central feature, for the position of the dolphins can be seen to be derived from those that supported the sea snail shell in the 1652 design.[37]

Ultimately, to replace the original, overly diminutive, centrepiece, Bernini designed a colossal male nude standing over a similar – but gigantic – snail shell, now shown lying on its side. With his right hand advanced the figure grasps the tail of a large fish, perhaps a carp, while, with his other hand lowered behind his back, he grasps its dorsal fin. The fish thrashes its head in desperation between his parted legs and spurts water from its open mouth. Its weight is taken by a coruscated protruberance from the mouth of the shell, which thus provides a third point of support for the figure, as well as its ankles. The violent *contrapposto* and windswept hair and beard recall Bernini's earlier group *Neptune and Triton*, and his body the figure of Pluto, particularly when seen from behind. But the closest prototype was Giambologna's figure of Ocean from the *Fountain of Ocean* in Florence which crowns the fountain with river-gods that had influenced those in the centre of Piazza Navona.

Original models survive for the whole group and for the head: the latter has much greater detail and was probably broken off a larger, more finished, rendering that has vanished. Bernini modelled it almost as a caricature, with thick protuberant lips, *retroussé* nose and overhanging brow recalling those of the River Plate: this has led to its name, the *Fountain of the Moor*. Both heads were perhaps inspired by the four drinking fountains with Tritons around the Isolotto in the Boboli Gardens. These models were the extent of Bernini's contribution, for he delegated the carving between 1653 and 1655 to G. A. Mari, and was paid only 300 scudi by the new pope, Alexander VII, for his personal efforts.

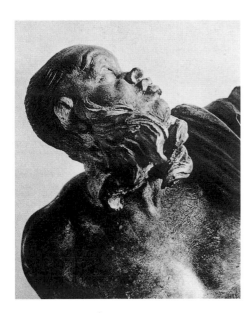

292. Head of the *modellino* for the River Plate, from the Farsetti Collection (Cà d'Oro, Venice).

293, 294. *Modellino* for the whole figure (private collection) and a larger fragmentary terracotta head for the *Fountain of the Moor* (Museo di Palazzo Venezia, Rome).

295. Another scheme for the *Fountain of the Moor*: two Tritons support four dolphins in mid-air (Royal Collection, Windsor Castle).

296. The *Fountain of the Moor* in Piazza Navona, Rome.

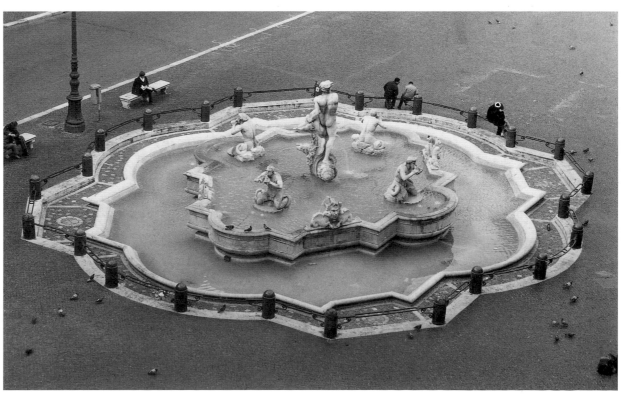

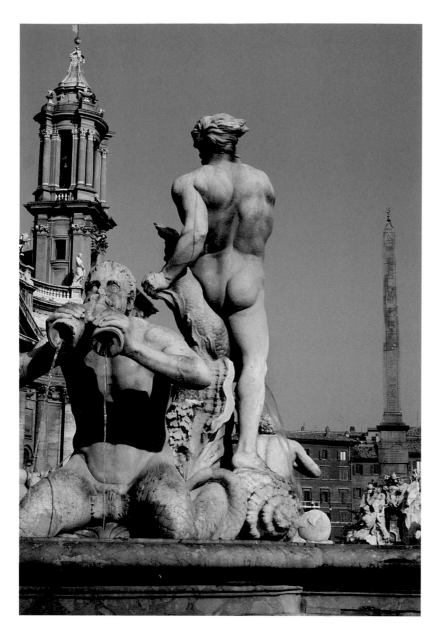

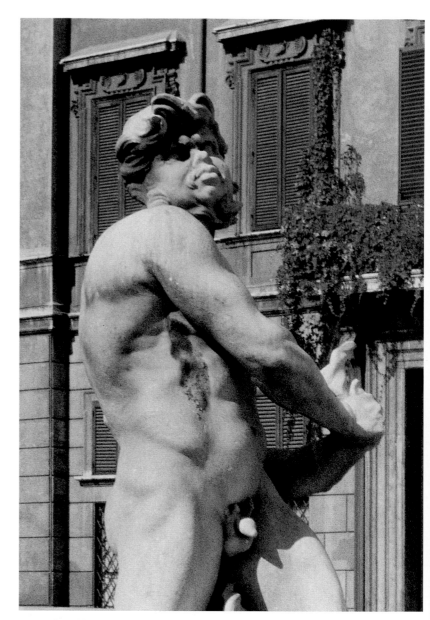

297, 298. Views of the central figure of the *Fountain of the Moor* in Piazza Navona, Rome: that from behind shows how Bernini made it relate to the campanili of Sant'Agnese and the *Fountain of the Four Rivers*.

299. Sketch by Bernini probably for the fountain at the northern end of Piazza Navona: Neptune astride a great oyster shell (Royal Collection, Windsor Castle).

With the centre and the southern end of Piazza Navona magnificently punctuated by grand fountains, the northern end cried out for a matching one. Indeed, a basin had already been constructed under Pope Gregory XIII. This is now crowned with a nineteenth-century statue of Neptune wrestling with a huge octopus, a melodramatic conception worthy of Jules Verne! An evocative drawing by Bernini shows a detailed and therefore advanced stage of a design for a fountain that relates either to the southern fountain before the moor and his shell were invented, or, as seems more probable, to the northern one. It has a quadrangular lobed ground plan and a series of four Tritons in mid-water blowing on shells, bringing up to date those of the Cinquecento prototype by Giacomo della Porta. Its centrepiece is a splendidly gesticulating figure of Neptune astride a great oyster shell. Instead of thrusting his trident downwards at the waves, he extends his right arm in an imperious gesture of command (like that of Giambologna's *Neptune* in Bologna, although he uses the other arm), while he holds his cloak and trident in the lowered left hand. The hinge of the shell bears a papal escutcheon. Four pairs of dolphins mounted on the lobes of the periphery spout water into an outer basin at ground level, probably to assist

300, 301. Two apparently successive projects in chalk for a fountain at Sassuolo (Royal Collection, Windsor Castle): they show Neptune astride an open shell and Neptune and Amphitrite.

housemaids actually drawing water with buckets and to allow animals to drink, since great fountains were designed to be of practical use. It is a pity that this noble project was never realized.

The fountains of Sassuolo

The highly accomplished drawing just discussed bears more than a passing resemblance in theme to another, more sketchy example executed rapidly and fluently in black chalk, showing Neptune standing astride an open shell, supported on the bent backs of a pair of sea centaurs. It is unclear whether this was envisaged as a free-standing piece, or intended for a large niche, but in any case it seems to be connected with one of three fountains that Bernini designed in 1652–3 for Francesco d'Este, Duke of Modena, following the success of his

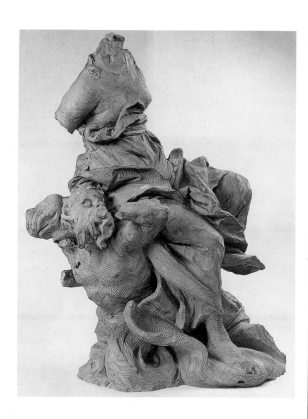

302, 303. Fountain of a marine deity with a fish: a chalk sketch
(J. Paul Getty Museum, California) and a presentation drawing in pen
and wash (Victoria and Albert Museum, London).

304. Terracotta model of a woman leaning on a Triton, probably
connected with the Sassuolo project (Fogg Museum of Art,
Cambridge, Mass.).

portrait bust.[38] These fountains were for niches in the walls of
the atrium and courtyard of Francesco's palace of Sassuolo.
Their carving was delegated to Raggi, and he in turn may
have subcontracted much of the work to local stonemasons,
for the figures are of indifferent quality, and are now in a
poor state of preservation.

Nevertheless, Bernini's preparatory drawings are
fascinating, for they show his restless imagination hard at
work. A further composition is emerging in which Neptune
no longer stands, but climbs a rocky mound to be with
Amphitrite, who lies provocatively at his knee with her left
foot dangling nonchalantly into the water contained in a shell
below. Constant adjustments between the poses of the two
figures are recorded by smudgy pentimenti on one of the
sheets, where for example the angle and position of the
trident are shown in alternative ways: the preferred solution is
then clarified on the verso of the same sheet, which the artist
turned over, so that it is upside down. The result is not unlike
Bernini's group of *Time Unveiling Truth*, on which he had been
engaged for several years just prior to the commission for
Sassuolo. A vivacious terracotta model of a nubile woman
leaning on a Triton may also have been made in connection
with this project.

For the central niche of the palace courtyard Bernini
produced an exploratory sketch in black chalk and a definitive
one in pen and wash, showing the main stages in the design
of a marine deity, seated on a rocky archway and struggling
with a huge fish, derived from the River Danube of the
Fountain of the Four Rivers. The chalk sketch has pentimenti
particularly towards the top, where the exact convolutions of
the fish's tail were being worked out, while the more finished
project has the finesse of a presentation drawing and so may
be one of those recorded as having been forwarded to Duke
Francesco for his approval. The asymmetrical design is
brought into equilibrium by a careful disposition of voids
and solids to either side of its vertical axis. These features are
mostly aligned with the regular, vertical indentations in the
lay of the paper, which provided a handy guide to the
sculptor as he drew. This resulted in an almost modular
system of design, which – like squaring – would have
facilitated eventual enlargement for the *modellino* by Raggi that
survives in Modena[39] and the production of full-scale *modelli*,
or direct transfer by measurement to the blocks of stone to
be carved *in situ*. The drama of the image was enhanced in
Bernini's second drawing by a heightening of the chiaroscuro
effect, achieved by reserving the white paper for highlights
and brushing on layers of wash to darken the shadows. The
vibrant result resembles very strong directional sunlight,
presumably calculated to correspond with natural conditions
in Sassuolo. The design is a triumph of the fountaineer's, as
well as of the draughtsman's, art.

Thereafter, the demand for Bernini's fountains continued
unabated. It was perhaps inevitable that he would recycle

ideas that he had explored earlier, produce concoctions of elements with which he had experimented and reuse various permutations. One such design was for a wall-fountain for Paolo Strada, to decorate the courtyard of his house on the Strada Nuova.[40] Strada was 'confidential chamberlain' to Pope Clement IX, by whom, in recognition of service, he was given the right in 1667–9 to a generous, private supply of water from the Acqua Felice. Bernini was responsible in his official capacity for the actual conduit to the house and probably designed the fountain immediately. A terracotta model in the Bargello Museum in Florence, though very highly finished and attractive, was possibly worked up by one of Bernini's assistants as a presentation piece for Pope Clement's personal approval.[41] The composition is focused on an open double shell with distinct ridges and supported on the entwined tails of a pair of dolphins swimming in the pool below, while above some surrounding rocky crags a pair of Tritons blowing their conches support the coat of arms at the apex.

The impact of Bernini's versatile imagination on the history of fountain design cannot be overemphasized. His vibrant creations of bizarre, but nonetheless harmonious, forms with writhing figures and sinuous fishes are always constrained within the visual frame of architecture, even if that architecture is heavily disguised as rusticated rocks. His fountains' principal views usually conform to the traditional eight points of the compass that had been recommended since the Renaissance, and Bernini often aligned them subtly with salient features in the surroundings, such as entries to streets or prominent buildings. They are frequently discovered quite unconsciously by the photographer, when searching for the most telling camera angles.

Bernini's fountains dominated the remainder of the Baroque era, and their influence spread all over northern Europe, only being purged by the austerity of Neoclassicism. Such was his range of fountain types, sometimes supplementing and sometimes supplanting those which already existed in the epoch of Mannerism, that virtually nothing new remained to be invented. Apart from many especially imaginative fantasies, Bernini's principal innovation was to bring all manner of weird and wonderful forms, conceived by his predecessors for the enjoyment of a small coterie of fortunate owners and their guests in the rustic settings of villa gardens, into the very heart of the city to relieve its tedium and punctuate its commotion. This is the gift bequeathed by Bernini to the people of the Eternal City.

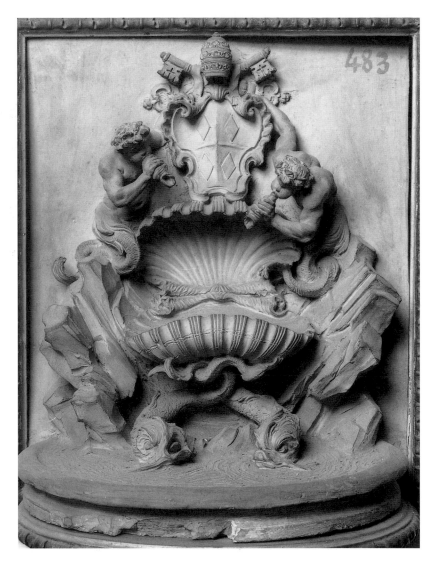

305. Terracotta model for a wall-fountain for Paolo Strada (Bargello, Florence).

306. Bernini 'friend of the waters' – a simple sketch for a fountain in front of Santa Maria in Trastevere, Rome (Chigi Archive, Musei Vaticani). See pp. 179–180.

10 * Bernini's buildings: the sculptor as architect

UP TO THE AGE OF TWENTY-FIVE, Bernini, like any gifted and ambitious young person, was completely absorbed in mastering his craft, in emancipating himself from his father's workshop (or, rather, in subtly assuming artistic leadership of it) and in making a name for himself. In all these aims he succeeded beyond his wildest dreams, achieving his knighthood in recognition of services rendered to the papacy, and the presidency of the guild of artists by dint of strength of character and sculptural skill. With Pope Urban's commission in 1624 for the renovation of the church and sanctuary of Santa Bibiana, his energies were channelled into the tangential field of architecture, in this case as a complete setting for his crucial new statue behind the altar. Planning of the Baldacchino of St Peter's proved to be as much a question of architectural and environmental considerations as of sculptural matters, though as has been shown, the structure was conceived as the centre of a complete scheme of sculptural embellishment around the piers of the crossing.

Bernini's status as a *uomo universale* was confirmed by his appointment in 1629, having barely reached the age of thirty, to succeed Carlo Maderno as architect of the most important building in the western world, the Basilica of St Peter. In the same year, upon the death of his father, he assumed a major position in civil engineering too, as surveyor of the water supply of the Acqua Vergine: this enabled him to make his mark on the secular city of Rome with amazing fountains, as well as on the ecclesiastical world of the Vatican. His multiple responsibilities stimulated him rather than overwhelmed him so that he lived in a state of permanent hyperactivity, which could be alarming to family and friends and positively threatening to the rest of the artistic community. He evidently thrived on his own success and was correspondingly utterly depressed by the few setbacks that he did suffer. These were all to do with the practicalities of architecture.

During the pontificate of his close friend and mentor, Urban VIII, at whose behest he had also taught himself the art of painting and with whom he communed on virtually equal terms daily over dinner, his activities were evenly balanced between sculpture and architecture. However, after the hiatus created by Innocent X's initial antipathy, Bernini's career was set on a path of increasingly architectural endeavour. This provided a background of frenetic practical activity, from which the carving by his own hand of occasional brilliant statues provided him with a form of physical exercise and spiritual, as well as psychological, release.

The Piazza San Pietro

The change in emphasis occurred early in 1655, with the election of Alexander VII, as Baldinucci explains:

The sun had not yet set on the day that was Cardinal Chigi's first in the office of Supreme Pontiff when he sent for Cavalier Bernini. With expressions of the utmost affection he encouraged Bernini to embark upon great things in order to carry out the vast plans that he had conceived for the greater embellishment of God's temple, the glorification of the papacy, and the decoration of Rome. Consequently the Pope wished to have Bernini with him every day, to have him mingle with the learned men with whom he adorned his table. The Pope used to say that he was astounded at how Bernini, by the sole force of his genius, could arrive at the point in the discussions that the others had scarcely attained with long study. The Pope named Bernini his own architect, something which the other popes had not done, as they all had family architects on which they wished to confer that post. After Alexander VII this was no longer the case. Because of the respect his successors had of Bernini's singular virtue, he held that post as long as he lived.

The eclipse was over and Bernini's star, conjoined with the heraldic star of the Chigi, was once again in the ascendant. Fabio Chigi's emblem of mounds surmounted by a star was soon to be as ubiquitous in Rome (and in his native Siena), as Urban's Barberini bees had been. The work Bernini had begun for Chigi as a cardinal, he now continued for him as pope, on an even grander scale. Now it was not only the Chigi family chapel, designed by Raphael, that was the focus of attention, but the whole church in which it was situated, Santa Maria del Popolo. Then the scheme was enlarged to comprise the adjacent Porta del Popolo, the principal point of entry to Rome from the north (i.e. from the rest of Europe), as well as the piazza within.[1] And, as if this were not challenge enough, in July 1656, as Baldinucci informs us,

307. Part of Bernini's Colonnade in Piazza San Pietro, Rome.

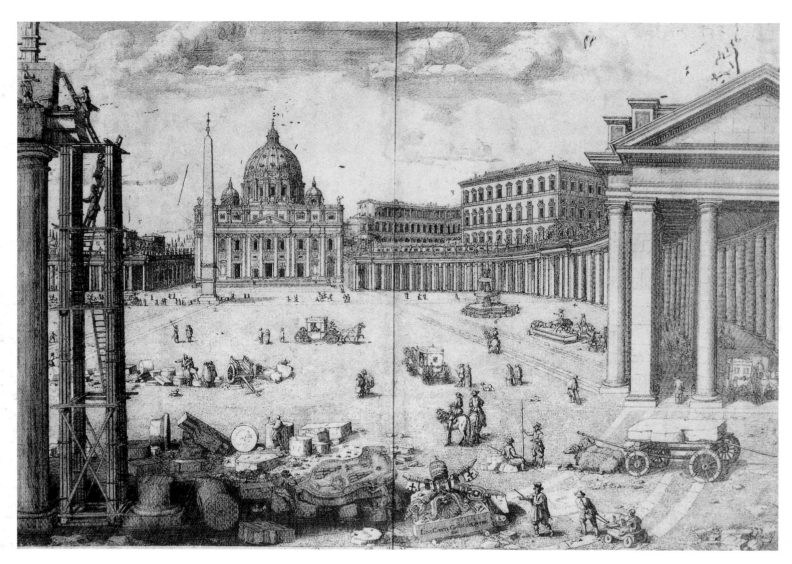

308. The Colonnade under construction (engraving after Lieven Cruyl, 1668). In the centre, columns are being carved; in the foreground, papal coats of arms; on the right, a block of marble for a coat of arms lies on an ox-cart.

Bernini was retained by the Pope with a monthly provision of two hundred and sixty scudi. He initiated and in due time finished the colonnade of St Peter's. In designing this great structure he wished to use an oval plan, thus departing from Michelangelo's design. He did so in order to bring the colonnade closer to the Apostolic Palace and so obstruct less the view of the square from the part of the palace built by Sixtus V, with its wing connecting with the Scala Regia.

Architecture, and sculpture associated with it, were Alexander's passions, rather than the art of painting. As Krautheimer has noted: 'On matters financial and economic Alexander appears to have been both innocent and heedless.'[2] The political power of the Church had been severely restricted in 1648 by the Treaty of Westphalia, and the balance of power in the west now lay with Spain and France. So the new pope had to solace himself with promoting the glory of Rome, the Church and the Chigi by continuing — almost to completion — the campaign of building in St

Peter's and its immediate environs. Inside the basilica, Bernini and the pope were working westwards from the crossing, already complete with Baldacchino, to the chancel end with its elaborate construction to house and celebrate the *Cathedra Petri*; they also turned eastwards outside from the recently completed façade (*c*. 1620), where the space facing the basilica was an unseemly shambles.

A roughly rectangular and generally unpaved forecourt — where a great Egyptian obelisk had recently been raised with great engineering skill by Fontana in 1586 near a refurbished fountain, off-centre — gave unceremoniously onto the cramped quarters of the area known as the Borgo. An engraving of the early 1640s by Silvestre shows its state when Alexander instructed Bernini to take it in hand and endow it with a grandeur that befitted the central church of Christendom.[3] Old St Peter's had at least offered shelter to pilgrims in a narthex and an enclosed atrium. An initial plan of Bernini's simply regularized the existing 'square' with arcades down either side (diverging towards the façade in an attempt to minimize its great width visually); an earlier scheme was rejected, on the grounds that it would have kept the crowds too far away from the window of the Vatican

309. An engraving of an early version of Bernini's scheme for the Colonnade (1659), showing one whole segment in plan and elevation, and a bird's-eye view including the so-called 'third arm' in the centre.

Palace from which the pope gave his benedictions. Before Bernini's involvement, a hexagonal and even an oval plan, both opening gradually outwards from the foot of the steps, had been mooted, though with their long axes in line with that of the basilica. These also provided for a twin fountain to be erected symmetrically opposite the existing one. Double or even triple porticoes were suggested on the authority of ancient precedent. Eventually, in close consultation with his patron, Bernini arrived at the final concept of swivelling the oval through ninety degrees, so that its long axis was now perpendicular to that of the basilica and could therefore more easily accommodate the elegant progression of fountain–obelisk–fountain previously envisaged.[4]

The whole of the oval plan was distanced from the façade and grand steps by two straight wings, still diverging towards the façade. Applying the favourite Renaissance analogy of the human body, in a couple of drawings the basilica was shown

as the head, the steps the neck and shoulders, and the encompassing segments of portico the embracing arms. Vertical and horizontal sight-lines were carefully taken into consideration, as a number of hasty chalk sketches that survive in the Vatican Library attest. Furthermore the punctilious notes in Alexander VII's personal daybook corroborate the nature and co-operative spirit of the accompanying discussions. Paramount always was the pilgrims' clear view of the benediction window, the one still used today, where the pope is shown worldwide on television giving his Christmas and Easter blessings in many languages.

Once the curved plan was adapted, the earlier idea of arcades had for practical reasons to be abandoned in favour of colonnades; the columns are now four deep, creating a wider centre aisle for carriages flanked by two narrower ones for pedestrians. These colonnades thus formed the most extensive *porte-cochère* in the world and could accommodate whole processions of grandees and their outriders in the dry, or in the cool, depending on the season. The intention is clear from an engraving of 1668 by Lieven Cruyl. The all-embracing plan was publicized and celebrated in 1659, complete with angels trumpeting the fame of Alexander

Bernini's buildings 213

310. *St Agnes*, a cast in bronze from Bernini's lost model for one of the statues of saints to stand on top of the colonnade (private collection).

(and by extension of his chosen artist), in an enormous engraving, designed by Bernini himself.

Bernini, dramatist that he was, had also conceived an unusual idea of restricting access to the broad end of the oval opposite the basilica to two openings in the colonnade on either side of the central axis, so that the great central opening of today with its generous view would have been blocked by an independent, third wing of colonnade. Accordingly, the extant arms of the colonnade are not by any means semi-ovals, but only quadrants.[5] While featuring in the

engraving, in celebratory medals and at the extreme left of Cruyl's engraving, this segment was never built. Regrettably this left room for the megalomaniac Mussolini to drive his appallingly overbearing and monotonous Via della Conciliazione straight up from the banks of the Tiber into what should have been an enclosed piazza, with complete disregard for historicity, aesthetics or the character of the old city.

Predictably, in view of the patron and the designer, the colonnade was not to remain a piece of plain, unadorned architecture, despite the notional severity of the Doric order that was selected for its columns. Its skyline, in keeping with respectable ancient and Renaissance precedent, was to be punctuated by an array of statues the like of which had never been seen. Almost every saint in the Catholic calendar could be accommodated here, two over the double pilasters of the straight corridors and one over every radiating row of four columns, to proclaim their faith to all comers and comfort with their intercessions the exhausted pilgrims resting in the piazza below in 'the embrace of Mother Church'. So many are they, one hundred and forty in all, that a whole book has recently been dedicated to them.[6] They are '*il gran Teatro del Vaticano*', including as they do saints, martyrs, popes and founders of monastic orders, their dramatic contours standing out bravely against the skyline.

Naturally, there was no question of Bernini himself carving any of the ten-foot-high figures, but he did take his usual trouble in designing a number of crucial ones, as is attested by a few surviving drawings[7] and one or two *bozzetti* in terracotta, while his models for some others were preserved, like that for the Tomb of Countess Matilda, by making casts from them in bronze. The actual statues are mostly seen *contre-jour*, so that detail is lost. Marked postures, broad swathes of drapery and distinct, obvious gestures with rhetorically extended hands or martyrs' palms were required. Some ten carvers in all were employed, though Lazzaro Morelli (1619–90), who had made fifty wax figurines for a preliminary wooden model of one of the curving arms, was the most continuously employed: between 1662–73 he carved no fewer than forty-seven of them.

Six great curvilinear Chigi coats of arms surmounted by the papal insignia were also required to mark the entrances to the pair of straight corridors and the pavilions at the centres and ends of the curved arms; they were carved in two alternating patterns. One of these is shown being carved on the ground in Cruyl's engraved view, while a pre-shaped block for another is being hauled in by ox cart at the right, with the beasts collapsing under their burden. These arms were flanked by the most significant saints, for instance the pretty pair *St Catherine of Alexandria* and *St Agnes* among the earliest, carved to the design of Bernini himself in 1662 over the entrance to the

308

straight right corridor which leads to the Scala Regia. (The models of these two from which Morelli worked were among the few preserved by casting in bronze.) Teamwork and productivity then became the order of the day, with in some cases an inevitable falling off in quality of design and execution over the ensuing decade. Nevertheless, like any grandiose public undertaking, it is the enormous success of the whole that counts and not the individual qualities of its components.

311. Part of Piazza San Pietro. The sections of the Colonnade immediately in front of the basilica, which at a glance look parallel, in fact diverge as they approach it; the effect is to make the façade look narrower.

312, 313, 314. The Scala Regia runs from the right-hand straight section of the Colonnade into the Vatican Palace. Bernini designed the reverse of a commemorative medal, 1663 (Biblioteca Vaticana). On the right of the landing halfway up stands *The Vision of the Emperor Constantine* (see plate 357), which is visible also from the portico.

The Scala Regia

Once the building of the colonnades and the carving of the prototype statues were under way in 1662, Bernini turned to another, more purely architectural project, adjacent to the basilica, a 'Royal Staircase' to provide access from St Peter's and the piazza up into the Vatican Palace. As Baldinucci relates:

The Scala Regia is also a marvellous work by Bernini and the most difficult he ever executed, for he had to shore up the walls of the Sala Regia and the Pauline Chapel and set both rooms over the vault of the Scala Regia . . . the beautiful perspectives of steps, columns, architraves, pediments, and vaults bring into delightful harmony the stairway's wide entrance and its narrow exit. Bernini used to say that this stairway was the least defective thing he had ever done.

The main aesthetic decisions related to the due proportioning of the internal colonnade to either side, to distract the eye from the fact that it narrowed considerably towards the top. Bernini counteracted the effect of what would be a naturally exaggerated perspective by setting the flanking colonnades further from the walls at the beginning of the stairs than at the top. The heights of the columns on the upper run of stairs were also systematically reduced.[8] Typically, he also introduced a number of skylights, and in one to the east of the middle landing set stained glass with the Chigi stars against a turquoise background, to throw rays of bright but dappled light obliquely onto a grand statue, *The Vision of the Emperor Constantine*, that stood against the wall, imitating the effect of a heavenly vision.[9]

A presentation drawing in Munich prepared by Bernini's studio shows a stage just prior to the final design of the upper flight, from the level of the basilica, with a pair of trumpeting angels presenting the Chigi arms in front of the entrance arch, their legs and fluttering drapery impinging on the view of the coved ceiling.[10] They were subsequently reduced in size and their dangling legs lifted sideways so as to clear the view of the receding richly coffered vault. A neat drawing for a commemorative medal also records the earlier idea.

Bernini's churches

As if Bernini were not busy enough with these great projects at St Peter's and around Santa Maria del Popolo, Alexander also encouraged him to design a number of churches, one in the centre of the city and two outside.[11] As with Bernini's designs for family chapels, his overriding principle was to create a harmonious unity out of architectural space and form, sculpture (both narrative and ornamental), interior decoration and even church furniture. Bernini felt that the traditional cruciform plan, especially a Latin cross with a long nave, worked against such unity, its extremities not being generally visible at one glance. He preferred the centralized plans that had also fascinated his predecessors during the High Renaissance, not least Bramante in the initial conception of St Peter's itself. These involved a dome centred over a cylinder, square or Greek cross with shortened arms.

Bernini added to this traditional repertory a derivative of the circle, the oval, a shape which has since been regarded as the quintessence of Baroque design. Ancient Rome offered the classic domed cylinder in the Pantheon, which had long been converted to Christian use. Alexander was fascinated by it, revering it more than Urban VIII (who had pillaged bronze from it to cast his Baldacchino). He directed Bernini's attention to it on several occasions, wishing to free it from accretions of medieval building and thus to isolate it, ennobling the façade with an approach from a decent piazza, and finally to refurbish its massive, austere interior with stuccowork and Chigi stars in the coffering of its dome. Bernini made a few preparatory sketches, but his heart never seems to have been in the scheme and despite the pope's urgings he managed to avoid serious involvement, pretending 'that he did not have sufficient talent'.[12]

Even so, the Pantheon proved crucial to his choice of pattern for the church of the Assumption that he was commissioned to build to replace a demolished village church at the pope's country seat, newly acquired in 1661, at Ariccia, a few miles to the south-east of Rome. The palace was based on an older fortress built for defence on a promontory over a ravine. In view of the new owner's status, it was determined

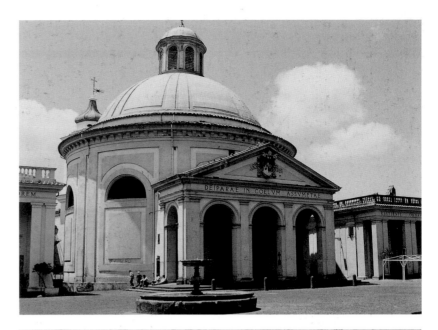

315, 316. Bernini's church of the Assumption, Ariccia: a general view of the façade and enclosing curved wings of architecture and a detail of the interior of the dome.

to introduce a spectacular church prominently into the equation, facing the palace across a piazza adorned with a pair of fountains, thus creating a unified urban design.[13] A polite screen of new buildings behind would hide the tumbledown village from the papal gaze. Asymmetry in the lie of the land forced Bernini to cant the church off the perpendicular axis from the main entrance, and in order to minimize the disruptive effect on a spectator emerging from the portal of the palace he decided on a cylindrical form for the church, avoiding the directional emphasis of a rectangular ground plan. Even so the ground had to be terraced out to provide sufficient space for the church and its neatly encompassing structures, but this had the advantage of providing a terrace which would enjoy a panoramic view sideways towards distant Rome. The church

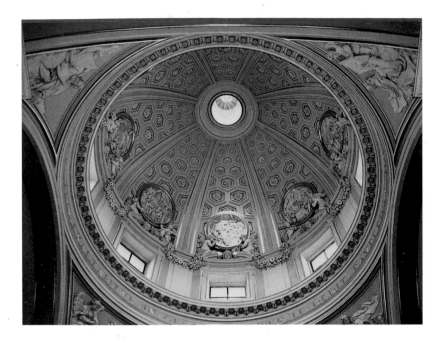

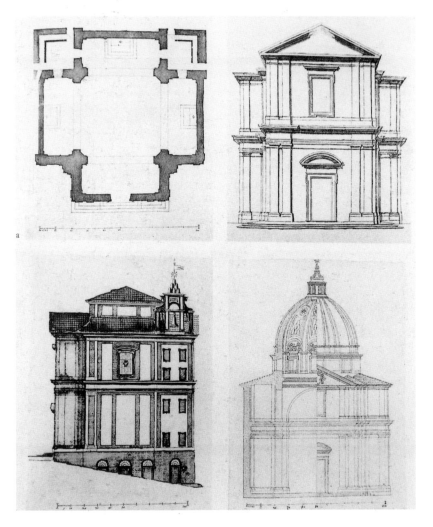

317, 318. San Tommaso di Villanova, Castel Gandolfo. Detail of dome with stucco roundels by Antonio Raggi: plan, section and elevation. The drawing bottom left shows an early project with a drum but no dome, and indicates the slope on which the church stands.

is half enclosed within a concave range of buildings running behind it. This was a favourite motif of Bernini's, informing his designs for the porch and forecourt of Sant'Andrea al Quirinale, which he had begun a couple of years earlier, and for the east façade of the Louvre Palace, in his most glamorous, if least practical, first project, drawn soon afterwards in 1665.[14]

For its exterior, Doric austerity was decreed, to let the basic forms of cube and cylinder tell, and the only Baroque element is the cartouche with the Chigi coat of arms in the pediment. It did not take Bernini long to reach this solution, for by December 1661 he was already in correspondence with the pope about designing foundation medals, and on an elegant reverse he emphasized the circularity of the church by isolating it within an unusually raised rim, and omitting the concave screen around it.

In the well-lit and predominantly white interior, the cylindrical, domed space feels breathtakingly immense. Frilly sculptural decoration was kept to a minimum and restricted to the springing of the great hexagonally coffered dome, which is articulated by plain tapering ribs, soaring up to the plain bright circle of the oculus beneath the lantern. These are inevitably marked by the Chigi mounds and star at their bases. Between each pair is a curvaceous broken pediment of voluted form, around which are entwined heavy swags of flowers, and on whose terminal scrolls teeter pairs of cherubim or seraphim. An original pen drawing for a segment of this ceiling survives at Windsor Castle. An overdoor lunette equates the Chigi star metaphorically with that of the Virgin Mary in an inscription, 'O Morning Star, pray for us.' Even the wooden cupboards are consistently oval in plan and counter-sunk into niches recessed into the outer wall, thus reflecting the way in which the convex church nestles within the concave surrounding façades.

In the same general direction out of Rome lies the pope's summer residence, Castel Gandolfo: as its name suggests this was once a castle and is perched on the rim of a volcanic crater, enjoying a glorious view over the tranquil, almost circular, Lake Albano below. Alexander visited on 14 October 1657, later noting punctiliously in his diary: 'We have settled on the design of the church of this locality and talked about putting in order the houses in the hamlet . . . and, four days later, with Bernini, made many designs.' An older village church was to be refurbished thoroughly and rededicated to San Tommaso di Villanova, newly canonized in 1658. It stands in a scenic position at the opposite end of the rectangular piazza running down the spine of the hill from the papal residence. To either side glimpses of the lake far below may be enjoyed, while one of the streets of the little town is aligned with its far transept. It thus has a scenographic quality typical of Bernini's taste.

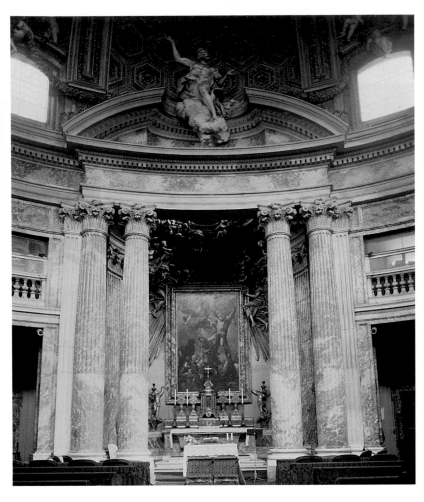

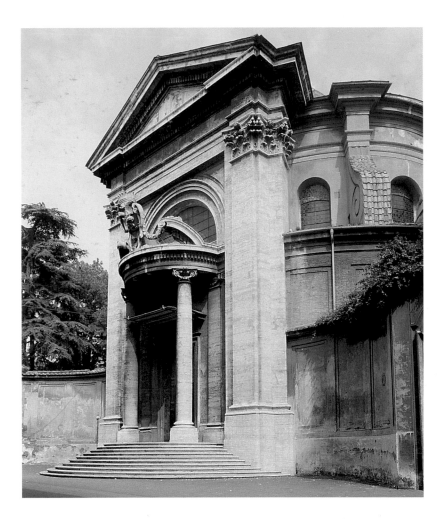

319, 320. Sant'Andrea al Quirinale, Rome: the high altar with St Andrew ascending; the façade and the porch.

Bernini chose a centrally planned, minimally cruciform structure, covered with a high dome and an elaborate lantern capped with a small onion dome supporting a golden globe and cross. The result is a compact edifice, whose dome is a landmark for miles around. Its interior is more ornate than that of the church at Ariccia. The dome is of the same basic design but the role of sculpture is enhanced. Not only do the paired putti in the vanes of the vault now support huge roundels with narrative scenes from the life of San Tommaso, but the pendentives provide fields on which to depict in quite high relief the Four Evangelists and their symbols: in charming variations on the usual representations, *St Luke*, patron of painters, is shown sketching a head of the Madonna on a pad held up for him by an angel, while *St Matthew* seems to be enthralled by what his symbolic angel has to tell him. All were modelled by Raggi in 1660–1, but unfortunately have had to be repaired after substantial war damage. There is also a sumptuous high altar with an oval *Crucifixion* painted by Pietro da Cortona. It is surveyed from above by a very active *God the Father*, and supported by seraphim in diverse attitudes, all expertly modelled by Raggi in white stucco, against a polychrome background. As one turns to leave, the Chigi arms over the portal bid farewell.

Far more important than these country churches (with their simplified and economical interpretation of the Baroque), and far more intimately planned and supervised by Bernini, was Sant'Andrea al Quirinale, in the heart of Rome. It was designed in collaboration with Pope Alexander, though this time he kept behind the scenes, for the church was administered by the Jesuit order, and was to serve their Novitiate.[15] Furthermore it was to be financed by Prince Camillo Pamphili, nephew of the preceding pope. Indeed a grandiose plan for the church had been sketched by Innocent's protégé Borromini, but it was rejected in order not to compete with the new Quirinal Palace that Innocent was having constructed directly opposite the site.[16] Bernini was preferred as architect by the new pope and initially suggested a pentagonal plan to accommodate the five chapels that the Jesuits required, but this unusual shape was soon abandoned in favour of his beloved oval. Unlike Borromini's smaller church of San Carlo alle Quattro Fontane nearby, which also approximates to an oval, the long axis of Bernini's oval was to run parallel with the street and *across* the church, rather like the Piazza San Pietro. Faced with a shortage of space in front of the oval, Bernini substituted for the normal entrance lobby a semicircular porch outside, with convex spreading steps, counter-sunk between concave flanking curtain walls. The porch is also crowned with a broken pediment of volutes. All of these forms provide a symphony of curves in three

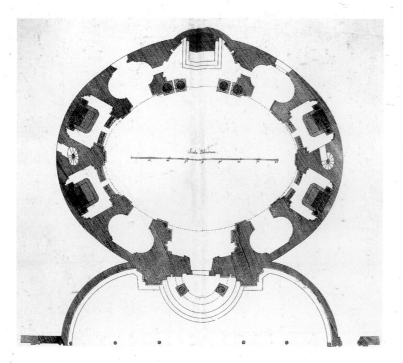

321. Sant'Andrea al Quirinale: plan.

322. Detail of the interior of Sant'Andrea al Quirinale, showing the arms of the Pamphili and banderole with dedication and a figure of Fame, modelled by Giovanni Rinaldi (1670).

dimensions, hewn out of golden travertine stone and crisply modelled in light and shade. Here Bernini's distinctly unorthodox architecture takes on a strongly sculptural bias in its sheer plasticity.

The interior, with its wide and flattened oval dome, well lit from windows all round, gives an impression of immense space, like the Pantheon, although it is far smaller. Unlike the Pantheon, or the church at Ariccia, there is no sense of austerity. On the contrary, one feels as though one has stepped inside a lavishly decorated jewelry box or perhaps one of the sacramental tabernacles covered with precious stones and gilt bronze that Bernini loved to design. Visitors are confronted across the shorter axis of the oval plan by a secondary, more or less oval, recess housing the high altar, lit by its own oculus. From the richly coloured altar painting of the *Crucifixion of St Andrew* by Il Borgognone, framed in red
325, 326 *breccia* marble and held in place by great gilt stucco angels, the eye is led up past a burst of golden rays (lit from the concealed, secondary lantern) and myriad tumbling cherubim in mid-flight, to a gigantic figure of St Andrew, arms outspread and kneeling on a bank of cloud. He is ascending effortlessly heavenwards, neatly framed within the broken pediment of the huge aedicula that defines the entrance to the sanctuary. Indeed he seems to have burst asunder a continuous pediment, forcing his way through by mystical

impetus and leaving an oval hole, open to the front, the curves of the pediment neatly framing his form.

The figure of St Andrew is one of Bernini's most awe-inspiring. His vigorously projecting left knee is propped on a puff of cumulus cloud; strongly modelled and knobbly, it indicates the strength still remaining in the elderly fisherman. Reflected light emphasizes the thrust of this lower leg, and (with the brief interval of his foreshortened torso leaning backwards) its strong diagonal line is seen to continue on through his outstretched forearm, with all its power dispersing through the open fingers of his gesticulating hand. The upward turn of his face, its axis and the direction of his entranced gaze run parallel with and are reinforced by this ascending diagonal line. It is counterbalanced visually in a minor key, *diminuendo*, by his other thrusting forearm and open hand. This secondary diagonal seems to run beneath his bent knee and expire in the little bump of cloud to the far left. Thus the saltire cross on which Andrew chose to be crucified (in order to differentiate himself from Christ), which features in the painting below, is reiterated in the pose of the ascending figure: indeed the artificial, gilded rays radiating from the altar oculus to either side of the picture mediate subtly between the two saltire shapes.

As he looks up towards paradise, Andrew's ecstatic face is strongly illuminated, as though by heavenly light but actually from the oculus at the centre of the main dome. The trajectory of his ascent also suggests that he is about to leave our worldly space through the shining oculus, *en route* for heaven, here represented by Bernini's golden ribbed and coffered firmament, with its populace of innocently playing infant angels. Meanwhile, in the golden glow of the lantern

323. Sant'Andrea al Quirinale, Rome: interior showing the dome and central lantern, surrounded by cherubim, but leaving a clear path for the saint's ascension.

(sunlight tinted by yellow stained glass), a single welcoming cherub peers down towards the aged martyr as he ascends. The mouth of the lantern is ringed by a chorus of stucco cherubim who are arranged to leave an inviting gap diagonally above him. Yet higher, above the ring of blindingly bright windows, the dove of the Holy Spirit hovers beneath the – again sombre – little dome of the lantern.

Even the natural veining of the reddish *breccia* marble on the flanking columns and pilasters is so selected as to reiterate the theme of rising diagonals, while its whitish-grey blotches resemble clouds seen against a blood-red sky, such as often accompanied martyrdoms. The expansive floor is inlaid with radiating patterns of grey marble, while directly in front of the entrance are the gloriously colourful coats of arms of the Society of Jesus and Cardinal Pietro Sforza Pallavicino who

had joined the Society in 1638. Over the marble pediment of this portal, opposite the patron saint, but in a realm below his, are a pair of winged figures, the foremost of which holds up diagonally to view the arms of Prince Camillo Pamphili and a great banderole flapping in a wind, with a laudatory dedication; the other represents Fame blowing her trumpet. They virtually obscure the dark pediment, so that one is convinced that they are hovering inside the very building. Above, in a lunette of clear glass, shine the Pamphili arms in full heraldic tinctures. The side-altars comprise no fewer than six marbles of diverse hue and throughout this wonderful interior are many other such embellishments.

By thus exploiting the internal space and even the shape of the building, its lighting and the combined arts of painting, sculpture and architecture, Bernini here achieves a totally unified work of art (*Gesamtkunstwerk*), as he had done in the far smaller Cornaro Chapel. The conviction with which he achieves his artistic goal reinforces his spiritual message as the beholder's spirit soars upwards alongside the resurrected saint.

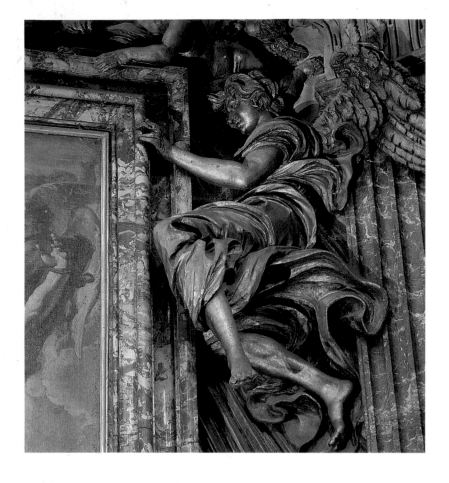

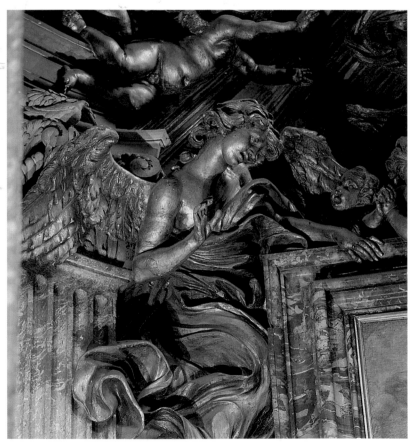

324, 325, 326. Sant'Andrea al Quirinale, Rome: two angels modelled by
Giovanni Rinaldi supporting the altar painting by Il Borgognone, and
(*right*) St Andrew – modelled by Antonio Raggi – ascending to heaven
above the chancel arch.

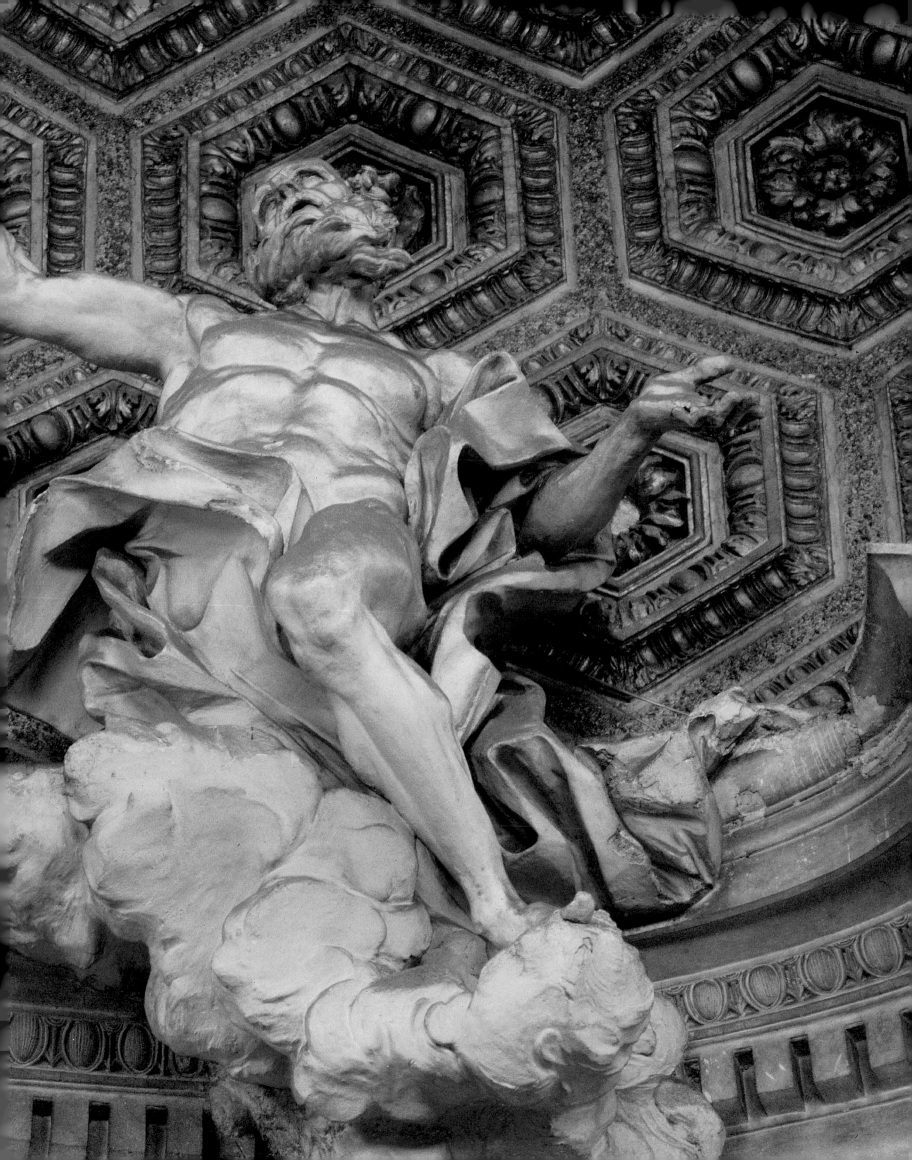

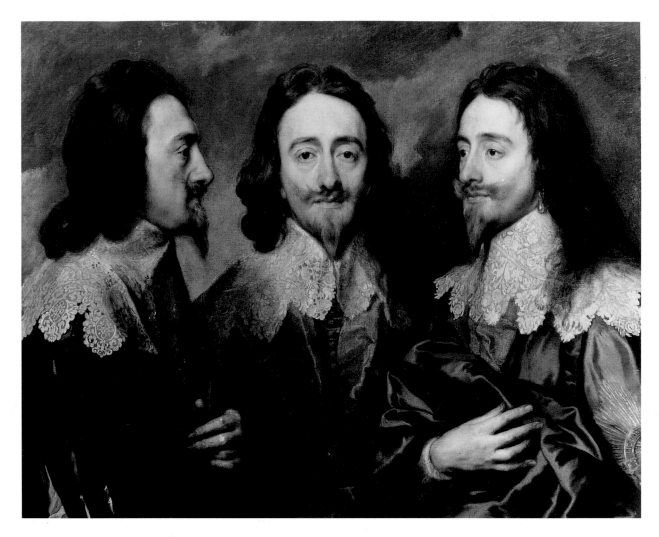

327. Anthony Van Dyck: *Triple-portrait of Charles I*
(Royal Collection, Windsor Castle).

 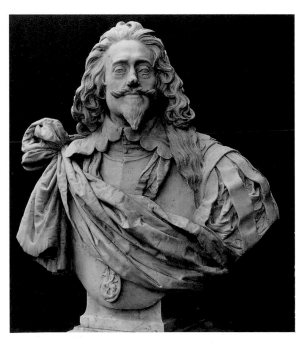 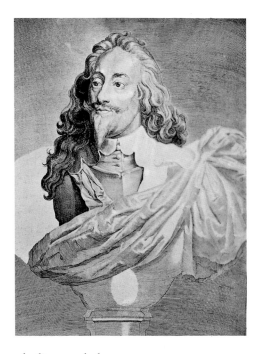

328, 329, 330. Three versions of Bernini's bust of Charles I which was destroyed in 1698: a recently discovered plaster cast
of the face alone (private collection); an eighteenth-century copy possibly by Francis Bird (Royal Collection,
Windsor Castle); and an engraving by Robert Van Voerst (British Museum, London).

11 * England and France: Bernini, servant of Kings

Charles I and Thomas Baker

Crown the hand which made so beautiful a work
King Charles I, 27 July 1637

ONE OF THE MOST CELEBRATED episodes in Bernini's career was concerned with England, though it was realized only through papal connections with France. He succeeded in carving a superb portrait of King Charles I *in absentia*, from a painting showing the monarch from three critical angles, full-face, profile and three-quarters, like a police photograph.[1] This 'triple-portrait' was in itself a masterpiece of spontaneity, dashed off for this very purpose by the greatest portraitist of the age, Sir Anthony van Dyck. In mid-1635, the king and queen learned that Bernini was to be permitted by the pope to carve a bust and had himself agreed to do so. Van Dyck, who had returned to London from a year's absence abroad, diligently applied himself to the urgent task. His painting, itself a treasure, remained in Bernini's possession, and was still in his palace in 1778.[2]

In late August 1636, it was reported to Henrietta Maria that 'the work of the Cavaliero Bernino is now nearing completion' and 'she said with great joy that she would write to tell this to the King', but it was not until April 1637 that the bust was actually exhibited in Rome prior to despatch to London.[3] This was done partly because of its success as a work of art, but also because of its presumed consequence in the religio-diplomatic drama that was being played out by the Barberini. Charles was the target of their campaign of conversion to Roman Catholicism, and this flattering image might even have had an effect in this direction when it reached the King's eyes in distant London.[4]

Cardinal Barberini wrote of it:

But the work of Cavaliere Bernino will deserve such honour, principally because it will be cherished by Her Majesty, although I make bold to say that it will not be something to be despised [i.e. by the king, whom he dared not name, being still a heretic], for the Cavaliere Bernino told me that better he knew not how to make it. For which reason I thanked him, and said that I wished to give him no other praise for the work than that it was the sum of his knowledge. Indeed he should be excused if the portrait is not a perfect likeness, since to make a likeness the artist has to see the original, but at least the diligence of the master cannot be called into question.

Barberini's judgment might be suspect, being that of a distinctly interested party. But praise was also heaped on the bust by a third party, the agent of the Duke of Modena. In the second of two letters to his master written a week apart, he went so far as to remark, with hyperbole, that the bust was 'worked with such excellence and mastery that art has never before made so beautiful a thing'. Another Roman correspondent confirmed that it was:

truly beautiful and you could not imagine the universal applause it has received, nor do I think that there exists a Cardinal, Ambassador or gentleman of quality who has not desired to see it. On the forehead, from the nature of the marble, there still remain some little spots, and one man said that they would disappear as soon as His Majesty shall become a Catholic [literally 'immaculate'].

Great pains were taken over the hazardous transportation of the delicately carved and daringly undercut marble image to its royal recipients.[5] Its packing was to be watched by George Con, a Catholic Scotsman who happened to be going to London, so that he could testify to its perfect condition on leaving Rome and supervise its careful unpacking at its destination (just as a museum curator or conservator does today when acting as courier for an important loan). Furthermore, one of Bernini's men was to accompany the bulky crate and its precious, fragile contents; it needed a pair of strong mules to support its weight. Passports and customs clearances were arranged at every step of the tortuous journey thanks to the Barberinis' diplomatic network, but even so not everything went smoothly.

Bernini's man had to spend many a restless night sleeping on top of the crate, to avoid its being tampered with by inquisitive customs officials or miscreants. But on Monday 27 July, after an eventful journey, every stage of which was reported to the nervous Barberini as well as to the English court, the crate was brought to the royal palace of Oatlands and opened under the very eyes of the king and queen. As the first plank of the crate was prized off, their superintendent of statues exclaimed that the bust was a miracle.

A few days later it was reported to Barberini 'the satisfaction of the King in respect of the Head passes all expression; no person of quality comes to court but is

immediately taken by the King himself to see it in public.' The Vatican representative also pressed into Charles's hand some medals of the pope, whispering tactfully that he might like them for the images on the reverses. These might have shown some of Bernini's recent achievements. But King Charles clasped the man's head and replied, 'I value them more for the portrait of the pope than for any other reason.' He showed them to those around him and then put them into his purse, turning back with a smile and an inclination of the head. Henrietta Maria wrote a gracious letter of thanks to Barberini, making a point of recommending him to Cardinal Mazarin. She also gave a gratuity to the two gentlemen who had been put to such trouble in conveying the bust, even though this was against the cardinal's express wishes, because he wanted the matter of its transport to be a personal favour from himself. George Con, the Scotsman, who was of higher rank, was persuaded to decline and his gratuity was added to that pressed on Bernini's man.

Baldinucci related a dramatic tale that Charles was so pleased with the bust that he took a diamond ring worth 6000 scudi, or £1500, off his own finger and handed it grandly to Bernini's man saying, memorably, 'Crown the hand which made so beautiful a work.' Such a munificent gesture was not out of character for the connoisseur king. However, Vatican etiquette demanded that Bernini's reward be seen to come from the Catholic queen, and so it came to pass, but only after unconscionable delays, which were not her fault. By January 1638, an intermediary admitted to having received the diamond, but his own plans to travel to Rome were not as immediate as Henrietta Maria had thought. Indeed, six months later he had still not left, writing to Rome:

Yesterday I had in my hands the Cavalier Bernino's reward which being a most beautiful diamond, I arranged for it to be valued by an expert who assured me it was worth a thousand pounds or 4000 scudi. I returned it to the Chamberlain so that I may receive it later at the hand of the Queen when it is time to speak with resolution of my departure.

By then the courtly, but irascible, Bernini was losing his patience and had to be reassured by the Italian intermediary: 'For the Cavaliere Bernino I have done what I would not do for me or for mine, even if it concerned a thousand lives. I have his reward and if I find a safe person before I return I will send it.' A curious counter-suggestion was then made from Rome that the relatively sober diamond ring should be commuted, not into cash, but into something of equivalent worth but more eye-catching and obviously valuable: a bejewelled miniature of the royal couple, or even a silver service for display that could be commissioned in Rome if the money were forwarded. Bernini himself must have been behind this, probably because he could not be seen to sell the royal gift, and perhaps did not intend to wear such a valuable ring whose security was always bound to be a problem. But the intermediary flatly refused, no doubt fearing to incur royal wrath at such an impertinent suggestion, with its implicit criticism of Charles's judgment.

It is interesting to note that, when it came to a reward for his bust of Louis XIV, he received it in the form of a miniature of the Sun King, surrounded by thirteen large diamonds the size of chick peas and 96 medium and small ones, which made it worth 3,000 scudi. This is described in the inventory of his effects as being in a big cupboard, and kept in a gilt tin box lined with black velvet to set it off.[6] Disgracefully, it was refashioned after his demise (omitting the portrait) by Bernini's son Paolo into a fashionable parure of fine jewelry for his daughter-in-law Laura! Disappointingly, there is no specific trace of the valuable diamond from England among the other various jewelry in the inventory, so perhaps it was secretly sold for cash once the donor had been executed and all hope of his conversion had been extinguished.

It was not until 25 September 1639 that the diamond ring reached Bernini's hand, even though he had specifically requested it, reasonably enough, for his wedding earlier in the year. Its worth was many times what he had been paid a decade earlier for his bust of Scipione Borghese, and twice as much as paid for the well over life-size statue of Urban VIII by the Roman Senate at this very date. Indeed, it was more than the already generous 3,000 scudi that the sculptor was to receive in 1650 for his more elaborate bust of the Duke of Modena, and more than he was paid for that of Louis XIV.

Before Bernini's diamond ultimately arrived, he had an unexpected further chance to ascertain from a third party how the bust was regarded and cared for in England. This was when he was visited in 1638 by Nicholas Stone the Younger, who wrote breathlessly in his notebook about what was for him, a humble student, a very significant interview with the greatest exponent of his craft in the whole of Europe:[7]

After foure times being att St. Peeters, one Friday morning the 22th of October I went to his housse (with a young man a painter that spoke Italian), where I understood that he was not uery well. I sent him upp the letter; after a little pausse he sent for me up to his bedd side, who when I came to him he told me that I was re[com]mended to a man that could not doe much wth such and the like compli[ment] first, but after he told me that after 2 or 3 dayes he hoped to [be] abrod againe and yt I should come againe to St. Peeters and I should haue what I desyred, being in a uery good umour hee askt me whether I had seene the head of marble wch was sent into England for the King, and to tell him the truth what was spoken of itt. I told him that whosouer I had heard admired itt nott only for the exquisitenesse of the worke but the likenesse and nere resemblance itt had to the King countenannce. He

sayd that diuers had told him so much but he could nott beliue itt, then he began to be uery free in his discourse to aske if nothing was broke of itt in carryage and how itt was preserued now from danger. I told him that when as I saw itt that all was hole and safe, the wch (saythe) I wonder att, but I tooke (sayth he) as much care of the packing as studye in making of itt; also I told him that now itt was preserued with a case of silke, he desyred to know in what manner. I told him that itt was made like a bagg getherd together on the top of the head and drawne together with a strink under the body with uery great care, he answered he was afraid thatt would be the causse to breake itt for sayes he in my time of doing of itt I did couer itt in the like manner to keepe itt from the flyes, but with a *grea-a-t* deale of danger, because in taking of the casse if itt hangs att any of the little lockes of hayre or one the worke of the band itt would be presently defaced, for itt greiue him to heare itt was broke, being he had taken so great paines and study of itt.

It is fascinating to note the sculptor's concern at the risks of what the English obviously thought was the most careful way of preserving the masterpiece, in a silken bag. The truth of Bernini's worry is borne out by the experience of modern museums, where, at least since the invention of vacuum cleaners, it has long been forbidden to use feather dusters on such delicate items for this very reason.

The tragedy is that this veritable *tour de force*, of which its author claimed that in the absence of its royal subject he 'knew not how to make it any better' is known to us only indirectly through an unfinished engraving and an inevitably rather bland later copy by an English sculptor based on a plaster cast, which was – happily – made before the original perished in a disastrous fire at Whitehall Palace in 1698. Two versions of the plaster cast have recently come to light. None of these copies, however, can adequately replicate the undercutting of the hair, beard and moustache or of the knotted sash.

'Bernini's bust of Charles I marks the point at which his reputation as the greatest sculptor of the age became an internationally acknowledged fact,' writes Ronald Lightbown, one of the most gifted researchers of its history, to whom the present account is deeply indebted:

we can suppose that in a country accustomed to the smooth, impersonal, essentially Mannerist royal portrait busts executed by Le Sueur, the use of forceful modelling and sharp undercutting to produce those strong contrasts of light and shade of which Bernini was such a master must have come as a delightful shock. We can suppose too that the modelling of the face had all that vivacity of animation which made Fulvio Testi say of the Borghese bust that 'it really lives and breathes'. The brilliance of invention which emphasised the movement of the head by the diagonal swing of the sash and the lock of hair falling on the left shoulder can still be felt in the copies, as can the skill with which the ridge of the breastplate

330
329

328

331. Anthony Van Dyck: *Queen Henrietta Maria*, detail (Royal Collection, Windsor Castle).

above the sash and the Garter George below it were used to establish the underlying frontality of the bust and stress simultaneously the sensation of movement.

Bernini exchanged Van Dyck's civilian clothes for armour. This was standard for any ruler at that time; he employed it in his most famous subsequent secular portrait busts, those of the Duke of Modena and of Louis XIV. He left the steel of the breastplate plain, as in basic combat armour, perhaps only to use it as a foil for the delicate facial features, luxuriantly curly hair and shimmering silks of the ribbon bearing the St George badge of the Order of the Garter and the generous sword scarf. The reverse is true of Le Sueur, who subconsciously over-decorated the armour to compensate for the bland features that were all he was capable of. The ebullient knot over the monarch's right shoulder is a brilliant invention of Bernini's that dramatically breaks the silhouette of the bust, emphasizing the asymmetry of the image and drawing one's eye to the swooping diagonals that intersect the composition. It conveys an impression of movement and swaggering grandeur appropriate for the king who was to be the leader of the cavaliers.

Lightbown concludes decisively:

Bernini's real contribution to formal portraits of this type was to break up their solemn rigidity by introducing movement, expression and a free play of light and shade without detracting from the dignity of the sitter. The Charles I bust belonged to the stage of Bernini's artistic creation when he was content merely to enliven the traditional type of bust of a secular ruler, and not to that later stage where asymmetry and great whorls of drapery produce an incomparable sense not only of majestic movement but also of irresistible grandeur.

Nevertheless, the bust is a step along the path to his extraordinary and unforgettable image of the Sun King.

351

Within ten days of the arrival in Oatlands of the king's bust it was reported to Cardinal Barberini that the queen now

wanted a portrait of herself. While it is perfectly possible to take this request at face value, it may alternatively be a diplomatically correct channelling of a request from the – still heretic – king for a bust of the wife he loved, and who had obtained for him such a magnificent form of present. A delay was occasioned, apparently by Henrietta's reluctance to submit to sittings with Van Dyck for the necessary views of her head. In the event only two were produced and, unlike the portraits of the king, on separate canvases, which indicates separate sittings for each view.

331

The queen also coquettishly insisted on wearing different dresses, corsages, jewels and arrangements of pearls, perhaps to give Bernini a degree of choice. Van Dyck of course had Bernini's finished bust of the king as a challenge to match and accordingly he paid great attention to puffing out the silks and satins of her sleeves to compete with its dramatic knotted sword-scarf, while in the profile version he added an outer cloak casually thrown round her shoulders to break the contours à la Bernini. A juxtaposition of the corresponding views indicates how well the busts might have matched had Bernini fallen in with Van Dyck's visual suggestions, and had the portrait of the queen ever been carved.

One reason for Henrietta's procrastination may have been embarrassment at the failure of others to forward to Bernini her reward for the first bust, the diamond ring, and her official letter of gratitude. The matter evidently became a source of scarcely veiled amusement at court, according to a story reported in June 1638 to Cardinal Barberini:

The other day while I was urging the Queen in his presence to allow herself to be portrayed, the King said, 'I am going hunting on Tuesday, and I will leave you my wife for all the rest of the week; persuade her, and guard her well': which was said in such a way as to cause all the Court to laugh, and everyone advised me to take good care of the Queen.

Another letter on the same day reported, more optimistically:

The Queen is at Greenwich, and by the grace of God enjoys good health. When I have finished this letter I shall go there to meet the Cavalier Van Dyck to see if it will be possible to make a single portrait of the Queen for the Cavalier Bernino to use.

So Henrietta probably sat for the court painter in the familiar surroundings of her beloved Queen's House, constructed for her some years earlier by Inigo Jones. By 27 August it was triumphantly reported: 'Her Majesty has at last put on exhibition the portraits for making her head, and they will be despatched on the first good occasion.' Van Dyck invoiced the King £20 for two paintings of the Queen 'pour Monsr. Bernino', probably later that year, which the monarch stingily reduced to £15. It was not until 26 June 1639 that Henrietta

actually wrote from Whitehall Palace requesting Bernini to make a bust of her based on Van Dyck's two pictures, but her delay is surely explicable by the fact that the diamond ring had still not reached him and she scarcely liked to ask him another favour before it did.

The very letter, written in her native French, survives, for Bernini pasted it onto the back of Van Dyck's triple-portrait of Charles. Its substance was known from a translation in the biography of Bernini by Baldinucci, who also noted tactfully that 'the troubles which shortly afterwards rose in the kingdom were the cause that no more was done about the Queen's portrait'. What a masterpiece of portraiture was lost to the world by the nascent Civil War, for Bernini, always keen to surpass himself, would surely have known how to endow his royal Franco-Italian and Catholic patroness with the feminine charms of his angels, saints and allegories of Christian virtue. He would have striven to outdo the bust of a decade earlier showing Maria Barberini Duglioli.

388

There is a postscript to the story of the bust of King Charles. At much the same date, another marble bust of great panache was carved illicitly by Bernini: it depicts Thomas Baker (1606–58), an Englishman, who *may* have transported Van Dyck's painting to Rome in 1635 and hence gained an introduction to Bernini.[8] There is, however, no documentary evidence for this, but only a statement made in 1713 by George Vertue that Mr Baker was 'the Gentleman by whom this picture [the Van Dyck] was sent to Rome . . . designing thereby to show King Charles what he could do from the life'. Vertue may have invented this to explain the rather puzzling existence of the bust and the actual coincidence of dates between the known movements of the picture and those of Baker. Thomas came from a well-placed family of country gentlemen that had risen to power under King Henry VIII and built a great house at Sissinghurst in Kent. His father was sheriff of Kent in 1605, but built another 'Great House' at Leyton to the north-east of London, because it was on the way to some estates of his in Suffolk. He was knighted at Northampton in 1603 by King James I, who was journeying south to claim the throne of England. From his father, Thomas Baker inherited as a minor in 1622 considerable estates and income in Lincoln, Sussex and Kent.

Thomas went up to Wadham College, Oxford, in October 1623. Following the death in 1625 of his mother, an important connection at court was made when his sister Elizabeth became a Maid of Honour to Queen Henrietta Maria, according to Lightbown, 'the most honourable form of guardianship for an orphan girl of good birth'. Between 1631 and 1637, Thomas went on an extended Grand Tour in Spain,

332. Close-up of the bust of Thomas Baker, to show its technical bravura (Victoria and Albert Museum, London).

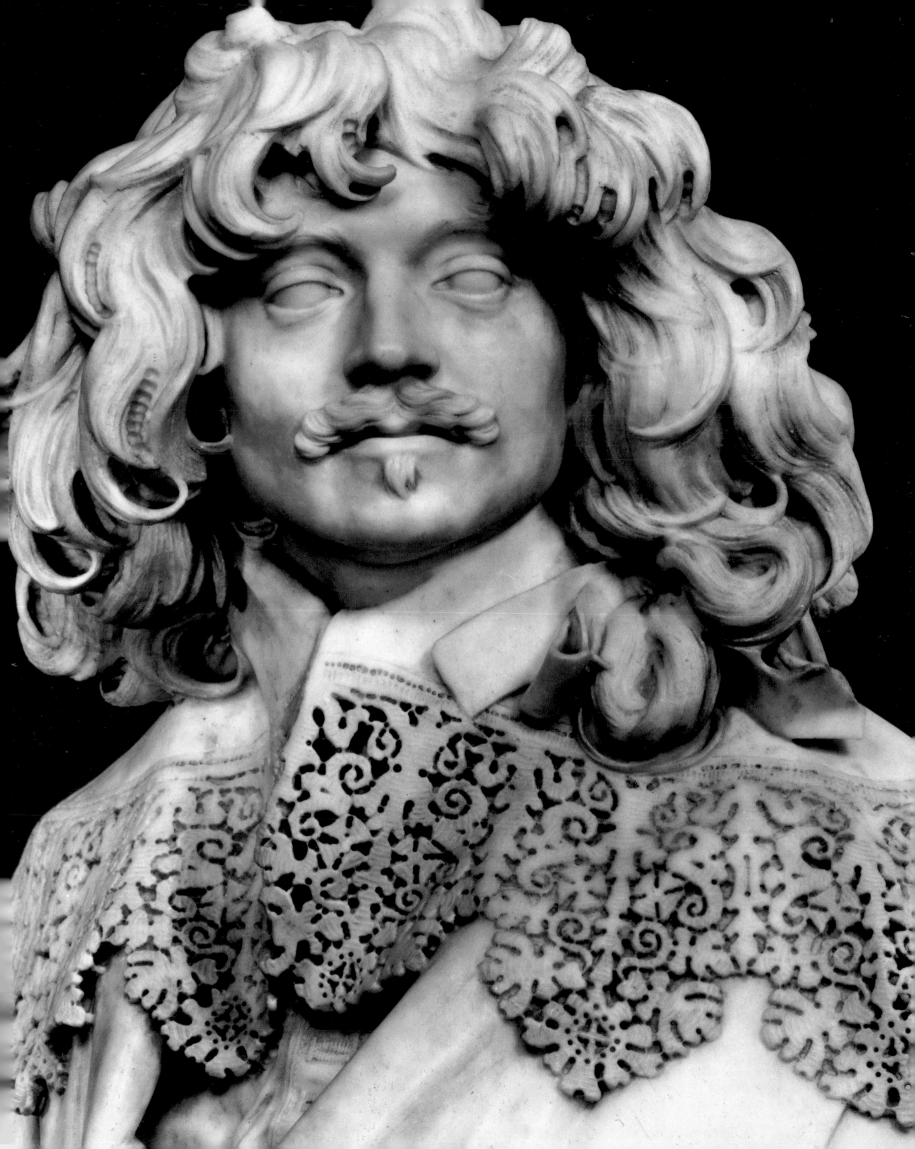

France and the Netherlands, sometimes in the company of relations. He reached Rome in time to dine – probably, as was customary, at the beginning of his stay – in the refectory of the English College in Rome, on 16 November 1636. There, in a good Catholic climate, and particularly as a connoisseur with a sister at court, he must have heard about the bust of his king, if he had not already.

According to Bernini's own account (given to Chantelou in 1665 when he was in Paris),

among the many busts that he had made was one of an Englishman who, on seeing the bust of the King of England that Bernini had just produced from the portraits by Van Dyck that had been sent to him, became desirous that the sculptor should make one of him. He would not stop pestering Bernini until he had agreed to do it, promising to give him anything that he wanted for it, as long as he did it without anyone knowing, which he did and the Englishman gave him 6000 scudi, or £1500, for it.

This staggering price would have remained in Bernini's mind, for it was half as much again as he had received from Henrietta Maria! Baker, for the Englishman whose name Bernini diplomatically forgot was surely he, presumably saw the bust of Charles in the studio, nearly finished, but not yet ready for exhibition to the public, as it was in April 1637.

Bernini gave a significantly different, perhaps more diplomatic but not necessarily more true, version of the story only a couple of years after it took place to Nicholas Stone the Younger, during his interview on 22 October 1638:

After this he began to tell us here was an English gent: who wooed him a long time to make his effiges in marble, and after a great deale of intreaty and the promise of a large some of money he did gett a mind to undertake itt because itt should goe into England, that thay might see the difference of doing a picture after the life or a painting; so he began to imbost his physyognymy, and being finisht and ready to begin in marble, itt fell out that his patrone the Pope came to here of itt who sent Cardinall Barberine to forbid him; the gentleman was to come the next morning to sett, in the meane time he defaced the modell in diuers places, when the gentleman came he began to excuse himselfe that thaire had binn a mischaunce to the modell and yt he had no mind to goe forward with itt; so I (sayth he) I return'd him his earnest, and desired him to pardon me; then was the gent. uery much moued that he should haue such dealing, being he had come so often and had sett diuers times already; and for my part (sayth the Cauelier) I could not belye itt being commanded to the contrary; for the Pope would haue no other picture sent into England from his hand but his Maity; then he askt the young man if he understood Italian well. Then he began to tell yt the Pope sent for him sence the doing of the former head, and would haue him doe another picture in marble after a painting for some other prince.

Given the timing of the interview this was most probably the proposed bust of Henrietta Maria. Bernini continued with an exposition of his theory of marble portraiture:

I told the Pope (says he) that if thaire were best picture done by the hand of Raphyell yett he would nott undertake to doe itt, for (says he) I told his Hollinesse that itt was impossible that a picture in marble could haue the resemblance of a liuing man; then he askt againe if he understood Italian well; he answerd the Cauelier, perfectly well. then sayth he, 'I told his Holinesse that if he went into the next rome and whyted all his face ouer and his eyes, if possible were, and come forth againe nott being a whit leaner nor lesse beard, only the chaunging of his couleur, no man would know you; for doe not wee see yt when a man is affrighted thare comes a pallnesse on the sudden? Presently wee say he likes nott the same man. How can itt than possible be that a marble picture can resemble the nature when itt is all one couleur, where to the contrary a man has on couleur in his face, another in his haire, a third in his lipps, and his eyes yett different from all the rest? Therefore sayd (the Cauelier Bernine) I conclude that itt is the inpossible thinge in the world to make a picture in stone naturally to resemble any person.

In spite of Bernini's protestations to the contrary, or perhaps after the episode of the papal interdict and the story of the aborted commission, Baker did obtain a highly finished bust of himself, indeed one which by general consent is one of the sculptor's masterpieces of character study and technical bravura. One cannot help feeling that Bernini came to like the persistent young English dandy, a rich youth of good looks and good family, with an excellent taste in art collecting. His tousled mop of hair, apparently freshly washed for the sittings for his portrait, appealed to the sculptor as a challenge to his virtuosity in undercutting fragile Carrara marble with a drill. There was a need for secrecy on both sides: the sculptor's on account of his patron's express veto, and the subject's out of fear of royal wrath incurred by the act of implicit *lèse-majesté* in having his likeness carved by the papal – and now virtually royal – sculptor in between producing the very images of the king and queen. This no doubt added spice to the illicit transaction for both parties, and the size of Bernini's enormous fee has an air of bribery about it.

In any event, the bust was commissioned privately, indeed very privately, unlike the majority of busts in that period, which were of secular or ecclesiastical dignitaries, destined for public display and propaganda. Baker had no such claim to distinction, and perhaps the gay air of spontaneity that Bernini captured so successfully has something to do with this lack of any formal obligation to convey rank or power. Testimony to the bust's appreciation once it reached England is to be found in the fact that it was later acquired by the court portrait painter, Sir Peter Lely, featuring in the posthumous sale of his effects in 1682.

Beginning the French connection:
Richelieu and Mazarin

Great advantages and salaries on the part of the King
Philippe, Comte de Béthune,
Ambassador of France to Rome, 1624

Bernini's relationship with France began early in his adult life and continued to its end.[9] As will be recalled from Chapter Three, when Maffeo Barberini went to inspect the *Apollo and Daphne* in *c.* 1621, he was accompanied by a French cardinal, François Escoubleau de Sourdis. The latter was Archbishop of Bordeaux and the bust that he commissioned from Bernini is still to be found there in the church of St Bruno.

Owing to the vagaries of papal patronage, whose direction might change with every new election, Bernini seems to have flirted in mid-career with the idea of moving to Paris, capital of what was emerging as the dominant nation in Europe, by way of an insurance policy should things in Rome turn against him. In the event, his own dominant position astride the art world of Rome was never seriously assailed and he preferred to remain there to guard it jealously, rather than risk all by going to France, even temporarily. Until, that is, late in life, when he was summoned personally by King Louis XIV to compete with French architects over the design of the main (east) front of the Louvre. Though ultimately disappointed in this, he did receive commissions to carve his world-famous bust of the king and to produce a splendid equestrian monument, both of which survive at the Palace of Versailles to this day. This important 'French connection' had been gradually established through his loyalty to and friendship with members of the Barberini family, not only Pope Urban VIII, but his powerful cardinal-nephews, in particular Antonio, who conducted papal relationships with France, and, ousted from Rome at Urban's demise, went on to hold high ecclesiastical offices there.

The Barberini family's closest contact in France was the
336 Italian Cardinal Mazarini, better known as Mazarin, who had been involved in the negotiations with the English court. Before he left Rome for France in December 1639, Mazarin proposed to Cardinal Antonio Barberini an ambitious commission for a full-length statue of Richelieu, his new protector. Bernini, captivated by the prospect of such a major and profitable job, was eager to make a start, demanding to know about the intended setting, so that he might adjust his composition accordingly. By July 1640, he was pestering Mazarin's correspondent in Rome for profiles of Richelieu, and when they finally arrived – probably the triple-portrait by
335 Philippe de Champaigne – with the French ambassador in

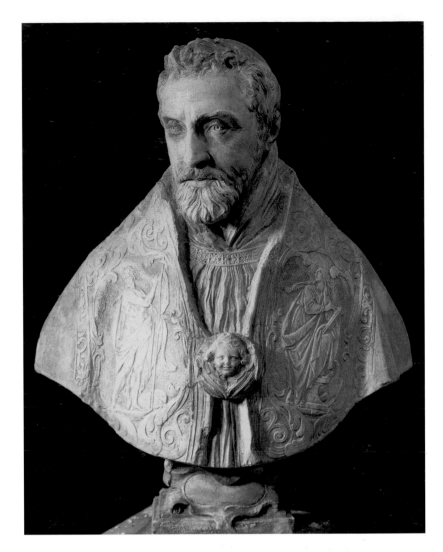

333. Portrait bust of François d' Escoubleau, Cardinal de Sourdis, (Church of St Bruno, Bordeaux).

September, he pounced on them and started work, probably with the head, for Mazarin was also keen to have a bust cast in bronze.

All was not well in the Barberini household, however: both pope and nephew were offended diplomatically at being bypassed over the commission to 'their' master-sculptor, for which their permission had not been requested. Furthermore, at a time when relations between Urban and Richelieu were already strained, the pope was outraged by the tactless choice of a full-length statue, a format at that time laden with implications of power and prestige. In November, Bernini defused the situation, which had perils for him too, by deciding 'for the moment' to reduce the portrait to no more than a bust, such as he already had in hand and which was indeed nearing completion, noting, persuasively, that the cardinal could then enjoy it in his own rooms. He promised – deliberately vaguely – to produce the statue '*dopo*' (afterwards).

The bust, finished by early January 1641, was unanimously proclaimed in Rome to be a miraculous, 'speaking' likeness and one that outdid even Bernini's most successful busts so

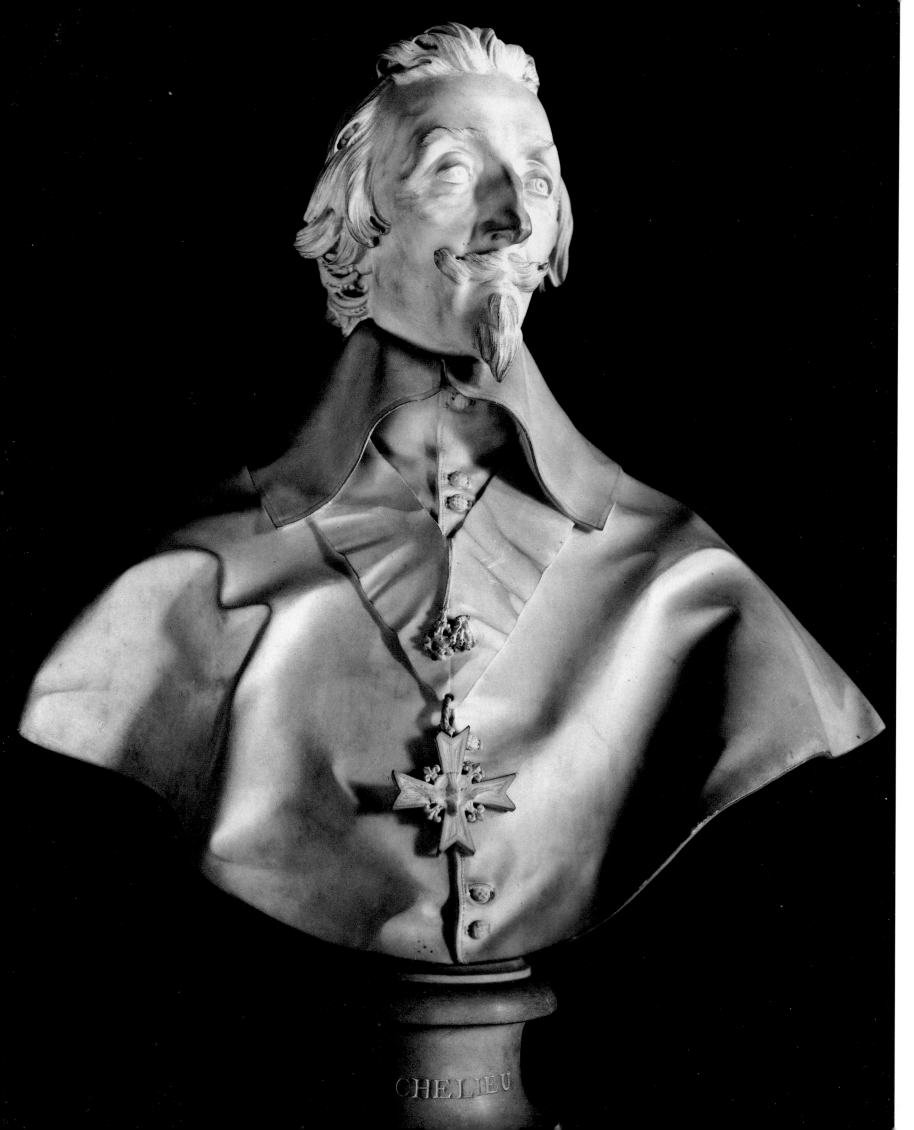

CHELIEU

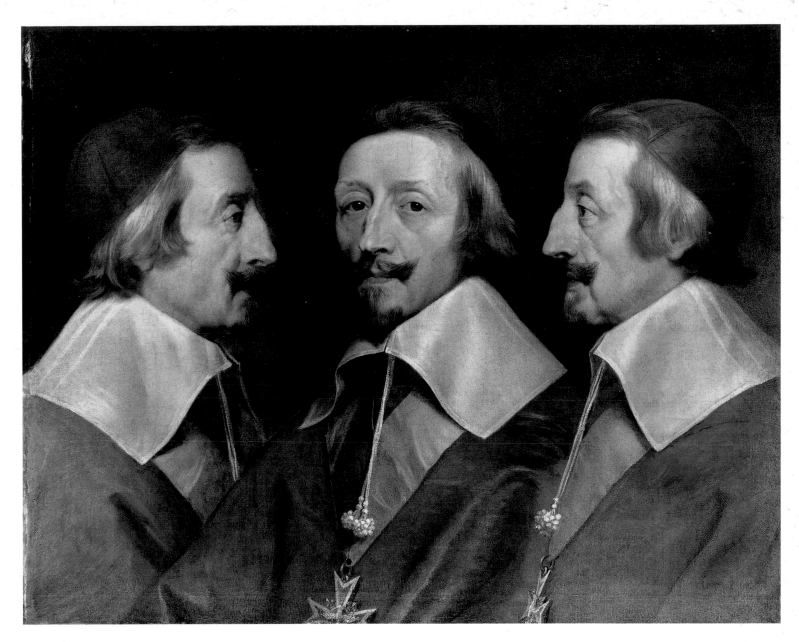

335. Philippe de Champaigne: *Triple-portrait of Cardinal Richelieu* (National Gallery, London).

334. Portrait bust of Cardinal Richelieu (Musée du Louvre, Paris).

far.[10] Cardinal Antonio was mollified, even proposing to have the sculptor make a bust of King Louis XIII in order that 'so glorious a minister should not be separated from a prince who was so universally admired'.

Mazarin's hour of triumph seemed nigh: not only would his master be flattered, but the whole of Paris would be agog, and Bernini's artistic supremacy would be established once and for all in France as well as in Rome. The treasured bust was escorted to Paris by two of Bernini's men in August 1641 and Mazarin was the first to see it, writing immediately to Cardinal Antonio that it 'excelled every imagination and that, not excluding the work of ancient sculptors, he felt that so beautiful and so perfect a head had never been produced before'. And to its maker he wrote later on, 'I do not believe

that a more lifelike, better explored or more highly finished head has ever left your hands.' This was a trifle hypocritical, for to his own brother Mazarin confessed that the bust was quite unlike Richelieu. In this he may only have been hastily echoing his master's voice, for unfortunately, despite its obvious qualities, the expression of slight disdain or surprise did not go down well with its subject, who claimed that he could not even recognize himself!

This was patently absurd, as can be seen when one compares it with other portraits. Nevertheless the French followed Richelieu's lead and took against it, though the general consensus, not to be too unfair, blamed the perceived shortcomings not so much on Bernini, as on the portraits from which he had worked. The triple portrait of Richelieu by Philippe de Champaigne resembles in type that of Van Dyck intended for the same purpose in the case of Charles I: today it is regarded as a masterpiece.

The immediate reaction in Paris was not really hostile to Bernini, for it was proposed to revive the plan for a statue and

336. Claude Warin: medal of Cardinal Mazarin, 1648
(British Museum, London).

to ask Van Dyck to make new and more compelling likenesses. In the event, Sir Anthony's death, followed so soon by that of Richelieu, terminated both projects. Bernini however was piqued by news of the carping criticism of his marble bust and within eighteen months had produced a new terracotta (or perhaps simply adjusted the original) to take into account the alleged shortcomings of his first effort, though presumably still only on the basis of the old profiles by Champaigne. In a letter of April 1644, this was said to be 'rather more beautiful and more like' and it served as a model for casting a couple of bronze busts, those now in Potsdam and Victoria, Australia.[11] The last that one learns of the matter is that 'a portrait of Richelieu and his bust in terracotta' were listed in a room on the *piano nobile* of Bernini's palace near two pictures of Urban VIII in the inventory of 1706.[12]

At this time Urban VIII was nearing the end of his life, and Bernini, fearing for his position in Rome under a new pope, enquired on 16 July 1644 of Mazarin, newly projected into power over foreign affairs by Richelieu's death, what terms he might expect were he to decamp to Paris. His old supporter was quick to respond, with offers of a salary and the grand title of Architect to the King, which indicates the role for which he was most needed in Paris, the completion of the Louvre Palace. He may also have had in mind the need for a tomb for Louis XIII in the royal mausoleum of St Denis. These generous offers were tempting, but Bernini procrastinated, keeping them in abeyance as insurance against his expected fall from grace in the Eternal City. Indeed Urban's successor, Innocent X of the Pamphili family, was an enemy of the Barberini and resented their depredations of the funds of the Holy See: this resentment was so serious that the most prominent Barberini went into voluntary exile.

Initially the sculptor explained his reluctance to leave by the need to bring the deceased pope's great tomb in St Peter's to a fitting conclusion. Then, in 1646 when it was decided to demolish his campanile on the façade of St Peter's, the outraged Bernini, out of feelings of frustration and a wish for revenge, turned to designing a high flown allegorical sculpture that he felt was applicable to his own situation, *Time Unveiling Truth*.[13] The concept of a figure of a hoary old man apparently supported in mid-air by only an end of the veil that he was tearing off the female allegory of Truth below seems unsuitable at first for rendering in sculpture, unless in a relief, but Bernini obstinately took this very impracticability as a challenge to his powers: in the event it defeated even him and only the luscious female figure was ever carved. It remained in his studio until his dying day, and in his will, he entailed this unwieldy statue upon the first-born son of each generation of his descendants, as a reminder that 'the most beautiful virtue in the world is truth, because in the end it is always revealed by time'. It still belongs to his heirs, though since 1914 it has been on loan to the Villa Borghese.[14]

Bernini's 'first thought' (*primo pensiero*) for the composition is an exploratory sketch in smudgy black chalk, with several pentimenti, showing Truth, coyly recumbent on a segment of a globe, still lying on the extensive veil that Time, hovering over her, pulls from her: his whole upper body is no more than indicated.[15] A fair copy of this sketch that fills in the missing torso merely serves to show how unsatisfactory the image would be, other than in relief.[16] By July 1647, Bernini had produced a model of the initial, two-figure group and requested his friend the Duke of Bracciano, whose bust he had executed years earlier, to sound out Mazarin discreetly to discover what his reaction to a group with such a theme might be. The duke vaunted its qualities (a 'jewel') to Mazarin, explaining how it could be made out of separate pieces for ease and safety of transport and then reassembled at its destination. Time was to be artificially held aloft above some 'columns, obelisks and mausolea' which he was shown as though knocking over, to symbolize the rise and fall of empires and human endeavours with his passage. Bernini could have cribbed this idea from an engraving and was now thinking in terms of a relief, although he did not want to flatten the figures at all. Truth was to hold out the sun in her right hand, as she loves the light of day, and to rest her feet on the globe, to show that truth was more precious than anything on earth, and indeed divine – imagery derived from Cesare Ripa's *Iconologia*.

Ultimately Bernini seems to have succumbed to practicality, but made a virtue out of this by dispensing with the figure of Time altogether as being otiose, now that Truth was indeed unveiled and free. However, a block of marble probably intended for Time remained ominously in the street outside the sculptor's house until his death.[17] Two further drawings in pen explore alternative positions for Truth, seated nearly upright, while Father Time is noticeable by his absence.[18] On the second of these sheets, the sculptor has

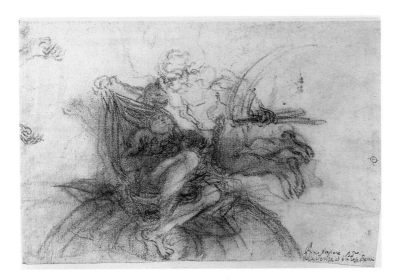

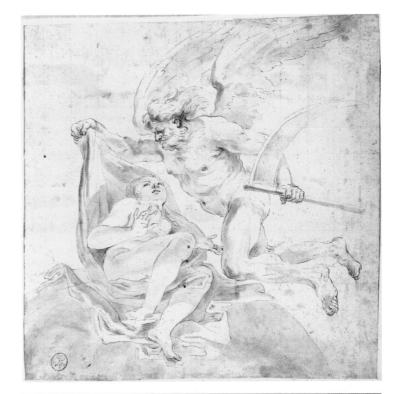

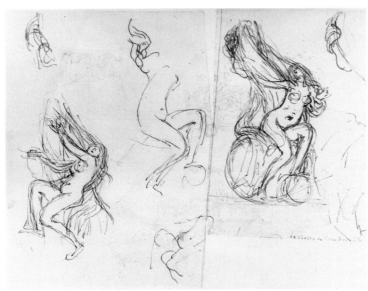

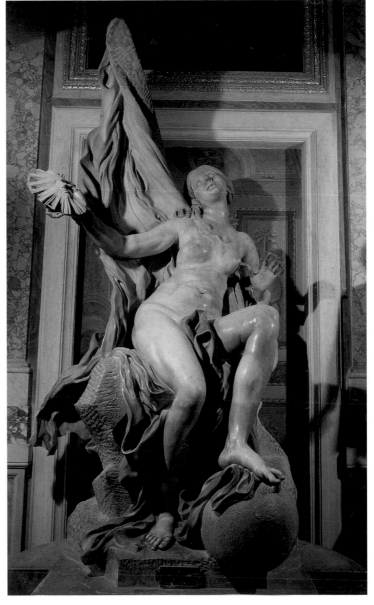

337, 338, 339. Sketches for *Time Unveiling Truth*. (*Top*) '*primo pensiero*' in black chalk (Museum der bildenden Künste, Leipzig); (*above right*) a more finished copy in pen and wash (Musée du Louvre, Paris); (*above*) later sketches for Truth on her own (Museum der bildenden Künste, Leipzig).

340. Truth from *Time Unveiling Truth* (Villa Borghese, Rome).

reached his preferred solution, as is corroborated by a terracotta model in the Louvre[19] and the statue itself. The expression on Truth's face conforms to his standard rendering of the female face in ecstasy as it beholds a vision of celestial joy, and is derived from that of the *Blessed Soul* or *St Bibiana*.

80, 81

Mazarin was intrigued by the laudatory letter from the Duke of Bracciano, and hoped that Bernini was thereby hinting that the time was ripe for an invitation to Paris, which would occasion his completion of the initial, ambitious project and enable him to bring it in person to its destination: 'If Bernini were to decide to let himself be seen in these parts . . . he would learn the high estimation in which both he and his works are held in France.' Bernini was alarmed and fell back on the straightforward proposition of

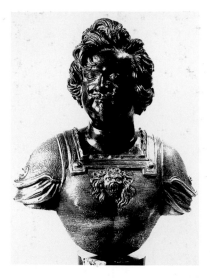

341. Paolo Giordano Orsini, Duke of Bracciano, small bronze bust, after a model by Bernini (Linsky Collection, Metropolitan Museum of Art, New York).

342. Fair copy by E. Benedetti after Bernini's sketch for a monumental staircase leading to Santissima Trinità dei Monti (predecessor of the Spanish Steps) with an equestrian monument of Louis XIV as its focus, c. 1660. The fountain of the *Barcaccia* appears at the bottom (Biblioteca Vaticana).

producing the sculpture for Mazarin at a good price, but not of coming to France to settle, as had once been suggested.

The explanation was simply that in 1652 Bernini had been rehabilitated in the eyes of Pope Innocent by the triumph of his *Fountain of the Four Rivers*; indeed he was now commissioned to carve more than one likeness of His Holiness. Mazarin owned a silver reduction of the fountain that had frustrated his own schemes, mounted as a table centre with realistically flowing water: perhaps he was given it as a consolation prize by a slightly guilty Bernini. Could this have been the silver model by which Bernini persuaded the pope to commission the fountain (see above, p. 196)? The cardinal also continued to request various designs from him, including tombs for himself and his parents. Cardinal Antonio Barberini, now enjoying high office in France, suggested in 1658 that he might commission and present marble busts of both Mazarin and the French king from Bernini, but this came to naught, and Bernini made no likeness of his friend. Mazarin meanwhile continued to try to tempt the sculptor to France, in 1655, 1657 and 1660, but in vain, with Bernini adopting on occasion an unpleasantly abrasive and superior tone, as he grew older, more famous, and ever surer of his position in Rome.

Frustrated as he was in his hopes of getting the elusive Bernini to France, Mazarin nevertheless invited him to submit designs for a major architectural commission that the French intended to allocate in Rome itself, in celebration of the Peace of the Pyrenees in 1659 by which France had established its superiority over the papacy and its primacy among the nations of Europe. This was a huge, 'serpentine' staircase, a forerunner of that known nowadays as the 'Spanish Steps',[20] in front of the church of Santissima Trinità de' Monti. Bernini would have been keen to be involved, at least behind the scenes, for these steps would formalize the rugged hillside above his and his father's early *Barcaccia* fountain, which would thereby be aggrandized. This failed, however, to gain papal approval, for it revolved around a centrepiece which was bound to be unacceptable to the pope and his fellow Romans, especially at the very heart of their own city: a monumental equestrian statue in bronze of Louis XIV, whose horse rears triumphantly. Such a provocative focus had never been dreamt of by the more diplomatically aware Mazarin.

Even after the demise of Mazarin in 1661, Bernini's talents continued to be championed in Paris by Cardinal Antonio Barberini. In a letter from Paris of 10 March 1656, it emerges that Antonio had ordered a second cast in bronze of Bernini's celebrated portrait of Urban, probably the one still in the Louvre, and had just received a bronze crucifix.[21] Antonio signed himself '*Affettuosissimo sempre*', an extraordinary sign of high regard for Bernini, who was – officially – a relatively lowly Knight of Christ.

The bronze image of the elderly Barberini pope, characterized most tenderly by his lifelong artist-protégé and friend, would have seemed very modern in its freedom and almost *trompe-l'œil* rendering of natural textures, notably the

ageing skin of Urban's face and his straggly moustache and beard. Its suggestion of the psychological dimension was utterly new too; French portraiture of the time was still to a large extent stylized and formal.

By the same year, 1656, Cardinal Barberini had also commissioned a group on that time-honoured theme of Italian sculpture, the Virgin and Child, for a high altar that Bernini had designed in St Joseph des Carmes, Paris.[22] Surprisingly, the Baroque sculptor had not yet tried his hand at this subject. It was carved from a model of Bernini's by his skilled associate Antonio Raggi, and is a very endearing rendering. The Virgin is uncannily reminiscent of Michelangelo's early *Madonna* in Notre-Dame, Bruges. Perhaps this prestigious and 'northern' source for the composition was suggested by the cardinal to gratify the French; it may have been known in Italy from a cast, copy or drawing.

Cardinal Antonio also commissioned from Bernini decorations for the church of Santissima Trinità de' Monti and designs for an elaborate firework display outside to celebrate the birth of the Dauphin in 1661. On 27 October 1662, he actually invited his illustrious friend to come to Paris, thus hoping to defuse tensions that had arisen between the Vatican and France, but Bernini replied that it was for the pope to make a final decision on this. Nothing happened, presumably because Alexander VII wanted to keep the artist hard at work on his great ecclesiastical projects in Rome, which were at a critical juncture.

The visit to Paris: projects for the Louvre

Buildings are portraits of the minds of princes
Gianlorenzo Bernini

What was in effect the denouement of Mazarin's lifelong plans took place under the aegis of Colbert in 1665, when Bernini actually set foot in France. It is a fascinating episode in seventeenth-century history, made all the more vivid by a day-to-day account penned — in the first instance, for his own brother — by Paul Fréart, Sieur de Chantelou, a *maître d'hôtel du roi*.[23]

Chantelou was an ideal choice as equerry to Bernini, for he was cultivated, yet not too grand, and had lived in Rome for some years. Indeed, he reminded Bernini that he had once given him some drawings. He also owned a remarkable collection of paintings, particularly some by Poussin: a couple of *Bacchanales*, a self-portrait and the second set of *The Seven Sacraments* (now on loan from the Duke of Sutherland to the National Gallery of Scotland, Edinburgh). Visiting Chantelou's house on 25 July, Bernini fell to his knees in front of these masterpieces, claiming that they made him feel that

343. *Virgin and Child*, designed by Bernini and carved by Antonio Raggi (Church of St Joseph des Carmes, Paris).

344, 345, 346. Bernini's successive designs for the east front of the Louvre, Paris (the first and third, Musée du Louvre, Paris; the second, Nationalmuseum, Stockholm).

he was nothing ('*che non sono niente*'): Poussin the austere, though colourful, classicist, who might have been regarded as the antithesis of a Baroque artist like Bernini, was instead revered by him as 'a great painter of history and myth' ('*un grande storiatore e grande favolleggiatore*'). Chantelou also had a good collection of casts of classical statuary which, on Bernini's suggestion, he offered to present to the academy in Paris for the edification of art students.

Such then was the man who was delegated by the royal host to make the elderly Italian hero of art welcome, to look after his every need, to act as a go-between and to keep an eye on his activities. His *Diary* is a document of major importance for the history not only of art, but of the court of King Louis XIV, of Franco-Italian relations and differing national attitudes. Furthermore, it furnishes the historian of sculpture with a blow-by-blow account of Bernini's method of creating a portrait bust, at least towards the end of his career. From this, one can also infer much about his sculptural technique in general, an aspect covered in Chapter Twelve.

In addition, Bernini's carefully recorded conversations with Chantelou after they had become better acquainted and grown to like each other contain an enlightening series of comments about sculptural practice, predecessors (retailing remarks by Michelangelo, for instance) and contemporaries – in short, what amounts to Bernini's common-sense philosophy of art. Being an author of comedies himself, the sculptor had a well-developed ability as a raconteur, and was

eager to convey his ideas, in order to make an impression on his captive foreign audience. He repeated a number of stories which one also comes across elsewhere, for example his emphasis on how difficult – if not impossible – it was to convey an impression of the natural colouring of a face in pure white marble which he had told Nicholas Stone the Younger years earlier.

The sojourn in France comprised three principal artistic projects, a new building for the Louvre (which occasioned his initial invitation), a portrait bust of the Sun King, laboriously executed in his lodgings, and a commission after he returned to Rome for a rearing equestrian monument, which was executed largely by French students and delivered only after his death.

In his fascinating book about this episode of Bernini's career, Cecil Gould put the matter in a nutshell:[24]

The journey came about as a result of negotiations conducted personally between the young King of France, Louis XIV, and the Pope, Alexander VII. Colbert, as Superintendent of the King's Buildings, had failed to find a French architect competent, in his view, to complete the Louvre. After consideration of plans sent by various Italians the King had requested the Pope to allow his own architect and artistic director, Bernini, to visit Paris. Louis had also written a personal invitation to Bernini himself.

Gould also neatly summarized the outcome:

The honours accorded to Bernini on this occasion were such as no previous artist had enjoyed, and appeared to the astonished and envious eyes of contemporaries to be appropriate only to royalty. Yet in the end the visit, which lasted a little less than six months, seemed to have come to nothing.

This is to anticipate, however; in the Paris of 1665 hopes were running high.

The diplomatic background was in fact strained: relations between France and the Vatican had ceased some years before Mazarin's death. Things came to a head over a minor incident in Rome in 1662, and it is likely that Antonio Barberini's initial invitation to Bernini was intended to help defuse the crisis, but instead the French went so far as to seize Avignon, a papal city, by way of reprisal and threatened war. Eventually, in a 'peace' agreement of February 1664, it was determined under duress that the 'Pope should send a mission to Louis by way of apology' (Gould). The head of this delicate mission was a nephew of the pope, Cardinal Flavio Chigi. He happened to be one of Bernini's best patrons and so could inform the French court authoritatively about current progress on the *Cathedra Petri* and the colonnade around the piazza.

Colbert had been Superintendent of the King's Buildings only since January 1665. He decided to abandon the plans for the Louvre east wing by the architect Louis Le Vau that were already in hand, and to try instead to obtain some from the great François Mansart, but he proved too elderly and choosy to be useful. So Colbert reluctantly determined to look outside France. In April, he disingenuously contrived to invite Bernini and three others, without any of them knowing that they were competing, to comment on Le Vau's plans, or, by implication, to submit rival ones, but Bernini was from the start the favourite contender for this outstandingly important commission.

In any case, within a fortnight Bernini wrote and accepted Colbert's commission, which had apparently been sent personally to him. He must have begun work in earnest, for within three months, on 25 July, his designs reached Paris; they must have been thought out and drawn for presentation

in a matter of eight weeks. Bernini's first, eye-catching and rather sculptural proposal was for a convex central element containing a great oval hall which sprang out boldly from between two concave wings. This clearly evolved directly from his own designs for the façade of Sant'Andrea al Quirinale of the previous decade and for the circular church of the Assumption at Ariccia, nestling within a complementary semicircle of enclosing buildings, which he had just designed.

Well after the event, Bernini claimed to Chantelou that he had not even glanced at Le Vau's plans that had been sent for his opinion, in order to keep his own mind clear. But the central feature of Le Vau's plan had been just such an oval hall breaking forward, though from a straight façade; Bernini's innovation was to ensconce it between concave forms, thereby emphasizing its projection. The oval – or circular – plan of the focal hall was a deliberate reference to ancient temples of the sun, having been invented by Le Vau and Le Brun for the palace of Louis' minister of finance, Fouquet, at Vaux-le-Vicomte. It would be strange if Bernini's use was conceived entirely independently of these immediate French precedents. In the same month that the plans arrived Cardinal Chigi was in Paris and was thus able to go over them with Colbert, no doubt promoting Bernini shamelessly. The king sent Bernini a jewelled miniature in gratitude.

Even so, Colbert's objections were so pointed that in mid-1665 Bernini had to supply a second, distinctly less ebullient, yet still novel plan, this time with a *concave* central emphasis, reversing his previous bold idea: this too was strongly criticized for its lack of practicality as a functional palace building and its failure to accommodate the new wing to the existing Cour Carrée of the Louvre Palace (this would have necessitated expensive demolition and reconstruction). But the prime mover, Louis, took to it, perhaps sensing the sheer originality and drama of the architect's proposal, and it was determined that he should be brought to Paris for on-site examinations and further discussion.

A courier was despatched to Rome bearing no less than 20,000 scudi – an enormous sum – to cover Bernini's travelling expenses and with instructions to escort him back to Paris with all due ceremony, reflecting not only the regard in which he was held by the king, but also the king's pre-eminent grandeur. After what amounted to a triumphal progress northwards, via the pope's native city of Siena (where two of Bernini's statues of saints had been installed in the Chigi Chapel two years previously[25]) and Bernini's family city of Florence (where he was cordially welcomed by the grand duke), he was met like an ambassador or grandee at Lyons by representatives of Colbert on the orders of the king. Bernini's own wry comment was that he was being treated like a travelling elephant, having in mind perhaps his own in Piazza Santa Maria sopra Minerva! Then on via

Fontainebleau to Paris, to be met most courteously on Monday 2 June 1665 on the outskirts of the capital by Chantelou, with a smart coach drawn by six powerful horses. From this point, Chantelou's *Diary* combined with the later account of Bernini's son Domenico, who accompanied him, and a welter of official and private correspondence from all sides, inundates one with information too various, detailed and distracting to relate here.[26]

Bernini was accommodated appropriately in a prestigious apartment in or near the Cour Carrée of the Louvre, the very building that he had been brought to redesign, if not demolish. This was of course highly convenient, for it enabled him immediately to appreciate the existing, very grand if by then old-fashioned Cour Carrée (which of course, happily, survives to this day) and every aspect of the future site of operations. He was formally welcomed on the evening of his arrival by Colbert, to whom he may have taken an instant dislike. A striking caricature that he captioned simply '*un cavaliere francese*' has been thought (e.g. by Gould) to represent Colbert. But might it not rather be of Chantelou, whose rank was less elevated?

Within two days the sculptor was taken to the palace of Saint Germain-en-Laye to meet the young king, and both were greatly taken with each other. Here let Gould take up the story:[27]

When Bernini and his party were shown in, the king was discovered leaning against a window. Bernini repeated, necessarily again in Italian, the substance of what he had already said to Chantelou, and presumably also to Colbert, concerning his reasons for wanting to come to France. He finished by saying, 'I have seen, Sire, palaces of emperors and popes which are to be found in Rome and on the route from Rome to Paris. But for a King of France, a monarch of our own time, there is need for something greater and more magnificent than any of these.' Then, with a sweeping gesture he declaimed his carefully rehearsed finale: 'Let no one speak to me of anything small.'

The king apparently muttered to his neighbour, 'Very good. Now I can see that this is indeed the man I imagined.' Then, addressing Bernini, he went on, 'I would quite like to preserve the work of my predecessors, but should it prove impossible to build on a grand scale without demolishing what they have left, so be it. Money is no problem.'

This suggests that Bernini had hinted at demolishing the old buildings. All had gone well, apart from the disparagement of French architecture, which – not surprisingly – slightly piqued the proud young monarch. Bernini's heedless lack of tact grated against French national pride and was to be the downfall of the whole affair.

In any case, Bernini went to work with a will on a third, completely new, project which respected the site and quadrilateral arrangement of the existing palace, while being

347, 348. Jean Warin: foundation medal for the east front of the Louvre, 1665 (British Museum, London).

349. Caricature by Bernini captioned '*un cavaliere francese*', usually identified as Colbert, but possibly Chantelou (Corsiniana, Rome).

original and grandiose. The façade was straight, with three projecting bays. It rose from a rocky foundation, via a rusticated ground floor (as in a traditional Italian Renaissance palace) to a *piano nobile* and high upper storey, the latter being linked by a colossal order of engaged columns and pilasters which rhythmically articulated the foremost parts of the façade. Above them ran a strongly projecting cornice, emphasized by dramatically projecting modillions casting strong staccato shadows. The whole was capped with a balustrade and crowned with a series of statues to punctuate the skyline. The only sculpture below them (apart from an enormous coat of arms with angelic supporters over the central window of the *piano nobile*) was a pair of colossal statues of Hercules with his club standing guard, as Bernini explained, on rocky pedestals flanking the main entrance. They recall Cellini's bronze satyr caryatids on the Porte Dorée at Fontainebleau. Here Bernini relied on the ability of his educated contemporaries to 'read' architecture for implicit symbolism.

The façade was to be understood as an ascent of the 'Mountain of Virtue' by the king, in the guise of Hercules.[28] Set on a rocky outcrop presenting the untamed power of Nature (though it was of course artificial) the rusticated masonry of the ground floor was meant to look tamer, but impressive and menacing nonetheless. The outcrop of rock was inspired by the same motif in the *Fountain of the Four Rivers*, and was relatively commonplace in the rendering of supposedly natural grottoes in late Renaissance ornamental gardens. The novelty of using it here was the civilized urban setting. The ground floor was to incorporate the existing palace, which was to be refaced with rough-hewn stone. The gigantic statues of Hercules that were to stand on either side of the entrance arch, Bernini explained, alluded to Louis' princely virtues of might and hard work ('*virtù e fatica*').

Bernini was drawing on a wide repertory of sources, all of which did homage to the might of his patron. Louis, on

entering such a palace and climbing the stairs to the grand reception rooms and then up to the further elegant accommodation above, was to be conceived as Hercules ascending the Mountain of Virtue, as mentioned above, and at the same time as Apollo – God of the Sun – on Mount Parnassus, dwelling-place of the Muses (recalling that the arts and sciences came under royal protection).

Louis was mightily flattered by this straightforward, allegorical imagery, and proclaimed happily that Bernini's final design had 'something of the grand and sententious' about it. On 20 June, after poring over the drawing of the elevation for the east front of the Louvre, the king was reported as saying, almost to himself, as Gould relates:[29]

'This is not only the most beautiful drawing ever made, but also the most beautiful that ever *could* be made. I am delighted that I asked the Holy Father to grant me the Signor Cavaliere. No one other than he would have been capable of this.' Then, turning to Bernini, he said, 'I had had high hopes of you, but your work has surpassed my expectation.'

A précis of this design was modelled within the circular confines of a large medal over four inches in diameter that Jean Warin produced rapidly in 1665 to commemorate the laying of the foundation stone.[30] Bernini predictably criticized it, on the grounds that it was in overly high relief, but upon being informed that this was Colbert's wish, he withdrew his complaint. Warin's portrait of Louis on the obverse is correspondingly deep too, and, today, this is generally accounted one of the masterpieces of modelled (as distinct from struck) medals. The original, cast in gold, was reckoned by Chantelou to be worth 500 écus, the same price as he elsewhere put upon a painting of *Moses Among the Bulrushes* by Veronese. Warin was paid 1199 livres for his pains on 10 December. The prime cast was set into a hollow in a marble block, with an inscription on a copper plate to either side, and just as the king was officially laying this, he decided

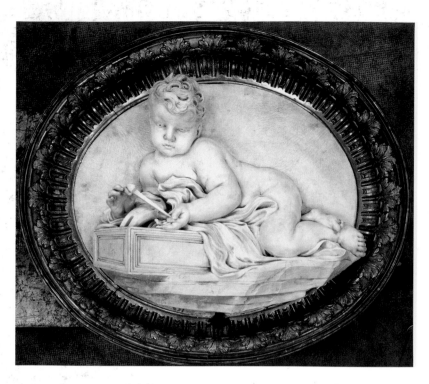

350. *Christ Child with the Instruments of the Passion*, carved by Bernini's son Paolo with some help from his father and given to the Queen of France in Paris (Musée du Louvre, Paris).

to show it to a courtier who was late for the ceremony, and it had to be prized out with the tip of some compasses. Finally Bernini cemented a building stone into place above this precious cache.

Nevertheless, as Gould summarizes:

Though the foundation stone of Bernini's Louvre was in fact laid, the work was then halted immediately. The expense would have been gigantic, including, as the final plan did, the masking of most of the existing building, in addition to the new work. It is certain, too, that by the time the crucial decision not to proceed with Bernini's plan was taken, in 1667, the King's interests were veering strongly towards Versailles. There were other reasons as well for rejecting Bernini's plan, such as the understandable resentment of the French architects, together with more fundamental and less discreditable factors. In the end a more restricted and less expensive project was executed at the Louvre under the direction of a trio of French artists.

The bust of the Sun King

I am stealing your likeness
Gianlorenzo Bernini to King Louis XIV, 28 June 1665

At the same crucial meeting on 20 June, only their second encounter, Louis approved Bernini's architectural design and also commissioned a portrait of himself.[31] This had been at the back of people's minds for several years, following on naturally from Cardinal Barberini's proposition of

commissioning a bust of Louis' father, Louis XIII. Bernini had taken the precaution of bringing with him from Rome his most skilled carver of the moment, Giulio Cartari (a favourite who, after the master's death, was to be given the choice of his spare terracotta models[32]). This order, long awaited, was most welcome to Bernini as an opportunity of demonstrating his principal prowess to king and courtiers, before their very eyes. From the moment the word left the royal lips to that when the portraitist touched in the pupils of the eyes with a piece of charcoal in the royal presence some three and a half months later (5 October) every detail of production of the portrait is recorded, as well as the sculptor's continual flow of pertinent – and often impertinent! – comments as he worked.

The following day Colbert ambitiously suggested making a full-length statue, not just a bust, but Bernini refused point-blank: there was not enough marble in Paris for a good bust, let alone a statue that would have to be seven or eight feet tall.

So feverishly did he labour at the age of sixty-six, for fear that it might prove to be his last work, that he sometimes brought himself to the verge of collapse. After working on the marble obsessively for one whole day – his first – on 14 July, Bernini was quite exhausted. Colbert admitted that the work already had '*de majesté et ressemblance*', but acidly added that the sculptor should try and keep control of himself, to which Bernini retorted that this was against his artistic nature and was for him the hardest thing in the world. He did not learn Colbert's lesson, for again on 23 July he worked all day until 5.30 p.m. and was then too tired to go out to dinner. This fire of artistic creation had always been characteristic, for once he had begun work, like many a creative artist, he became obsessed, snapping at those who, for his own welfare, wanted him to desist: '*Lasciate mi star qui ch'io son innamorato*' – 'Let me stay here: I am in love [with my work].'

Almost unbelievably, by way of light relief, he undertook to help his son Paolo, still a beginner who had accompanied him for the experience, with a marble bas-relief of the *Christ Child with the Instruments of the Passion*; this was a sentimental religious subject somewhat *à la* Duquesnoy, his Flemish rival, who was known for charming images of nude infants. Within a few days the father could no long forebear from intervening, by way of instruction: he retouched the drapery – supposedly one of the Virgin Mary's veils – and rationalized the action of the child as playing with a large nail and a hammer – symbols of the Crucifixion – that he has found in the open tool-box of his carpenter-father, Joseph.

Not surprisingly, the strain not only of the actual work but of being constantly under observation began to tell on the ageing artist. He had to respond with reasonable courtesy to naïve questions from amateurs or minor criticisms by

351. Bust of Louis XIV, the Sun King (Château de Versailles, Paris). Carved while Bernini was working on the east front of the Louvre, this superb bust took only three and a half months in 1665. Every stage was noted by Chantelou in his *Diary*.

356 professionals, such as the engraver Nanteuil, who pointed out that 'the pupils of the eyes were not focused on a single point, and the left cheek was too plump'.[33] Chantelou reports sadly that Bernini was always exhausted and depressed at the end of a good day's work. He did occasionally relax for a moment, but only with more work, either on his son's *Christ Child* (giving it a 'few caresses' as he put it) or by dashing off

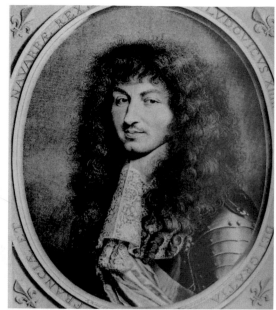

352, 353, 354. Alexander the Great as prototype for the portrait bust of Louis XIV: a Hellenistic bust, an ancient coin and a *denarius* of Vespasian as Sol.

355, 356. Jean Warin: reverse of a medal of Louis XIV showing the radiant sun and the globe, with inscription NEC PLURIBUS IMPAR, 1663, and an engraving of Louis XIV by Nanteuil.

a wonderfully vivacious drawing – usually of a devotional subject – for presentation, for example a *St Jerome in Penitence* or another of the *Virgin and Child with St Joseph*. He executed seven such drawings during his sojourn in France, including a *Madonna* for Mme de Chantelou and two self-portraits, one for Chantelou, the other for Colbert.[34]

When he was told that the bust was ready after such an amazingly short period of production, Louis came to admire it. The sculptor had set it on a table covered with a rich carpet in order to set off the dazzling marble. Bernini asked Louis to look directly at someone, so that he could re-mark the pupils in charcoal for the last time, for carving out a little more afterwards, probably to meet Nanteuil's criticism of some days earlier. Then he murmured that the bust was finished, adding that he wished it could have been even better, but that he had laboured over it with so much love that he did think it the least bad portrait that had ever left his hands! After briefly complimenting the king for his noble and co-operative spirit, he burst into tears – of pent-up emotion and exhaustion – and dashed out of the room.

Later on he recovered himself, the courtiers having apologized on his behalf to the king, who had been somewhat taken aback at the Latin's distinctly uncourtly emotional crisis. Louis went indulgently across to Paolo Bernini's relief of the *Christ Child*, saying, no doubt really to comfort the embarrassed father, that it could not be prettier, even if it was the work of a lad of only eighteen. Whereupon Gianlorenzo said that it was intended for the queen, and

expounded a beneficent theory that women in pregnancy should have beautiful and edifying things to behold ('*des objets nobles et agréables*'). The king then kissed him goodbye.

Bernini's bust of Louis is endowed with subtle symbolic meanings, which were to be enhanced by an extraordinary pedestal manufactured subsequently.[35] All revolved around the simple basic concept of the 'Sun King', but this was visually combined with a chance – but extremely flattering and therefore much emphasized – similarity in appearance between Louis, in the prime of life and still with a leonine mane of natural hair, and Alexander the Great, whose fine features had also been set off by a crop of luxuriant curls.

The radiant sun was a popular device, derived from antiquity, and had been adopted by Pope Urban VIII and Queen Christina before Louis took it up in 1662–3 and, as it were, immortalized it. This imagery underlay the concept of the base above which Bernini's bust was to stand, or rather seem to 'float': a great copper globe, with the land gilded and the seas picked out in blue enamel. This was to be labelled, as on a medal, with a motto, terse but pregnant with meaning, '*Picciola base*', in the sense that even the whole world was too small a base for so great a king as Louis. The globe in turn was to be steadied on a drapery of copper decorated with martial trophies, while the precarious whole was to be balanced on a special spreading platform. This was partly intended to keep the prying hands of visitors from being able to touch the marble and soil it with grease.

The Venetian Ambassador in Paris summed up quite simply the impression that the bust still conveys today: 'The King seems about to give an order [on the field of battle]; the bust has real movement although it has neither arms nor legs.' As Wittkower concludes his brilliant essay on the bust, 'one could survey the whole iconography of Louis XIV without finding a single portrait in which grandeur and royalty are so convincingly expressed'.

While the bust was a triumph which silenced his jealous enemies for a while, Bernini's own criticisms of what he saw in France verged on the ill-mannered and impressed his royal host unfavourably. Work on the rebuilding of the Louvre proceeded steadily, but had now reached a stage where the sculptor-architect felt that his own creative energy was no longer required and the – to him tedious – practical details that began to emerge could be left to local architects and craftsmen. After attending to one or two other projects he was finally allowed to set out for Rome on 20 October, amid much malicious gossip, for which his own peremptory attitude – it must be admitted – was in no small part to blame.

The equestrian monument

I am entrusting you with the thing that is dearest to me in all the world, my glory
King Louis XIV

Once Bernini had left Paris, his project for the Louvre died a lingering death by attrition, owing partly to its functional defects as a palace, but more so to the understandable antipathy of French native architects. It was finally cancelled in 1667. However, while his architectural abilities were in question, or at least the practicality of his buildings, Bernini's powers as a sculptor could not be in any doubt. By way of a consolation prize, and to keep him still within the French orbit, Colbert invited him only a few months later to produce a statue of the king, whom he now knew so well, on horseback and in marble, life-size or over: it might be set in the square between the palaces of the Louvre and Tuileries, or (like Giambologna's and Francavilla's equestrian portrait of King Henri IV that was mounted on the Pont Neuf until the Revolution) on a new bridge, or a building might even be constructed somewhere in Paris to display it to advantage.

This commission resulted from the long rumination that had begun with the ill-fated project for the steps below the
342 Santissima Trinità de' Monti. Indeed between 1669 and 1672, possibly in part to save the trouble and expense of transport to France, it was suggested that it be put precisely there, as the centrepiece of the grand landing between the stairs. Nevertheless, this would still have irritated the pope and the citizens of Rome and so was not followed up.

Bernini, ambitious as ever, swallowed his pride and accepted. He had begun a not dissimilar monumental
357 sculpture, in deep relief, of *The Vision of the Emperor Constantine* on a rearing horse for the landing of the Scala Regia of the Vatican and visible from the portico of St Peter's in 1662 before going to Paris. It was finished only after he returned to Rome, and was not installed until early in 1669, to be unveiled by the pope on 1 November 1670. The wish – probably on both sides – to see that very similar and time-consuming commission finished before embarking on the new one is probably the cause of an otherwise rather surprising delay of two years between Colbert's initial invitation and a second letter ratifying it in December 1669. He was to differentiate its composition sufficiently from that of the Emperor Constantine 'so that one can truly say that it is a new work by your hand'. Meanwhile, a huge block of marble had been delivered to Bernini's studio. Colbert fell in with the elderly master's sensible and constructive proposal to make only the preliminary model himself and to carve just the head of the king, while leaving the bulk of the work to the four sculpture students of the newly-founded French Academy in Rome; he was in any case being paid to supervise them and they would thereby gain practical experience under his eagle eye. Delegation had long been standard practice for major commissions, especially Bernini's.

The clay model, thirty inches high, is one of Bernini's 4, 361 biggest and most highly wrought: indeed it is one of the most exciting examples of modelling in the whole world. It was necessary to allow all the details to stand out clearly in full three dimensions, for the final work was going to be executed by inexperienced hands. The model was also to serve as a teaching aid to the French students, and so had a secondary function as a demonstration of the master's technique, style and sheer bravura.

The clay model perfectly exemplifies his aim of making the ultimate marble look malleable, for one can sense his modelling tools and even bare fingers coursing over the swelling surfaces to create the calligraphic S-shapes of tail and mane, of the monarch's luxuriant curls and of the ridged folds and troughs in the cloak below. Nevertheless, all their exaggerated sinuosity is disciplined by a firm underlying matrix of vertical lines of gravity and matched diagonals informing the sharply bent, or vigorously straightened, limbs of rider and steed. In spite of all provisos to the contrary, it is similar to the final composition of *The Vision of the Emperor Constantine*.

The rearing horses, easy for a painter but exceedingly difficult to render in sculpture, were inspired by two frescos by Raphael and his school in the Stanze of the Vatican, the *Repulse of Attila* and the *Expulsion of Heliodorus*.

A brilliant presentation drawing, with dramatic shadows 358 floated on in wash over sepia ink lines and with the highlights reserved in the white of the paper, was destined for the French officials and their royal master. It shows the final evolution of the whole project by 1671, for it indicates that the rearing horse was to be supported not on a fallen enemy, as was usually the case in marble or stone monuments (a means of disguising the necessary support for the horse's

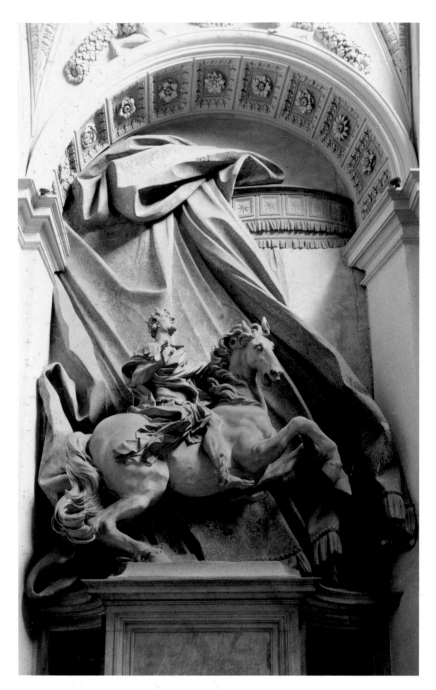

357. *The Vision of the Emperor Constantine* (Scala Regia, Vatican).

'Virtue'. He was also shown with a radiant smile to recall the sun, according to contemporaries (on whom we must rely, for the expression was changed after Bernini's death).

The equestrian group was carved from a vast monolith, 'bigger than any that had ever been seen in the city of Rome'. A point of honour among Italian sculptors held that sculptural prowess could only be demonstrated if monoliths were used; joining pieces together was frowned upon (although it had been allowed for *St Longinus*).

Work began on the marble only in May 1671: the intervening period must have been gainfully occupied with the students' construction in a mixture of clay and plaster of a *modello in grande* from which they could check the proportions as carving proceeded. Carving was almost finished by August 1673, and the statue was sufficiently advanced by November, four years after the intial order, for the Jesuit, Padre Oliva, a friend of Bernini, to pen a paean of praise for the benefit of a correspondent in Paris:[36]

I went yesterday to see the famous colossus that Cavaliere Bernini has made to immortalize the glory of the Most Christian King. In terms of mass it surpasses all the statues in Rome or elsewhere, as far as I know, even those that we admire by Phidias or Praxiteles. The horse, even though it is in marble, seems to be moving and ready to neigh, the king about to speak and to smile, so lifelike does it appear. I rejoice for the City of Paris on account of what one will soon see on its main square, a work than which Europe has not seen, nor will ever see a better, not only for what it shows but for the way in which the King is represented.

In spite of Bernini's protestations to the contrary, and unknown to at least some of the French observers, including Louis, not only the composition, but also several of the most exciting passages and details were very close indeed to *The Vision of the Emperor Constantine*.

Other supporters of Bernini praised the finished work too, but the sceptical Colbert demanded to see highly finished sketches, ostensibly to choose where it would be shown and to see the type of pedestal. These drawings are thought to be the two finished views, front and back, on coloured paper with white heightening, that are now in Edinburgh. At least they persuaded Colbert to order the necessary marble for the base in Paris in October 1673, but he was ungratefully quick to stop Bernini's salary the following year, now that the work was complete. A full year after Bernini's death (1680), his heirs were still pressing the French to make up their minds to remove the bulky statue, as it was encumbering the courtyard of what was no longer a working studio, but a private house.

Colbert himself died in 1683, before the complicated and hazardous process of shipping the huge statue to France finally began on 15 July 1684. It reached Le Havre in January

underbelly), or on rocks, as in the model, but on the unfurled standards of the king's conquered foes.

The whole sculpture was to balance atop a rocky crag with diagonal strata and jutting points, just like the islet of the *Fountain of the Four Rivers* and the foundations that Bernini had proposed for the third design of the Louvre. The king is clad in classical, not contemporary, armour and holds out a commander's baton. He rides without stirrups or reins, as the ancients did. In conjunction with the imperious expression on his face, these elements provide clues to the subliminal message that was to be conveyed by the finished statue: Louis was once more to be seen as a new Hercules, as in the Louvre façade, here aspiring to the very peak of the 'Mountain of

358. Presentation drawing of the equestrian monument of Louis XIV (Museo Civico, Bassano del Grappa).

359. Finished view of the equestrian monument of Louis XIV from the back (National Gallery of Scotland, Edinburgh).

1685, and was loaded on to a smaller barge for the journey up the River Seine to Paris, where it arrived three months later. But it was not to be installed there, perhaps owing to adverse professional judgments about its suitability for the centre of the city, and was laboriously transferred to a more rustic location, the Orangery at the Palace of Versailles, whither Louis had transferred his court in 1682. The king first set eyes on the statue in the afternoon of Wednesday, 14 November 1685, seventeen years after the project had been conceived. Now forty-seven years old and plagued with gout and other infirmities, he disliked the joyous, youthful allegory. With its creator Bernini and its promoter Colbert both dead, the work had no sponsor at court before the middle-aged and tetchy monarch. He was mortified, superciliously proclaiming that the 'man and the horse were so badly done that he wished them to be removed instantly from the Orangery and broken up'.

This was a curious overreaction from one who had only eight years earlier specially commissioned from Chéron a commemorative medal of Bernini and who had just brought 397 Bernini's earlier bust from the Louvre and installed it at Versailles. Most probably the lapse of time and changes of fashion and circumstances proved fatal: by this date the Versailles School of sculpture was flourishing in France and, although it owed much to former students of Bernini himself in the French Academy in Rome, thinking there had followed a classicizing path, in reaction against what had come to be seen as the 'excesses' of Baroque style. Of the latter, the group is indeed a prime example, and it must, therefore, have instantly offended the eyes of Louis, whose personal taste had changed too.

Louis' advisers persuaded him to adopt the more economical expedient of banishing the statue to a far point on a vista across a pool in the gardens, which needed to be articulated by just such a large feature. Thereafter it was moved yet again to beyond the Lake of the Swiss Guards. Its 360, 398 imagery happened to lend itself to transmutation into a classical subject; only minimal changes were needed and these were wrought by Girardon in 1687. By adding a helmet,

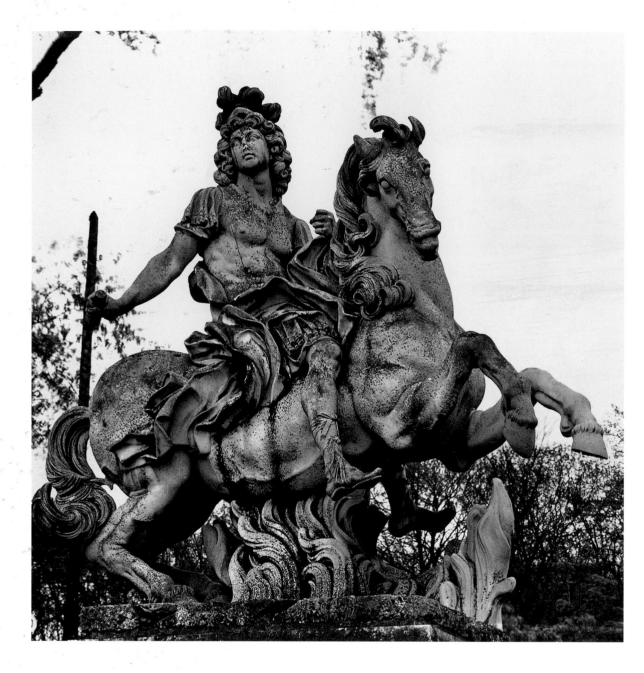

360. Equestrian monument of Louis XIV after later alteration by Girardon in 1687 to represent Marcus Curtius, when still in the gardens (now Écurie, Château de Versailles, Paris).

361. Detail of Bernini's terracotta model for the equestrian monument of Louis XIV (Villa Borghese, Rome). See also plate 4.

recutting the face to erase the smile and likeness to the king and recarving the unfurled banners below into flames, Girardon made Louis into the stoical hero Marcus Curtius riding his horse into a fiery crevasse. By a supreme irony, this change of identity and remote location ultimately saved the statue from the fate of the eleven later equestrian and other statues of royalty that were destroyed by the mob during the Revolution in 1792.

In spite of its reduced circumstances as a garden statue, Bernini's monument exerted considerable influence on his successors in the art of sculpture. Le Brun plagiarized it for a *Monument to the Glory of Louis XIV*, simply adding some banal dying adversaries on the rock below; a marble version was not carried out but resulted in some reductions in bronze to the scale of a statuette, while four of the most celebrated equestrians of the School of Versailles – Coysevox's two marble groups of *Fame* and *Mercury* (1701), and Guillaume Coustou's *Chevaux de Marly* of 1745 – are also indebted to its Baroque interpretation of antique sources.[37] However, its finest hour was to come in *c.* 1770, with the equally colossal – and, because its use of bronze obviates the need for any artificial support, more satisfactory – reinterpretation by Falconet in his triumphant image of Peter the Great for the centre of St Petersburg.

248 *England and France*

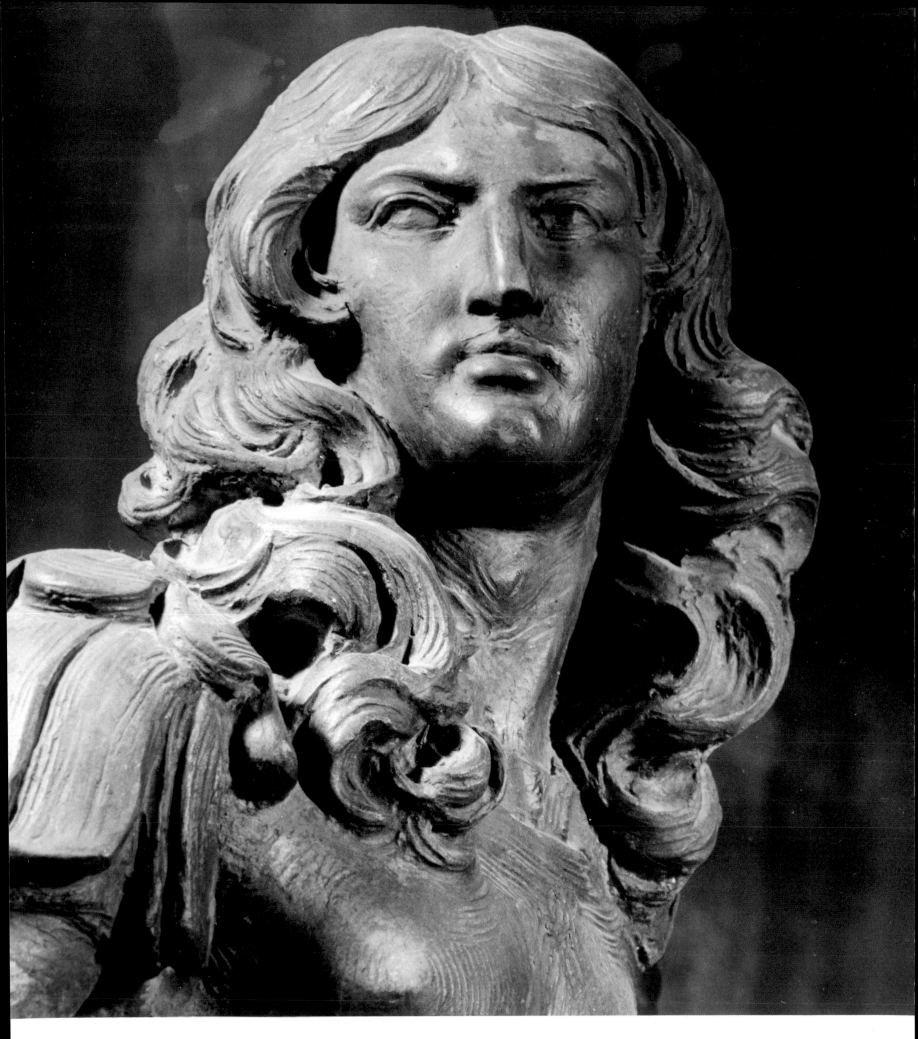

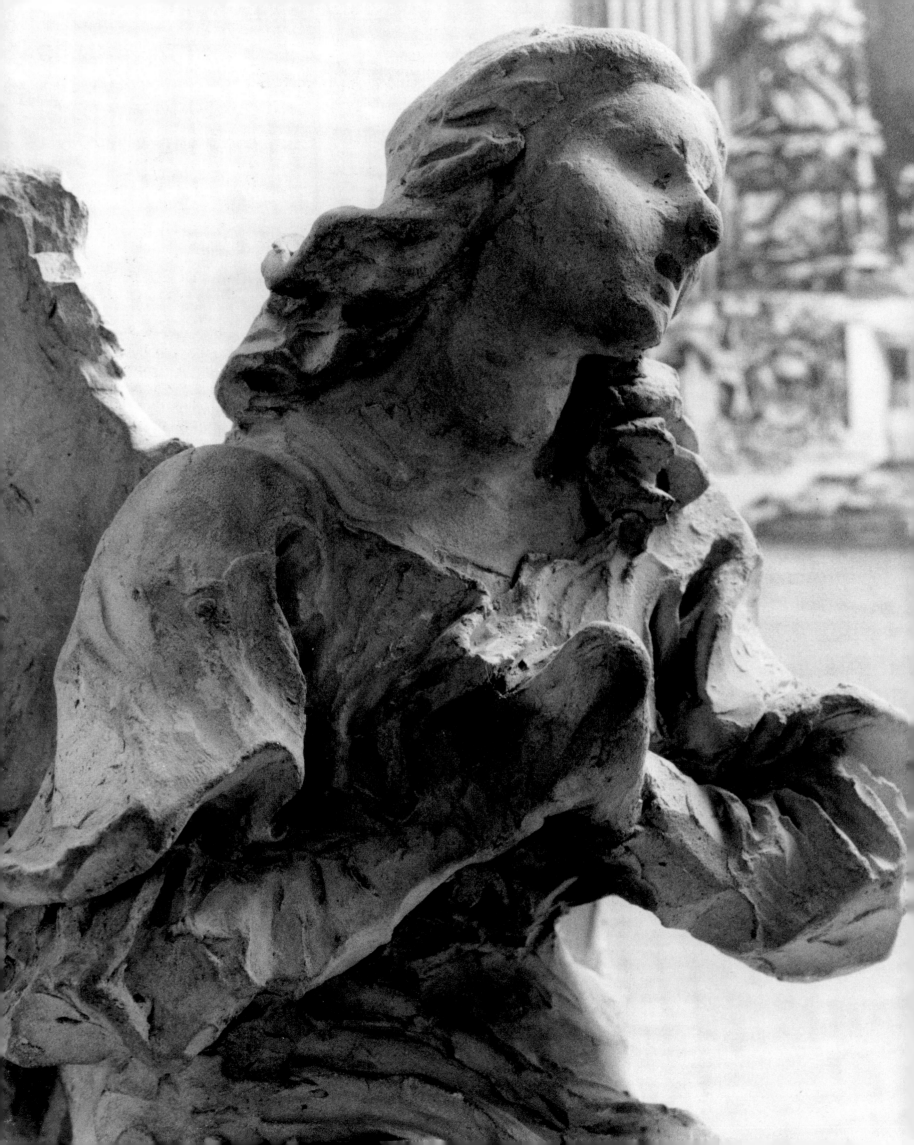

12 * Genius of the Baroque: talents and techniques

BERNINI's genius was so many-sided, and he was at the centre of attention in one of the best documented cities in the world for so many years, that a great deal is known about his working methods in the various disciplines and skills of which he was a master. In this last chapter, therefore, we shall look briefly at his use of models in clay and terracotta (of which much has been said already in discussion of particular projects), at his technique of carving in stone (known in detail from Chantelou's description of his French visit) and at his designs for the theatre, for coins and medals and his presentation drawings.

Bernini's use of models

Things of little worth
Bernini's heirs, 1706

In a document dated 17 April 1706, Bernini's sons and executors give us the following heart-breaking information:

In the studio there were some plaster heads and other parts of the body, together with some clay models that were half broken. By being taken to the wardrobe they became all broken and smashed, and they are not there any longer. A share of them was given to Sig. Giulio Cartari, a pupil of the *cavaliere*, as they were things of little worth . . . what with moving about from one room to another, and because of the lapse of time over twenty five years they are broken.[1]

Such was the fate of the majority of Bernini's working models, or *bozzetti*.

Today it seems scarcely credible that Bernini's sons – one of them a sculptor and another his father's biographer – should have set so little store by the models. Since the previous century such working models had been eagerly sought by connoisseurs.[2] The Medici Grand Dukes, for instance, owned collections of them, as did some of their courtiers. So it is surprising that there was no market for Bernini's models, even broken ones (unless so many were available that the market was saturated). Perhaps his heirs had grown to hate them, for their supremely gifted but obsessive father had not been an easy man to live with.

Certain of the more prized, prestigious or ornamental clay models (mostly now lost) were distributed around the house outside the confines of Bernini's studio: on the *piano nobile*, for example, stood two terracotta busts of his favourite patron, Pope Urban VIII, one of his next most important patron, Cardinal Borghese and another of the powerful Cardinal Richelieu.

Despite the irresponsible vandalism of his sons, however, there still survives a larger number of models by Bernini than by any other sculptor, a fact partly due to the loving care of his pupil Cartari, and partly to the models' subsequent and increasingly careful owners. Other pupils and assistants had been allowed to keep models from which they had worked on the great collaborative commissions over Bernini's long career, while several of the families of the popes with whom he was involved, notably the Chigi, also owned models relating to their own commissions.[3]

Today, Bernini's models are distributed worldwide. The main holdings are shared between three cities: Rome, where they are divided among three museums, Palazzo Venezia, the Museo di Roma in Palazzo Braschi, and the Vatican;[4] Cambridge, Massachusetts, in the Fogg Museum of Art;[5] and St Petersburg, Russia, in the State Hermitage.[6]

The provenance of these models, at one time mysterious, has only recently become clear. The largest number derive from the collection of Bartolomeo Cavaceppi (1717–99), the celebrated sculptor and restorer of antiquities.[7] He amassed a large collection including several by Bernini. Some he sold to a visitor from Venice, Abbot Filippo Farsetti (1703–74), who sold them on later to Tsar Paul of Russia in 1799. They were finally transferred to the Hermitage in St Petersburg in 1919.[8] Just two of Farsetti's Bernini models remain in Venice, in the gallery of the Cà d'Oro. Cavaceppi left the remainder to the Academy of St Luke, in Rome, which (rather disgracefully) sold them to the Marchese Torlonia. From him they passed by various dealers to the collections of the Palazzo Venezia and the Palazzo Braschi, the remainder eventually entering the Fogg Museum of Art in 1937.

What were these sketch-models made for, and why are they of interest? Earlier sculptors had often worked out their designs on paper, but this was of limited help in tackling the problem of the third dimension. This is of course the real challenge presented by the medium of sculpture. There are occasional references to small-scale models in documents

362. Terracotta *bozzetto* for the left-hand kneeling angel of the Altar of the Blessed Sacrament in St Peter's. A close-up showing Bernini's modelling technique (Fogg Museum of Art, Cambridge, Mass.).

366

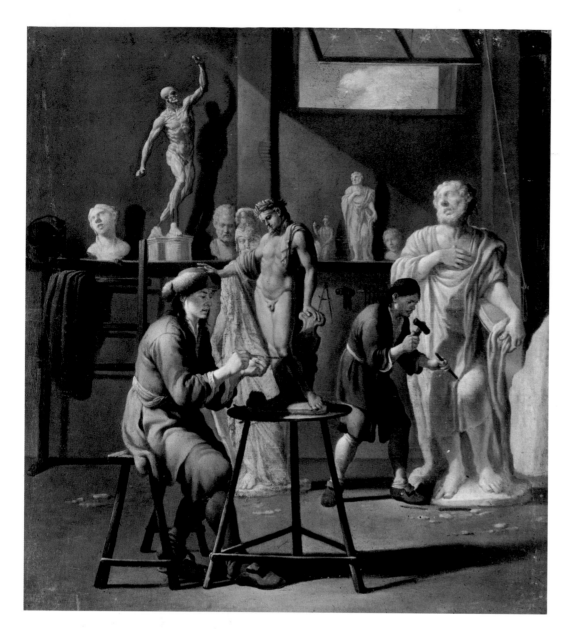

363. A painting of the interior of a typical seventeenth-century sculptor's studio, attributed to Michael Sweerts: the sculptor puts the finishing touches to a clay model, while a stonecarver blocks out a marble statue, of which the model is on the shelf behind (Hunterian Art Gallery, Glasgow University).

364, 365. A model of a hand and a plaque of two putti with martyrs' palms, such as were listed in Bernini's studio (Fogg Museum of Art, Cambridge, Mass.).

from Donatello's day onwards, but very few survive from the fifteenth century, apart from some that were preserved by casting in bronze. Not until the High Renaissance does one begin to benefit from the survival of models in wax such as the *Deposition* with wooden cross and ladders created by Jacopo Sansovino for Perugino to paint from. We also know that, when sharing a studio with Andrea del Sarto, Jacopo made models for figures in Andrea's paintings.

Michelangelo seems to have explored ideas for sculpture with equal ease on paper or in wax or clay: indeed, his early,

cross-hatched and carefully shaded pen drawings recall his technique of modelling forms and then carving them with a claw-chisel, changing his angle of attack on the block with every rise and fall of the surface. He also used chalk to good effect, especially later in life, while his narrative paintings have the incisive quality of relief sculpture. Regrettably, Michelangelo destroyed most of his models in order to keep his ideas from rivals.

Benvenuto Cellini, a goldsmith by training, had been brought up to use wax for modelling and his deft touch is recorded in a wax model for his statue of *Perseus*, but he also used drawings as an approach to sculpture, as witness his beautiful sheets showing the *Satyr Caryatid* and *Juno* for Fontainebleau. By contrast, Giambologna, the Medicean court sculptor who dominated Florentine, and in effect European, sculpture from around 1570 until his death in 1608, does not appear to have drawn at all, at any rate in an exploratory way, but he made models instead.

It soon became Giambologna's standard practice (as we learn from the evidence of a pupil, Sirigatti, that is preserved

in printed form⁹) after producing a *primo pensiero* (first thought) or *bozzetto* (sketch) in wax if necessary round a wire armature, to make a rather larger *modellino* (small model) for the next stage of a composition in clay, which could then be baked into terracotta. This would be detailed enough to serve his assistants for enlargement to the full size of the intended statue, a stage called the *modello in grande* (as distinct from the earlier, sketchy *bozzetto*, and the later *modellino*). Too big to be fired in a kiln, such a *modello* had to be formed around a rough wooden armature, bulked out with bundles of straw or cloth and allowed to dry naturally in the sun into *terra cruda*. Six such *modelli in grande* and some heads of others for Bernini's work in St Peter's have survived.

The infant Bernini would have been brought up by his father, Pietro, in this established Florentine method of producing a statue. Gianlorenzo, however, found it useful to revert to Michelangelo's practice of exploring sculptural ideas in the first instance by means of drawing. Pen and ink permitted rapid sketches, for example those for the revitalized skeleton on the Tomb of Urban VIII, or those enumerating

367. A *primo pensiero* modelled in wax by Giambologna (1529–1608) for his group of *Florence Triumphant over Pisa, c.* 1565 (Victoria and Albert Museum, London).

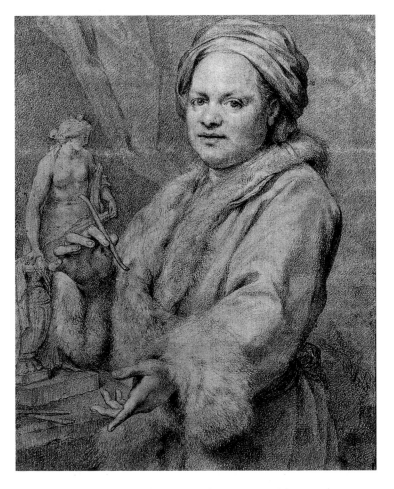

366. A drawing by Antonio Marron showing Bartolomeo Cavaceppi (1717–99), a Roman sculptor who owned a large collection of terracotta models, including many by Bernini (Staatliche Museen zu Berlin).

all the permutations of the design for the central rocky mass for the *Fountain of the Four Rivers*, while soft black chalk could be smudged with the thumb to help merge one idea in flux into another supervening one. Such *pentimenti* were the essence of his initial acts of creating a complex group, such as that of Neptune and Amphitrite for the fountain at Sassuolo. No models in wax by him survive.¹⁰

At the next stage, that of the *bozzetti* or *modellino*, Bernini worked in moist clay, as Giambologna had done, but his *bozzetti* are even freer. In his maturity, Bernini would build up a mound of clay on his workbench or modeller's turntable, pummelling it into rough shape with his hands, in a frenzy of creative energy, then gouge out the sinuous folds of his

368. Bernini's *bozzetto* for the kneeling figure of Pope Alexander VII on his tomb (Victoria and Albert Museum, London).

characteristic, 'windswept' drapery with a wooden modelling tool (*stecca*), and sometimes actually carve away at the block of clay with a spatula or a gouge-chisel. We have already seen this process in action in the discussion of the two Angels on the Ponte Sant'Angelo (Chapter Eight).

The classic example of the basic phase is the head of Alexander VII on the superbly managed *bozzetto* for the kneeling figure on his tomb. The isosceles pyramidal form of the kneeling pope has been clearly established, and it has been endowed with a feeling of life and mood by the broadly hewn planes of the crinkled cope and the dark openings that Bernini has excavated beneath it, conveying different planes and textures with a toothed tool. The separately modelled head was then literally stuck on at its apex, and Bernini established its exact angle with a small wedge of moist clay at the back of the neck, enabling him to move it about until he was quite satisfied with the effect. In this particular model he did not go into the details of eyes or mouth, and yet the tilt of the tiny head and the shadowed eye-sockets convey the illusion of a human presence that is little short of miraculous.

While Alexander was imagined in a reverie, an even greater challenge was proposed – and met – by Bernini toward the end of his career, when he decided to portray as witnesses to *The Ecstasy of St Teresa* a number of members of the Cornaro family, who were his patrons, as though they were viewing the event from boxes in a theatre. The impression of animated conversation between the two bearded ecclesiastics on the left

369. Four members of the Cornaro family: a detail from a damaged but vivacious *bozzetto* for their chapel with *The Ecstasy of St Teresa* in Santa Maria della Vittoria, Rome (Fogg Museum of Art, Cambridge, Mass.).

is brilliantly achieved by the angles of their heads, their reciprocal glances, and the spontaneous gestures of their hands. Such economy of means used to such good ends bespeaks a truly great artist. The Cornaro Chapel is a classic case of how the freshness of a *bozzetto* can evaporate in the finished work: although the composition and dramatis personae survive (with a Cornaro doge in the middle ground now attempting to exit right), all spontaneity has gone because of the intervention of the workshop. The telling idea of having one hand of a prelate coming right over the cushioned edge of the balcony into the spectator's 'real' space has also disappeared, regrettably, while the coffering of the internal ceiling and other details of architecture have gained undue prominence.

It had been remarked as early as 1550, when Vasari wrote his *Lives of the Artists*, that such working models often convey the fire of an artist's imagination and the spontaneous reactions to an idea of his skilled eyes and hands better than the finished work that eventually results, for there is a tendency for the latter to grow stale during the more deliberate and time-consuming processes of execution, whether in paint or, even more so, in marble. The rapid and summary technique of modelling employed by Bernini certainly endowed these little creations with a sense of life, movement and monumentality that belies their physical size.

One of the earliest of Bernini's models to exhibit a mature freedom of handling combined with a tight control of the medium, is the model, very obviously a sketch, for the 87–89 Memorial to Carlo Barberini (1630) in Santa Maria in Aracoeli, Rome. The pensive, helmeted female figure is thought to represent the Church Militant, and this may account for the firm set of her jaw. The design recorded in this small plaque of freely modelled terracotta, sketchy as it is, was virtually the one that Bernini himself carved on the large memorial (3.5 x 4.3 metres). The figure is perched precariously atop the curling upper edge of an unfurled cartouche of strapwork which is irregular and very anarchitectonic in outline. The only palpable alteration in the final version is the reversal of the position of the tail of the windswept cloak: it is easy to see how this was occasioned by the presence, to the left, of the coat of arms, with which the cloak would have been confused had it not been rearranged. The traces of modelling tools making broad striations on the moist surface of the clay recall the brush strokes of a painter, applying oil paint rapidly to canvas – Bernini was a competent, if not brilliant, painter.

The strength of the model stems not only from the sureness of touch, but from the fundamental structure of the composition, whereby one is enabled instantly to comprehend how the parts of the body are interrelated and how the figure is ponderated. The slight deformation of the face by the

370. Detail of the carefully worked *bozzetto* for the Church Militant on the Memorial to Carlo Barberini of 1630 in Santa Maria in Aracoeli, Rome (Fogg Museum of Art, Cambridge, Mass.).

pressure with which it leans against the clenched knuckles of the cloaked hand is but one indication of Bernini's profound observation and practised rendering in artistic shorthand. This is a classic example of the potential of transferring techniques typical of one medium to another: in this instance the linear hatching of drawing is imitated by the tiny parallel grooves made by dragging a toothed tool across the clay to cast a linear shadow in raking light. Different pressures on the tool resulted in different depths of groove and a corresponding variation in the intensity of the shadows.

The back of the small sketch-model for the colossal *St* 118 *Longinus* was scooped out hollow with a toothed tool. This had the technical advantage of making the thickness of the clay more uniform, thereby minimizing the risk of firecracks in the eventual terracotta. The accident of the Fogg *bozzetto*'s survival furnishes a very early term, if not the very first, in a

sequence that ultimately produced the marble colossus. In fact only one other model survives, very badly damaged but now expertly pieced together and preserved in the Museo di Roma. It was discovered in 1982 as part of the in-filling – which also included fragmentary antiquities – behind a fireplace in a house in Rome.[11] The head, arms and left leg are missing, but what remains is part of a model measuring over two feet high, in which one can still read the play of folds in the drapery, all carefully worked by short, deft strokes of a toothed modelling tool made from ever-differing directions to emphasize the movement of the surface as well as the weave of the fictive cloth. At lower left, the dramatic S-bend, with zigzag lines of crumpled ridges of material, is recognizably the same as in the final statue.

From differences of colour and handling it has been inferred that this *modellino* was fired in at least two parts divided around the figure's hips. This may account for the fact that it broke up so readily later. Apart from enabling a smaller kiln to be used and minimizing the risk of fire-cracks in the model, this sectioning also corresponds to the actual construction of the final statue, which was too large and unstable to be carved as a monolith, and was therefore made up of four different pieces of marble, dowelled or otherwise jointed together and the divisions plastered over.

The next stage after the sketchy *bozzetto* and the larger and more refined *modellino*, such as the one just discussed, was the creation of a full-size *modello* in a mixture of clay and plaster, often whitewashed, from which the final effect could be judged and, if necessary, corrected. Such objects could on occasion, with some difficulty, even be placed in their intended locations, for sculptor and patron to judge whether they would look satisfactory. This was certainly the case with the angels for the arms of the *Cathedra Petri*.

From the *modello in grande*, measurements could be taken by means of a framework set up around it with plumb-lines hanging down around its salient points, from which horizontal measurements to strategic high or low points of the composition could be made. These measurements were then transferred by drilling into the block of marble to a corresponding depth to within a few fractions of an inch, avoiding unsightly holes on the finished work, and leaving sufficient marble for the sculptor to make his final adjustments to the surface. The transfer of dimensions could be supervised by a foreman and the drilling and roughing out (*abbozzare*, in Italian) would, as was traditional, be delegated to simple stone-carvers (*scarpellini*) and apprentices, to economize on the time and talents of the master-sculptor.

Let us now turn to the large models by Bernini that survive: as has been related, a pair of angels some five feet high was run up to furnish the front 'legs' of the throne of St Peter on the full-size model of the whole project erected in

1658–60. These are the earliest of Bernini's *modelli in grande* to survive. Following the enlargement of the tableau, they had to be remodelled by Bernini at seven and a half feet high – well over life-size – which would have necessitated working from a platform for their chests and heads. It is therefore amazing to find the same spontaneity in these breathtaking creations as in a *bozzetto*, which can be worked conveniently on a rotating modelling stool in clay with a stylus, toothed tool and fingers. Thanks to their partial disintegration, we can see that they are not solid, but firmly constructed on a wooden base and upright support, just as they might be today. An iron armature runs out to all areas needing support – notably the wings – and around it are lashed bundles of cane to form the bulk of the limbs. Only then was the clay mixed with straw applied, to flesh out the figure and its drapery.

One can visualize the sculptor, by now nearly seventy, rolling up his sleeves, donning a smock, clambering onto the platform and dipping his hands eagerly into a bucket of prepared clay, then ramming it onto this curious mannequin of wood, iron and cane. He would have worked it well into the interstices to make it grip and then slapped on more material, smoothing it with his palms and excavating the nooks and crannies in the complex pattern of folds with his fingers. The rotund faces with enormous, appealing eyes, straight noses and rosebud lips – as so often in his work – slightly parted, all framed in a mass of prettily curling hair that punctuates the silhouette, make these huge models some of his most attractive creations, worthy of the prominent place by the throne occupied by the bronzes that were cast from them. Even so, these huge models of angels proved to be not quite definitive, for their superbly curvaceous wings were shorn off in the final castings, probably to simplify the silhouette of the throne, as it stands out in darkly patinated bronze against the background of gilded clouds. They were not entirely wasted, however, for fortuitously they served to provide Bernini with the basic scheme – on an appropriately monumental scale – for a series of angels complete with wings that he was commissioned to carve in marble only a couple of years later, in 1667, for the Ponte Sant'Angelo.

The method of construction of the *modelli in grande* is even more apparent in the case of the later pair of kneeling angels made in the spring of 1673 by a French assistant under Bernini's supervision. These were the summation of a series of wonderfully deft *bozzetti* that the seventy-five-year-old sculptor had made with his own hands for the Altar of the Blessed Sacrament in St Peter's. The clay over the left shoulder of the right-hand angel has broken off, to reveal a

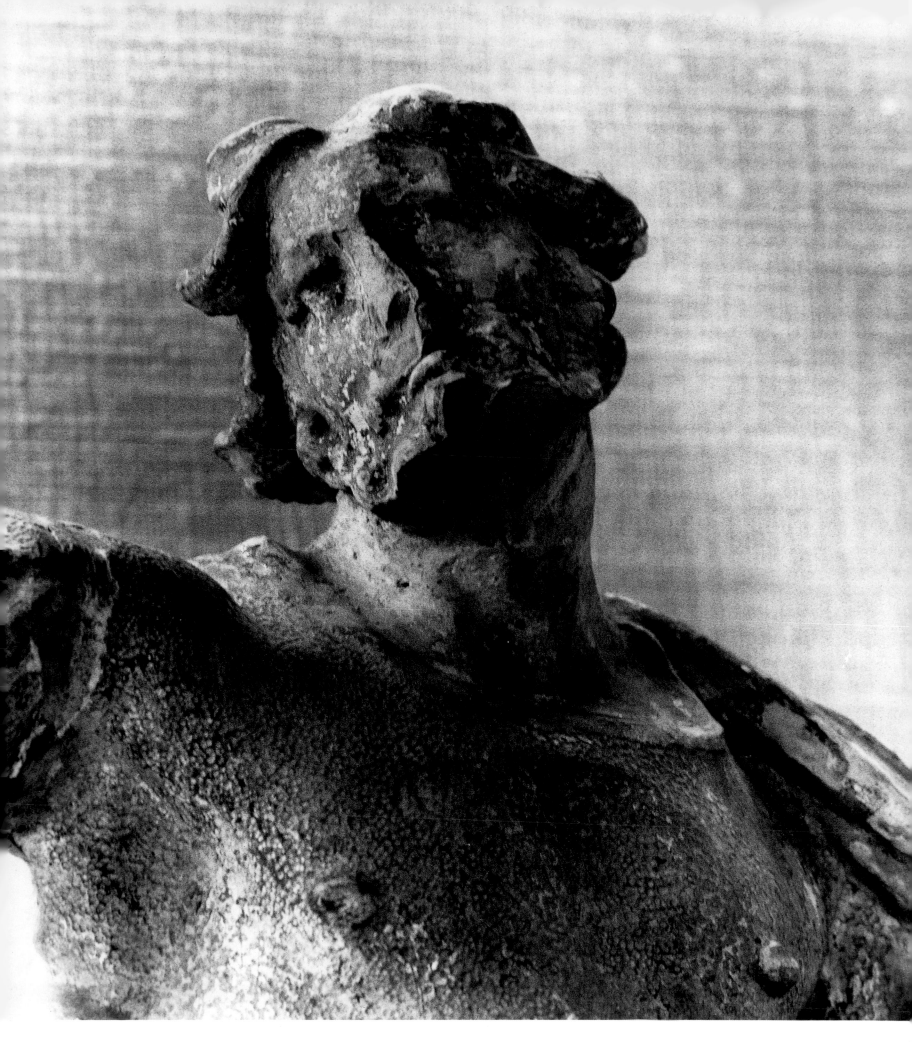

372, 373. The full-size *modello* for the right-hand kneeling angel of the Altar of the Blessed Sacrament, St Peter's; the iron armatures of the wings and the bundled twigs inside the shoulder have been revealed by damage (Pinacoteca Vaticana).

bundle of twigs tightly lashed with string to serve as the arm bone. Round the bundle was bound laterally with straw a layer of rough clay, approximately to the muscles of the biceps, while on top the flesh was applied in a mixture of clay or stucco with straw clippings to bind it. The iron armatures of the outlines of the wings are more than apparent. Happily, these two models were treasured as finished works of art for devotional purposes in a little church elsewhere in Rome until 1844, when they were transferred to the Vatican museums.

To revert to the well-preserved *bozzetto* of *St Longinus* in the Fogg, it is interesting to note that it was covered with a layer of gesso and gilded, and the saint's cuirass was punched to render a diverse texture. The piece was evidently, therefore, an important memento of the early ideas of Bernini and a desirable work of art in its own right. Many surviving *bozzetti* were originally so treated, probably to make them a brighter focus in the décor of a sombre interior and to make them resemble the more valuable materials of bronze, or – more prized still because of being indistinguishable by the eye from gold itself – gilt bronze. A seventeenth-century owner would not have been at all enamoured with the base clay out of which the model was formed, even though it was often impressed with the fingerprints of its maker, the factor so attractive to the twentieth-century purist.

Despite the recently established provenances of the majority of the surviving models, the problem remains of distinguishing between those by Bernini's own hand and those manufactured by his assistants, for whatever purpose. The spontaneous fluidity and sheer attack on the clay that are manifest in many of the rougher *bozzetti* point to Bernini's own handiwork, under the fire of artistic inspiration. Even so,

one has to bear in mind that pupils might well have tried to imitate this very freedom of execution: this seems likely to have been the case with a couple of models depicting Tritons now in Detroit.

Such problems become still greater when one is confronted with more finished *modellini*: how is one to distinguish between an authentic high finish imparted by Bernini to a model destined for presentation or made to provide the basis for accurate enlargement, and that of a careful pupil or copyist working on a reduced scale from observation of a finished marble statue? The only *modellini* associable with the series of statues of *c.* 1620, the first manifestation of Bernini's mature sculptural genius, all fall into this category, and scholars or connoisseurs remain divided as to their precise status. Three, those for Neptune, Pluto and David, are in the Hermitage and thus have the benefit of the Cavaceppi–Farsetti pedigree. Probably the earliest – and certainly the finest – is a partially draped torso of a mature, bearded male figure lacking all its extremities. In the catalogue of the Farsetti collection there was an item that corresponds, '*Nettuno del Bernini*'.[12] The rough breaks of the limbs and the neck enable one to see that the model is solid, and this is a good sign, for it suggests that it was worked up *ex nihilo*, rather than being cast from piece moulds (as was the next Hermitage model for the torso of Pluto). Like the fragments of the larger terracotta of *St Longinus*, the torso of Neptune thus appears to be a remnant of a true *modellino*. The difficult torsion of the thorax and the corresponding pull on the drapery running diagonally around it and flying out in a spiral behind are brilliantly achieved, and strongly suggest Bernini's own hand. Indeed, at this early stage of his career there is less reason to suspect the involvement of other sculptors in so personal an offering as there would be in a model for a major commission.

The torso of Pluto in the Hermitage is hollow, a factor which would have facilitated firing in a kiln, but is not atypical of Bernini's authentic *bozzetti* or *modellini*. On the other hand it could be argued that for the more highly finished type of model, Bernini might have relied on assistants to prepare items by taking piece moulds from original, solid models which did not lend themselves readily to kiln firing, but only to drying in the sun into *terra cruda*. After removing the plaster moulds and while the clay was still ductile (in a leathery state) he could then have added some finishing touches himself to the epidermis and sponged the surface to imitate the porous, palpitating softness of human flesh (a Giambologna trick recommended by Sirigatti).

Exactly the same may be said of the lovely little terracotta face of Proserpina (now in the Cleveland Museum of Art), weeping as she is abducted by Pluto. This is a fragment (evidently preserved for its beauty) of a highly finished,

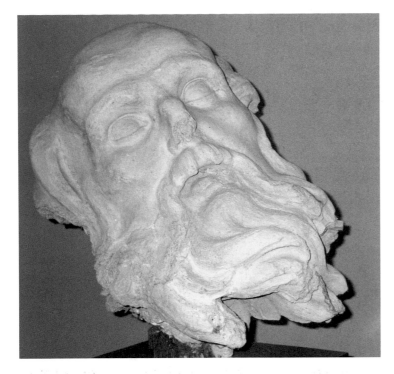

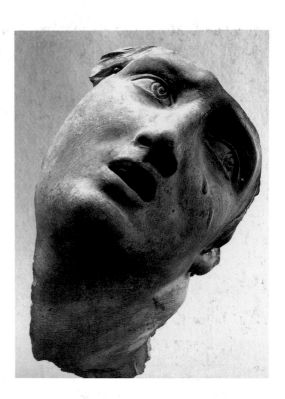

374. Fragmentary head from the full-size *modello* of one of the Fathers of the Church who support the *Cathedra Petri* (Pinacoteca Vaticana).

375. Fragmentary terracotta face of Proserpina from a lost *modellino* of *Pluto Abducting Proserpina* (Cleveland Museum of Art).

376. A model of a Triton with dolphins, one of two which may be by a pupil, rather than by Bernini himself (Detroit Institute of Arts).

hollow-cast model, which, calculating from the six-inch-high face, must have been some four feet high. Thus, it would have been half the size of the marble group, which is between seven and eight feet high.

Another possibility is that the face of Proserpina is a fragment not of the complete group, but of a bust-like detail, in which her expression could be established in greater detail than on a *modellino* of the normal, smaller size. A similar head of Pluto might also have once existed. Full-scale models for the heads of the four Fathers of the Church survive, as does a *modello* of *St Jerome* for the Chigi Chapel in Siena Cathedral. Such disembodied heads, as well as other fragments of well known statues either in terracotta or plaster, frequently feature in pictures of studio interiors and in inventories of sculptors' or other artists' studio contents. They were especially used by painters for the academic study of foreshortening and the fall of light and shade.

The third model in the Hermitage, that of Bernini's *David*, raises another issue in determining the originality of models: variations of detail are presumed to precede a marble version, for a copyist may be expected to copy everything very accurately. With this particular model, the design of the base, David's harp and the abandoned armour of King Saul all differ considerably from that of the statue in the Villa Borghese. This has been taken to indicate that it *is* a preliminary model, even though it is not at all sketchy, but then a *finished* model ought not to be sketchy in any case. We may be witnessing here the loss of spontaneity as a composition nears a final stage so bemoaned by Vasari years before.

Four of Bernini's most attractive models were found in an attic of the palace of the papal Chigi family in Rome and

given to the Vatican Library in 1923.[13] Two are successive,
154 cognate designs for the allegorical female figure of Charity
that Bernini designed to lean against the left end of the
sarcophagus of the Tomb of Urban VIII. So integral are they
to the story of that great project that they have been dealt
with in Chapter Seven.

The other two are cognate models for a pair of statues,
210, 213 *Daniel in the Lions' Den* and *Habakkuk and an Angel*, commissioned
in 1655 by Pope Alexander VII Chigi to fill niches in the
family chapel in Santa Maria del Popolo, also described
earlier (Chapter Eight). Olga Raggio explains the choice of
the connected subjects:

Bernini evoked the story of the two prophets as recounted in Bel and
the Dragon, the third apocryphal addition to the Book of Daniel (in
the Old Testament). There it is told how the Prophet Daniel was cast
into the lions' den by the Babylonians, but was saved by the Prophet
Habbakuk, who miraculously, was transported to Daniel's care by an
angel. The story, which is read in the Catholic Liturgy on the Tuesday
before Palm Sunday, was considered a prefiguration of the
Resurrection of Christ as well as a symbol of salvation through the
Eucharist.

Thus even the pre-existent niches could be taken as symbolic
of the cavern in which the miracles occurred. In a mortuary
chapel the symbolism would have been clear to any devout
believer.

Bernini was obsessed with perfecting the pose of Daniel,
as is shown in a series of five delicate chalk drawings in
Leipzig which study his more or less nude body, the last of
which corresponds to that shown in the model under
consideration. 'Daniel's slender body appears to rise toward a
vision, to be enveloped by a spiritual breeze, his drapery
flickering across his body like a flame,' as Raggio so
eloquently expresses it. His clasped hands form a sort of
arrowhead thrusting heavenwards, which leads the fluttering
forms of the drapery diagonally to his right, while the thrust
of his bent knee and the turn of his head, accentuated by the
flowing locks of his hair, point in the opposite direction. The
somnolent lion serves to fill the resultant gap in the
composition behind the prophet's foot: it must have been
known to Canova, whose sleeping lions flanking the Tomb of
Clement XIII in St Peter's are so closely similar. The axis of
the figure is serpentine and has a flame-like silhouette, thus
conforming – surprisingly though perhaps not by chance – to
one of the compositional tenets of Michelangelo. The
surfaces of nude flesh have been carefully smoothed with the
fingers, and yet much of the freshness of a working sketch-
model still remains.

While there are still differences between the model and
the final statue of Daniel, that for Habakkuk is virtually
identical. Furthermore, at 20 in. (52 cm.) high, it is one size

377. A finished presentation model for Bernini's *David* (State
Hermitage, St Petersburg).

larger than the one for Daniel, which is 16¾ in. (41.6 cm.)
high.[14] These factors indicate that it was almost certainly the
definitive *modellino* for that group. Raggio once again
succinctly interprets the subject:

Habakkuk surrenders to the will of the angel, who is about to lift him
by his hair and transport him to Daniel's cave. The tension expressed
by their meeting gazes, the contrast between the powerful physique of
the prophet and the supernatural grace of the angel, the expressivity of
the tightly bunched and cascading draperies, the play of intersecting
diagonal lines – all owe much to Bernini's earlier portrayals of mystical
experiences, such as the *Saint Longinus* and *The Ecstasy of Saint Theresa*.

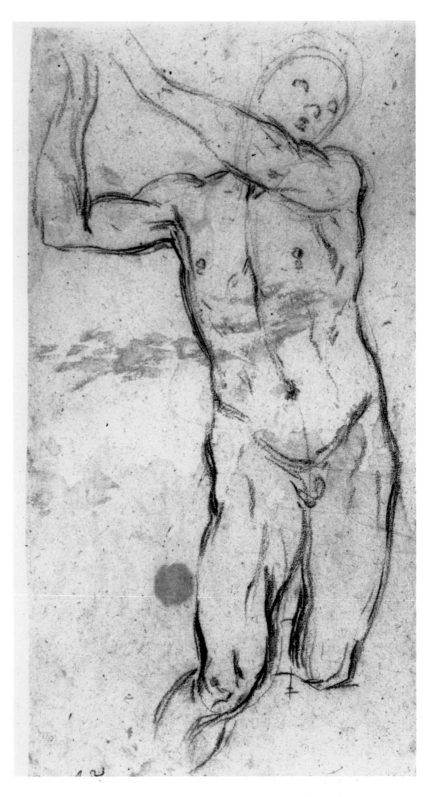

378, 379. Chalk drawings for *Daniel in the Lions' Den* in the Chigi Chapel, Santa Maria del Popolo, Rome (Museum der bildenden Künste, Leipzig).

Other finished *modellini* by Bernini and his immediate entourage survive in some numbers, probably because their attractive subjects and the ease with which they could be recognized encouraged their preservation as collectible works of art in their own right, as well as constituting attractive souvenirs of Rome itself. Two adorable renderings of animals, the elephant for the *Elephant and Obelisk* in Piazza Santa Maria sopra Minerva and the lion drinking for the *Fountain of the Four Rivers* have been discussed under those projects. Both have a lovingly smoothed surface and a perfection of detail that appeals to unbiased observers, as Bernini's original clients would have been, wanting to know exactly what a pet project would look like.

The sculptor at work: Bernini carves a bust

The King and I must finish this
Gianlorenzo Bernini, 1665

Chantelou's invaluable account of Bernini making the bust of Louis XIV enables one to track the whole process of creation of a single work. From it one may infer how he had produced the long series of busts of which this was to be the apogee: the same procedures had created varied images of maturity and old age, of vigour and concentration, or of lassitude and despair, eyes that seem to fix one eternally with their gaze and lips that are parted as though to speak.

The process began the moment he first set eyes on the handsome monarch. Of the period of one hundred or so days that elapsed before completion, Bernini worked on it for some forty-eight days, totting up half days and occasional recorded hours (not counting the basic blocking out of the marble and other supporting activities that were performed by Cartari). Bernini's initial demand, perhaps rather exaggerated in order to impress Louis with the gravity and complexity of the undertaking, was for twenty sittings of two hours. In fact, he had got wind of the king's intention earlier in the month and laid in a stock of clay in which to model the pose and movement (*l'action*) of such a bust, before bothering with the likeness (*la ressemblance*).

The very next day after the commission the sculptor and his assistant went all over Paris searching for blocks of marble and found only two not particularly good pieces. On the third day, the sculptor was taken again to St Germain to see Louis, first of all during a game of real tennis, and later, after dinner, during an ambassadorial reception, where he drew a full-face and a profile; these views, especially the latter, were and still are the standard approaches to making a head. Neither survives, probably owing to heavy use in the following weeks. The many subsequent jottings he made on paper, some of which might even have been like his caricatures to catch the essentials of the head, are also lost. But some of them would probably have resembled the delicate and spontaneous sketch he had made in chalk years earlier of Scipione Borghese. He claimed to have made them in order to refresh his memory occasionally, but not to copy from, for to do that would mean that the bust would be a copy of a copy! The choice of initial views also of course recalls the similar data on Richelieu that had been supplied by Philippe de Champaigne and on Charles I and his queen by Van Dyck.

From these outlines Bernini worked all the following day 'putting up' a clay model of the head till seven at night, when he went to church for St John's Day and then took a stroll along the Seine. He spent two more working days on the

model, before once again returning to see the king. Chantelou noted with some surprise that he was quite happy for his subject to move about and act naturally, rather than to pose formally, as in a traditional sitting. Centuries later Rodin was to allow his models the same freedom for the same reason, to encourage an effect of spontaneity and lifelike movement in his rendering.

Once, when their eyes met, the sculptor apologized, *'Sto rubando'* ('I am stealing [your likeness]') to which the witty young king instantly retorted in Italian, *'Si, ma è per restituire'* ('Yes, but only to give it back again.') *'Pero per restituir meno del rubato'* ('But I'll be giving back far less than I've stolen!'), replied the courtly Bernini. Such quick-fire repartee gives the flavour of the amazingly warm rapport that developed instantly between the young king and the distinguished elderly Italian, of whom Louis seems to have stood in some awe, despite his social inferiority, and whose frequent *faux pas* he was usually prepared to forgive (apart from one or two of his more tactless criticisms of French achievements). It is an indication of high intelligence on both sides.

Blocking-out the marble began on 6 July: in principle this was a task to be undertaken by a junior, in this case Cartari and maybe his son Pietro, but the master involved himself too, in order to get the feel of the particular block of marble that they had chosen. It took all day and the overheated Bernini complained of catching cold afterwards because the windows of the studio were all broken. In fact it was probably due to sheer nervous exhaustion, for he was also supervising the work on the Louvre. Colbert deigned to come and look at the model. While preliminary work on the marble was going on (14–27 July), Bernini again went and sketched the king when he was in council, embodying the results in the clay model: indeed he seems to have made more than one small model, to try out alternative poses. These would have been kept moist under damp rags so that the surface remained workable as the interior was slowly hardening. He also worked directly on the marble bust, trying to see the king always at the same time of day in order that the lighting might be identical, and stayed for about an hour. Thirteen such formal sittings are recorded.

Against some criticism that he was showing too little hair over the forehead, Bernini held his ground, explaining that the brow was one of the most telling parts of the head and that Louis had an especially noble one, so that it would be a shame to cover it with more hair: sculptors did not have the advantage that painters did of being able to show things beneath one another by using different colours. Even so, after a delay of a week to save face, Chantelou recorded carefully that he did, diplomatically, carve a wisp of hair (*un flocon*) over the royal forehead. To do this he must have had to cut back the surface of the forehead around it, if only by a

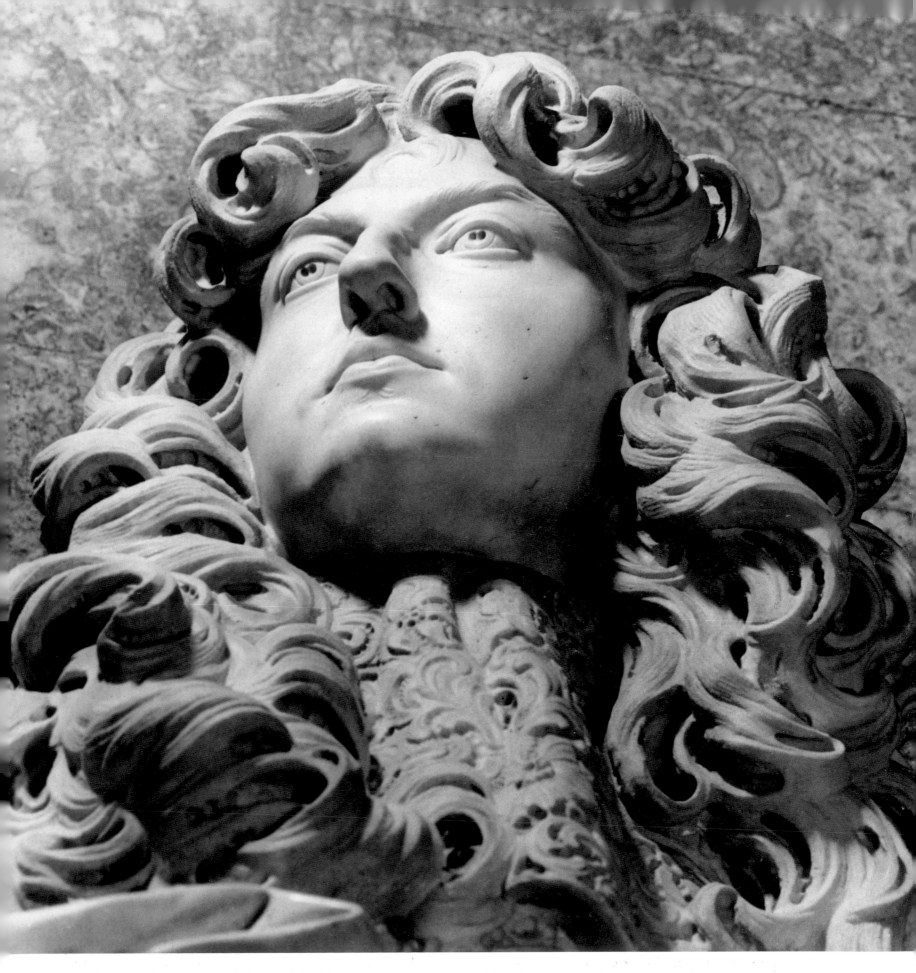

380. Close-up of Bernini's bust of King Louis XIV demonstrating the virtuosity of his techniques of carving. He used the drill to undercut the locks of hair, to make shadows in the pupils of the monarch's eyes and to create a facsimile lace jabot (Château de Versailles, Paris).

fraction of an inch, inevitably leaving the bumps over the eyebrows more prominent. This was immediately criticized by Jean Warin, who as a medallist had concentrated all his professional attention for years on the king's profile, ever since childhood.[15] Bernini justified his deviation from the royal model by his need to refer to the most famous profile from antiquity, that of Alexander the Great.[16]

352, 353

After only ten days' hard work, the marble bust seemed to one courtier far advanced, and by 29 July even the normally hyper-critical Colbert praised Bernini's progress. The next day, as the hair was being picked out, a royal favourite, Madame de Lionne, told Bernini, '*N'y touchez plus, il est si bien; j'ai peur que vous ne le gâtiez*' ('Don't touch it any more, it's so good; I'm afraid that you'll spoil it').

Just before that the sculptor had asked for a length of taffeta with which to model the drapery. He may have wished to sketch its movement in a strong breeze, to catch its quality as floating textile: indeed, he confided in Chantelou that he hoped it would end up looking like real '*gros taffeta*', but was not sure that he would succeed. He may also have arranged it round the shoulders of the clay model as was traditional practice, keeping the folds in place and stiffening the loose end at the right by soaking it in a slip of clay or in some size, and propping it up with a stick, a procedure that made it hold the complex shapes when it dried out.

Within a few days he began to work the drapery on the marble using only the drill, a delicate tool, because the marble was friable (*cotto*), and so he risked breaking it if he used the chisel, as he would normally have done. In the exciting, whiplash patterns of curving, almost faceted folds, Bernini drew upon a lifetime's experience of managing drapery on his figure sculpture: starting from the assured windings of Neptune's dolphin-like cloak, through the studies of banner-like drapes or unfurled scrolls of parchment, as at Sant'Andrea al Quirinale, to that of King Charles's knotted sword scarf and the Duke d'Este's deftly rippling cloak. In Louis' freely flowing and seemingly autonomous cloak he surpassed all these efforts with a bravura that has never since been matched.

After each meeting with Louis, he would work directly on the marble, while his almost photographic memory was still fresh (11 August). The likeness was now physically accurate, even down to marking in with charcoal the dark pupils of the eyes, for cutting out later with a chisel. This much had been done from memory and some imagination. The really challenging part was about to begin: the king and Bernini were going to have to work on the expression together, and this would of course convey his actual character: '*Il faut que le Roi et moi finissons ceci*' ('The King and I must finish this.') As he explained on 12 August to Chantelou (who was well versed in normal studio practice and consequently surprised by

Bernini's departure from it), his many sketches from life had been made to get the appearance of Louis completely into his head: '*per insupparsi et imbeversi dell "imagine del Re"*' ('to steep myself in, and imbue myself with, the features of the king'). He went on to expound the difficulties of portraiture in marble; it was still harder in bronze, which either darkened too much or, if gilded, was vitiated by reflections.

From now on Chantelou charts the rest of the campaign of bringing the face to perfection, including its expression: attention was paid on the twenty-second day of work to cheek, eyes, mouth and chin, and on the twenty-sixth day to the fine, aquiline nose. This he emphasized in accordance with contemporary theories relating the physiognomical appearances of human beings to that of various animals, with their respective characters. The eagle was also, conveniently for Louis, a symbol of Jupiter, king of the gods. Chantelou thought that Bernini's own face, and particularly his eye, had something of an eagle about it.

The eyes were followed over the ensuing ten days of carving by the mouth, eyebrows and forehead, then the nose and a blemish near the king's eye, as well as some hairs on his underlip. On the fortieth day Bernini was so far advanced that he no longer needed to work with the chisel, which could cause accidental fractures elsewhere, and therefore he could afford to remove a strut of marble that had been left to support the drapery. This would have been like those that survive on his statue of *Time Unveiling Truth*: because it was never quite finished, the figure's outspread fingers, especially vulnerable, retain struts of marble.

The intricate task of drilling out all the interstices of the patterned lace stock at Louis' throat (which he modelled from one of three real ones) had been left till last, as it could be done with a fine hand-drill. This took no less than three days of concentrated effort, during which Bernini joked at how ridiculous it was to be making Venetian lace out of marble. The jabot was carefully detached (*fouillé et dégagé*) from the adjacent curls of hair, probably by repeated drilling and filing. Bernini only regretted that because of the friability of this particular piece of marble he was prevented from using the chisel in the hair, which would have given a more natural effect, rather than the sequences of little black holes that give a pleasing, if more 'Impressionist' or even 'Pointilliste' effect, though they do not disconcert the modern observer.

Meanwhile the bust was set up high on a wooden stand to show it off to advantage, and last minute changes were made from a couple of final sessions with its subject. Next, the surfaces to be smooth were gently polished with powder of pumice stone on linen cloths: as the sculptor explained to his distinctly over-eager audience, marble had to be worked with patience. Next day no-one could come and see it, as it was turned upside down in a cradle for its socle to be secured

with an iron bar and some cement. After this it was finally mounted for display on a wooden stand (*sgabello*), as a temporary measure, until an elaborate allegorical base that had been under discussion for some weeks could be prepared. The very last touches were made, as we have seen, literally when the king came to admire the 'finished' work: even now Bernini was not quite satisfied with the direction or expression of the eyes. He had the temerity to request the monarch to look straight at someone, and then retouched the pupils with charcoal, to mark where a tiny bit of extra shadow should be carved out later.

This attention to the eyes and their glance is expounded eloquently by Wittkower:[17]

The eye has always presented sculptors with one of their greatest difficulties in the modelling of a head. This is due to the fact that, of all the parts of the human body, the eye alone has a design in it which exists only in terms of colour and not of shape – I mean, the iris and the pupil. The problem is to translate this coloured design into colourless sculptural form . . . considerable interest is attached to Bernini's treatment of the eye . . . His portraits and heroic figures, expressive as they are of determination and will-power, have always the chiselled eye, while for some of his saints and for his allegorical figures he retained the blank eyeball. So Bernini's first and last concern was for the look, and its firmness and determination is one of the most striking features of the bust.

On one occasion, when describing the King's features, Bernini mentioned that his eye-sockets were big, whereas the eyes themselves were small, and at another time he goes so far as to say that the eyes appeared somewhat dead and that the King hardly ever opened them wide. The eyes of the King were, in fact, extremely small. This is clearly borne out by other portraits, such as the rather uninspired pastel by Le Brun of slightly later date. And the faithful engravings by Nanteuil show the King with narrow and almost oriental-looking eyes which have a drooping and rather shifty look about them. Bernini . . . retained the narrow shape of the eyes; they are small in relation to the head, though slightly bigger than in Nanteuil's engraving. The magnetism of these small eyes comes not merely from their concentrated gaze, but also from the size of the eye-sockets which, large as they may have been in reality, were emphasized in the bust by the sharp definition in the modelling. The hollow between the eyebrows and the cheeks becomes part of the eye itself, and is indeed very large in relation to the rest of the head. The result is that, without departing from reality, Bernini was able to make the eyes the dominating feature in the face. Bernini's intentions in making the eyes appear so large are reflected in Chantelou's retort to a critic: 'Small eyes are all right in life, but big eyes give life to dead matter'. It is not for this reason alone that Bernini emphasized the eyes in his bust and gave them great intensity . . . he had his own ideas about a truly royal gaze: it should express *noblesse* and *grandeur*.

Bernini's technique of carving

I have overcome the difficulty of making marble like wax
Gianlorenzo Bernini, 1673

One of Bernini's best known remarks was uttered as an answer to some criticisms of the fluttering drapery and wind-tossed mane of the equestrian monument to Louis XIV. 'Not even the ancients', he said, 'succeeded in making rocks so obedient to their hands that they seemed like pasta' (*'rendere i sassi logi ubbediente alla mano come se stati fossero di pasta'*) – a very Italian simile. Whether this was an appropriate goal for stone carving was, and remains, a matter of debate.

In Baldinucci's words: 'There was perhaps never anyone who manipulated marble with more facility and boldness.' And elsewhere:

When not diverted by architectural projects, Bernini normally spent up to seven straight hours without resting when working in marble: a sustained effort that his young assistants could not maintain. If, sometimes, one of them tried to tear him away he would resist saying: 'Let me stay here for I am enthralled.' He remained, then, so steadfastly at his work that he seemed to be in ecstasy, and it appeared from his eyes that he wanted his spirit to issue forth to give life to the stone. Because of his intense concentration it was always necessary to have a young assistant on the scaffolding with him to prevent him from falling as he paid no attention when he moved about. The cardinals and princes who came to watch him work would seat themselves without a word and just as silently, so as not to distract him for a moment, make their departure. He proceeded in this manner for the entire working session and at the end he would be bathed in perspiration and, in his last years, very lowered in spirits. But because of his excellent constitution a little rest would restore him.

Bernini criticized even his great idol, Michelangelo, for not having had the ability to make his figures look as though they were made out of flesh (*'non avere avuto l'abilità di far apparire di carne le sue figure'*), and, by contrast, claimed that he himself had overcome the difficulty of making marble look as malleable as wax, and thus to a certain extent assimilated the art of the sculpture with that of painting. As Baldinucci relates:

Although some censured the drapery of his figures as too complex and sharp, he felt this, on the contrary, to be a special indication of his skill. Through it he demonstrated that he had overcome the great difficulty of making the marble, so to say, flexible and of finding a way to combine painting and sculpture, something that had not been done by other artists. This was the case, he said, because they did not have the courage to render stones as obedient to the hand as if they were dough or wax.

381, 382, 383. Views from the side, above and below of Bernini's not quite finished bust of Pope Clement X (Palazzo Altieri, Rome). These show how he utilized fully the depth and breadth of the block of marble.

The unfinished bust of Pope Clement X that Bernini was working on in 1676 until the subject's death that was then abandoned survives to show the penultimate stages of his technical procedure.[18] Views from above and below show how the sculptor used the full extent of his block of marble. The head and collar just clear the rear plane of the block, while the tips of the lower three fingers of the benediction hand fall in the same vertical plane as the foremost tip of the scroll held in the pope's left hand: this notional plane is almost certainly only just behind the original front face of the block. Below, the foremost projection is the curled end of the ribbon that disguises the truncation of the waist, on which the pope's name is painted, though it was probably intended to be properly incised. In contrast to the back which remains in the rough, just as it had been quarried, the underside is neatly hatched with a point-chisel, obviously to ensure that the bust would stand up steadily.

Bernini sometimes used this technique for matt surfacing, when he wanted to make a contrast with a polished part, as for example on the globe beneath the left foot of *Time Unveiling Truth*. The drapery separating it from the highly polished foot is also left with the striations of a riffler (rasp) to indicate its natural woven texture and the direction of flow of its folds (though there too, some lack of finish may accentuate the effect more than the sculptor would have allowed had it ever been delivered to a client, instead of being left in the relative seclusion of his own house). Similar contrasts may be noted in many of his statues, for instance *The Ecstasy of St Teresa*, where the hatched surface of the rock-like clouds contrasts sharply with the smooth gleam of highly buffed marble in the agitated folds of her habit.

The bust of Clement also shares with *Time Unveiling Truth* the fascinating feature of the struts of marble that were always left until the last moment, usually until after the statue had been safely installed, before being gingerly cut away. The pope's right hand is still linked to his front by a substantial, tapering strut of roughly square cross-section, just as the hand of Truth is linked to her body by a short strut running from near her left nipple to the tip of that thumb. The four extended fingers of both these respective hands are linked by further braces of uncarved marble. This would have been the case as well with every extended hand or other delicate extremity that Bernini ever carved, for instance the left hand of *St Longinus*.

A comparison of these three hands also serves to demonstrate the range of possible finishes on their palms too: Clement's is gouged out vigorously in broad planes and volumes, the ball of the thumb is differentiated from the indented 'life-line', as are the pads of adipose tissue from the bony extrusions of the fingers, the creases of which are sharply incised and even marked with the tip of a drill. The

palm of Longinus is covered evenly with the sinuous grooves of a point-chisel, emphasizing the rise and fall of the flesh over its underlying bony structure; the palm of Truth is the unblemished one of a young woman, pink, smooth, and soft to the touch, symbolically like that of a newborn, innocent baby. The marble here has been carefully reduced by abrasion into a smooth, if not highly polished, surface that renders spectacularly well the pores of palpitating flesh.

It is certainly true that for detailed work Bernini sometimes hired specialist assistants, such as Finelli or, later, Cartari: expert finishers of intricate, *trompe l'œil* detail, their work has recently been revindicated, by the discovery of a lost bust of Urban VIII's niece, Maria Barberini, who had married Tolomeo Duglioli of Bologna and died at the age of only twenty in 1621. Previously known only from an ecstatic description by Nicodemus Tessin penned after his visit to the Barberini Palace in 1688, this is now available for examination in two mid-nineteenth-century photographs, rediscovered only in 1970, that had been taken when the bust was still at the Sciarra Palace, a residence belonging to collateral descendants of the Barberini. We can now see the delicate undercutting of her curls and the bouquet of flowers in her coiffure, and even more so the delicate piercing of her upstanding starched collar of finest lace, as well as of a jewel in the form of the Barberini bee that looks as though it has just settled on her jacket, over her heart.

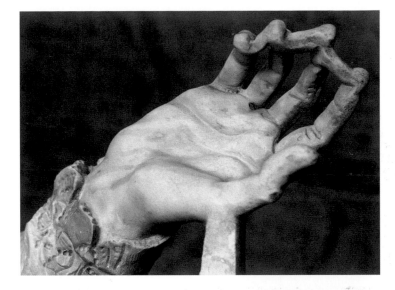

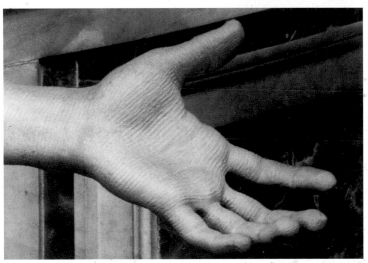

384. Truth: detail from *Time Unveiling Truth* showing her feet, drapery and globe, revealing different techniques of finishing to convey contrasting textures (Villa Borghese, Rome).

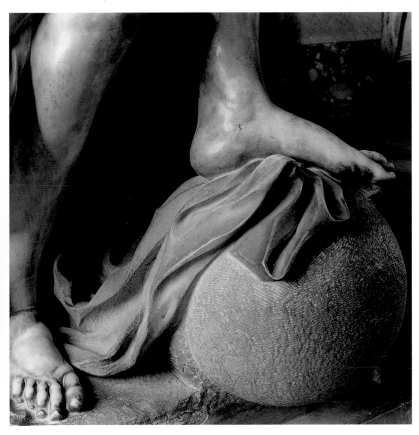

385. The right hand with remaining struts of marble of Bernini's bust of Clement X (see plates opposite).

386. The left hand of *St Longinus*, showing the careful striations, rather than a high polish, with which the sculptor finished the prominent statue in St Peter's (see also plates 117–120).

387. The left hand with remaining struts of marble of Truth from *Time Unveiling Truth* (see plates 337–340, 379).

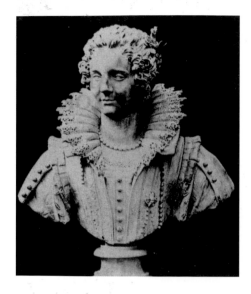

388. An old photograph showing the missing bust carved with great finesse by Bernini and Raggi of the niece of Pope Urban VIII, Maria Barberini Duglioli.

From inventories and contemporary accounts, we know that when it was received from the sculptor in 1627 it was to be kept for safety inside a cage of iron wire, to keep any admiring, but prying and potentially destructive, hands away from the dainty lace collar and attractive curls. By 1649, this had been replaced by a special vitrine made of walnut (standing on four giltwood bun feet carved with Barberini bees) with three large panes of glass (probably at the front and sides). This was presumably to exclude dust and so to avoid the need ever to brush it down, however carefully. The sensible attempt at conservation was spoiled however by the fact that one of the panes was carefully listed as being 'half-broken'!

Bernini and the theatre

Bernini, a Florentine sculptor, architect, painter, and poet, who, a little before my coming to the Citty, gave a publiq Opera (for so they call shews of that kind) wherein he painted the scenes, cut the statues, invented the engines, compos'd the musiq, writ the comedy, and built the theatre
John Evelyn, *Diary*, 17 November 1644

Bernini was indeed a man of many parts. Primarily an artist who preferred working in three dimensions, he could also turn his hand to narrative and portraiture in two dimensions, whether drawn or painted. Working for the stage entailed thinking in three dimensions as regards the movements of the actors and although the scenery was flat, it could give the effects of perspective. The backdrop in particular often had to convey a feeling of infinite depth. An especially beautiful and unique drawing in pen and wash of a seascape at sunrise, the vista framed by crags and devoid of figures, is perhaps a sketch for such a backdrop. Its subject certainly recalls a passage in Baldinucci:

It was Bernini who first invented that beautiful stage machine for representing the rising of the sun. It was so much talked about that Louis XIII, the French King of glorious memory, asked him for a model of it. Bernini sent it to him with careful instructions, at the end of which he wrote these words, 'It will work when I send you my head and hands.'

According to Domenico Bernini, his father turned to writing plays at the age of thirty-seven (*c.* 1635) but a letter written by a third party in 1634 suggests that he had been penning comedies for some years by then.[19] In fact the earliest reference to a play is in 1633. Only one — seemingly incomplete — script by Bernini survives: it is for a comedy about a theatrical impresario, who turns out to be the author himself. Otherwise one has only the evidence of his biographers, brief excerpts that he narrated from memory to Chantelou to pass the time, occasional letters and contemporary witnesses such as Evelyn. Baldinucci described at length Bernini's activities in this sphere, which naturally made him extremely popular with his fellow citizens of Rome:

It is not surprising at all that a man of Bernini's excellence in the three arts, whose common source is drawing, also possessed in high measure the fine gift of composing excellent and most ingenious theatrical productions since it derives from the same genius and is the fruit of the same vitality and spirit. Bernini was, then, outstanding in dramatic actions and in composing plays. He put on many productions which were highly applauded for their scope and creativity during the time of Urban VIII and Innocent X. He created most admirably all the parts both serious and comic in all the various styles that up to his time had been represented on the stage . . . by the force of his genius. Sometimes it took an entire month for Bernini to act out all the parts himself in order to instruct the others and then to adapt the part for each individual. The keenness of the witticisms, the bizarreness of the devices through which he derided abuses and struck at bad behavior were such that whole books could be made of them . . . those who were the butt of his witticisms and mockeries, who for the most part were present at the performances, never took offence. Bernini's ability to blend his talents in the arts for the invention of stage machinery has never been equalled in my opinion. They say that in the celebrated spectacle *The Inundation of the Tiber* he made it appear that a great mass of water advanced from far away little by little breaking through the dykes. When the water broke through the last dyke facing the audience, it flowed forward with such a rush and spread so much terror among the spectators that there was no one, not even among the most knowledgeable, who did not quickly get up to leave in fear of an actual flood. Then, suddenly, with the opening of a sluice gate, all the water was drained away.

Spectacles involving the flooding of certain suitable arenas in order to hold mock sea-battles (*naumachia*) or to stage marine spectacles out-of-doors were not uncommon, the courtyard

of the Pitti Palace in Florence and Piazza Navona in Rome both serving on occasion. Another of Bernini's spectacles is thus described by Baldinucci:

Another time he made it appear that by a casual unforeseen accident the theatre caught fire. Bernini represented a carnival carriage, behind which some servants with torches walked. The person whose job it was to perpetrate the trick repeatedly brushed his torch against the stage set as happened sometimes. It was as if he wanted to spread the flames above the wall partitions. Those who did not know the game cried out loudly for him to stop so that he would not set fire to the scenery. Scarcely had fear been engendered in the audience by the action and the outcry, when the whole set was seen burning with artificial flames. There was such terror among the spectators that it was necessary to reveal the trick to keep them from fleeing. Once he composed two prologues for a spectacle to be performed in two theatres, one opposite the other, so that the people could hear the play in one theatre as well as in the other. The spectators in the regular theatre, who were the most important and famous, saw themselves re-created in effigy by masks in the other theatre in a manner so lifelike that they were amazed. One of the prologues faced outward, while the other was reversed, as the parts were played. It was delightful to see the departure of the people – in carriages, on foot and on horseback – at the conclusion. The fame of the play *La Fiera*, produced for Cardinal Antonio Barberini during the reign of Urban VIII, will live forever. There was everything in it that one is accustomed to seeing in such gatherings. The same is true of the spectacle *La Marina* which was done with a new invention and that of the *Palazzo d'Atlante e d'Astolfo* which astonished the age.

Finally, Baldinucci noted:

He said he had a fine idea for a play in which all the errors that come from running the stage machinery would be revealed along with their corrections, and still another not yet presented, for giving the ladies away on the stage. He disapproved of horses or other real creatures appearing on stage, saying that art consists in everything being simulated although seeming to be real.

Bernini had had experience of designing ephemeral scenery and apparatus since the papacy of Urban VIII, when he had to produce some for the celebrations in St Peter's of major festivals: for the canonization in 1629 of the Florentine Andrea Corsini he erected a 'theatre of most beautiful perspective with colonnades, four paintings . . . various statues of prophets and theological virtues, all gilded'; and for the Forty Hours' Devotion in the Cappella Paolina of St Peter's he employed for the first time concealed light sources for a 'Glory of Paradise, which was most resplendent without one's seeing any lights, because behind the clouds were 2,000 lamps'. These ephemeral though very memorable schemes acted as sounding boards for public opinion and as a testing

389. An evocative drawing in pen and wash of a sunrise, an unusual subject for Bernini, that was perhaps for a backdrop to one of his theatrical productions.

ground for new ideas which Bernini sometimes went on to embody in permanent form. Two drawings also record elaborate designs for carnival floats and carriages. He even lent his hand to designing firework displays, one in Piazza di Spagna to celebrate the birth of the Spanish Infanta (1651), and another for the birth in 1661 of the French Dauphin, in front of Santissima Trinità dei Monti.

Drawings for presentation, designs for medals and caricatures

Bernini was most singular in the arts he pursued because he possessed in high measure skill in drawing
Filippo Baldinucci, 1682

A general survey of Bernini's *œuvre* cannot pretend to do justice to every facet of his immense production, and this is especially true of his myriad drawings. As has been remarked, they have been the subject of an exhaustive monograph in German in the 1930s and – those in Leipzig – of a major exhibition catalogue in America (1981). Those in the Royal Collection were studied by Anthony Blunt and certain others have been carefully catalogued in their respective collections or for exhibitions. Sketches made in preparation for major

390. *St Jerome in Penitence*, one of Bernini's occasional drawings of a penitential Christian theme (or sometimes a self-portrait) made for presentation to patrons or friends: this sheet was given to Colbert (Musée du Louvre, Paris).

projects have been adduced where relevant in preceding chapters in an attempt to show how Bernini used them during the creative process. As the percipient connoisseur Baldinucci puts it, 'In these drawings one notes a marvellous symmetry, a great sense of majesty, and a boldness of touch that is really a miracle.'

In his house in Rome, Bernini informed Chantelou, he had a special gallery in which he walked about as he dreamed up most of his compositions: as ideas occurred to him he drew them on the wall with charcoal. He felt that it was normal for an imaginative person to have thought after thought on a given subject, and to draw them one after the other, not neatening or correcting earlier ones, but always rushing on to a fresh one out of a delight in novelty. If possible he then left these ideas to mature for a month or two, after which he was in a position to choose the best; failing that, when he was pressed for time, he would look at them through different sorts of spectacles, with coloured

lenses or ones that magnified or reduced, or in a mirror, to see the large sketches back to front. Such a series of tests enabled him to escape the excitement of mere novelty and to make a valid decision. Presumably from time to time he would have the wall of the gallery whitewashed to provide a fresh surface on which to work.

One category that has been touched on only as regards a form of relaxation in which he indulged during his visit to Paris, is that of presentation pieces. He could dash off a superb drawing such as his *St Jerome in Penitence* (Louvre)[20] in an evening. The artist gave it to Colbert, to mollify him, and the latter requested a self-portrait too, as did Chantelou. Both were gratified and Madame de Chantelou received as a farewell present a drawing of the Madonna. Bernini told his companion in Paris that he made three every year in Rome – presumably as Christmas presents – for the pope, for Queen Christina of Sweden and for Cardinal Chigi. And very welcome gifts they must have been too. They are imbued with religious fervour of an almost abandoned kind, showing hermit saints adoring the crucifix in dramatic poses of self-abasement. The Madonnas and Holy Families, surrounded by cherubim, are of a lighter tone, though sincerely religious nonetheless. A signed fresco in the Chigi Palace at Ariccia is typical and quite charming: it shows an elderly St Joseph about to kiss the naked Christ child squirming in his arms. Similar, more elaborate, drawings were furnished on occasion to engravers in order to make illustrations for books, notably one of the *Vision of the Blood of the Redeemer*.

Bernini always enjoyed a challenge and one of these was to design reverses for coins and medals: this involved adapting the composition harmoniously to the circular flan of metal and working boldly so that the design would be legible within the small compass of a coin (and withstand daily wear), or the slightly larger disc of a medal.[21] Bernini's interest might have been fired in childhood by the gift of 'twelve gold medals, as many as he could hold in his hands' that were the reward pressed on him by Pope Paul V for the spontaneous drawing of St Paul. And at his death, the sculptor possessed eighty-three coins and medals, though of these twenty-two had gone missing by 1706, 'having been given to his grandchildren as playthings when they were little and ill'!

Bernini's practical activities with medals began in 1626, when Urban VIII dedicated the annual medal of year four of his reign to celebrating the Baldacchino. Its reverse featured the penultimate design, of which it is important evidence. The dies were cut to Bernini's design by specialists. Other reverses reflecting Bernini's work followed: the façade of Santa Bibiana (1627) and the canonization of Andrea Corsini (1629), for which he had designed the apparatus in St Peter's and of which the reverse furnishes the only visual image. This was the year too when Bernini was appointed Architect of

237

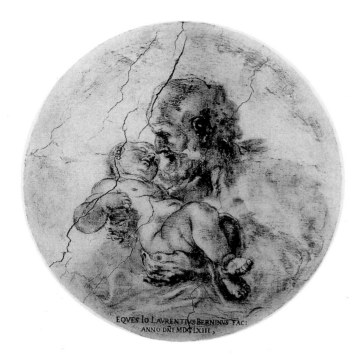

391. A signed fresco dated 1663 in the Chigi Palace at Ariccia, showing St Joseph adoring the Christ child.

392. Bernini's design in pen and wash for the reverse of a medal of Alexander VII to commemorate the passing of a plague in Rome (De Pass Collection, County Museum and Art Gallery, Truro).

St Peter's. In 1633 the final design of the Baldacchino was celebrated, while under Innocent X the interior of the Basilica (1648) and the *Fountain of the Four Rivers* (1652) were honorifically featured.

In the reign of Alexander VII Bernini's involvement was stepped up and autograph drawings survive for certain medals. The sketch for the plague medal of 1657 has been mentioned in connection with the omnipresence of death in the period. In the following year he produced a pair of highly refined drawings for the obverse and reverse of a new silver scudo: these show respectively the Chigi arms on a scrolling shield with papal insignia, a semi-recumbent figure of St Peter above and a soldier in Roman armour (perhaps a memory of St Martin?) ostentatiously giving alms to a crippled beggar. The reference may be to San Tommaso di Villanova, canonized in that year, 1658, for he was a greater believer in charitable giving (it is to him that Bernini's church at Castel Gandolfo is dedicated).

Bernini's most ambitious design for a medal reverse shows
394 Androcles and the Lion. It was designed for a rich citizen, Prince Domenico Jacobacci, in honour of Pope Alexander. He commissioned not only this unusually large and
395 impressive medal (99 mm. in diameter) but also an engraving designed by Bernini, showing its two faces flanking the Chigi crest, on a fictive scroll with an honorific inscription held open in mid-air by two putti.

Several other medals celebrate Bernini's architectural achievements, and some of them were indeed designed by
313 him. Most interesting are those recording the unexecuted third wing of the Piazza San Pietro; others commemorate the

393. A silver papal scudo of 1658, struck from designs by Bernini (British Museum, London).

church of the Assumption at Ariccia, the Scala Regia, the *Cathedra Petri*, for which a drawing and a wax model on slate are preserved in the British Museum, and the new apse of Santa Maria Maggiore, to name but the most outstanding. Bernini's last drawings for medal reverses are on a sheet in Düsseldorf which shows two alternative designs for a medal to celebrate the canonization of San Pietro di Alcantara and Santa Maria Maddalena dei Pazzi in 1669: the two saints kneel on a cloud facing one another, reacting with awe to the presence of the Holy Spirit above them.[22]

Medals made from Bernini's designs for the equestrian monument to Louis XIV have been adduced above as evidence of his original intentions for supporting the rearing horse, and that by Chéron, in the design of which Bernini 235 may have had a hand, celebrating the inauguration of the new angelic decorations of the Ponte Sant'Angelo, has been discussed. In his seventy-sixth year Bernini was celebrated as

master of all three fine arts and of geometry in a delightful medal cast by Chéron; the profile may reflect the missing, late self-portrait bust recorded in France soon after his death. 397

A particular product of his boldness in drawing was his work in that sort of sketch we call caricature or 'charged strokes', which for a joke distort in an uncomplimentary way the appearance of others, without taking away the likeness or grandeur if the subjects were, as often happened, princes. Such personages are inclined to be amused at such entertainment even when their own appearance is concerned and would pass around the drawings for other persons of high rank to see.

Thus writes Baldinucci of one of the – for us – most fascinating byways of Bernini's productivity.[23] He was not the inventor of the genre; for that, credit must go to Leonardo da Vinci, and in his own day the Carracci had also practised this form of light relief. But, as he became more confident of his position in life, Bernini became addicted to such naughtiness, a by-product of his habit of trying to catch the essence of things, of situations and of people such as Scipione 97 Borghese. Regrettably, probably to protect his name – and because all concerned would recognize the subject of a given caricature – few are labelled, so that we cannot identify the butts of his barbed humour. Or else they are captioned so vaguely as to be of little use today. As mentioned above, Cecil Gould thought that the caricature of 'Un cavaliere francese' represented the insincere Colbert, but it may rather be a 349 gentle dig at his friend Chantelou. Apart from a number of buffoon-like and extremely fat clerics, or thin ones squinting through spectacles, the most daring – and damning – of all is perhaps his visual lampoon of poor Pope Innocent XI, a sickly old man, conducting business – as was then not totally unheard of – from his bed. Bernini makes of him a crouching grasshopper, wearing a great mitre resembling some monstrous insect cranium, diminutive amid the bedclothes of a long bed, propped up against pillows and emphasizing papal orders with his spindly fingers.

394, 395. *Androcles and the Lion*: a medal honouring Pope Alexander VII, commissioned by Domenico Jacobaeci (Art Gallery of Ontario), and an engraving commissioned by the pope showing a scroll with the same medal held by putti.

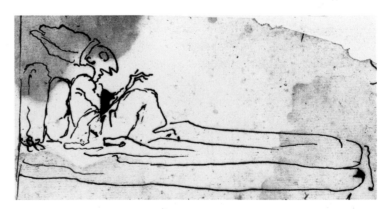

396. Bernini's caricature of Pope Innocent XI (Museum der bildenden Künste, Leipzig).

Epilogue: Bernini the Man – life, death and reputation

Cavalier Bernini was not only the best sculptor and architect of his century but, to put it simply, the greatest man as well.

Cardinal Pallavicini

'BERNINI was a man of average stature with a somewhat dark complexion and black hair that turned white with age,' Baldinucci tells us, continuing:

His eye was spirited and lively with a piercing gaze under heavy eyebrows. His behaviour was fierce, his speech made a most effective impression. When giving orders, he terrified by his gaze alone. He was much inclined to anger and quickly inflamed. To those who rebuked him for it, he would respond that the same fire that seared him more than others also impelled him to work harder than others who were not subject to such passions. This same natural fervour kept him in a state of poor health until the age of forty. Because of it he could not bear without injury the rays of the sun or even the reflection of the rays, which often gave him migraine. With increasing years this excessive heat lessened and he entered into a state of perfect health which he enjoyed until his last illness. His moderate eating habits helped maintain his good health. Ordinarily he allowed nothing to be prepared for him except a small dish of meat and a great quantity of fruit. He used to say in jest that this craving for fruit was the original sin of those born in Naples. With such an equable manner of life, Bernini kept himself so strong that he seemed to be tireless. Bernini said of himself that if he put together all the time he spent at meals and in sleep during his life, he thought all such inactivity would not come to a full month. Moreover, he never undertook any task that could be done by others.

Turning to Bernini's reputation with his contemporaries, Baldinucci goes on:

Bernini was always highly esteemed and even revered by the great. He was so generously remunerated that it seems to be a certainty that there was no one else in recent centuries, no matter what his excellence, whose works were so richly rewarded. We have spoken in previous accounts of the tributes he received from the great: of the visits of pontiffs, of that of Her Majesty the Queen of Sweden, and of many cardinals. We will add that Bernini constantly received Italian and northern European princes who were drawn to his house by the desire to see him work. Cardinal Maffeo Barberini (later Urban VIII), Cardinal Fabio Chigi (later Alexander VII), the Cardinals Antonio Barberini, Rapaccioli, Chigi, and Rinaldo d'Este visited him constantly. The last named esteemed so greatly even a line from Bernini's hand that when he took him to Tivoli to see if the design of

a fountain for his famous garden had been well executed, he made him a gift of a ring with five diamonds for a slight retouching of certain stuccos; and afterwards Cardinal d'Este rewarded him with a silver basin of like value. His Holiness Innocent XI, the reigning pontiff, showed how highly he valued Bernini when he cut the expenses and appropriations for the palace extensively; in words filled with love and great esteem he ordered that Bernini's allowance be left intact.

This account of the esteem in which Bernini was held is confirmed in numberless other sources. Urban VIII told him: 'You are made for Rome and Rome for you' (*'Voi Siete fatto per Roma e Roma per voi'*); he called him, 'A rare man, a sublime intellect, and born by divine dispensation to illuminate this century to the glory of Rome' (*'Huomo raro, ingegno sublime, e nato per dispositione divina, e per gloria di Roma a portar luce al secolo'*); and when the sculptor had been ill with one of his attacks of depression he confessed that, 'he would have liked to embalm Bernini to render him eternal' (*'haverebbe voluto imbalsamare e rendere eterno il Bernino'*).

Baldinucci concludes:

In his will, Bernini left His Holiness the Pope a large painting of Christ by his own hand. To Her Majesty the Queen of Sweden he left the beautiful marble image of the Saviour . . . to the Most Eminent Cardinal Altieri, a marble bust-length portrait of Clement; to the Most Eminent Cardinal Azzolino, his most kind protector, a bust of Innocent X, his supporter. Not having anything else in marble he left Cardinal Rospigliosi a painting by his own hand. He most strictly enjoined that his beautiful statue of Truth be left in his own house. It is the only work by his chisel that remains the property of his children.

The circumstances of Bernini's death and the religious fervour with which he confronted it, after so much 'practice' during the last forty years of his life, detain Baldinucci for several paragraphs, which are very moving. He then relates how it was received by his eminent admirers:

It would take too long to tell of the sorrow that such a loss brought to all Rome. I will only say that Her Majesty the Queen, whose sublime intellect knew through long experience the subtle gifts of so great a man, paid extraordinary tribute to him. It seemed to her that with

Bernini's death the world had lost the one who had played a unique role in making our century glorious. On the day of Bernini's death the Pope sent a noble gift to that Queen by means of his privy chamberlain. The Queen asked the chamberlain what was being said in Rome concerning the estate left by Bernini. When she learned that it was worth about four hundred thousand scudi, she said, 'I would be ashamed if he had served me and had left so little.'

The pomp with which the body of our artist was borne to the church of S. Maria Maggiore where his family had their burial place, corresponded to the dignity of the deceased and the capabilities and love of his children, who ordered a most noble funeral and distributed both candles and alms on a grand scale. The talents and pens of the learned were exhausted in the composition of eulogies, sonnets, lyric poems, erudite verses in Latin, and the most ingenious vernacular poetry was written in praise of Bernini and publicly exhibited. All the Roman nobility and the northern European nobility then in the city gathered together. There was, in short, a crowd so numerous that it was necessary to postpone somewhat the time for the interment of the body. Bernini was buried in a lead coffin in the . . . tomb commemorative of his name and of his person.

This was beneath a simple slab of marble incised also with his coat of arms, but it is in a significant spot just by the altar railings of Santa Maria Maggiore.

The commemorative medal by Chéron bore on its reverse the complimentary motto, 'Alone of his kind in individual things, but unique in everything' ('Singularis in singulis, in omnibus unicus'). In 1682 Baldinucci summed him up as 'a man who in the arts of painting, sculpture and architecture was not only great but extraordinary. To be ranked with the most splendid and renowned masters of antiquity and of modern times, he lacked little from fortune save the time at which he lived.'

He was evidently admired, too, in intellectual circles. On 29 January 1633 the celebrated poet Fulvio Testi wrote to a friend describing what amounted to 'salons' that he held in his house for literati, wits and men of the world, and announcing that he had managed to persuade Bernini to grace their company over carnival, calling him 'that most famous sculptor, the Michelangelo of our century in both painting and sculpture'.

The English seem to have amused the great man, for he allowed the egregious Thomas Baker to cajole and bribe him into carving his portrait, in the teeth of a papal interdiction, and, as we have seen, he also received most kindly Nicholas Stone the Younger, who arrived with an interpreter at an inconvenient moment on 22 October 1638, when Bernini was ill in bed. Four days later an overawed Stone confided to his notebook, 'I waited on Cauelyer Bernine at St Peters (being Tuesday); he fauoured me so farr as to show me the statua that he had under hand in the church, and told me that for a

while he should be bussy thaire, but when he had done and that he was att his housse I should be welcome to spend my time with the other of his disciples.'[1] Six years later, when John Evelyn visited Rome in 1644 he noted in a summary of observations: 'For sculptors and architects we found Bernini and Algardi were in greatest esteeme.' It would not have pleased the former to have his name conjoined with that of his leading rival and exact contemporary; it is interesting that they were being mentioned in the same breath, though Algardi was, conveniently for Bernini, removed from the scene by his death in 1654.

The only area of his professional life where Bernini's reputation was less secure was architecture, in particular the recurrent allegations of incompetence or negligence with regard to the failed campanile and to some cracks in the drum of the dome of St Peter's. These were virulently renewed by enemies immediately after his death in 1680, and both his own son Domenico and Filippo Baldinucci went to great pains to prove them ill-founded.

But what of his private character, Bernini the man? Here, it appears, his laudatory biographers have been economical with the truth. He was notorious for his ruthless ambition and the lengths to which he would go to defeat his rivals. Passeri recorded in print that he was like the dragon guarding the Gardens of the Hesperides, who worked against anyone attempting to gain the golden apples of papal grace, and spat poison and sharply pointed darts of hatred all over the path that led to possession of the highest favours. ('Quel dragone custode vigilante degl'Orti Esperidi pressava che altri non rapisse li pomi d'oro delle gratie pontificie, e vomitava da per tutto veleno e sampre spine pungentissime d'aversioni per quel sentiero che conduceva al possesso degli alti favori'). Someone else, less well-placed, called him a 'malicious and wily' man ('uomo tristo ed astuto').

In 1638 there occurred a truly regrettable episode in his private life, the attempted murder of his younger brother, the sculptor Luigi Bernini. This was a crime of passion. Early one morning he had observed Luigi leaving the house of his own beloved mistress Costanza, who accompanied him amorously to the door in a suggestively dishevelled state. Gianlorenzo pursued him to their workplace at St Peter's and set about him with an iron crowbar. Fortunately he only broke a couple of Luigi's ribs. But more reprehensible still is the fact that Bernini then sent a servant to disfigure the faithless and doubly inconstant Costanza (who had betrayed first her husband Matteo, Bernini's employee, and now his employer as well) with the slash of a razor. Finding her in bed, the servant carried out his task. Gianlorenzo continued to be enraged, later pursuing Luigi, sword in hand, to their own house, where he broke down a door closed against him by their mother, and then on to Santa Maria Maggiore nearby, where the fugitive Luigi sought sanctuary in church and

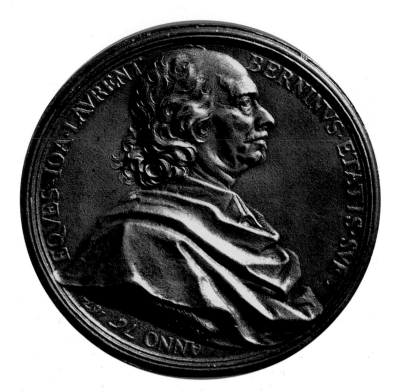

397. C.-J.-F. Chéron: honorific medal of Bernini at the age of 76, with allegorical reverse of the three fine arts and geometry in action (Victoria and Albert Museum, London).

Gianlorenzo had to give up the chase, contenting himself with kicking at the door. Criminal proceedings inevitably ensued and it is from a deposition that the whole disgraceful affair has been reconstructed. Bernini was deservedly fined a large sum, 3000 scudi, the price of one of his own princely portrait busts, but, amazingly, Pope Urban waived the fine, and the poor servant suffered exile. Luigi prudently took himself off to Bologna to work on a Bernini project in San Paolo Maggiore. Possibly it was out of remorse for this assault that Gianlorenzo later felt obliged to bail out Luigi, who had been caught committing sodomy in St Peter's, by agreeing with Pope Clement X to carve for nothing the statue of the Blessed Ludovica Albertoni.

Bernini's mother Angelica was naturally appalled and threw herself on the mercy of Cardinal Francesco Barberini (chairman of the board of works at St Peter's and hence Gianlorenzo's most important employer) to mitigate the penalties, and to reason with her eldest son who, it was said, was acting presumptuously, as though he were 'king of creation' ('padron del mondo'). This was probably out of injured pride and sheer bravado. Later, he fell into a deep depression, as is recorded by a correspondent of the Duke of Modena on 28 May 1639. Pope Urban put pressure on him to mend his scandalous amatory ways and marry. So, at the age of forty-two, a priest at the Chiesa Nuova directed him (quite undeservedly one might feel) towards a perfect wife, nearly twenty years his junior, and allegedly the prettiest girl in the whole of Rome. Bernini told the over-indulgent Urban in delight that he could not have made her more beautiful had

he had to model her himself out of wax. Caterina Tezio (1617–73) was, he said, 'faultlessly docile [perhaps she was secretly terrified of him] prudent and not at all tricky, beautiful but without affectation, and was such a perfect mixture of seriousness, pleasantness, generosity and hard work, that she might have been said to be a gift stored up in heaven for some great man'. Bernini's revulsion against Costanza is proved not only by his paying a servant to disfigure her, but also by his cutting her head off a joint portrait in his house that he had painted when he was 'fiercely in love' with her. He also sent her carved portrait into exile, and possibly, as has already been suggested, recreated her in the hateful guise of Medusa as a constant reminder and warning to himself. His marriage also gave him an excuse to move out of the family house, where he was no longer entirely welcome, and to set up afresh in an extensive property, reflecting his prosperity, in Via della Mercede, round the corner from the Collegio della Propaganda Fide and Sant'Andrea delle Fratte. It was there that he was to end his days. This was the house whose contents are so vividly enumerated in the inventory associated with his will. Predictably his marriage to the fair Caterina also had its ups and downs, though seemingly more on account of his fiery temper and obstinacy, than of illicit affairs.

These extremes of behaviour resulted probably not only from a fiery Mediterranean temperament and an upbringing in the rough conditions of a sculptor's workshop, but a manic-depressive psychological profile, such as is frequently associated with creative genius in any field, and is normally excused as an 'artistic temperament'. This was exacerbated by a degree of success early in life which would have turned the head of even a well-balanced individual. Furthermore, Bernini was indulged by a strong protector, in Maffeo

Barberini, who was prepared to overlook even heinous crimes for the sake of his artistic prowess. In short, his moral character had been warped by artistic and worldly success. However, the effect of these traumatic events was to make him reform his ways and turn into an exceptionally devout Roman Catholic, diverting his energies from amorous escapades to religious exercises. Bernini's despicable fall from grace, but apparently sincere repentance over the next forty years of his life, perhaps makes him seem more approachable as a fallible human being.

It has to be admitted, however, that feelings of dislike, tinged with envy, were mingled with admiration for the papal protégé, who was seen to be richly rewarded from the coffers of the Vatican, which the Roman populace was required to fill by punitive taxation. The same fate befell Pope Innocent X, ironically enough, for he had initially made a stand against his predecessor's extravagance on works of art. In Rome these criticisms found their outlet in barbed sonnets pinned secretly at night-time beneath an ancient statue familiarly known as 'Pasquino' – hence the noun 'pasquinade' – which still stands near Piazza Navona. After the waters of the *Fountain of the Four Rivers* had been turned on in 1651, and while books and sonnets in its honour proliferated among the gentry and a comedy was produced as well, the Plebs Romana hit back, via the petrified lips of Pasquino: 'What we want is not obelisks and fountains; bread is what we want – bread, bread and more bread!' (*'Noi volemo altro che guglie e fontane: pane volemo, pane, pane, pane!'*). A more educated critic, parodying a biblical passage, rudely told the pope in Latin, 'Command those stones to turn into bread' (*'Dic ut lapides isti panes fiant'*). (Bernini had once proudly proclaimed that he could make stone look as soft as pasta, but it remained inedible.)

When Bernini was in France, Chantelou relates, and a certain Monsieur de Ménars was praising his mythological statues as superior even to classical sculpture, the sculptor responded with due modesty: he owed his whole reputation to his guiding star, which kept his name to the fore as long as he was alive, but, once he was dead, his fame would diminish or even be extinguished altogether. It was an accurate premonition. Bernini had lived so long and kept so firm a grip on artistic patronage in Rome, partly through his genius and partly through his strength of character and his ruthless suppression of potential rivals, that, after his death, there was bound to be a negative reaction. This was most pronounced in France and manifested itself in the disgrace into which his equestrian monument to Louis XIV fell. Taste had changed. Under Louis XIV and his court painter Lebrun a new school of sculpture emerged to furnish the statuary at Versailles, respecting the rules of antique sculpture and avoiding what were now perceived as the excesses of Bernini's late style. In Rome and Florence the Baroque style survived – with some slight transmutations – much longer than in France, indeed for a good three-quarters of a century, until it was swept away by the Grecian austerity of Canova and Neoclassicism, its disrepute confirmed by the passionately intellectual critic Winckelmann.

In England too, Sir Joshua Reynolds censured Bernini on several counts in his *Discourses*, presented at the nascent Royal Academy.[2] First, he took him to task for the imaginative individuality of expression on the face of the *David*:

As in Invention, so likewise in Expression, care must be taken not to run into particularities. Those expressions alone should be given to the figures which their respective situations generally produce. Nor is this enough; each person should also have that expression which men of his rank generally exhibit. The joy, or the grief of a character of dignity, is not to be expressed in the same manner as a similar passion in a vulgar face. Upon this principle, Bernini, perhaps may be subject to censure. This sculptor, in many respects admirable, has given a very mean expression to his statue of David, who is represented as just going to throw the stone from the sling; and in order to give it the expression of energy, he has made him biting his underlip. This expression is far from being general, and still farther from being dignified. He might have seen it in an instance or two; and he mistook accident for generality.

This was the very feature over which Bernini had taken so much trouble, studying it from his own face grimacing in a mirror.

Reynolds, due to a profound misunderstanding of Bernini's aims, singled out for criticism precisely those technical accomplishments of which the sculptor was most proud:

The folly of attempting to make stone sport or flutter in the air, is so apparent, that it carries with it its own reprehension; and yet to accomplish this, seemed to be the great ambition of many modern sculptors, particularly Bernini: his heart was so much set on overcoming this difficulty, that he was forever attempting it, though by that attempt he risked everything that was valuable in the Art [sculpture]. Bernini stands in the first class of modern sculptors, and therefore it is the business of criticism to prevent the ill effects of so powerful an example. From his very early work of Apollo and Daphne, the world justly expected he would rival the best productions of ancient Greece; but he soon strayed from the right path. And though there is in his works something which always distinguishes him from the common herd, yet he appears in his latter performances to have lost his way. Instead of pursuing the study of that ideal beauty with which he had so successfully begun, he turned his mind to an injudicious quest for novelty; attempted what was not within the province of the Art, and endeavoured to overcome the hardness and obstinacy of his materials; which even supposing he had accomplished, so far as to make this species of drapery appear natural,

the ill effect and confusion occasioned by its being detached from the figure to which it belongs, ought to have been alone a sufficient reason to have deterred him from that practice.

Reynolds drew the same lesson from *Neptune and Triton*:

We have not, I think, in our Academy, any of Bernini's works, except a cast of the head of his Neptune; this will be sufficient to serve us for an example of the mischief produced by this attempt of representing the effects of the wind: the locks of the hair are flying abroad in all directions, insomuch that it is not a superficial view that can discover what the object is which is represented, or distinguish those flying locks from the features, as they are all of the same colour, of equal solidity, and consequently project with equal force. The same entangled confusion which is here occasioned by the hair, is produced by drapery flying off; which the eye must, for the same reason, inevitably mingle and confound with the principal parts of the figure.

Reynolds's demolition of such crucial aspects of Bernini's sculpture and indeed his whole approach to art, combined with the censure of Winckelmann on the Continent, set the tone for a series of later detractors, although some of these criticisms must have been fuelled by anti-Catholic prejudice.

Most virulent of his critics in England was the moderately distinguished Neoclassical sculptor, John Flaxman. In his *Address on the Death of Thomas Banks* (another English sculptor, who died in 1805) Flaxman launched a tirade of abuse at Bernini's deliberate amalgamation of the arts of sculpture and painting, which his critic maintained should be kept quite separate and have different goals. Flaxman's choice of language is intemperate and his knowledge imperfect and prejudiced, so that it makes amusing reading today:

In Rome (the centre from which the arts have emanated for centuries past), about 150 years since, the taste of Bernini, the Neapolitan sculptor, infected and prevailed over the Florentine and Roman schools . . .

Before he was twenty years old, he not only composed but completed a marble group, the size of nature, of Apollo and Daphne, at the moment the nymph is changing into a laurel tree; the delicate characters of the figures, the sprightly expression, the smooth finish of the material and the light execution of the foliage, so captivated public taste that M. Angelo was forgotten, the antique statues disregarded, and nothing looked on with delight that was not produced by the new favourite . . .

The attitudes of his figures are much twisted, the heads turned with a meretricious grace, the countenances simper affectedly, or are deformed by low passions; the poor and vulgar limbs and bodies are loaded with draperies of such protruding or flying folds, as equally to expose the unskilfulness of the artist and the solidity of the material on which he worked.

Flaxman's views are typical of the Neoclassical generation for whom Bernini was 'a baneful influence, which corrupted public taste for upwards of one hundred years afterwards'.

Rudolf Wittkower sums up what ensued:

What Winckelmann, the classicist doctrinaire, had begun, Ruskin, the medieval revivalist, completed. To Ruskin it seemed 'impossible for false taste and base feeling to sink lower'. As if this slaughter of a great master's fame upon the altar of dogmatic ideas was not enough, those who in more recent times fanatically advocated 'truth to material' and 'functional art' regarded Bernini and all he stood for as the Antichrist personified.

As a corrective for this extreme 'modern' view, however, Wittkower was able to adduce a sensible statement made in 1951 by the greatest sculptor of the twentieth century, Henry Moore: 'Truth to material should not be a criterion of the value of a work – otherwise a snowman made by a child would have to be praised at the expense of a Rodin or a Bernini.' According to Wittkower this

reveals with unanswerable logic the fallacy of the reproof. It may not be by chance that Bernini's name, next to Rodin's, came to Henry Moore's mind when writing his lines; for basic tendencies of modern sculpture, though not, of course, its formal language, were anticipated by the great Baroque artist. His vision of space, his attempt to draw the beholder physically and emotionally into the 'aura' of his figures, closely corresponds to modern conceptions. It seems that such similarity of approach engenders a willingness to see his art with fresh eyes.

So it was that, just after the middle of the twentieth century, the tide began to turn back in Bernini's favour by the agency of a great sculptor and a distinguished art historian. Since 1955, Wittkower's monograph has stood like a beacon guiding both public and students of art back towards a just appreciation of the sculptor's stature.

In Bernini's native Italy, meanwhile, a Catholic country where it was slightly easier to shift biased opinions, a similar task had been performed as long before as 1900 by Stanislao Fraschetti, who published a luxuriously produced tome giving a fully documented and well illustrated historical account of all Bernini's activities.[3] This may have been occasioned by a revival of interest in Bernini in Rome caused by the tercentenary in 1898 of the sculptor's birth, when out of civic pride his memory was honoured by the erection of a marble plaque and a bust on the outside of his property in Via della Mercede. Even so, Bernini still remained to be popularized in Italy, against the currents of contemporary taste, until, in 1953, two years ahead of Wittkower in England, Mondadori published an inexpensive handbook in Italian by Valentino Martinelli. In 1965 Penguin produced Howard Hibbard's excellent survey in paperback, and so by then, it could be claimed, Bernini's star, eclipsed for so many years, shone once more in the firmament of great artists.

398. A late nineteenth-century lithograph by Jacottet (1890) showing the new railway running directly behind Bernini's monument to Louis XIV, now transformed into *Marcus Curtius*, at the bottom of the gardens of Versailles.

399. Lead cast of the equestrian monument next to I. M. Pei's glass pyramid in the courtyard of the Louvre.

Two practical manifestations of this revival may be mentioned. In France, where Bernini's reputation suffered its first reverse in the eyes of the Sun King himself, the equestrian monument that proved to be the focus of criticism and that over the centuries was banished ever further into the gardens of Versailles – until in the age of steam it was finally demeaned by having a railway line laid directly behind it – has recently enjoyed a reversal of fortune. Having survived both world wars unscathed (though unprotected), it was vandalized and covered with political graffiti. Ironically this had the effect of securing its salvation, for it has since been conserved and displayed, not in the Orangery, but in the royal stables (Grand Ecurie du Roi). Media interest on this account in the 1980s finally secured for it the accolade of having a copy cast in lead and displayed near I. M. Pei's scintillating glass pyramid of the new Grand Louvre. There it serves to articulate the great courtyard, only a stone's throw from the prestigious location always preferred by Bernini himself. A booklet aptly calling it a 'displaced' statue was published to draw attention to the spectacular and unexpected revival of its fortunes.[4]

A final vindication of Bernini's triumph over his critics came in his native land in 1992, when the Banca d'Italia issued a new banknote with the high face value of fifty thousand lire (roughly equivalent to twenty pounds sterling or thirty American dollars), starring on the obverse his distinctive face in middle life and featuring alongside it the *Triton Fountain*. On its reverse is a montage consisting of his drawing for the medal showing the Scala Regia, a diagram of its cross-section and *The Vision of the Emperor Constantine* with its triumphantly rearing horse. Italians and visitors are therefore daily reminded of Bernini's pre-eminence as one of the truly great figures of Italy – and of the world.

400. The new 50,000 lire banknote of 1992 by G. Pino, showing Bernini and his works.

The standard catalogue of Bernini's works is that by Wittkower, published in 1955 and revised most recently in 1990. (See Bibliography.) In all editions the catalogue numbers remain the same, and, for ease of reference, these have been provided whenever a work by Bernini is mentioned.

Prologue: 'Padre Scultore' - Pietro Bernini and his studio

1. Pope-Hennessy, 1963, see notes to plates 137–8; Bernini, 1989.
2. Pope-Hennessy, 1963, pl. 138, specified *Assumptions* in the Pinacoteca, Bologna, and in the North Carolina Museum of Art.
3. Pope-Hennessy, 1963, figs 151, 156.
4. Bernini, 1989, pl. XIII and p. 93, fig. 24a.
5. Pope-Hennessy, 1963, pl. 137; Bernini, 1989, pl. XVI, p. 94, fig. 27a.
6. Pope-Hennessy, 1963, pl. 114.
7. See below, p. 231, pl. 333.
8. Not treated here: see Wittkower, no. 16; and Bernini, 1989, p. 97, fig. 37a.

1. Father and son: Pietro and Gianlorenzo in partnership

1. Wittkower, no. 1.
2. Wittkower, no. 2.
3. Lavin, 1968, pp. 229–32; Scribner, 1991, pp. 50–1; Schlegel, 1978, no. 3, pp. 8–10. Three others connected with Bernini are recorded in contemporary documents but seem to be lost: a pair of seated putti bound together by a cloth belonged to the Barberini family ('*Due putti nel Naturale nudi a sedere con un pannino che li cingie*' – Barberini inventories between 1629 and 1640); and another belonging to the Ludovisi that showed a marble child weeping seated on a bed of flowers and bitten by a viper ('*Puttino di marmo piangente a sedere in una mappa di fiori morzicato da una vipera*' – Ludovisi inventory 1633): this can hardly be identical (as Lavin, 1968, p. 232, note 67, supposed, but Schlegel, 1967, did not) with the group now in Berlin showing a putto bitten by a dolphin, for the latter could not be confused with a snake, nor does that putto sit on a bed of flowers; nor is the villain of the piece in any way hidden, so that it could be taken as an allegory of deceit, as Bellori later described it.
4. Birgit Laschke, *Fra Giovan Angelo da Montorsoli: ein florentiner Bildhauer des 16. Jahrhunderts*, Berlin, 1993, p. 63, pls 49–51.
5. See Wittkower, 1990, pp. 138–9, pls 108–9.
6. It was sketched there by E. Parrocel (known as 'le Romain') around 1732 and carefully labelled 'in casa Bernini', see Borsi, Acidini Luchinat and Quinterio, 1981, unnumbered plate.
7. Olga Raggio, 'A New Bacchic Group by Bernini', in *Apollo*, 108, 1978, p. 106 ff.
8. Mark S. Weil, 'Un fauno molestato da cupidi: forma e significato', in Fagiolo dell'Arco, 1987, pp. 73–90.
9. Similar subjects were later taken up by and eventually became a hallmark of the Flemish immigrant sculptor François Duquesnoy.
10. Federico Zeri, *Mai di traverso*, Milan, 1982, pp. 95–6; idem, *Dietro l'immagine*, Milan, 1990, pp. 268–72, figs 34–7; Gonzales-Palacios, 1991, pp. 102–3, no. 3; A. Bacchi, *Scultura del '600 a Roma*, Milan, 1996, pls 203–6.
11. Sloane, 1974, pp. 551–4; Martinelli, 1962, pp. 267–88.
12. Martinelli, 1962, p. 287, doc. XXIX, (account rendered by the stonemasons Giuseppe di Giacomo and Paolo Massone and Company for services between January 1618 and the last day of July 1619) '*il lavoro dell'hornamento del giardino secreto la metà della balustra a mano manca dinanzi il Palazzo et altro . . . per le tre fontanelle fatte a cunchiglia di trevertino intagliate a bacelli con suoi piedi sotto la balaustra*', I am not sure if the connection between this documentary reference and the balustrade with fountains at Cliveden has been noted previously.
13. Wittkower, no. 3.
14. See Preimesberger, 1985, pp. 1–7, pls 1–4.
15. M. G. Ciardi Duprè, 'Per la cronologia dei disegni di Baccio Bandinelli fino al 1540', in *Commentari*, XVII, 1966, pp. 154–8, fig. 16, note 32.
16. C. de Tolnay, *Michelangelo, III, The Medici Chapel*, Princeton, N. J., 1970, pls 286–89.
17. Wittkower, no. 4.
18. Today it is in the Cathedral Museum in Florence.
19. See Lavin, 1968, pp. 233–4; A. F. Radcliffe et al., *The Thyssen-Bornemisza Collection: Renaissance and later sculpture*, London, 1992, no. 18.

2. Coming of age: the first portraits

1. See *Antichi Maestri Pittori*, (exh. cat.), Turin, 1992. no 7, pp. 100–9; my thanks are due to Dr Giancarlo Gallino for kindly supplying the photograph and permitting its reproduction.
2. R. Borghini, *Il Riposo*, 1584, pp. 21–2. These therefore provide a touchstone of excellence in Tuscan portraiture by which Gianlorenzo's efforts are to be judged. Indeed they serve as a valuable corrective to an over-indulgent assessment of his initial brilliance in this demanding field of sculpture. See: J. Pope-Hennessy, 'Portrait Sculptures by Ridolfo Sirigatti', in *Victoria and Albert Museum Bulletin*, I, 2, 1965, pp. 33–6.
3. A. Grisebach, *Römische Porträtbüsten der Gegenreformation*, Leipzig, 1936; Riccoboni, 1942, plates 121, 126, 149, 160, 163.
4. Wittkower, no. 2.
5. Lavin, 1968, pp. 224–7.
6. Lavin, 1968, pp. 237, 246, doc. 18; H. Olsen, *Statens Museum for Kunst, Aeldre Udenlandsk Skulptur*, Copenhagen, 1980, pp. 19–20, pl. 84.
7. Wittkower, no. 5.
8. Wittkower, no. 6 (1).
9. H. Olsen, *Statens Museum for Kunst, Aeldre Udenlandsk Skulptur*, Copenhagen, 1980, p. 20, pl. 83.
10. Françoise de la Moureyre-Gavoty, *Institut de France: Paris, Musée Jacquemart-André, Sculpture Italienne*, Paris, 1975, no. 194.
11. See entry by the present writer and essay by Charles Scribner III in Christie's, New York, 'An Important Sculpture by Bernini', 10 January 1990, lot 201.
12. This was when Bernini was engaged in Paris in 1665 on a bust of King Louis XIV, and Chantelou recorded the remarks in his diary, see below, pp. 237–45, also for literary references.
13. It took Giambologna a lifetime to earn such honours. He was seventy when he received the same Order of the Knights of Christ in 1599. He celebrated the award with a small self-portrait bust.

3. The great mythological groups: Aeneas, Proserpina and Daphne

1. Wittkower, no. 8, '*per una statua da lui fatta de novo*'; Kauffman, 1970, pp. 30–8.
2. Virgil, *Aeneid*, ii, l. 707 ff.
3. Aeneas' poor wife, Princess Creusa (daughter of King Priam of Troy), was unable to keep up, and so does not feature in this necessarily compact group.
4. Leonardo da Vinci in his *Treatise on Painting* of a century or more earlier had noted how youth, maturity and old age could easily be distinguished and should carefully be portrayed in the case of all animals, including man himself: 'All the parts of any animal should correspond with the age of the whole figure.' Young creatures (here Ascanius) have few muscles or veins showing on their limbs, which tend to be rounded or smooth, while grown men (here Aeneas) have a stronger, muscular appearance, and old ones (here Anchises) have a skin that is wrinkled, creased, veined and with many muscles showing. Bernini's sculpture thus provides an apt illustration to Leonardo's textbook: both artists of course understood that these characteristics were equally important to the accurate depiction of mankind and animals in sculpture as in painting.
5. It has been described how this was a replacement for a statue begun by Cordier. Cordier's partly carved block was given to Gianlorenzo, who carved out of it his *St Sebastian*.
6. It may also allude symbolically to his prowess as 'Pater Familias'.
7. Faldi, 1954, pp. 26–7, no. 32.
8. Preimesberger, 1985, pp. 7–10.
9. The very name of its Borghese patron, Scipione, means in Latin 'a staff' and this was the role that the cardinal-nephew was seen to fulfil with regard to his elderly uncle, Paul V. The physical support offered by Aeneas to his father symbolized Scipione's moral support of the pope, while the presence of the little Ascanius suggested continuity between the generations of the Church and the greater political strength that a joint effort produced. Maffeo Barberini, Gianlorenzo's protector and a cardinal colleague of Scipione's, was also writing at this very period about the notable expansion of the sway of the Catholic Church and may have made suggestions to both patron and sculptor about the treatment of this particular theme.
10. Wittkower, no. 11 (1); Giuliano, 1992, p. 209, repro. (model in private collection and marble statue in the Louvre).
11. Wittkower, no. 9; pp. 180–2 below.
12. Wittkower, no. 10; Faldi, 1954, no. 33; Kauffman, 1970, pp. 43–50.
13. Now lost; see p. 39.
14. Faldi, 1954, p. 30.
15. For example, Bartolommeo Ammanati's *Hercules and Antaeus* on the fountain in the garden of the Medici Villa Il Castello.
16. In the garden of Villa Il Boschetto, San Pietro di Lavagno, near Verona: Paola Rossi, *Girolamo Campagna*, Verona, 1968, pp. 26–7, pl. 16.
17. Lavin, 1981, pp. 57–61.
18. It is the visual equivalent of the figure known in rhetoric as 'chiasmos'.
19. This second rendering including Cerberus may have been influenced by the composition of a monumental bronze group of the same subject currently ascribed to Vincenzo de' Rossi, which was in a *casino* in the gardens of a house belonging to the Salviati family in Borgo Pinti, Florence (now on permanent loan from the National Trust to the Victoria and Albert Museum, London). There also exists, in the Museo Nazionale del Bargello, Florence, a reduced version of this in bronze in which Cerberus, long missing from the full-scale group, takes his due place beneath Proserpina, snapping at her feet as they hang tantalizingly down.

Though it is not exactly documented, this composition dates from before 1591, when the statuette featured in an inventory of the effects of Cardinal Ferdinando de' Medici from his villa in Rome, which was taken after he returned to Florence to assume the Grand Ducal crown in 1587. Therefore Pietro Bernini could possibly have known the monumental version from his Florentine apprenticeship, or the statuette after he went to Rome in 1580, and so been able to recall either (or both) thirty years later, when Gianlorenzo confronted the same subject. Antonia Bostrom, 'A bronze group of the Rape of Proserpina at Cliveden House in Buckinghamshire', in *Burlington Magazine*, CXXXII, 1990, pp. 829–40.

20. This is surprising, and may be due partly to the lack of photographs from the right angles, but it is also symptomatic of the tendency in traditional study of the history of art to divide Mannerism from the Baroque along the specious watershed of the year 1600 and to attribute radically different approaches to either style, rather than see them in large part as a continuum. Especially in the art of sculpture, with its greater practical difficulties than for instance those of painting, there is a marked tendency for practitioners to look very carefully at the work of their predecessors in order to take advantage of their solutions.

21. Avery and Radcliffe, 1978, no. 210.

22. Italo Faldi, 'Il mito della classicità e il restauro delle sculture antiche nel XVII secolo a Roma', in Giuliano, 1992, pp. 222–3.

23. Winner, 1985, pp. 193–207.

24. Later in his career, Gianlorenzo was involved by Pope Alexander VII in a project to remount the *Horse Tamers* at either side of a triumphal arch giving on to the Via Pia, as is recorded in a drawing in Berlin; see Winner, 1985, fig. 14.

25. Giuliano, 1992, pp. 2, 7, 74–83.

26. Wittkower, no. 18; Faldi, 1954, no. 35; Kauffman, 1970, pp. 59–77.

27. It should be noted that as the group was mounted lengthwise against a wall, only one long side of the pedestal was visible originally. The second cartouche supported by a stylized eagle was added to enhance the opposite side by Lorenzo Cardelli only in 1785, when the group was moved into a central position in the room (Faldi, 1954, p. 35, fig. 53a).

28. The Latin original inscribed on the cartouche of the pedestal reads: 'Quisquis amans sequitur fugitivae gaudia formae, Fronde manus implet, baccas seu carpit amaras.'

29. Chantelou, 1981, p. 36, 12 June 1665.

30. See p. 231.

31. Kauffman, 1970, pls. 34, 34a. Prototypes that Gianlorenzo could hardly have known by any stretch of the imagination have been noted in German art, a fine drawing of *Death and the Maiden* by Hans Leu of 1525, and a bronze group for a fountain in the castle at Trent by Peter Flötner, for which a small bronze model, piped to serve as a table fountain, exists in Nuremberg. The latter serves best by its leaden composition and prosaic rendering to show by contrast how brilliantly *mouvementé* and emotionally pregnant is Bernini's rendering.

32. It also features in low relief on an anonymous Italian plaquette, associated loosely with the 'Orpheus Master' (J. Pope-Hennessy, *Catalogue of Italian Plaquettes from the Kress Collection*, London, 1965, no. 309, fig. 280).

33. H. Utz, 'Skulpturen und andere Arbeiten des Battista Lorenzi', in *Metropolitan Museum Journal*, 7, 1973, pp. 37–70, especially pp. 59–60.

34. Preston Remington, 'Alpheus and Arethusa: a marble group by Battista Lorenzi', in *Bulletin of the Metropolitan Museum of Art*, 1933, pp. 61–5.

35. In a footnote Remington noted: 'It has been

suggested that Bernini may have known the group . . and based his composition upon it.'

36. See Kenseth, 1981, pp. 195–202, figs 17–27, for a telling sequence of photographs from rotating viewpoints.

37. Montagu, 1985, p. 26.

38. Montagu continues: 'and in the *Santa Bibiana*, in the Angels on the Altar of S. Agostino, and in the bust of Maria Duglioli Barberini, where in the lost original the lace collar was pierced so that one could see through it, and was so delicate that it seemed inconceivable that it could have been worked without breaking – so delicate in fact that it had to be protected by a metal cage or glass case'. For this bust see pp. 268, pl. 388.

39. Wittkower, no. 17; Faldi, 1954, no. 34; Kauffman, 1970, pp. 51–8.

40. By an at present anonymous sculptor – perhaps Rustici, Leonardo's associate – who also manufactured as finished statuettes in terracotta for domestic decoration many groups with unruly children and river-gods; see C. Avery, *Fingerprints of the Artist: European Terra-Cotta Sculpture from the Arthur M. Sackler Collections*, Cambridge, Mass., 1980, pp. 46–9, no. 9.

41. Chantelou, 1981, p. 58: 'Le Cavalier a dit qu'il s'est servi, pour tâcher d'y réussir, d'un moyen qu'il a trouvé de lui-même, qui est que, quand il veut donner l'expression à une figure qu'il voulait représenter, il se met dans l'acte même qu'il se propose de donner à cette figure, et se fait dessiner dans cet acte par un qui dessine bien.'

42. Haskell and Penny, 1981–2, p. 221, especially their statement: 'As early as 1622 an English visitor was told that the *Gladiator* was one of the two chief sculptures in the Villa Borghese.'

43. Preimesberger, 1985, pp. 10–13, for a wide-ranging analysis of this and other influences on Bernini's interpretation and composition and from which the citations in my text are drawn.

44. Preimesberger, 1985, pp. 12–13.

45. Kenseth, 1981, p. 194 ff.

4. The patronage of Urban VIII Barberini

1. Wittkower, nos 19 (1) and (1a).

2. Wittkower, no. 19 (2a); see below, p. 89.

3. This is neatly summarized by R. Preimesberger and M. Mezzatesta, s.v., 'Bernini', in *The Dictionary of Art*, London, 1996, 3, p. 834: 'Bernini's career as an architect began modestly in 1624 with the construction of the façade of S. Bibiana, Rome. Small though this project was in scope, it already showed the combination of tradition and originality that was to make his architecture so influential not only in Rome but also on the course of Baroque design throughout Europe. The façade consists of an open, arcaded loggia with a palace-like storey above. The central element of this upper part is a deep, pedimented aedicule that breaks dramatically the skyline of the balustraded flanking wings.'

4. Wittkower, no. 20.

5. This was a device Bernini might have learned from Jacopo Sansovino's clever use in his *Madonna del Parto* in Sant'Agostino, Rome, of a shell niche as a kind of halo for one or other figure, depending on one's point of view. C. Avery, *Florentine Renaissance Sculpture*, London, 1970, pl. 122.

6. For documents, see Pope-Hennessy, 1963, cat. p. 126 ff. The block of marble, at 60 scudi – the same price as for the one for *David* – represented ten per cent of the total outlay of 600 scudi.

7. Wittkower, no. 33.

8. See Mezzatesta, 1982, nos 2–4: to a total of six casts known hitherto may now be added a seventh, equally convincing, one illustrated here by courtesy of Messrs A. Vecht, Amsterdam.

9. M. Visonà, 'Stefano Speranza, uno scultore fra

Albani e Bernini', in *Paragone (Arte)* XLVI, 1995, pp. 81–109.

10. Wittkower, no. 34.

11. Lavin, 1981, pp. 72–7, no. 6.

12. Wittkower, no. 26.

13. See below, p. 255.

14. I. Lavin, 'Bernini's Memorial Plaque for Carlo Barberini', in *Journal of the Society of Architectural Historians*, XLII, 1983, 1, pp. 6–10.

15. Wittkower, no. 27.

16. Wittkower, no. 37.

17. Wittkower, no. 38.

5. Popes and prelates: the mature portraits

1. Wittkower, no. 13. The fact that Maffeo Barberini was still only a cardinal corroborates a document of late 1622: Lavin, 1968, p. 240.

2. Sir Joshua Reynolds, W. Cotton (ed.), *Notes on Pictures*, London, 1859, p. 7.

3. In the event they were bequeathed by a third party to the Confraternity of the Resurrection which ran San Giacomo degli Spagnuoli: see Lavin, 1993/94, p. 193.

4. Lavin (1993/94, pp. 205–6) points out that Gianlorenzo reduced the normal 'Four Last Things' to two allegories of Everyman and Everywoman in contrasting psychological and spiritual states: his choice of imagery is remarkably close to four engravings of heads in ovals representing *Death*, *Purgatory*, *Hell* and *Heaven* by a German engraver, Alexander Mair (1605). The busts also resemble some tiny images of related heads rendered in coloured wax by one Bernardo Azzolino, who joined the painters' guild in Rome in 1618 and so would have been known to Bernini, its president.

5. Wittkower, no. 15. Pietro Bernini carved one (or both) of the allegorical figures of *Religion* and *Wisdom* that flanked the tomb, but since demolition in 1843 everything save the bust has vanished.

6. Wittkower, no. 14.

7. I. Lavin, 'Bernini's bust of Cardinal Montalto', in *Burlington Magazine*, CXXVII, 1985, pp. 32–8.

8. The palace stood on the Esquiline Hill, where the main railway station of Rome now sprawls.

9. S. Rinehart, 'A Bernini Bust at Castle Howard', in *Burlington Magazine*, CIX, 1967, pp. 437–43; C. Avery in G. Jackson-Stops (ed.), *The Treasure Houses of Great Britain* (exh. cat.), National Gallery of Art, Washington D.C., New Haven and London, 1985, p. 271, no. 192; M. Baker, 'Bernini's bust of Monsignor Carlo Antonio del Pozzo' in *National Art-Collections Fund Review*, 1987, pp. 99–101. For the bust of Francesco Barberini, see Ulrich Middeldorf, *Catalogue of Sculpture in the Kress Collection*, London, 1976, pp. 80–1, (K-1828).

10. Wittkower, no. 36; for the small bronze versions, see G. Rubsamen, *The Orsini Inventories*, Malibu, Calif., 1980, p. 45, no. 72.

11. Letter from Fulvio Testi 29 January 1633 to Count Francesco Fontana; see Wittkower, no. 31.

12. Brauer and Wittkower, 1931, pl. 11.

13. Brauer and Wittkower, 1931, pl. 146a.

14. Now in the Galleria Nazionale d'Arte Antica, Rome, which happens to be in the Barberini Palace: Wittkower, no. 19 (2a).

15. Myron Laskin, Jr. and Michael Pantazzi (eds), Catalogue of the National Gallery of Canada, Ottawa, *European and American Painting, Sculpture, and Decorative Arts*, vol. 1: 1300–1800, Ottawa, 1987, pp. 30–2; see also *Vatican Splendour*, 1986, pp. 76–7, no. 14.

16. One of them was for the Barberini Palace. Another was commissioned for the town hall of Camerino in 1643, earning Bernini 300 scudi. This was probably negotiated by a certain Cardinal Giovi, who was presiding over the major project of Urban's tomb, and owned a marble version himself in his villa in Rome (Wittkower, nos 19 (6) and (2b)) until 1902, when it was removed to the Vatican Library

(Biblioteca Apostolica Vaticana, Museo Sacro, no. 227); Wittkower, no. 19 (2) and (2b); see also *Vatican Collections*, 1983, p. 84, no. 26; *Vatican Splendour*, 1986, p. 78, no. 15.

17. Wittkower, no. 19 (4); Louvre, no. 1544, see *Catalogue des Sculptures*, II, Paris, 1922, pp. 152–3; Bandera Bistoletti, 1985, pl. 44.

18. Noted by the author during a visit in 1974, this fine, contemporary cast may be identical with a lost one from Santa Maria di Monte Santo (Wittkower, no. 19 (4a)). It was purchased probably in the late nineteenth century by the ninth Duke of Marlborough, who converted to Catholicism and introduced two marble busts of cardinals into the palace as well, presumably to give a distinctly 'Roman' flavour to its interior, where the sculpture had been preponderantly secular hitherto.

19. Wittkower, no. 19 (5).

20. See Chapter Eleven.

21. Wittkower, no. 51 (2); he eventually bequeathed it to a mutual friend of his and of Queen Christina of Sweden, Cardinal Azzolino, who was described as his '*protettore cordialissimo*'.

22. Wittkower, nos 65, 78a (1966 ed.); see p. 266.

23. Wittkower, no. 35.

24. Wittkower, no. 41.

25. Wittkower, no. 54.

26. See below pp. 225 ff., 231 ff.

27. The Grand Duke of Tuscany, the Duke of Bracciano and Queen Christina of Sweden all reacted keenly to it.

28. F. Hartt, *Michelangelo: the Complete Sculpture*, London, 1969, p. 156, no. 15; p. 276, no. 34.

6. Architect to St Peter's: the Baldacchino and Cathedra Petri

1. Chantelou, 1981, entry for 23 August 1665; for the Baldacchino see Wittkower, no. 21.

2. Royal Collection, Windsor Castle (Blunt and Cooke, 1960, no. 23): sometimes attributed to Borromini, who certainly helped Bernini in designing the superstructure.

3. Montagu, 1989, p. 70.

4. Albertina, Vienna: see Kauffmann, 1970, pl. 51.

5. Victoria and Albert Museum, London, c. 60 cm. high (A.2–1974); see Montagu, 1989, p. 52, fig. 59.

6. Philipp Fehl, 'The "Stemme" on Bernini's Baldacchino in St Peter's: a Forgotten Compliment', in *Burlington Magazine*, CXVIII, 1976, pp. 484–91, figs 35–40, 43–8.

7. Wittkower, nos 28–9.

8. Joachim von Sandrart, A. R. Peltzer (ed.), *Académie der Bau-, Bild- und Mahlerey-Künste von 1675*, Munich, 1925, p. 286; see below, pp. 255–6.

9. R. Battaglia, *Crocifissi del Bernini in S. Pietro in Vaticano*, Rome, 1942; Wittkower, no. 57; *Vatican Collections*, 1982, no. 33; *Vatican Splendour*, 1986, p. 96, nos 24, 25; Montagu, 1996, pp. 121–2, figs 154–6.

10. Royal Collection, Windsor Castle (5634): Blunt and Cooke, 1960, p. 27, no. 66.

11. Christie's, London, 4 July 1989, lot 107.

12. An alternative model showing the living Christ on the cross was also produced, though in smaller numbers, see Wittkower, no. 57 (3) and Schlegel, 1978, pp. 5–9, no. 5.

13. Finberg 1919, p. 176.

14. Wittkower, no. 61.

15. W. Weaver, 'A Seat for St Peter', in *The Connoisseur*, September 1982, pp. 112–13; *Bernini in Vaticano*, 1981, p. 261, no. 264 and *Vatican Treasures*, 1993, pp. 165–6, no. 66.

16. *Vatican Treasures*, 1993, p. 165, no. 65.

17. The wooden casing was substituted with a more expensive bronze version cast by Del Duca in 1646, under Innocent X, but, once the ancient throne had been given a yet more sumptuous setting, it seems to have been melted down for the metal.

18. Lavin, 1981, pp. 174–93.

19. See below, pp. 119–26.

20. There are quite serious repairs in stucco on the bodies of these figures, though their feet and wings are authentic: Mezzatesta, 1982, no. 7, note 14.

21. The model and finished container bear two subsidiary scenes in which Peter was also involved in the New Testament: Christ giving him the notional keys of the church and Christ washing the disciples' feet as a sign of great humility, in the prelude to the Last Supper. See Mezzatesta 1982, figs 35–6.

22. In the Pinacoteca of the Vatican Museums: see *Bernini in Vaticano*, 1981, nos 111–12. The room in which all the big models are displayed, towards the end of the itinerary of the Pinacoteca, is often closed; it may be necessary to ask an attendant in order to see them.

23. See p. 256.

24. Wittkower, no. 61 (7).

25. Wittkower, no. 78; Borsi, 1984, pp. 348–49, no. 74; Laura Falaschi, 'Il Ciborio del Santissimo Sacramento in San Pietro in Vaticano' in Martinelli, 1996, pp. 71–136, 275–89.

26. Lavin, 1981, pp. 316–35, nos 89–93.

27. The State Hermitage Museum, St Petersburg (1867). I am indebted to Mrs Irina Grigorieva, Keeper of European Drawings, for supplying the photograph, through the good offices of my friend and colleague, Dr Sergei Androssov.

28. B. Boucher, *The Sculpture of Jacopo Sansovino*, New Haven and London, 1991, II, no. 16, pl. 111.

29. A trial cast for this statuette, rather flawed, survives in the Walters Art Gallery, Baltimore (54.2281: gift of C. Morgan Marshall 1942); see M. Weil, 'A statuette of the Risen Christ designed by Gianlorenzo Bernini', *Journal of the Walters Art Gallery*, XXIX–XXX, 1966–7, pp. 6–15; Mezzatesta, 1982, no. 11; C. Snow, 'Examination of a Bernini Bronze', *Journal of the Walters Art Gallery*, XLI, 1983, pp. 77–9; J. Spicer, 'A second Bernini bronze for the Walters', *The Walters: Monthly Bulletin*, November, 1992, pp. 4–5.

30. Mainly in Windsor and Leipzig.

31. See Lavin, 1978, pp. 398–405.

7. The papal tombs: Bernini and the Dance of Death

1. Compare with the last will and testament of Gianlorenzo Bernini: 'I leave the arrangements for my funeral to my heirs undersigned, reminding them that the poor deceased have greater need of masses and prayers to be said, than of the outward show of a funeral' (my translation from Borsi, Acidini Luchinat and Quinterio, 1981, p. 60).

2. Wittkower, no. 30; Lavin, 1981, pp. 62–71, nos 2–5.

3. Brauer and Wittkower, 1931, pp. 22–5.

4. Pope-Hennessy, 1963, pp. 97–8, pls 99–100.

5. For a detailed account of the tomb and the ramifications of its iconography, some of which are embodied in my text below, see Philipp P. Fehl, 'L'umiltà cristiana e il monumento sontuoso: la tomba di Urbano VIII del Bernini', in Fagiolo, 1987, pp. 185–207.

6. Della Porta's allegorical statues once on the pediment are not shown in pl. 148; see Riccoboni, 1942, pls 114–15; they were not so utilized and are now in Palazzo Farnese.

7. Riccoboni, 1942, pl. 9.

8. C. de Tolnay, *Michelangelo, I, The Youth of Michelangelo*, Princeton, N. J., 1969, pp. 38–9; this may be recorded in Bandinelli's drawing for a monument to Clement VII (now in the Louvre).

9. Riccoboni, 1942, pl. 98.

10. C. de Tolnay, *Michelangelo, I, The Youth of Michelangelo*, Princeton, N. J., 1969, pl. 249; F. Santi, *Vincenzo Danti Scultore*, Bologna, 1989, pl. 1.

11. Respectively, see Venturi, 1937, X, 3, p. 676, fig. 552 and p. 680, fig. 555.

12. John Evelyn, *The Diary*, A. Dobson (ed.), London, 1906, I, p. 185, 17 November.

13. L. O. Larsson, 'Gianlorenzo Bernini and Joseph Heinz', *Konsthistorisk Tidskrift*, 1/2, 1975, pp. 23–6.

14. O. Raggio in *Vatican Collections*, 1982, no. 27, writes eloquently: 'Charity's stance is a spiralling *contrapposto*. She holds a large child, who is feeding at her left breast, while she turns her head toward a little boy standing to her right. Leaning against a downturned torch, he seems to be wiping away his tears. On the other side of Charity, two babies, crouching on the ground, embrace and kiss. In 1980–1, a thick coat of black paint was removed from the surface of the sculpture. Some traces of an earlier water gilding were left, however, as well as a gold-leaf edge applied as a border to Charity's garments. The back of the group is unfinished. The artist worked the clay with fingers and modeling tools, achieving an effect of lively, energetic contrasts between the deep undercutting and sharp edges of the crumpled draperies and the tender surfaces of the naked bodies, highlighted by delicate brushwork – as on Charity's right shoulder – or by the application of a granular film of clay wash to the flesh of the two kissing babies. The technique and the amazing freshness of the group have precise parallels in the handling of some of the clay sketches by Bernini now in the Fogg Art Museum – especially, the sketch of a helmeted female figure for the memorial to Carlo Barberini.'

15. See pp. 91–2.

16. Brauer and Wittkower, 1931, pl. 13b.

17. Lavin, 1981, nos 3–5: three were originally on a single sheet, but two have been cut off.

18. Chantelou, 1981, p. 190: on seeing the skeletal *gisant* of Louis XII in St Denis.

19. Bernini, 1713, p. 171 ff: '*la divozione della buona morte*'.

20. *Ibid.*: '*Quel passo a tutti era difficile, perchè a tutti giungera nuovo, perciò si figurava spesso volte di morire, per poter con questo esercizio assuefarsi, e disporsi al combattimento del vero.*'

21. I. Lavin, 'Bernini's Death', in *Art Bulletin*, LIV, 1972, p. 184.

22. H. Knackfuss, *Holbein*, London, 1899, pp. 90–105, figs 71–9.

23. Blumenthal, 1980, no. 45.

24. Blumenthal, 1980, p. 152, no. 72.

25. De Courcy McIntosh (ed.), *Florentine Drawings of the Seventeenth and Eighteenth Centuries from the Musée des Beaux-Arts de Lille*, (exh. cat.), The Frick Art Museum, Pittsburgh, 1994.

26. Wittkower, no. 43; G. A. Popescu, 'Bernini e la stilistica della morte' in Fagiolo, 1987, pp. 173–84.

27. Wittkower, no. 43; originally it was on a pillar.

28. Ezekiel, chapter 37, vv. 1–37: Wittkower, no. 46; Blunt, 1978, p. 73; Lavin 1980, pp. 22–49, 188–92.

29. By Giorgio Ghisi, after a design by G. B. Bertano, both of Mantua: S. Massari (ed.), *Incisori Mantovani del '500, Giovan Baltista, Adamo, Diana Scultori e Giorgio Ghisi, dalle collezioni del Gabinetto Nazionale delle Stampe e della Calcografia Nazionale*, Rome, 1980, no. 202.

30. Marcello Aldega and Margot Gordon, *Italian Drawings XVI to XVIII Century*, (exh. cat.), New York and Rome, 1988, p. 50, no. 29: I am grateful to the owners for their kind permission to reproduce a photograph.

31. See C. Avery, in catalogue entry for Christie's sale, London, 15 December 1972, lot 311, with earlier literature. Purchased subsequently by the Victoria and Albert Museum, London.

32. Brauer and Wittkower, 1931, pls 113a and 113b.

33. See below, pp. 144–9.

34. Brauer and Wittkower, 1931, pls 121 and 193b; Wittkower, no. 81; *Bernini in Vaticano*, 1981, p. 259, no. 262; Marc Worsdale, 'Bernini studio drawings for a catafalque and fireworks', in *Burlington Magazine*, 1978, pp. 462–6.

35. Lavin, 1993/94, pl. 219.

36. Arts Council of Great Britain, *Italian Bronze Statuettes*, (exh. cat.), Victoria and Albert Museum, London,

1961, nos 187a–d; *Five College Roman Baroque Festival,* 1974; *Roman Baroque Sculpture,* (exh. cat.), Smith College Museum of Art, Northampton, Mass., 1974, nos 7–9; Borsi, Acidini Luchinat and Quinterio, 1981, p. 108: '*Quattro testine di getto di bronzo con li suoi piedi di pietra, quali erano li vasi della carrozza.*'

37. Wittkower, no. 77.
38. Zollikofer, 1994, to whose painstaking studies I am greatly indebted.
39. See p. 254.
40. Wittkower, no. 77.
41. Zollikofer, 1994, pp. 15–20.
42. Zollikofer, 1994, pp. 42–3.
43. Wittkower, no. 65 (4).
44. Wittkower, no. 64.
45. Wittkower, no. 56; Mezzatesta, 1982, no. 17.

8. *Mystic vision: the later religious sculpture*

1. Blunt, 1978, p. 67.
2. Blunt, 1978, p. 71.
3. Judith Bernstock, 'Bernini's Memorial to Maria Raggi', in *Art Bulletin,* LXII, 1980, p. 243 ff.; Lavin, 1980, pp. 67–70.
4. A prototype for Bernini's solution is to be found in Antonio Rossellino's memorial to Antonio Nori in Santa Croce, Florence, where a cloth of state is suspended from a mini-baldacchino against three faces of an octagonal pier: it hangs limply with only a few folds, while a superimposed aureole of black marble contains a vision of the Virgin and Child; see Lavin, 1980, fig. 125.
5. Blunt, 1978, p. 72, notes that the pier was originally in rough travertine stone, not clad as today in polished marble; thus the contrast of materials would have been more striking.
6. Incidentally, this is the statue that inspired Bernini's Aeneas in *The Flight from Troy.*
7. Blunt, 1978, p. 73; Lavin, 1980, pp. 22–49; Wittkower, no. 46.
8. Instances being, to name but the most prominent, the Chapel of the Cardinal of Portugal in San Miniato al Monte, Florence, by the Rossellino brothers, and the Chigi Chapel in Santa Maria del Popolo, Rome, by Raphael and his school, in which Bernini was to become personally involved later in his career; see below, p. 153.
9. Wittkower, no. 48; W. Barcham, 'Some new documents on Federico Cornaro's two chapels in Rome', *Burlington Magazine,* CXXXV, 1993, pp. 821–2.
10. Teresa, *Vita,* chapter XXIX, paragraphs 12–13; E. A. Peers, *Saint Teresa of Jesus: The Complete Works,* London and New York, 1963, I, p. 192 ff.
11. As pointed out by Lavin, 1980, p. 139.
12. The words were also echoed in the dedicatory inscription of 1652 to Cardinal Federico Cornaro.
13. Lavin, 1980, pls 183–91.
14. Lavin, 1981, nos 10–13.
15. Androssov, 1992, p. 59, no. 16.
16. Wittkower, no. 76; Blunt, 1978, pp. 79–80; S. K. Perlove, *Bernini and the Idealization of Death: The Blessed Ludovica Albertoni and the Altieri Chapel,* University Park, Pa. and London, 1990; Careri, 1995, pp. 51–86.
17. This was in order to expiate the crime of sodomy committed by his brother Luigi in 1670.
18. The windows are seven feet high and four feet wide.
19. Lavin, 1981, no. 86.
20. Androssov, 1992, no. 24.
21. Mezzatesta, 1982, no. 10.
22. For example Stefano Maderno's *St Cecilia* in Santa Maria in Trastevere, only a few hundred yards from San Francesco a Ripa.
23. Wittkower, no. 58; Lavin, 1981, pp. 164–73, nos 32–6.
24. J. Shearman, 'The Chigi Chapel in S. Maria del Popolo', in *Journal of the Warburg and Courtauld Institutes,* XXIV, 1961, pp. 129 ff.
25. Lorenzo Lotti, called Lorenzetto, 1490–1541: see

Venturi, *Storia,* 1935, X, I, pp. 302–16, figs 230–1; Pope-Hennessy, 1963, p. 44, fig. 44.
26. Lavin 1981, nos. 32–6.
27. Lavin, 1981, pp. 149–57, nos. 28–30.
28. Wittkower, no. 63; Lavin, 1981, pp. 228–40, nos. 59–62.
29. Borsi, 1984, figs 204–13.
30. Now in Termini Imerese, see Wittkower, no. 63; for a detailed discussion of this and other models, see Giancarlo Gentilini and Carlo Sisi, *La scultura: bozzetti in terracotta,* (exh. cat.), Palazzo Chigi Saraceni, Siena, 1989, nos. 229–37, colour plate XVIII.
31. Wittkower, no. 72; M. Weil, *The History and Decoration of the Ponte S. Angelo,* University Park, Pa. and London, 1974; D'Onofrio, 1981.
32. Peter was by Lorenzetto, 1530, and Paul by Pietro Taccone, 1464: see Riccoboni, 1942, pp. 14, 76, pl. 17; D'Onofrio, 1981, pls 30, 45, 57.
33. D'Onofrio, 1981, pl. 44.
34. The latter was the label 'Jesus of Nazareth, King of the Jews' (the Latin initials of which are I. N. R. I.) written by Pontius Pilate to affix to the top of the cross. This offended the Sanhedrin, but Pilate refused to alter it, in his famous words, 'Quod scripsi, scripsi' ('What I have written, I have written').
35. Except in the case of the two with the sponge and the spear at the Castel Sant'Angelo end, which could easily be seen from behind, from the road along the river bank.
36. This special viewing scenario is altered in the case of Bernini's original angels, which were kept back and ultimately displayed, as though they were meant to be a symmetrical pair, to either side of the chancel of Sant'Andrea delle Fratte, Bernini's own church, not fifty yards from his own house. For the drawings, see Brauer and Wittkower, 1931, pls 120a, 120b.
37. See Lavin, 1978; Androssov, 1992, nos 21–3; J.-R. Gaborit, *The Louvre, European Sculpture,* London, 1994; Barberini, 1991, pp. 47–8; Mezzatesta, 1982, nos 8–9.
38. D'Onofrio, 1981, pp. 92–3, pls 53–4.
39. Wittkower, no. 75; Careri, 1995, pp. 11–50.
40. Scribner, 1991, p. 114.
41. Blunt, 1978, p. 81; Martinelli, 1996, pp. 191–2, 225–6, 307–8.
42. Wittkower, no. 79; I. Lavin, 'Bernini's Death', *Art Bulletin,* LIV, 1972, p. 159 ff; I. Lavin, 'Afterthoughts on Bernini's Death', *Art Bulletin,* LV, 1973, pp. 429–36; J. C. Harrison, *The Chrysler Museum, Handbook of the European and American Collections. Selected Paintings, Sculpture and Drawings,* Norfolk, Va., 1992, p. 46, no. 37.
43. Here Baldinucci explains: 'He meant it as a gift for the monarch, but in this intention he was unsuccessful. The Queen's opinion of, and esteem for, the statue was so great that, not finding herself in circumstances in which it was possible to give a comparable gift in exchange, she chose to reject it rather than fail in the slightest degree to equal the royal magnificence of Bernini's spirit. Bernini, therefore, had to leave it to her in his will.'
44. Emilio Altieri (1590–1676), elected pope in 1670. Three busts were to be supplied: one for the room of his adopted nephew, Cardinal Paluzzo Albertoni-Altieri (of the Albertoni Chapel); one for the refectory of Santissima Trinità de' Convalescenti e dei Pellegrini, and another for the library of Palazzo Altieri, where the only surviving one is still to be found. See Wittkower, no. 78a (1966 ed.); Martinelli, 1959, pp. 204–27; Martinelli, 1965, pp. 282–6.
45. Notable are the struts of marble left to support the right arm and to brace the delicate fingertips. For safety's sake, these would have been removed only after the bust was installed: see p. 266.
46. A marble was sent to Paris in 1681, along with a fine copy of the bust of Christ, for Pierre Cureau de la Chambre: see Lavin, 1973, p. 429, note 8.

47. Luke, chapter 22, v. 42.
48. I. Lavin, 'On the Pedestal of Bernini's Bust of the Savior', *Art Bulletin,* LX, 1978, pp. 548–9.
49. Blunt, 1978, p. 81.

9. *'Friend of the waters': Bernini's Roman fountains*

1. Baldinucci, 1966, p. 147: '*che, essendo fatte le fontane per lo godimento dell'acqua doveansi quelle sempre far cadere in modo, che potessero esser vedute*'.
2. See p. 188.
3. 'Do you really dare, you winds, without my divine assent
 To confound earth and sky, and raise this riot of water?
 You, whom I – ! Well, you have made the storm, I must lay it.
 Next time, I shall not let you so lightly redeem your sins.
 Now leave, and quickly leave, and tell your overlord this –
 Not to him but to me was allotted the stern trident,
 Dominion over the seas . . .
 He spoke; and before he had finished, the insurgent sea was calmed,
 The mob of cloud dispersed and the sun restored to power.'
4. This is piped inside the hollow casting to emit water from its prongs, an illogical allusion to the classical myth, where water might have dripped, but not spurted, from the trident. The tensile strength of bronze enabled Lorenzi to make his figure stand up with its legs wide apart in action, while Bernini, by reverting to marble, was forced to insert the crouching Triton between the legs of his statue to lend physical support.
5. Hildegard Utz, 'Skulpturen und andere Arbeiten des Battista Lorenzi', in *Metropolitan Museum Journal,* 7, 1973, pp. 60–1, pls 6–7.
6. Avery and Radcliffe, 1978, no. 41.
7. The weathered originals are now in the Giardino del Lago in the park of the Villa Borghese: D'Onofrio, 1986, fig. 126.
8. Monsieur La Rocque, an 'amateur des arts' (according to the title of a book he published in 1783 about his Grand Tour in 1775–8), judged the group 'very ingeniously thought out', adding that, 'Bernini surpassed himself in the broad handling of its execution'. He approved of the measures taken to conserve it.
9. Androssov, 1992, p. 52.
10. Another plaster cast of it had belonged far earlier (before 1731) to the English sculptor Francis Bird.
11. Thomas Jenkins, a shrewd merchant banker and art dealer who resided in Rome, sold *Neptune and Triton* within months to Sir Joshua Reynolds, who wrote to the Duke of Rutland: 'I have made a great purchase of Mr Jenkins – a statue of Neptune and a Triton grouped together, which was a fountain in the Villa Negroni (formerly Montalto). It is near eight feet high and reckond [sic] Bernini's greatest work. It will cost me about seven hundred guineas before I get possession of it. I buy it upon speculation and hope to be able to sell it for a thousand.' It reached London in 1787, where it was admired in Sir Joshua's coach-house by, among others, the young sculptor Nollekens, who liked it as much as he did the work of Michelangelo and Giambologna. Exhibited in the Haymarket, Sir Joshua greedily broadcast an asking price of 1500 guineas, but there were no takers, and his executors eventually had to settle for a mere five hundred pounds. It was acquired by Lord Yarborough and, after a series of moves, reached Brocklesby Park in 1906, whence it was ultimately acquired by the Victoria and Albert Museum in 1950. Pope-Hennessy, 1964, pp. 596–600, no. 637: it cost the nation £15,000, with the assistance of the National

Art-Collections Fund, far less in real terms than Reynolds had paid for it in 1786, although admittedly it had suffered considerably more damage from exposure to the English weather.
12. Wittkower, no. 80 (1); D'Onofrio, 1986, pp. 356–70.
13. Avery, 1987, p. 214, 240–1.
14. D'Onofrio, 1986, pp. 130–3.
15. D'Onofrio, 1986, pp. 160–3.
16. Arduino Colasanti, *Le Fontane d'Italia*, Milan, 1926, p. 182; D'Onofrio, 1986, pp. 510–18.
17. Wittkower, no. 32; D'Onofrio, 1986, pp. 371–84.
18. Claudio Pizzorusso, *A Boboli e altrove, sculture e scultori Fiorentini del Seicento*, Florence, 1989, pp. 35–6, fig. 15.
19. Montagu, 1989, p. 30, fig. 35.
20. Sylvia Pressouyre, *Nicolas Cordier*, Rome, 1984, pp. 419–24, pls 212–17.
21. In the Biblioteca di Archeologia e Storia dell'Arte, Rome, Lanciani Collection.
22. Hibbard, 1965, p. 112.
23. Furthermore, as noted by Hibbard on p. 112, 'The image may be even more complex since dolphins symbolized princely benefaction and the bees on the Barberini arms were recognized emblems of divine providence. The Triton thus emerges as a symbol of enlightened papal government under divine guidance.'
24. Wittkower, no. 80 (2) and (3). The concept of a shell-shaped fountain projecting around the corner of a building recalls Buontalenti's fountain on the acute angle of the building at the junction of Borgo San Jacopo and Via dello Sprone in Florence, erected, it is thought, in *c.* 1608.
25. The horizontal lower valve of the shell with its corrugated edge may also be a recollection of the similar huge cockle-shell into which Neptune's trident spurts water in Stoldo Lorenzi's fountain in the Boboli Gardens, or of those that project between the curving steps of Francesco del Tadda's and G. F. Susini's *Fontana del Carciofo* (*Fountain of the Artichoke*) on the terrace behind the Pitti Palace.
26. By 1638 when it also featured in a description, Bernini had also created a similar fountain in the atrium of Palazzo Barberini, which, alas, is now lost: 'An open shell, into which a Sun showered water; around this sun a great bee [Apone] was in mid flight to quench its thirst, and also in turn to spread "honey-water".' The bee was some two feet across! Two whole and two half tortoises spouted water into a lower basin, and the niche was ornamented with fictive rocky masses.
27. Wittkower, no. 71.
28. See *Burlington Magazine*, September 1983, pl. 55: MS *Os Desenhos dos Antiguallias*, folio 31v., Library of El Escorial.
29. For example, the 'Pashley Sarcophagus', Fitzwilliam Museum, Cambridge (G. R. 1–1835).
30. Hibbard, 1965, p. 213.
31. Wittkower, no. 50; D'Onofrio, 1977, pp. 450–503.
32. Montagu, 1985, pp. 91, 483, pl. 74; also, compare with pl. 75.
33. Avery, 1987, pp. 215–18; 229.
34. Gallery of the Accademia di San Luca, Rome. See Gonzales-Palacios, 1991, no. 4; Angela Cipriani, 'Un bozzetto per il leone della Fontana dei Fiumi', in Fagiolo, 1987, pp. 139–48.
35. D'Onofrio, 1977, pp. 504–11.
36. She installed it on a fountain in the garden of the Villa Doria Pamphili on the Janiculan Hill. However, the original, very weathered, shell is preserved in the private apartments of Palazzo Doria Pamphili in the centre of Rome.
37. Two other *bozzetti* in Detroit, each with only a single Triton astride dolphins, and holding aloft a sea-serpent and a cockle-shell respectively, are slighter and so seem more likely to record abandoned ideas for replacing Giacomo della Porta's four statues in the basin around the periphery of the

fountain. They are no longer believed to be autograph productions by the master himself. See below, p. 258, pl. 376.
38. Wittkower, no. 80 (6).
39. In the Museo Estense; see J. Bentini (ed.), *Sculture a Corte: terrecotte, marmi, gessi della Galleria Estense dal XVI–XIX secolo*, (exh. cat.), Rocca di Vignola, Modena, 1996, p. xvi.
40. Wittkower, no. 80 (5).
41. Owing to a change of ownership of the palace at Via della Panetteria 15, the coat of arms has since been changed to those of the Antamoro family.

10. *Bernini's buildings: the sculptor as architect*
1. See above pp. 153–6.
2. R. Krautheimer, *The Rome of Alexander VII, 1655–1667*, Princeton, N. J., 1985, pp. 13–14.
3. S. Boorsch, 'The Building of the Vatican', *Metropolitan Museum of Art Bulletin*, Winter 1982–83, p. 28.
4. Borsi, 1984, pp. 64–96 for full survey of plans, elevations etc.
5. Borsi, 1984, p. 88, diagram.
6. V. Martinelli, *Le statue berniniane del Colonnato di San Pietro*, Rome, 1987.
7. Lavin, 1981, pp. 208–18, nos 49–55.
8. Borsi, 1984, pp. 178–83, 338, 358–9 documentary appendix F.
9. See below, p. 245.
10. Borsi, 1984, p. 178, fig. 244.
11. Wittkower, no. 62; Borsi, 1984, pp. 101–31, 332–338.
12. Borsi, 1984, p. 101.
13. Regrettably the feeling of unity is largely spoilt by a modern roadway, though it can still be apprehended out of peak hours.
14. Also for his 'builder-pope', Bernini redesigned the façade of a monastic church that had been built a short walk from Ariccia, at Galloro, as recently as 1624. Great clusters of superimposed pilasters on high pedestals that support the pediment project with sculptural force from the otherwise planar and unadorned façade, endowing it with considerable solidity and strength: this is a design of classic simplicity that is deeply satisfying.
15. Borsi, 1984, pp. 101–14, 332; Wittkower, no. 62 (3); Careri, 1995, pp. 87–101.
16. Now the official residence of the President of the Italian Republic and seat of high government ministries.

11. *England and France: Bernini, servant of Kings*
1. Lightbown, 1981, for the following account of the three busts for England.
2. It was bought by King George IV in 1822.
3. Wittkower, no. 39.
4. See p. 226.
5. Lightbown, 1968.
6. Borsi, Acidini Luchinat and Quinterio, 1981, p. 113.
7. Finberg, 1919, p. 170.
8. Wittkower, no. 40; Pope-Hennessy, 1964, p. 600, no. 638.
9. Recently expertly re-examined by M. Laurain-Portemer, 'Fortuna e sfortuna di Bernini nella Francia di Mazzarino', in Fagiolo, 1987, pp. 113–38: the following account is deeply indebted to this accurate summary of her earlier research.
10. Wittkower, no. 42 (1).
11. Wittkower, no. 42 (2); see R. Wittkower, 'Two Bronzes by Bernini', in *Art Bulletin of Victoria*, I, 1970–1, pp. 11–18; M. Laurain-Portemer, in Fagiolo, 1987, p. 120, fig. 4.
12. Borsi, Acidini Luchinat and Quinterio, 1981, p. 111.
13. Wittkower, no. 49.
14. Borsi, Acidini Luchinat and Quinterio, 1981, p. 42; Faldi, 1954, pp. 39–41, no. 37.
15. Lavin, 1981, p. 101, no. 14.
16. M. Laurain-Portemer, in Fagiolo, 1987, p. 126, fig. 5.
17. Borsi, Acidini Luchinat and Quinterio, 1981, pp. 42,

105: '*Un sasso che stava in strada fu venduto per scudi centoventi alli 8 gennaro 1689 . . .*'
18. Lavin, 1981, pp. 102–3, nos 15, 16.
19. M. Laurain-Portemer, in Fagiolo, 1987, p. 129, fig. 6.
20. M. Laurain-Portemer, in Fagiolo, 1987, p. 134, fig. 8.
21. Wittkower, no. 19 (4); Gould, 1982, p. 7; Bandera Bistoletti, 1985, pp. 43–4, note 14, figs 44–6.
22. Wittkower, no. 53.
23. Chantelou, 1981.
24. Gould, 1982, pp. 1, 2.
25. *St Jerome* and *St Mary Magdalene*, see pp. 157–61, and plates 209, 212.
26. The interested reader is accordingly referred to Cecil Gould's eminently readable book, *Bernini in France: an Episode in Seventeeth-Century History*, Princeton, N. J., 1982, and to the highly informative edition of Paul Fréart de Chantelou, A. Blunt *The Diary of the Cavaliere Bernini's Visit to France*, Guildford, 1986.
27. Gould, 1982, pp. 33–4.
28. Lavin, 1993/94, pp. 241–56.
29. Gould, 1982, p. 39.
30. Mark Jones, *A Catalogue of the French Medals in the British Museum, Volume Two, 1600–1672*, 1988, pp. 224–6, no. 239 (colour plates). Jones gives the relevant extracts from Chantelou and other sources.
31. Wittkower, no. 70.
32. See p. 251.
33. See below, p. 265.
34. Gould, 1982, p. 103.
35. Lavin, 1993/94, pp. 256–66.
36. Hoog, 1989, p. 37: this monograph on the equestrian monument discusses in detail the history, critical reception and subsequent fate of the group until today.
37. Hoog, 1989, figs 31–6.

12. *Genius of the Baroque: talents and techniques*
1. Borsi, 1980, pp. 107, 120.
2. Charles Avery, 'Terracotta: the fingerprints of the sculptor', in Avery, 1988, pp. 4–18.
3. Raggio, 1983.
4. Barberini, 1991; Barberini, 1994; Bianca di Gioia, 1991; *Bernini in Vaticano*, 1981, pp. 108–154; *Vatican Collections*, 1983, p. 80 ff.; Raggio, 1983; *Vatican Splendour*, 1986, pp. 90–3.
5. Norton, 1914; Opdycke, 1938; Lavin, 1978.
6. See Androssov, 1992, pp. 52–78, nos 13–29.
7. Barberini, 1994.
8. Androssov, 1992, pp. 139–53.
9. Raffaello Borghini, *Il Riposo*, Florence, 1584, p. 184. See Charles Avery, 'Giambologna's sketch-models and his sculptural technique', in Avery, 1988, pp. 79–86; see also Lavin, 1967; Grazia Agostini, 'La "pratica" del bozzetto', in *La Civiltà del Cotto*, (exh. cat.), Impruneta, 1980, pp. 114–21; Elena Bianca di Gioia, 'Bozzetti e modelli: breve nota sulla loro funzione e sulle tecniche in uso tra XVI e XVII secolo', in *Archeologia nel Centro Storico*, (exh. cat.), Castel Sant'Angelo, Rome, 1986, pp. 161–5.
10. Admittedly, the normally reasonably reliable German artist-historian Sandrart recalled seeing twenty-two models for the *St Longinus* in the studio. These he described as being made of wax, but he may have mistaken the medium, for the only surviving such models are in clay: Joachim von Sandrart, A. Peltzer (ed.), *Teutsche Akademie*, (Nürnberg 1675), 1925, p. 286. For the bozzetto of Alexander VII in the Victoria and Albert Museum, London (A. 17-1932), see Pope-Hennessy, 1964, no. 639.
11. The house proved to have been the home of a little-known sculptor of the generation after Bernini, Francesco Antonio Fontana, who inhabited it between 1696 and his death in 1707. He had acquired antiquities and worked for the important Chigi family in the 1660s and 1670s. See Elena

Bianca di Gioia, 'Bozzetti barocchi dallo studio di F. A. Fontana', entry no. 12, in *Archeologia nel Centro Storico*, (exh. cat.), Castel Sant'Angelo, Rome, 1986, pp. 171–9; *idem*, 'Un bozzetto del "San Longino" di Gian Lorenzo Bernini ritrovato nella bottega di Francesco Antonio Fontana', in *Antologia di Belle Arti*, N. S., entry nos 21–2, 1984, pp. 65–9; *idem*, 1990, pp. 40–3.

12. Interestingly enough Farsetti also owned a full-size plaster cast of the complete group of *Neptune and Triton*.

13. Heavily overpainted to resemble bronze and thoroughly cleaned in 1988, they were probably some of the terracottas once owned by Cardinal Flavio Chigi (1641–93) that were described in an inventory of the collection in the Casino at the Quattro Fontane in 1692: see Raggio, 1983.

14. While both models used to be in the collection of the Chigi family, they are – surprisingly – not an exact pair and seem to have been acquired by Cardinal Flavio at different dates. Habbakuk was his by 1666, but Daniel did not enter the collection until 1692, at the same time as the successive models for the figure of Charity on the Tomb of Urban VIII: see Raggio, 1983, p. 379, notes 20–1.

15. Mark Jones, 'Jean Warin', in *The Medal*, 11, Summer 1987, pp. 7–23; see especially fig. 26, a double portrait of Warin showing a classical coin to Louis as a little boy.

16. See p. 244, plates 352–4.

17. Wittkower, 1951, pp. 9–12.

18. Wittkower, no. 78a (1966 ed.).

19. Donald Beecher and Massimo Gavolella, 'A Comedy by Bernini', in Lavin, 1985, pp. 63–113.

20. Brauer and Wittkower, 1931; Lavin, 1981.

21. Luigi Michelini Tocci and Marc Worsdale, 'Bernini nelle medaglie e nelle monete', in *Bernini in Vaticano*, 1981, pp. 281–309.

22. Kunstmuseum, Düsseldorf; see Tocci and Worsdale in *Bernini in Vaticano*, 1981, p. 303, no. 314.

23. I. Lavin, 'Bernini and the Art of Social Satire', in Lavin, 1981, pp. 26–54.

*Epilogue: Bernini the man -
life, death and reputation*

1. Finberg, 1919, p. 171.
2. R. Lavine (ed.), *Sir Joshua Reynolds: Discourses on Art*, New York, 1961, pp. 58, 161–2.
3. Stanislao Fraschetti, *Il Bernini: la sua vita, la sua opera, il suo tempo*, Rome, 1900.
4. Hoog, 1989.

Bibliography

ANDROSSOV, 1992
Sergei Androssov, *Alle origini di Canova: le terrecotte della collezione Farsetti*, (exh. cat.), Rome and Venice, 1992.
AVERY, 1987
Charles Avery, *Giambologna: the Complete Sculpture*, Oxford, 1987.
AVERY, 1988
Charles Avery, *Studies in European Sculpture II*, London, 1988.
AVERY AND RADCLIFFE, 1978
Charles Avery and Anthony Radcliffe, *Giambologna, Sculptor to the Medici*, (exh. cat.), London, 1978.
BACCHI, 1996
Andrea Bacchi, *Scultura del '600 a Roma*, Milan, 1996.
BALDINUCCI, 1966
Catherine and Robert Enggass, *The Life of Bernini by Filippo Baldinucci*, University Park, Pa. and London, 1966.
BANDERA BISTOLETTI, 1985
Sandrina Bandera Bistoletti, 'Bernini in Francia: lettura di testi berniniani: qualche scoperta e nuove osservazioni. Dal *Journal* di Chantelou e dai documenti della Bibliothèque Nationale di Parigi', in *Paragone, Arte*, XXXVI, no. 429, November 1985, pp. 43–76.
BARBERINI, 1991
Maria Giulia Barberini, *Sculture in Terracotta del Barocco Romano: Bozzetti e modelli del Museo Nazionale del Palazzo di Venezia*, (exh. cat.), Rome, 1991.
BARBERINI, 1994
Maria Giulia Barberini, 'I bozzetti ed i modelli dei secoli XVI–XVIII della collezione di Bartolomeo Cavaceppi', in Maria Giulia Barberini and Carlo Gasparri, *Bartolomeo Cavaceppi, scultor romano (1717–1700)*, (exh. cat.), Rome, 1994, pp. 115–37.
BERNINI, 1713
Domenico Bernini, *Vita del Cavalier Gio. Lorenzo Bernini*, Rome, 1713.
BERNINI, 1989
Scramasax, *Pietro Bernini: un preludio al Barocco* (exh. cat.), Florence, 1989.
BERNINI IN VATICANO, 1981
Comitato Vaticano per l'anno Berniniano, *Bernini in Vaticano*, (exh. cat.), Vatican, 1981.
BIANCA DI GIOIA, 1990
Elena Bianca di Gioia, *Museo di Roma: Le Collezioni di Scultura del Seicento e Settecento*, Comune di Roma, no. 28, Rome, 1990.
BLUMENTHAL, 1980
Arthur R. Blumenthal, *Theater Art of the Medici*, (exh. cat.), Hanover, N. H. and London, 1980.

BLUNT AND COOKE, 1960
Anthony Blunt and H. L. Cooke, *The Roman Drawings of the Seventeenth and Eighteenth centuries in the Collection of Her Majesty the Queen at Windsor Castle*, London, 1960.
BLUNT, 1978
Anthony Blunt, 'Gianlorenzo Bernini: illusionism and mysticism', in *Art History*, I, 1978, pp. 67–89.
BOORSCH, 1982
Suzanne Boorsch, 'The Building of the Vatican', in *The Metropolitan Museum of Art Bulletin*, Winter 1982.
BORSI, 1984
Franco Borsi, *Bernini*, New York, 1984.
BORSI, ACIDINI LUCHINAT AND QUINTERIO, 1981
Franco Borsi, Cristina Acidini Luchinat and Francesco Quinterio, *Gian Lorenzo Bernini: Il testamento; La casa; La raccolta dei beni*, Florence, 1981.
BRAUER AND WITTKOWER, 1931
H. Brauer and R. Wittkower, *Die Zeichnungen des Gianlorenzo Bernini*, Berlin, 1931.
CARERI, 1995
Giovanni Careri, *Bernini: Flights of Love, the Art of Devotion*, Chicago, Ill. and London, 1995.
CHANTELOU, 1981
Paul Fréart de Chantelou, *Journal de Voyage du Cavalier Bernin en France*, edited by Ludovic Lalanne with notes by Jean Paul Guibbert, Clamecy, 1981.
FAGIOLO DELL'ARCO, 1967
Maurizio and Marcello Fagiolo dell'Arco, *Bernini: una introduzione al gran teatro del barocco*, Rome, 1967.
FAGIOLO, 1987
Marcello Fagiolo (ed.), *Gian Lorenzo Bernini e le arti visive*, Rome, 1987.
FALDI, 1954
Italo Faldi, *Galleria Borghese: le sculture del secolo XVI al XIX*, Rome, 1954.
FINBERG, 1919
A. J. Finberg, 'The Diary of Nicholas Stone, Junior', in *The Walpole Society*, VII, 1918–19.
GIULIANO, 1992
Antonio Giuliano, *La collezione Boncompagni Ludovisi: Algardi, Bernini e la fortuna dell'antico*, (exh. cat.), Rome, 1992.
GONZALES-PALACIOS, 1991
Alvar Gonzales-Palacios, *Fasto Romano: dipinti, sculture, arredi dai palazzi di Roma*, (exh. cat.), Rome, 1991.
GOULD, 1982
Cecil Gould, *Bernini in France: An Episode in Seventeenth-Century History*, Princeton, N. J., 1982.
HASKELL AND PENNY, 1981–2
Francis Haskell and Nicholas Penny, *Taste and the Antique*, New Haven and London, 1981.

HIBBARD, 1965
Howard Hibbard, *Bernini*, Harmondsworth, 1965.
HOOG, 1989
Simone Hoog, *Le Bernin Louis XIV, une statue "déplacée"*, Paris, 1989.
KAUFFMAN, 1970
Hans R. Kauffmann, *Giovanni Lorenzo Bernini: die figürlichen Kompositionen*, Berlin, 1970.
KENSETH, 1981
Joy Kenseth, 'Bernini's Borghese Sculptures: Another View', in *Art Bulletin*, June 1981, pp. 191–202.
LAVIN, 1967
Irving Lavin, 'Bozzetti and Modelli: Notes on Sculptural Procedure from the Early Renaissance through Bernini', in *Akten der 21. Internationalen Congresses für Kunstgeschichte, 1964: Stil und Uberlieferung*, 1967, pp. 93–104.
LAVIN, 1968
Irving Lavin, 'Five new youthful sculptures by Gianlorenzo Bernini and a revised chronology of his early works', in *Art Bulletin*, 1968, pp. 223–48.
LAVIN, 1973
Irving Lavin, 'Afterthoughts on Bernini's Death', in *Art Bulletin*, LV, 1973, pp. 429–36.
LAVIN, 1978
Irving Lavin, 'Calculated Spontaneity: Bernini and the terracotta sketch', in *Apollo*, CVII, 1978, pp. 398–405.
LAVIN, 1980
Irving Lavin, *Bernini and the Unity of the Visual Arts*, New York and London, 1980.
LAVIN, 1981
Irving Lavin et al., *Drawings by Gianlorenzo Bernini from the Museum der Bildenden Künste Leipzig, German Democratic Republic*, (exh. cat.), Princeton, N. J., 1981.
LAVIN, 1985
Irving Lavin (ed.), *Gianlorenzo Bernini: New Aspects of His Art and Thought, A Commemorative Volume*, University Park, Pa. and London, 1985.
LAVIN, 1993/94
Irving Lavin, *Past-present: Essays on Historicism in Art from Donatello to Picasso*, Princeton, N. J., 1993 (references to the Italian edition *Passato e presente nella storia dell'arte*, Turin, 1994).
LIGHTBOWN, 1968
Ronald Lightbown, 'The Journey of the Bernini bust of Charles I to England', in *The Connoisseur*, CLXIX, 1968, pp. 217–20.
LIGHTBOWN, 1981
Ronald Lightbown, 'Bernini's Busts of English Patrons', in *Art the Ape of Nature: Studies in Honor of H. W. Janson*, New York, 1981.

MARTINELLI, 1959
Valerio Martinelli, 'Novità Berniniane, 3. Le sculture per gli Altieri', *Commentari*, X, 1959, pp. 204–27.
MARTINELLI, 1962
Valerio Martinelli, 'Novità Berniniane, 4: "Flora" e "Priapo", i due termini già nella Villa Borghese a Roma', in *Commentari*, XIII, 1962, pp. 267–88.
MARTINELLI, 1965
Valerio Martinelli, 'Note sul Clemente X di G. L. Bernini, *Commentari*, XVI, 1965, pp. 282–6.
MARTINELLI, 1994
Valerio Martinelli, *Gian Lorenzo Bernini e la sua cerchia*, Naples, 1994.
MARTINELLI, 1996
Valerio Martinelli (ed.), *L'Ultimo Bernini 1665–1680: Nuovi argomenti, documenti e immagine*, Rome, 1996.
MEZZATESTA, 1982
Michael P. Mezzatesta, *The Art of Gianlorenzo Bernini*, (exh. cat.), Fort Worth, Tex., 1982.
MONTAGU, 1985
Jennifer Montagu, *Alessandro Algardi*, New Haven and London, 1985.
MONTAGU, 1989
Jennifer Montagu, *Roman Baroque Sculpture: the Industry of Art*, New Haven and London, 1989.
MONTAGU, 1996
Jennifer Montagu, *Gold, Silver and Bronze, Metal Sculpture of the Roman Baroque*, New Haven and London, 1996.
NORTON, 1914
Richard Norton, *Bernini and other studies in the history of art*, New York and London, 1914.
D'ONOFRIO, 1977
Cesare d'Onofrio, *Acque e fontane di Roma*, Rome, 1977.
D'ONOFRIO, 1981
Cesare d'Onofrio. *Gian Lorenzo Bernini e gli angeli di Ponte S. Angelo: storia di un ponte*, Rome, 1981.
D'ONOFRIO, 1986
Cesare d'Onofrio, *Le Fontane di Roma*, Rome, 1986.

OPDYCKE, 1938
Leonard Opdycke, 'A group of models for Berninesque sculpture', in *The Bulletin of the Fogg Museum of Art, Harvard University*, VII, 1938, pp. 26–30.
POPE-HENNESSY, 1963
John Pope-Hennessy, *High Renaissance and Baroque Sculpture*, London, 1963.
POPE-HENNESSY, 1964
John Pope-Hennessy, *Catalogue of Italian Sculpture in the Victoria and Albert Museum*, London 1964.
PREIMESBERGER, 1985
Rudolf Preimesberger, 'Themes from Art Theory in the Early Works of Bernini', in Lavin, 1985, pp. 1–18.
RAGGIO, 1983
Olga Raggio, 'Bernini and the Collection of Cardinal Flavio Chigi', in *Apollo*, 1983, pp. 368–79.
RICCOBONI, 1942
Alberto Riccoboni, *Roma nell'arte, la scultura nell'evo moderno*, Rome, 1942.
SCHLEGEL, 1978
Ursula Schlegel, Staatliche Museen, Preussischer Kulturbesitz: *Die Bildwerke der Skulpturengalerie Berlin: Band 1, Die italienischen Bildwerke des 17. und 18. Jahrhunderts in Stein, Holz, Ton, Wachs und Bronz mit Ausnahme der Plaketten und Medaillen*, Berlin, 1978.
SCRIBNER, 1991
Charles Scribner III, *Gianlorenzo Bernini*, New York, 1991.
SLOANE, 1974
Catherine Sloane, 'Two Statues by Bernini in Morristown, New Jersey', in *Art Bulletin*, LVI, December 1974, pp. 551–4.
TORRITI, 1975
Pietro Torriti, *Pietro Tacca da Carrara*, Genoa, 1975.
VATICAN COLLECTIONS, 1983
Metropolitan Museum of Art and Musei Vaticani, *The Vatican Collections: the Papacy and Art*, (exh. cat.), New York, 1983.

VATICAN SPLENDOUR, 1986
Catherine Johnston, Gyde Vanier Shepher and Marc Worsdale, *Vatican Splendour: Masterpieces of Baroque Art*, (exh. cat.), Ottawa, 1986.
VATICAN TREASURES, 1993
Giovanni Morello (ed.), *Vatican Treasures: 2000 Years of Art and Culture in the Vatican and Italy*, (exh. cat.), Milan and New York, 1993.
VENTURI, 1937
Adolfo Venturi, *Storia dell'Arte Italiana, X, La scultura del Cinquecento*, Milan, 1937.
WINNER, 1985
Matthias Winner, 'Bernini the sculptor and the classical heritage in his early years: Praxiteles', Bernini's, and Lanfranco's Pluto and Proserpina', in *Römisches Jahrbuch für Kunstgeschichte*, 22, 1985, pp. 195–207.
WITTKOWER, 1951
Rudolf Wittkower, 'Bernini's bust of Louis XIV', Oxford (The Charlton Lectures on Art), 1951.
WITTKOWER, 1961/1975
Rudolf Wittkower, 'The Vicissitudes of a dynastic monument: Bernini's equestrian statue of Louis XIV', in Rudolf Wittkower, *Studies in the Italian Baroque*, London, 1975, pp. 84–102.
WITTKOWER, 1990
Rudolf Wittkower, *Bernini: the sculptor of the Roman Baroque*, Milan, 1990 (the latest edition of his monograph of 1955, previously revised in 1966 and 1981).
ZOLLIKOFER, 1994
Kaspar Zollikofer, *Berninis Grabmal für Alexander VII. Fiktion und Repräsentation*, (Römische Studien der Bibliotheca Hertziana, vol. 7), Worms, 1994.

Photo Credits

DAVID FINN:
2, 3, 4, 5, 6, 9, 11, 14, 29, 30, 37, 40, 41, 42, 44, 49, 52, 53, 56, 58, 61, 65, 66, 67, 68, 70, 73, 74, 75, 78, 81, 85, 86, 91, 98, 105, 110, 134, 135, 136, 137, 142, 154, 155, 156, 162, 172, 179, 180, 181, 182, 184, 186, 187, 192, 193, 194, 197, 198, 199, 202, 203, 204, 205, 206, 207, 209, 211, 212, 214, 216, 220, 221, 222, 223, 226, 230, 231, 232, 233, 234, 236, 237, 242, 248, 250, 251, 252, 259, 260, 267, 268, 283, 284, 288, 289, 297, 298, 307, 319, 320, 323, 324, 325, 326, 334, 340, 351, 357, 360, 361, 362, 368, 369, 370, 371, 380, 384, 386

MUSEUMS AND GALLERIES

Bassano del Grappa, Museo Civico: 358
Berlin, Staatliche Museen Preussischer Kulturbesitz: 13, 15, 366
Blenheim Palace: 101
Bologna, Museo Civico: 286
Boston, Boston Museum of Fine Arts: 7
Cambridge, Mass., Fogg Museum of Art, Harvard University: 141, 146, 211, 221, 222, 223, 226, 304, 362, 364, 365, 369, 370, 371
Chicago, The Art Institute of Chicago: 50
Cleveland, © The Cleveland Museum of Art, 1997, John L. Severance Fund, 1968.101: 375
Copenhagen, Statens Museum for Kunst: 34, 38
Detroit, Detroit Institute of Arts: 134, 376
Dresden, Gemäldegalerie Alte Meister: 12
Düsseldorf, Akademie: 290
Edinburgh, National Galleries of Scotland: 94, 359

Florence, Museo Nazionale del Bargello: 305
Fort Worth, Texas, Kimbell Art Museum: 220, 224
Glasgow, Glasgow University: 363
Hamburg, Hamburger Kunsthalle: 95
Leipzig, Museum der bildenden Künste: 51, 83, 88, 143, 157, 159, 160, 161, 213, 218, 285, 337, 339, 378, 379, 396
London, The Royal Collection © Her Majesty Queen Elizabeth II: 140, 178, 195, 213, 239, 256, 271, 272, 291, 295, 299, 300, 301, 327, 329, 331; By courtesy of the National Portrait Gallery (private collection): 328; Reproduced by courtesy of the Trustees of the National Gallery: 335; Copyright British Museum: 173, 330, 336, 347, 348, 353, 354, 393; © The Board of the Trustees of the Victoria and Albert Museum: 36, 116, 200, 242, 248, 303, 332, 367, 368, 379, 397
Madrid, Thyssen-Bornemisza Foundation: 28
Malibu, J. Paul Getty Museum: 14, 302
New York, The Metropolitan Museum of Art: 17, 18, 19, 21, 64, 341; Pierpont Morgan Library: 96; M. Aldega and M. Gordon, 171
Norfolk, Virginia, Chrysler Museum: 241
Ottawa, National Gallery of Canada: 100
Paris, Château de Versailles: 351, 360, 380; Galerie Uraeus: 22; Musée du Louvre: 77, 334, 338, 344, 346, 350, 390
Rome, Galleria Nazionale: 240; Biblioteca Vaticana: 97, 139, 272, 342; Museo di Roma: 119; Musei Vaticani: 62, 154, 306, 374; Museo di Palazzo Venezia: 225, 294, tailpiece; Gabinetto Nazionale delle Stampe: 217

Saint Petersburg, State Hermitage Museum: 144, 228, 229, 247, 377
Toronto, Art Gallery of Ontario: 394, 395; Mr and Mrs J. Tanenbaum: 39, 40
Truro, County Museum and Art Gallery: 392
Vienna, Graphische Sammlung Albertina: 113
Washington D.C., National Gallery of Art, Samuel H. Kress Collection: 93

PHOTOGRAPHERS AND AGENCIES

Jorg P. Anders, Berlin: 366
Anderson/Alinari: 45, 71, 80, 84, 90, 102, 151, 314
Archives Photographiques, Paris: 334
Victoria Avery: 139, 372, 373
Tim Benton: 56
Caisse Nationale des Monuments Historiques, Paris: 343
Christie's Images, London: 172, 177
Conway Library, Courtauld Institute of Art, London: 32, 33, 92, 104, 109, 173, 249, 258, 305, 346, 392
Giraudon, Paris: 333
Studio Krimp: 82
Georgina Masson: 268
Réunion des Musées Nationaux, Photo H. Lewandowski: 77
Scala, Milan: 138
John D. Schiff, New York: 341
Soprintendenza per i beni artistici e storici di Roma: 225, 294

Index

Numbers in **bold** refer to plates

A *modellino* in terracotta by Bernini for an escutcheon
on the *Fountain of the Four Rivers*
(Museo di Palazzo Venezia, Rome).
See plate 277.